Meissen Snuff Boxes
of the Eighteenth Century

RÖBBIG · MÜNCHEN HIRMER

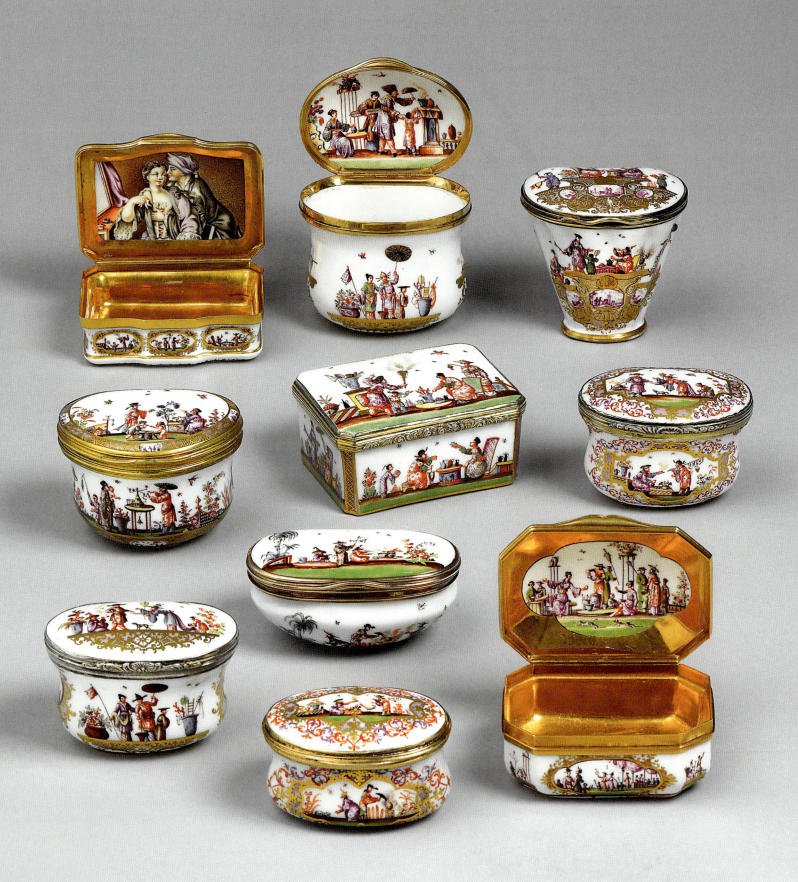

Table of Contents

Foreword	5
Porcelain Snuff Boxes of the Eighteenth Century: An Introduction *Barbara Beaucamp-Markowsky*	8

Essays

Snuff Boxes and the Taking of Snuff: On the Purpose of Luxury *Hans Ottomeyer*	14
Precious Snuff Boxes in Princely Collections of the Eighteenth Century *Lorenz Seelig*	28
Pleasure and Principle: Collecting Snuff Boxes from 1800 onwards *Heike Zech*	50
Eighteenth-Century Meissen Porcelain Snuff Boxes *Ulrich Pietsch*	70
Image and Symbol: On the Use and Meaning of the Snuff Box as Reflected by Meissen Figures of the Eighteenth Century *Sarah-Katharina Acevedo*	100

Catalogue 118

Appendix

The Work Reports of Meissen Modellers and Decorators concerning Snuff Boxes *Selected and transcribed by Ulrich Pietsch*	378
Literature	410
Index	422
Image Credits	434

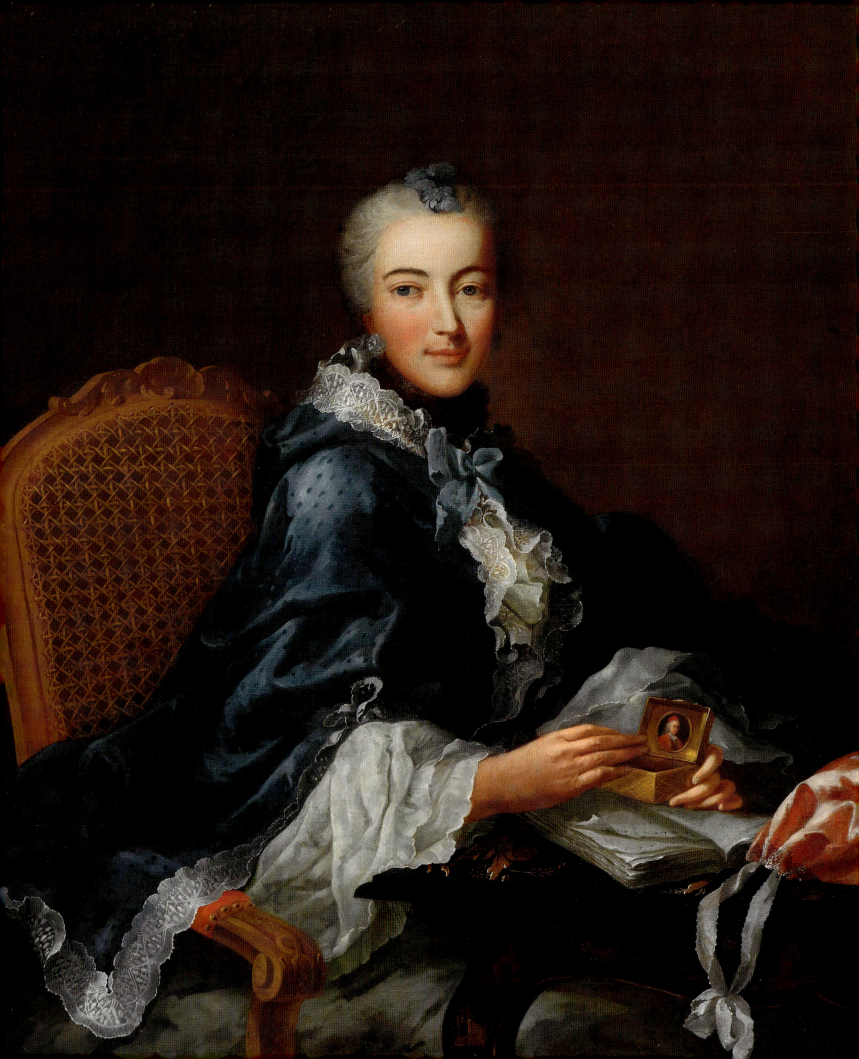

Foreword

" Meissen porcelain snuff boxes of the eighteenth century have always been and still remain very special treasures. They are the expression of the enormous creativity of a brilliant modeller and sculptor, a highly specialised painter, and important Dresden goldsmiths. Additionally, in contrast to the individual pieces of services, snuff boxes, as independent art works with a more conceptual purpose, mirror tendencies in changes of style, both in society and at the manufactory in Meissen, and are consequently unique witnesses, of astonishing quality, to the finest flowering of European decorative art. Their timeless beauty makes them unmatched and uniquely precious objects among European ceramics of the eighteenth century. "

Gerhard Röbbig

As well as demonstrating technical and artistic dominance the earliest products of the Meissen porcelain manufactory provide a present-day public with a picture of the customs and manners of the time. In earlier days coffee, tea, cocoa, and tobacco were imported to Europe from distant territories via long sea routes, they were the fashionable luxury goods of the time and their consumption reached a highpoint of refinement in the eighteenth century. The luxury goods industry responded to the demand for the requisite utensils with the greatest finesse and artistry. Thanks to princely intervention and the absence of market economy constraints this led in Meissen to the production of masterpieces *en miniature*. Nowadays these stimulants are far more easily available and are still commonly enjoyed on account of their specific properties. However, due to state intervention the consumption of tobacco, which is known to reduce life expectancy in the form of smoking or even snuff-taking, is increasingly publicly stigmatised. It will probably, in the not-too-distant future, provoke, at best, a disapproving shake of the head, at least in Europe, North America, and its enclaves.

It was not unusual for kings and princes to succumb to the vice of snuff-taking and they collected a sizable number of snuff boxes made of costly materials of various origins and, from the early eighteenth century onwards, naturally of porcelain also. Rarely have the snuff boxes in princely collections of the eighteenth century survived in their original context—they were either given as presents or sold and eventually formed the basis of important collections put together by following generations of collectors.

This catalogue is devoted to 124 Meissen snuff boxes of the eighteenth century from private collections. These snuff boxes, all of them carefully selected and part of collections that have been compiled over a period of years, come from collectors who, as well as their passion for Meissen porcelain, share a number of other traits. Reflecting the nature of these objects they are without exception experienced collectors with a tendency towards perfectionism, gifted with a finely honed gaze and the patience necessary to discover the numerous details that are first revealed by examining the painting of a snuff box through a magnifying glass. In much the same way as art dealing collecting, too, has undergone changes in recent years. Collectors such as Dr. Ernst Schneider or Dr. Fritz Mannheimer, prototypes of the *collector generalis,* whose collections of Meissen, today in Schloss Lustheim near Munich and in the Rijksmuseum in Amsterdam respectively, are among the most exceptional of their kind, were followed by a new type of collectors who increasingly specialised in specific areas of Meissen porcelain, which gradually shifted certain categories and manufactories into a niche. Nevertheless, the appreciation of and demand for quality seems unchanged as is shown by a series of important volumes on Meissen porcelain that have appeared recently.

The authors Barbara Beaucamp-Markowsky, Hans Ottomeyer, Lorenz Seelig, Ulrich Pietsch, Heike Zech, and Sarah-Katharina Acevedo take a broad approach to the theme of the snuff box in order to properly position its significance in the cultural history of the eighteenth century: Hans Ottomeyer begins with a thematic approach to the subject and traces the origins of the use of tobacco and the development of the snuff box in Europe. Lorenz Seelig follows with a contribution on snuff boxes in princely collections of the eighteenth century. Heike Zech expands the thematic repertoire of the catalogue with a contribution about the collecting of snuff boxes since the nineteenth century, devoting particular attention to the collection of Sir Arthur Gilbert. Ulrich Pietsch focuses on the theme of the Meissen snuff box in general from the beginning, when it was made of Böttger stoneware, to the important figure of Johann Joachim Kaendler, the creator and modeller of numerous forms of snuff boxes, and offers an overview of the known and definitely identifiable Meissen painters of snuff boxes. The essay section ends with Sarah-Katharina Acevedo's overview of the figures and groups modelled by Johann Joachim Kaendler that are directly related to the theme of the porcelain snuff box.

The extensive catalogue section that follows offers numerous close-up photographs of snuff box painting that disclose interesting details to the viewer and, through the presentation of the graphic works that served as models—in as far as they are known—reveals the sources of the painters at Meissen. Descriptions of the individual snuff boxes and additional information complete this section.

The standard work on this theme, Barbara Beaucamp-Markowsky's publication *Porzellandosen des 18. Jahrhunderts,* first appeared in 1985 (the English edition *Collection of Eighteenth Century Porcelain Boxes* was published in 1988). The wealth of material compiled and the multitude of different examples offered make this work still indispensable today in identifying and attributing snuff boxes of the eighteenth century, and we are most grateful to Ms. Beaucamp-Markowsky for kindly agreeing to write the introduction to this catalogue.

Michael Röbbig-Reyes

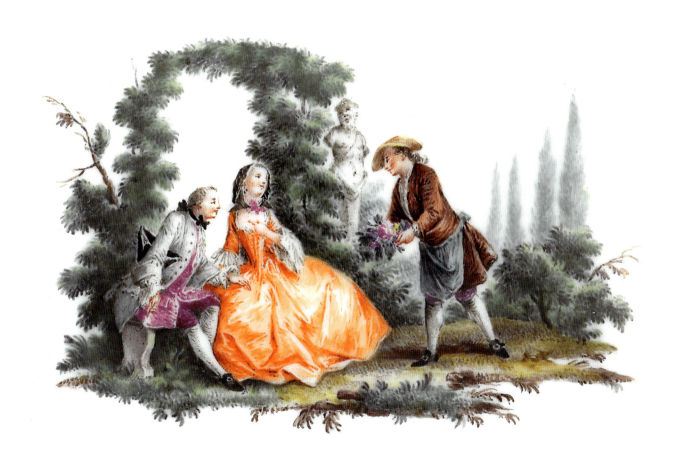

Porcelain Snuff Boxes of the Eighteenth Century: An Introduction

Barbara Beaucamp-Markowsky

Porcelain Snuff Boxes of the Eighteenth Century: An Introduction
Barbara Beaucamp-Markowsky

Fittingly invented around the start of the *galant* century, porcelain gave this era's most exquisite attribute, the snuff box, a completely new appearance. Although boxes of many different kinds of materials—precious and base metals, tortoiseshell, mother-of-pearl, or hard stone—and made in very simple or highly elaborate ways had long since become a much-appreciated utensil, porcelain boxes represented an entirely new type. White, decorated in brilliant colours, and with an almost limitless variety of forms, they soon captivated an entire epoch.

Boxes made of gold and silver generally provided the models for their design. French gold and silversmiths had created the most wonderful boxes since the end of the seventeenth century. The increasing use of snuff boxes—in this context one thinks of the reproving comments made by Liselotte von der Pfalz (1652–1722) on the fashion for taking snuff at the court of Versailles—is reflected by the various series of prints with designs for snuff boxes and snuff box lids that were published in Paris in the first quarter of the eighteenth century.[1] All of these were intended as models for goldsmiths and the inspiration they provided for the chaser or engraver was primarily in the area of decoration rather than form. The same applies to the "Goldschmids Büchlein" by Paul Decker the Elder (1677–1713), which appeared in Augsburg in 1715. It, too, provides a wealth of variations on the principal ornaments used during the Régence—mythological animals and chinoiseries *en miniature* interspersed among symmetrical leaf- and strapwork patterns, although a number of designs also show three-dimensional views of flat, oval, or cartouche-shaped boxes.

For the modellers at Meissen these prints of various ornaments were not of primary importance. From the very start they were able to study original examples of fashionable gold and silver boxes and had no need to reinvent cartouche-shaped, scalloped boxes, oval or round, or rectangular boxes with inward tapering or bellied sides and rounded or

scalloped corners. They translated the basic forms of contemporary gold and silver models into the new material porcelain. For the richly chased or engraved decoration of the originals they substituted smooth surfaces suitable for painting with a polychrome décor—a field in which the manufacture achieved both technical and artistic mastery by the second decade of the eighteenth century. A manufactory report from 20 November 1728 provides evidence of the use of French originals in Meissen: "[…] and so different kinds of snuff boxes have been made, the models for which were sent from France. They are now to be painted in the finest manner and enamelled with gold."[2] Among the numerous models for snuff boxes listed in the work reports of Johann Joachim Kaendler (1706–1775) and of his colleague, Johann Friedrich Eberlein (1696–1749), mention is made of boxes "of a silver kind" as well as tortoiseshell and hard stone boxes (1731, 1739, 1744).

One of the earliest types of snuff boxes manufactured in Meissen—oval in plan with bellied sides—is not apparently based on any particular model but seems to have been developed by the young manufactory especially for the new ceramic material. Simple in form and produced in various sizes with only minimal variations, it can be regarded as the Meissen snuff box *par excellence*. Its regular form and smooth surfaces provided an ideal surface for painting that was just as suitable for the chinoiseries of the early period as for the "Watteau scenes" of the mature Meissen style, on which account it was able to maintain its dominant role until the middle of the century.

The painting of the porcelain boxes in colour is their incomparable privilege. This applies both to the brilliance of the colours and to their durability. Although related to painting with enamels on gold and silver boxes, on gleaming white porcelain the coloured décor represented a stunningly beautiful innovation. We owe the decorative patterns and the rich variety found in the painting of eighteenth century porcelain snuff boxes to Meissen. Essentially, the painters made use of the large family of décors that dominated painted porcelain services and that ranged from chinoiseries and merchant shipping scenes in the early period to Watteau and hunting scenes, battles, landscapes, strewn flowers, fruit and birds, and eventually to Boucher putti in the late period. The coloured grounds originally created for porcelain services represent a special aspect. They were now used on these tiny containers and gave the miniature scenes, which were painted inside curved reserves left in the ground, a particular radiance. The same applies to the "mosaic décor," minutely structured patterns made up of scales, little squares, diamond-shaped lattices, or other graphic ornament, within which small pictures, framed by curling *rocailles,* were painted on reserves.

The nature of the painting is of particular importance in identifying and dating Meissen porcelain snuff boxes. It developed independently of similar contemporary pieces made of gold or silver and was also largely uninfluenced by the inventions of the ornament engraver. Every single box was based on a consistent iconographical program that defined the theme for the painting of all the external surfaces, and frequently for the inside of the lid also. On the other hand these lids often conceal miniature tableaus that are among the loveliest, and thematically most original, of all painting on porcelain—for example quotations from prints made after the great French painters that show elegant society

engaging in its graceful amusements or slightly risqué mythological subjects that provided material for conversation when proffering a "prise" of snuff.

Miniature portraits, commissioned works that called for considerable skill, were often discretely placed on the inside of lids.[3] Unlike the decorative painting on the outsides of the boxes these portraits—like many of the scenes painted inside lids—were carried out in the enamel painters' fine stippling technique, which connects them to the gold box. And it is from such boxes that the idea of placing the depiction of the highest quality inside the snuff box was probably borrowed from. The golden *boîtes-à-portrait* of Louis XIV (1638–1715) contained the King's portrait inside the lid—the box was therefore in a certain sense a container for the royal portrait. In the golden boxes that the young King Louis XV (1710–1774) gave as tokens of his favour—the gold box was the costly predecessor of the later, and considerably more modest, order of merit—the royal portrait is on the inside of the lid,[4] whereas later in the eighteenth century the miniature portrait was generally found on the outside of the lid. In Meissen, in contrast, the main picture remained concealed on the inside of the lid, a tradition followed by most of the other European manufactories. In this way the porcelain box retained a delightful charm lacking in the luxurious gold box, which ostentatiously displays all its brilliance and richness on the exterior.

The relief décor also forms part of the decoration of porcelain boxes. Frequently, like the form of the snuff boxes, it was inspired by contemporary gold and silver boxes—as is shown above all by the many different and highly imaginative snuff boxes whose external surfaces are decorated with relief *rocaille* cartouches. The linear patterns of guilloche work on gold boxes are also to be found on a number of Meissen snuff boxes. Here too, however, the porcelain modellers developed their own delightful forms of decoration and created a wealth of ornamental and figural relief décors.

Until the mid-eighteenth century Meissen exerted a decisive influence on the porcelain snuff box as a type. While its basic forms—rectangular, round, scalloped, or oval—were derived from models made of precious metal or other materials, within these constraints it soon developed an astonishing formal richness. The new ceramic substance offered the great advantage that it could be used to reproduce all imaginable forms and decorative techniques. The work of the gold and silversmith—beating, casting, chasing, and engraving—or of the stone cutter could be translated into porcelain by means of an easily-shaped clay or plaster model and reproduced as often as required. Snuff boxes in the form of roses, pears, apples, or pug dogs extended the range of this capricious genre. The variety of models, many of which were also produced in sizes "large, medium, and small," and the different ways in which they were painted using the entire palette of the manufactory décors resulted in a lavish supply in different price ranges.

The porcelain snuff boxes were placed in the hands of a goldsmith to be completed. The precise fitting of the mounts to the—internally unglazed—edges of box and lid and a perfect closing mechanism were essential for every snuff box. For this important work the manufactory placed goldsmiths under contract who also carried out other, similar kinds of work such as mounts for bottles, scissors cases or holders.

The materials used were silver and gold, copper and different kinds of brass. In contrast to France, in Germany mounts were not hallmarked—disappointingly for modern-day admirers, as this obliges them to do without an absolutely certain dating and provenance. Mounts of precious metal considerably increased the price of the snuff box. The gold mounts made in Dresden for a portrait snuff box commissioned in Meissen, decorated externally with scattered flowers and internally with the portrait of an English lady for whom it was intended, with painting of the highest quality throughout, cost more than twice as much as the porcelain box without mounts.[5]

Unlike the costly gold and jewel boxes its more modest material value meant that the snuff box was not destined to become a "precious object" in a princely state treasury. Its particular characteristic, the way in which the loveliest and most carefully chosen painting is concealed inside the box, speaks for itself. The porcelain snuff box, admired and collected for its own sake, and additionally also fragile, is truly an *objet de vertu* of the *galant* epoch.

[1] Cf. Snowman 1990, pp. 33–43, figs. 24–28, 32–44, and Beaucamp-Markowsky 1985, fig. p. 17.

[2] Cf. Beaucamp-Markowsky 1985, p. 608.

[3] An exception here is a Meissen snuff box made around 1750 with a portrait of Tsarina Elisabeth I on the outside of the lid, which is in the collections of the Hermitage in St. Petersburg, cf. Beaucamp-Markowsky 1985, p. 83, cat. no. 52.

[4] Cf. Snowman 1990, p. 107, figs. 170–74, p. 108, figs. 175/76 and pp. 138/39, figs. 269–75.

[5] Cf. Beaucamp-Markowsky 1985, p. 160, cat. no. 117 and fig. p. 151.

Snuff Boxes and the Taking of Snuff: On the Purpose of Luxury

Hans Ottomeyer

Snuff Boxes and the Taking of Snuff:
On the Purpose of Luxury
Hans Ottomeyer

The beginnings seem clear: the encyclopaedias, lexica and, more recently, also entries on the Internet essentially all recount the same legend. The missionary Romano Pane, who was left behind by the discoverers of the West Indies in 1496, wrote in a well-known report that these Indians, who were believed to be natives of India, intoxicated themselves by inhaling the smoke of dried tobacco leaves and by insufflating the ground powder of these plants, which then altered their mental state. On the other hand we are told that Montezuma smoked aromatic rolled tobacco leaves after a meal.

Around 1560 the French diplomat Jean Nicot (1530–1600), who spend some time as an envoy at the Portuguese court, examined and described the properties of tobacco as a healing plant. It was around the same time that the plant was given the name "Herba Nicotiana" in Nicot's honour.

Catharina de Medici (1519–1589) made excessive use of this gift from the New World as a stimulant and tonic. It was said that she took snuff powder as a kind of panacea. The tobacco plant was cultivated in the Botanical Gardens in Paris, where it was ennobled with the name, the "queen's herb," to honour the French queen and her snuff, which was known as the *poudre de la reine*.

This kind of "personality advertising" led to such rapid success that in the seventeenth century numerous bans were introduced to restrict the use of this herb, which was now regarded as harmful. In 1604 the King of England forbade his people to smoke like savages. In 1615 Holland followed the same line and imposed an official ban on smoking. In 1636 the Tsar took the simpler approach of having the nose of those who used snuff cut off, as a kind of analogous physical punishment. Nevertheless, the market still grew and, in response to demand, the areas where tobacco was cultivated continued to increase in size. Alsace and Flanders planted different species of tobacco plants to produce snuff tobacco in their own

manufactories. In Holland tobacco was grown near Amersfort, Utrecht, and Geldern. Virginia and Maryland exported tobacco to Europe. Turkish areas of the Balkans succeeded in producing particularly strong sorts that were much in demand. But the main producer remained the Spanish state manufactory Sevilla, which from 1677 onwards produced "Spaniol" in what were known as "carrots." These were pressed strands of tobacco that were fermented and coated with fat to improve and preserve the aroma. Brand names used for snuff tobacco included, for instance, "Parisian" or tobaccos from St. Omer or Strasbourg. In Germany the company Bernhard in Offenburg am Main produced snuff tobacco from 1733 onwards and still exists today.

The various kinds differed in terms of consistency, colour, and aromatic additives. The consumer could choose between fine Spanish, flaky English, or the coarser Italian kinds of snuff tobacco. Portuguese "Green" came from Brazil, the Spanish variety was yellowish in colour, red snuff was produced by adding pomegranate blossoms, while the clove powder added to Malabar snuff was said to improve the flavour; essentially almost every preference could be catered for.[1] From the very start it was said that "tobacco is used by women" and that "a delicate tobacco box is regarded as part of elegant dress."[2]

The snuff boxes that were used from the end of the seventeenth century onwards differed from the snuff bottles used by the common people. These bottles were made of stoneware, faience, or glass and were closed with a screw cap or a simple cork. A dot of powder was taken from the bottle and spread on what was called the "tabatiere," the area on the back of the hand between thumb and index finger.

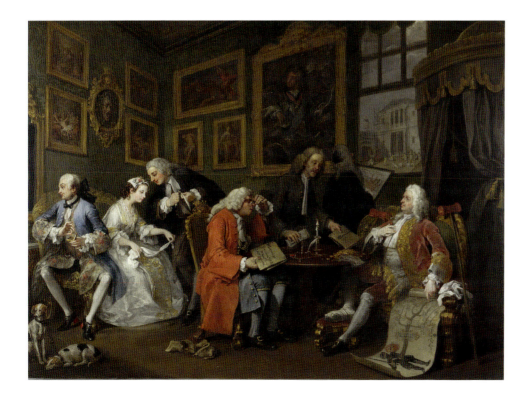

Fig. I.1
William Hogarth (1697–1764), *Marriage A-la-Mode: The Marriage Settlement*, c. 1743, oil on canvas, 69.9 x 90.8 cm, London, National Gallery

Quite clearly it was incomparably more elegant to use a snuff box. A gentleman kept this item in the capacious pocket of his frock-coat, whereas ladies kept their snuff boxes in a skirt pocket. The box was held in the left hand, opened with the thumb and then, with the other fingers splayed, a pinch was taken between thumb and index finger and inhaled through each nostril. How one held the box, turned or splayed the fingers all formed part of a changing code of "savoir faire" that during this epoch was used as way of categorising people socially. Much the same applied to snuff boxes themselves. These were "all kinds of boxes or containers in which one can conveniently carry snuff on one's person."[3] The fashion came from France. The snuff box luxury is attributed to the war minister François-Michel Le Tellier, Marquis de Louvois (1641–1691), who proudly displayed the great power and wealth he had attained.[4]

Monarchs soon adapted the custom of giving gifts of valuable snuff boxes decorated with their portrait in a medallion framed by "Indian" diamonds. Those who received these gifts displayed them like a kind of ceremonial decoration: "On mesurait le luxe d'un seigneur au nombre et à la richesse de ses boîtes, et comme témoignage de son fortune inespérée."[5]

Snuff boxes were usually made by goldsmiths, *orfèvres bijoutiers,* who also produced boxes in which to keep beauty marks, chocolate boxes, boxes for handles, for walking sticks, and swords. They offered all these items for sale and occasionally created matching sets with the same design and decoration.

Contrary to the somewhat excessively speculative suppositions recently made by art history snuff boxes did not form part of the *Kunstkammer* nor of princely art collections, but, much like sticks, swords, and pocket watches, were regarded as part of the private wardrobe. They were kept together, inventoried and, in terms of the legal formalities pertaining to inheritance at that time, were regarded as private property. The way in which they were made and given as gifts also followed rules and conventions somewhat different to what has been previously assumed.

In his famous work *Il Principe* (English: *The Prince*) from 1532, which has been republished and translated hundreds of times, Niccolo Machiavelli (1469–1527) deals with the manner in which princes should make gifts. In a chapter devoted to "Generosity" he says that no one should give gifts of things that do not belong to him, that is to say the only acceptable gifts are those which clearly belong to the person giving the gift and which come from his own manufactories, regalia, or privileges. This applies also to gifts that one has received oneself as a present. One should never give a gift of something acquired as the result of appropriation, robbery, taxes, and duties paid by subjects, these are most unsuitable! On this account the royal court in Saxony generally gave gifts of agate, chrysoprase, and porcelain, in Berlin the court used amber and precious objects made by privileged Huguenot craftsmen as gifts, in Brunswick silver gifts were given, and in Russia items made of tula or malachite. As regards to snuff boxes, which were popular gifts, this seems to have been a basic rule.

Snuff boxes, filled with gold coins or jewels, were often given as a "gift of honour," as a way of propitiating the recipient, whom, however, one did not wish to simply present with

Fig. I.2
Jewellery designs for Duke Carl August II. Christian (1746–1795) and Prince Maximilian Joseph von Pfalz-Zweibrücken (1756–1825) from *Cahier de Bijouteries dans le Goût Moderne comme Boites, Pommes de canne, bagues, cachets […]*, p. 1, Jean Baptiste Fay, Paris c. 1780, Paris, Musée des arts décoratifs, Collection Maciet

cash, or they were used as an expression of thanks for services rendered. At an early stage the initials of the person giving the gift, and also their portrait, began to be added to snuff boxes. There were numerous different occasions on which snuff boxes, with or without contents, could change owners: as a New Year's gift, on name days, as a way of congratulating someone and as a farewell present or memento *en souvenir*.

In contrast among emissaries and professional diplomats snuff boxes were a hard currency. In his memoires written in 1842 the great satirist Karl Heinrich Ritter von Lang (1764–1835) reported that during the European peace negotiations at the Congress of Rastatt from 1797 to 1799 so many snuff boxes changed hands that the recipients were able to return them to the jeweller and obtain from him the value of the piece in cash. For this reason, but also as a kind of advertising, the jeweller attached a label with his address to the snuff box.

By the end of the century snuff boxes had become something different, they were no longer representative containers for snuff, but, through the act of giving and being given as gifts they became a valuable distinction or accolade that had significance as a memento but also a concrete material value. In the mid-nineteenth century the old Stechlin described this situation in the eponymous novel by Theodor Fontane (1819–1898), using carefully weighted words: "[...] in fact I cannot bear the giving of gifts, there is something about it that is reminiscent of bribery and it looks like a tip [...], but there is something pleasant about the snuff box. When things are going well it is a family heirloom and when things are bad a last refuge."[6]

Snuff boxes could cost enormous amounts, but could also be affordable. Generally a balance was held between the costliness of the materials invested in them and the artistic skills used in making them, and they clearly stated the rank to which the particular gentleman or lady laid claim. In this context we can quote Denis Diderot (1713–1784): "his servant, his watch and his snuff box define the gentleman."[7]

The snuff boxes that the French sovereign gave as gifts were worth on average 2,000 *livres,* the Court Office registers as "Present du Roi" thirty-seven snuff boxes which King Louis XV (1710–1774) ordered to be made for a total of 62,476 *livres*.[8] Magnificent snuff box collections were put together for the sake of the objects themselves. In her estate Madame de Pompadour (1721–1764) left snuff boxes worth 300,000 *livres,* Louis-François de Bourbon (1717–1776) owned more than 800 of such precious boxes.[9]

The most famous collector of snuff boxes and one of the heaviest consumers of snuff of his time was Frederick the Great (1712–1786), for whom the procedure of snuff taking was both a visual delight as well a way of limiting his indulgence of this vice. In his wide-spanning *Geschichte der deutschen Höfe seit der Reformation,* which appeared between 1851–58, the German historian Eduard Vehse writes as follows about Frederick II and his almost Pantagruelian passion: "Frederick's only expensive hobby was boxes. He left 130 of them in which he had invested the sum of 1,300,000 *Taler.* There were always several of these boxes on his tables. And he always carried two filled boxes of immense size in his pockets—for he took enormous pinches. 'It is difficult,' the English envoy Harris writes, 'to approach him without having to sneeze.' Büsching is of the opinion that the king developed the habit of taking large amounts of snuff during his military campaigns, when he always

Fig. I.3
Modèles de dessins de boites ornés d'arabesques et d'entrelacs, from Johann Leonard Wüst (c. 1665–1735) and Jeremias Wolff (1663–1724), *Schneid- und Etz Büchlein,* Augsburg c. 1710, Paris, Musée des arts décoratifs, Collection Maciet

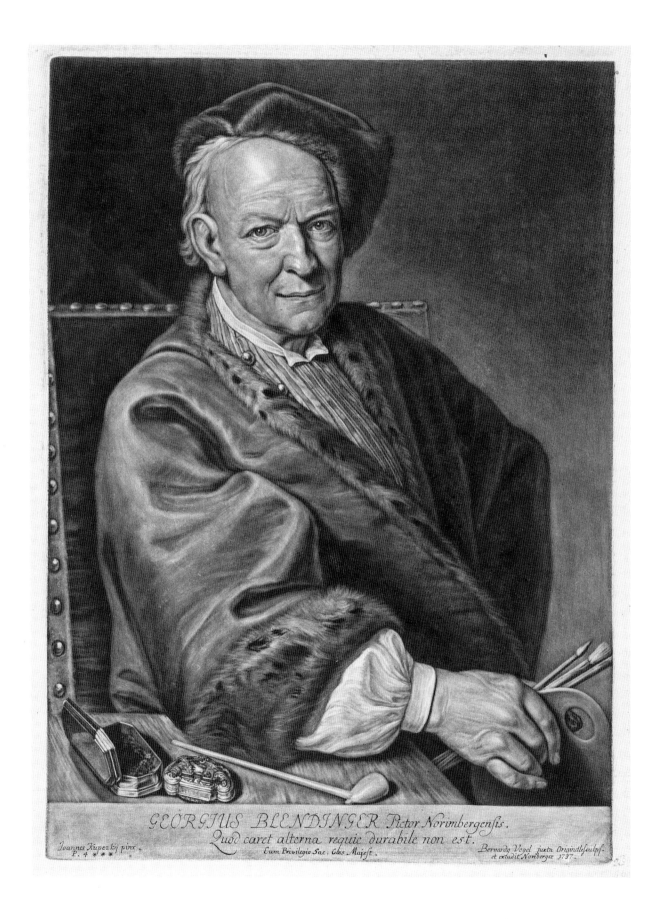

rode, walked, or stood among his soldiers, to avoid being affected by their unpleasant body odour. He always had to have a few thousand pounds of Spaniol in store. In contrast for Frederick the way the members of his detested father's *Tabakskollegium* smoked was a source of horror."[10] "[...] you saw the traces of the Spanish tobacco on their faces and clothing; he hated all of that. And in 1775 in Potsdam the traveller Moore saw inside the king's clothes chamber [...] two yellow waistcoats, rather thickly coated with Spaniol dust."[11] When Frederick purchased something he displayed a sense of economy and curiosity, along with an interest in technical details. His trusted valet Michael Fredersdorf, who also administered the coffers from which the king financed his personal purchases, was ordered to bring back from Paris new vermeil snuff boxes for the king "the best that they produce there and of such a kind that allows one to see how they are made."[12] Perhaps Frederick had inherited this passion for snuff boxes from his mother, Queen Sophie Dorothea from the House of Braunschweig-Lüneburg (1687–1757). She had acquired numerous snuff boxes and favoured those *avec antiques,* that is with classical motifs, in addition to which she bought fifteen amber boxes, which she gave as a specifically "Prussian" gift to her relatives at the court in Hanover. As an analogous conclusion we could assume that Meissen porcelain boxes were regarded as a particularly "Saxon" gift.

For instance: in 1768 Frederick the Great sent from Meissen a Meissen porcelain box to his old friend Frau von Camas and in the accompanying letter left it up to her to decide whether she should use this box to keep cosmetics, beauty marks, snuff, confectionary, or pills in. The fragile art works from Meissen were suitable for all these purposes and were indeed probably employed at different times for different purposes.[13]

Snuff boxes for women were common. The Berlin art historian Walter Stengel has systematically combed through newspaper announcements, notices of loss made to the police, and notices of theft in Berlin in order to discover who used what in which way and where it got lost. Men generally had their snuff boxes stolen by pickpockets, whereas women tended to forget theirs in church pews. Both men and women inhaled snuff in church in order to remain awake during the lengthy sermons from the pulpit and to avoid being poked with a rod as "church sleepers," which would have embarrassed them in front of the rest of the congregation. Women then often forgot their snuff boxes and generally left them lying on church benches.

According to these reports the boxes owned by the common people were made of Iserlohn brass, pewter, Dutch pottery, horn, mussel shells, or of wood. In addition to these materials a number of different forms are mentioned, such as shells, ring cakes, coins, hats, beets, melons, or oranges.

The great secret of snuff boxes lay in the way they closed. The construction, although simple, was difficult to manufacture. To prevent the fine-grained powder from trickling through a gap between the rim of the container and the lid the frame had to be fitted very tightly and with great precision against the edges of the box, which was difficult to do with fragile or soft materials. As so often with items of decorative handcraft this precision was not achieved by means of measurement but by adapting and fitting, by the use of knacks, manual dexterity and the experience acquired through years of practice. Today the art of

Fig. I.4
Bernhard Vogel (1683–1737), *Portrait of Georg Blendinger,* mezzotint after a painting by Johann Kupecky (1667–1740), Nuremberg 1737, Brunswick, Herzog Anton Ulrich-Museum

the *boîtier* has been forgotten. The two parts of the frame on the lid and the box fitted together so perfectly by means of a stepped profile that not a single grain could escape. This millimetre-precise perfection was also applied to the work on the hinge and its invisible technique. The simple butt hinge was placed slightly under tension and often had a slight curve. This allowed the lid to be opened against a slight resistance and to be closed again by exerting slight pressure, so that the snuff box could not open of its own accord. This play between tension and easy manoeuvrability determined the function of the snuff box and was proudly demonstrated by the user.

In terms of handcraft the hinge technique was a "high-tech" solution and far more sophisticated than the caps used for snuff bottles or the sliding lids of tobacco boxes. It was regarded as part of good manners to play with the artistic snuff box, to open and close it, to turn it this way and that, and to offer the contents to others as a sign of affection or esteem. Snuff boxes had their own interior life through the design of the inside of the lid where concealed pictures and portraits were to be found. Often snuff boxes were gilded internally in order to prevent oxidation through the essential oils.

Those with a pronounced sense of their own importance carried several snuff boxes in order to make a suitable impression, "à prendre le tabac avec grâce." Just like the ancient Romans, who according to Pliny the Elder (23–79 AD) wore winter rings and summer rings according to the season, the man of the world and the lady of fashion possessed both summer and winter snuff boxes.[14]

The history of the snuff box is characterised by a rich variety that is expressed in the range of different materials used, the many basic forms and methods of decoration. Few other areas of the decorative arts have produced quite as many fantastical and fanciful forms. The design of these precious little objects delighted people through motifs rich in associations, their gleam, reflections, colours, and the way in which their appearance changes according to the quality and incidence of light. In the courtly world that produced snuff boxes as specific personal accessories distinction and rank were important concepts and aims. Over the course of their long history snuff boxes were increasingly evaluated less in terms of how they functioned and more according to the fashionable message, their value as a memento, the precious nature of the material used and the artistry employed in making them. These containers first appeared in the early modern age, around 1600, and fell out of use after 1840. Snuff boxes represent in a positive sense the significance of variety, a term that has so far led a rather shadowy existence but which, as regards a perception determined by aesthetic premises, can help reveal the core statements of a culture.

Whatever words one may choose to paraphrase this term, whether variety, manifoldness or, perhaps best of all, "different in nature," none of them have been assessed positively or explicitly in the aesthetics of the creation of art. Theories on this subject have been developed relatively recently, but always in the context of the Anglo-American term "diversity," the preservation of which is seen as an important value in both the natural sciences and sociology.

But beyond these words and terms, variety is a goal of the production of art and is manifest in numerous art works that have been handed down to us. Where the intention is

Fig. I.5
Christian Bernhard Rode (1725–1797),
Der Künstler im Kreis seiner Familie,
c. 1745, oil on canvas, 66 x 91.5 cm,
Berlin, Staatliche Museen zu Berlin,
Gemäldegalerie

to help people to express their particular concerns difference in nature remains a primary strategy in art production. The diversity of ornamental forms is at variance with the simplicity of the shapes, appliances, and objects that are to be decorated. The possibilities of design are increased by the use of rare materials, carefully chosen motifs, new methods of decoration, and unusual figurations of the art works.

Such investments are most worthwhile when they can be seen at a prominent place or form a diversified group of objects put together according to interest and curiosity. Collections of this kind allow comparisons to be made and specific qualities to be discussed and in this way enable us to discern what is special about each piece. Only the parallels discovered in discussion reveal what makes something special.

In European thought the term variety is not ascribed any particular virtue, apart from that of pleasure, the *variatio delectat*. This motto, however, is corrupted Latin for the *varietas delectat* of Cicero, which was already a familiar saying in the days of antiquity.

As an aesthetic goal diversity differs fundamentally from those aesthetic goals currently regarded as valid, such as uniformity, similarity, plainness, and other monomaniac forms propagated by the industrial repetitiveness of the series. Research into diversity has shown that variety of form, richness of invention, fantasy, and exuberant powers of imagination are related to the prosperity and thriving economic conditions that make cultural diversity possible in the first place. The "Charta der Vielfalt" (Diversity Charter), a tolerance edict issued by the German business world in 2010, excludes any questions about culture.

Nevertheless, the arts of diversity and intentional richness of design are present in numerous strands of tradition and call for an assessment.

Time and time again it is surprising to note how it is precisely the differences within this microcosm of the accessory that enable us to clearly trace the patterns of thought, action, and perception of an epoch. Diversity of design is a term that has recently developed into a new model of cultural identity. Snuff boxes anticipated all of this in a playful way and in the process connected indigenous products with distant worlds, and harmonised exotic motifs and selected rare materials with the European arts.

It is still astonishing to note how many such artefacts were made in the international context referred to. These works have been carefully preserved and handed down from generation to generation, allowing them to repeatedly make their strong impact, like messages from a world gone by. They delight the eye, are miracles of technology and the arts, a fount of knowledge and, like their contents, a source of inspiration for the mind.

Fig. I.6
Johann Heinrich Tischbein (1722–1789), *Anton Heinrich Friedrich Graf von Stadion zu Thann und Warthausen*, c. 1752, oil on canvas, 109.4 x 89.3 cm, Frankfurt am Main, Goethe-Museum

[1] Zedler 1743, Sp. 604–609.
[2] Ibid.
[3] Ibid., Sp. 134.
[4] Havard 1890, Sp. 341.
[5] Ibid., Sp. 348, after Saint-Simon.
[6] Fontane 1899, chapter 23.
[7] Diderot 1796.
[8] Bouilhet 1909, p. 210.
[9] Ibid., p. 209.
[10] Vehse 1970, pp. 162ff.
[11] Vehse 1970, pp. 162ff.
[12] Stengel 1950, p. 9.
[13] Ibid.
[14] Seelig 2007, p. 40.

Precious Snuff Boxes in Princely Collections of the Eighteenth Century

Lorenz Seelig

**Precious Snuff Boxes in Princely
Collections of the Eighteenth Century**
Lorenz Seelig

Small caskets, capsules, and boxes of silver and gold or made of rare and exotic materials traditionally formed part of princely treasuries and *Kunstkammer* and were occasionally used to keep pieces of jewellery or other precious items in.[1] From the early eighteenth century onwards another kind of container emerged:[2] the snuff box, in which the noble gentleman, or indeed lady, could carry the requisite amount of snuff on their person. Within just a few decades the snuff box advanced to become a fashionable article *par excellence.* In general terms this reflected the increasing importance of what were called "fancy goods."[3] Alongside snuff boxes the costly accessories of the elegant world included buttons, buckles, *châtelaines,* watches, signets, *carnets de bal* (cases containing little tablets on which the ladies of society noted in advance the names of their dance partners)[4] and other kinds of cases, also described as *souvenirs,* containing little notebooks or tablets,[5] in addition fans, flasks, lorgnettes, and other eyesight aids, knobs, handles and hooks for sticks as well as rapier and umbrella handles, and also *navettes* (little shuttles used to make especially tatted lace[6]), *nécessaires* and cases in which to keep hair pins, sewing needles, toothpicks, tweezers, and a variety of other utensils or also to store sealing wax.[7]

Among all these various fashionable accessories, many of which often had a personal and intimate character, snuff boxes held a very special position. They could be easily held in one hand and carried in a coat pocket or could be elegantly displayed when used; much like the fan they could also function as an instrument of non-verbal communication. At the same time if sufficiently elaborate and expensively made they were suitable pieces for princely collections and the treasuries of ruling dynasties.[8] More decisively than other fancy goods, snuff boxes laid claim to the status of "miniature art works" that invited and rewarded examination in close detail.

In the eighteenth century Paris was the leading centre for the manufacture of elaborate boxes that were used, primarily, to keep snuff in, but also for powder, make-up, and

beauty spots or even for pills and dragées. Consequently, collections of such boxes were put together in France at an early date. Although Louis XIV (1638–1715) abhorred the use of snuff and therefore probably did not own any snuff containers himself, snuff was used at the court of Versailles. Philippe II, Duke of Orléans (1674–1723), the nephew of the *roi soleil* who became regent after Louis's death, owned a large number of *tabatières* and *drageoirs*. The snuff box collection of his spouse, Louise-Françoise-Marie de Bourbon (1677–1749), Duchess of Orléans, was also very extensive: in 1723 she owned either sixty-seven or eighty-seven snuff boxes. As ladies also took snuff it is not surprising that they soon emerged as collectors of snuff boxes and indeed delicately shaped snuff boxes became a favourite collector's item among noble and aristocratic ladies. Guidelines on ceremony and etiquette from this period describe the collecting of small works of art and precious items as an activity ideally suited to ladies.[9]

The status of collectors of expensive boxes is demonstrated by the collection of Jeanne-Antoinette Poisson, Marquise de Pompadour (1721–1764), who herself also used snuff.[10] Unlike the collections mentioned above we have detailed information about the snuff boxes owned by this mistress of Louis XV. The inventory of her estate compiled in 1764–65 lists seventy-eight boxes and similar containers,[11] most of which were made of gold and decorated with enamel. Alongside snuff boxes made of various hard stones, ivory, mother-of-pearl etc. her estate also included numerous boxes made of lacquer, most probably East Asian, which from the seventeen-forties onwards were increasingly used for snuff boxes. A round box with *vernis noir* is also listed.[12] This was most likely a box made of papier-mâché coated with *vernis Martin*, which was made by the Martin Brothers, Parisian lacquer work specialists[13] (of the four brothers Guillaume, who died in 1749, was the most important). Last, but not least, the inventory also contained two Sèvres porcelain boxes with gold mounts with a very high assessed value.[14] In such *objets de vertu*[15] it was not solely the expensiveness of the material that counted, the sophistication of the techniques used and the subtlety of the décor also played important roles. As boxes of this kind were often very light they were particularly suitable as "summer snuff boxes."[16] The diary of the Parisian *marchand mercier* or dealer in luxury goods, Lazare Duvaux (1703–1758), provides us with unusually detailed information for the years 1748–1758 about the acquisition, repair, and reworking of the boxes owned by Madame de Pompadour.[17]

The snuff box collection of Louis-François de Bourbon Prince de Conti (1717–1776) was also unusually extensive. He is said to have owned 800 snuff boxes and 4,000 rings.[18] These snuff boxes—similar to those owned by Madame de Pompadour—were made of gold, enamel, stone, lacquer, or *vernis Martin*. In two auctions held after the Prince's death only thirty-four gold boxes were called. This suggests that the sometimes astonishing figures about the size of snuff box collections should be treated with a degree of caution. But certainly this expresses a culminating tendency in the second half of the eighteenth century to follow fashion by owning a large number of snuff boxes. In this regard the critical observer Louis-Sébastien Mercier (1740–1814) wrote in his *Tableau de Paris*, published in the seventeen-eighties, that it was a sign of good taste to use a different snuff box every day. He noted that if one owned 300 snuff boxes and a similar number of rings, one had no

Fig. II.1
Snuff box in the form of a ship,
Russia (?), end of seventeenth century,
St. Petersburg, State Hermitage,
inv. no. 3-3676

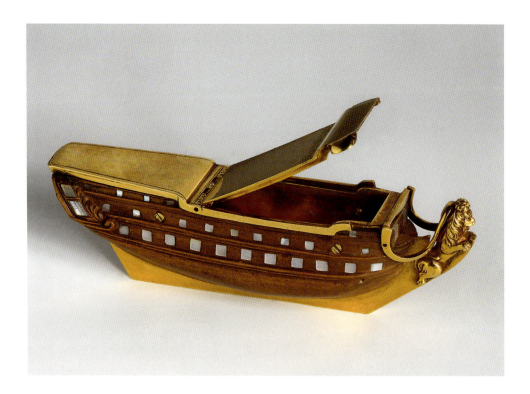

need of one's own library or a natural history cabinet.[19] Here Mercier is probably referring to systematically organised collections, such as collections of boxes with a mineralogical relevance (see pp. 37, 40).

The occasional discrepancy between reports about the size of snuff box collections and the actual documentary evidence is well illustrated by the boxes allegedly owned by Margaret Bentinck, Second Duchess of Portland (1715–1785), who—according to a statement by Horace Walpole (1717–1797)[20]—is supposed to have owned hundreds of old-fashioned snuff boxes once in the possession of her mother. However, the auction catalogue for 1786 lists fewer than fifty such boxes.

The snuff box collections in France and England mentioned above were not used for purposes of dynastic representation, in contrast to the collections that will be dealt with below. Here pride of place must go to the court of the Tsars based in St. Petersburg which adopted patterns of taste from Western Europe.[21] Tsar Peter I the Great (1672–1725), who visited the electoral *Kunstkammer* in Dresden in 1698 and inspected it in detail, owned a number of snuff boxes, including one that was a gift from Augustus the Strong (1670–1733).[22] Obviously, these pieces had a pronounced individual character and one was for example, in the form of a ship (see fig. II.1).[23] Snuff boxes are also listed in the inventory of the estate of Tsarina Catherine I (1684–1727), the second spouse of Peter the Great, which was compiled in 1727. The collecting of snuff boxes by the Russian tsars reached its high point under Catharine II the Great (1729–1796), who, drawing on limitless financial

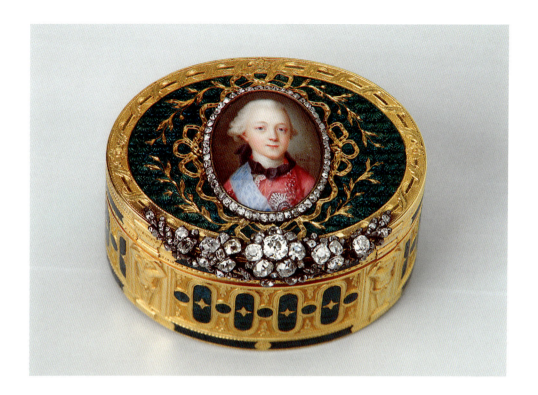

Fig. II.2
Jean-Pierre Ador (1724-1784), snuff box with the portrait of Grand Duke Paul, St. Petersburg 1774, St. Petersburg, State Hermitage, inv. no. 3-4498

means, commissioned or bought art objects and often acquired entire collections. She had a particular fondness for snuff boxes and therefore summoned important craftsmen from Paris, Geneva, or Berlin to St. Petersburg, where they produced excellent gold boxes—often opulently decorated with precious stones (see fig. II.2). Consequently, the Tsarina's snuff box collection was larger than that of any western European ruler. The way in which the snuff boxes owned by Catherine were presented is unusually well documented: display cases were arranged along the walls of the Diamond Room (formerly the State Bedroom) in the Winter Palace in St. Petersburg which, in addition to jewellery made of diamonds and other precious stones, also contained a wide variety of *objets de vertu:* snuff boxes but also watches, chains, rings, bands, and rapier handles. The Tsarina also kept snuff boxes on tables and window sills. Although Catharine the Great took snuff herself she never carried a snuff box on her person.

Snuff boxes played a significant role in the treasuries of the various rulers in the Holy Roman Empire of the German Nation from as early as the first quarter of the eighteenth century. This was particularly true of the House of Wettin.[24] In 1707 Augustus the Strong—Frederick August I as Elector of Saxony, August II as King of Poland—acquired, probably in Amsterdam, a sardonyx snuff box still in the Grünes Gewölbe in Dresden today, which appealed to his particular fondness for precious objects made of hard stones with gold mounts. In 1710 he bought a carved ivory snuff box with gold mounts and an engraved silver snuff box from Johann Melchior Dinglinger (1664–1731). Further purchases of snuff

Fig. II.3
Carnelian set of Augustus the Strong (overall view), Dresden, c. 1718–33, Staatliche Kunstsammlungen Dresden, Grünes Gewölbe, inv. nos. VIII 225–245a

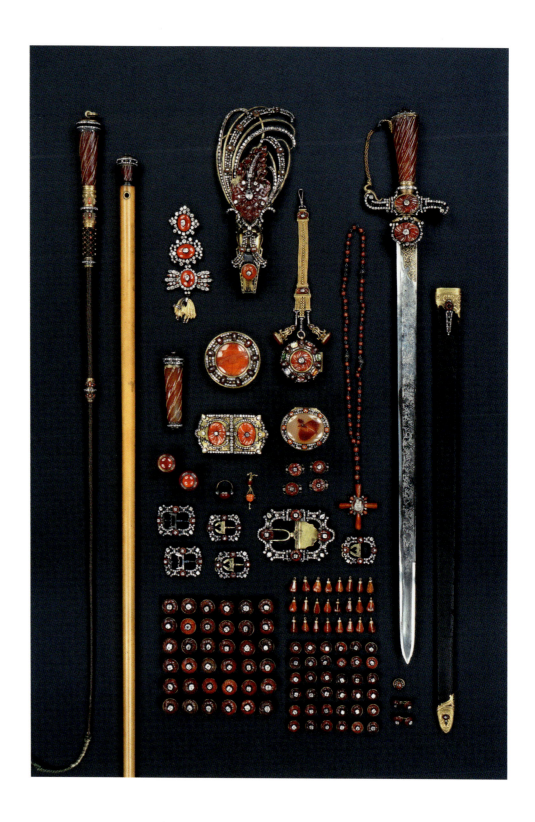

Fig. II.4
Hunting snuff box from the carnelian set of Augustus the Strong, workshop Johann Melchior Dinglinger (1664–1731) and Johann Christoph Hübner (c. 1665–1739), Dresden c. 1720–21, Staatliche Kunstsammlungen Dresden, Grünes Gewölbe, inv. no. VIII 235

boxes soon followed. However, most of the snuff boxes owned by Augustus the Strong were not intended to stand alone as individual pieces but formed part of decorative sets, which, alongside various buttons, shoe and knee buckles, hat brims, bands or aigrettes, epaulettes and decorations of chivalric orders also included pocket watches, walking sticks and rapiers as well as—in the hunting sets—hunting whips and hunting daggers complete with baldric (figs. II.3–4). Almost all such sets included one or two snuff boxes whose occasionally unusual forms did not always comply with the contemporary canon. The snuff boxes that formed part of hunting sets had a particular importance and were sometimes larger than usual so as to hold the amount of snuff needed during a day's hunting. These boxes were thus more costume accessories than original elements of a snuff box collection.

Initially, from autumn 1716, Augustus the Strong presented his jewels in a small room whose walls and ceiling were lined with mirrors—a *cabinet de glasse pour Les ioyaux du Roy*—which adjoined the monarch's dining hall in the Residenzschloss in Dresden.[25] The design of this mirrored cabinet, which was made by mostly Parisian craftsmen using precious materials,[26] was essentially based on the rooms in Versailles that housed the collections of Louis XIV, which Augustus the Strong, when still a prince, had possibly seen for himself during his "grand tour" in 1687.[27] The more easily accessible *cabinet des glaces* of the "Grand Dauphin," Louis de France (1661–1711), the son of Louis XIV, which was located in his apartments on the ground floor of the palace in Versailles, was probably a still more influential model. This room, which had probably just been completed at the time of Augustus's visit to Versailles, was used to display the most important hard stone objects and bronzes from the "Grand Dauphin's" collection.[28]

Shortly after the celebration in 1719 of the marriage of Crown Prince Frederick August (1696–1763) to the Emperor's daughter Maria Josepha (1699–1757) a radical redesign was undertaken: from this time onwards Augustus the Strong decided to exhibit the jewels in the Grünes Gewölbe, called the "secret repository." Initially the jewels were kept in a cabinet about 5.6 metres wide with mirrored doors that was made at the end of 1719 or the start of 1720. The king himself celebrated the opening of these doors which first exposed the treasures to view. As part of transformation of the Grünes Gewölbe into a treasury museum in the years 1727–29 and the creation of the jewel chamber the presentation became even more elaborate and was made into a kind of "tour conceived along theatrical lines."[29] However, the jewels displayed in the Grünes Gewölbe were also used, as Augustus II the Strong, his son Augustus III, and their successors wore them on festive occasions[30] and at such times also carried the snuff boxes with them. As indispensable parts of the "state treasury"[31] in the first half of the eighteenth century the snuff boxes of the House of Wettin in the Grünes Gewölbe represented in both material and artistic terms the high point of the appreciation of this particular branch of decorative art.

A comparison with the snuff boxes owned by Elector Maximilian II Emanuel von Bayern (1662–1726), who had lived since 1704 in exile in the Spanish Netherlands and France, where he could directly participate in the luxury of the French court, is most instructive. In Paris Max Emmanuel had immediate contact with the *marchands merciers*,

who offered fashionable fancy goods for sale, and with the craftsmen themselves. For instance the Parisian goldsmith George supplied Max Emanuel with golden snuff boxes in 1707 and 1716,[32] some of which bore the Elector's portrait and were therefore probably intended for use as gifts. Max Emanuel also showed particular interest in turned snuff boxes made from organic materials such as ivory and tortoiseshell, the latter decorated using the fashionable piqué technique (see fig. II.5; the décor is drawn using fine gold or silver nails and strips that are hammered or inlaid into the tortoiseshell). Naturally, these were individual commissions and purchases not intended to help build up a comprehensive collection. Consequently, there were only few snuff boxes in the treasury of the Bavarian Electors in Munich as is revealed by the first inventory made in 1730 and by further lists compiled later in the eighteenth century.

Around the same time, between 1730 and 1733, under Elector Karl Albrecht von Bayern (1697–1745) the treasury was installed in its own presentation room on the ground floor of the Residenz in Munich, which had glazed wall cabinets lined internally with mirrors.[33] The designs were supplied by the young architect François Cuvilliés the Elder (1695–1768). Here the Bavarian Wittelsbachs followed the trend of the time to display a wide variety of different precious items. But a detailed look reveals fundamental differences to the concept of Augustus the Strong: in Munich the decoration in just white and gold—with stucco work on the ceiling and carved boiseries—dispensed with costly materials and essentially matched the decoration in the state rooms of the electoral Residenz that were created at the same time. The programmatic relationship to the Ancestral Gallery, the room immediately preceding the treasury, was of great significance: having walked through the long room lined by portraits of the rulers of Bavaria since the Middle Ages, one arrived at the dynastic treasury of the Wittelsbachs, which had been in existence since the sixteenth century. In contrast to the Grünes Gewölbe in Dresden the glazed wall cabinets in Munich (which resembled display cases) and the way in which they were fitted-out did not apparently take account of the specific character of the precious objects displayed in them; snuff boxes played only a minor role.

Much the same applies to the Electors Palatine from the House of Wittelsbach who resided in Düsseldorf and later in Mannheim. In the inventories of the Mannheim treasury compiled in 1733 and 1782 only six and eighteen snuff boxes respectively are mentioned—most of them made of plain materials. Naturally, there were also individual collections that did not belong to the official treasury. For instance, as is confirmed by the inventory of her estate made in 1794, Electress Elisabeth Auguste von Pfalz-Sulzbach (1721–1794) owned a total of 123 snuff boxes "of different kinds and materials" which were decorated with diamonds and pearls, as well as some made of hard stones and "petrified wood"[34] ("petrified wood," actually silicified wood, was much used, above all in the second half of the eighteenth century, on account of its striking markings; the use in this attractive material was also motivated by an interest in geology[35]).

Alongside the Houses of Wettin and Wittelsbach, the Hohenzollerns emerged as important commissioners and collectors of snuff boxes. Queen Sophie Dorothea (1687–1757), the spouse of Frederick Wilhelm I (1688–1740) and mother of Frederick II the

Fig. II.5
Snuff box made from tortoiseshell with gold piqué decoration, Paris, probably c. 1701, Munich, Bayerische Verwaltung der Staatlichen Schlösser, Gärten und Seen, Schatzkammer der Residenz, inv. no. 1074

Great (1712–1786), compiled a collection of several hundred pieces in her Berlin summer residence, Monbijou: the largest of the snuff box collections put together by a German princess in the eighteenth century. According to the inventory from 1742 it comprised 403 boxes. The inventory of her estate from 1758 lists only 372,[36] presumably a number of snuff boxes had been given as gifts in the intervening period. Although the collection included a number of important pieces made of gold, it was, in general, characterised by an exceptional variety of materials and forms, for instance there were examples made of hard stones—some in the shape of animals—and others made of petrified wood, mother-of-pearl, or of glass, most of which came from glass works in Brandenburg;[37] Sophie Dorothea also decorated glass snuff boxes herself, for example she "painted behind" prints applied to the glass.[38] Court jeweller Samuel Colliveaux (c. 1669–1736) and Christian Ludwig Gotzkowsky (1697–1761), a dealer in fancy goods, both of whom were based in Berlin, supplied the Queen with luxury products and played an important role in putting together this exquisite collection.[39] The fact that Sophie Dorothea's boxes—or at least a number of them—were kept together in what was called the *Cedern Kasten* ("Cedar Chest") in Schloss Monbijou, suggests that the Queen regarded them as a collection. In addition numerous snuff boxes stood around on various pieces of furniture.[40]

Frederick the Great was certainly motivated to acquire and collect snuff boxes by his mother's example.[41] However, in choosing his pieces he applied different criteria. While the king occasionally acquired simple snuff boxes made of porcelain, mother-of-pearl, or

with *vernis Martin* decoration, as payments made to the brothers Christian Ludwig and Johann Ernst Gotzkowsky (1710–1775) confirm,[42] his main interest was in showpiece boxes of the very finest quality,[43] made of chiselled or enamelled gold, or elaborately designed hard stone boxes with gold mounts. Diamonds and other precious stones were also used to make these snuff boxes even more costly (see fig. II.6). Almost all of them were made by Berlin goldsmiths who were encouraged by the royal commissions to produce their very finest work. Here, too, Frederick was able to exert his influence on the design and craftsmanship, in some cases by presenting the craftsmen with his own designs. In contrast we do not know of Frederick owning any boxes from Paris, or at least no such boxes have survived (but in 1751 the king did write to his *Kammerdiener [valet-de-chambre]*, Michael Gabriel Fredersdorf [1708–1758], who was in Paris at the time, asking the servant to bring him a box "of the best kind that they make there and one that allows you to see how it is made.")[44] Accordingly he prohibited the import of gold *objets de vertu* from France. Thus, the showpiece boxes of the Hohenzollern king which, at least in later years, have a character that unmistakeably reflects the monarch's personal taste, in the eighteenth century occupy a special position.

The importance of Frederick's gold snuff boxes is also illustrated by the extent of the collection: the inventory made of Frederick's estate in Sanssouci after his death in 1786 listed 119 snuff boxes decorated with diamonds and a gold box and there were four further boxes in the Stadtschloss in Potsdam, making a total of 124 ornamental snuff boxes; there were also many stone boxes and parts of stone boxes without mounts. The inventory, which concentrated on precious items, contains no porcelain snuff boxes. As Frederick the Great gave a large number of fine snuff boxes as gifts we can assume that the monarch commissioned or owned between 300 and 400 such boxes.[45] But whether we can speak here of a collection in the narrower sense of the term is questionable. Unlike his mother he apparently did not keep the snuff boxes together in a piece of furniture designed for this purpose. A number of snuff boxes always lay ready for use on tables and chests-of-drawers; the king, who himself made excessive use of snuff,[46] carried boxes with him in his coat pocket.

Snuff boxes also played an important role at the smaller courts within the Holy Roman Empire ruled by dukes, landgraves, and margraves. In the first third of the eighteenth century in the Grauer Hof, the ducal residence in Brunswick which was probably built from 1717 onwards, the snuff boxes owned by Duke August Wilhelm zu Braunschweig und Lüneburg (1662–1731) were displayed in four wall cabinets, as we learn from a description dated 1728 made by Johann Friedrich Armand von Uffenbach (1687–1769) from Frankfurt during his travels:[47] "the four corners were occupied by corner cabinets of incomparable quality that contained nothing but an unbelievable number of snuff boxes of very great value."[48] The fittings designed to contain the art collections were probably ordered by August Wilhelm; a print depicting a banquet held in the Grauer Hof in 1728 shows a room in which the open wall cabinets are filled with silver vessels.[49] This suggests that August Wilhelm liked to present his precious pieces in what were apparently glazed wall cabinets and in this respect followed a tendency that manifested itself around the same time in Dresden and Munich.

However, this snuff box collection did not remain long in existence: during a financial crisis at the Brunswick court in the seventeen-seventies or early seventeen-eighties the gold mounts were separated from the snuff boxes and melted down.[50] Two inventories of precious items at the Brunswick court compiled in the seventeen-sixties to seventeen-eighties still record eighteen valuable snuff boxes that formed a complete group.[51]

The Landgraves of Hessen-Kassel also collected snuff boxes; according to the records available these were mainly plain stone boxes—generally without precious metal mounts—of the kind produced by the stone grinding mill in Kassel. The inventory compiled in 1763 of the cut stone objects sent to be exhibited in the *Kunsthaus* in Kassel lists around 150 stone snuff boxes and other stone boxes.[52] This expression of the ruler's interest in mineralogy is coupled with his pride in his territory's natural resources, which were an economic factor of considerable importance (similarly Frederick the Great chose chrysopras from deposits in the recently captured province of Silesia as the material for showpiece boxes [see fig. II.6] and table-tops[53]).

The collection of Duke Anton Ulrich von Sachsen-Meiningen (1687–1763) also concentrated on stone boxes. At the start of his reign in 1746, the prince acquired 202 stone boxes, with and without mounts from a Frankfurt dealer, almost all of which came from the Idar-Oberstein region.[54] This important collection of parts of snuff boxes is today in the Naturhistorisches Museum in Schleusingen.

At other courts, in contrast, it was mostly expensively worked gold snuff boxes that were collected, Schwerin being one example. The inventory made in 1808 of the Schwerin palace of the Dukes of Mecklenburg-Schwerin lists around seventy examples, a number of which are today in the Staatliches Museum Schwerin. The Dukes of Mecklenburg-Schwerin showed their interest in costly gold boxes at an early stage and acquired snuff boxes from the Berlin goldsmiths Louis Buyrette, or his widow, and Daniel Baudesson (1716–1785) and in 1748/49 from Johann Friedrich Dinglinger (1702–1767) in Dresden[55] and thus showed that they followed the example of the leading courts in northern and central Germany, the Houses of Hohenzollern and Wettin.

There are a number of individual reports on the snuff box collections of the two lines of the Margraves of Baden. The Margravine Sibylla Augusta of Baden-Baden, née Princess of Sachsen-Lauenburg (1675–1733), who possessed a sizable fortune, built up a notable, although not very large, collection of boxes and snuff boxes, which was put up for auction in 1755 as part of the *Fideikommiss* collection.[56] Reflecting her preference for elaborate pieces of handcraft and, in particular, carved stone objects[57] most of the boxes she owned were made of hard stones and mollusc shells or mother-of-pearl.[58]

Margravine Caroline Luise of Baden-Durlach, née Princess of Hessen-Darmstadt (1723–1783), was also a passionate and extremely knowledgeable commissioner of art works[59]—not just in the field of paintings but also in the area of the decorative arts. She ordered stone boxes personally[60] and also bought snuff boxes and pieces of porcelain in Paris herself. Together with other small precious items the gold boxes at the court in Karlsruhe in the second half of the eighteenth century were kept, like in Brunswick, in built-in cabinets in the private chambers of the Residenz.

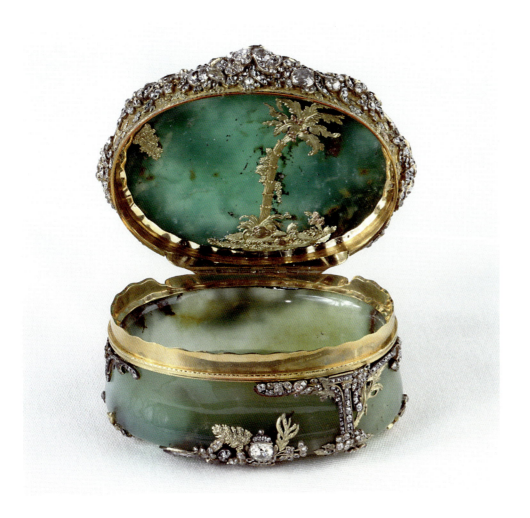

Fig. II.6
Snuff box, Berlin c. 1765, Berlin, Stiftung Preussische Schlösser und Gärten Berlin-Brandenburg, Schloss Charlottenburg, inv. no. Hz 3583 (property of the Haus Hohenzollern)

The example of Margravine Caroline Luise shows that a number of princely persons acquired and collected snuff boxes according to their personal taste and ventured beyond the usual demands of representation. Here special mention should be made of the gold box collection of Prince Carl Anselm von Thurn und Taxis (1733–1805) which first became known in the nineteen-nineties (see fig. II.7). As the imperial "Principal Commissioner" at the Perpetual Diet he resided in Regensburg. Thanks to the substantial income generated by the Thurn und Taxis's postal service the Prince was able to acquire important pieces of jewellery and *objets de vertu*. The snuff boxes he bought were not just used as gifts but were clearly intended as collector's pieces. This is revealed by an inventory from 1796,[61] in which the *Tabatieres Superbes et en bijoux pour L'Hyver* owned by Carl Anselm form a separate group that heads the list. A total of sixty-nine pieces are recorded, most of them made of gold but some of hard stones, along with a number of single pieces made of platinum, lacquer, tortoiseshell, ivory, and stoneware, always related to gold mounts (in contrast examples made of porcelain are lacking). The sixty-nine *Tabatières d'Été* form a second

41

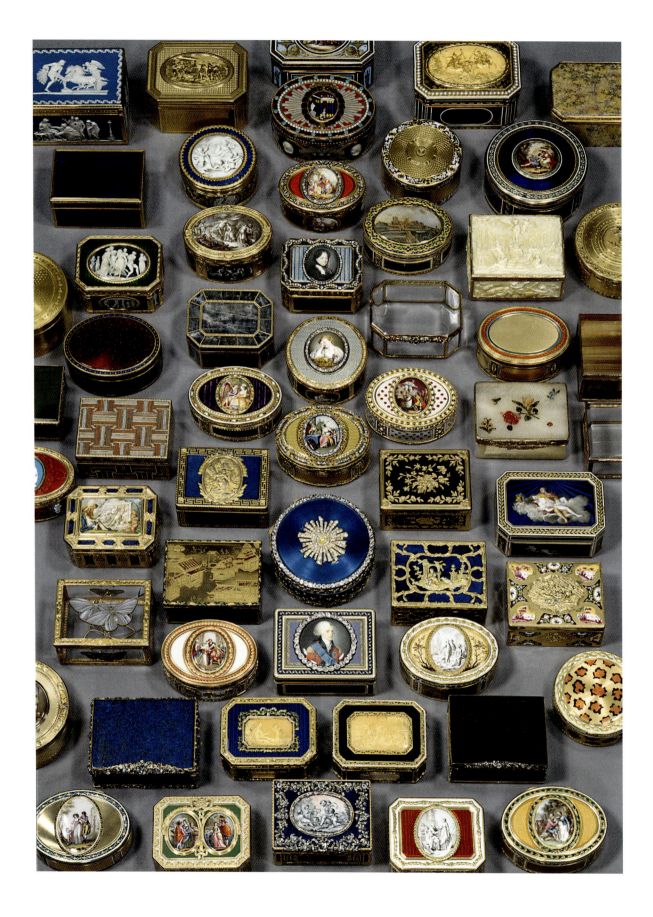

category. Here the pieces are not listed individually and only a brief description is given: *De differents desseins et gouts avec des peintures, les cercles en or et émaillés.* These were probably lighter boxes intended for use in summer, in some cases their sides were decorated with miniatures: the paintings, however, were not done in enamel colours but rather on parchment or ivory. Some of these boxes, too, had gold mounts *(cercles)*, at least a number of which were decorated with enamel.

The entries in the accounts books of the court at Regensburg provide important additional information on the inventory of precious items compiled in 1796. These accounts books contain, above all, illuminating information about prices.[62] We learn, for instance, that Prince Carl Anselm also owned simple snuff boxes, apparently even without gold mounts, made, for example, of papier-mâché—probably decorated with lacquer—and of wood, which were purchased at low prices. The same applies to two ivory snuff boxes and a Wedgewood stoneware box. In contrast tortoiseshell snuff boxes, which were used above all as a medium for miniature portraits, were comparatively expensive, especially if lined with gold. As a rule gold snuff boxes, which play the most important role among the pieces owned by the Prince, were priced far more highly, especially those decorated with diamonds.

Reports in the archives show that, on the one hand, Carl Anselm collected a very wide range of boxes but, on the other hand, for the *Tabatières Superbes* he selected special pieces, most of them gold snuff boxes, with just a few examples made of other materials. Within this collection he aimed for the greatest possible diversity, as is demonstrated by the snuff boxes and other containers from the ensemble which were acquired from the Princes of Thurn und Taxis in 1993 by the Bayerisches Nationalmuseum and are now in the state-owned Fürstliche Schatzkammer Thurn und Taxis in Regensburg. This indicates that Carl Anselm was interested in having a wide range of different forms, décors, colours, and materials. He clearly also wanted his collection to contain boxes from many different places of manufacture. Consequently, alongside the dominant gold boxes from Paris, there are others from Berlin, Dresden, Hanau, Vienna, London, and St. Petersburg. In accordance with this fact, in the inventory of 1796 the places and countries of origin are, in a number of cases, also named.

The exceptional importance of the Thurn und Taxis snuff box collection is due, in part, to the fact that we have unusually detailed information about how the pieces were acquired. Prince Carl Anselm bought most of his snuff boxes through his *valet-de-chambre* Adrian Morin (c. 1727–1800)[63], a native of Paris who at the same time was an independent dealer in fancy goods in Regensburg. As the seat of the Perpetual Diet the Free Imperial City of Regensburg was a meeting point for elegant society, which created an enormous demand for fashionable articles. Morin's trade book, which has survived in the Fürst Thurn und Taxis Central Archive, is a record, unique for Germany, of the activities of an eighteenth-century dealer in luxury goods and contains detailed information on Morin's purchases, especially in the area of snuff boxes. He generally made his purchases at the fair in Frankfurt which was attended by manufacturers of and dealers in luxury goods, above all from Germany and Switzerland. But in Hanau—the leading centre of the production of fancy goods in Germany[64]—he also bought gold snuff boxes directly from the manufactur-

Fig. II.7
Overview of Prince Carl Anselm von Thurn und Taxis's collection of snuff boxes, Regensburg, Fürstliche Schatzkammer Thurn und Taxis—Zweigmuseum des Bayerischen Nationalmuseums, inv. no. 91/214–268

ers there. A native of Paris, Morin was extremely well informed about current fashions and decisively influenced the taste of the collector Carl Anselm von Thurn und Taxis, who, after a longer visit to Paris in 1752–53, never visited France again.

An unusual occurrence provides us with precise details about where this snuff box collection was kept: after a catastrophic fire that destroyed most of the princely residence in Regensburg, the Freisinger Hof, Carl Anselm wrote a letter of thanks in French to his *valet-de-chambre* Morin who, in the Prince's absence, had rescued his snuff box collection.[65] This letter reveals that after the fire, and most likely also beforehand, the gold boxes were kept in the Prince's writing desk. This shows that the collection was not publicly accessible—the examination and use of the snuff boxes was reserved for the princely collector alone. However, as the desk did not seem a safe enough place, Carl Anselm commissioned the manufacture of a large chest with iron handles as a repository for the snuff boxes, which in the case of a fire could be easily carried away—safety was now the order of the day.

There is a remarkable parallel between the snuff box collection of Prince Carl Anselm von Thurn und Taxis and the collection of Duke Karl Alexander von Lothringen (1712–1780), who was a good two decades older. The collection put together by this General Governor of the Austrian Netherlands in Brussels was also intended more to satisfy a personal passion for collecting rather than to serve as a demonstration of princely magnificence. Karl Alexander's diary as well as invoices from the court bookkeeping provide detailed information about the Duke's acquisition of snuff boxes. On the one hand he possessed elaborate gold snuff boxes and after his death in 1781 nine gold boxes, which Emperor Joseph II (1741–1790) had selected, were sent to the court in Vienna,[66] among them one of the most important examples of eighteenth century Viennese gold snuff boxes (see fig. II.8).[67] On the other hand he also acquired snuff boxes made of porcelain which did not necessarily have to form part of his own collection but could, for instance, be used as gifts; the porcelain manufactory in Tournai in 1767 supplied seventy snuff boxes to the Brussels court which were decorated by the porcelain painter Georg Christoph Lindemann (c. 1735–1780).[68] The less costly pieces included boxes made of tortoiseshell, a snuff box with *vernis Martin* decoration and one made of rosewood, there were also boxes made of mother-of-pearl, and ivory, amber, glass, and various hard stones and some made of porcelain and faience.[69] We also have details about where the snuff boxes were kept: like Prince Carl Anselm Duke Karl Alexander, too, kept his most valuable snuff boxes in a writing desk in his study.[70] Incidentally, his spouse, Archduchess Maria Anna (1718–1744), a sister of Empress Maria Theresa (1717–1780), also had a small collection of snuff boxes consisting of nineteen boxes made of gold, agate, lapis-lazuli, lacquer, ivory, mother-of-pearl and *burgau*—the shimmering, iridescent shell of the *Turbo marmoratus* (the marbled turban shell). This collection also included two Meissen porcelain snuff boxes.[71]

However, what was probably the most extensive collection of snuff boxes in eighteenth-century Germany was owned not by a prince but an aristocrat: Heinrich

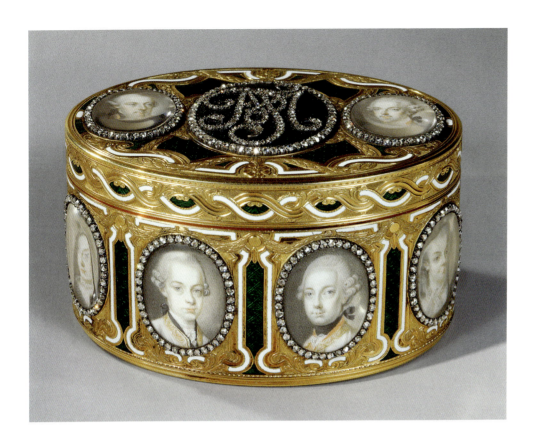

Fig. II.8
Snuff box with the portraits of the imperial family, Franz von Mack (1730–1807) and Master IR, Vienna c. 1773, Kunsthistorisches Museum, Kunstkammer, inv. no. 1604

Reichsgraf von Brühl (1700–1763), who under August III held the position of prime minister of Electoral Saxony. Details of the size of his collection vary. The most reliable come from the inventory of his estate which lists 835 examples, most of them made of gold or with gold mounts, with a total value of 101,864 *reichstaler* and 16 *groschen*. These 835 boxes included around 270 porcelain snuff boxes, some of them decorated with precious stones; the unusually high proportion of porcelain boxes reflects Count Brühl's position as Director General of the Meissen Manufactory which allowed him to take pieces produced there as he wished. As further snuff boxes are listed at other places in the inventory of his estate, the total reaches around 850 boxes.[72] In an entry in his diary made in 1756 Ernst Ahasverus Heinrich Graf von Lehndorff (1727–1811) wrote about Brühl's collection of snuff boxes: "there is nothing richer than this cabinet." This could be taken as meaning that the snuff boxes were kept together in a small room where, perhaps, they were presented as a collection. At the same time the boxes also served as accessories; supposedly every day a different snuff box and matching walking stick were chosen to suit what the Count was wearing.[73] The exorbitant collection owned by this powerful minister offers a perfect expression of the double function of the snuff box as both a coveted collector's item and a fashionable accessory.

[1] See, for instance, Die Münchner Kunstkammer 2008, vol. 3, pp. 536–37, 544, index, see Behälter, Kästchen.

[2] We also encounter individual containers for tobacco in the seventeenth century. The following note was previously overlooked: "1. Small bottle for tobacco powder of black ebony inlaid with white ivory and decorated with silver"; the little tobacco bottle belonged to a *Kunstschrank* (collector's cabinet) put together by the Augsburg art agent Philipp Hainhofer (1578–1647) and acquired in 1647 by Duke August the Younger zu Braunschweig und Lüneburg (1579–1666) for General Carl Gustav Wrangel (1613–1676; Gobiet 1984, p. 859), which today is in the Kunsthistorisches Museum in Vienna—without its original contents (Mundt 2009, pp. 17–18).

[3] Ricketts 1971; Beaucamp-Markowsky 1985, p. 23; Grégoire 2011, pp. 28–32; Kugel 2012, pp. 207, 384.

[4] Bursche 1996, pp. 18–19, no. 2.

[5] On the "étuis à tablettes" see Maze-Sencier 1885, pp. 821–23 and Grandjean/Aschengreen Piacenti/Truman/Blunt 1975, pp. 137–38, no. 62.

[6] On this branch see Grandjean/Aschengreen Piacenti/Truman/Blunt 1975, pp. 133–34, no. 60 and Truman 2013, pp. 110–11, no. 19.—On the "private" portraits of gentlewomen making pieces of textile handcraft, see Bischoff 2003a, pp. 254–67.

[7] On the "étuis de cire à cacheter" see Grandjean/Aschengreen Piacenti/Truman/Blunt 1975, pp. 143–44, no. 66.

[8] On snuff box collections and how they were kept see Seelig 2007, pp. 33–40 (with further references) and Truman 2013, pp. 45–51; as a summary, see Koch 2010, p. 120. On cabinets of precious items and treasure chambers see Syndram 2006b, pp. 93–100.

[9] Bischoff 2003b, pp. 75–76; Trauth 2008, p. 98.

[10] Claessens-Peré 1996, p. 42.

[11] Cordey 1939, pp. 197–200, 202, 206–07.

[12] Cordey 1939, p. 200, no. 2408.

[13] See, among others, Le Corbeiller 1966, pp. 114–15; Grandjean/Aschengreen Piacenti/Truman/Blunt 1975, pp. 106–08, no. 50 and now exh. cat. Münster 2013 (my thanks are due to Dr. Monika Kopplin, Director of the Museum für Lackkunst in Münster, who generously made the catalogue manuscript available to me and provided me with other useful references).

[14] Cordey 1939, p. 199, nos. 2384, 2388.

[15] On the category 'objets de vertu' or 'objects of vertu' see Ricketts 1971 and Grégoire 2011, p. 24.

[16] See also exh. cat. Münster 2013.

[17] On Lazare Duvaux see, among others, Beaucamp-Markowsky 1985, p. 23, and above all Sargentson 1996, pp. 33–34, 74–76.

[18] Claessens-Peré 1996, p. 42; Seelig 2007, p. 36.

[19] Seelig 2007, p. 36.

[20] On Horace Walpole's own collection, which included twenty-five very different examples (including some of Meissen porcelain) see Le Corbeiller 1966, p. 126.

21 See summary by Seelig 2007, pp. 34–36 (with literature).

22 Kostjuk 2009, pp. 54, 56-57, 60-62; on the visit to Dresden by Peter the Great see also Syndram 2012, p. 121.

23 Kostjuk 2009, p. 55, fig. 1; exh. cat. St. Petersburg 2010, p. 32, no. 3 (Olga Kostjuk).

24 On the following see, among others, Seelig 2007, pp. 20–23, 37 (with literature).

25 On the following see Syndram 1999, pp. 116, 119; Arnold 2001, pp. 257–62; Syndram 2006a, pp. 37–38; Syndram 2006b, pp. 99–100.

26 On the German mirrored cabinet as a type see Lohneis 1985 and—particularly also with regard to the function as a room for collections—Loibl 1989, pp. 81–83, 88; on the mirrored cabinets within the European context see Bischoff 2004.

27 Syndram 1999, pp. 10–12, 120; on the rooms see Castelluccio 2002, especially pp. 103–17.

28 Castelluccio 2002, pp. 163–65.

29 Syndram 2006a, p. 38; see also Arnold 2001, pp. 262–64.

30 Arnold 2001, pp. 248–56.

31 Syndram 2008, pp. 45, 50.

32 Tillmann 2009, pp. 192, 195.

33 Seelig 1980, among others pp. 267–68; Heym 2006, pp. 74–75, fig. p. 75; Marr 2011, pp. 159–60.—On collection cabinets lined internally with mirrors see Loibl 1989, p. 88, note 21.

34 Fuchs 1999, p. 130, pp. 137–39.

35 Seelig 2007, p. 324, no. 54.

36 Schepkowski 2009, p. 14; on the estate inventory see Kemper 2005, p. 72.

37 On snuff boxes made of glass see Stengel 1950, pp. 12–15.

38 On similar activities of princely and noble ladies see Bischoff 2008, pp. 38–40.

39 Stengel 1950, p. 11; Schepkowski 2009, pp. 14–15.

40 Schepkowski 2009, p. 14.

41 Baer 2005, p. 92; Schepkowski 2009, p. 22; Koch 2010, p. 123.

42 Schepkowski 2009, p. 22, pp. 414–17.

43 Exh. cat. Potsdam 1993; Baer 2005; Koch 2010.

44 Richter 1926, p. 179; see also Stengel 1950, p. 10.

45 Exh. cat. Potsdam 1993, p. 2; Seelig 2207, p. 38; Schepkowski 2009, p. 22; Koch 2010, pp. 123, 126.

46 Exh. cat. Potsdam 1993, pp. 12-13; Koch 2010, p. 126.

47 On the Grauer Hof and Uffenbach's descriptions of his travels see Marth 2004, pp. 70–72.

48 Schütte 1997, p. 155; Seelig 2007, pp. 33–34.

49 Marth 2004, p. 70, fig. 62.

50 On sales under Duke Carl Wilhelm Ferdinand (1735–1806) see Walz 2004, pp. 156–57.

51 Schütte 1999, p. 155, pp. 255–56; Seelig 2007, p. 34.

52 Seelig 2007, p. 37.

53 Koch 2010, p. 126; Sommer 2012, pp. 187–88, fig. 3; Holzhey 2012, pp. 76–80.

54 Schmidt 1995; Schmidt 1996; Holzhey 2012, pp. 85–86.

55 Seelig 2007, p. 36; Möller 2011, p. 162.

56 Seelig 2007, p. 38.

57 Grimm 2008; on snuff boxes see idem., p. 135.

58 Renner 1941, p. 126, pp.146–47, 228, 240–41, 261, 272–73.

59 Trauth 2008, p. 98 compares Sibylla Augusta and Caroline Luise as collectors of painting.

60 Seelig 2007, pp. 92, 107, 457, note 726.

61 Seelig 2007, pp. 89–92, 476–78.

62 Seelig 2007, pp. 92–96.

63 Seelig 2007, pp. 97–103.

64 See Seelig 2013.

65 Seelig 2007, pp. 87–89, fig. 35.

66 De Ren 1996, p. 47.

67 On the magnificent snuff box with the portraits of Maria Theresa and her family most probably made by jeweller Franz (von) Mack and a goldsmith with the initials IR see now extensively Yonan 2009, pp. 186–88.

68 De Ren 1996, p. 46.

69 De Ren 1996, pp. 47–48.

70 De Ren 1996, p. 49.

71 De Ren 1996, p. 45.

72 On Brühl's collection of snuff boxes see Schwarm-Tomisch 2000, pp. 126–27, also with details of the prices of the porcelain boxes. On the estate and its whereabouts see ibid., pp. 124–25 and elsewhere as well as Koch 2009, pp. 105–19.

73 Seelig 2007, p. 40.

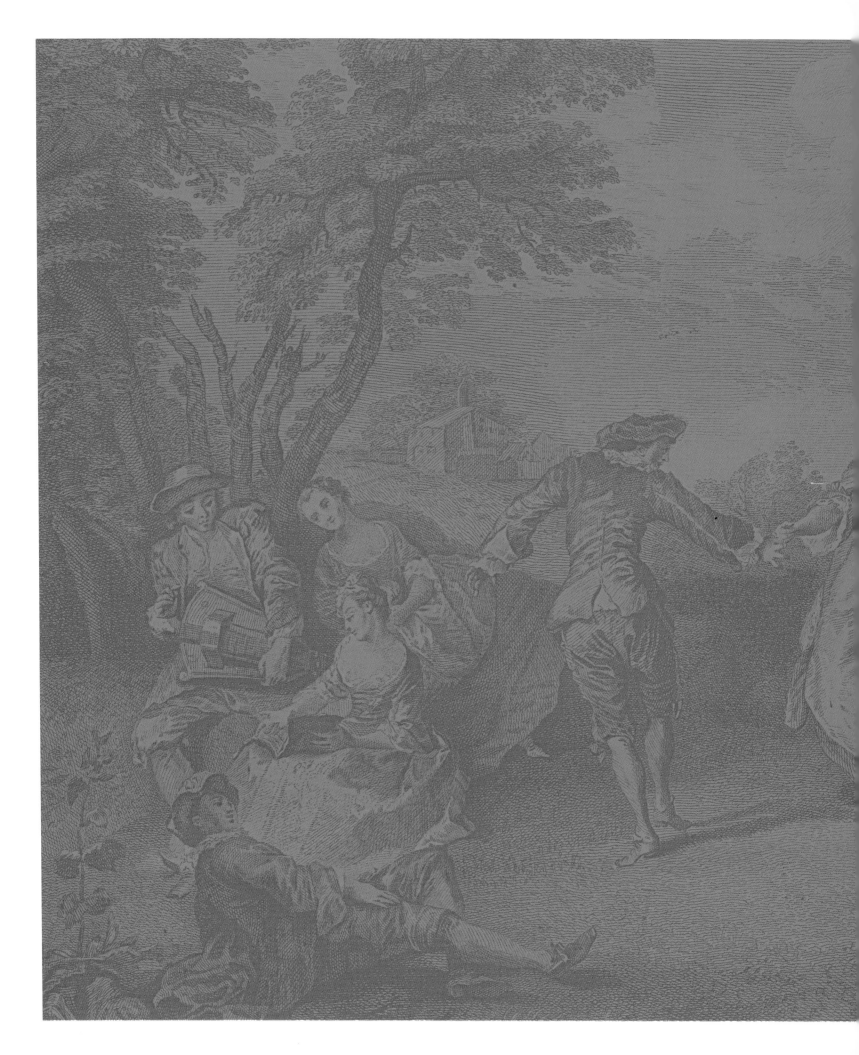

Pleasure and Principle: Collecting Snuff Boxes from 1800 onwards

Heike Zech

**Pleasure and Principle: Collecting Snuff Boxes
from 1800 onwards**
Heike Zech

When asked about his motivation for collecting, Sir Arthur Gilbert (1913–2000, ennobled in 1999), answered with the simple and timeless confession "I just love beautiful things." His snuff boxes, in particular gold boxes, are one of the finest and best-known collections of these small-scale masterpieces formed during the twentieth century nach twentieth century (see figs. III.1–4).[1] But Sir Arthur Gilbert was by no means the only collector to fall for these precious eighteenth-century boxes long after the courtly culture of the snuff box discussed in the previous chapters had ebbed away. Pleasure was the guiding principle of his collecting; the principle that drove him to try and assemble the best and most comprehensive collection of snuff boxes of his time.

Sir Arthur was not too interested in snuff-taking. Nor was he, as the youngest son of a family of Polish immigrants in London, born into the tradition of collecting snuff boxes. His exceptional fascination with the boxes was twofold. In addition to their beauty, which can only be fully appreciated when they are studied from all sides and opened, he was passionate about the stories behind each of his boxes. Many of them present European history in a nutshell. He loved the privilege of owning, handling, and sharing masterpieces that are closely associated with some of the greatest rulers of the period, such as King Frederick II of Prussia (1712–1786) or Empress Catherine II of Russia (1729–1796).

Here, collecting outside, respectively after the primarily courtly "Tradition of the Snuff Box" discussed in the previous chapters, will be explored. It is not necessarily linked to a specific period or the particular social rank of the collector, even though the precious materials used to make the most intricate and prized boxes ensured that collecting them remained the preserve of the wealthy. For the people of the eighteenth and early nineteenth centuries, a snuff box was primarily an object of daily use that spoke of the here and now. This could be in a very direct way, as for example in the enamelled maps of theatres of war

on boxes made during the Seven Years' War (1756–63). In addition, design and material advertised the owner's social rank and aspirations. Snuff boxes were means of self-expression as well as means of communication and in this respect were comparable to fans. The *Exercise de la Tabatière* ("The Exercise of the Snuff Box" which means the art of handling a snuff box) was an elaborate form of sign language and ritualised communication at court.[2] Those skilled in the art of using snuff boxes to exchange subtle messages are long gone, but the boxes are like a tangible echo of their conversations that has been preserved across time. It is this human context that is the great joy and one of the main attractions for modern collectors of snuff boxes, even more so than the precious materials of which they are made. As the scholar and art historian Clare Le Corbeiller pithily observed, "snuff boxes [are] both pleasantly familiar and pleasantly strange."[3]

Sir Arthur Gilbert declared beauty was his main motivation for collecting, and everyone who collects, either for themselves or a public institution, will agree that the quality of design and making are indeed an extremely important consideration. It is this consideration that unites the eighteenth-century collector with the modern one. During the eighteenth century princes and others acquired snuff boxes from *marchands merciers* in Paris, at auction, at the famous fairs in Frankfurt and Leipzig or directly from factories such as Meissen.[4] The palace of Heinrich, Count Brühl (1700–1763) in Dresden also served as a showcase for Meissen porcelain of all sizes and descriptions. Brühl's task was to persuade visiting ambassadors and others to invest in the "white gold" from Meissen. Among the wares exhibited at his palace were porcelain snuff boxes which also formed a significant part of his famous personal collection of boxes.[5] Brühl's boxes were more than display pieces that were shown to visitors by his daughter, Maria Amalie, Countess Mniszech (1736–1772). They were an ostentatious assembly of highly fashionable decorative pieces. One visitor, Ernst Ahasverus Heinrich, Count von Lehndorff (1727–1811), reported that the boxes were on display in cabinets in a room called *Serre-papier* and remarked in his diary that: "There is probably nothing more lavish than this cabinet."[6] The boxes were also essential elements of the count's outfits. But in contrast to his famous library and collection of paintings which were acquired by Catherine the Great (1729–1756), Brühl's snuff boxes were dispersed at several auctions in the seventeen-sixties. Today very few boxes can be traced back to Brühl's magnificent collection. The lack of importance attached to his collection of boxes in the context of the other objects he collected illustrates that in this period snuff boxes were considered first and foremost luxurious fashion articles and indispensable accessories of an elegant gentleman or lady. This view would only change towards the end of the eighteenth century.

The transition of snuff boxes from fashion accessory to art object worthy of a collection was a gradual one, but with time precious boxes came to be perceived as "objects of beauty rather than function."[7] There is a strong relation between collecting snuff boxes and the idea of the connoisseur.[8] Only in the nineteenth century, gold and silver marks on boxes started to be a scholarly interest, for example.[9]

The Napoleonic Wars (1792–1815) brought about a fundamental shift in European political landscape, which in turn had a dramatic impact on art and culture. The function and exquisite workmanship of snuff boxes paled next to the precious materials used to

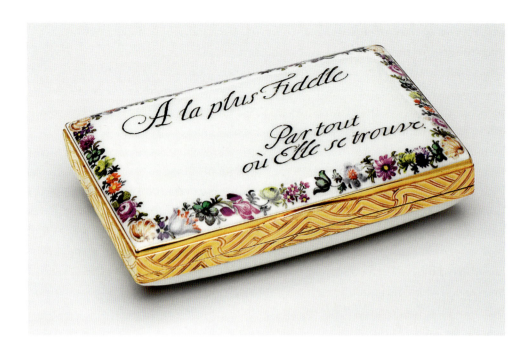

Fig. III.1:
Meissen box in the shape of a letter with a view of London on the inside of the lid, with gold mounts, Germany, c. 1755, London, The Rosalinde and Arthur Gilbert Collection on loan to the Victoria and Albert Museum, museum no. Loan:Gilbert.505-2008

make them. The watershed moment came in 1814–15. Viscount Castlereagh (1769–1822) did not hesitate to melt down the gold boxes sent to him after the Congress of Vienna in order to have the material used for an inkstand.[10]

Gold boxes were still produced in Meissen, Geneva, and other places across Europe, but the heyday of these objects as masterpieces of innovative design and craftsmanship was over. The patrons of gold box makers were succeeded by collectors who appreciated the small-scale masterpieces as works of art and antiques, and acquired them for their art collections and interiors. It is thanks to these collectors, and to a lesser extent to the descendents of the original owners of these boxes, that snuff boxes have survived at all. Auction houses and dealers, such as Samson Wertheimer in London (1811–1892) or the Durlacher Brothers (London and New York, 1843–1969) succeeded the *marchands merciers* of the eighteenth century in supplying collectors with boxes.[11] The only link between the eighteenth-century owners of snuff boxes and their nineteenth-century collector-heirs was the notion that to collect snuff boxes was a sign of class and taste.

To reconstruct such early collections of snuff boxes is often a difficult, if not impossible task. Inventories and auction catalogues are among the available sources for the quantity and range of early collections. The moment of their dispersal was often the only time when such collections were advertised to the public. Such catalogues tend to offer very generic descriptions that can no longer be matched to specific boxes. The first significant sales of snuff boxes took place even before the French Revolution (1789–99), and marked the transition of boxes from functional, elegant wares to collectibles. The collection of the Prince of Conti is such an example. It comprised 432 lots of snuff boxes

when it was sold between 1777 and 1779, even though Conti reputedly owned more than 800 snuff boxes.[12]

It is also rare to be able to reconstruct the ownership history of an eighteenth-century snuff box across the centuries. Even if marks, portraits, or inscriptions identify the place of production and one of the early owners, the history of ownership during the nineteenth century is often elusive. This first generation of collectors appear to have been fascinated by boxes for reasons entirely separate from the original use or aesthetic values. Horace Walpole (1717–1797) is an example of such an early collector: His collector's cabinet at Strawberry Hill in Twickenham, the so-called *Tribuna*, is known to have also comprised a snuff box.[13] Nonetheless, Walpole does not appear to have prized snuff boxes as an object type. He mocked the Duchess of Portland who "had hundreds of old-fashioned snuff boxes that were her mother's who wore three different every week."[14] The box he kept at Strawberry Hill had been owned by the Earl of Hertford, and it is arguably this illustrious provenance which triggered Walpole's interest in the piece rather than its aesthetic values.[15] But one box does not make a collection, and this certainly was not a collection of snuff boxes in a modern sense.

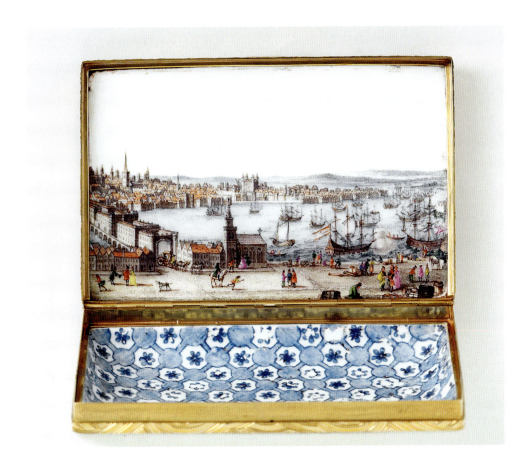

Fig. III.2:
The view of London on the inside of the lid of the box illustrated in fig. III.1, London, The Rosalinde and Arthur Gilbert Collection on loan to the Victoria and Albert Museum, museum no. Loan:Gilbert.505-2008

In England at least, collecting gold boxes remained the prerogative of the wealthy and well born, and the English royal family had a particularly keen interest in the field. The Prince Regent (later King George IV [1762–1830]) and his mother Queen Charlotte (1744–1818) were among the most avid collectors of the time.[16] By the second half of the century, precious boxes had become an indispensable part of every art collection, along with paintings, gold and silver, high-end ceramics, and furniture. They were a crucial element of the *Goût Rothschild*.[17] This dynasty of bankers, with branches in Frankfurt, Paris, and London, assembled collections of art unrivalled in splendour, scope, and quality. The snuff boxes they collected tended to be of French origin or in French taste, mirroring Rothschild preferences in other areas of collecting. Several family members competed with each other for the best pieces which are documented in the Waddesdon Manor catalogue.[18] Three collectors in particular were instrumental in building this collection of snuff boxes, and shared a similar taste. Baron Ferdinand de Rothschild (1839–1898) purchased primarily from London dealers, but also inherited a number of boxes from his father, Anselm. His interest in snuff boxes stemmed from his fascination with the *Ancien Régime* and the arts and culture of pre-Revolutionary France. Baron Ferdinand's sister, Miss Alice de Rothschild (1847–1922) shared her brother's taste. Both greatly admired the extremely fine miniatures produced by the van Blarenberghe family which depict courtly life in rich detail. Boxes decorated with their intricate compositions were one of the main attractions of the collections at Waddesdon Manor. But Miss Alice also had another passion that informed her collecting, namely her love for pet dogs, especially pugs. Hence her interest in all objects that featured pugs in one way or another led, among other things, to her pur-

Fig. III.3:
Cartouche-shaped Meissen porcelain box with battle scenes in the manner of Georg Philipp Rugendas and the portrait of Landgrave Ludwig VIII of Hesse-Darmstadt on the inside of the lid, Germany, c. 1755, London, The Rosalinde and Arthur Gilbert Collection on loan to the Victoria and Albert Museum, museum no. Loan:Gilbert.504-2008

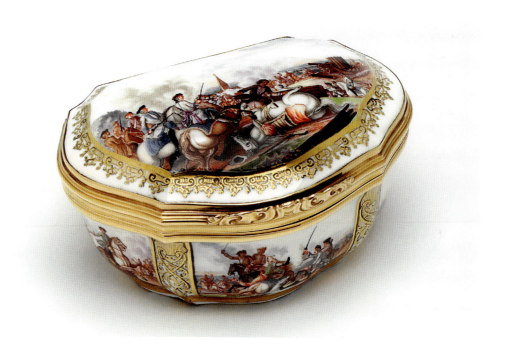

chase of one of the famous Meissen pug boxes for Waddesdon Manor.[19] In doing so she was part of a tradition that can be traced back to Count Brühl, who owned several of these boxes, and which has continued into the twentieth century when another box of this type was acquired for the Thyssen-Bornemisza Collection (see fig. III.10).[20]

Alice's passion for dogs was arguably also behind the acquisition of another famous porcelain box which first sold at auction at Christie's, London, on 8 June 1904. The box, in the collection of Prince George, Duke of Cambridge (1819–1904) was lot 421 and was bought for £720 by the art dealer Hamburger.[21] He almost certainly sold it to Alice. The oval box is set with plaques of Sèvres porcelain and the two dogs playing on the plaque on the lid are believed to be Madame de Pompadour's pets, Iñes and Mimi (see fig. III.6). The third member of the Rothschild family with a particular passion for snuff boxes, and with a similar taste like Ferdinand and Alice, was Edmond (1845–1933). A member of the French branch of the dynasty, his collections also found their way to Waddesdon Manor.[22]

When discussing the collections of snuff boxes at Waddesdon Manor, the pieces at The Wallace Collection in London also come to mind. This world-famous private collection has remained unchanged since the late nineteenth century. The Wallace Collection, kept at Hertford House, is the smallest of the national museums in London. Nevertheless its collections include old master paintings, arms and armour, and decorative arts. The collection was assembled over the course of five generations between circa 1760 and 1880, by figures that included the first four Marquesses of Hertford and Sir Richard Wallace (1819–1890), the illegitimate son of the 4th Marquess. In 1897 his widow, Lady Wallace, left Hertford House, on Manchester Square, and the collections displayed in there to Great Britain, on the condition that nothing be added or removed. The result of her generosity is a fantastic insight into a collection formed over more than a century. In taste and presentation, it is comparable to the Rothschild collections at Waddesdon Manor: Rich holdings of French eighteenth-century art are embedded in opulent nineteenth-century interiors. As it survives today, the collection reflects Sir Richard Wallace's taste in particular. He lived and collected in Paris for most of his life, and only moved to London in 1872 to receive his inheritance. He brought with him his collection, which included numerous French snuff boxes.

The recently published catalogue of the snuff boxes in The Wallace Collection by Charles Truman includes notes on the provenance of the boxes from the first owners to the present.[23] Three boxes in the collection can be traced back to an early sale of snuff boxes from the estate of M. Daugny, sold at auction in 1858. At the time, two of the three were bought by Jean-Marie Allègre, then acquired by a dealer known as "Mannheimer" at the sale of Allègre's collection in 1872. They are first documented in Richard Wallace's collection shortly afterwards, so it may be that "Mannheimer" purchased them on his instructions. The third box found its way into the collection by a different route that so far has remained obscure.[24] The Wallace Collection also includes earlier acquisitions of snuff boxes by the Marquess of Hertford during the first half of the nineteenth century.[25] Francis Charles Seymour, 3rd Marquess of Hertford (1777–1842) was described as the owner of "a vast collection of gold and silver coins, portraits, drawings, curious snuff-boxes and watches."[26] But it was really Richard Seymour-Conway, 4th Marquess of Hertford

(1800–1870), who established The Wallace Collection as it exists today. It is not clear, though, whether he also acquired a significant number of snuff boxes, although this seems likely. He was one of the richest men of his time and during his years in Paris he developed a taste for collecting eighteenth-century French decorative arts. Aged only twenty-one he wrote a letter to his mother that already demonstrates his keen interest in snuff boxes: "snuff boxes […] nothing I like half so much."[27]

The second half of the nineteenth century also marked the beginning of a new era of public collecting which saw the emergence of museums of arts and design. The museum now known as the Victoria and Albert Museum in London was established in 1852 as South Kensington Museum and it became the model for other comparable institutions across Europe, such as at Paris (1882–1901), Budapest, Vienna (1864), Hamburg (1866), and Dresden (1876) to name only a few. The collections displayed at these new institutions were alongside princely and royal collections. All aimed not just to preserve and exhibit beautiful and important works of art, but to promote the collaboration between the arts and industrial manufacturing. Snuff boxes were among the objects acquired by these fledgling institutions as excellent examples of craftsmanship and design. From the start, private collectors have been, and continue to be, instrumental in expanding these public collections through bequests and donations. In 1855, the Victoria and Albert Museum purchased eight Meissen snuff boxes from the collection of Ralph Bernal (1783–1854).[28] Bernal was a British politician who inherited estates in the West Indies,[29] which allowed him to in-

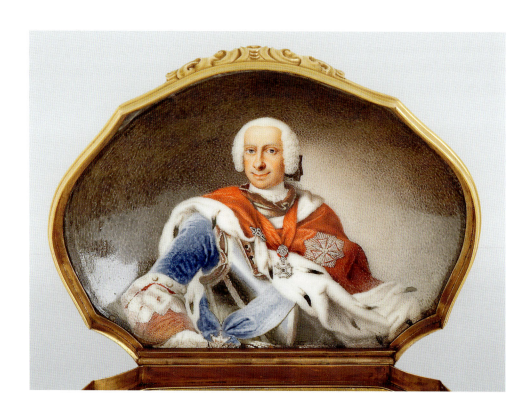

Fig. III.4:
The portrait of Landgrave Ludwig VIII of Hesse-Darmstadt on the inside of the lid of the box illustrated in fig. III.3, London, The Rosalinde and Arthur Gilbert Collection on loan to the Victoria and Albert Museum, museum no. Loan:Gilbert.505-2008

dulge his passion of collecting. After his death, his collection was sold at auction.[30] The museum had tried, and failed, under its founder Henry Cole (1808–1882) to secure the entire collection.[31] Bernal's collection therefore was dispersed, and only the auction catalogue remains as record of it in its entirety. A generation later, John Jones (1798/99–1882) bequeathed his whole collection of furniture, porcelain, silver, and tapestries—including some forty snuff boxes—to the V&A. His only condition was that it should be shown together as the "Jones Collection." His generous gesture provided the foundation of the museum's holdings of continental art between 1600 and 1800[32] (see figs. III.8–9) and will also present the core of the new permanent exhibition that will open in 2014.

Collectors' interest in snuff boxes continued to grow at the start of the twentieth century. Such was competition for the most desirable boxes that not even royal collectors were able to secure the pieces they wanted without delay. When Queen Mary (1867–1953) attempted to buy one of the famous boxes associated with the collection of Frederick the Great of Prussia at a London auction in 1927, she was outbid by the Countess de Villeneuve. Mary, however, was persistent and followed the market closely. Five years later, when the box was offered at auction once more, she succeeded in securing this masterpiece for the Royal Collection, and for a significantly lower price than the Countess had paid at the previous auction.[33]

Paris entrepreneur Ernest Cognacq (1839–1928) was a contemporary of Alice de Rothschild and Queen Mary, but in contrast he was a self-made man. He opened the famed Art Nouveau department store *La Samaritaine* in Paris in 1869. During the first decades

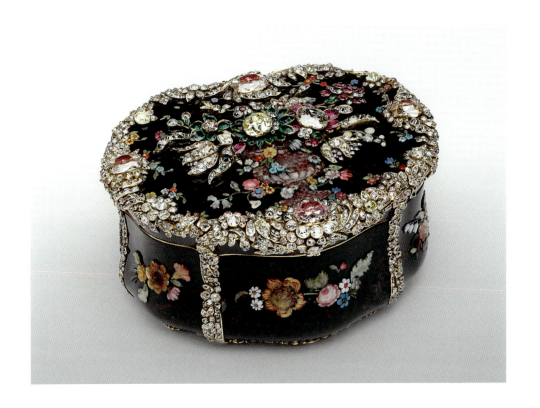

Fig. III.5:
Bloodstone, gold, diamonds, emeralds, glass, foil snuff box with a vase of flowers, designed by Jean Guillaume George Krüger, Berlin, c. 1765; associated with Frederick the Great of Prussia, purchased from the Thurn & Taxis Collection, 1993; London, The Rosalinde and Arthur Gilbert Collection on loan to the Victoria and Albert Museum, museum no. Loan:Gilbert.414-2008

of the twentieth century Cognacq and his second wife Marie-Louise Jay (1838–1925) collected European decorative arts of the eighteenth century. The collection was first shown to the public in 1917, at one of Cognacq's department stores. The couple bequeathed their treasures to the City of Paris, and today it is open to the public as Musée Cognacq-Jay at the Hôtel Donon. The museum has an excellent collection of snuff boxes which has been published recently by Christiane Grégoire. Together with other objects of *vertu,* the snuff boxes account for approximately one quarter of the whole collection. Unlike London's The Wallace Collection, this is not a closed collection: New acquisitions have continued since Cognacq and Jay's bequest to the City of Paris.[34]

The Musée Cognacq-Jay is an excellent example of an entrepreneur's private collection of the early twentieth century that has remained intact because of its owner's decision to share it with the public. The same is true of The Wallace Collection, assembled by an aristocrat and now an independent national museum, and of the collections of John Jones, a self-made businessman whose collecting legacy endures in the galleries of the Victoria and Albert Museum. The generous attitude of all these men suggested to twentieth-century collectors how they too could lend or bequeath snuff boxes to public collections and thus preserve their collections in their name for future generations.

Jack and Belle Linsky are among the most important collectors of snuff boxes in the twentieth century, as was Jimmy Ortiz-Patiño whose collection was sold at auction in 1973.[35] Russian immigrants to New York, the Linskys' collection has been cared for by The Metropolitan Museum of Art since the nineteen-eighties. They were among the first American immigrant collectors to develop a passion for this area of collecting. As with many other collectors of the period, the Linskys focussed on a select range of collecting areas and appear to have had little interest in contemporary art. In addition to paintings, in particular those of the early Italian and Netherlandish schools, they were drawn to sculpture and the decorative arts. Eighteenth-century porcelain became a key area of interest and one they pursued with verve and dedication. They bought an unusually large number of porcelain snuff boxes, but seem to have been less keen on French gold boxes. The Metropolitan Museum of Art catalogue of their collection lists thirty-four porcelain boxes, with many Meissen examples (see fig. IV.1), among them two rather fine and comparatively early circular boxes with chinoiserie decoration. The collection also comprises Nymphenburg work, as well as Italian, Russian, Danish, French, Austrian, and English boxes. Olga Raggio, the scholar who catalogued their decorative arts collection, recounts that the couple's passion for collecting was taken to another level entirely when in 1952 they moved to a new home on New York's elegant Fifth Avenue. Over the next two decades they amassed one of the greatest private collections in New York with, in Raggio's words, a "bold and single-minded determination."[36]

North America had by now become a centre for the collecting of eighteenth-century decorative arts on a grand scale, as the example of oil magnate Charles B. Wrightsman (1895–1986) and his wife Jayne (born 1919) demonstrates. Like Jack and Belle Linsky, they started collecting systematically in 1952. In the nineteen-seventies they sponsored the creation of a suite of period rooms at The Metropolitan Museum of Art, New York, for the display of masterpieces from their magnificent collection.[37] It goes without saying that

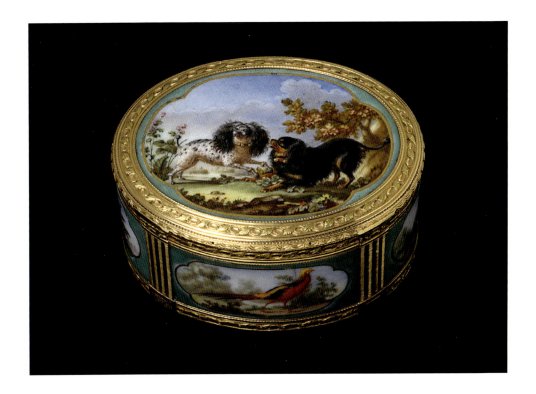

Fig. III.6:
Snuff box with Sèvres porcelain panels, gold mounts marked Louis Roucel, Paris, 1772–73; the lid with a miniature of Madame de Pompadour's dogs; Waddesdon, The Rothschild Collection (The National Trust)

some exquisite snuff boxes—in gold as well as in porcelain—belong to the Wrightsman Collection, including two Meissen porcelain pug boxes.[38]

The pleasure of handling and studying these small boxes is the leitmotif of private collecting. Nonetheless, to the present day private collectors also continue to share their treasures with a wider public. An English collector in Germany was inspired to send his collection of porcelain boxes on long-term loan to the Rijksmuseum, Amsterdam, because of one particular Meissen box in the museum's holdings. The preface to the catalogue of his collection which was published by the museum in 1988, outlines the owner's philosophy of collecting. He identifies two types of twentieth-century collectors, the "hoarders" and the "sharers." Touchingly, he dedicates the volume to his father, "who pointed me in the right direction and then let me walk and make my own mistakes."[39] A century after the Rothschilds, collecting could still be a family affair.

Like the Rothschilds, or the founding fathers of The Wallace Collection, Dr. Anton C. R. Dreesmann (1923–2000) also belonged to a dynasty of collectors. The impressive collection of this Dutch economist and businessman included paintings and decorative arts with some exquisite snuff boxes. It was sold at auction in London in 2002. His father and grandfather were collectors in their own right, although on a different scale and with different areas of interest. Anton C. R. Dreesmann was a talented and successful entrepreneur—and university teacher of Economics—as well as a collector. His knowledge, infallible memory, and his speed reading skills are still remembered by dealers and expert

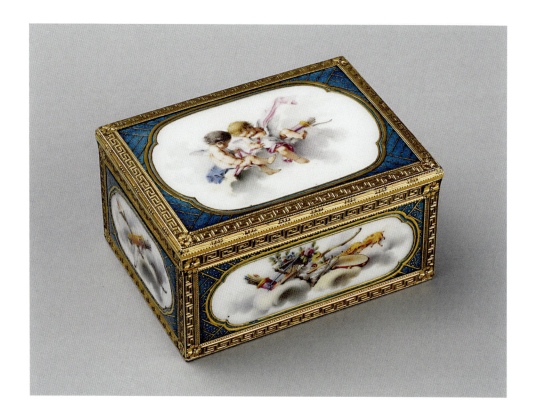

Fig. III.7:
Snuff box with Sèvres porcelain panels, gold mounts marked Jean Ducrollay, Paris, 1759–60; London, The Wallace Collection, inv. no. G31; by kind permission of the Trustees of The Wallace Collection

advisers. He collected snuff boxes as part of his "lifelong quest for beautiful and rare objects from across a wide spectrum," and he found handling his treasures a form of relaxation.[40]

Not all twentieth-century collectors were introduced to art in general and collecting in particular by their parents, as the example of Jack and Belle Linsky shows. Sir Arthur Gilbert and his first wife Rosalinde (1913–1995) were the children of Polish immigrants who worked in London as furriers and tailors respectively. Both crafts require a keen eye for style and a feel for the precious quality of materials. The families lived in Golders Green, a North London suburb.[41] Arthur, who was born as Arthur Bernstein and took his first wife's name, came from a family that can be regarded as affluent.[42] His older brother William Bernstein appears to have been the first family member to have collected antique art, as Sir Arthur pointed out repeatedly in interviews. But William's collecting taste was very different from that of his younger brother. According to Arthur, William collected sixteenth-century art. He owned a Gutenberg Bible and displayed a certain passion for linenfold panelling, but this does not amount to significant or systematic collecting. Nonetheless, Arthur and Rosalinde decorated their first homes in a mock-Tudor style similar to William's, first in Great Britain and subsequently in California where they moved in 1949.[43]

In London the Gilberts ran a successful fashion label and even participated in the *Britain Can Make It* show at the Victoria and Albert Museum in 1948. Rosalinde's designs

are influenced by French designers of the period as well as by historic dress. They are characterised by a preference for premium materials, a playful fascination with patterns which incorporate a multitude of small elements and, of course, rich and precious detailing. This suggests that Sir Arthur's love of the history and exquisite detail of snuff boxes developed from the couple's passion for historicising styles and craftsmanship on a small scale that they promoted in their designs for clothes. The Gilberts' background in the textile industry provides an interesting parallel with John Jones who was also a tailor, and, among other things, made his fortune supplying military uniforms to the British army during the Crimean War. In 1949 the Gilberts closed their business and moved to Los Angeles where Arthur soon established himself as a property developer. Only a decade or so after leaving the fashion industry they started collecting. Their move to a new family home in the nineteen-sixties prompted them to begin collecting masterpieces from the seventeenth, eighteenth, and nineteenth centuries, and it was then they acquired the first snuff boxes. Surviving letters and receipts suggest Sir Arthur's interest in snuff boxes increased further during the nineteen-seventies.[44] The first catalogue of his snuff boxes, *Gold Boxes: Superb Examples of the Goldsmiths' Art* (1983), was compiled by Géza von Habsburg-Lothringen and lists sixty-eight boxes.[45] Today the collection comprises more than two hundred snuff boxes (see fig. III.5), including some ten porcelain boxes (see figs. III.3–4). The boxes are one of four material groups represented in the collection, and one of the main attractions of the permanent exhibition of The Gilbert Collection at the Victoria and Albert Museum.

The first porcelain boxes were acquired by Sir Arthur around 1990. By then, Rosalinde and Sir Arthur had already clearly established that their collection was to be of museum quality, that it was to represent the entire range of eighteenth-century gold box production, and that it was to be displayed on loan at the Los Angeles County Museum of Art. The Gilberts were particularly intrigued by Meissen boxes in the shape of envelopes, that feature lids decorated with mock addresses in beautiful calligraphy such as "A la plus Fidelle / Partout / où Elle se trouve" (see fig. III.1). The base of these boxes is often painted with a wax seal and the inside of the lid reveals colourful, detailed scenes, such as a view of London with the Old London Bridge (see fig. III.2).

The taste of the young Gilberts embodied by the Rococo-inspired dresses they designed in London, with their rich details and luxurious materials, can still be sensed in their collecting. The *Goût Gilbert* (for want of a better word) can be considered a development of the *Goût Rothschild*. It is informed not only by their passion for masterpieces that exhibit the greatest craftsmanship on the smallest of scales, but also by their keen desire to share this passion with the wider public during their own lifetime. Creating a coherent, lavish and exclusive interior at their own home ceased to be their main concern. Instead, they sought systematically to create a comprehensive collection of museum quality, and to make this accessible to the largest number of people possible. This is reflected in the Gilberts' clear distinction between the décor of their home and the collection they showed at the Los Angeles County Museum.

That said, they did not consider it a contradiction to show off parts of their collection destined for the museum in their bungalow at Beverly Hills in a museum-like presentation

with period showcases and labels. Visitors to the Gilberts' home remember the sensual pleasure of admiring, handling, and opening gold boxes, of listening to the rich sound of a gold box closing, of chatting to Sir Arthur and Rosalinde about its decoration, being baffled by a maker's skill, or simply marvelling at the precious materials and princely origins encompassed in a single box. But Sir Arthur did not just extend this invitation to admire gold boxes to those who visited his home. He was possibly the first ever private collector to personally point out the marvels of his collection to unsuspecting visitors who wandered innocently into the galleries of the Los Angeles County Museum where his boxes were displayed. The stories of Sir Arthur Gilbert, in hot pursuit of a surprised visitor and brandishing a magnifying glass as though it were a weapon, are nowadays one of the best-known tales surrounding the collection.[46]

Sir Arthur had every right to be proud of his magnificent collection, and even more so since he was able to secure snuff boxes that even the Rothschilds had no hope of buying. It is interesting to note that nineteenth-century private collectors of gold boxes had simply no access to some of the most wonderful eighteenth-century pieces because in those days they were still in the possession of the heirs of their original princely owners. Only after the Second World War did some of these world-famous boxes come onto the market for the first time. One particularly renowned collection of boxes partly offered for sale was that owned by the Princess of Thurn and Taxis in Regensburg (see fig. III.5). The Gilberts enthusiastically embraced this opportunity, and pursued boxes from such princely collections with unrivalled determination.[47] The result is The Rosalinde and Arthur Gilbert Collection of gold boxes, which following its transfer to Great Britain in 1996 has found a home at the Victoria and Albert Museum since 2008.

From the nineteenth century onwards, collectors saw snuff boxes not as functional objects but as elegant and beautiful works of art. There has only been space here to discuss a few of the many collectors of these boxes, and of those I have focussed on collectors in the English-speaking world. The collecting activities of these few show the continued appeal of French style, the so-called *grand goût,* with its elegance of form and decoration, and the perennial fascination that the history surrounding these boxes holds for later generations. As these notes on collectors and collections have shown, while collectors can be aristocratic, self-made or independently wealthy, all are intrigued by the beauty and symbolism that surround these precious little boxes. And while the collectors of snuff boxes down the centuries perceived and displayed their treasures in different ways, all experienced the unstoppable pleasure of collecting them or, as Philippe de Montebello, former director of The Metropolitan Museum of Art, said of Jack and Belle Linsky in his introduction to the catalogue of their collection: "They had the freedom to be bold, wilful, even capricious, and they exercised it unsparingly. […] the Linskys bought for themselves only, submitting totally to the pleasure principle."[48]

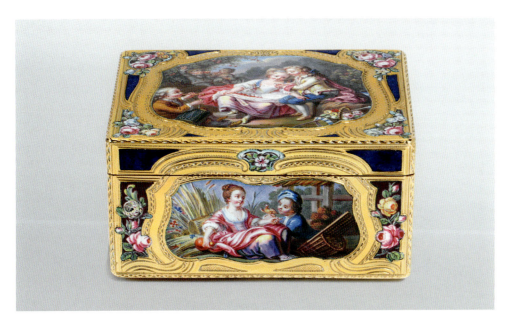

Fig. III.8:
Gold box enamelled with the Four Seasons; the enamelling attributed to Le Sueur, Paris, c. 1761; bequeathed by John Jones; London, Victoria and Albert Museum, museum no. 916-1882

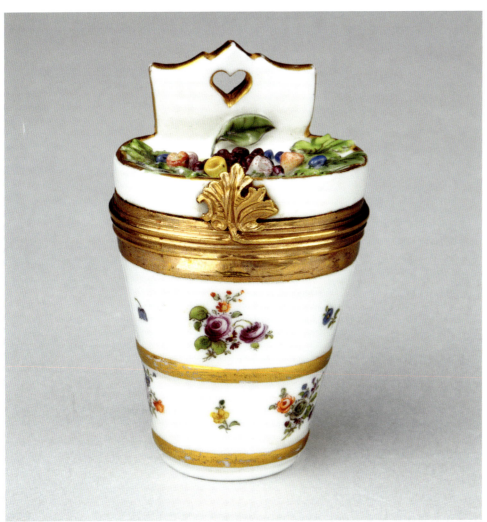

Fig. III. 9:
Meissen patch box in the shape of a flower basket; with gold mounts, Germany, c. 1750; bequeathed by John Jones; London, Victoria and Albert Museum, museum no. 939-1882

65

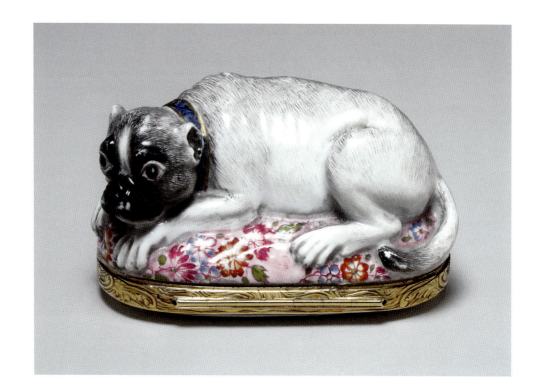

Fig. III. 10:
Meissen porcelain box in the shape of a recumbent pug dog, with gold mounts, Germany, c. 1755;
The Thyssen-Bornemisza Collection

1. The collection has been at the Victoria and Albert Museum (V&A) since 2008. Its arrival at the museum was marked by the publication of a handy guide: see Schroder 2009; for the collections's snuff boxes see also Truman 1999, Truman 1991, and Zech 2010.

2. See previous chapters, and most recently: Truman 2013a, pp. 18–19 and Murdoch 2013; both with further references.

3. Le Corbeiller 1966, preface.

4. The role of *marchands merciers,* dealers and producers of luxury wares in the eighteenth century, is the focus of the following volume: Sargentson, 1996. On the trade routes of boxes in the eighteenth century, see also Seelig 2007, pp. 43–44 (more general remarks) and pp. 97–117 (Thurn und Taxis).

5. Count Brühl was not the only one to form a personal collection of snuff boxes, but his collection was considered one of the largest already in the eighteenth century. Using inventories taken after the death of Brühl Koch could confirm that the collection comprised of around 850 boxes: see Koch, 2013, pp. 184–94; see also Seelig 2007, p. 39.
 In their introduction to the catalogue of the gold boxes in the Thyssen-Bornemisza Collection Anna Somers Cocks and Charles Truman include their definition of a collector of gold boxes in the eighteenth century as follows: "several men and women could be said to be collectors of such things, in that they possessed a number of boxes far in excess of their needs, and even beyond the number dictated by rapidly changing fashions." Among these early collectors were the Prince de Conti and Comtesse de Verrure. Her estate was sold at auction with more than two hundred snuff boxes. See Somers Cocks/Truman 1984, pp. 58–59. In his most recent publication Truman also discusses aspects of collecting gold boxes from the eighteenth century onwards: Truman 2013a, pp. 45–51.

6 "Es gibt wohl nichts Reicheres als dieses Kabinett." Quoted after Koch 2013, p. 187.

7 See Somers Cocks/Truman 1984, p. 59.

8 The term "connoisseur" is used in English since the early eighteenth century, but with a narrower use. In 1719 J. Richardson's *Two Discourses on the Art of Criticism, as It Relates to Painting and the Sciences of a Connoisseur* was published. See: "connoisseur, n.". OED Online. June 2013. Oxford University Press. 21 July 2013 <http://www.oed.com/view/Entry/39381?rskey=7bqPG7&result=1&isAdvanced=false>.

9 Truman 2013b, esp. p. 20.

10 Returning gold boxes to the goldsmith in return for money is a custom known from the eighteenth century. Castlereagh's approach appears to be an early example of the decline of gold boxes as a form that is also owed to the gradual decline of taking snuff in favour of smoking cigars and cigarettes.

 The origin of the material is explained on the foot of the set: "This inkstand is composed of the gold taken from the portrait snuff boxes which were presented by the SOVEREIGNS of Europe whose Arms are engraved hereon to Viscount Castlereagh upon the signature of the several treaties concluded in the Years 1813, 1814, & 1815." Castlereagh Inkstand, Gold, London, Paul Storr/Rundell, Bridge & Rundell, 1817–1817; London, Victoria and Albert Museum, mus. no. M.8-2003.

11 Westgarth 2009, p. 184.

12 Snowman 1974, p. 6.

13 See also Snodin 2010.

14 Cited in Truman 2013a, p. 46.

15 Truman also follows this interpretation: "Most of the boxes in these eighteenth-century collections were not acquired as objects of veneration, as in the sense of a 'collection,' but were used either for pleasure or promotion." Truman 2013a, p. 46.

16 Truman 2013a, p. 46, with further references.

17 Somers Cocks and Truman point out the different rank of various collecting interests and go as far as to describe "gold boxes as mere adjuncts to the creation of a French interior." Somers Cocks/Truman 1984, p. 60.

18 Grandjean/Aschengreen Piacenti/Truman/Blunt 1975, esp. pp. 15–18; Rothschild 1979; Shirley 2013. Unfortunately the whereabouts of the gold boxes of Waddesdon Manor has remained a mystery ever since the break-in on 10 June 2003 when more than one hundred boxes were stolen.

19 Grandjean/Aschengreen Piacenti/Truman/Blunt 1975, p. 17.

20 The interest in pugs in the eighteenth century, is indeed a vast and fascinating subject. Here it may suffice to mention the German *Mopsorden,* the Order of the Pug. It was established in Saxony in 1738 after Pope Clemens XII issued a bull forbidding Catholics to join Masonic lodges as a satirical response and alternative group. Further notes and references in Koch 2013 and Somers Cocks/Truman 1984, esp. p. 270, cat. no. 92.

21 The gold mounts of the box are marked for 1772–73 which led Eriksen to argue that it is a new mount for the very plaques which were sold at auction on 26 April 1773 as part of the estate of Madame de Pompadour. See Grandjean/Aschengreen Piacenti/Truman/Blunt 1975, pp. 111–15, cat. no. 52; see also Eriksen 1968, esp. pp. 122–23, cat. no. 42A.

22 Shirley 2013, p. 228.

23 Truman 2013a, pp. 123–26, cat. no. 24; see also Savill 1991.

24 Truman 2013a, p. 47.

25 Wallis 2013.

26 The quote is attributed to Harriet Wilson, a well-known courtesan of the period in London. She remarked upon a dinner party at Dorchester House in London that must have taken place before 1830. Quoted after Wallis 2013, p. 350.

27 Ibid., p. 350.

28 London, Victoria and Albert Museum, mus. nos. 2333, 2338–41, 2248, and 2251–1855.

29 Davies 2004.

30 Auct. cat. Christie, Manson & Woods London 1855.

31 Henry Cole Diaries, 1822–22 (type manuscript), London, V&A archivee for Art and Design.

32 The Jones Collection comprises 1034 objects, among them more than forty snuff boxes. See also mus. cat. London 1924.

33 See Jones 2013, esp. p. 210.

34 Grégoire 2011, esp. pp. 20–24.

35 Auct. Cat. Christie, Manson & Woods London 1973. Before the auction, Kenneth Snowman compiled a catalogue of the collection to give, at least on paper, an idea of the importance of the collection for future collectors and researchers. See Snowman 1974.

36 Raggio, Olga in mus. cat. New York 1984, p. 13.

37 Parker/Le Corbeiller 1979; Rothschild 1979.

38 Watson 1970, esp. p. 203, cat. no. 32 and p. 216, cat. no. 44. Aside from these examples from Meissen, the collection also contains a variation of the Chelsea manufactory: see p. 222, cat. no. 50.

39 Beaucamp-Markowsky 1988.

40 The quote is taken from Simon Levie's introduction to the 2002 auction catalogue. Five porcelain boxes were sold at this auction, including a Meissen snuff box from around 1750 with decoration attributed to Johann Martin Heinrici which features three compartments for different types of snuff. Auct. Cat. Christie's Amsterdam 2002, pp. 9–14 and pp. 46–50, lots 778–87.

41 Golders Green was constructed in the early twentieth century as a garden suburb with tube station. The station was constructed first, family homes followed. Immigrants coming to England from East Europe from around 1900 up to the First World War, were particularly attracted to the area if financial means allowed it. The choice of area in itself shows a certain wealth, at a time when most immigrants settled in East London.

42 Especially towards the end of Sir Arthur Gilbert's life his story was sometimes been described as the American dream from rags to riches. Tom Freudenheim opposed this version of Sir Arthur Gilbert's biography very rightly in his *Guardian* obituary: Freudenheim, Tom, "Sir Arthur Gilbert: Expatriate Philanthropist whose Fabulous Los Angeles Collection Revitalised Somerset House," in *The Guardian*, 4 September 2001.

43 This information is based on Sir Arthur's own account, as given in a series of interviews, and therefore have to be treated with a certain amount of caution. The biographies of the Gilberts continue to be studied as part of research on the Rosalinde and Arthur Gilbert Collection at the V & A. A more detailed sketch of the Gilberts and their collections is planned by the author for 2014. The information used here is held by the V&A archivee of Art and Design.

44 This is another parallel to John Jones who amassed his collection over the course of three decades after giving up his business in 1850. It might be that the experience of handling fabric and working with patterns is a particularly good preparation for the appreciation of decorative arts. The attention to detail and design is certainly paramount in both areas.

45 The catalogue was published by the Gilberts themselves to promote their long-term loans to Los Angeles County Museum. See Habsburg-Lothringen 1983.

46 See Schroder 2009.

47 The best known examples for this phenomenon are the snuff boxes associated with Frederick the Great of Prussia. Sir Arthur Gilbert was able to buy six such boxes, five of them with lavish diamond decoration. One of these boxes was offered by the Anhalt-Dessau family (Loan: Gilbert. 413–2008), another one from the historic Thurn & Taxis Collection (Loan: Gilbert. 414–2008; see fig. III.5). See Truman 1991, pp. 205–23, cat. nos. 71–75; Truman 1999, pp. 40–42, cat. no. 21.

48 See mus. cat. New York 1984.

Eighteenth-Century Meissen Porcelain Snuff Boxes

Ulrich Pietsch

**Eighteenth-Century Meissen
Porcelain Snuff Boxes**
Ulrich Pietsch

Meissen porcelain snuff boxes or *tabatières* are among the most magnificent and beautiful objects ever produced in this material. It was not only the Saxon electors and Polish kings Augustus II, known as Augustus the Strong (1670–1733), and his son Augustus III (1696–1763) who were fascinated by them, but also other European monarchs as well as the ministers in their service, their allies, favourites, and mistresses, who were frequently honoured with the gift of one of these luxurious *galanterie* objects.

The variety of forms they took, together with the decoration painted on them, reflects the whole repertoire of forms and décors of the manufactory at its heyday in the *galant* period of the eighteenth century. Furthermore, forms and decoration match the changes in art and fashion, since in order to ensure the maximum share of the market, the manufactory had constantly to have an eye on keeping abreast with general trends in the arts. At the time porcelain first began to be made in Meissen there was a strong Oriental influence following the taste for the Chinese fashion particularly favoured in Saxony, but at the same time the craftsmen also turned to European vessel forms and subjects for their painted decoration, since porcelain pieces were used not only as decoration in royal cabinets or in Augustus the Strong's porcelain palace, the Japanese Palace in Dresden. They also had to serve as functional objects for use in Western culture. It is true that this compatibility was less important in the case of the snuff boxes, which were designed as *galanterie* wares, but nevertheless their painted decoration developed on exactly the same lines as that of tableware, moving from chinoiserie via idealised landscapes, *Kauffahrtei* scenes (Oriental harbour scenes with European merchants and merchant ships), portrayals of battles and hunting scenes, imaginary exotic "Indian" (i.e. East Asian) flowers, *Holzschnittblumen* (woodcut flowers) and insects, and then botanical flower paintings followed by ornithological subjects, scenes from Watteau and mythological subjects.

Alongside the move to porcelain vessels there was also a development towards the creation of special shapes for snuff boxes such as heart-shaped ones or boxes in the shape of human or animal figures such as pug dogs (cat. no. 107), sheep, and mice, shapes of fruit such as apples, pears, or plums, forms which were not suitable for use as tableware models. A heart-shaped box (see fig. IV.1), for example, is the subject of a porcelain group by the Meissen modeller Johann Joachim Kaendler (1706–1775) dating from 1738, with the title *Herzdosenkauf* ("Buying a Heart Box," see fig. V.7). For Freemasons Kaendler created a special triangular snuff box,[1] since the triangle with the magic, all-seeing eye is the symbol representing the Omniscient One for the Freemasons.

Beginnings under Johann Friedrich Böttger

Between the time of the founding of the factory in 1710 and the death of the inventor of European hard-paste porcelain, Johann Friedrich Böttger (1682–1719), there were initially very few snuff boxes produced at the Royal Meissen Porcelain Manufactory. In the factory's first inventory of 1711,[2] there are no records of snuff boxes made in Böttger stoneware or Böttger porcelain but nevertheless the *Inventory of the Royal Warehouse in Dresden* dated 1719 lists a snuff box "raw" (unfired), and with one red stoneware as well as one in white porcelain.[3]

Fig. IV.1
Heart-shaped model by Johann Joachim Kaendler (1706–1775), c. 1735, The Jack and Belle Linsky Collection, Metropolitan Collection, New York, The Metropolitan Museum of Art, inv. no.1982.60.334

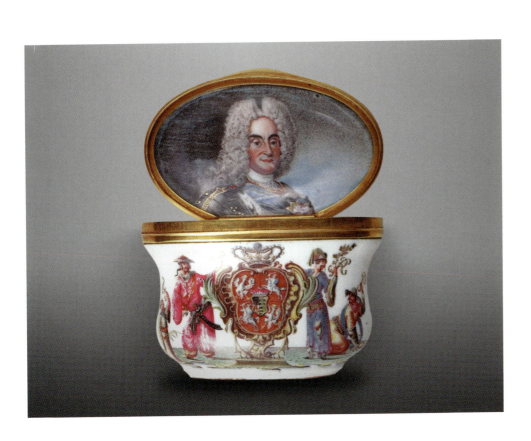

Fig. IV.2
Snuff box with coat of arms of Saxony-Poland and the portrait of Augustus the Strong (1670–1733), c. 1725, c. 1725, private collection

Fig. IV.3
Böttger porcelain snuff box, 1714–23, with monogram and Chinese figures painted by Bartolomäus Seuter (1678–1754), Augsburg, c. 1724–25; cat. no. 1

To date, however, records have been found of only one example in stoneware and one in Böttger porcelain in private collections. The polished stoneware box, formerly to be seen on loan in the Rijksmuseum in Amsterdam, has a mascaroon in relief on the front of the box and on the lid a winged putto holding a dolphin.[4] Its lobed and scalloped form with a straight back already represents the style usual in the seventeen-twenties and seventeen-thirties. Another snuff box, which is preserved in the Dresden Porcelain Collection and was thought to be Böttger stoneware,[5] has after recent research been definitely shown to be made of jasper. At the time Böttger stoneware, on account of its similarity to jasper, was often called "jasper porcelain" so that such mistakes do occasionally occur.

A box that is as far as we know the only snuff box made of Böttger porcelain in existence in a private collection has the shape of a flat, rectangular box with a slightly domed lid (see fig. IV.3, cat. no. 1). It was decorated with chinoiserie scenes and a crowned monogram painted in gold; this painting was, however, probably not carried out in the Meissen factory but in the goldsmith's workshop of the "Porcelanschmeltzer" (porcelain enameller) Bartholomäus Seuter (1678–1754), who was granted in 1726 express permission by the city council of his home city of Augsburg to decorate Meissen porcelain with gold, silver, and enamel colours. It is possible though that even before then he had been decorating porcelain without this official permission, so that one can probably date the snuff box to the period around 1722, before Meissen porcelain started to be painted with the manufactory mark of the crossed swords of the electorate of Saxony in underglaze blue. Seuter painted the lid of the box with fine gold chinoiserie figures standing under a palm tree on each side of a crowned mirror monogram with the initials "CM." The inside of the cover and the base of the box are also similarly decorated with scenes with Chinese figures, of the type familiar in the enamel colours of Höroldt. The inner surfaces of the box were covered with gold by the artist, also the exterior sides, the long sides of which are decorated with "Indian" floral motifs in oval reserves against a gold ground.

The small number of snuff boxes made of Böttger stoneware or Böttger porcelain suggests that in this period neither snuff-taking nor the use of the snuff box was widespread.

Chinese and Japanese Figures as the Stuff of Dreams for Court Society

It was not until Johann Gregorius Höroldt (1696–1775) arrived in Meissen in May 1720 from the Viennese factory of the merchant Claudius Innocentius du Paquier (1679–1751), and started painting in enamel on porcelain, bringing the art rapidly to the peak of perfection, that these boxes began to be produced in significant numbers, as can be observed from what has been passed down to us in the holdings of museums and private collections. The question remains, however, whether the increased production came about because of a rise in demand from consumers or whether on the contrary the factory increased sales by offering a wider selection. Since until his death the Dresden court silversmith Johann Jakob Irminger (1635–1724) was the only modeller the factory had, it was restricted to his snuff

box designs which were modelled on contemporary designs for boxes made in silver and gold (cat. nos. 2–6).

Until 1726 even Höroldt himself was capable of decorating his porcelain only with enamel colours, not with gold; this work was executed even in Böttger's time by the Dresden goldsmith George Funcke (dates unknown). But the whole procedure was extremely complicated because the pieces to be painted had to be transported by boat from Meissen to Dresden, where Funcke painted the gold decoration onto them, but he was unable to fire them due to the lack of a suitable kiln. He therefore had to send them back the way they had come to the Meissen factory, whence they were delivered back to him again for polishing with an agate burnisher. Only then were they delivered to the Dresden warehouse to be sold on.

The early Meissen snuff boxes produced in the Meissen manufactory usually bear the first maker's mark "K.P.M." (Königliche Porcelain Manufactur) in underglaze blue also combined occasionally with the crossed swords of the Elector of Saxony. As a rule the vessel is oval in shape, tapering towards the bottom, decorated with concentric deep fluting in lustre around the base, the box closing with a slightly domed lid. Again we may assume that Johann Jakob Irminger was the designer of the boxes, since they correspond in their form to the silver snuff boxes of the time. In this period the painted decoration on both inner and outer surfaces of the lid and on the sides of the box consists almost always of figural scenes, nowadays usually called "Höroldt chinoiseries," although in the historical records of the manufactory they are always described as Japanese figures.

The preference for this subject is first and foremost an expression of the enthusiasm of contemporary society for Chinese and Japanese cultures, one of the outstanding products of which was after all the highly-prized porcelain which people in Europe had been trying intensively over a long period to copy, and which in England is still today called "china." As Augustus the Strong was one of the greatest admirers of the Oriental it is hardly surprising that he wanted pieces from his huge East-Asian porcelain collection to be copied exactly, both in their form and decoration, and that he "was anxious to see the Indian [East Asian] increasingly copied."[6] In other words, what he wanted was to have copies both of the forms and decoration of the models in his extensive porcelain collection. With the possession of this incomparable collection and the opportunity to copy its treasures as required in his own factory, he was providing evidence not least of his cultural credentials in being able to follow the major movements in taste of his day.

Thus under the rule of Augustus the Strong the fashion for chinoiserie flourished especially in Saxony since the King had built here not only his summer palace Pillnitz in the Chinese style and his porcelain palace, the Japanese Palace, in the Japanese style. And then from around 1723 the painter Höroldt composed a pattern book with more than a thousand individual sketches of Chinese figures, which he, together with the artists in his studio, used for the decoration of porcelain vases and tableware, and of snuff boxes as well. Thus the number of pieces of Meissen porcelain decorated by Höroldt and his artists is immense, painted in ever new variations on vessels and containers, including snuff boxes. On the early examples one may find occasionally chinoiserie decoration by Höroldt's first

Fig. IV.4
Johann Martin Heinrici (1711–1786), *Maria Josepha, Electoral Princess of Saxony and Polish Queen (1699–1757)*, enamel on porcelain, 1756, Dresden, Staatliche Kunstsammlungen Dresden, porcelain collection, inv. no. PE 3609

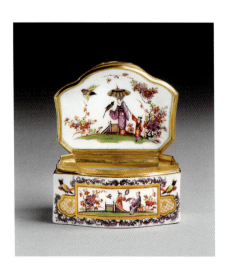

Fig. IV.5
Snuff box, painted by Johann Ehrenfried Stadler (1701–1741), c. 1728–30, cat. no. 19

apprentice, Johann George Heintze (born c. 1706/07), who was working for him as early as 1720. One of his most consistent imitators in this style, however, was Christian Friedrich Herold (1700–1779), who was working as a journeyman for Höroldt from 1725 onwards. Herold almost always painted his Chinese or Japanese figures outlined on a green platform of grass in a garden planted with flowering shrubs, where they are shown seated on chairs and stools at low tables, drinking tea with their parasols open to protect themselves from the sun. They are always set against the white porcelain, without a background of any kind (cat. nos. 7, 10, 13, 14, 16, and 17).

Johann Ehrenfried Stadler (1701–1741) also created his chinoiserie scenes in the same way, but in his case the figures were portrayed as rather bizarre and stylised Orientals, which serves as an infallible guide to the identification of his work (cat. no. 19). His artistic signature is clearly identifiable in the cryptogram on a Meissen porcelain lantern in the Dresden porcelain collection in that, as a rule, he chose a two-dimensional portrayal of the figures in the interests of decorative effect. The faces and the hands were delineated with fine lines in iron-red without any hint of flesh colour. The coiffure of the women is mostly made up of black coils which hang down from the head to the shoulders like a wig. Since we have evidence so far of only one snuff box painted in his style Stadler cannot really be considered a specialist in this field (cat. no. 19, fig. IV.5).

Adam Friedrich von Löwenfinck (1714–1754), whose style was sometimes imitated by other painters (cat. nos. 20 and 21), worked in a similar way, although there are only very few snuff boxes that can be ascribed to him.[7] He used in particular childlike Oriental figures which he copied directly from Japanese models from the porcelain factory of Sakaida Kakiemon in Arita. Löwenfinck frequently added to the range of these models, which were available in abundance in the collection of Augustus the Strong, creations of his own with outlined figures filled in with radiant enamel colours without the addition of a landscape in the background. A cylindrical tankard created by him in 1730, signed with a red "L" and now in the Rijksmuseum in Amsterdam, demonstrates in the dynamic flowing painting of the figures precisely those stylistic qualities that permit an identification of his artist's hand.[8]

Philipp Ernst Schindler Senior (1694–1765) also placed his chinoiserie scenes on a white background but he differed markedly from the other painters in his moulded painting style and in his chubby-faced figures with their round eyes and long noses, as well as in the portrayal of naked children. Furthermore he left on the stand of an ecuelle that is now in the Bavarian National museum his cryptogram "PES," so that it is possible by means of style comparison to ascribe other decorations to him (see fig. VI.1).[9] However Schindler used the cryptogram only once, while on other painted pieces he often marked the outline of a triangle standing on a point as a secret painter's mark and this appears on numerous pictures on snuff box lids (cat. nos. 11, 12, 43, 45, 46, 48, 101, and 103).

Chinoiserie, as a form of artistic expression that idealised the daily life of people in China and Japan, making of it a kind of stylised dream world, exerted such a strong power of fascination that Europeans may well have begun to visualise heaven not so much located in the hereafter as rather in the Far East. From travel accounts, often illustrated with

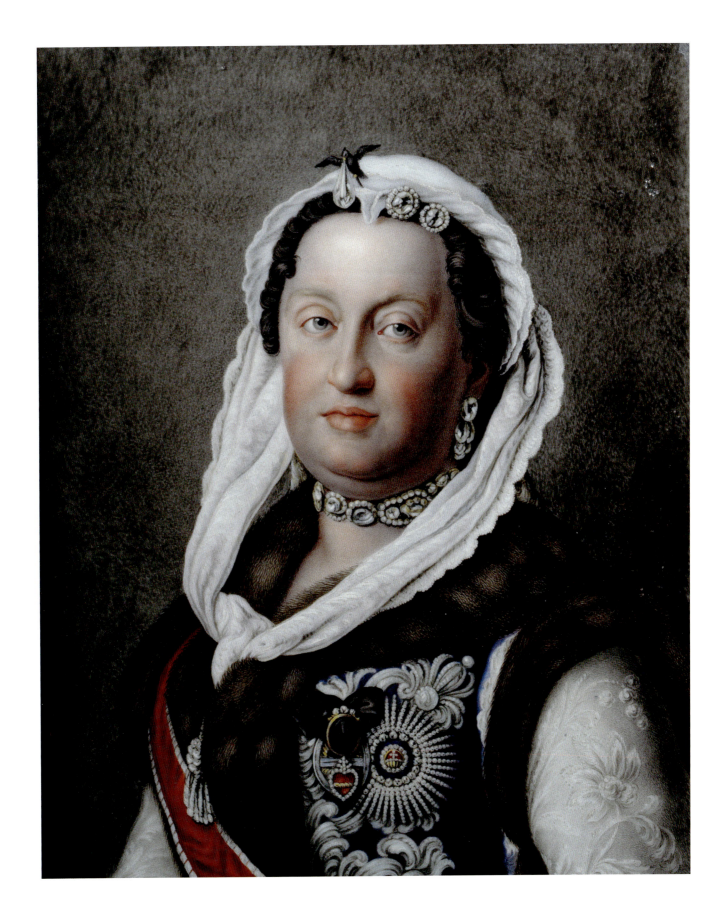

copperplate engravings, of merchants and missionaries, beginning with the voyage in search of trade by Marco Polo (1254–1324) and continuing with the Jesuit priest Matteo Ricci (1552–1610) and then Joan Nieuhof (1618–1672), the globetrotter from The Netherlands, the people of the western hemisphere learnt of the strange appearance of the people of the East, of their peculiar customs and habits as well as what seemed to them to be an apparently carefree and haphazard existence. Höroldt, together with other artists and artisans of his day, portrays Asian people with their rich costumes and bizarre headgear often taking part in the tea ceremony or in other activities where the purpose was the enjoyment of life in the midst of a landscape that seemed like a Garden of Eden, luxuriant with exotic plants and adorned with fantastical edifices. Court society, used to a life ruled by etiquette and formal ceremonies, where escape from the daily routine of convention, strict rules, and intrigues was rarely possible, must have regarded the life depicted in chinoiserie scenes as an arcadia and in appreciating the works of art people must have, at least in spirit, fulfilled a longing for a serene and peaceful world. At the same time the stimulating effect of snuff would have allowed the imagination to soar. Consequently the fashion for all things Chinese dominated Meissen porcelain painting until 1735 whereas the varieties of Chinese "snuff bottles" made of enamel, glass, or semi-precious stones were not emulated here.

After the death of Irminger in 1724 the manufactory followed various precedents in the modelling of snuff boxes. For example on 2 November 1726 the director of the factory's sales outlet in Dresden, Samuel Chladni (1684–1753), sent a "snuff box which is to be copied in several examples for Her Highness, the electoral princess. Work was immediately begun on these so that as soon as possible they could be taken to be high-fired, painted with fine colours, and immediately dispatched to the warehouse in Dresden."[10] By the end of the month there were already several boxes that had been fired, but their sides had been made too thin so that they warped in the firing and had to be made again. It is in this context that we learn that the model was made "after a Viennese porcelain snuff box."[11] By the end of December two new boxes had been produced, which "turned out very well even when fired,"[12] and these were then passed on to Höroldt for painting. Once finished they were sent to the warehouse in Dresden on 27 January 1727.[13] The recipient was the daughter of the Habsburg emperor, the electoral princess Maria Josepha of Saxony (1699–1757), wife of the Elector of Saxony Frederick Augustus II. Possibly she already owned a snuff box made by the Viennese factory and was now having copies made in Meissen. She was apparently so delighted with the results that when they were delivered to her she wanted more to be made, which she then received in March of that year, one "in the new style," each with painted decoration by Höroldt.[14]

The example set by the snuff-taking princess seems to have had an effect on other members of the aristocracy, who then began to order individual boxes from Meissen for themselves. We have preserved to us this example made for the privy councillor and field marshal of Augustus the Strong, Count August Christoph von Wackerbarth (1662–1734), who had an especially close relationship with the elector and his wife, having not only made the preparations for their betrothal but also organised the lavish celebrations for their

Fig. IV.6
Artist unknown, *Françoise Marie de Bourbon (1677–1749) Duchess of Chartres and Orleans,* oil on canvas, Château de Sceaux

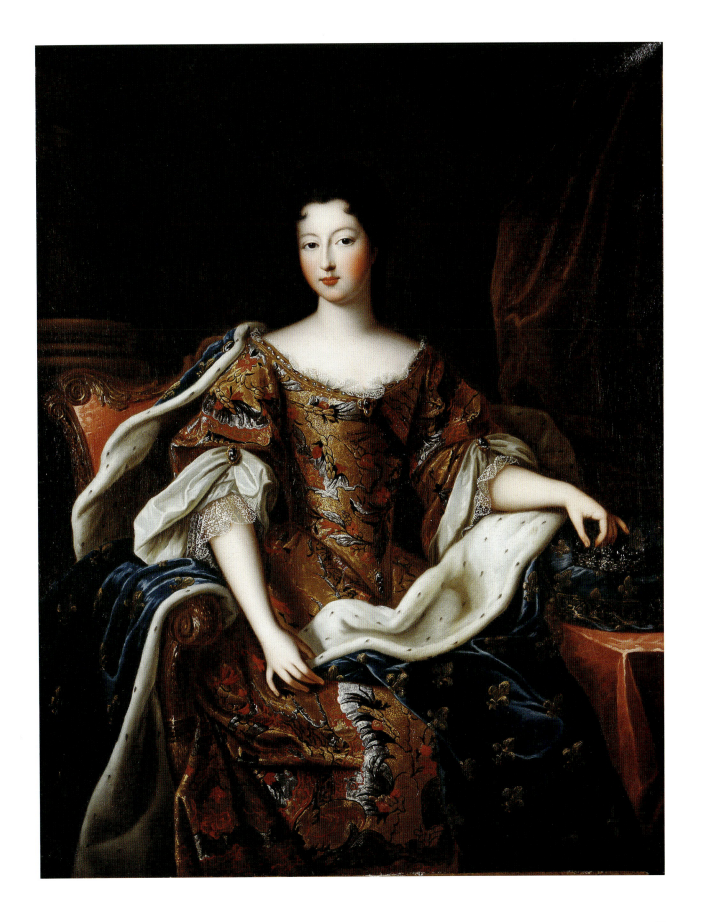

wedding in 1719 in Dresden. Moreover, from 1711 to 1719 Wackerbarth had been vice-chairman of the Meissen manufactory commission which supervised the enterprise. In April 1727 he sent a "model in lead"[15] to Meissen, from which he wanted several pieces to be made in porcelain and doubtless he received them.

Augustus the Strong may well have owned a considerable number of snuff boxes of which there is no mention in the records, which is why so little is known about the nature and appearance of the boxes made specifically for him. Only in the case of the few examples that bear his portrait can we be certain that he was the one who commissioned them, but these were probably not destined for his own use but rather as presents. One of the earliest examples of this kind, with which Höroldt achieved some success with his employer, is now in a private collection (see fig. IV.2). The exterior of the snuff box, probably made around 1723, is painted with chinoiserie figures, which in many respects shows the connection to the ruler, and in addition his portrait with the Polish Order of the White Eagle is painted on the inner side of the lid. On the front of the box two Oriental figures present a crowned cartouche with the coat of arms of the Kingdom of Poland and of the Duchy of Lithuania, and on the central shield the arms of the elector of Saxony with the elector's coronet. The figures are flanked to left and right by two others, each holding in the hand a golden initial, and these letters make up the abbreviation "FARP" ("Fridericus Augustus Rex Poloniae"). The theme is developed even further, for on the lid there are again two chinoiserie figures assisted by secondary figures holding the royal crown of Poland above the entwined golden monogram "FARP," while on the back there are also two figures holding aloft the Order of the White Eagle with a blue band, suspended from a curved rod of oak branches. Whether the miniature portrait as well as the figures was the work of Höroldt or of another artist is uncertain,[16] but what we do know is that this snuff box represents probably the earliest example of a portrait box in which Höroldt combined the chinoiserie figures so beloved by Augustus the Strong with the distinguished royal insignia as a way of honouring the monarch.

The Saxon chamberlain and mining councillor, Count Hans Caspar von Lesgewang (died 1729), emerged as another lover of Meissen boxes. As a member of the manufacturing commission, however, he did not want to abide by the general regulation according to which all goods had to be officially invoiced through the Dresden warehouse before being offered for sale. The account written by the bookkeeper Johann David Reinhard (born c. 1684) runs as follows: "So Count Lesgewang did not favour this procedure but declared that he wanted to take possession of these boxes himself without going through the invoicing process at the warehouse."[17] Reinhard was ready to grant Lesgewang his wish but was unable to circumvent the fact that he had to pay for them. This circumstance may serve as evidence of how loved and highly prized the Meissen snuff boxes were even from a relatively early date. This is also confirmed by the manufactory report of 12 December 1727, in which it is written: "because the enamelled porcelain snuff boxes are so sought after by their admirers they are decorated with painting of the finest—as well as the more mundane—quality and up to 12 pieces just in the past week have been delivered to the director Herr Chladni."[18]

Gradually the high quality of the objects was spoken of beyond the confines of the Dresden court so that in August 1732, for example, there was an order from the Duchess of Orléans, Françoise Marie de Bourbon (1677–1749) for "two snuff boxes to be made in Paris according to the accompanying model sent here,"[19] which was after, in 1728, "also now various different styles of snuff boxes, from the models that have so far been received from France, have been produced and are to be painted and enamelled in gold in the most excellent way."[20] However, the mother-in-law of the duchess, Elisabeth Charlotte of the Palatinate, known as Liselotte (1652–1722), looked down on her not only on the grounds that she was illegitimate, for she was the daughter of the mistress of Louis XIV, Françoise-Athénaïs de Rochechouart de Mortemart, known as Madame de Montespan (1640–1707), but also because of her laziness, drunkenness and probably also because of her predilection for snuff, which she was greatly disapproved of.[21] Also, the Austrian military commander Prince Eugen Franz von Savoyen-Carignan (1663–1736) received in August 1731 "one enamelled snuff box according to the attached description,"[22] in other words he had obviously special requirements concerning the appearance of his porcelain snuff box which it went without saying the Meissen factory was able to fulfil.

Snuff Box Design by Johann Joachim Kaendler and His Colleagues

Since 1731 the sculptor Johann Joachim Kaendler (1706–1775) had been working as a modeller at the Meissen manufactory. In addition to his main task of modelling large animal figures for the Japanese Palace of Augustus the Strong he was occasionally employed making smaller pieces such as shoe buckles, handles for jugs and other items of tableware, and sugar bowls and it was not until May 1733 that he modelled his first snuff box. This was no conventional snuff box, however, but a double one, "as two kinds of snuff can be put in it."[23] It was followed in November 1733 by "a new eight-lobed snuff box,"[24] the form of which would later be modified in a variety of ways (cat. no. 10).

It was not long, however, before Kaendler ceased to be satisfied with smooth forms. While they offered sufficient surface area for the painting by Höroldt and his studio they did not offer any scope for Kaendler to display his sculptural abilities. In January 1735 therefore he made "a snuff box with ornamentation and all kinds of elaborate foliate moulding [...]"[25] (cat. nos. 28 and 34). Soon after Kaendler's arrival at the manufactory the two champions of the art of Meissen porcelain came into conflict, for Kaendler could not accept being told what to do by Höroldt, who as a painter was also in charge of the porcelain making despite not knowing the first thing about it. The quarrel escalated over the six-year period of the making of the famous Swan Service (1737–1742) for the prime minister at the court of Saxony and Poland, Count Heinrich von Brühl (1700–1763), with Kaendler blaming Höroldt for the many failed firings that occurred which caused the completion of the service to be delayed for such a long time. It is quite clear that Kaendler had deliberately provoked the quarrel and in the design of the vessels had done his utmost to forestall more lavish painting of the objects by creating shell-shaped mould-

Fig. IV.7
Snuff box in the form of a shell, model by Johann Gottlieb Ehder (1717–1750), c. 1745, cat. no. 60

ing and highly sculptural marine and mythological subjects, so that all that was left to the painters to do was the painted decoration of the figures and the application of the coat of arms and a few scattered *indianische Blumen*. In the course of designing the service, in June 1741 the modeller Johann Gottlieb Ehder (1717–1750) moreover made "a snuff box in the shape of a seashell with a lid"[26] that in its design bore a striking resemblance to the shapes in the service. In this case too the painter—probably Johann George Heintze (born c. 1706/07)—was confined to painting the inside of the lid with a *galant* comic scene (see fig. IV.7, cat. no. 60).

After the man who had commissioned the service, who also held the office of director of the manufactory at the time, turned against Höroldt in 1741 and appointed Kaendler as chief modeller, the quarrels between the two adversaries were by no means at an end but from then on Kaendler was able make his own decisions about his work.

Thus in June 1735 he made "A snuff box [...] together with its own lid with very intricate basket weave [*Ozier*] decoration"[27] while at the same time he was working on "two bowl shapes with basket weaving around the edge,"[28] these possibly destined for the dinner service of Count Alexander Joseph Sułkowski (1695–1762). This demonstrates Kaendler's highly economical working methods, which meant that he often applied a newly-created moulded relief design to vessels of several kinds. Considered overall the repertoire of forms and designs is extremely diverse and varied. Nevertheless, a design once modelled would sometimes be reworked and modified. It is not always the case that the snuff boxes which have been preserved tally with the information in the work reports of the modellers, particularly since sometimes there is only mention of making a snuff box without further description.

A good example of a particularly ornate relief design is presented by the hunting scene snuff box that Kaendler began work on in May 1737 and completed by July (see fig. IV.8, cat. no. 46). As can be seen in the work report this was intended for Count Heinrich von Brühl, "Began work on a very elaborate snuff box for His Excellency the Privy Councillor von Brühl with a great deal of moulded decoration in low relief and is to have hunting motifs on the lid and sides which have to be completely finished in the coming month." [29] The short sides of the quatrefoil bombé box were decorated by Kaendler with a classic Baroque shell ornamentation, while on the long sides, the lid, and the base there are fine reliefs with hunting scenes, the composition derived from various engravings.

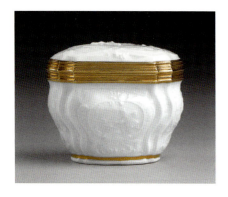

Fig. IV.8
Snuff box with hunting scenes in relief, model by Johann Joachim Kaendler (1706–1775), 1737, cat. no. 46

Later, in August 1745, the *Modellmeister* created another lid for a hunting snuff box with the portrayal of a stag hunt and yet another with a hunt for wild boar.[30]

Further reliefs created by Kaendler contain for example a representation of the Allegory of Justice,[31] the story of Meleager and Atalanta,[32] or Watteauesque figures,[33] while in others he confined himself to purely ornamental décors carved in *Tiefschnitt*.[34] Kaendler decorated some boxes with portrait medallions such as a Roman head,[35] the head of King Augustus III as well as that of a Roman emperor (see fig. IV.9, cat. no. 51),[36] and yet another with the likeness of the Tsarina Anna Ivanovna (born 1693, reg. 1730–40).[37] Finally in September 1742 Kaendler made another snuff box lid "[...] on which there is the name

Augustus Rex in stylised form [AR-monogram] resting on a pedestal with a crown above, with in addition flowers in low relief and other ornamentation."[38]

Kaendler and his colleagues created almost all the snuff boxes according to their own original designs and only rarely took as models pieces in other materials such as silver, tortoiseshell, stone, and brass.[39]

One particularly idiosyncratic example is the snuff box in the form of a rose, which Kaendler modelled in October 1740 together with Johann Gottlieb Ehder (1717–1750) no doubt destined for elegant ladies,[40] while a month later his assistant Johann Friedrich Eberlein (1696–1749) followed this with two further models for boxes based on vegetable subjects in the form of a cabbage and an "Indian fruit," presumably an orange or a peach (see fig. IV.10).[41] It seems almost as if the other modellers competed with each other to find the most bizarre artistic forms, with the result that very unusual boxes were created. For example in July 1740 Ehder came up with "a snuff box in the form of a birdcage."[42] We have no way now of knowing what motivated the modeller to create the design, but he would probably have been familiar with the symbolic meaning of the birdcage, which in the language of imagery represented woman's innocence. If the cage is opened and the bird flies away, then that signifies the loss of virginity. This idea can be transferred to the opening of the snuff box with the pictures on the inside of the lid including not only "innocent" scenes but also ones (cat. no. 9). Kaendler's snuff box in the shape of a grape hod (the basket carried on the back by harvesters; see fig. IV.17) seems comparatively innocuous in comparison. The model was created in May 1737 and clearly met with great enthusiasm, as it was manufactured again and again (cat. nos. 18, 54–57, and 98).[43] Peter Reinicke (1711/15–1768) on the other hand, like Ehder, made his mark with several somewhat sensational designs.

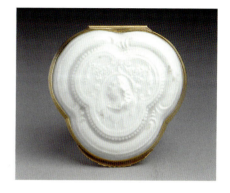

Fig. IV.9
Snuff box with the portrait in relief of the Polish King Augustus III (1696–1763) and the head of a Roman emperor, model of 1737 by Johann Joachim Kaendler (1706–1775), cat. no. 51

In November 1767 he created a whole series of new models representing an apple, a snail shell, a boat, a bathtub, and an onion, while the highlight was a box representing a clock case.[44]

The demand for Meissen porcelain snuff boxes had risen so enormously during the first half of the eighteenth century that the directorate of the manufactory felt it necessary not only to adapt the painted decorations to current trends in art but also constantly to bring out new forms in order to create new incentives to purchase.

Kaendler's ambition of decorating the snuff boxes with figural decoration or producing them in the shape of a full figure were initially realised in the so-called "pug dog boxes" (cat. nos. 81, 99, 100, 102, and 107). The first example of this kind, a "snuff box in the shape of a pug dog for the privy cabinet minister His Excellency Count Brühl," dates from June 1741.[45] It was followed in August and October of the same year by two more,[46] when it is possible Johann Gottlieb Ehder completed the August box in December, since the description in his work report sounds extremely similar.[47] In January 1742 we hear once again of two pug dog boxes by Kaendler[48] and what is striking about all these models is the fact that they were made for Count Heinrich von Brühl. This is hardly surprising in view of the fondness of the prime minister of Saxony and Poland for this particular breed. It is expressed among other ways in the fact that in 1743/44 he had his favourite pug portrayed

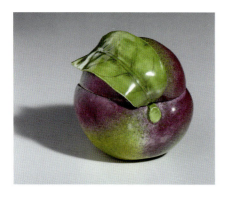

Fig. IV.10
Snuff box unmounted in the form of a peach, model by Johann Friedrich Eberlein (1696–1749), 1740, Dresden, Staatliche Kunstsammlungen Dresden, porcelain collection, inv. no. PE 2161

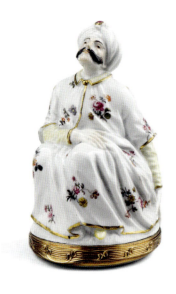

Fig. IV.11
Snuff box in the form of a seated Turk, model by Johann Joachim Kaendler (1706–1775), 1744, Schwerin, Staatliches Museum Schwerin, Kunstsammlungen, Schlösser und Gärten, inv. no. KG 20966

life-size in porcelain by Kaendler and Ehder (see fig. IV.12).[49] What is more, not only was Brühl a Freemason but he was also a member of the so-called "Order of the Pug Dog," a society of Freemasons to which women were also admitted that had a pug as its emblem.[50]

Presumably Ehder was behind the idea of decorating snuff boxes with sculptural figures of animals, since as early as 1739 he placed a cat on one of the models.[51] It was only later that the modellers went over to making the whole snuff box in the form of a figure occasionally. Thus Kaendler records in March 1741 "a snuff box in the form of an Indian figure,"[52] which is probably identical with the Turkish figure, since at this time anything exotic and Oriental was described as "Indian." A moulding of this snuff box arrived in the ducal collection in Schwerin and is to be found today in the State Museum in the city (see fig. IV.11). The unusual bearing of the figure, the odd straining in the posture, and the way the head pressed down into the neck, together with the fact that the left hand is reaching towards the hem of the garment is only to be explained when one sees its companion piece, a Turkish woman who is lifting up her long dress at the back so that her behind is visible over a large chamber pot.[53] Accordingly one may suppose that the Turkish man is also sitting on a chamber pot and doing his business. So these two snuff boxes can be classed in the ranks of the frivolous and titillating portrayals found especially in snuff box painting.

By contrast the snuff boxes made in 1769 by Ehder and Kaendler in the form of a sphinx[54] and a sheep are far more innocent. The latter is the embodiment of a typical subject of the age of sentimentalism, with the sheep being led on a ribbon by Cupid, the god of desire, while on the lid there is a relief, again with an image of Cupid, here with a lion led on a rope and the caption *Dompté par l'Amour* ("Tamed by Love").[55] The snuff box was destined, as can be seen from the work report, for the Saxon electoral princess Marie Amalie Auguste (1752–1828), the wife of the elector Frederick Augustus III., known as the Just (1750–1827). At this time the number of figural snuff boxes being made had already greatly declined in favour of simple classical forms, for the age of the fanciful Rococo was gradually drawing to an end. Occasionally one does still find what had been usual since the seventeen-forties, that is rectangular or oval boxes on the outer sides of which pictorial fields are surrounded by sculptural *rocaille* frames (see for example cat. nos. 84 and 117) which are mostly described as "French ornamental styles,"[56] but ultimately the surfaces are left perfectly smooth and thus provide a larger area for painting. In addition the figural boxes proved to be less practical since the many indentations in the interior made taking the snuff out more difficult since it would stick to the surface in places and be hard to remove.

As well as designing snuff boxes Kaendler was often occupied in fitting boxes into already existing gold mounts, which was certainly no easy undertaking given the fifteen per cent shrinkage of the paste during the firing, though there is no doubt Kaendler would have solved this problem with the same supreme skill he showed in devising and making new models.[57]

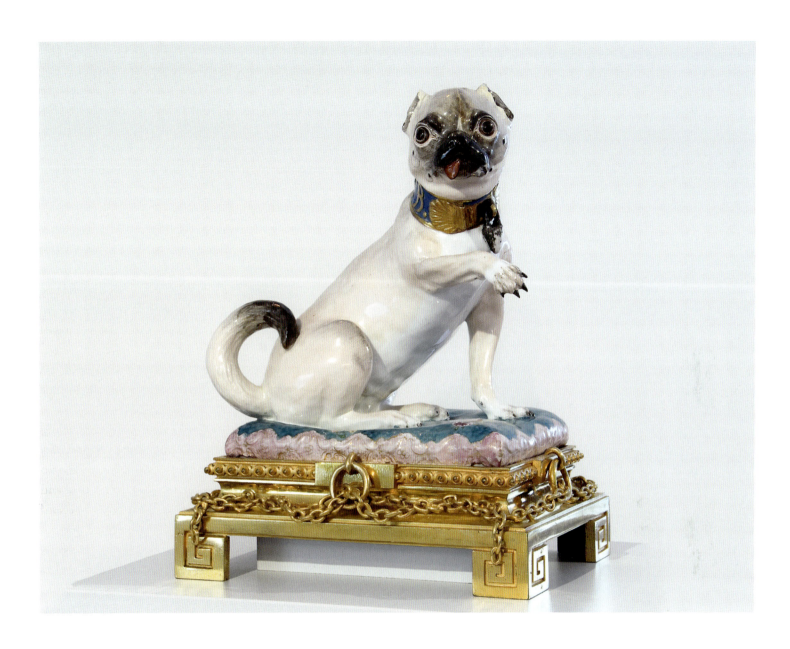

Fig. IV.12
Pug dog belonging to Count Heinrich von Brühl, model by Johann Joachim Kaendler (1706–1775) and Johann Gottlieb Ehder (1717–1750), 1743–44, Garmisch-Partenkirchen, Marianne-Aschenbrenner Stiftung

Snuff Box Decoration by the Meissen Painters

As well as the countless number of Höroldt chinoiserie decorations, Meissen porcelain pieces, including snuff boxes, were by the seventeen-twenties already being decorated with harbour scenes of merchant ships, the so-called *Kauffahrtei* scenes. One of the earliest examples of this kind is a box signed by the painter Christian Friedrich Herold (1700–1779) that is in the Dresden porcelain collection (outside see fig. VI.5; inside see fig. IV.13). The sides still have chinoiserie scenes in the traditional manner but the lid and the base were decorated by the painter with beautiful triangular compositions showing Oriental and European merchants surrounded by barrels and bales of goods, always with a

harbour scene of a bay as background and a variety of groups of people and merchant ships. Bringing into play all his imagination Herold lined the shores with lighthouses, cliffs, castles, and palm trees swaying in the wind, with the glow of the setting sun visible behind dark clouds. But it is the inner surface of the lid that presents the real surprise with its portrayal of Jupiter and Semele after an engraving by Bernard Picard (1673–1733). Herold was employed as a painter in the Meissen manufactory from 1725 until his death in 1779 and was noted for his illegal activity of *Hausmalerei* (painting done off the factory premises) working in enamels on copper snuff boxes for the Berlin goldsmith Charles Fromery (1685–1738), but receiving commissions from elsewhere as well.

Although Herold is not specifically named as a painter of snuff boxes in the manufactory's list of painters, he nevertheless counts as one of the most experienced artists in this field, creating both chinoiserie and harbour scenes as well as other subjects during the course of his long life. Like Johann George Heintze he was supremely skilled combining the two styles on occasion in a masterly and very harmonious way. Here he may have had in mind the trade of European merchants with the East, in particular that of the *Verenigten Geoctroyeerden Oostindischen Compagnie* [United Dutch East India Company], which since the seventeenth century had been shipping from Asia to Amsterdam luxury goods such as silk, jade, tea, pepper, and above all porcelain, which they then sold at sky-high prices to the princes of Europe.

Heintze's style is characterised above all by slender figures with small heads, which he always portrayed in lively detail. They were almost always added as staffage in imaginary landscapes which he composed either with towering, bizarre rock formations, palm trees

Fig. IV.13
Snuff box with harbour and chinoiserie scenes as well as the portrayal of Jupiter and Semele painted by Christian Friedrich Herold (1700–1779), c. 1728–30; Dresden, Staatliche Kunstsammlungen Dresden, porcelain collection, inv. no. PE 1536

and exotic buildings on the shores of a bay with its harbour, or with shepherds, wanderers on foot and on horseback set amongst the rocky landscape of a mountainous region, or indeed parks peopled with elegant cavaliers and ladies. As graphic sources for his views of harbours and palaces Heintze often liked to use the album by Johann Wilhelm Baur (1607–1640) entitled *Underschidliche Prospecten, Welche Er In Dennen Landen Italiae, Und Dan Auf Seiner Heimreis, Friaul Karnten Steir ff, Nach Dem Leben Gezeichnet* [Various views drawn from life in the regions of Italy and then on the return journey in Friuli, Carinthia, Styria etc] and *Iconographia: Vierdter Theil. Begreifft in sich von allerhand Meer-Porten, Garten, Palatia, so hin und wider durch Italiam, Neapolj, und dero Benachbarten Provincien und Landen, [et]c. zu sehen, und von dem Auctore ad Vivum gezeichnet worden* [Iconography: part four. Includes all kinds of seaports, gardens, palaces here and there in Italy, Naples, and the neighbouring provinces and states, drawn from life by the author] dated 1682, in each case illustrated with numerous engravings by Melchior Küsel (1626–1683). It is possible Heintze worked on several boxes at the same time, for some have exactly the same décor (cat. nos. 29, 30, 99, and 100). In addition Heintze apparently had a taste for dramatic lighting effects as in the evocative representation of a camp fire on the shore (cat. no. 28, figs. IV.14) or of a storm with flashes of lightning and the subsequent rainbow in the mountains (cat. no. 34, figs. IV.15–16). In his miniatures the milestones, obelisks, and fountains that feature so frequently almost amount to a signature of his work, but chinoiserie scenes as such are seldom found in his oeuvre (cat. no. 18).

The *Kauffahrtei* scenes of Heintze and Herold are so similar in style, that an unambiguous attribution to one or the other of them can sometimes be difficult. Sometimes too they worked together on a box, in which case Herold did the main scene on the inside of the lid and Heintze decorated the outside (cat. no. 34).

Together with the harbour scenes, hunting scenes feature prominently in snuff box painting, for not only was hunting stag and boar one of the favourite pastimes of the ruling class but it was also a status symbol of princes, protected by privilege, so that a hunting party was almost always the highlight rounding off court festivities. It goes without saying that at such festivities people liked to smoke and take snuff. In view of the number of snuff boxes with hunting references, whether in moulded relief or painted images, one can speak of an actual category of "hunting snuff boxes." As a rule the painters drew inspiration from engravings by Johann Elias Ridinger (1698–1767), transferring his complete compositions as porcelain painting as they did with other subjects, or adapting them freely for their own versions (cat. nos. 89–95). One of the most beautiful examples of this kind is a flat, lobed box with domed lid which was manufactured, as we know from its "K.P.M"-mark, as early as around 1722 but did not receive its decoration painted by Johann George Heintze until 1740 (cat. no. 89). For the three main images, on the outside and inside of the lid as well as the underside, the painter used prints by Ridinger and repeated these miniature pictures making exact copies on another snuff box in the form of a grape hod, which is today to be found in the Ernst Schneider Porcelain Collection of the Bayerisches Nationalmuseum (fig. IV.17). A further painted box, also decorated on the outside with hunting scenes after Ridinger (cat. no. 90), shows that the wife of the Polish king and elector of Saxony

Fig. IV.14
Underside of a snuff box, painted by Johann George Heintze (born c. 1706/07), c. 1735, cat. no. 28

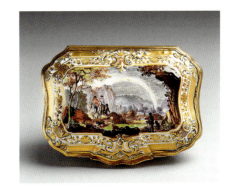

Figs. IV.15 and IV.16
Underside and lid of a snuff box, painted by Johann George Heintze (born c. 1706/07), c. 1735, cat. no. 34

Fig. IV.17
Snuff box in the form of a grape hod, model by Johann Joachim Kaendler (1706–1775), 1737, painted by Johann George Heintze (born c. 1706/07), c. 1740, Munich, Bayerisches Nationalmuseum, porcelain collection, Ernst Schneider Foundation, Schloss Lustheim, inv. no. ES 2185

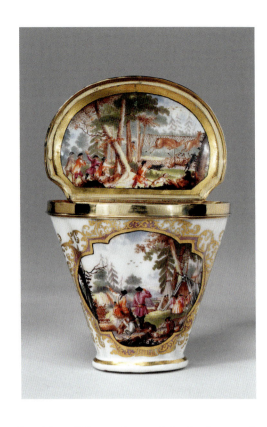

Augustus III (1696–1763), the Habsburg archduchess Maria Josepha (1699–1757) indulged in a passion for hunting as well as for snuff, for her dog is pictured on the lid wearing a ribbon round its neck with the initials "MJR" (Maria Josepha Regina) identifying her as the dog's owner.

A true specialist in hunting scenes was the painter Christian Friedrich Kühnel (1719–1792), whose style can be identified by the hunting scene on a bowl stand with the signature "C.F. Kühnel 35 years in service. 57 years old. 1776" that is in the Landesmuseum Württemberg in Stuttgart (inv. nos. G 30,146; see fig. IV.19).[58] If one compares the individual features of the decoration of the plate, such as a the frontal view of a huntsman riding to hounds and blowing his horn, who seems to be hurling himself forward out of the background, with the same subject on a snuff box (cat. no. 95), there can be no doubt that the miniature painting here is also the work of Kühnel.

As the sport of hunting served among other things to maintain the military fitness of princes, it is no surprise that so-called battle painting was used not only on porcelain tableware but also found its way onto snuff boxes, for among officers drinking, smoking, and taking snuff were common practice. In the Meissen manufactory there were many painters who specialised in battle painting, such as Gottlob Siegmund Birckner (1712–1771), who in his work reports is named not only as a painter of "naval battles" but also in 1745 as the supervisor responsible for the engravings of battle scenes.[59] Heintze, too, painted battle scenes, as did Christian Friedrich Kühnel (1719–1792), who in 1774 was named as, "the unique, the best […] master of battle scenes."[60] However, the name of the artist who painted the snuff boxes with these subjects after engravings by Georg Philipp Rugendas the Elder is not recorded (cat. no. 96).

The model of a battle-scene snuff box in the form of a campaign tent (cat. no. 97) is a special case. The wording *Hoch löbl[iches]: Brühl[sches Regiment* [Most praiseworthy: Regiment of Count Brühl] on one side of the roof of the tent and a gold Augustus Rex monogram painted on the other side provide evidence of the purpose for which these boxes, of which there are three examples still in existence, were made.[61] The reference to the Brühl regiment relates to the Saxon-Polish infantry regiment which was under the command of Count Heinrich von Brühl as general from 1742 onwards. The pictures on the sides showing bivouacked soldiers in front of Königstein fortress and two men on horse-

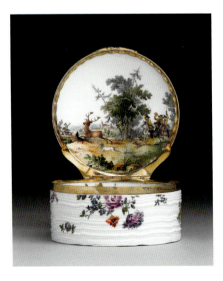

Fig. IV.18
Snuff box with a hunting scene by Christian Friedrich Kühnel (1719–1792), c. 1750, cat. no. 95

back, possibly King Augustus III and Count von Brühl himself, may well be a reference to the two Silesian Wars of 1740–42 and 1745 so the snuff boxes were probably presents from General von Brühl to officers of his who had emerged with honour from the military clashes with the Prussians.

Bonaventura Gottlieb Häuer (1709–1782) was another battle painter, who, like the others, had at his command a wider range of subject matter. In 1765 for example he painted a snuff box with "prospects,"[62] but his true talent appears in the portrayal of people working in the mines of Saxony, which are found in his hand on tableware and occasionally also on snuff boxes. It seems that these were in considerable demand, for those who worked in mining and with the extraction of mineral resources made a large contribution to the prosperity of the electorate of Saxony, and no less importantly provided the raw materials for Meissen porcelain and were held in high esteem at court and in society at large. No doubt these mining officials enjoyed an income that enabled them to indulge easily in pleasures such as taking snuff. Häuer, as the son of Samuel Häuer the senior official in the Freiberg mining guild, was familiar with mining from his own observation and was thus in a position to portray in detail the world and daily work of the miners in his painting on porcelain. One of his masterpieces among the snuff boxes is one with a painting on the

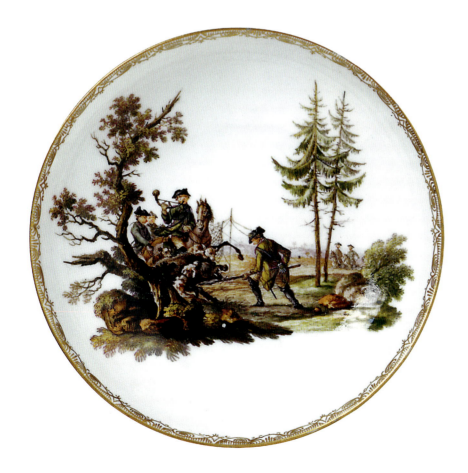

Fig. IV.19
Stand for a bowl with a hunting scene, signed and dated by Christian Friedrich Kühnel (1719–1792), 1776, Stuttgart, Landesmuseum Württemberg, inv. nos. G 30, 146

inside of the lid of two young boy miners holding the arms of Saxony and Poland (cat. no. 98, fig. IV.20). On the front of the box there is a mining official standing in his black uniform and gold-braided cap with the gold Augustus Rex initials on the front. The gentleman wearing a green cape and yellow frock coat, black breeches, and white stockings, carrying his black three-corned hat under one arm and his walking stick in the other, may well be Augustus III portrayed on a visit to Freiberg. Maybe the snuff box was a present from the monarch to a faithful servant.

In the seventeen-forties and seventeen-fifties so-called "Watteau painting" was predominant after a large bundle of copperplate engravings of paintings by French artists of the Rococo was acquired by the manufactory and placed at the disposal of the porcelain painters as models to copy. In 1744 a total of eleven artists specialised in this area. The subject of the 1717 painting by Jean-Antoine Watteau (1684–1721) *The Embarkation for Cythera* in the Louvre embodies symptomatically, just as the chinoiserie scenes did, the idealised escape from court society into a virtual world free from social constraints, where in a pleasure-oriented environment people could give free rein to their feelings. So what could be better suited to the decoration of snuff boxes than the countless open-air scenes of shepherds and shepherdesses, bacchanalia, dancing parties, picnics, plays, and concerts which make up practically the entire subject matter of French Rococo painting? There is hardly an engraving of work by Claude Audran III (1658–1734), Pierre Aveline (1656–1722), Jacques-Philippe Le Bas (1707–1783), François Boucher (1703–1770), Anne-Claude-Philippe Comte de Caylus (1692–1765), Charles-Nicolas II Cochin (1715–1790), Gabriel Huquier (1695–1772), François Joullain (1697–1778), Nicolas III de Larmessin (1640–1725), Simon François Ravenet (1706–1774), Gérard Jean-Baptiste Scotin (born 1698), Simon Henri Thomassin (1687–1741), and others, from which the Meissen painters did not take individual subjects in the so-called "Watteau décors" or, in the case of their own figural compositions, took individual aspects and used them in playful combinations. The painters were able to use engravings of the Watteau paintings from the collection made by Jean de Julienne (1686–1766) and published by him under the title *Recueil Julienne* in two volumes dated 1726 and 1735. In addition they enthusiastically availed themselves of printed reproductions of paintings by other artists, as well as of original engravings of *galant* scenes of which they had equally large bundles at their disposal. For the colouring of the paintings they had to draw on their own imagination since the engravings were not in colour. In the early seventeen-forties the Watteauesque painting was as a rule done using coloured enamels, but this changed around the middle of the century.

In 1748 a breakfast and toilet service with "Watteau décor" arrived in Naples at the court of King Charles V of Sicily and VII of Naples (1716–1788) and his wife Maria Amalia Christina, Princess of Saxony (1724–1760). It was a present from Augustus III and his wife Maria Josepha to mark the tenth wedding anniversary of the young couple. This ensemble, which had been made at the Meissen factory from 1745 onwards, included bowls for coffee, tea and chocolate, tureens, soup bowls, table bells, candelabra and all the components of a toilet set such as washbasins, boxes for sewing requisites, a reel for thread and a thimble as well as a number of snuff boxes (cat. no. 40; fig. IV.21). There is no

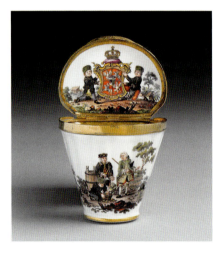

Fig. IV.20
Snuff box with the Saxon-Polish coat of arms and decoration with mining figures, painted by Bonaventura Gottlieb Häuer (1709–1782), c. 1740, cat. no. 98

mention made of the fact that all the pieces were also decorated with gold ornamentation as well as with the multi-coloured Alliance coat of arms of Naples and Sicily with Saxony and Poland in the work reports of the painters—apart from Gottlob Siegmund Birckner, Johann Jacob Wagner (1709/10–1797) was also involved—nor of the vivid copper green colour with internal line drawing in black that was used on all the pieces. Presumably the green, which stands out in sharp contrast on the white porcelain, was chosen because green and white were the colours of the coat of arms of the electorate of Saxony. Until 1750–55 the use of *en camaïeu* copper green was compulsory for all the Watteauesque painting (cat. no. 64), until finally a transparent, delicate-pink iron-red was chosen as a flesh colour and then only the clothes of the figures and the landscape remained in green (cat. nos. 41, 42, and 108). Occasionally a sepia brown *en camaïeu* is to be found on the boxes with Watteau painting. However this shade was limited to only a few examples (cat. nos. 35–37).[63]

Together with the "Watteau décors" which were frequently painted on the inside of the snuff boxes as well as the outside, other subjects are occasionally to be found in the lid of some specimens. These may include actual portraits (cat. nos. 55, 57, 109, 110, 111, 112, and 114) or simply images of beautiful women (cat. nos. 71 and 100). Among the portrait painters Philipp Ernst Schindler Senior and his son of the same name (1727–1793) are particularly outstanding but certainly the most productive in this field was Johann Justus Töpfer (c. 1713–1777), who painted portraits in miniature not only of Polish royalty, electoral princesses of Saxony, Countess Maria Anna Franziska von Brühl (1717–1762) and the Russian Tsarina, but also of many other members of the aristocracy. These images were not always intended for snuff box lids but all the same between July 1763 and 1764 he produced miniature portraits for a total of twenty-six boxes.[64]

Similarly the painter Johann Jacob Wagner mentions in his work reports numerous snuff box lids with portraits, including likenesses of the Tsarina Elisabeth (born 1709, reg. 1741–61),[65] Queen Maria Josepha,[66] Maria Theresa as Queen of Hungary (born 1717, reg. 1741–80),[67] the electoral princess Elisabeth Auguste von Pfalz-Sulzbach (1721–1794; cat. no. 54)[68] and her husband the elector Carl Theodor (1724–1799),[69] as well as other members of the nobility not specifically mentioned by name.

One of the best portraitists alongside Wagner was without doubt Johann Martin Heinrici (1711–1786). His likenesses of Augustus III (cat. no. 108) and his wife Maria Josepha (cat. no. 113) are particularly to be admired and are among the best portraits ever painted on snuff box lids. They are based on a pastel by Anton Raphael Mengs (1728–1779) in the one case and a painting by Count Pietro Rotari (1707–1762) in the other. Like Wagner Heinrici also painted portraits of the elector of Pfalz-Sulzbach and his wife (cat. no. 114).

Owners were also fond of having pictures of their favourite dogs, pugs in particular (cat. nos. 101, 103, and 105), which were portrayed, occasionally in pairs, in an extremely lively way by Philipp Ernst Schindler Senior for example (see fig. IV.22). Indeed in 1742 both Schindler and his son are described as specialists in the art of painting snuff box lids (cat. nos. 11, 12, 43–46, 48, 101, and 103).[70]

At the same time that Watteauesque painting was so popular, as an expression of a movement in taste towards nature in the spirit of the Early Enlightenment, society became

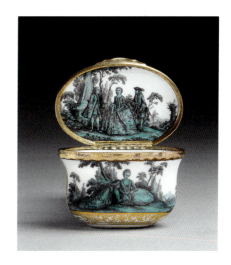

Fig. IV.21
Snuff box with "Watteau décor" and the coat of arms of the Alliance of Saxony and Poland with Naples and Sicily, painted by Gottlob Siegmund Birckner (1712–1771), c. 1745, cat. no. 40

fascinated with flora and fauna, so that pictures of European flowers, plants, and animals in decorative art and thus in porcelain painting were the object of increased interest. They gradually replaced the *indianische Blumen* (cat. no. 77), iridescent birds of paradise, and grotesque creatures of fable still so greatly loved in the seventeen-thirties. At this time painters used as their source published books on plants such as the *Phytantoza Iconographica* by Johann Wilhelm Weinmann (1683–1741; Nuremberg 1737–45), illustrated with engravings of flowers among other things, erroneously described in the Meissen manufactory as *Holzschnittblumen* (woodcut flowers). In addition the ornithological illustrations in bird books such as *A History of Birds* by Eleazar Albin (1690–1742; London 1731–38) were used. Nevertheless it is only rarely that one finds these rather matter-of-fact subjects on the *galant* snuff boxes, such as one box with individual *Holzschnittblumen* on the outside and a sleeping pug dog inside the lid (fig. IV.22, cat. no. 105), while there are no examples of décors based on Albin's bird illustrations. Only later, in the seventeen-fifties, did the Meissen artists occasionally paint the boxes with so-called natural flowers, mostly in the form of a still life (cat. nos. 78–82) and also with domestic birds (cat. nos. 84–87). One of the most gifted painters of domestic birds was Carl Gottlob Albert (c. 1728–1772), who began his career at the Meissen manufactory as an apprentice in 1744 and in 1756 was recruited by Wilhelm Kaspar Wegely (1714–1764) and lured away to Berlin. It is not known whether he also painted snuff boxes while at Meissen.

Around the middle of the century the use of mythological subjects, which had played a minor role in the seventeen-twenties, increased, appearing more and more frequently in the aftermath of the Seven Years' War (1756–63). At this time as well as later they were described as "Ovid décors." This genre was adopted by Birckner but above all by Wagner, for whom in June 1745 *Bräuers Ovidische Verwandlungen* was acquired by the manufactory for his use. This refers to the edition of Ovid's *Metamorphoses* by Johann Wilhelm Baur (1607–1640): *Ovidii Metamorphosis, oder Verwandlungs Bücher mit 151 Kupferstichillustrationen*, published in Augsburg in 1641. Wagner appears to have made extensive use of these illustrations (cat. nos. 116–19). For example, he produced paintings of the metamorphosis of the nymph Syrinx into a reed (cat. no. 119) as well as that of Perseus and Andromeda, both of which, with their delicate stippling and perfectly balanced colour combinations can be classed as true works of art in miniature. Yet, despite the change in direction towards stories and themes from antiquity during this period of intellectual and cultural upheaval, painters still also reverted to décors based on paintings of an erotic, even lascivious nature, for example works by François Boucher (1703–1770; cat. no. 117). Among these backward-looking tendencies, holding fast to the past and firmly resisting new developments, we may include the décors with so-called *genies,* that is children, putti, and winged cupids, clothed to a greater or lesser degree, mimicking the adult world, such as for example the works modelled by Kaendler in March 1769 called "Gardener boys" and "Gardener girls," "Shepherd boys" or "Children," figures portrayed in the forest playing the horn or lyre.[71] Painters in this genre include among others Heinrich Christian Wahnes (c. 1700–1782) and Isaak Jakob Clauce (1728–1803). Wahnes is described in the records of the Meissen manufactory for 1752 as being "constantly occupied in painting

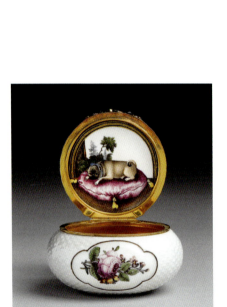

Fig. IV.22
Snuff box with basketweave moulding, painted with *Holzschnittblumen* and pug, c. 1750, cat. no. 105

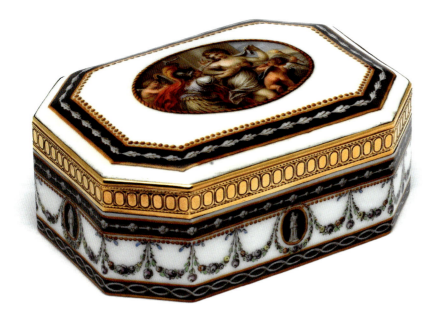

Fig. IV.23
Snuff box, painted in the "pigtail" style, the outside with Antony and Cleopatra, the inside with the Albrechtsburg, c. 1770, London, The Rosalinde and Arthur Gilbert Collection on loan to the Victoria and Albert Museum

small children on snuff boxes and tableware and having served for twelve years in the factory."[72] The factory administration initially considered dismissing him on account of the poor quality of the finished work he produced but in the report of June 1765 he is again named as a painter of scenes of children but from 1769 due to poor eyesight he was only allowed to paint "Indian" motifs.[73] Clauce, who arrived at the Meissen factory in 1753, was an established miniature painter and together with Heinrici was considered as one of the best portraitists. It seems that in January 1756 he was working as a *Hausmaler* in Dresden where he had been sent on the orders of the King and Count von Brühl "for the completion of their snuff boxes in enamel colours."[74] After the start of the Seven Years' War Claus then went to Berlin, where he worked in the Gotzkowsky factory until 1763, and from then on in the Royal Manufactory. The snuff boxes he painted here allow us to come to conclusions concerning his work at Meissen, so that one can attribute to him above all cherubs and putti with fluttering garments floating on clouds (cat. nos. 110 and 120).

There was no change either in another particular transitional style followed at this time, the so-called "pigtail style" (see fig. IV.23), with the first tentative attempts to neo-classicise the *style rocaille,* when the prince elector Xaver of Saxony-Poland (1730–1806) in February 1764 entrusted the Dresden painter Christian Wilhelm Ernst Dietrich (1712–1774) "with the establishment and administration of a school of art at the Meissen manufactory […] in order to reform taste in the direction of the style of Louis VI and classical models."[75] Dietrich was personally too committed to the art of the late Rococo to be able to undertake a radical reform of porcelain painting and after only a year he resigned from his post. Of course the archaeologist, antiquarian and writer of the Early Enlightenment, Johann Joachim Winckelmann (1717–1768) had already in 1754 in his *Gedanken über die*

Nachahmung der griechischen Werke in der Malerei und Bildhauerkunst [Thoughts on the Imitation of Greek Works in Painting and Sculpture] praised *edle Einfalt und stille Größe* [noble simplicity and quiet grandeur] as the distinguishing qualities of Greek masterpieces which he recommended as the ideals for the art of his own day, but the time was not yet ripe for fundamental change in art. The nobility held rigidly to traditional structures and it was only philosophers such as Charles de Secondat, Baron de Montesquieu (1689–1755) and Jean Jacques Rousseau (1712–1778) who began to prepare the path for radical social and political change in their writings. It was not until 1780, as the French Revolution and the end of the *ancien regime* drew near, that purely classical forms and décors gained acceptance (cat. no. 124), marking the start of a new era in decorative art. Following this dramatic upheaval the snuff box lost its importance as a status symbol and became a more utilitarian object. Nevertheless the quality of design and decoration continued at a high level. The strict proportions of the box shapes remained without any kind of relief decoration, retaining a purely classical décor with acanthus branches, sphinxes, portraits *en grisaille* surrounded by portraits *en grisaille*, frames with beading and egg-and-dart ornamentation, as well as other motifs taken from classical architecture. In the pictures on the insides of the lids now there are often scenes from the Iliad or the Odyssey, as for example in a snuff box which shows Telemachus taking leave of Penelope after a painting by Angelika Kauffmann (1741–1807; cat. no. 121).

[1] See Kaendler's work report of January 1741, Staatliche Porzellan-Manufaktur Meissen (SPMM), archive, AA I Ab 16, fol. 8r: "A snuff box in the form of a triangle that was ordered by Secretary Vithen, for Freemasons" [Eine Tabattiere in gestalt eines Triangels, Welche Von den Herren Secretario Vithen bestellet worden, Vor Frey Mayer], Pietsch 2002, p. 76. In addition he mentions an oval snuff box that was to be painted with pairs of dividers, another masonic symbol, see work report of April 1742, AA I Aa 28, fol. 147r: "Made a model of an oval snuff box on which a number of pairs of dividers are to be painted" [Eine ovale Tabattiere gefertiget nebst Deckel Worauf lauter Zirckul gemahlet Werden sollen], Pietsch 2002, p. 90.

[2] Sächsisches Hauptstaatsarchiv Dresden, Locat 41910, pp. 294a–305b, *Inventarium Aller zu denen Königl. Neuen Manufacturen gehörigen Massen, gebrandten und ungebrandten Geschirr, Brennöfen, Geräthschafften und dergl. so anitzo in Meißen befindl. Anno 1711 d. 3. Aug. in Meißen.*

[3] SPMM, archive, AA I Aa 1, fols. 23–31, 35; I Aa Ib, fols. 334–44, 345–48, 349–59; see Boltz 2000, p. 95.

[4] See Boltz 2000, p. 96, figs. 114 a and b.

[5] See Beaucamp-Markowsky 1985, p. 27, cat. no. 1.

[6] See SPMM, archive, AA I Aa 3, fol. 415.

[7] See an example in the Mme. Louis Solvay Collection, Musées Royaux d'Art et d'Histoire, Brussels, published in Marïen-Dugardin 1995, p. 58, cat. no. 101, and in the Ralph H. Wark Collection, The Cummer Museum of Art and Gardens, Jacksonville, Fla., published in Pietsch 2011, pp. 212–13, cat. nos. 198 and 199.

[8] Rijksmuseum, Amsterdam, inv. no. BK-17361, published in Den Blaauwen 2000, pp. 276–78, cat. no. 201.

9. Published in Eikelmann 2004, pp. 124–25. The hypothesis that the monogram stands for "Princeps Elector Saxoniae" is entirely unfounded, as had this been the case, it would certainly not have been hidden but would have had to have been placed in large letters in a prominent position, see Lübke 2008, pp. 3–20.

10. See SPMM, archive, AA I Aa 10, fol. 180v.

11. See SPMM, archive, AA I Aa 10, fol. 185r.

12. See SPMM, archive, AA I Aa 10, fol. 207r.

13. See SPMM, archive, AA I Aa 10, fol. 213r: "20. On 27 January 2 snuff boxes with fine-looking painting were sent to the agent at the sales outlet" [20. Sind 2. Stück Schnuptobacks-Dosen, die an Mahlerey ein gutes Ansehen haben, am 27. Januar zum Waaren-Lager an den Factor abgesendet worden].

14. See SPMM, archive, AA I Aa 10, fols. 221 v and 251.

15. See SPMM, archive, AA I Aa 10, fol. 270.

16. Beaucamp (1985, p. 29) suspects the hand to have been that of a painter in enamels from the school of Georg Friedrich Dinglinger (1666–1720).

17. See SPMM, archive, Rapport no. XXIII of 20 November 1728.

18. See SPMM, archive, Rapport no. XXIII of 20 November 1728, fol. 432.

19. See SPMM, archive, Rapport no. X of 31 August 1732.

20. See SPMM, archive, Rapport no. XXIII.

21. See Holland 1874, p. 238; Rolland 1863, p. 157.

22. See SPMM, archive, Rapport no. X, 31 August 1732.

23. Kaendler's work report of May 1733: "da zweyerlei Tobacken hinein gethan werden," Pietsch 2002, p. 19.

24. "Eine Neue 8Paßigte Schnupftobacks Doße gefertiget," Pietsch 2002, p. 21.

25. "Eine Schnupff Tabacks Doße mit Zieraten und allerhand mühsamen Laubwercke gefertiget," SPMM, archive, AA I Aa 24, fol. 32r, Pietsch 2002, p. 28.

26. SPMM, archive, AA I Ab 16, fol. 175.

27. SPMM, archive, AA I Aa 24, fol. 259r, Pietsch 2002, p. 32; see a snuff box with the so-called "Sulkowski-Ozier" moulded relief pattern in the Heine Collection, Det Danske Kunstindustrimuseet, Copenhagen, ill. in Beaucamp-Markowsky 1985, p. 186, cat. no. 142.

28. See note 24.

29. SPMM, archive, AA I Ab 9, fol. 89v, Pietsch 2002, p. 47; in the report of July 1737 one then finds the following: "Completed the model for a very elaborate snuff box for His Excellency Count Brühl, with low-relief hunting scenes and ornaments." [Die mühsame Tabattiere Vor Ihro Excell: den Herrn Grafen von Brühl vollends gefertiget Worauf flach erhaben Jagten und Zieraten befindlich gewesen], SPMM, archive, AA I Ab 9, fol. 164r, Pietsch 2002, p. 48.

30. Work report of August 1746, AA I Ab 26, fol. 7r: "Made a model of a snuff box lid with a stag hunt shown in low relief in a little landscape, very tidily executed. Made a model of another snuff box lid of the same kind with a boar hunt shown in low relief, which was formerly far too big and is now tidily executed on a smaller scale." [Einen Tabattjeren Deckel Worauf eine Hirsch Jagd flach erhaben in einem Landschäfftlein aufs Sauberste Vorgestellet poußiret. Noch einen dergleichen Tabattjeren Deckel Worauf eine Wilde Schweins Jagd ebenfalls flach erhaben, Welches Vorhero Viel zu groß gewesen, aufs Sauberste ins kleine poußiret], Pietsch 2002, pp. 110–11.

31. See work report of March 1741, AA I Ab 16, fols. 69r–70v: "Made a wax model of a snuff box lid for Secretary Coeßarn bearing an image of Justice with sword and scales in low relief, sitting on a rock"

[Einen Tabattieren Deckel für den Herren Zeug Secretario Coeßarn in Wackß pousieret Worauf das Bild der Gerechtigkeit mit der Waage und Schwerdt, flach erhaben oder Paßreliefi befindl. War, Wie sie auf einem Felsen sietzet], Pietsch 2002, p. 77.

[32] See work report of June 1742, AA I Aa 28, fols. 174r–175r: "Began to make corrections to a snuff box model made by the sculptor Ehder [Johann Gottlieb Ehder, 1717–1750] bearing the story of Meleager and Atlanta. There remains a certain amount to do" [An einer Tabattiere Zu poußiren angefangen, um solche zu Corrigiren an Welcher Vorhero der Bildhauer Ehder gearbeitet, Worauf die Historia des Meleagers und der Atlanta befindl. Woran aber noch zu thun übrig blieben], Pietsch 2002, p. 91.

[33] See work report of June 1745, AA I Ab 24, fol. 250r: "Made corrections to a very elaborate snuff box with Watteau figures, and put it in order" [Eine sehr mühsame Tabattjere mit Watteauischen Füguren Corrigiret und in tüchtigen Stand gesetzet], Pietsch 2002, p. 108.

[34] See work report of February 1739, AA I Ab 12, fols. 23r–24r: "Made a model for a new and very elaborate snuff box tidily edged with mouldings but then incised it with neat grotesque work, both on the box and the lid" [Eine Neue sehr mühsame Tabattiere gefertiget sauber Verkröpffet Nach gehends aber über und über saubers Crotesco Werk Ein Rattiret sowohl auf den Corpus als auf den Deckel], Pietsch 2002, p. 60.

[35] See work report of July 1742, AA I Aa 28, fol. 205r: "Made a clay model of a snuff box for His Excellency Count Wackerbarth [Joseph Anton Gabaleon von Wackerbarth-Salmour, 1685–1761, Saxon cabinet minister] with an ancient Roman head on it" [Eine Tabattiere Vor den Herren Grafen Von Wackerbarths Excellenz in Thon poußiret Worauf ein alter Römer Kopff befindlich War], Pietsch 2002, p. 91.

[36] See work report of May 1737, AA I Ab 9, fols. 88r–89v: "Made a model for a very elaborate snuff box with low-relief decoration in the antique manner, on the lid is the small low-relief portrait of His Majesty the King [Augustus III], but an ancient Roman head on the bottom" [Eine sehr mühsame Tabattiere gefertiget mit Antiquen flachen Zieraten auf dem Deckel ist Ihro Maj. des Königs Porträit klein und flach befindlich, auf dem Boden aber ein altes Römische Köpffgen], Pietsch 2002, p. 47, cat. no. 51; work report of July 1737, AA I Ab 9, fol. 164r: "Made corrections to 4 porcelain paste snuff box lids with portraits of the King" [4 Stück Tabattieren Deckel in der Maßa corrigiret Worauf das Königl. Porträit befindl.], Pietsch 2002, p. 48; work report of May 1738, AA I Ab 11, fols. 199r–119v: "Made adjustments to three snuff box lids in porcelain paste with the most high likeness of His Majesty our King" [Drey Stück Tabattieren Deckel, wo Ihro Majt. Unsers Königs Hoh. Bildnis darauf befindl. in der Massa nachgeholfen], Pietsch 2002, p. 54; work report of April 1739, fols. 74r–75r: "Made corrections and adjustments to seven snuff box lids in porcelain paste with the Most High portrait of His Royal Majesty, along with their boxes" [Sieben Stück Tabattieren Deckel worauf Ihro Königl. Majt Höchstes Porträit befindl. In der Massa Corrigiret und Nach geholfen, sammbt denen darzu gehörigen Untertheilen], Pietsch 2002, p. 61; and work report of February 1742, AA I Aa 28, fol. 115r: "2. Executed a very clear-cut small-scale likeness of our most gracious Lord His Royal Majesty on a snuff box for the privy cabinet minister His Excellency Count Brühl, in low relief in the antique manner." [Ihro Königl Majt. unser allergnädigsten Herren Höchstes Bildnis ins kleine zu einer Tabattiere Vor Ihro Hoch Reichß Gräfl. des Herren geheimden Cabinets Ministerii Von Brühls Excellenz aufs sauberste gefertiget Welches flach erhaben auf antique arth vorgestellet worden], Pietsch 2002, pp. 88–89.

[37] See work report of February 1738, AA I Ab 11, fols. 60r–61r: "The portrait of Her Majesty the Tsarina that was modelled in wax last month: modelled in wax once again so that it can be used on a raised round lid of a rappee [a kind of snuff] box and so that new moulds can be made." [Das Porträit von Ihro Majt. der Carin Welches vorigen Monath in Wachß poußiret Worden, Noch Einmal in Wachß solcher gestalt eingerichtet, daß es auf einen rund erhabenen Rappe Dosen Deckel hat können gebrauchet und aufs Neue eingerichtet werden können], Pietsch 2002, p. 52. An example of this box model is preserved at the Hermitage, St. Petersburg (inv. no. 3607), published in Beaucamp-Markowsky 1985, pp. 190–92, cat. no. 146.

[38] See work report of September 1742, AA I Aa 28, fols. 271r–272r: "worauf der Verzogene Nahme Augustus Rex oben mit einer Crone auf einem Postamente stehend zu sehen ist, Woran auch noch flache Blumen nebst anderen ornamenten zu sehen sind," Pietsch 2002, pp. 92-93.

39 See work report of April 1735, AA I Aa 24, fol. 173r: "Made a model for a snuff box after a silver one." [Eine Schnupf Tobacks Doße Nach einer Sielbernen gefertiget], Pietsch 2002, p. 30; work report of December 1738, AA I Ab 11, fol. 256b r: "Made a model for a snuff box with shell decoration, copied from a tortoiseshell box provided for the purpose, for the warehouse." [Eine Tabattiere aufs Waaren Lager Muscheligt, Nach einem Von Schild Kröt Darzu erhaltenen Modelle gefertiget], Pietsch 2002, p. 59; work report of February 1739, AA I Ab 12, fol. 24r: "Made a model for another snuff box, copied from a stone box which has clear-cut mouldings and scalloping, with a matching lid." [Annoch eine Tabattiere nach einem Von Stein gefertigten Modell poußiret. Es ist solche Sauber verkröpfft und aus geschweifft sammbt dem Darzu gehörigen Deckel], Pietsch 2002, p. 61; and and work report of April 1740, AA I Aa 26, fol. 63r/v: "Made a model for a snuff box lid copied from a box in brass." [Einen Tobacks Dosen Deckel nach Messing Modelle gefertiget], Pietsch 2002, p. 70.

40 See Kaendler's work report of August–October 1740, AA I Ab 14, fol. 229r: "A rose-shaped box for rappee snuff with its lid, for the warehouse." [Eine Dose in gestalt einer Rose zum rappee sambt Deckel zum Waaren Lager], Pietsch 2002, p. 74; and Ehder's of the same month, AA I Ab 14, fol. 235: "A snuff box representing a rose." [1 Tabatiere, welche eine Rose vorstellet]; for an illustration of an example from the M. and Mme. Gerald Panchaud Collection, see Beaucamp- Markowsky 1985, p. 231, cat. no. 184.

41 See Eberlein's work report of November 1740, ibid., fol. 257: "A snuff box of an Indian fruit […] A snuff box of a cabbage head." [Eine Schnubtobacks Dose von einer Indianischen Frucht […] Eine Schnubtobacks Dose von einen Krauthet].

42 See work report of July 1740, ibid., fol. 133: "A snuff box in the form of a birdcage" [1 Tabattiere, welche einen Vogelbauer vorstellet].

43 See Kaendler's work report of May 1737, AA I Ab 9, fol. 88: "Made a model for a snuff box in the form of a grape hod" [Eine Tabattiere gefertiget in gestalt einer Wein oder Wintzer Putte], Pietsch 2002, p. 46.

44 See Reinicke's work report of November 1767, AA I Ab 43, fol. 109b: "2. Made a clay model of a snuff box in the shape of an apple. 6. and 7. Clay models of two snuff boxes, one in the shape of a snail shell and one as a little boat. 8. Clay model of a snuff box in the shape of a bath tub. 10. Clay model of an oval snuff box in the shape of an onion. 11. Clay model in the shape of a clock case." [2. eine Tobatier in Apfelgestalt in Thon posirt; 6. und 7. je eine Tabatiere als Schneckenhaus und als Schiffgen in Thon posirt; 8. eine ovale Tabatiere als Badewanne in Thon posirt; 10. eine ovale Tabatiere zwiebelförmig in Thon posirt; 11. eine ovale Tabatiere in gestalt eines Uhrgehäuses in Thon posirt.]. A snuff box in the form of an apple is preserved in the collections of The Metropolitan Museum of Art, New York, inv. no. 1971, 134, and published in Beaucamp-Markowsky 1985, p. 234, cat. no. 186, where it is given a dating that is too early, around 1740-50.

45 See Kaendler's work report of June 1741, AA I Ab 16, fols. 172r–173v, "Eine Tabattiere in gestalt eines Mopß Hundes Vor Ihro Hoch Reichß Gräfl. des Herren Cabinets Ministers Von Brühl gefertiget," Pietsch 2002, p. 80.

46 See work report of August 1741, ibid., fol. 204r: "Made a model for a snuff box in the form of a pug dog lying on the grass for the privy cabinet minister His Excellency Count Brühl, and a lid to match" [Vor Ihro Hoch Reichßgr., des Herren Geheimden Cabinets Ministers de Brühls Excellenz eine Tabattiere in Gestalt eines Mopß Hündgens wie er auf einem rasen liget nebst darzu gehörigen Deckel in Thon poussiret], Pietsch 2002, p. 81; and work report of October 1741, ibid., fols. 272r–273r: "Made models of a new snuff box for the privy cabinet minister His Excellency Count Brühl and a very tidy little pug dog to go on the top." [Vor Ihro Hoch Reichß Gräfl. Des Herren geheimden Cabinets Ministers von Brühls Excellenz eine Neue Tabattiere gefertiget und oben auf den Deckel ein kleines Mops Hündgen aufs suberste poussiret], Pietsch 2002, p. 83.

47 See Ehder's work report of December 1741, AA I Ab 16, unpaginagted loose sheet: "1 gadrooned snuff box, lying on the lid is a pug dog surrounded by grass and flowers, for His … [etc. etc.] von Brühl."

48 See Kaendler's work report of January 1742, AA Ia 28, fol. 75r: "Made corrections to a clay model for a snuff box of the large kind for His Excellency the privy cabinet minister Count Brühl with a pug dog lying

on the lid, investing it with a more natural appearance." [Eine Tabattiere große Sorte Vor Sr. Hoch Reichß Gräfl. Des Hrn geheimden Cabinets Ministeri Von Brühls Excellenz worauf ein Mopß-Hund auf deren Decke befindl. in Thon corrigiret und Natürliches ansehen hinein gebracht] and: "Yet another snuff box for the same gentleman and likewise with a pug dog, made corrections and put it in order." [Annoch Eine Tabattiere Vor Eben die selben aber Ebenfalls mit einem Mopß Hündgen Corrigiret und tüchtig gemacht], Pietsch 2002, p. 88.

49 See Kaendler's work report of November 1743, AA I Ab 20, fols. 269b r–269c r: "Made and to a large extent completed a model for His Excellency Count Brühl of a pug dog done from life at Hubertusburg, the remaining work to be done by the sculptor Ehder" [Vor Sr. Hoch Reichß gräfl. Excellenz Von Brühl Eben falls einen Mopßhund nach dem Leben in Hubertusburg größtentheils fertig poußiret, das übrige aber dem Bildhauer Ehdern Vollends fertigen laßen], Pietsch 2002, p. 99; and Ehder's work report of January 1744, Aa I Ab 22, fol. 46: "Made a clay model for H.E. […] Count Brühl, a pug dog in life size sitting on a trimmed cushion" [Für Sr. H. R. Gr. […] von Brühl einen Mopshund in Lebensgröße auf einer bordirten Küssen sitzend, in Thon rein bohsirt].

50 On this point see Schwarm-Tomisch 2000, p. 223.

51 See Ehder's work report of October 1739, AA I Ab 12, fol. 240r: "1 cat for a snuff box" [1 Katze, zu einer Tobattiere]; see an example in the Madame Louis Solvay Collection, Musées Royaux d'Art et d'Histoire, Brussels, published in Marïen-Dugardin 1995, pp. 59–60, cat. no. 116.

52 See work report of March 1744, AA I Ab 22, fols. 87r–88r, Pietsch 2002, p. 102.

53 See an example in a New York private collection published in Beaucamp-Markowsky 1985, p. 229, cat. no. 182.

54 See Ehder's work report of November 1747, AA I Ab 28, fol. 406: "Made a new clay model for a snuff box representing a sphinx" [1 Tabattiere, eine Sphinx vorstellend, von Thon neu bouhsirt] and Kaendler's of December 1747, AA I Ab 28, fol. 425r: "Made corrections to a model for a sphinx that can be used for a snuff box." [Einen Sphinx welcher eine Tabattjere abgiebet im Modell Corrigiret], Pietsch 2002, p. 122.

55 See work report of July 1769, AA I Ab 45, fols. 284r–285r: "Made a model for a snuff box in the form of a little sheep lying down and being held on a line by a Cupid. For Her Most Serene Highness the Electress [Marie Amalie Auguste, wife of Elector Frederick August III of Saxony], on the lid of which there is to be a lion in low relief, still to be completed, which is likewise being led on a leash by Cupid, with the inscription below: *Dompté par l'amour*." [Eine Tabatjere in Gestalt eines Schäfgens so ein Cupido gebunden hält liegend. Vor die durchlauchtigste poußiret, auf deßen Deckel welcher annoch zu fertigen ein Löwe baßire- lieve, wie solcher Von Cupido gebunden geführet wird, mit der Unterschrift: *Dompté par l'amour*], Pietsch 2002, p. 182.

56 See Ehder's work report of December 1741, AA I Ab 16, unpaginated loose sheet: "Dressed the cracks on a clay model for a gadrooned snuff box and lid with French ornamentation." [1 goudronnirte Tabattiere samt Decken mit französischen Zierrathen in Thon verputzt].

57 See Kaendler's work reports of July 1741, AA I Ab 16, fols. 192 r–193 v: "Made a model for a new eight-lobed snuff box for the gentleman of the chamber Herr Pizowsky, to fit a gold mount." [Vor den Cammer Herren Pizowsky einen neuen Tabattieren Deckel 8Paßicht in ein Goldenes Beschläge gefertiget], Pietsch 2002, p. 81; August 1741, AA I Ab 16, fols. 204r–205v: "Made a clay model of a new snuff box to fit a gold mount for His Excellency Count Wackerbarth [Joseph Anton Gabaleon von Wackerbarth-Sal- mour, 1685–1761, Saxon cabinet minister], which was ordered by Herr Böhmern" [Eine Neue Tabattiere zu einem goldenen Beschläge Vor des Herren Grafen von Wackerbarths Excellenz, Welche von Herrn Böh- mern bestellet worden, in Thon poussiret], Pietsch 2002, p. 82, and: "12. Made a model for a new snuff box lid to fit in a gold mount for Herr Caprano [Andreas Caprano, a Dresden merchant]" [Vor Hr. Caprano einen neuen Tabattieren Deckel zu einem goldenen Beschläge gefertiget], Pietsch 2002, p. 82; Octo- ber 1741, AA I Ab 16, fol. 272r–273r: "Made a model of a new snuff box to fit a gold mount provided for the purpose." [Eine Neue Tabattiere nach einem goldenen darzu gegebenen Beschläge gefertiget],

Pietsch 2002, p. 84; November 1741, AA I Ab 16, fols. 287r–288r: "Made a clay model of a snuff box for Herr Benz and Herr Rader [Philipp Adam Benz and August Wolfgang Rader, Augsburg merchants], which has clear-cut moulded borders very carefully done to fit a mount provided for the purpose." [Eine Tabattiere Vor Hr Benz und Radern in Thon poussiret Welche Sauber Verkröpft und sehr Mühsam in das darzu gegebene Beschläge zu paßen gewesen], ibid.; September 1743, AA I Ab 20, fols. b r-230c r: "Made a model for a new snuff box to fit a gold mount" [Eine Neue Tabattjere Zu einem goldenen Beschläge gefertiget], ibid., p. 99; May 1744, AA I Ab 22, fol. 226r/v: "Made a model of a lid and box for a snuff box in accordance with a gold mount provided for the purpose" [Ein Unter und Obertheil zu einer Tabattjere nach einem darzu gegebenen goldenen Beschläge gefertiget], ibid., p. 102; and April 1747, AA I Ab 28, fols. 100r–101r: "Made a model for a snuff box to fit a gold mount" [Einen Tabattjeren Deckel in ein Goldenes beschläge gefertiget], Pietsch 2002, p. 118.

58 Published in exh. cat. Dresden 2010, pp. 376–77, cat. no. 481.

59 See Rückert 1990, p. 139.

60 Sächsisches Hauptstaatsarchiv Dresden, Locat 1344, XX, fol. 20; quoted from ibid., p. 168.

61 In addition to the snuff box in private ownership, cat. no. 97, there is another at The Metropolitan Museum of Art, New York, The Lesley and Emma Sheafer Collection, inv. no. 1974.356.308; and another at the Muzeum Narodowe in Warsaw, inv. no. SZC 1350 MNW.

62 See Rückert 1990, p. 153.

63 For a further example see Beaucamp-Markowsky 1985, pp. 100–01, cat. no. 69.

64 See Rückert 1990, p. 198.

65 Work report of October 1744, SPMM, archive, AA I Ab 22, fol. 405: "Snuff box lid with a portratit of Her Majesty the Tsarina, entirely completed" [1. Tabattierendeckel mit Czarin Mayth. Portrait ganz verferttiget] (further examples follow in March 1745).

66 Work report of July 1745, ibid., fol. 275: "Snuff box lid with a portrait of Her Majesty the Queen" [1. Detto [Tabattieren] Deckel mit Ihro Mayt. der Königin Portrait].

67 Work report of August 1745, ibid., fol. 317: "Snuff box lid with a portrait of Her Majesty the Queen of Hungary" [1. Tabattierendeckel mit Ihro Mayth. der Königin von Ungarn Portrait].

68 Work report of November 1746, ibid., fol. 391: "Snuff box lid with the Electress of the Palatinate, completed" [1. Detto [Tabattieren] Deckel mit der Churfürstin von der Pfalz verferttiget].

69 Work report of December 1746, ibid., fol. 403: "Snuff box lid with a portrait of His Serene Highness the Elector of the Palatinate, completed." [1. Tabattieren Deckel mit Ihro Durchl. des Churfürst von der Pfalz Portrait verferttiget].

70 SPMM, archive, AA I Ab 18, fols. 260/61, see Rückert 1990, p. 189.

71 Work report of March 1769, SPMM, archive, AA I Ab 45, fols. 99r–100r.

72 See SächsHStA Dresden, Locat 1343, XVb, fol. 456–57, quoted from Rückert 1990, p. 200.

73 See AA I Ab 40 und SächsHStA Dresden, Locat 522, "Vorträge und Resolutiones," VI, 1769, fol. 28, quoted from Rückert 1990, p. 200.

74 See AA I Ab 39, §4 and appendix 2, quoted from Rückert 1990, p. 141.

75 See Rückert 1990, p. 142.

Image and Symbol: On the Use and Meaning of the Snuff Box as Reflected by Meissen Figures of the Eighteenth Century

Sarah-Katharina Acevedo

Image and Symbol: On the Use and Meaning of the Snuff Box as Reflected by Meissen Figures of the Eighteenth Century
Sarah-Katharina Acevedo

As well as costly and exquisite containers for snuff the porcelain manufactory at Meissen also produced a variety of figures with courtly associations that, through the medium of what was known as "white gold," present to the viewer the variety of ways in which the snuff box was used. These porcelain figures and groups illustrate the many different facets of life at court in the eighteenth century and—reflecting the historical reality—position the snuff box, and consequently also the fashion for taking snuff, not only in the formal public sphere but also in private space.

As regards the latter aspect an excellent example is offered by the lady with her housekeeping books, probably modelled by Johann Joachim Kaendler (1706–1775) in 1754–55 (see fig. V.1), which was made after a print by Jacques-Philippe Le Bas (1707–1783) with the title *L'Œconom* that dates from 1754 (see fig. V.2). This print in turn reproduces a painting by Jean-Baptiste Siméon Chardin (1699–1779) which this artist supplied to Queen Luise Ulrike of Schweden (1720–1782) in 1747 (see fig. V.3). One year earlier the Queen, a sister of Frederick the Great, had ordered and received a picture by this Parisian artist called *Les Amusements de la Vie Privée* that is the counterpart to the picture of the prudent housekeeper. With their accurate depictions of scenes from everyday life Chardin's paintings were widely admired and popular in the mid-eighteenth century and were avidly acquired by connoisseurs and collectors of that time. Prints of these works made the pictures and motifs of this member of the *Académie Royale* accessible to a wider public.[1]

The porcelain piece shows a young, simply dressed woman sitting in a chair and bent slightly forward over her open housekeeping book that lies on a narrow Louis XV *table à écrire*. A second book, apparently with writing in ink, rests on her lap. Whereas the lady is writing with a quill held in her right hand, between the thumb and index finger of her left hand she holds an open, golden box whose contents, on closer inspection, can be clearly identified as snuff tobacco.

Fig. V.1
Johann Joachim Kaendler (1706–1775), *Die umsichtige Hausfrau*, model probably c. 1754–55, Pauls-Eisenbeiss Collection

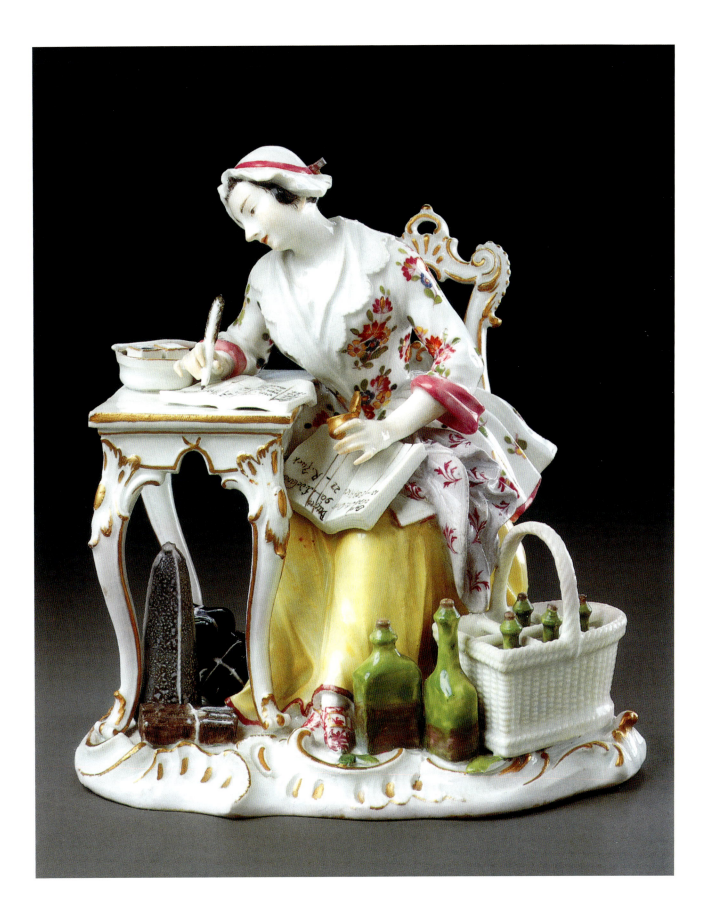

103

Fig. V.2
Jacques-Philippe Le Bas (1707–1783), print after the painting *L'Œconom* by Jean-Baptiste Siméon Chardin (1699–1779), Paris, 1754, London, British Museum

A similar figure has come down to us that shows a gentleman in the act of writing a letter, also seated at a desk in the style of Louis XV (see fig. V.4). Contrary to the widespread assumption that this is a counterpart to the prudent housewife, this figure was not modelled for this purpose but was made as early as 1740, as is confirmed by Johann Joachim Kaendler's description in his *Taxa*, a list of the works made for the manufactory outside of normal working hours: "1. figure, a gentleman writing a love letter, with a quill in his hand and seated at a desk."[2]

The relevant literature suggests that the source for this figure, too, was a print after a painting by Chardin: *Le Chateau de Carte* by Pierre Filloeul (1696–after 1754; see fig. V.5), which dates from 1737. It shows a young man sitting upright at a card table, his attention fully concentrated on his attempt to build a house of cards.[3] Although the print of Chardin's

Fig. V.3
Jean-Baptiste Siméon Chardin
(1699–1779), *L'Œconom*, Paris, 1754,
Stockholm, Nationalmuseum

work was indeed widely disseminated, it seems more likely that the porcelain figure of the gentleman writing is borrowed from a plate by Albrecht Schmidt (1667–1744) from a *Musterbuch* (a kind of sample book of graphic art) published between 1710 and 1720 in Augsburg (see fig. V.6), which we know to have been in the manufactory archive in Meissen (inv. no. VA1885/2).[4] This oval print shows a gentleman in what is probably a military tent, engaged in writing a letter. Unlike the young man in the porcelain group he supports his head with his left hand. The way in which he sits with his leg extended far to the right, bent over a desk strewn with writing implements, his clothing (and in particular his frock-coat) and, not least importantly, the manner in which he holds the pen in his right hand all strongly suggest that the model was provided by print from the sample book with the title "Libenter stude, Studia scribe. Studiere gerne, laß schreiben nicht ferne." Beside the

Fig. V.4
Johann Joachim Kaendler (1706–1775), *Cavalier Writing,* model 1740, Röbbig Munich

inkwell on the young courtier's desk we also see an inkwell, blotting sand, a scissors to sharpen the point of his quill, candle stumps, and sealing wax, as well as a pocket watch on a ribbon, and a snuff box, the presence of which in what is apparently an intimate setting suggests to the viewer that it was also common practice to take snuff while engaged in private activities.

Numerous casts of the gentleman writing have survived, but the piece of paper he is writing upon while seated at his elegant desk is not always a love letter. For example: the dashing young man shown here confirms the receipt of a message and writes: "Madame, J'ay receu la letre obligeante," whereas an example from the Dresden Porcelain Collection begins his letter with the plea "Mademoiselle, Pardonnez moi," and others confess defeats. The variations, while numerous, seem always to relate to amorous escapades of courtly life.[5]

In life at court the snuff box—much like the fan—played an important role in such escapades, as it was not merely a fashionable accessory but could be used as an instrument of communication. At times it was employed with subtlety, at others provocatively presented. The acquisition of such a box therefore involved a certain frisson and, as another group from Europe's first porcelain manufactory shows (see fig. V.7), was an experience of

Fig. V.5
Pierre Filloeul (1696–after 1754), copper etching after the painting *Le Chateau de Carte* by Jean-Baptiste Siméon Chardin (1699–1779), 1737, London British Museum

Fig. V.6
Albrecht Schmidt (1667–1744), *Libenter stude, Studia scribe*, plate from a sample book, Augsburg 1710–20, Meißen, Staatliche Porzellan-Manufaktur, archive

a special kind. The entry on "Galanterie-Waren" (fancy goods) in Zedler's *Universallexikon* provides information about the way in which small, precious items of every kind were usually purchased: "Waaren, (Galanterie-), sold mostly by the French and the Italians, but many also made by people in Nuremberg and Augsburg, so that not only are they found in the most elegant towns, where the courts reside, but second-quality goods are also distributed throughout the country by people who carry them around on trays. […] In Germany such fancy goods are mostly bought at the Easter and Michaelmas Fairs in Leipzig, where people from many different countries bring their wares and sell them themselves."[6]

Meissen snuff boxes in particular might have been acquired only in one of the sales branches.[7] A young woman carrying a small chest, who represents a dealer in fancy goods—as described by Zedler in his lexicon—forms part of a group with the later fine-sounding name *Herzdosenkauf* (Buying a Heart-Shaped Snuff Box). As the name suggests the four figures shown are involved in the purchase of a snuff box, most likely intended as a present from the gentleman to the noble lady, who is seated. She has taken her place on a visitor's chair at the centre of the group, dressed in a magnificently ornamented crinoline and wearing an ermine-trimmed shawl, which identifies her as a member of the highest aristocracy. In one hand she holds a large gold-painted, heart-shaped box, in the other a

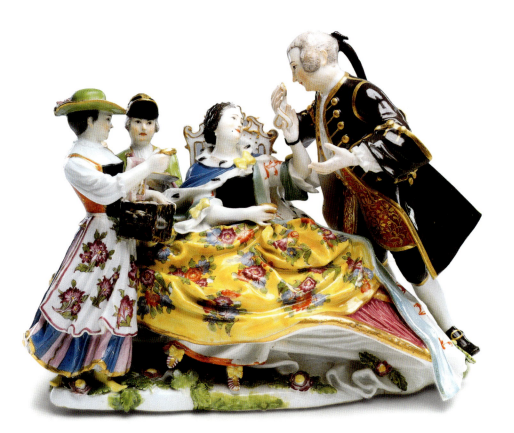

Fig. V.7
Johann Joachim Kaendler (1706–1775), *Herzdosenkauf* (Buying a Heart-Shaped Snuff Box), model c. 1738, Pauls-Eisenbeiss Collection

completely gilded oval snuff box with bellied sides. A young messenger boy stands behind her on her right. Beside him, captured in an elegant movement, stands the seller of fancy goods carrying a wooden chest in which she presents jewellery of all kinds as well as snuff boxes. Opposite her—on the left of the elegant seated lady—a gentleman with a small gold-painted box in his right hand apparently attempts to influence her choice. Kaendler's work reports provide us with no information about the creation of this model, but the group is mentioned in 1738 in a report about the work he carried out after normal hours, at which time a plaster model of it was made: "The Grund brothers have cast a group with a servant and a Tyrolean girl in plaster."[8]

In general a distinction was drawn between two kinds of boxes; those whose external form revealed their significance, and those in which the painting on the inside of the lid was intended only for the eyes of the owner or the person to whom it was given. It can be assumed that a box in the shape of a heart (see fig. IV.1) generally served as a gift, whereas boxes with erotic depictions or scenes with an unmistakeable meaning were intended for personal use, either to delight their owner when looked at in a quiet moment or to be presented to a second person on an appropriate occasion. This was generally done undemonstratively when proffering the snuff box, as illustrated by a further Kaendler group that shows a pair of lovers tenderly touching each other while enjoying a pinch of snuff (see fig. V.8).

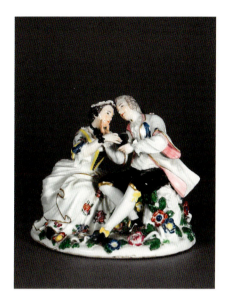

Fig. V.8
Johann Joachim Kaendler (1706–1775), *Cavalier and Lady with a Snuff Box*, model 1745, Röbbig Munich

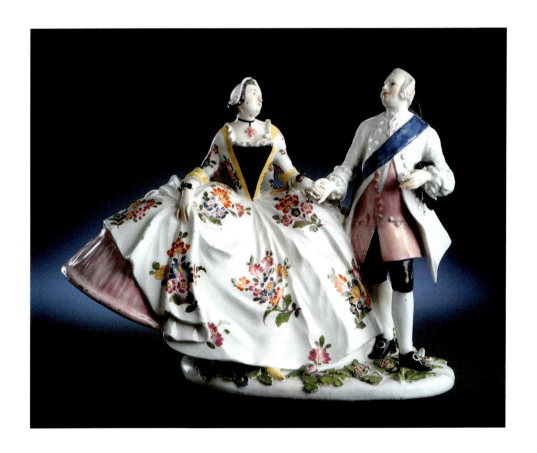

Fig. V.9
Johann Joachim Kaendler (1706–1775), *Cavalier Wearing the Order of the Polish White Eagle, Leading a Lady by the Hand*, model June 1744, Pauls-Eisenbeiss Collection

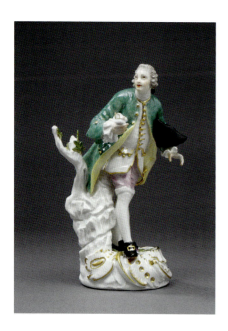

Fig. V.10
Johann Joachim Kaendler (1706–1775), *Cavalier with Snuff Box,* model c. 1750, Röbbig Munich

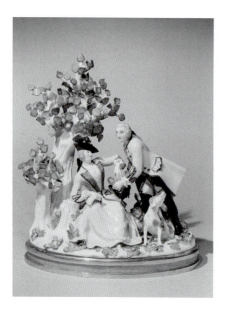

Fig. V.11
Johann Joachim Kaendler (1706–1775), *Hunters,* model c. 1745, New York, The Metropolitan Museum of Art, Irwin Untermyer Collection

But also in a formal setting carrying a snuff box on one's person, publicly enjoying snuff and proffering it when a suitable occasion arose were among the obligations of a fashionable cavalier; whether dressed in full formal attire with decorations (see fig. V.9) or more casually in a simple frock-coat (see fig. V.10). The nature of the particular occasion also suggested the kind of snuff box to be carried on one's person; for instance the parforce huntsman from the hunting group in the collection of Irwin Untermyer, in The Metropolitan Museum in New York (see fig. V.11), would most probably have proffered to the seated lady a box decorated with hunting motifs, like cat. nos. 89–95. This group, too, is listed in Kaendler's *Taxa*,[9] which mentions four further groups with snuff boxes.

A distinction should also be drawn between the different ways in which gifts were made; as well as the private present there was the diplomatic gift, which had been an integral part of politics at European courts since the early modern period.[10] A register consisting of several volumes with the title *Présents du Roi* provides information about the gifts given by Louis XIV, XV, and XVI during their reigns, and also tells us about their value, those who received them, and the occasions on which they were given. Alongside *boîtes à portrait* (also called *contrefait boxes,* i.e. a miniature portrait in a costly frame; see fig. V.12) the most precious little treasures given to a person of the highest rank included jewellery and also snuff boxes.[11] The latter were often decorated with the portrait of the respective potentate on the inside of the lid—like cat. nos. 108–15. They were often given to envoys or ambassadors as a gesture intended to exert a binding political effect or, with a far more profound intention and a greater degree of effectiveness, were sent to members of other noble families. For instance a portrait by Laurent Péchaux (1729–1821) shows Maria Louisa of Parma (1751–1819), grand-daughter of Philip V of Spain (1683–1746) and of Louis XV (1710–1774), holding a portrait box decorated with the likeness of her future spouse, the Prince of Asturias and later King Charles IV of Spain (1748–1819; see fig. V.13).

In his *Taxa* Kaendler lists a further figure, a Harlequin (see fig. V.14),[12] and with this piece we leave the field of *galant* depictions and turn to porcelain from the Meissen manufactory that uses *commedia dell'arte* figures as its subjects. The roots of this unusual depiction of a dancing Harlequin who wears a monocle and has a snuff box strategically tied in front of his crotch lie in the world of the theatre in Paris at the start of the eighteenth century.

In 1682 Louis XIV moved his court to Versailles; the following decades were marked by military conflicts, an economic crisis and religious unrest that gradually dimmed the radiance of the *roi soleil*. During this time the King increasingly developed a particular kind of piety and withdrew from public and court life. Also, in the later years of his long reign—partly under the influence of Françoise d'Aubigné (1635–1719, better known as Marquise de Maintenon)—he severely reduced the entertainments provided at court. Consequently, Paris again became a centre of amusements, even though the pleasures of the theatre were no longer reserved exclusively for the nobility. The increasing prosperity of the middle-classes had quickly led to marriages between persons of different social standings and Louis XIV's practice of raising loyal middle-class agents to the nobility effectively helped to blur the boundaries between different classes. This change of public led to a revolution

within the theatre in Paris: new kinds of light entertainment were introduced, such as opera-ballet or comedy with spoken dialogue interspersed with musical interludes. The most prominent theatres, including the Académie Royale de Musique, the Comédie Française, and the Théâtre de la foire, now offered satirical spectacles of a libertarian kind and the *Comédie Italienne,* which had been banned in 1697 on account of its satires of the king and the court, from 1715 onwards once again presented its traditional characters,[13] among whom Harlequin had always played a special role, to a delighted Parisian public.

In volume 12 of the *Oeuvres complètes de Marmontel* Jean François Marmontel (1723–1799) describes this figure as follows: "his character is a mixture of ignorance, naivety, high-spiritedness, stupidity and grace: he is a kind of incomplete man, a big child who has bright and intelligent moments and whose ineptitude and mistakes have something engagingly provocative about them. The true model for his play is the litheness, agility, and endearing quality of a young cat, with a crude and rough exterior which makes his actions all the more amusing; his role is that of an acquiescent patient, loyal, trusting, greedy, always in love, always in trouble either with his master or with himself, who is sad, who can console himself with the ease of a child and whose pain is as amusing as his joy. This role demands a great deal of naturalness and spirit, much grace and flexibility."[14]

The depiction of these characteristics, paired with an awareness of the primarily satirical character of the *commedia dell'arte* itself, provides an ideal background for an examination of the smirking porcelain Harlequin wearing the typical costume. With his tongue stuck out, he dances in a happy and carefree manner and makes fun of fashionable manners at court. He does not keep the snuff box, which here has become a symbol of a refined way of life, in a pocket so as to elegantly present it, as a noble gentleman would do, but instead wears it tied around his waist like a hip bag. The monocle, which he holds the wrong way around, stands for the learning found at court and the cultured aesthetes there and, by being used incorrectly, is made seem just as ridiculous as the fashionable snuff container.

The figure of a monkey sitting on a tree stump and holding a snuff box in its paws also comes from a very different context to the elegant groups with snuff boxes, yet in a certain sense can be related to the figure of Harlequin. This piece, one of the earliest of its kind made of Meissen porcelain, was probably modelled by Johann Joachim Kaendler in February 1732 (see fig. V.17).[15]

Depictions of primates are to be found in antique illustrations, in medieval mosaics, and in illuminated manuscripts. These are generally Barbary macaques (magots), which, although such monkeys did not belong to the fauna in any other part of Europe, were found on the Rock of Gibraltar. Through the busy trade with East Asia at the end of the sixteenth and beginning of the seventeenth centuries the first species of guenons, which are native to the wooded coastal regions of West Africa, arrived on the European mainland. A short time later various species of monkeys from India and Southern Asia were brought to Europe, among them different species of macaques from the islands that today constitute Indonesia, and from the forests around the Gulf of Guinea. Later, in the course of the exploration of the coasts of Central and South America, these were followed by various kinds of marmosets, squirrel monkeys, and Capuchin monkeys. While monkeys had always been

Fig. V.12
Unidentified artist, print of a *boîtes à portrait* of Louis XV, Meißen, Staatliche Porzellan-Manufaktur, archive, inv. no. VA 1553

regarded as an embodiment of the rare and exotic, from the early modern period they became a luxury object and thus a fitting attribute for princely courts. It is therefore not surprising that examples of the rarest species, which towards the end of the sixteenth century had survived the perilous sea journey from Central or South America or Africa, were everywhere reserved for princely menageries.[16]

Within the context of the iconography of power the keeping of animals by princely courts grew in importance in the seventeenth century. With the erection of the menagerie in Versailles between 1663 and 1670, Louis Le Vau (1612–1670), who was commissioned by Louis XIV, created a fundamental and highly influential type for the menagerie that set the standard for all later European menageries built in the eighteenth century. Within the gardens of Versailles an autonomous, self-contained complex was erected in which exotic wild animals as well as native and foreign species of birds were kept. It was laid out in a star-shaped pattern around a central courtyard, the centre of which was occupied by the octagonal salon of a pleasure palace known as the *Château de la Ménagerie*.[17]

It is scarcely surprising that King Augustus II, who, on being crowned King of Poland, entered the top echelons of European aristocracy, was inspired by the overwhelming demonstrative grandeur of the buildings of Louis XIV and pursued plans to construct a Saxon Versailles, complete with a menagerie. Augustus, too, had a sizable collection of animals, ranging from common domestic poultry to native game and exotic animals from many different lands. The exotic species included gifts from other dignitaries, were acquired by Augustus himself or were brought directly to the royal court from their native countries by a Saxon expedition to West Africa in 1731–33, which was commissioned by the King. As a magnificent palace in the style of Versailles was never built in Moritzburg, Pillnitz, or Großsedlitz, the animals were not kept at a central location in Dresden but in various complexes outside the city; the Jägerhof with the lion house was regarded as the Dresden menagerie. After losing interest in the further development of Schloss Pillnitz, from 1725 Augustus the Strong focussed his attention on the design of a "porcelain palace," known as the Japanese Palace, which was intended to house, among other things, his collection of Asiatica. The existing collection was augmented by pieces of Meissen porcelain made "in the Japanese manner." The collection of East Asian porcelain was to be displayed on the ground floor of the palace, with the pieces produced in Saxony on the main floor. This magnificent building was also intended to have a menagerie in which the animals—in accordance with the overall concept for the Japanese Palace—were to be made of porcelain and housed in one of the galleries of the palace. Impressive sculptures of monkeys were made in Meissen for the animal gallery of Augustus the Strong (1670–1733). We know of models by Johann Gottlieb Kirchner (born in 1706) and by Johann Joachim Kaendler.[18]

We also know that Kaendler studied the animals kept in the Moritzburg menagerie, which enabled him to give his creatures a particularly realistic, true-to-nature quality that was even further heightened by the way in which they were painted. However, prints were also commonly used as a source of models and motifs in the Meissen manufactory and in particular the monkey with fruit recalls the popular tradition of allegories of the Five Senses, which had developed from the sixteenth century onwards, particularly in The

Fig. V.13
Laurent Pécheux (1729–1821), *Maria Louisa of Parma (1751–1819), later Queen of Spain,* 1765, oil on canvas, 230.8 x 164.5 cm, New York, The Metropolitan Museum of Art

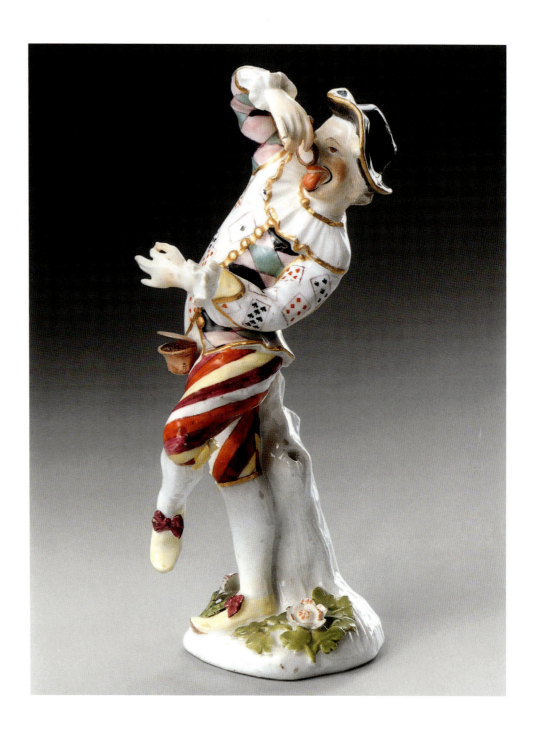

Fig. V.14
Johann Joachim Kaendler (1706–1775),
Harlequin with Snuff Box, model
c. 1740–41, Pauls-Eisenbeiss Collection

Netherlands, but was also found in France and Germany.[19] In these prints the monkey accompanies the Allegory of Taste; this refers to monkeys' apparently choosy feeding habits which had been noted since the days of classical antiquity and led to them being attributed with a highly developed sense of taste. Consequently, monkeys occur in numerous prints (see fig. V.15) and also, for example, in the form of a spot-nosed monkey, in the painting *The Sense of Taste* by Peter Paul Rubens (1577–1640) and Jan Brueghel (1568–1625), today in the Prado in Madrid. In such depictions not only does the primate's

good taste manifest itself, the animals are also often shown in the same pose or making the same movement as the personification (generally female) of the sense of taste. This brings us to a second, highly important characteristic that shaped the image of the monkey right up to the Baroque era: its propensity to mimic or imitate. According to the relevant literary and visual sources humans had traditionally exploited this trait when hunting monkeys. For instance a print by Jan Collaert (1566–1628) after Jan van der Straet (1523–1605; see fig. V.16) illustrates what humanist Konrad Heresbach (born 1496) wrote about the hunting of monkeys in his Thereutik § 167: hunters "when they spy the animals sitting in the trees place a basin filled with water where the animals can see it and then wash their hands in it. The hunters then replace the bowl of water with a bowl of glue. As it is in the nature of these animals to imitate and mimic everything, they climb down from the trees and smear themselves with the glue; when their eyelids are completely glued together they can no longer see and can then be caught."[20]

The Meissen monkey seated and holding a snuff box in its paw also imitates an aspect of human behaviour that could certainly be regularly observed at court: with an elaborate gesture he takes a pinch with the thumb and forefinger of his left paw and brings it to his nose. The way in which he holds the snuff container in his right paw shows an equal measure of elegance and caution. This allegorical creature and symbol of select taste in the sixteenth and seventeenth century no longer holds a simple piece of fruit in his paw, but a new, contemporary symbol of good taste and a refined way of life: a beautifully formed porcelain snuff box filled with the modern as well as exotic luxury good, tobacco—passion and vice of the *galant* society of the eighteenth century.

Fig. V.15
Hendrick Goltzius (1558–1617), copper engraving *Der Geschmackssinn* from the series *Die Fünf Sinne*, Wolfenbüttel, Herzog August Bibliothek

Fig. V.16
Jan Collaert (1561–1620) after Jan van der Straet (1523–1605), copper engraving *Die Affenjagd* from the series *Venationes ferarum, avium, piscium, pugnae et mutae bestiarum*, Wolfenbüttel, Herzog August Bibliothek

Fig. V.17
Johann Joachim Kaendler (1706–1775), *Monkey with Snuff Box,* model probably c. 1732, Dresden, Staatliche Kunstsammlungen Dresden, porcelain collection

[1] Cf. exh. cat. Karlsruhe 1999, p. 205, cat. no. 69.

[2] Rafael 2009, p. 48, no. 31: "1. Figur, einen Monsieur, der einen Liebes-Brieff schreibt, vorstellend, mit der Feder in der Hand am Tische sizend."

[3] Up to the present we know of a total of four paintings of the same subject, which differ in size and format: one is in the collection of the Louvre, one is owned by the Rothschild Family Trust (since 2012 on show in Waddesdon Manor), a further one is in the National Gallery, London, and the last is in the National Gallery of Art, Washington, D.C. Just as there are various versions of the painting in existence, the prints of the young man playing cards also differ. The plate by Pierre Filloeul (1696–after 1754) from 1737 reproduces the painting owned by the Rothschilds, a further one by François-Bernard Lépiciés (1698–1755) from 1743 uses the London version and a last one by Pierre-Alexandre Aveline (1702–1760), also published in 1743, was based on the painting in Washington, D.C. (cf. exh. cat. Waddesdon Manor 2012, pp. 54ff.)

4 It is not known when this print entered the collection of the manufactory. However, a motif based on it that shows a man writing can be found on a saucer in the Arnhold Collection, which has been dated 1723–24, the painting has been attributed to Johann Gregorius Höroldt (1696–1775; see Cassidy-Geiger 2008, p. 291; cat. no. 70a).

5 Cf. exh. cat. Dresden 2010, cat. no. 341.

6 Zedler 1732–54 (1962), vol. 52, pp. 64–65: "Waaren, (Galanterie-), welche mehrentheils die Franzosen und Italiener führen, deren auch viele von Nürnbergern und Augspurgern verfertiget werden, damit sie nicht nur die vornehmsten Städte, absonderlich wo Höfe sind, besetzen, sondern auch durch ihre Tablet-Träger die schlechtesten von dergleichen Waaren im gantzen Lande herum schicken. […] In Deutschland werden die Galanterien absonderlich auf der Leipziger Oster- und Michaelis-Messe eingekauft, wohin viele Nationen ihre Galanterie-Waaren, die sie absonderlich machen, bringen, und aus der ersten Hand verkaufen."

7 Cf. Beaucamp-Markowsky 1985, p. 23.

8 Menzhausen 1993, p. 100; here the formers Johann Elias (1703–1758) and Johann Georg Grund (1708–1781) are meant; see Rückert 1990, p. 109.

9 Rafael 2009, p. 58, no. 167: "Groupgen, die parforce Jagd vorstellend, da einer in parforce Jagd-Habit zu ihr komenden Cavalier Schnupff-Tabacc präsentiret wird, neben welcher sich ein sich krazender Hund befindet, 18. Thlr. [Members of a par-force hunt, the gentleman in hunting livery presents snuff to the lady, a dog stands beside him, scratching itself, 18. Thlr.]."

10 Literature on the tradition and meaning of the political gift, particularly with regard to presents of Meissen porcelain, is offered by Cassidy-Geiger 2007.

11 Cassidy-Geiger 2007, pp. 6ff.

12 Rafael 2009, p. 47, no. 23: "1. Arlequin, so statt des Hosen Knopffs eine Tabatiere hat, und Schnupff Tabacc herausnimt, in der linkcken Hand eine Brille hat, 2 Thlr. 12 g. [1. Harlequin who has a snuff box in the place of fly buttons and takes a pinch from it, holding in his left hand a pair of glasses, 2 Thlr. 12 g.]."

13 Cf. Cowart 2009.

14 Marmontel 1818, vol. 12, pp. 278–79: " Son charactère est un mélange d'ignorance, de naïveté, d'esprit, de bêtise, et de grâce: c'est une espèce d'homme ébauché, un grand enfant, qui a des lueurs de raison et d'intelligence, et dont toutes les méprises ou les mal adresses ont quelque chose de piquant. Le vrai modèle de son jeu est la souplesse, l'agilité, la gentilesse d'un jeune chat, avec une écorce de grossièreté qui rend son action plus plaisante; son rôle est celui d'un valet patient, fidèle, crédule, gourmand, toujours amoureux, toujours dans l'embarras, ou pour son maître, ou pour lui-même, qui s'afflige, qui se console avec la facilité d'un enfant, et dont la douleur est aussi amusant que la joie. Ce rôle exige beaucoup de naturel et d'esprit, beaucoup de grâce et de souplesse."

15 Cf. Wittwer 2004, p. 291; apart from the illustrated example in the porcelain collection in Dresden, there is a further example of the monkey with snuff box in the collection of the Rijksmuseum Amsterdam, and another animal of this kind was sold at the auction of the collection of Sir Gawain and Lady Baillie on 1 May 2013 in London.

16 Dietrich 2004, pp. 22ff.

17 On the history of the Baroque menagerie see Paust 1995.

18 On the concept and history of the Japanese Palace see Wittwer 2004, pp. 32–57; on animal sculpture in Meissen porcelain in the Japanese Palace in general see esp. pp. 59–72.

19 In his contribution to the *Festschrift* for Dagobert Frey Hans Kaufmann throws light upon the tradition of the depiction of the five senses in the seventeenth century and on how it became established (see Kauffmann 1943).

20 Quoted from Blusch 1997, p. 156: "wenn sie jene Tiere in den Bäumen sitzen sehen, stellen sie eine mit Wasser gefüllte Schüssel in Sichtweite auf und waschen sich darin die Augen, dann setzen sie eine Schüssel mit Leim statt mit Wasser dorthin und entfernen sich. Da es nun aber in der Natur des Tieres liegt, alles nachzumachen und nachzuäffen, klettert es vom Baum herab und beschmiert sich mit Leim; und wenn seine Augenlider dann ganz verklebt sind, kann es nichts mehr sehen und wird so schließlich gefangen."

Catalogue

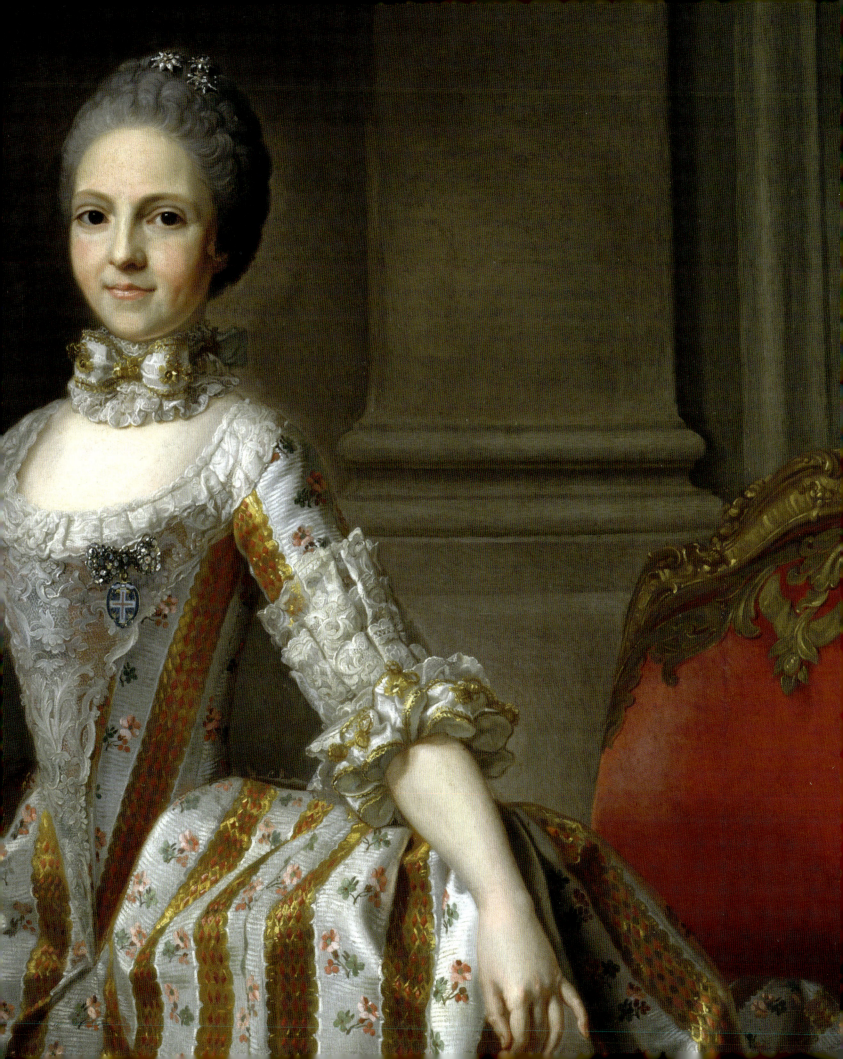

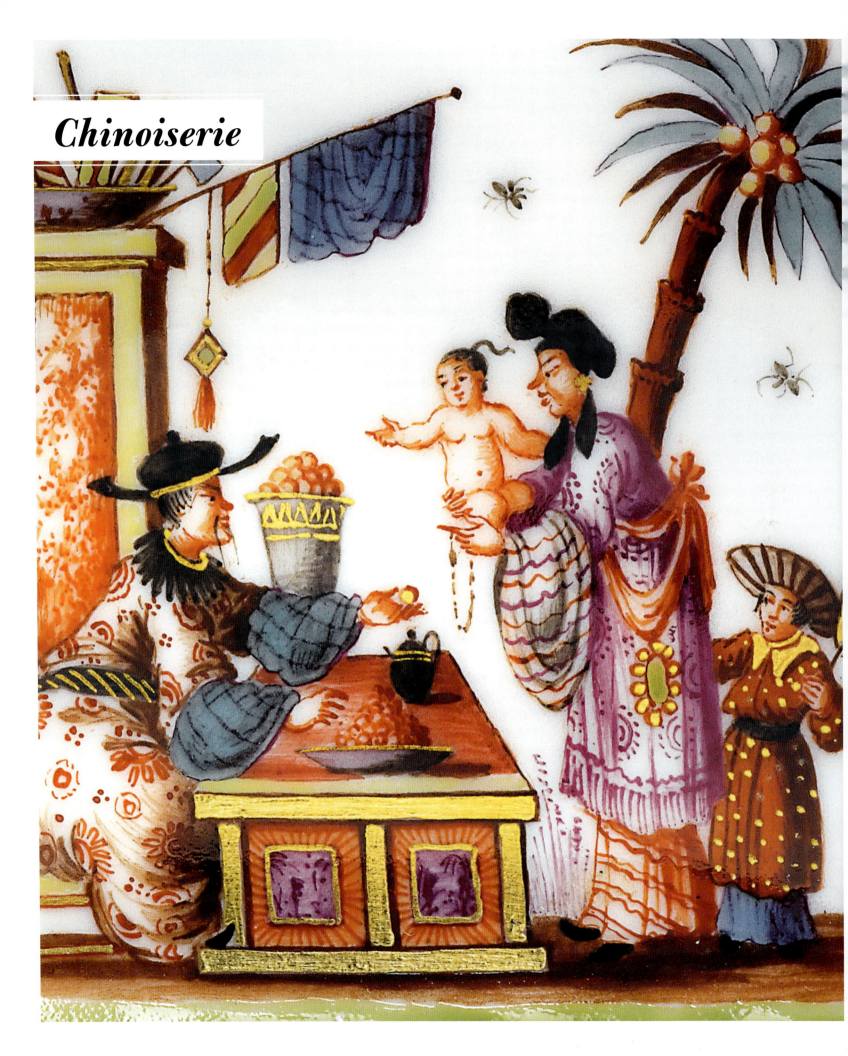
Chinoiserie

Cat. no. 1

SNUFF BOX

Böttger porcelain, manufacture 1714–23
Probably painted by Bartholomäus Seuter (1678–1754)
Augsburg, c. 1724/25
With contemporary gold mounts
Height 2.5 cm, width 8.5 cm, depth 6.3 cm

Augsburg *Hausmaler* Bartholomäus Seuter painted golden Chinese figures on the inside of the slightly domed lid of this flat, rectangular snuff box with gold mounts, whereas on the outside of the lid a large mirrored monogram "CM" under a royal crown is flanked on either side by a pair of Chinese men, one tall, the other shorter, standing beneath a palm tree. It has not yet proved possible to identify the European ruler to whom the monogram refers. The snuff box may have been a gift from Augustus the Strong (1670–1733), who frequently gave presents of this kind to monarchs with whom he was on friendly terms. The bottom of the box has a further Chinese scene placed on a leaf-work and network pattern console, while the reserve in each of the gilded sides of the box is filled with *indianische Blumen*. The complete gilding of all the internal surfaces makes this box a particularly costly piece. Snuff boxes made of Böttger porcelain painted with golden Chinese figures by the Seuter brothers are extremely rare; apart from this magnificent example no further such pieces have been identified as yet. UP

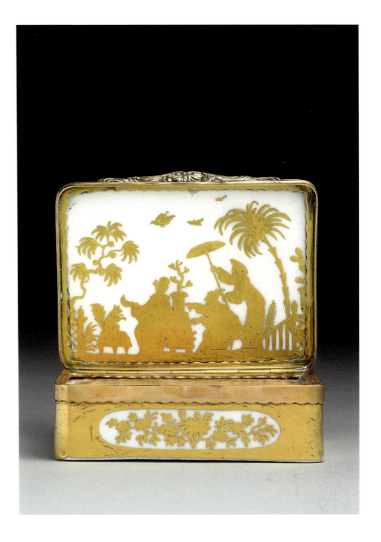

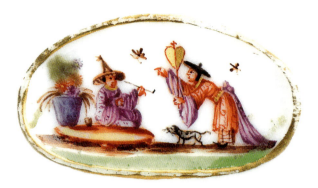

SNUFF BOX

Manufacture c. 1723/24
Probably painted by Johann Gregorius Höroldt (1696–1775), c. 1725
With contemporary silver gilt mounts
Height 3.8 cm, width 7 cm, depth 4 cm

The purple fluting on the tapered body of this oval box is outlined in gold. The box is decorated with three figural scenes, one on the outside and one on the inside of the lid, and the third on the bottom. They come from the fantastical dream world of the chinoiserie, which Johann Gregorius Höroldt defined for the painters in his workshop in his sketchbook, known as the Schulz Codex. Although none of the surviving drawings from the sketchbook served as a model for the décor of this snuff box, the painter without doubt based his scenes on similar motifs. He shows Chinese men seated at a table taking tea, while others, among them a Moor, approach from the right to join in the ceremony. It is conceivable that Höroldt painted this box himself. The shape of the snuff box is derived from a design by the Dresden court goldsmith, Johann Jakob Irminger (1635–1724) who was responsible for designing all the vessels in the Meissen manufactory between 1710 and 1724. He generally made the models in silver and then had these cast in Böttger stoneware and Böttger porcelain. A snuff box with the same shape and similar décor is housed in the Forsyth Wickes Collection in the Museum of Fine Arts in Boston (published in mus. cat. Boston 1992, p. 240, cat.no. 197). UP

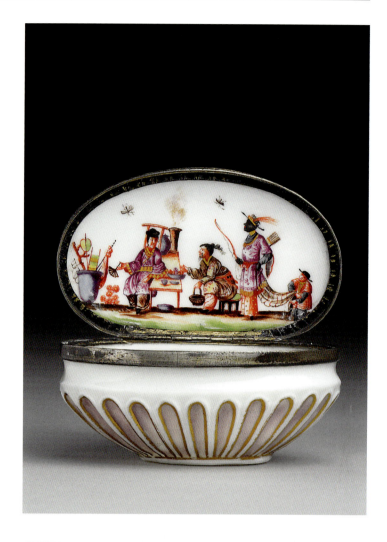

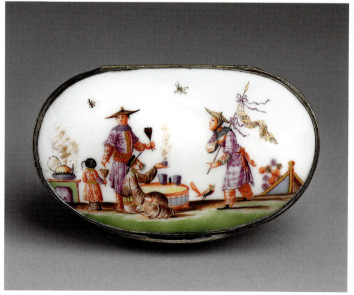

Cat. no. 3

SNUFF BOX

Manufacture c. 1723/24
Probably painted by Johann Gregorius Höroldt (1696–1775), c. 1725
With contemporary silver gilt mounts
Height 5.1 cm, width 7.6 cm, depth 5.1 cm

The bowl-shaped snuff box with fluted sides is closed by a gently domed lid decorated with a fan made of fluting, which is fixed to the container by silver gilt mounts. The form was designed by the Dresden court goldsmith Johann Jakob Irminger (1635–1724) after one of his own silver models. The gold-edged turquoise green fluting is surrounded by insects and *indianische Blumen*, while the inside of the lid, which is painted in *en camaïeu* purple, shows polychrome Chinese scenes with similar motifs. The figures, which are painted in colours used in the early days of the Meissen manufactory, seem compact and slightly squat, but stylistically they exhibit many characteristics familiar with the work of Johann Gregorius Höroldt. However, it is also possible that an apprentice from the master's workshop painted this piece in Höroldts's style. In the standard manner, the painter placed the Asians in a garden setting on a base formed by a green and brown area of ground on which a coconut palm stands, edged on the right by a fence that carries a vase. The people are shown squatting on the ground, sitting on a flat footstool or an easy chair, or standing. They hold items such as a toy frame, a parasol, a teacup, or various other objects in their hands. UP

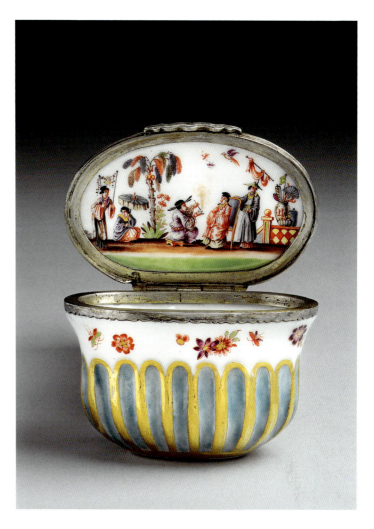

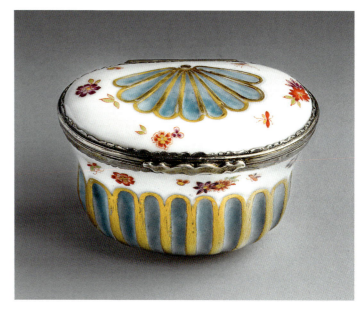

Cat. no. 4

SNUFF BOX

Manufacture 1722/23
Painted by Johann Gregorius Höroldt (1696–1775), 1724
"K.P.M."-mark in underglaze blue and
crossed swords mark in underglaze blue
inside on the bottom of the box
(in use from December 1722 to April 1723)
With contemporary copper gilt mounts
Height 3.3 cm, width 7.5 cm, depth 4.2 cm

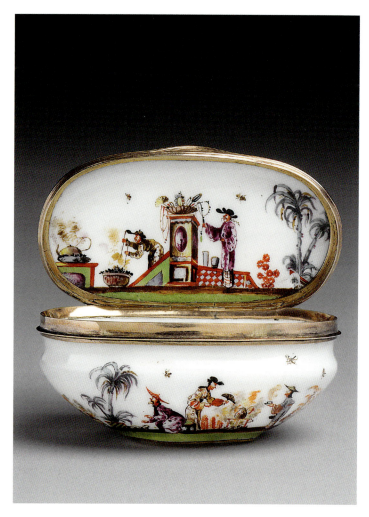

This long oval box with sides that curve downwards to a flat base is covered by a gently domed lid with gilt copper mounts and a thumb rest. The form, which is based on a silver piece, was most probably modelled by Johann Jacob Irminger (1635–1724), who designed the entire range of vessels made of Böttger red ironstone and Böttger porcelain. The painting by Johann Gregorius Höroldt uses the early enamel colours iron-red, purple, green brown, enamel blue, and grey as well as gold and depicts exquisite miniature figural scenes in the Chinese manner. The figures grouped around the sides of the box are flanked by palm trees and other exotic plants. As in the scenes on the lid the painter places his figures on a base consisting of a strip of green grass covered by a dark brown surface where they seem to be enjoying the pleasant aspects of life. He shows them in a garden setting wearing elaborate garments, amidst small items of furniture and fences, preparing food and drinks, and enjoying tea and tobacco. In each scene the painter depicts steam and smoke curling upwards, creating a certain impression of depth that is further heightened by the insects fluttering above. The curious movements made by his slender figures bring them close to the realm of caricature, provoking from the viewer a response that combines admiration with amusement. In addition, the idea of painting the small Chinese scene on the bottom of the box entirely in purple contains an element of surprise. This principle was used often in later boxes.

The motif employed to decorate the lid of the present box, which shows a Chinaman standing holding a Turkish crescent with another man sitting in front of an open fire on which a steaming pot stands, is also found on the inside of a box in private ownership formerly on loan to the Rijksmuseum Amsterdam (cf. Beaucamp-Markowsky 1985, pp. 36f., cat. no. 11). This composition appears yet again on the outside of the lid of a snuff box (also in private ownership, formerly on loan to the Rijksmuseum Amsterdam, cf. Beaucamp-Markowsky 1985, p. 35, cat. no. 9), the inside of which is decorated with a Chinaman standing in front of a tall, square plinth, a depiction also found on the inside of the lid of the present piece. Höroldt used this latter motif yet again to decorate the inside of the lid of a box now in the State Hermitage Museum in St. Petersburg. The scene on the front of the box in St. Petersburg shows a Chinaman seated at a table and another man standing opposite him who carries on his shoulder a rod with a cloth draped around it (Beaucamp-Markowsky 1985, p. 34, cat. no. 7). This image is used again on the back of the present box. And yet a further example can be cited: the group with a Chinese man holding a Turkish crescent and a man sitting

in front of him is found inside the lid of a box (cat. no. 5) on the front of which we encounter a depiction similar to that on the front of the present snuff box, which is to be found a further time on an example in the collection of Madame Louis Solvay, Musées Royaux d'Art et d'Histoire, Brussels (cf. Marien-Dugardin 1995, p. 56, fig. 97). However, in all these repetitions of essentially similar motifs they are generally combined with other figures or placed in different contexts so that method employed is not immediately apparent to the layperson. At the same time, however, it confirms Höroldt's economical way of working which avoided having to invent a different décor for every box. UP

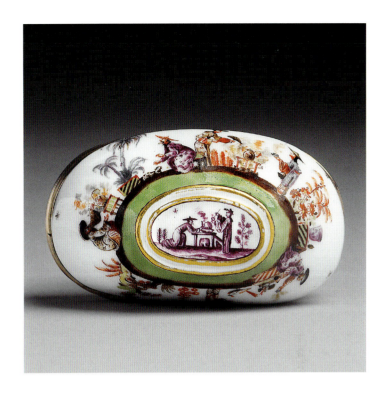

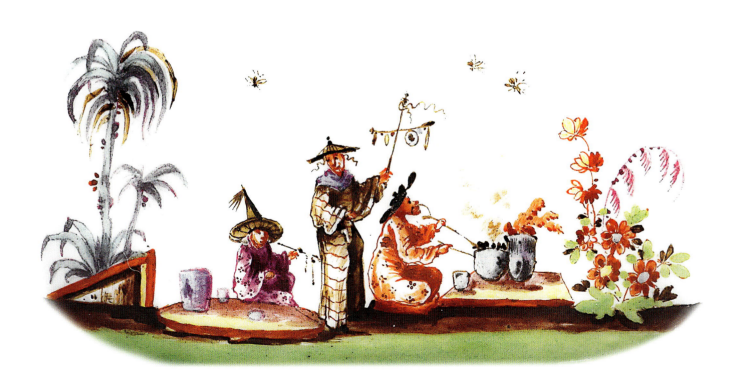

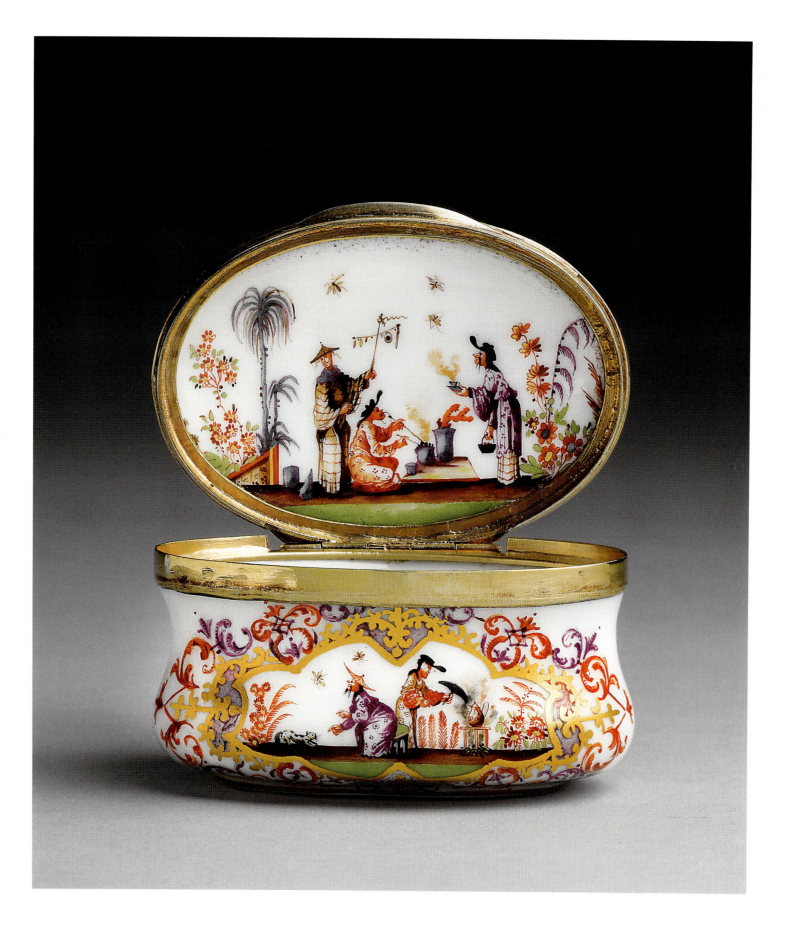

Cat. no. 5

SNUFF BOX

Manufacture 1722/23
Most probably painted by
Johann Gregorius Höroldt (1696–1775),
c. 1724
"K.P.M."-mark in underglaze blue and
crossed swords mark in underglaze blue
inside on the bottom (in use from
December 1722 to April 1723)
Contemporary silver gilt mounts with hallmarks:
crossed electoral swords and "SD"
Height 4.2 cm, width 6 cm, depth 3.5 cm

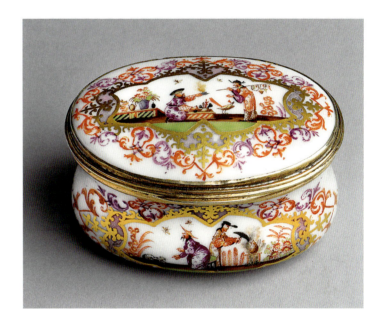

This oval snuff box with bellied sides is closed by a gently domed lid with silver gilt mounts. The form is based on a silver original and was most probably modelled by Johann Jacob Irminger (1635–1724), as at this point in time the manufactory did not employ an own modeller for its vessels. On the outside of the box and the inside of the lid Johann Gregorius Höroldt painted his typical chinoiserie scenes with figures of the kind also found in his sketchbook, known as the Schulz Codex. The colours used, iron-red, purple, green, brown, enamel blue, and grey, are not mixed with other shades. Höroldt placed all the scenes on a brown strip of ground behind a base of green grass, which is flanked on the left and right by "Indian" flowering shrubs. Everywhere insects flutter through the air and steam coils upwards from tea kettles, pots, and cups, as the painter shows the Asians, who could quite conceivably be Japanese, making and drinking tea. The figures are shown standing or seated like silhouettes against a white background. Their elaborate clothing, lamp-shade-like hats, and black plaits not only lend them an exotic note but, combined with their curious movements, introduce an element of satire. Apart from the scenes in the lid and on the bottom of the box all the groups of figures are placed in curved cartouches framed by foliate ornament in gold, iron-red, and purple, highlighted with perlmutter lustre.

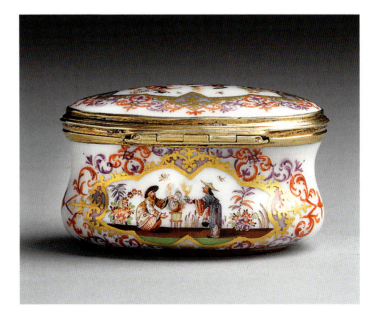

Depictions similar to those in the lid and on the front are also to be found on other snuff boxes, for instance on a privately owned example, previously on loan to the Rijksmuseum Amsterdam (cf. Beaucamp-Markowsky 1985, pp. 36f., cat. no. 11),

on a further snuff box in the State Hermitage Museum in St. Petersburg (cf. Beaucamp-Markowsky 1985, p. 34, cat. no. 7), and on a box in private ownership (underside, cat. no. 24), as well as on a box in the collection of Madame Louis Solvay, Musées Royaux d'Art et d'Histoire, Brussels (cf. Marien-Dugardin 1995, p. 56, fig. 97). This confirms that Höroldt made repeated use of the motifs and compositions he invented and, as shown by the examples referred to here, also occasionally combined them with other figures or placed them in new contexts.

UP

Cat. no. 6

SNUFF BOX

Painted by Johann Gregorius Höroldt (1696–1775),
c. 1728
With contemporary silver gilt mounts
Height 4.6 cm, width 6.5 cm, depth 4.7 cm

Literature:

Jakobsen/Pietsch 1997, p. 262, cat. no. 215 and fig. p. 263

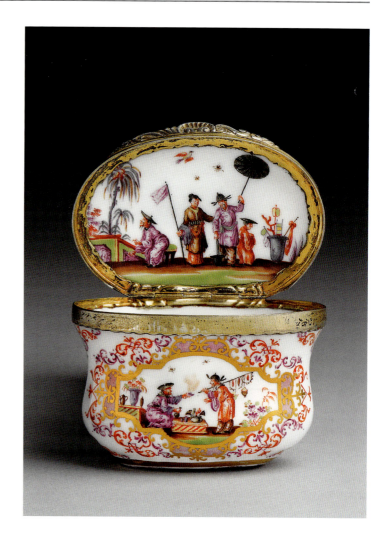

This oval box with bellied sides is closed by a slightly domed lid with silver gilt mounts. The form, which is based on that of silver snuff boxes from the period, was already used as a prototype in Meissen around 1722/23. Johann Gregorius Höroldt painted the long sides and the lid with figural chinoiseries which are placed in quatrefoil cartouches made of leaf-work in gold, purple, and iron-red over perlmutter lustre. The painter devoted particular attention to the painting on the inside of the lid, which is not contained in a cartouche. Here he depicted his figures at a larger scale and enriched them with numerous details. For his scenes he made use of the typical clichéd impressions of life in Asia from his time that were spread by the prints used to illustrate travel descriptions. The European image of China emphasised the foreign and exotic qualities and this distortion of reality led to the development of an idealised type commonly described as

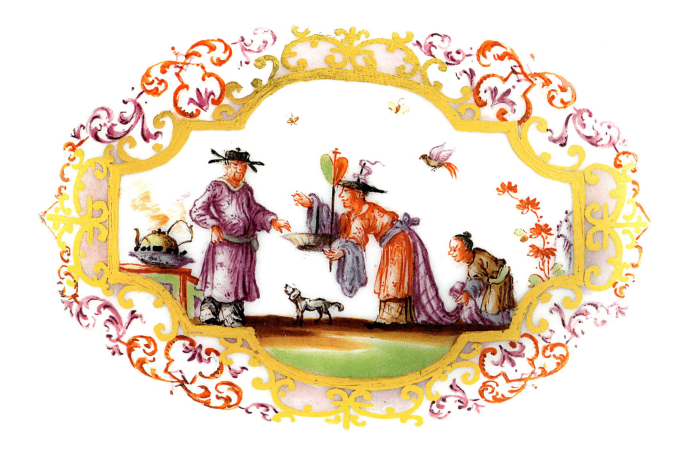

chinoiserie that is found throughout the decorative arts of the eighteenth century. Höroldt's sketch book, which he probably started to keep around 1723/24, contains a wealth of such chinoiserie scenes that were also used and occasionally varied by the painters in his workshop. While there are no drawings in the sketch book that match the scenes on this snuff box, it is possible that some of the leaves from the book have been lost. In terms of content the theme is almost always the same: Asian figures stand or sit together in groups, they drink tea or are involved in making it, some of them hold fans, flags, or parasols, play with children or dogs and lead lives of ease in gardens with palms and flowering shrubs, like in a kind of paradise. The scene on the front of the snuff box is to be found again on a further box in private ownership (cf. Jakobsen/Pietsch 1997, p. 262, cat. no. 214 and fig. p. 263). This repeated use of similar compositions reveals that Höroldt's approach was not based solely on artistic innovation but was also influenced by economic constraints. UP

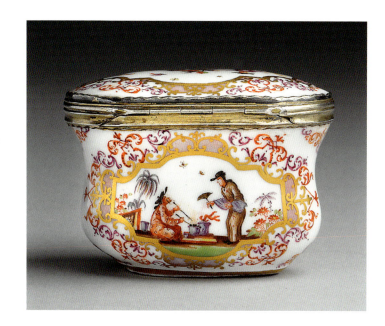

Cat. no. 7

SNUFF BOX

Most probably painted by
Christian Friedrich Herold (1700–1779),
c. 1730–35
With contemporary silver gilt mounts
Height 4.6 cm, width 6.5 cm, depth 4.5 cm

The polychrome chinoiseries that decorate the lid and the long sides of this bellied box are placed on golden leaf-work consoles highlighted with purple lustre, while the base for the figural scene on the inside of the lid is formed by a green strip of lawn. The painter, most probably Christian Friedrich Herold, shows the Chinese in accordance with the design principles of Johann Gregorius Höroldt, drinking tea, standing wearing magnificent garments, or sitting on stools or on the ground, waving fans or flags, or holding parasols aloft. The depictions are flanked by exotic flowering plants, while a dog or a chicken on the ground or birds and insects in the air add further life to the scene. For many years Herold painted porcelain vessels with variations on chinoiseries of this kind. As a result of this routine his work acquired a certain stylised quality and was no longer as inventive as it had been at the end of the seventeen-twenties, but despite the somewhat schematic approach it reveals no artistic weaknesses. The cartouches framed by golden leaf-work and areas of purple lustre found on the narrow ends and on the bottom of the oval box, which contain miniature depictions, painted *en camaïeu* purple, of European gentlemen in idealised landscapes or Chinese people seated at a tea-table, still retain the strength and liveliness that originally characterised Christian Friedrich Herold's art. The painter repeated the figural composition on the front of the present box on a further snuff box of the same shape (cat. no. 13). UP

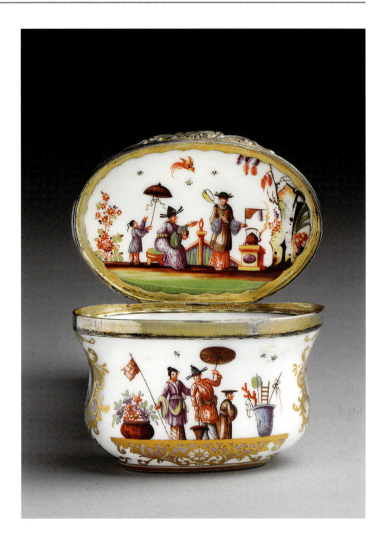

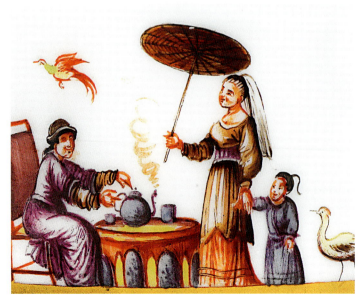

Cat. no. 8

SNUFF BOX

Painted by Philipp Ernst Schindler Senior (1694–1765), c. 1730
With contemporary silver gilt mounts
Height 4.6 cm, width 6.5 cm, depth 4.5 cm

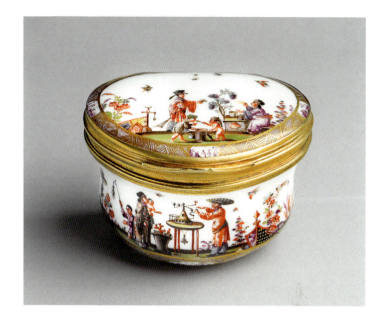

The shape of this snuff box with bellied sides is essentially an oval distended at the front; it is covered by a slightly domed lid with gold mounts. The chinoiseries painted on all sides by Philipp Ernst Schindler are of remarkably fine quality. The figural scene on the outside of the lid is framed by a golden zigzag border highlighted with perlmutter lustre, a similar border on the bottom of the piece frames a purplish-red diamond pattern with a coloured cruciform flower at the centre and four half flowers at the edges. Oval areas placed on the long and short axes of the border show miniature Chinese painted *en camaïeu* purple. The larger polychrome figural scenes depict the Chinese enjoying tea or playing with their children on green lawns in gardens with blossoming shrubs and flowers. The painter shows many of the children naked or lightly clad, often wearing just a simple cloth head-covering, whereas the adults are dressed in elaborate garments and wear fanciful hats. All the scenes have a particularly narrative character and are filled with activity: the children tease or attempt to catch each other, while the adults pick grapes or in another scene demonstrate to their fascinated offspring how a tiny carousel, operated by a crank arm, works. The chubby-cheeked faces with long, upturned noses and the sculptural way in which the heads and limbs are depicted are all typical of Schindler's style.

UP

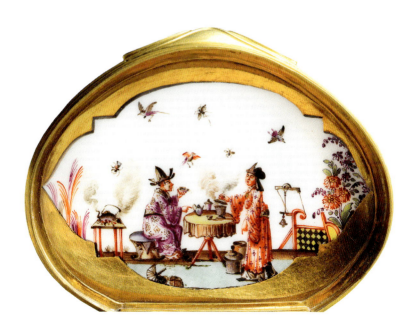

Cat. no. 9

SNUFF BOX

Manufacture 1722/23
Probably painted by Johann Gregorius Höroldt (1696–1775), c. 1724
"K.P.M."-mark in underglaze blue and crossed swords mark in underglaze blue inside bottom of the box
(in use from December 1722 to April 1723)
With contemporary gold mounts
Height 2.9 cm, width 6.9 cm, depth 5.4 cm

Literature:
Beaucamp-Markowsky 1985, p. 32, cat. no. 5

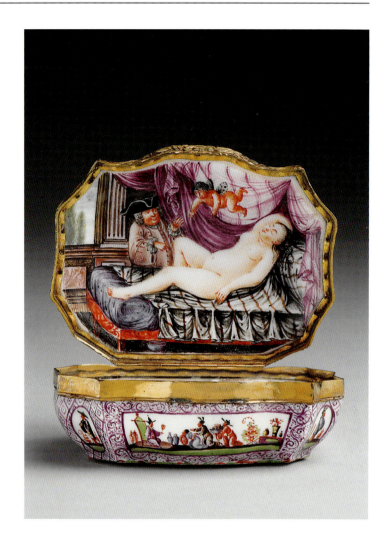

This snuff box is scalloped in plan with a flat base; it has curved sides and is closed by a slightly domed lid with gold mounts and a thumb rest. The form is based on a silver original and was probably modelled by Johann Jacob Irminger (1635–1724), who designed the entire range of vessels made of Böttger stoneware and Böttger porcelain. The painting in the early enamel colours iron-red, purple, green, brown, and blue was carried out by Johann Gregorius Höroldt. Apart from the base the entire box is covered by a purple ground of lattice and leaf-work ornament in which quatrefoil, oval, rectangular, and trapezoidal reserves were left. They contain typical Höroldt chinoiseries in miniature format, a theme on which this painter produced innumerable variations. The composition on the outside of the lid is of particularly high quality and shows a tea ceremony set in a garden. A man and a woman sit opposite each other at a table laid with tea things that is placed at a diagonal to the picture plane. Another lady approaching from the right carries a steaming tea cup, while behind her a man sitting beside a palm tree prepares the brew in a kettle over an open coal fire.

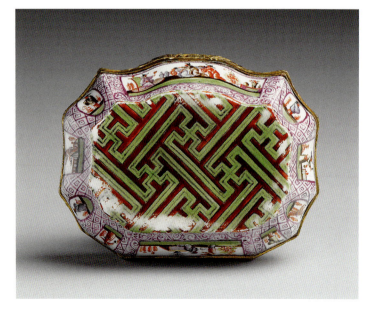

At the time this painting was done drinking tea, coffee, and chocolate still represented a special luxury so that scenes of this kind not only enhanced the snuff box but, through the chinoiseries, also lent it an exotic character. The scene on the inside of the lid refers to snuff's qualities as a stimulant. A somewhat stocky older gentleman wearing a frock-coat and a tricorn stands beside a lady reclining naked on a bed and with his index finger points at her *mons veneris,* while Cupid

descends from above to inspire the lovemaking about to take place. Erotic and occasionally pornographic scenes are frequently found in snuff boxes in the first half of the eighteenth century but generally—at least in the case of porcelain boxes from the Meissen manufactory—were concealed inside the box and therefore could be seen only by the user when the lid was flipped open. For the suggestive scene on this snuff box Höroldt probably used a print by the Augsburg engraver Jonathan Gottfried Pfautz (1687–1760).

The pale green swastika ornament on an iron-red ground used to decorate the bottom of this snuff box is taken from Japanese decorative art.
UP

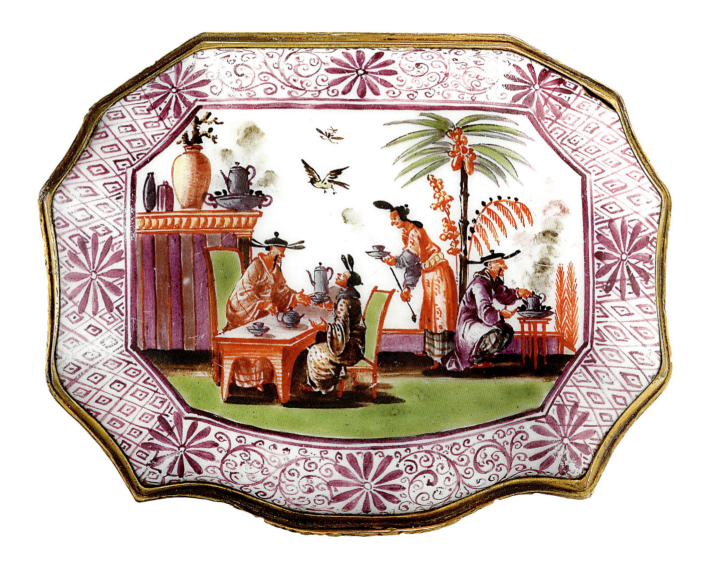

Cat. no. 10

SNUFF BOX

Manufacture c. 1730
Painted by Philipp Ernst Schindler Senior (1694–1765), c. 1730
Cryptic painter's mark on the inside
of the lid at the front edge of the table-top: "△"
With contemporary silver gilt mounts
Height 3.4 cm, width 8 cm, depth 6.5 cm

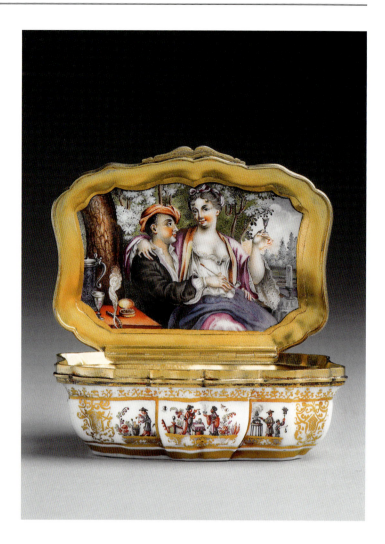

This box in the shape of a cartouche with a straight edge at the back and bellied sides is covered by a slightly domed lid with silver gilt mounts. The scalloped sides of the box are decorated with finely made gold leaf-work borders that frame individual polychrome chinoiseries on gold leaf-work consoles, highlighted with areas of lustre. In further, even smaller, paintings inserted in the gold ornament that runs around the edge of the lid idealised landscapes are depicted in *en camaïeu* purple. The figural scenes show Chinese men and women standing or seated, drinking tea, playing with their children in gardens with flowering shrubs and colourful wooden fences. The highly individual design, in which colour is used to model the figures, and in particular the faces with upturned noses and saucer eyes and the presence of small naked children held aloft by their mothers exactly matches the style of painting on a saucer in the Bayerisches Nationalmuseum Munich, Meissener Porcelain Collection, Ernst Schneider Foundation, Schloss Lustheim (inv. no. ES 102) which is marked with the cryptogram "PES" (Philipp Ernst Schindler; see fig. VI.1), and is similar to other porcelain décors in the manner of the Höroldt chinoiseries, which bear a cryptic painter's mark in the form of a tiny, empty triangle. This allows the present chinoiseries to be attributed to the painter Philipp Ernst Schindler Senior.

The empty triangle is also found in the décor on the inside of the lid, confirming without doubt that the painting was done by Schindler, even though the courtly motif is executed in a completely different manner to the other scenes. Two lovers sit beneath a tree in a garden. The lady, her bosom revealed, turns towards the viewer, she holds a wine glass in her left hand and is seated on the lap of a gentleman who wears a dressing gown and a night-cap and holds a long white clay pipe in his right hand. A wine ewer, a further glass, a smoking fuse, and an open gold

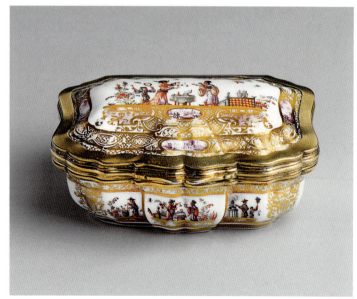

snuff box stand on the table beside the couple. The scene is based on a print by Bernard Picart (1673–1733), in which allusion is made to the consumption of tobacco and wine as a means of igniting the fires of love; the caption to the print makes the theme unambiguously clear. The same motif is painted on the inside of the lid of a snuff box with the same form now in a Swiss private collection (cf. Beaucamp-Markowsky 1985, p. 64, cat. no. 36). UP

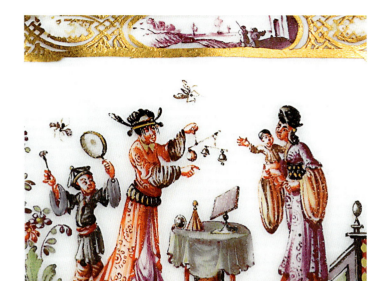

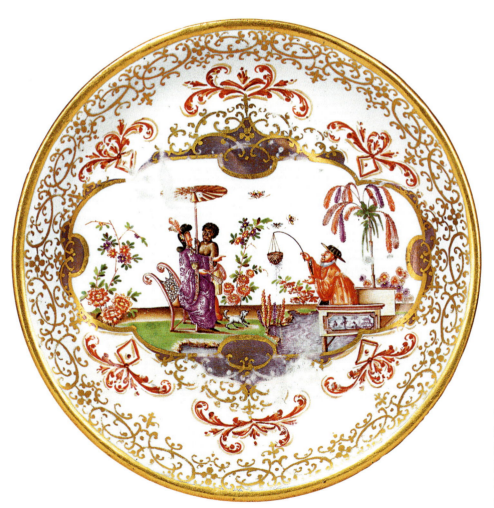

VI.1
Saucer, signed with the cryptogram "PES" (at the back of chair) for Philipp Ernst Schindler Senior, Munich, Bayerisches Nationalmuseum, Meissener Porcelain Collection, Ernst Schneider Foundation (inv. no. ES 102)

Cat. no. 11

SNUFF BOX

Painted by Philipp Ernst Schindler Senior (1694–1765),
c. 1730
Cryptic painter's mark on the inside of the lid
on the lace sleeve of the woman's raised arm and,
on the outside, just to the right of the base of
the flowering shrub on the extreme left: "△"
With contemporary gold mounts
Height 3 cm, width 7.5 cm, depth 5.6 cm

Provenance:
Formerly H. Joseph collection

Literature:
Joseph 1977, p. 25, fig. 7; Bursche 1998,
p. 41 and figs. 8 and 9

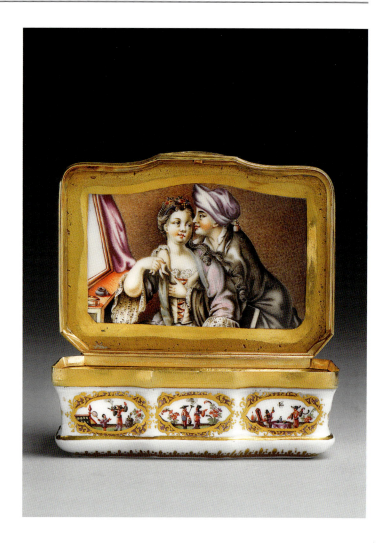

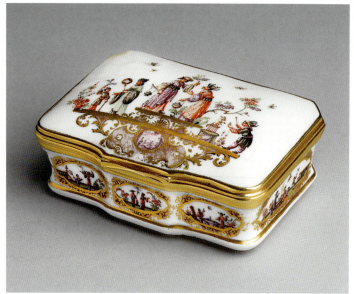

The rectangular snuff box has rounded and chamfered corners, a projecting central section and a slightly domed lid with gold mounts. It was painted on all sides by Philipp Ernst Schindler Senior, as is confirmed by the two cryptic painter's marks. Schindler decorated the long and short sides of the container with figural chinoiseries. They are inserted in quatrefoil cartouches made of golden leaf-work over purple lustre, one on each of the short ends and at the back, and three at the front. In contrast, on the lid Schindler placed the scene showing a number of Chinese persons on a golden leaf-work console in which a small merchant shipping scene painted *en camaïeu* purple is integrated. The depiction on the bottom of the box is framed by a gold lace border. Schindler's typical style is particularly evident in the larger depictions: the figures wear elaborate clothing and fanciful head coverings and each of them holds an object of some kind; the painter presents the activities of the individual persons in a narrative fashion employing an enormous wealth of movement: a child with a feather headdress is training a rabbit that sits on a plinth in front of him, two men stand opposite each other on the left and right of a flat table and present various strange objects, several more of which lie on the table in front of them, a couple swing censers, and a woman with a fan stands in front of a child who holds up a toy. The miniature scenes on the

sides are similar; the dominant themes are the tea ceremony and the playing of music. The chubby-cheeked faces and long,— upturned noses of the figures are, like the limbs, sculpturally modelled entirely in iron-red enamel colour and, as a whole, make an extremely lively effect. This applies also to the courtly scene on the inside of the lid, which shows a gentleman in a dressing gown and night-cap approaching a noble, elegantly-dressed lady from the right. He has placed one arm around her shoulder and the other under her bosom as if he is about to give her a kiss. She does not seem displeased by the gentleman's— intention, as she gives him a friendly look and gently takes hold of his right hand. Schindler borrowed the composition from a copperplate print presumably by Jeremias Wolff (1663–1724).

UP

Cat. no. 12

SNUFF BOX

Manufacture c. 1730

Painted by Philipp Ernst Schindler Senior (1694–1765), c. 1730

Cryptic painter's mark on the plinth of the bust: "△"

With contemporary silver gilt mounts

Height 3.6 cm, width 7.8 cm, depth 5.8 cm

Literature:

Joseph 1977, p. 24, fig. 4; Beaucamp-Markowsky 1985, p. 55, cat. no. 26; Bursche 1998

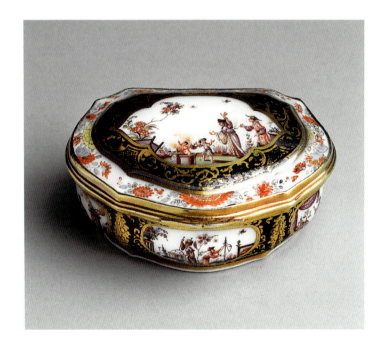

This snuff box in the form of a scalloped quatrefoil cartouche with a straight edge at the back has a slightly domed lid with silver gilt mounts. The outside of the box is covered with an underglaze blue ground in which four horizontal oval reserves, outlined in gold, were left on the sides, while the quatrefoil reserve on the lid is framed by gold leaf-work and has an additional frieze of *indianische Blumen*. Like the scene on the bottom of the box these reserves all contain figural chinoiseries in the typical manner of Philipp Ernst Schindler, which can be easily distinguished from the style of other painters of this time by the décor of a saucer with the cryptogram "PES" in the Bayerisches Nationalmuseum, Meissener Porcelain Collection, Ernst Schneider Foundation, Schloss Lustheim (inv. no. ES 102, see fig. VI.1). The typical characteristics of his work include a strongly linear style combined with painterly modelling of the chubby-cheeked faces and well-proportioned limbs, round eyes and long, upturned noses as well as rich clothing, fanciful hats, and feather headdresses. The narrative approach shown in the exotic scenes is also typical of Schindler's work: adults play with their children, some of whom are naked, or are shown drinking tea in a garden setting or using

 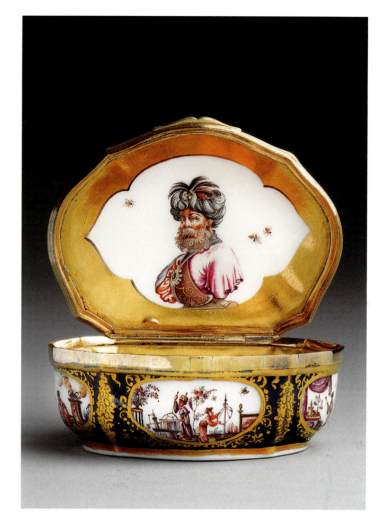

VI.2
Stefano della Bella (1610–1664), *Bearded Man with Turban in Three-Quarter-Profile to the Right*, Karlsruhe, Staatliche Kunsthalle, Kupferstichkabinett (inv. no. V 205,8)

mysterious objects. Making expansive gestures they swing censers, carry frames with colourful toys above their heads, or perform strange religious rituals amidst blossoming "Indian" shrubs and flowers. A quatrefoil cartouche reserve outlined in brown was left in the gold ground on the inside of the lid. It contains the bust of an Oriental with a full beard and turban that stands on a flat base with three insects fluttering around it. Here, once again, Schindler succeeds in portraying a lively and expressive face that he based on an unknown print. This may have been a reverse engraving of a plate by Stefano della Bella (1610–1664), made by an artist whom, as yet, it has not proved possible to identify.

UP

Cat. no. 13

SNUFF BOX

Most probably painted by
Christian Friedrich Herold (1700–1779),
c. 1735
With contemporary gold mounts
Height 6.6 cm, width 6.8 cm, depth 5 cm

From around 1735 the painter Christian Friedrich Herold stopped making use of the sketches of Johann Gregorius Höroldt and instead employed his own compositions which he had collected over the course of time and probably recorded in the form of drawings so as to use them several times. The depiction on the front of this box matches that on another snuff box, also painted by Herold, just as the scene on the back of the present snuff box corresponds with that on the outside of the lid of the comparable piece just referred to (cat. no. 7). The frequent repetition involved in this extremely economical method of working resulted in a certain stylisation and simplification of the décors. Nevertheless, thanks to the three-dimensional way of painting and the rich details of the garments the figures remain very lively and the narrative details lose nothing of their exotic character. Apart from the painting on the bottom of the box and the inside of the lid Herold placed the scenes on golden leaf-work and trellis consoles, partly highlighted with purple lustre. On the narrow ends of the bellied oval snuff box he added upright ovals painted *en camaïeu* purple, each showing a Chinaman under a palm tree, and repeated the same method in the console on the outside of the lid, where the inserted rectangular painting shows

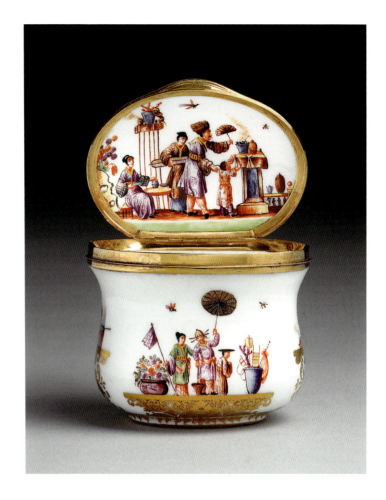

a traveller beside a pollarded willow in a European landscape. The somewhat larger Chinese figures on the inside of the lid stand on a lawn composed of brown and green strips, from which a cliff of perforated tuff stone rises at the left-hand edge. On the right a steaming pot rests on a plinth, a Chinese man holding a fan and wearing a kind of feather headdress approaches it, guiding a child forward with his right hand. The painter probably associated this exotic head gear with his idea of an "Indian"—a term frequently used for Asians around this time.

The scene on the bottom painted *en camaïeu* purple is of particularly high quality and has stylistic traits in common with a saucer signed by Herold with "CFH zu güttigen andencken 1743" ("CFH in fond memory 1743") in the Kunstindustrimuseet Copenhagen (inv. no. B 45/1944, cf. exh. cat. Dresden 2010, p. 224, cat. no. 125). UP

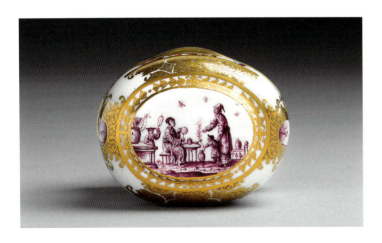

Cat. no. 14

SNUFF BOX

Painted by Christian Friedrich Herold (1700–1779),
c. 1735
With contemporary silver gilt mounts
Height 4.5 cm, width 7.5 cm, depth 5.5 cm

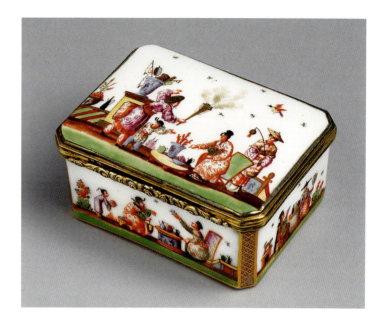

This rectangular snuff box with chamfered corners and gilded mounts was painted by Christian Friedrich Herold. It represents the painter's mature style in which the figural chinoiseries are no longer set in quatrefoil cartouches, but are placed freely, without a depicted background or sky, on a base of green and brown ground. Only the bottom of the box, which is painted *en camaïeu* purple, departs from this scheme and shows a bare-headed Asian squatting on the ground beside a tall plinth, on which there is a hearth with a steaming tea-kettle; the river flowing through the landscape behind him is edged by tall mountains. Herold decorated the corners of the box with gold trellis ornament over perlmutter lustre. As so often his depictions reflect a European image of China and present an idealised view of that country which he transforms into a kind of paradise. The rich, diversely ornamented clothing consisting of long garments with wide sleeves, baggy trousers, lampshade-like straw hats, and black caps and hats suggests a sense of well-being and prosperity. The people in the gardens with blossoming shrubs are generally shown making gestures of invitation to each other. They pass each other steaming cups of tea, greet each other in a friendly manner, provide shade for each other with their colourful parasols, or create a cooling breeze with their fans. The predominant atmosphere is harmonious, cheerful, and summery, far removed from any suggestion of strife or grief. The objects depicted, such as tall plinths, vases, tables, chairs, and garden fences, are almost always ornamented and decorated with little Asian figures, network patterns or marbling, while pieces of coral, fans, flags, and crosses poke out of the vases and dishes.

Johann Gregorius Höroldt (1696–1775), the head painter in Meissen, introduced this kind of chinoiserie, which always

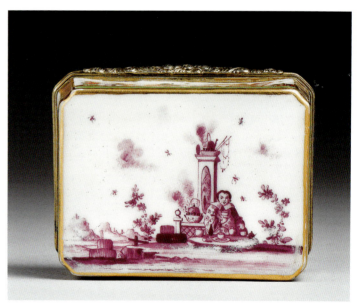

shifts between admiration and a kind of caricature, in 1720 and in the years that followed developed this style further. Herold, who was employed as a journeyman painter in Meissen in 1725, was among those artists who followed the style of the Höroldt chinoiseries most closely and acquired an important reputation through his painting of snuff boxes. UP

Cat. no. 15

SNUFF BOXES

Probably painted by Johann Gregorius Höroldt (1696–1775),
c. 1728/30
With contemporary gold mounts
Height 3.6 cm, width 7.2 cm, depth 5.3 cm

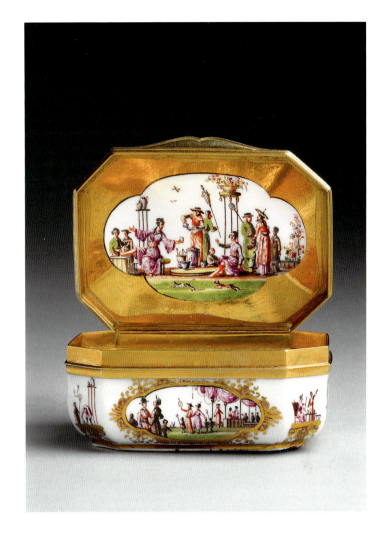

This rectangular box is gilded internally and has chamfered corners. All the sides are painted with figural chinoiseries that are framed in several different ways. On the long and narrow sides they are inserted in quatrefoil gold leaf-work cartouches and placed on consoles of leaf-work over purple lustre. The scene on the outside of the lid is surrounded by two leaf and network frames, while the scene with various Chinese persons on the inside is set in a quatrefoil reserve left in the gold ground. In all the compositions the wealth of figures used is particularly striking, as is the similarity of the style employed throughout, which is characterised by bodies and limbs elongated in an almost mannerist way and rather small heads. The design concept for the most part corresponds with the models in the sketch book of Johann Gregorius Höroldt, who himself occasionally painted in this unfamiliar style, for example on a signed vase dated 1727, formerly in the porcelain collection of the Staatliche Kunstsammlungen Dresden but lost since 1945, on its counterpart which is still in the Dresden collection (inv. no. PE 647), and on a further vase in the Rijksmuseum Amsterdam (inv. no. BK 17386; cf. Pietsch 1996, pp. 15, 194f., cat. no. 145 and pp. 198f., cat. no. 147). This does not completely confirm that Höroldt was responsible for the painting of this snuff box, as it could also be the work of one of his numerous apprentices, for whom Höroldt might have made the initial drawing and who may possibly have painted just one snuff box. Whatever the case, the painter certainly already had considerable skill in composition, as instead of placing all the figures together they are arranged in groups in the foreground, middle ground, and background, an approach not often found in chinoiseries. The way the figures are positioned on a brown and green area of ground reflects the standard scheme, as do the activities of the Chinese, who are shown preparing, offering, and enjoying tea, attending an audience with their ruler, playing with children and dogs, and simply idling away their time, carrying with them parasols and fans. UP

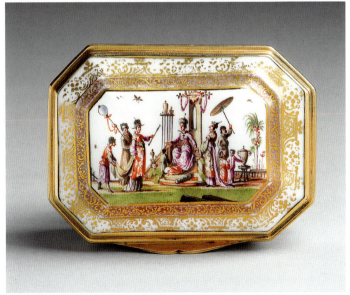

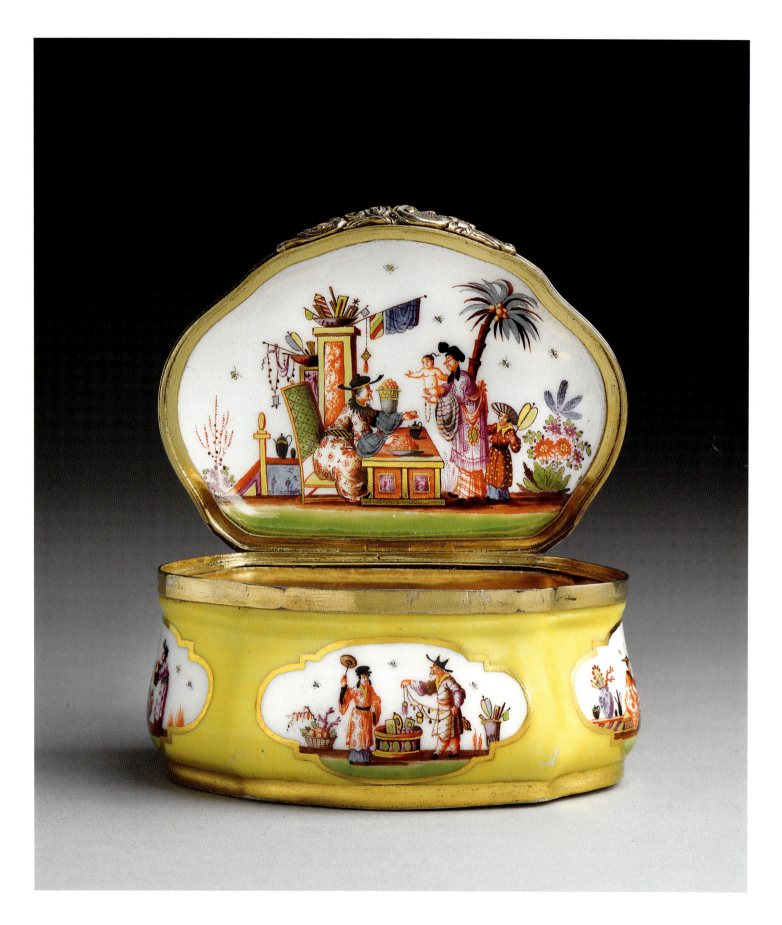

Cat. no. 16

SNUFF BOX

Painted by Christian Friedrich Herold (1700–1779),
c. 1730
With contemporary silver gilt mounts
Height 4.5 cm, width 8.5 cm, depth 6.2 cm

Provenance:
Formerly H. Joseph Collection, exhibited in Amsterdam, Rijksmuseum 1972–2003, and London, Somerset House, Gilbert Collection 2003–08

Literature:
Beaucamp-Markowsky 1985, p. 52, cat. no. 23

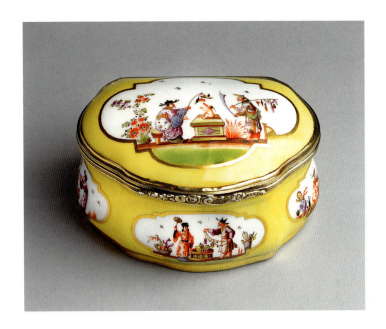

This snuff box in the form of a quatrefoil cartouche with a straight edge at the back is covered externally with a yellow ground in which gold-framed reserves in the shape of a quatrefoil cartouche were left on all sides, including the slightly domed lid and the flat bottom. These reserves contain chinoiseries with figures in pairs or groups of three, which stylistically can be attributed to Christian Friedrich Herold.

The copyright, as it were, for subjects of this kind can be allocated to Johann Gregorius Höroldt (1696–1775). Inspired by prints used to illustrate descriptions of travels in China and Japan, he recorded innumerable versions of these subjects in his sketch book, known as the Schulz Codex, in the form of pen drawings, sometimes with wash. These furnished not only Höroldt himself but also the journeymen and apprentices of his Meissen painting workshop with ideas and models for porcelain décors. Consequently, although each artist had his individual style, the "Höroldt chinoiseries" as a whole have a relatively uniform appearance.

Herold also made use of these models; for instance on the lid of the present box he combined two different motifs from sheet 69 of the sketch book (see fig. VI.3) to create a new composition, while for the inside of the lid he used a depiction from sheet 67, which he modified only slightly. The painter probably derived the other scenes, which are variations on regularly repeated themes, from his own imagination. UP

VI.3
Schulz Codex, sheet 69, detail, Leipzig, Grassi Museum für Angewandte Kunst

Cat. no. 17

SNUFF BOX

Model by Johann Joachim Kaendler (1706–1775),
1737
Painted by Christian Friedrich Herold (1700–1779),
c. 1738
With contemporary silver gilt mounts
Height 8.5 cm, width 6.6 cm, depth 5.2 cm

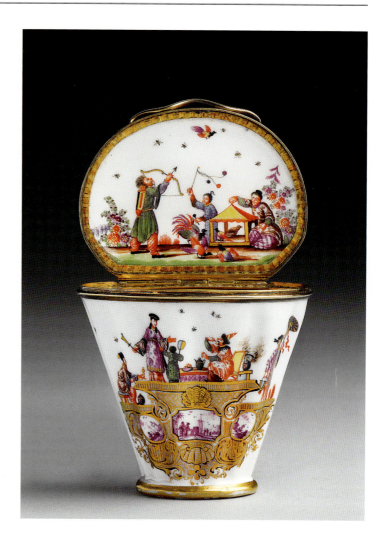

The model for this snuff box can probably be traced back to the Meissen modelling master Kaendler, as in his work report from May 1737 he writes as follows: "4. Completed a snuff box in the form of a wine or winegrower's barrel" ("4. Eine Tabattiere gefertiget in gestalt einer Wein oder Wintzer Putte"; quoted from Pietsch 2002, p. 46). The gadrooned oval form that slopes outwards from the base and has a slightly domed lid matches this description.

Most of the Meissen chinoiseries on vessels and snuff boxes were painted by Christian Friedrich Herold, an artist with a particularly fertile imagination. He regularly invented new motifs and arrangements of figures, but occasionally also repeated earlier compositions on a number of pieces. He also used them on enamel snuff boxes, which, while employed in Meissen, he made without permission for Alexander Fromery in Berlin. In this snuff box he placed his figures on straight or stepped gold plinths made of *Laub- und Bandelwerk,* and shell and network ornament over purple lustre. These bases incorporate small merchant shipping scenes painted *en camaïeu* purple, which also represent a speciality among Herold's subjects. The only scene without a console or ornamental frame is on the inside of the lid and, as usual, is placed on a base of brown and green ground, on which the figures cast their shadows. Here the master depicts a man shooting with bow and arrow at a bird flying above him, while a woman on the ground is releasing other birds from a bird cage, and a child behind her waves a two-tailed whip in the air. The other scenes are somewhat calmer: couples sit at tables and drink tea or children wave torches, flags, and fans. The faces with snub noses, modelled in iron-red enamel colour, and black hair tied in plaits or pony-tails are typical of Herold. Despite the wealth of detail and the liveliness of the scenes, around this time we can detect a certain stylised quality in the depictions that resulted

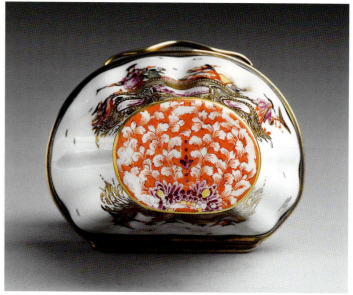

from the use of constant repetition in chinoiserie painting. Nevertheless, through the richness of the motifs and the use of gold and purple, they still make a costly impression. The dense, iron-red peony blossom ornament painted on the bottom of the box, with halves of purple chrysanthemums with yellow receptacles inserted on one side, was done with particular mastery. UP

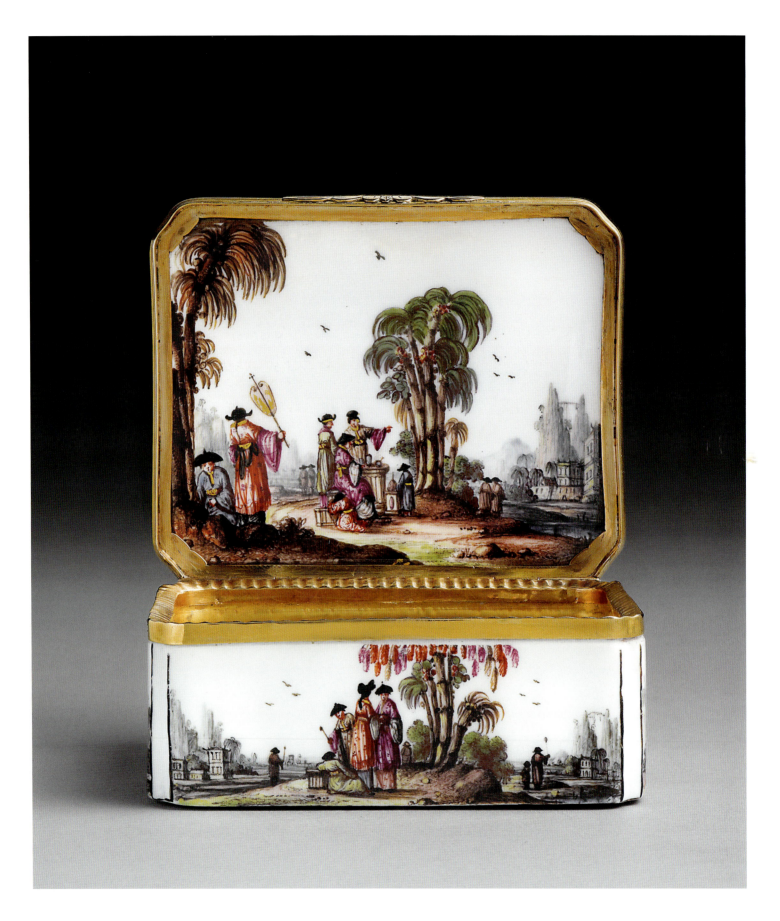

146

Cat. no. 18

SNUFF BOX

Probably painted by Johann George Heintze
(born c. 1706/07), c. 1735
With contemporary gold mounts
Height 4.2 cm, width 8.7 cm, depth 7 cm

Literature:
Exh. cat. Cologne 2010, pp. 222f., cat. no. 97

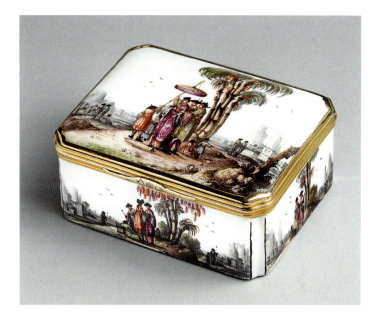

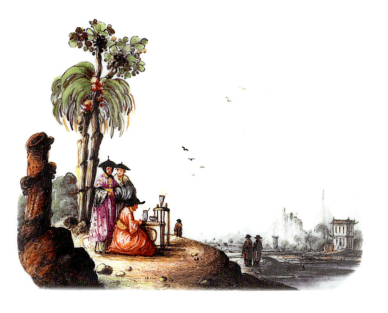

The rectangular form of this snuff box, which is gilded internally and has chamfered corners, is similar to that of cat. no. 14, with the difference that in this box the narrow white areas between the long and short sides are bordered by dark brown lines. The painting on all sides reflects the style of Johann George Heintze who here placed his figural Chinese scenes in exotic idealised landscapes. While in the foreground the figures, who wear long, richly patterned garments, gold belts and collars, and black hats, are grouped around clusters of palm trees, the harbours in the middle ground and background with palaces and jagged, fantastical mountains connected by bridges are populated by other figures, which are shown smaller the further away they are from the viewer. By using more vivid colouring in the foreground and paler colours tinged with grey closer to the distant horizon, the painter succeeds in creating a marvellous impression of depth, which is further heightened by brown palm trees or tree stumps cut off by the left-hand edge of the picture. This snuff box offers yet a further testimonial to the mastery of Johann George Heintze. UP

Cat. no. 19

SNUFF BOX

Painted by Johann Ehrenfried Stadler (1701–1741),
c. 1728–30
With contemporary gold mounts
Height 3.5 cm, width 6.2 cm, depth 4.9 cm

Literature:

Seyffarth 1960

The long sides, the bottom, and the lid of this quatrefoil-shaped box with a straight edge at the back are painted with bizarre chinoiserie figures framed by cartouches of gold mesh, partly over a perlmutter lustre ground, and by gold, blue, and red leafwork. Colourful exotic birds stand on brackets attached to the sides of the cartouches. In contrast, the short ends of the container are decorated with simple *indianische Blumen*. This box can only have been painted by Johann Ehrenfried Stadler, who has entered the specialist literature as the "master of the Chinese with fans." His highly individual style of painting, which differs distinctly from chinoiseries by other artists, is well documented by the cryptic signature on a Meissen porcelain lantern in the porcelain collection of the Staatliche Kunstsammlungen Dresden (inv. no. PE 1522, see fig. VI.4; cf. Pietsch 1996, pp. 206f., cat. no. 153). Typical characteristics of his work include the strongly graphical quality of the faces of his stylised, richly dressed figures, who carry fans of various kinds or striped parasols and stand on green strips of grass surrounded by the large flowers of blossoming East Asian plants. This snuff box is one of the few containers of this kind that Stadler painted. UP

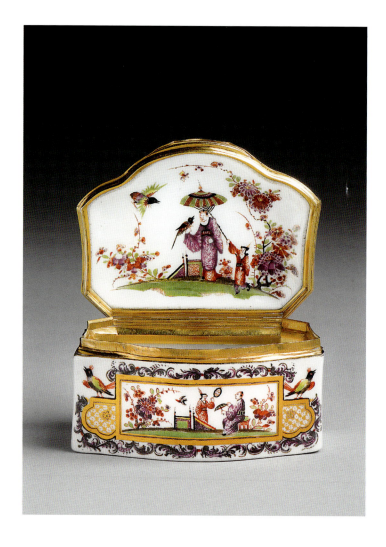

VI.4
Porcelain lantern, signed with the cryptic signature of Johann Ehrenfried Stadler, Meissen 1727, Dresden, Staatliche Kunstsammlungen Dresden, Porcelain Collection (inv. no. PE 1522)

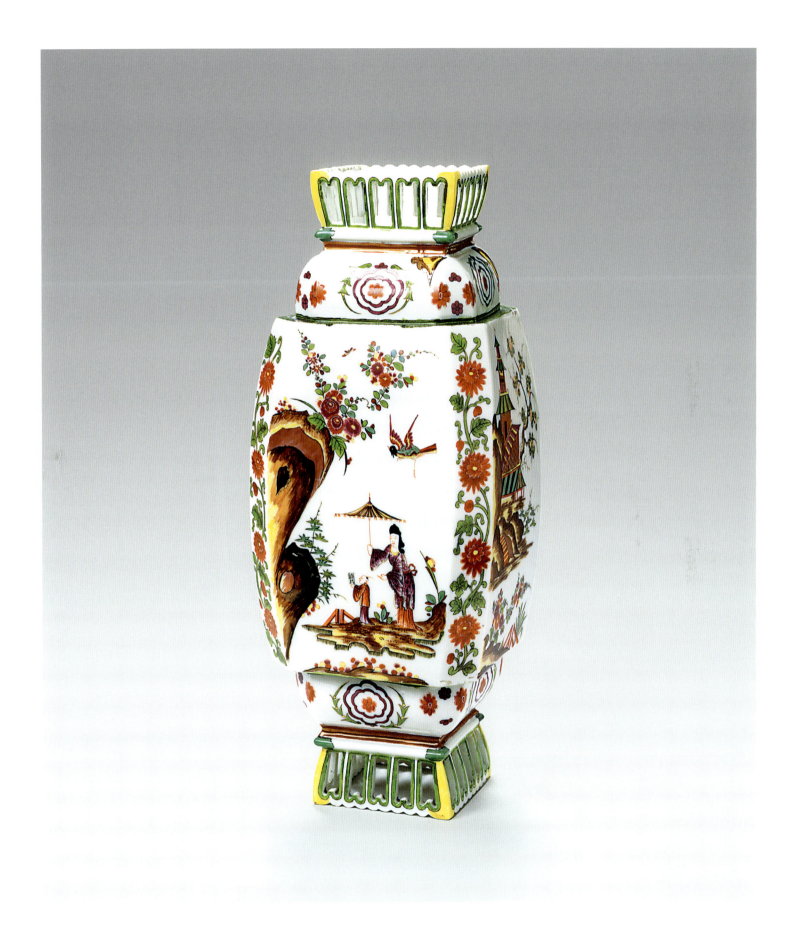

Cat. no. 20

SNUFF BOX

Manufacture c. 1722/23
Painted c. 1735
"K.P.M."-mark in underglaze blue and crossed swords mark in underglaze blue inside on the bottom (in use from December 1722 to April 1723)
With contemporary gold mounts
Height 4.9 cm, width 6.3 cm, depth 4 cm

Provenance:
Formerly Andreina Torré Collection, Zurich

Literature:
Beaucamp-Markowsky 1985, p. 63, cat. no. 35

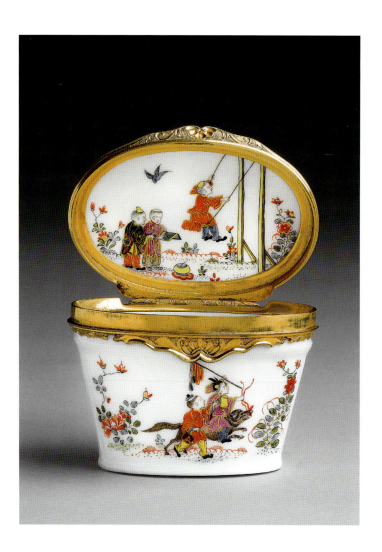

This oval box with sides that splay outwards from the base is closed by a slightly domed lid with gold mounts. The figural chinoiserie scenes on both sides of the lid and on the long sides of the oval container represent a special example of this genre of Meissen porcelain painting and differ clearly from the method developed by Johann Gregorius Höroldt, whose small figures are generally inserted in richly decorated cartouche frames. Most of the scenes on the present box are based on models from the Japanese Sakaida Kakiemon manufactory and present children, wearing kimonos or baggy trousers, at play. They are shown seated on a swing, gambolling with a dog-like mythical beast and waving flags, or dancing to the sounds of a horn and clarinet. Only the pairs of figures inside on the bottom of the box and on the back, who are directly quoted from Kakiemon décors, could conceivably be adults. Porcelain painters in Meissen interested in taking this approach had no shortage of models, as large numbers of them were available in the royal collections of Augustus the Strong in the Japanese Palace, and in accordance with the king's express wishes the Saxon manufacturers imitated both their form and décor.

One of the protagonists of those Meissen artists who based their work on Japanese porcelain painting was Adam Friedrich von Löwenfinck (1714–1754), whose characteristic style can be defined by a signed tankard in the Rijksmuseum Amsterdam (cf. mus. cat. Amsterdam 2000, pp. 276ff., cat. no. 201). Although a number of details on the snuff box are very similar to the depictions on this mug, for instance the golden folds of the garments and the blades of grass on the ground that form a frieze made up of arches, the round heads, always with the same tonsure, and a number of other details are depicted very differently, making Löwenfinck's authorship appear doubtful. It seems more likely that this snuff box was painted by an artist from the same studio who worked in a similar style. UP

Cat. no. 21

SNUFF BOX

Painted c. 1735–40
With contemporary silver gilt mounts
Height 4 cm, diameter 6 cm

The gold-framed quatrefoil reserves made in the coral-red ground of this circular box with bellied side walls and a slightly domed lid contain depictions of Chinese or Japanese children: one plays his triangle for a friend, another blows soap bubbles into the air which another boy tries to catch; two play teacher and pupil and one encourages a mythical animal to run. On the scene on the inside of the lid children stage a bacchanal: one of them, seated on a barrel, pours wine from a jug into a goblet, whereas another has turned on the tap in the barrel to allow wine to flow into a carafe. Two other children sit opposite each other at a table, one holds a full glass in his hand, the other raises his glass to toast two musicians who are playing the horn and fiddle under a pergola. The black outlines give the naïve depictions a strongly graphical quality and, as is particularly clear in the case of the boy with the triangle and the flower basket on his back, are based on décors from the Japanese Sakaida Kakiemon manufactory near Arita, which the porcelain painters in Meissen had the opportunity to study and copy in Augustus the Strong's extensive collection in the Japanese Palace in Dresden. It can be proven that Adam Friedrich von Löwenfinck (1714–1754), for example, took this approach, but the simplicity of the depictions on this snuff box exclude him as the possible painter of these scenes.

There are two similarly painted round boxes in the Metropolitan Museum, New York, The Jack and Belle Linsky Collection (cf. Beaucamp-Markowsky 1985, p. 62, cat. nos. 33 and 34).

UP

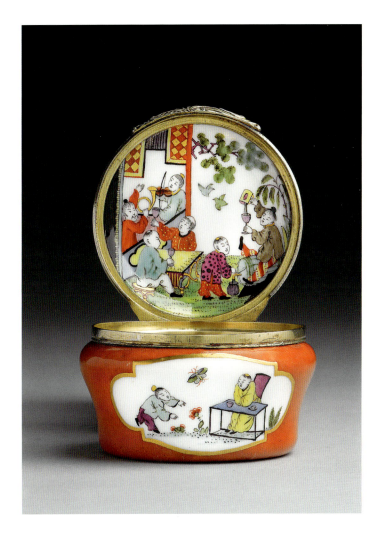

Kauffahrtei

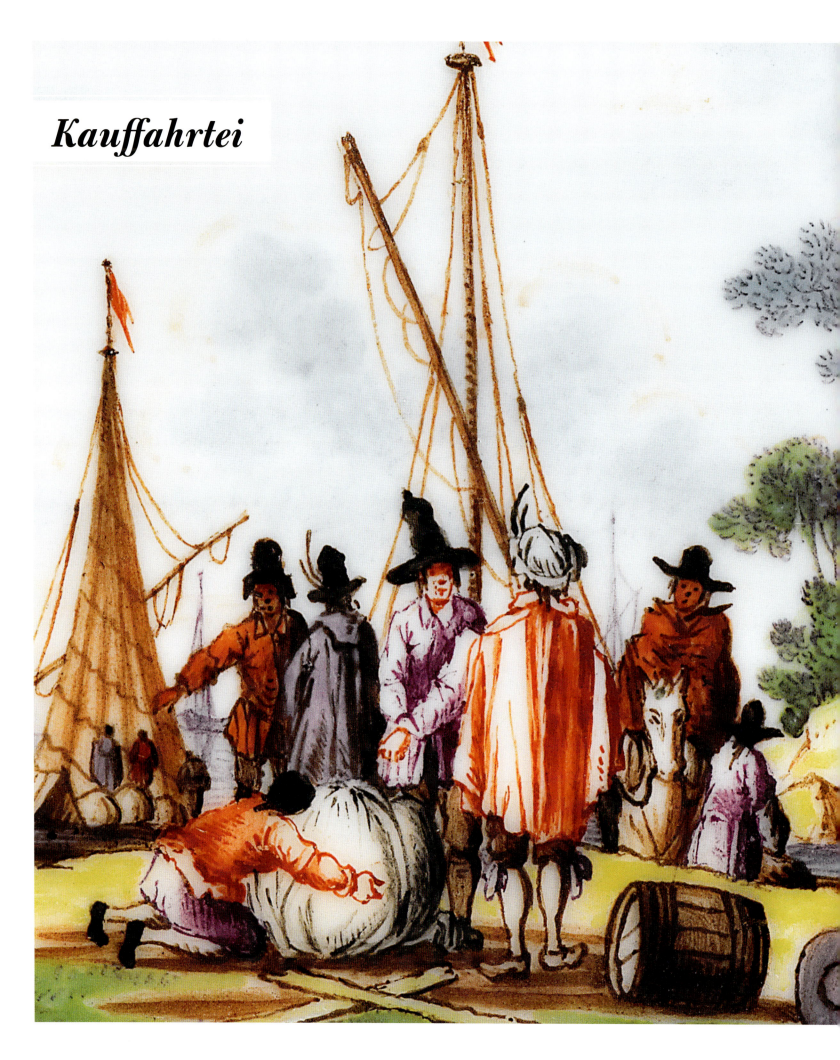

Cat. no. 22

SNUFF BOX

Manufacture c. 1723/24
Probably painted by Johann George Heintze (born c. 1706/07), c. 1725
With contemporary copper gilt mounts
Height 5.6 cm, width 7 cm, depth 4.2 cm

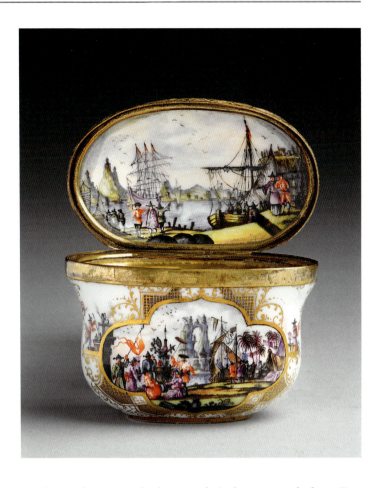

This oval box with slightly bellied sides stands on a flat base and has a slightly domed lid. The original gilt copper mounts are decorated with a fine line and tendril ornament and include a thumb rest. It is likely that an original in silver provided the model for the form, as, at the time it was made, following the death of Johann Jacob Irminger (1635–1724) the manufactory no longer had a suitable designer of forms who could have produced his own creations.

The painting was carried out using the early enamel colours iron-red, purple, green, brown, blue, and some black and gold.

The décor consists of a large quatrefoil cartouche on the front, the back and the lid, while the outside of the base and the inside of the lid are decorated with a scene outlined in gold. The cartouches use rich ornament consisting of gold and iron-red leaf-work, flowers with four petals, and areas of gold trellis over grounds of Böttger lustre. The little Chinese figures standing on leaf-work consoles at the sides of the cartouches represent an exotic element; they are involved in various activities such as making tea, painting a porcelain vase, or playing with a monkey. In iconographical terms the miniature pictures inside the frames belong to what are known as merchant shipping scenes, which Johann Gregorius Höroldt and his first apprentice, Johann George Heintze, painted on Meissen porcelain as early as 1724. They show harbour landscapes with tall cliffs of the kind familiar from prints used to illustrate descriptions of travels through China. The tall tower-like buildings, palm trees and pagodas lining the bays in which large and small ships sail also seem to have been taken from such illustrations, as the painters in Meissen had no other visual sources to draw on. The figures represent European and Chinese merchants grouped closely together and surrounded by porcelain vessels, crates, boxes, and bales of goods, a reference to the busy trade in luxury goods from East Asia conducted by the Amsterdam-based Dutch East India Company.

This is certainly an early work by Johann George Heintze, who entered the manufactory in 1720 and soon became one of its best landscape and figure painters. His repertoire, in which he always allows his fantasy free rein, is apparently limitless. The clear, definite accentuation of the foreground, middle ground, and background and the shimmering sky dotted with clouds and enlivened by flocks of birds create a sense of spatial depth. Heintze's characteristic stylistic devices include architectural motifs immersed in shadows, such as town walls, monumental columns and pedestals, which are placed on the left- or right-hand edges of the picture, or dark objects in the foreground that create a clever play of light and make everything that lies deeper in the picture shine more brightly. UP

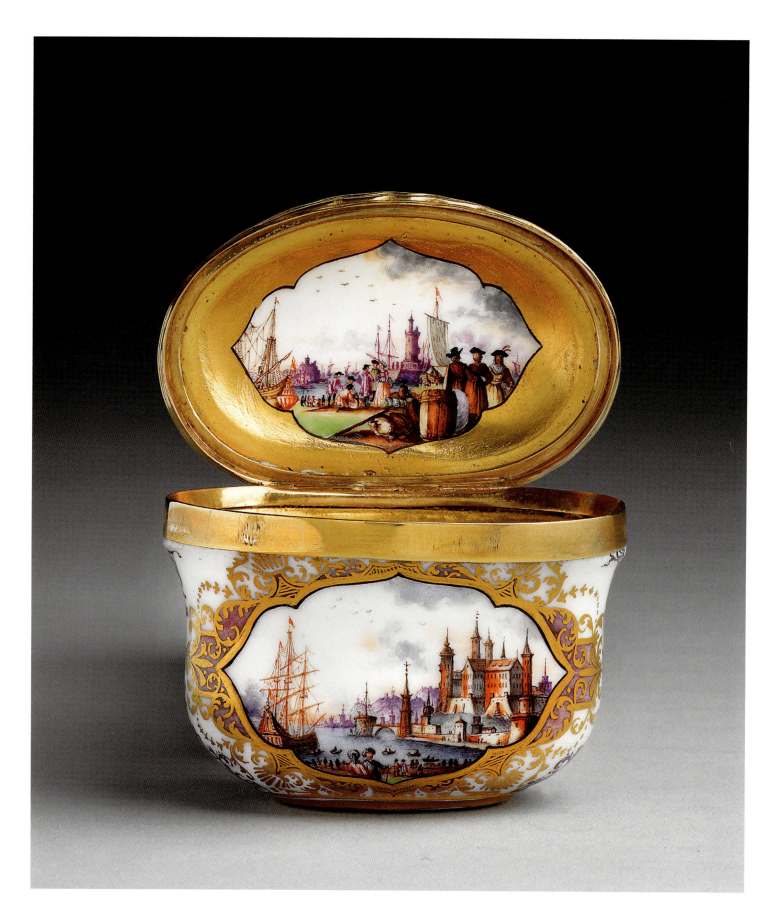

154

Cat. no. 23

SNUFF BOX

Painted by Johann George Heintze (born c. 1706/07),
c. 1730–35
Crossed swords mark in underglaze blue
beneath the gilding
With contemporary gold mounts
Height 5.2 cm, width 7 cm, depth 4.5 cm

Literature:
Jakobsen/Pietsch 1997, p. 101, cat. no. 65

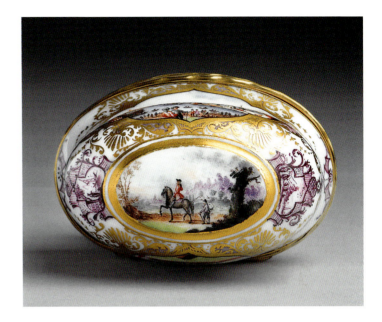

The quatrefoil cartouches with scalloped outlines on the outside of the lid and on the two long sides of this box, which are framed by gold leaf-work over perlmutter lustre, and the quatrefoil cartouche in a reserve in the gold ground on the inside of the lid contain scenes of harbours and merchant shipping painted with great mastery by Johann George Heintze. They show proud sailing ships, heavily laden barges, mighty palaces and defensive castle complexes. Heintze's great artistic talent is evident in his depiction of both landscapes and figures. Generally, the foreground and middle ground are occupied by merchants, the Orientals wearing turbans and the Europeans black hats, who stand beside bales of goods and barrels, while the viewer's gaze is guided across a bay lined by high mountains.

Heintze used a number of artistic devices to create the exceptional depth in his miniature paintings, for instance by cutting off the figures in the foreground with the edge of the painting and making the other figures increasingly smaller the closer they are to the distant seashore, so that those furthest away seem to consist just of delicate dots of colour. Furthermore, he bathed the entire landscape, all the buildings and ships in greyish-violet light and above the scene painted flocks of birds high in the cloudy vault of the sky, through which the last rays of the setting sun appear to shimmer. The subject of the porcelain painting on the bottom of the box is quite different, but here, too, the design principles and compositional scheme described above were followed. We see an idealised mountainous landscape with a wanderer in

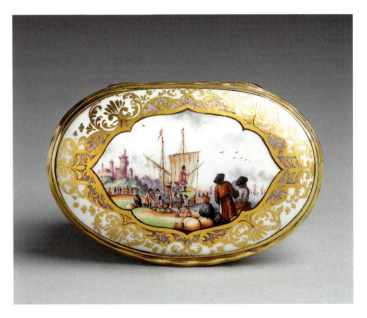

the foreground and a horseman in courtly dress riding past him on a black steed. The miniatures painted *en camaïeu* purple and integrated in leaf-work frames on the left and right of the oval painting on the bottom of the box contain two further mercantile scenes and contribute to the extremely rich and costly effect made by this snuff box. UP

Cat. no. 24

SNUFF BOX

Probably painted by Johann Gregorius Höroldt (1696–1775), c. 1728
With contemporary silver gilt mounts
Height 4.7 cm, width 6.6 cm, depth 4.6 cm

Form as cat. no. 7. The painting, most likely carried out by Johann Gregorius Höroldt, consists of a total of five quatrefoil cartouches with polychrome harbour scenes on the sides and on the lid, which are framed by *Laub- und Bandelwerk* in gold, iron-red, and purple and by areas of lustre. The painting on the inside of the lid lacks a surround of this kind. The scenes transport the viewer to the distant world of East Asia where various Europeans wearing typical tricorne hats, alone, in pairs, or in larger groups, enjoy an unconstrained existence in a fairy-tale, exotic idealised landscape. They generally stand with their back to the viewer on a green spit of land dotted with palm trees that projects into a bay lined by craggy mountains; they carry a fan, a flag, or a fishing rod and gaze pensively at the coastline in front of them. Depictions of this kind with the appropriate framing are based on a design and compositional scheme developed by Höroldt, which other painters in his workshop, such as Heintze or Herold, regarded as a binding model and which they used in a similar manner. The chinoiserie scene on the bottom of the box painted *en camaïeu* purple employs the same figural composition as another snuff box painted by Höroldt, now in private ownership (cat. no. 5). UP

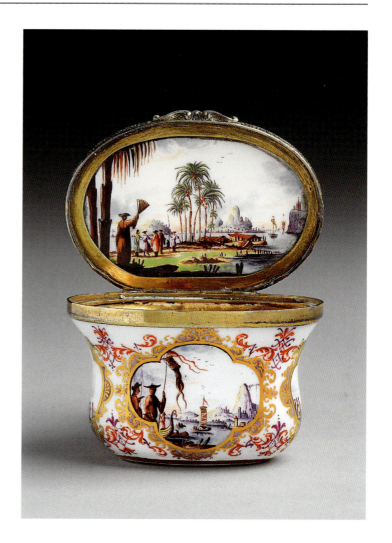

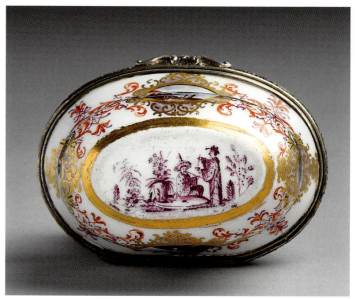

Cat. no. 25

SNUFF BOX

Most probably painted by
Christian Friedrich Herold (1700–1779),
c. 1735
On the bales of goods on the right-hand,
narrow side possibly a cryptic painter's mark "H,"
standing for Christian Friedrich Herold
With contemporary silver gilt mounts
Height 4.6 cm, width 6.5 cm, depth 4.5 cm

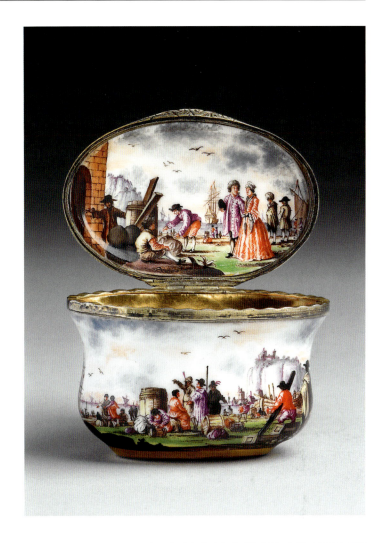

This oval box with slightly bellied sides and a slightly domed lid is particularly remarkable for its continuous décor consisting of merchant shipping and harbour scenes, probably designed by Christian Friedrich Herold. European and Oriental merchants bargain over their wares, bales are tied up, and packages loaded on ships. The impression conveyed is one of busy activity that is greatly heightened by the apparent boundlessness of the painting *en miniature;* at the top the simple silver gilt mount forms the only border to the image, at the bottom the snuff box is terminated by the gold frame of the horizontal oval, monochrome iron-red cartouche on the base of the box.

The depiction of the landscape with rocky cliffs in the background is particularly interesting as it suggests possible sources for Herold's inspiration. As in the case of early chinoiseries from Höroldt's painting workshop, here the painter may have drawn from illustrated travel reports, such as those written by Athanasius Kircher (1602–1680) or Arnoldus Montanus (1625–1683). These writings depict various facets of the picturesque and—particularly for European observers from the courtly world of the eighteenth century—exotic landscapes of Japan and China. These are characterized in particular by cliffs that drop steeply to the sea and rocks covered in vegetation that rise directly out of the water. However, the architecture of the palaces and castles that crown the cliff tops on this snuff box is distinctly European, which in turn points to Dutch and French prints from the seventeenth and early eighteenth century, the heyday of the Dutch East India Company. Combining different motifs or varying them was standard practice and makes each piece of porcelain decorated with merchant shipping scenes unique. SKA

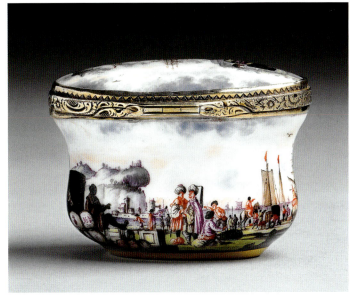

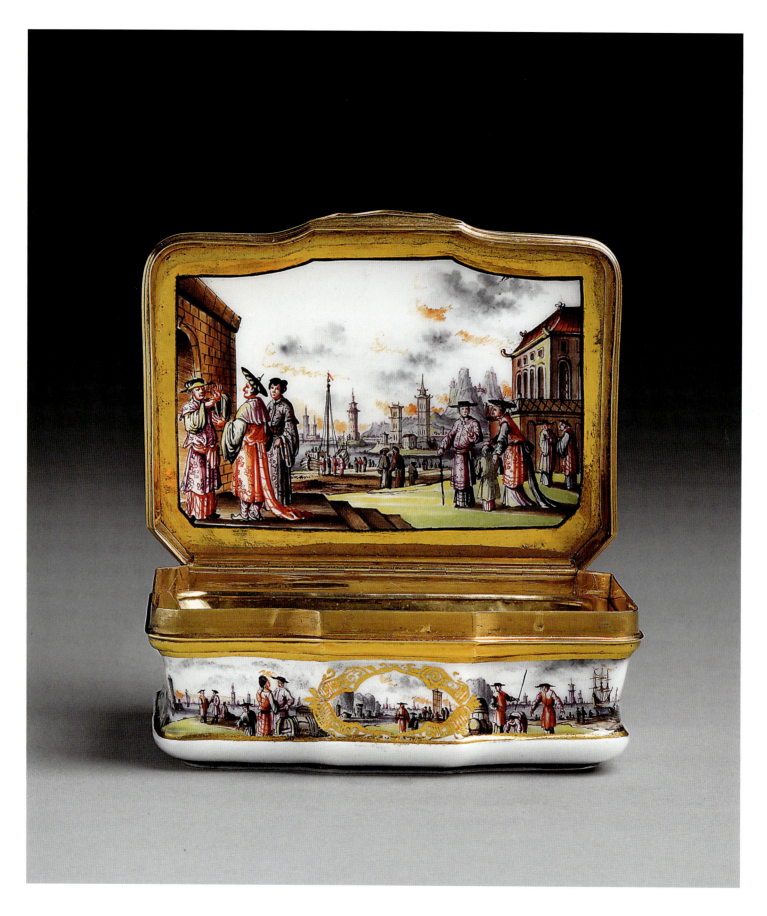

Cat. no. 26

SNUFF BOX

Probably painted by Christian Friedrich Herold (1700–1779), c. 1728–30
With contemporary gold mounts
Height 3 cm, width 7.6 cm, depth 5.7 cm

Provenance:

Duke of Cambridge; Hamburg, Collection Ernesto and Emily Blohm

Literature:

Jedding 1982, p. 182, cat. no. 189;
exh. cat. Cologne 2010, p. 221, cat. no. 96

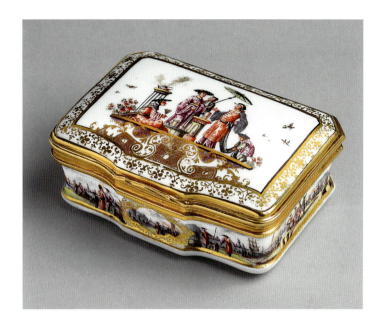

Form as cat. no. 11. The décor of this snuff box is a combination of figural chinoiserie and merchant shipping scenes, both areas in which painter Christian Friedrich Herold displayed the same high level of artistic mastery. The decoration of the lid in particular is pure chinoiserie with the figures placed on a console made of gold leaf- and network over areas of purple lustre. The centre of the skilful triangular composition is formed by three Chinese men, one holding a parasol, who are grouped around a table. They are flanked on the left by a seated woman wearing a hat and veil and holding a fan and on the right by a boy bending to raise the sash of the man standing in front of him. All the other scenes, such as those in the lid and on the bottom of the box, as well as the continuous décor on the sides, combine both subjects. We see Asians and Europeans standing together in groups, some gesticulating, others deep in conversation, against the backdrop of exotic maritime bays in which ships lie at anchor or in a roadstead. New variations on scenes of this kind were constantly produced and relate to the close commercial contacts between Dutch merchants and East Asian countries from which spices, teas, silks, jade, and porcelain were shipped to Europe. UP

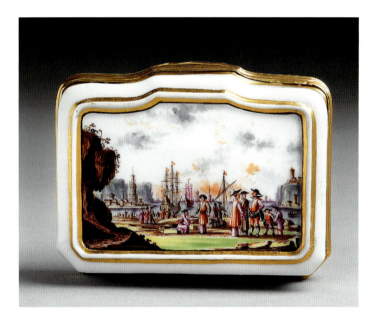

Cat. no. 27

SNUFF BOX

Painted by Christian Friedrich Herold (1700–1779),
c. 1730
With contemporary silver gilt mounts
Signed on the inside of the lid, bottom right: "CFH"
Height 2.9 cm, width 7.5 cm, depth 5.7 cm

Literature:
Seitler 1959, pp. 20–26, figs. 7 and 8

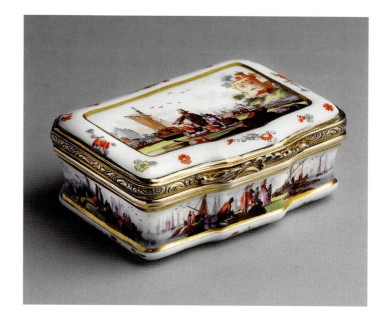

Only two examples of Christian Friedrich Herold's signature are to be found on Meissen snuff boxes, one on the present box, the second on a box now in the porcelain collection of the Staatliche Kunstsammlungen Dresden (see. fig. VI.5). These marks not only allow the works to be definitively attributed but also enable us to characterise the style of Herold's décors, which, incidentally, we also know from signed Berlin enamel snuff boxes. This rectangular Meissen box has both rounded and chamfered corners and a projecting central section. The inside of the lid is decorated with a superbly painted trading scene: a group of Oriental and European merchants stand together on a spit of land in a harbour, their expressive gestures convey the bargaining and negotiating involved in conducting business. In the foreground a worker is engaged in lifting a large bale of goods that lies on the ground beside a number of barrels and tubs. On the ends of three of these containers we can make out the painter's three initials. To the right he frames the painting with a part of a plant-covered warehouse out of which a goods hoist projects. Near a round tower that occupies the middle ground a number of barges and boats are anchoring or being loaded or unloaded. On the milky-grey horizon we see sailing ships in a bay edged by mountains; the cloudy vault of the heavens is dotted with flocks of birds. All the other surfaces of this snuff box are painted with scenes composed in much the same manner using similar groups of figures that are framed by gold lines and flowers in the Japanese Kakiemon style. Many of the persons depicted are seen from behind, they wear tall black hats or large turbans, and their iron-red and purple

coloured garments hang in long parallel folds. Apart from the base formed by green, yellow, and brown areas of ground, the depictions as a whole, despite occasional modulations of colour, are essentially graphical in style as is evidenced, for example, by the lines and dots used to make the eyes, mouths, and noses of the figures.

UP

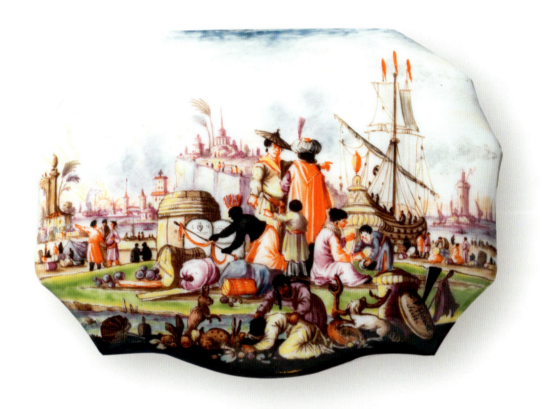

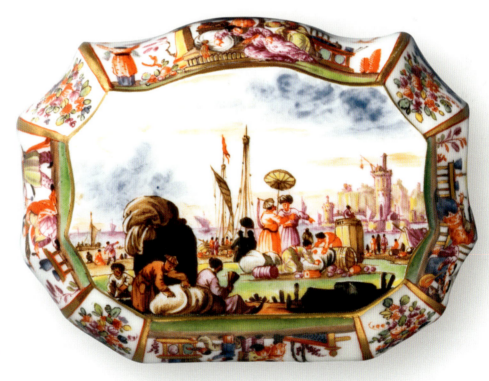

VI.5
Snuff box, signed "C.F. Herold fecit,"
Meissen c. 1730, Dresden, Staatliche
Kunstsammlungen Dresden, Porcelain
Collection, inv. no. PE 1536

Cat. no. 28

SNUFF BOX

Model by Johann Joachim Kaendler (1706–1775), 1735
Painted by Johann George Heintze (born c. 1706/07),
c. 1735
With contemporary gold mounts
Height 3.6 cm, width 8.1 cm, depth 6 cm

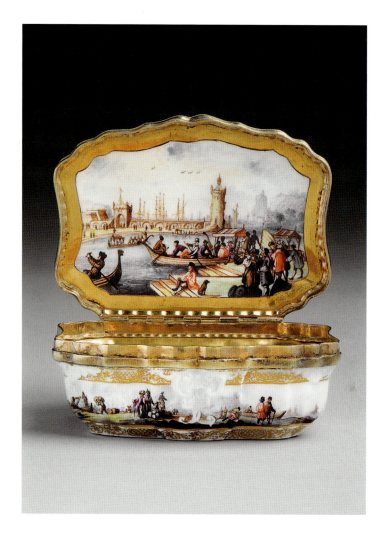

This snuff box in the shape of a cartouche has a richly scalloped outline and a straight edge at the back. A sculptural shell ornament is used on the edge of the container and the lid. The box was painted on all sides with fine harbour scenes by Johann George Heintze. Apart from the inside of the lid all of these are surrounded by a gold border made up of mesh and leaf-work. The décor is continued around the container and each of the sides shows a spit of land projecting into a body of water on which Oriental merchants wearing turbans and Europeans with hats stand beside bales of goods and barrels and negotiate with each other, while port workers deal with the goods and transport them with cranes. The painter paid particular attention to the scenes in the larger areas on both sides of the lid and on the bottom of the box, for which existing etchings served as a source of inspiration. For the inside of the lid he used a print by Melchior Küsel (1626–1683) entitled *Mohle zu Neapoli sambt der Cinosura und dem Castel novo* from the series *Iconographia* by Johann Wilhelm Baur (1607–1640), fourth part, Augsburg 1682 (see fig. VI.6), while for the scene on the bottom of the box he made use of an etching by Anthony van Zijlvelt (1637–1695) entitled *Haven met ruine van een tooren* after a drawing by Johannes Lingelbach (1622–1674; see fig. VI.7). From the Küsel print Heintze simply took certain elements and composed them to form an independent picture. On the inside of the lid we see a stone-built pier with a tall lighthouse at the end, while various boats are crossing the water. Two of these, which have a kind of protective sun canopy, were borrowed from the print. In contrast all the figures in the foreground are a product of the painter's own imagination. Heintze took a different approach to the print by Zijlvelt; he omitted only the group of figures on the left of the picture and repeated the remainder of the composition with the men gathered around a camp fire in the foreground, the barge occupied by figures in the middle ground, and the entire back-

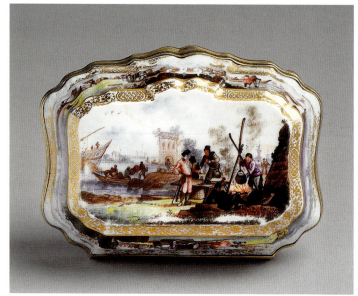

VI.6
Melchior Küsel (1626–1683), *Mohle zu Neapoli sambt der Cinosura und dem Castell novo*, etching from the series *Iconographia* by Johann Wilhelm Baur (1607–1640), part four, Augsburg c. 1682, Brunswick, Herzog Anton Ulrich-Museum

VI.7
Anthony van Zijlvelt (1637–1695), *Haven met ruine vann een toren*, from the series *Havens van Genua* after a drawing by Johannes Lingelbach (1622–1674), Amsterdam, Rijksmuseum, Kupferstich-kabinett

ground with the prow of a ship projecting into the picture area from the left and the central tower with trees beside it. He even used the dark silhouette of a round tower that is cut off by the right-hand edge of the print in the same manner to frame his image.

It has not yet proved possible to find the original of the harbour scene on the outside of the lid, in which the painter shows a large sailing ship at anchor with mounted horsemen and camels used as beasts of burden nearby, while a European gentleman doffs his hat and bows to an apparently Turkish merchant who is standing in a barge.

Depictions of this kind address the theme of trade in luxury goods from East Asia and the Mediterranean area, as Meissen snuff boxes were bought not only by aristocratic ladies and gentlemen but also by wealthy merchants from the major European commercial towns. UP

Cat. no. 29

SNUFF BOX

Painted by Johann George Heintze (born c. 1706/07),
c. 1730
With contemporary gold mounts
Height 3.7 cm, width 7.4 cm, depth 5.6 cm

Provenance:
Mrs. Charles E. Dunlap/British Rail Pension Fund

Johann George Heintze painted harbour scenes on all the sides of this quatrefoil-shaped box with a straight edge at the back. For the depictions on the outside and inside of the lid the painter used two etchings by Anthony van Zijlvelt (1637–1695), which, apart from eliminating a number of the figures, he transferred directly to the décor of the porcelain piece (see figs. VI.8 and VI.9).

The scene on the outside of the lid shows the loading of a merchant ship that lies at anchor in the background. A sail has been spread out to dry on its stern, while in the foreground, beside an obelisk and a Triton fountain, a man is filling a barrel with drinking water and others are carrying barrels to the ship. In the right-hand half of the picture a merchant with a dog, who stands with his back to the viewer, observes the activities of the

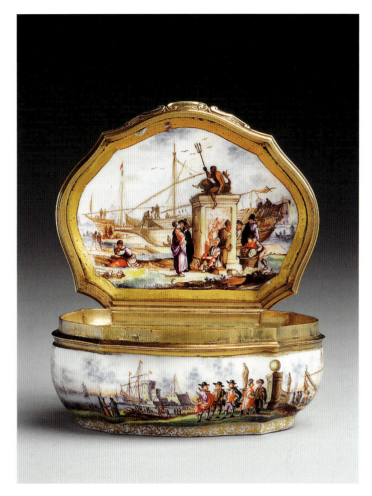

VI.8
Anthony van Zijlvelt (1637–1695), *Haven met verschillende mensen rond een fontein*, etching from the series *Havens van Genua* after a drawing by Johannes Lingelbach (1622–1674), Amsterdam, Rijksmuseum, Kupferstichkabinett

165

VI.9
Anthony van Zijlvelt (1637–1695), *Haven met het standbeeld van Neptunus*, etching from the series *Havens van Genua* after a drawing by Johannes Lingelbach (1622–1674), Amsterdam, Rijksmuseum, Kupferstichkabinett

port workers and the seamen. The scene on the inside of the lid shows similar activities: a number of figures are grouped around a centrally positioned statue of the sea god Neptune with his trident, while further behind two ships lie in the harbour.

On the bottom of the box, which is painted *en camaïeu* purple, Heintze shows a harbour set against the backdrop of a mighty fortress in a large city. A three-masted ship with unfurled sails lies at anchor, the quays are populated by a number of people, and on the left in the foreground three men discuss their business. On the front and the two short sides of the box there are further polychrome harbour scenes that employ the usual repertoire of marine bays, ships, and figures. The scene with three European merchants wearing black hats and two Orientals with white turbans, who stand beside each other on a green strip of a lawn near a plinth on which a sphere rests, is worthy of particular attention. The scene on the back of the box is flanked by two miniature landscapes painted *en camaïeu* purple and framed by gold leaf-work. It shows a horseman against a backdrop formed by a marine bay, a town, and a harbour. Heintze repeated all the views on this box, including the one on the bottom, in an almost identical manner on a snuff box of a similar shape now in private ownership (cf. cat. no. 30). UP

Cat. no. 30

SNUFF BOX

Painted by Johann George Heintze (born c. 1706/07),
c. 1730
With contemporary gold mounts
Height 3.5 cm, width 7.9 cm, depth 5.7 cm

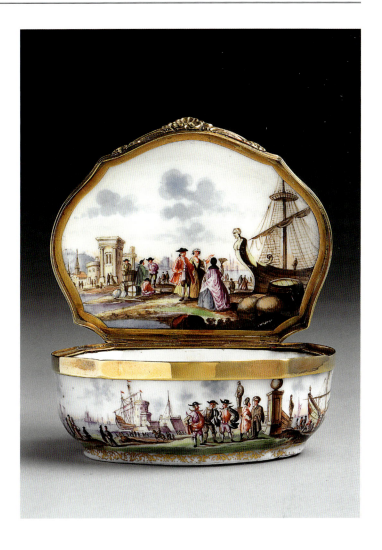

The form of the snuff box is the same as cat. no. 12. The harbour scenes and mercantile activities depicted on both sides of the lid were probably painted by Heintze using as his models prints no longer known today. Each scene is set on a spit of land in the foreground on which a group of elegant people stands beside a plinth that carries a stone statue or near a figurehead of a ship and where wharves with further ships and buildings are staggered in depth as they recede towards the purplish grey horizon.

The scenes on the sides and the bottom of the box are identical with those on another example in private ownership (cat. no. 29), allowing us to conclude that, for economic reasons, the painter occasionally painted several snuff boxes at the same time. The same approach can also be identified in a number of lids that bear completely identical depictions (cf., for example, cat. nos. 49 and 50). UP

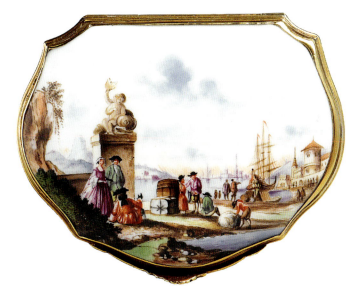

Cat. no. 31

SNUFF BOX

Painted c. 1735
With contemporary bronze gilt mounts
Height 3.6 cm, width 6.9 cm, depth 5.3 cm

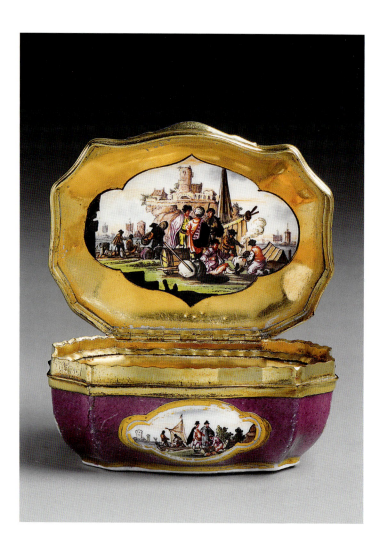

The form of the snuff box is the same as cat. no. 9. The outside of this elegantly curved and scalloped snuff box was decorated with a purple ground, whereas the inside was completely covered with gold. On the sides, the bottom, and on both sides of the lid areas of the purple ground or gilding were omitted to insert quatrefoil cartouches. A single gold band surrounds the cartouches on the lid and bottom, whereas a double band encloses the round cartouches on the sides. The paintings have considerable perspective depth and show commercial activities or scenes from harbour life: workers stow bales of goods, various figures, apparently Europeans and Orientals, engage in commercial transactions against harbour buildings or ruins that occupy the centre of the scene or terminate the middle ground at the sides and guide the viewer's gaze to a horizon seen at eventide that is enlivened with sailing ships.

There are numerous prints of both Dutch and French origin that depict harbours and coastal landscapes of this kind. These prints were available in the painting workshops of the Meissen manufactory, and, much like with the numerous chinoiserie scenes made after Höroldt's work, elements from them were varied and combined as wished and used in decorating pieces of porcelain. SKA

Cat. no. 32

SNUFF BOX

Most probably painted by
Christian Friedrich Herold (1700–1779),
c. 1735–40
With contemporary gold mounts
Height 4.1 cm, diameter 7.5 cm

The scenes of merchant shipping on this round snuff box with cylindrical sides and a slightly domed lid were probably painted by Christian Friedrich Herold. Apart from the inside of the lid most of the depictions show idealised landscapes in which generally a wide range of figures, including merchants, port workers, ship captains, and horsemen, is placed. Here and there an Oriental wearing a turban can be identified, while the rest of the men wear black hats, red or brown jackets, and yellow or purple coloured knee breeches. They are engaged in registering or transporting bales of goods and barrels while ships and barges move across a bay lined by mountains, lighthouses, and castles, or lie at anchor. To achieve the maximum spatial depth the painter brought the individual figures or couples into the immediate foreground and spread the landscape out behind them. A tower, a tent, and a number of barrels that are cut off by the edge of the picture form dark sides to the painting that contrast strongly with the light-coloured background that is slightly tinged with grey.

For the inside of the lid Herold chose a veduta of the city of Meissen with the River Elbe and above it the Albrechtsburg, at that time the seat of the royal porcelain manufactory. A partly covered stone bridge that spans the river leads from the right bank of the Elbe to the city and the Burgberg. On the near bank workers are engaged in handling goods and on the far side of the river, closer to the city, a ferry has just moored. UP

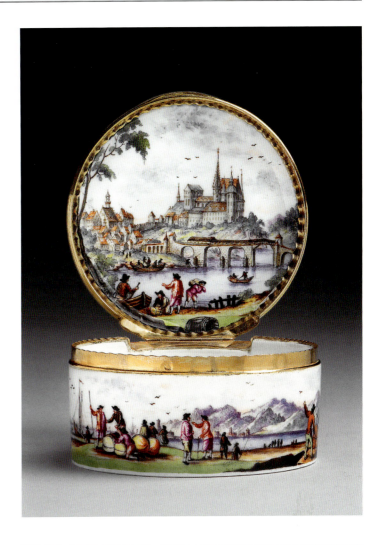

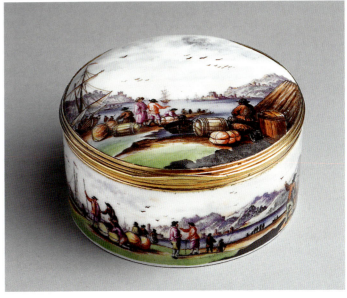

Cat. no. 33

SNUFF BOX

Manufacture c. 1735
Painted by Philipp Ernst Schindler Senior (1694–1765)
and Johann George Heintze (born c. 1706/07), c. 1735–40
Cryptic painter's mark at bottom right
on the inside of the lid: "△"
With contemporary gold mounts
Height 3.9 cm, width 7.4 cm, depth 5.8 cm

Literature:
Bursche 1998

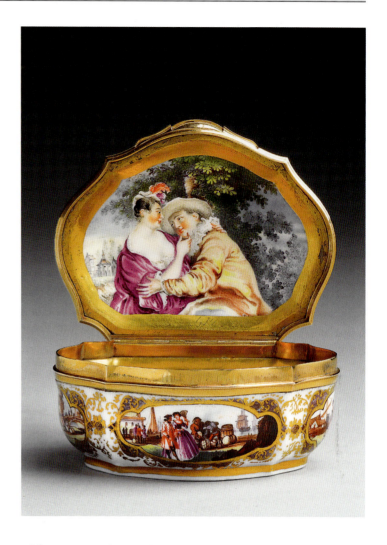

This box with bellied sides is in the shape of a cartouche with a straight edge at the back and is closed by a slightly domed lid with gold mounts. The gold leaf-work border that runs around the edge of the lid is interrupted at regular intervals by miniature oval pictures showing harbour scenes painted *en camaïeu* purple. At the centre of the lid a quatrefoil cartouche, surrounded by a pattern of gold mesh with cruciform flowers, contains a polychrome genre scene whose composition is closely based on a reproduction print made by Gérard Jean-Baptiste Scotin (1698–1755) after the painting *La Serenade Italienne* by Jean-Antoine Watteau (1684–1721): three comedians wearing white ruffs, two singing and the third playing the guitar, serenade a lady who is seated against a park-like background (see fig. VI.11). On each of the four sides of the box the painter presents a quatrefoil cartouche framed by gold leaf-work over a lustre ground. These cartouches contain further harbour scenes. We see elegant couples and a number of merchants and port workers standing near a bay with barrels and bales of goods beside them, while in the background large commercial ships in full sail arrive in and depart from the harbour. On the base of the box there is yet a further scene of this kind painted *en camaïeu* purple using a strongly graphical style. In the foreground on the left a port worker, seen from behind, rests one arm on a large barrel; with the hand of his extended right arm he points towards a group of figures in the middle ground. Behind a lady and two gentlemen a number of Orientals and Europeans are busy with various containers, while camels stand ready to transport the goods. The painter depicted the landscapes in the background of the scenes with great attention to detail and achieved a wonderful effect of depth through the reflections in the surface of the water and the use of colours with a greyish tinge. The tall, slender figures with small heads suggest that Johann George Heintze painted the entire outside of this snuff box.

The courtly depiction on the inside of the lid is by a different hand. It bears a cryptic painter's mark, a tiny empty triangle that was allocated to Philipp Ernst Schindler Senior. He used delicate dots of colour to depict an elegant couple dressed as harlequins. Both are shown half-length and turn towards each other with gestures of great affection. The lady, wearing a purple gown with a very low neckline, encircles the man's neck with her left arm and fondles his chin with her right hand, while he gently brushes her arm. Her small cap set at a rakish angle and adorned with a feather identify her as an *innamorata*, while the wide-

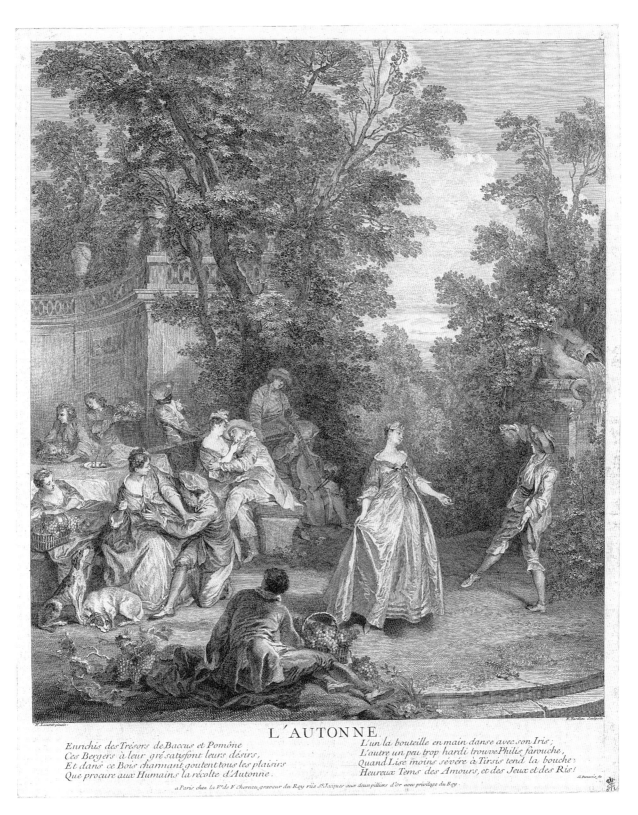

VI.10
Nicolas-Henri Tardieu (1674–1749), etching after the painting
L'Autonne by Nicolas Lancret (1690–1745), Dresden,
Staatliche Kunstsammlungen Dresden, Kupferstichkabinett

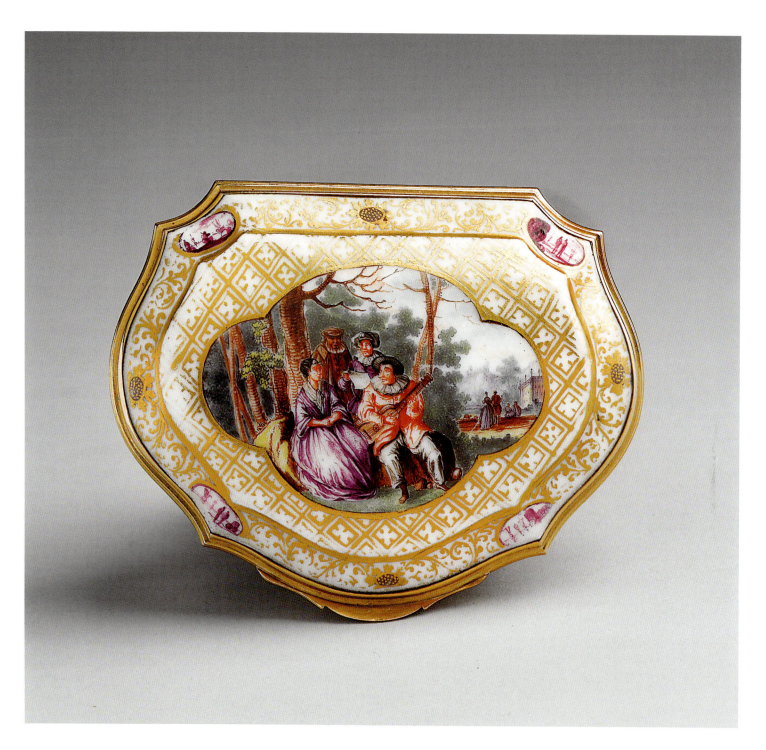

brimmed hat and white neck ruff over a yellow jacket worn by her partner is the typical garb of Harlequin or Giles from the *commedia dell'arte*. The scene is set in front of a deciduous tree that spreads its leafy branches behind the couple and on the left reveals a view of a Chinese pavilion in the background. Schindler used as his model an etching by Nicolas-Henri Tardieu (1674–1749) made after the painting *L'Automne* by Nicolas Lancret (1690–1745; see fig. VI.10). The couple, who are positioned in the middle ground of the print, were detached from their context and given a different background.

UP

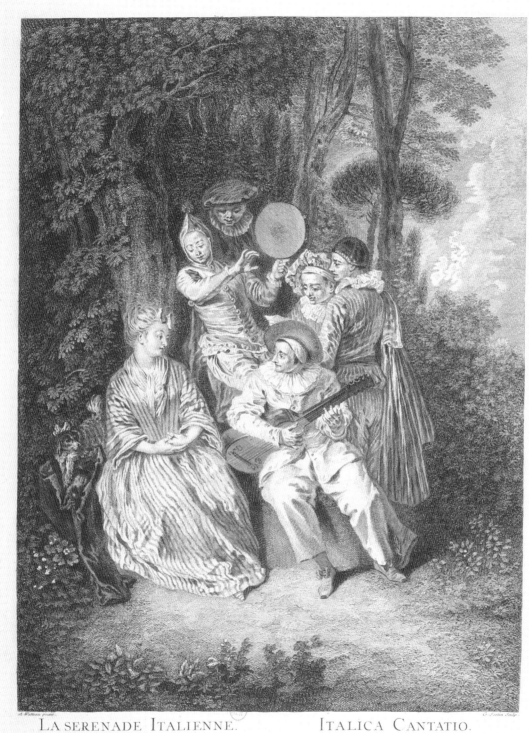

VI.11
Gérard Jean-Baptiste Scotin (1698–1755), etching after the painting *La Serenade Italienne* by Jean-Antoine Watteau (1684–1721), Paris, Bibliothèque nationale de France

Cat. no. 34

SNUFF BOX

Model by Johann Joachim Kaendler (1700–1775), 1735
Painted by Johann George Heintze (born c. 1706/07)
and Christian Friedrich Herold (1700–1779), c. 1735
With contemporary bronze gilt mounts
Height 6.4 cm, width 13.1 cm, depth 9.3 cm

The scalloped rectangular form of this snuff box with chamfered corners, a projecting central section at the front, and a straight edge at the back has a leaf-work ornament at the corners, the centre of the long sides and on the lid. Magnificent frames of gold bands and gold lace borders along with wide areas of diaper pattern and leaf-work separate the individual scenes on the outside of the box. The stylistic differences suggest that the painting on the lid, the bottom, and the back of the box can be attributed to Heintze, while the unframed depiction on the inside of the lid, the two scenes on the front, and those on the short ends of the box are probably by Christian Friedrich Herold. It was not unusual to divide up the work between two painters in this way, but this was generally organised so that the inside of the lid was painted by one artist and the entire outside of the box by the other. This allows us to suspect that Herold had to interrupt his painting of this snuff box for some unknown reason and Heintze completed the work. Both were excellent "landscape and shipping painters" who on this piece produced some of their best work. Herold's merchant shipping scene on the inside of the lid is framed on the left and right by dark cliffs cut off by the picture edge. A variety of activities take place on the peninsula in the foreground: on the left a Moor wearing a turban and mounted on a horse addresses an Oriental, also wearing a turban, whose back is turned to the viewer. The two stumps of classical columns lying on the ground at the very front of the picture locate this landscape in the Levant. Four other persons stand together at the centre of the scene, while on the right a number of harbour workers are handling barrels and bales that are to be transported by a rider and a loaded camel to a ship docked at the jetty behind. Towers and city fortifications line the shores of the bay that opens up in the grey-violet background. Only a little sunlight penetrates the dark, cloud-scattered sky above. The subjects of the other pictures attributed to Herold are similar; all are

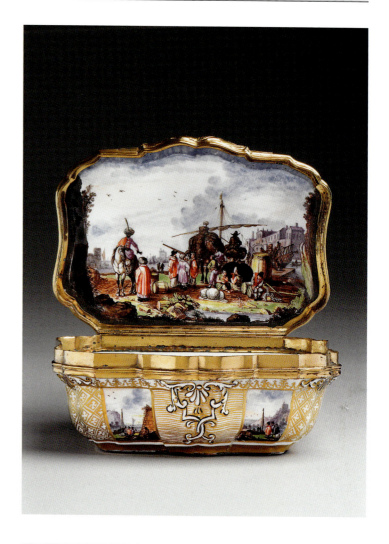

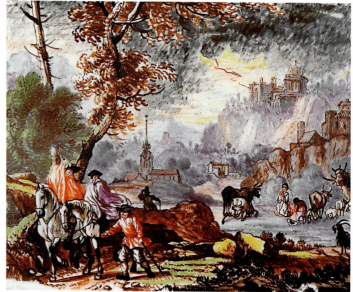

painted in the same style, characterised by the free but certain brushstrokes, clear outlines, and the dominance of shades of brown.

The fluid, painterly style of the works by Heintze makes them clearly different and they also depict unusual situations: mountainous landscapes with figures in winter, during a storm, and with a rainbow. The winter landscape shows a ship locked in a frozen-over river beside which some ice skaters enjoy their sport. The storm landscape has a pair of horsemen in the foreground who have sought shelter under the trees, while the cowherds remain in the steamy vapours given off by their animals and lightning flashes from the threateningly dark sky above. On the lid we see a further group of horsemen in a valley, above which a rainbow describes an arch. UP

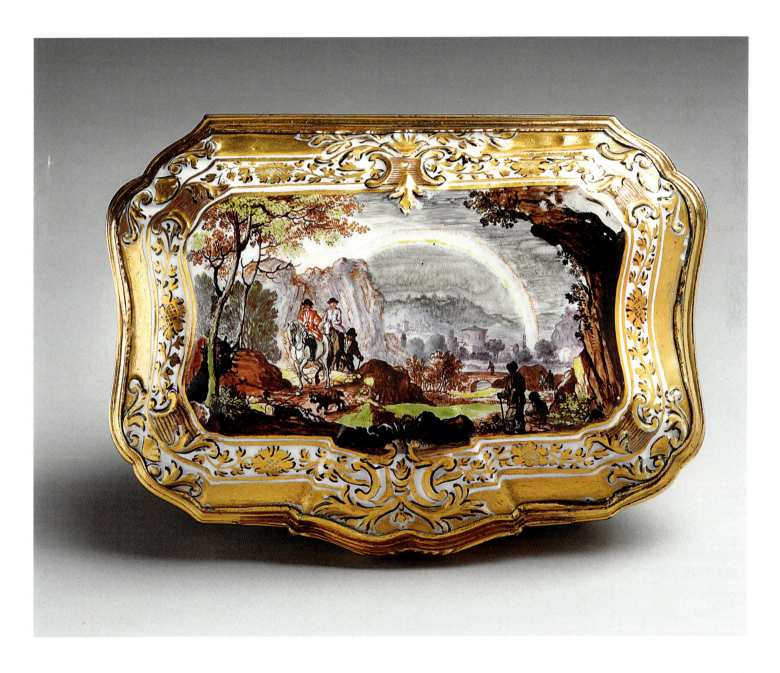

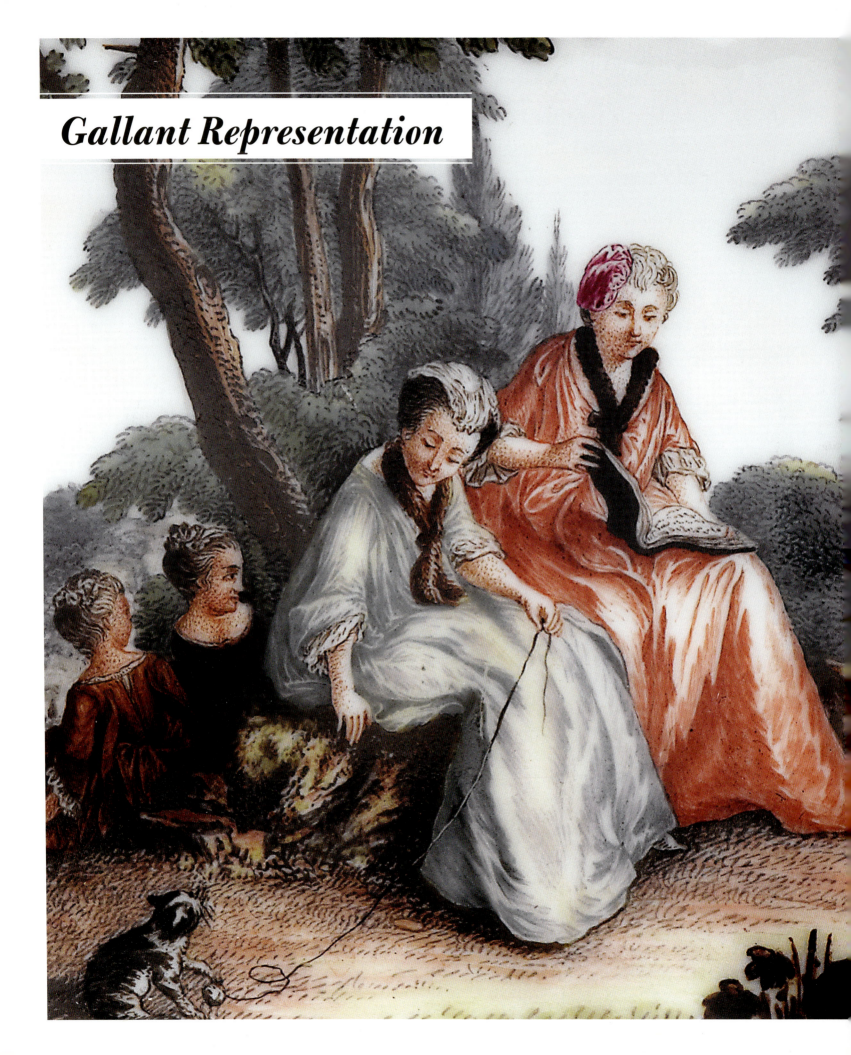

Gallant Representation

Cat. no. 35

SNUFF BOX

Painted c. 1745
With contemporary gold mounts
Height 4.1 cm, width 5.1 cm, depth 5 cm

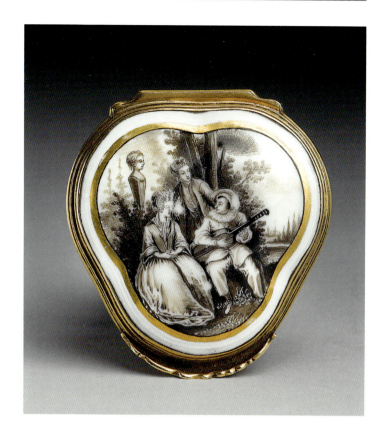

This snuff box in the shape of a trefoil with splayed sides is closed by a moulded lid with gold mounts. All the surfaces are decorated with what is known as "Watteau painting" in sepia brown and black. Each of the three images on the sides is bordered by a gold band, lined internally in black, and by gold leaf-work. The linear style of the depictions reflects the engravings that were used as models. Showing considerable artistic ability the painter detached the courtly motifs he wished to use from their original context and distributed them among the individual scenes on the box. However, he did not rely solely on reproductions of paintings by Jean-Antoine Watteau (1684–1721) such as *Le Contredanse* (see fig. VI.13), *La Serenade Italienne* (see fig. VI.11), *Les Agréements de l'Été* (see fig. VI.16), and *Le Lorgneur* (see fig. VI.14), but based the main motif on the inside of the lid, a couple with a birdcage, on a print of the painting *Le Printemps* (see fig. VI.12) by Nicolas Lancret (1690–1745). These quotations complete the circle of motifs from the art of Watteau, which, outside France, was still much favoured by society at this time, while also following the fashionable tendencies of the first half of the eighteenth century.

Comparable pieces are a box with the same form and similar décor now in private ownership, formerly on loan to the Rijksmuseum Amsterdam (see Beaucamp-Markowsky 1985, pp. 100f., cat. no. 69), and a further box in private ownership (see cat. no. 36). UP

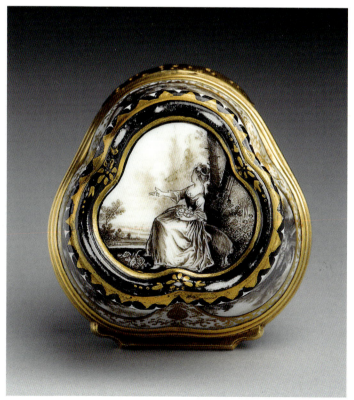

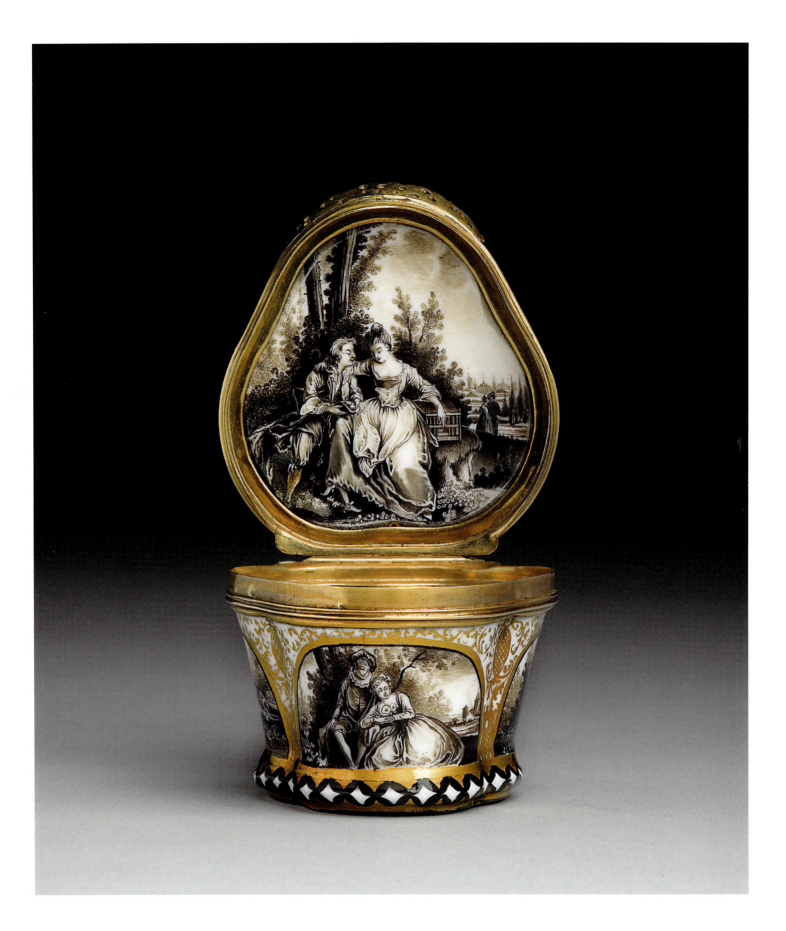

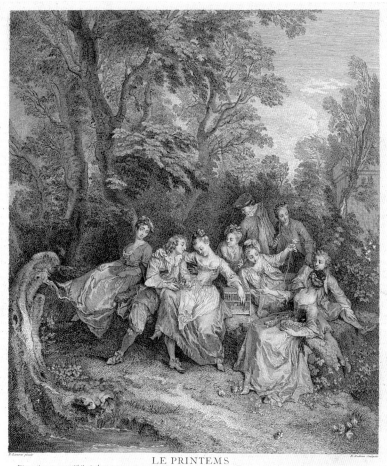

VI.12
Jacques-Philippe Le Bas (1707–1783), etching after the painting *Le Printemps* by Nicolas Lancret (1690–1745), Dresden, Staatliche Kunstsammlungen Dresden, Kupferstichkabinett

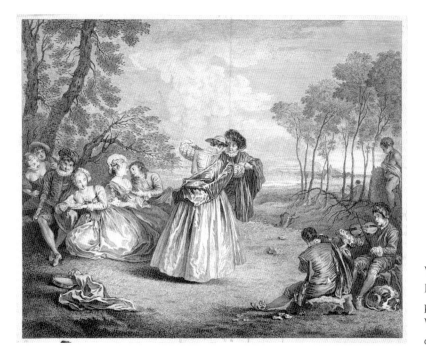

VI.13
Etienne Brion (born 1729), etching after the painting *Le Contredanse* by Jean-Antoine Watteau (1684–1721), Geneva, Musée d'art et d'histoire

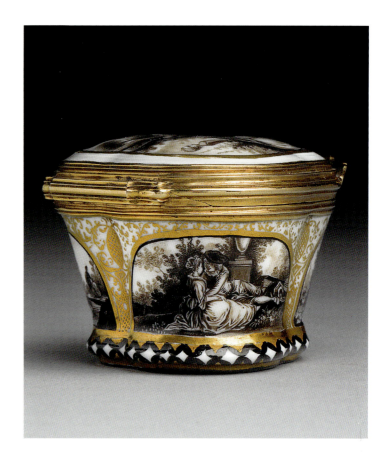

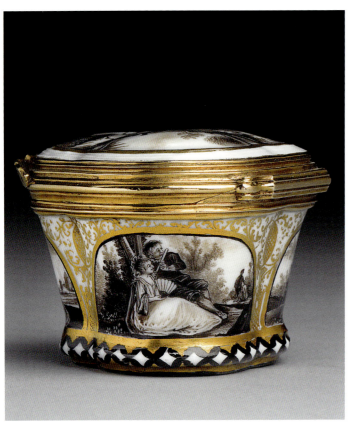

VI.14
Gérard Jean-Baptiste Scotin (1698–1755),
etching after the painting *Le Lorgneur*
by Jean-Antoine Watteau (1684–1721),
Paris, Bibliothèque nationale de France

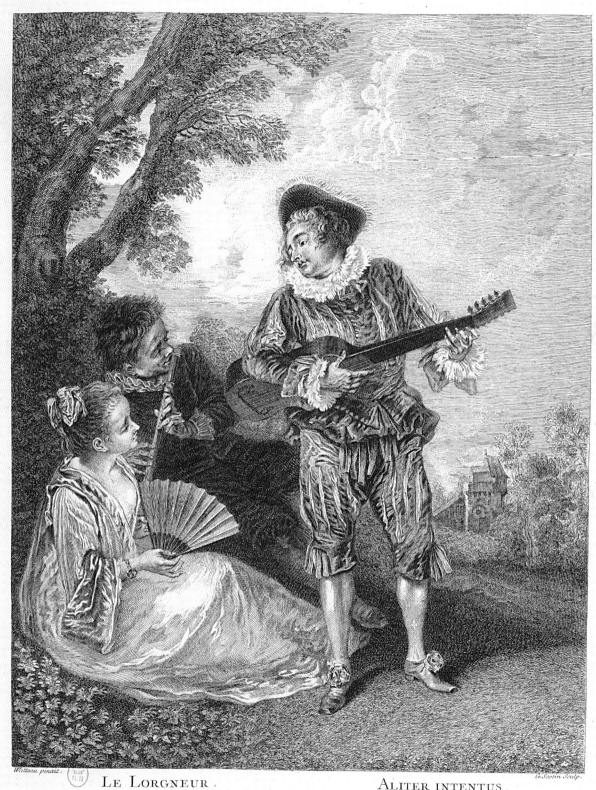

LE LORGNEUR. ALITER INTENTUS.
Gravée d'apres le Tableau original Peint par Scalptus juxtà Exemplar Ejusdem magnitudinis
Watteau, de mesme grandeur. à Wateavo Depictum.

du Cabinet de Mr. de Jullienne.

Avec privilège du Roy. à Paris chez F. Chereau graveur du Roy ruë St Jacques aux deux pilliers d'Or.

Cat. no. 36

SNUFF BOX

Painted c. 1735
With contemporary silver gilt mounts
Height 3.7 cm, width 5.1 cm, depth 5 cm

Form as cat. no. 35. All known boxes with this form (cf. a snuff box in private ownership, cat. no. 35 and a further box, also in private ownership, formerly on loan to the Rijksmuseum Amsterdam, see Beaucamp-Markowsky 1985, pp. 100f., cat. no. 69) are decorated with what are called "Watteau scenes" in sepia brown and black, seemingly by the same painter as they all display a similar style. For the scenes the painter chose elements from prints made by different artists after paintings by Jean-Antoine Watteau (1684–1721). For the inside of the lid he took the left-hand group of figures from a reproduction of the painting entitled *Leçon D'Amour* (see fig. VI.15), but omitted the man instructing the three ladies in the art of love, and adopted a similar approach for the other scenes on the snuff box which he based on prints of the paintings *Fêtes au Dieu Pan* (see fig. VI.17), *Les Agréements de l'Été* (see fig. VI.16), and *Le Printemps* (see fig. VI.12). Using individual motifs as set pieces and detaching them from their context robs them of some of their meaning and in the process emphasises their purely decorative qualities. Yet, they retain the character of flirtatious love scenes along with an erotic *frisson*, aspects that were particularly popular in court society during the *galant* era and led to Meissen snuff boxes painted in this manner being sold in large numbers. UP

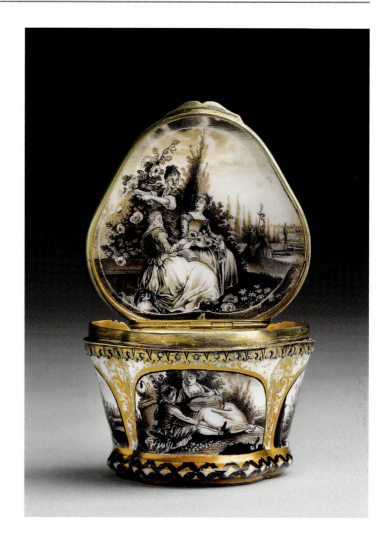

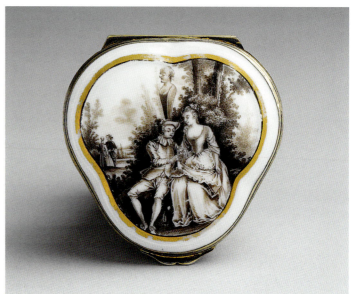

VI.15
Gérard Jean-Baptiste Scotin (1698–1755), etching after the painting *Leçon d'Amour* by Jean-Antoine Watteau (1684–1721), Paris, Bibliothèque nationale de France

VI.16
François Joullain (1697–1778), etching after the painting *Les Agréements de l'Été* by Jean-Antoine Watteau (1684–1721), Dresden, Staatliche Kunstsammlungen Dresden, Kupferstichkabinett

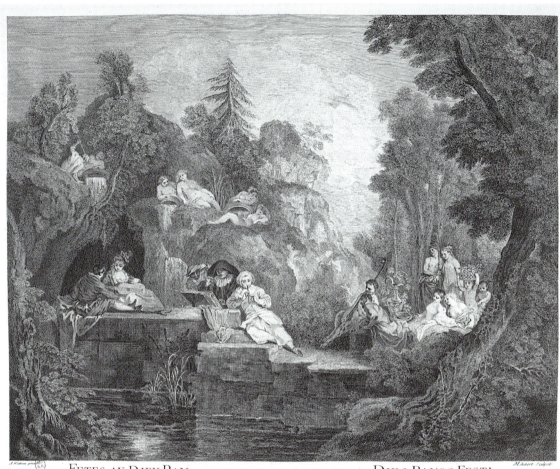

FETES AU DIEU PAN — DIES PANOS FESTI

Gravées d'après le Tableau original Peint par Watteau haut de 2 pieds sur 2 pieds 6 pouces de large. Sculpti juxta Exemplar à Watteano depictum altitudo 2 pedum et latitudo 2 pedes cum 6 continet.

VI.17
Michel Guillaume Aubert (1700–1757), etching after the painting *Fêtes au Dieu Pan* by Jean-Antoine Watteau (1684–1721), Paris, Bibliothèque nationale de France

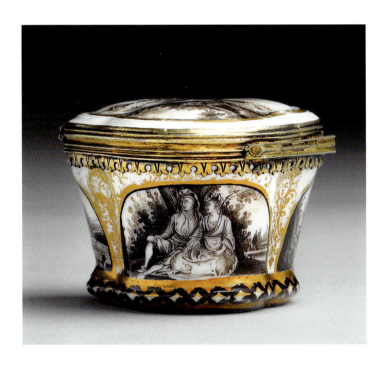
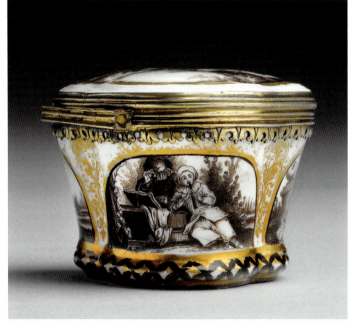

Cat. no. 37

SNUFF BOX

Painted c. 1740
With contemporary copper gilt mounts
Height 5.2 cm, width 6.1 cm, depth 4.2 cm

Literature:
Ducret 1973, pp. 26 and 151, figs. 223 and 224;
Beaucamp-Markowsky 1985, p. 102, cat. no. 70;
exh. cat. Cologne 2010, p. 191, cat. no. 83

This snuff box, which is rectangular in plan with chamfered corners, splays outwards from the base. Somewhat below the rim a continuous moulding runs around the box. Like the edge mouldings of the lid and the rim of the box it is completely gilded, while the entire outside of the box is covered with a black ground. In this the painter incised the outlines for branches bearing blossoms and tendrils in black and gold, while a band of winding golden tendrils runs around the box, directly below the top. The painter lavished particular attention on the scene on the inside of the lid, which is painted in subdued black and sepia and reproduces almost in its entirety a print by Simon Henri Thomassin (1687–1741) made after the painting *L'Amour d'Arlequin* by Jean-Antoine Watteau (1684–1721; see fig. VI.18). Only the herm of Pan and a male figure at the right-hand edge of the reproduction were omitted. The strongly linear quality of the porcelain painting imitates the characteristics of etching, an impression made all the more convincing by the black and brown colouring. UP

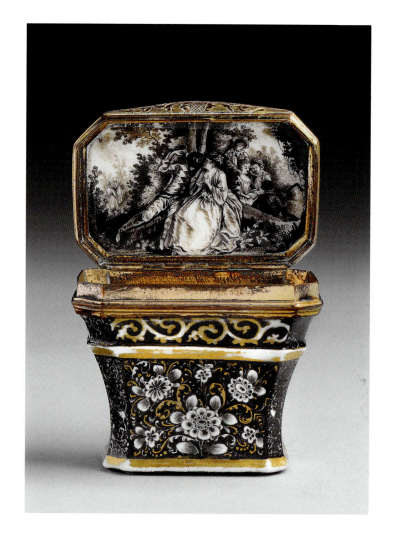

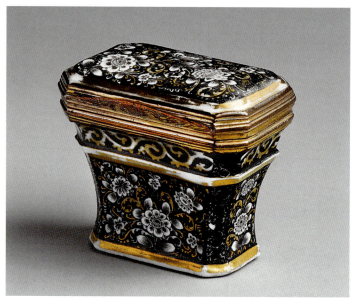

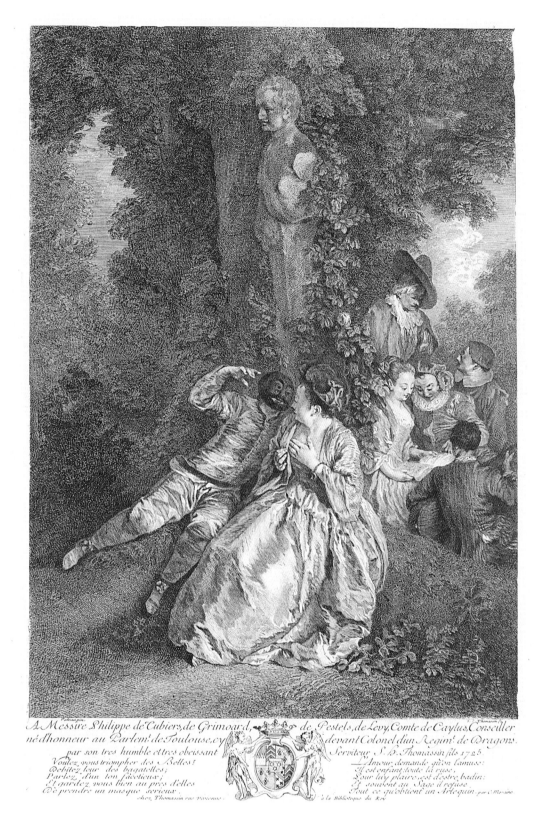

VI.18
Simon Henrí Thomassin (1687–1741), etching after the painting *L'Amour d'Arlequin* by Jean-Antoine Watteau (1684–1721), Geneva, Musée d'art et d'histoire

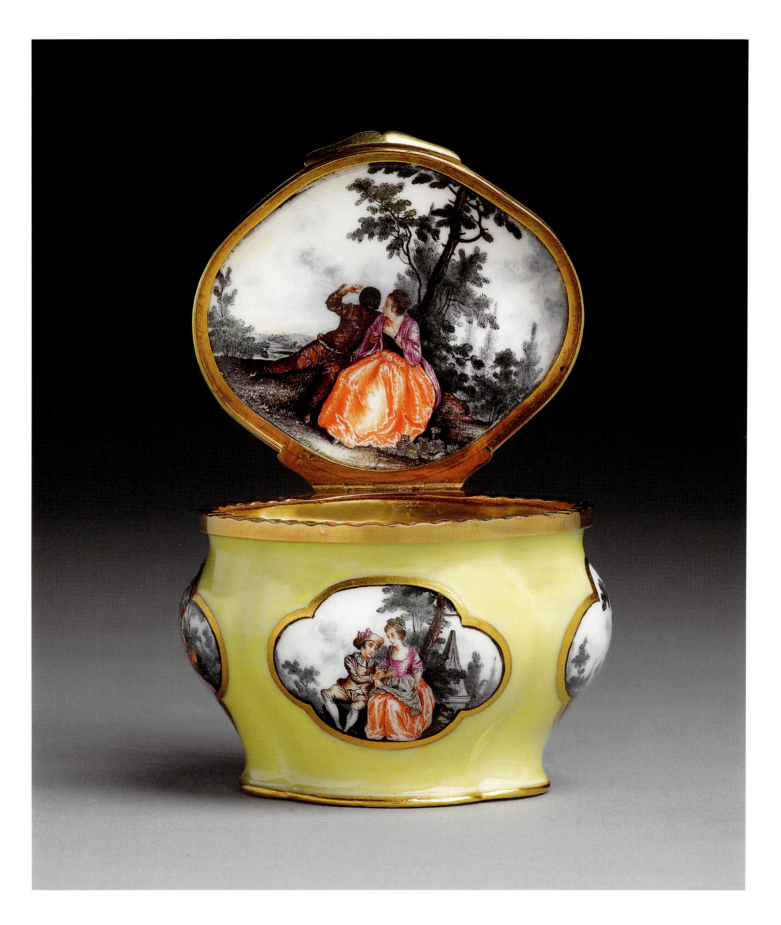

188

Cat. no. 38

SNUFF BOX

Painted c. 1745
With contemporary gold mounts
Height 4.9 cm, width 6.3 cm, depth 5.3 cm

This snuff box with bulbous sides is a quatrefoil in plan. A *galant* scene, based on print reproductions of Watteau paintings, was painted in each of the gold-framed quatrefoil reserves made in the yellow ground on the sides and the outside of the lid, as well as on the bottom of the box and the inside of the lid. The unknown painter borrowed the main motifs of the paintings *L'Amour d'Arlequin* (see fig. VI.18) and *Le Printemps* (see fig. VI.19) in their entirety for the inside of the lid and the front of the box respectively, while for the other miniature depictions he took individual elements such as courtly couples, the figure of a lady with a child, or children on their own from the paintings *L'Accordée de Village* (see fig. VI.20), *Le Berger Empressé* (see fig. VI.22) and *La Diseuse D'Aventure*. The purchaser of the snuff box was probably unaware of this approach, as it was unlikely that he was familiar with the prints that served as models, but whatever the case these *galant* scenes completely met the taste of the Rococo period. Even though at the time these pieces of Meissen porcelain were decorated with motifs borrowed from his paintings Jean-Antoine Watteau (1684–1721) had already been dead for more than twenty years and played hardly any role in French art, decoration in this manner continued to arouse great interest among buyers outside of France until about the middle of the eighteenth century. UP

VI.19
François Boucher (1703–1770), copper engraving after the painting *Le Printemps* by Jean-Antoine Watteau (1684–1721), Paris, Bibliothèque nationale de France

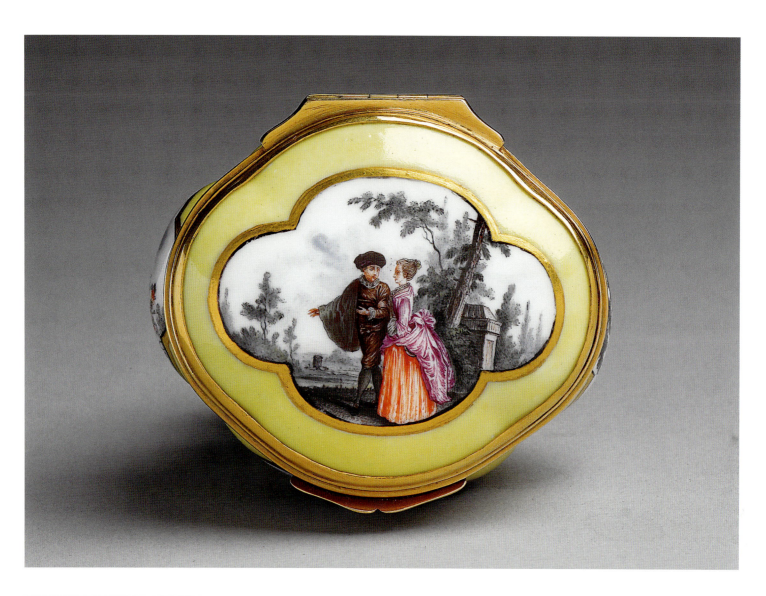
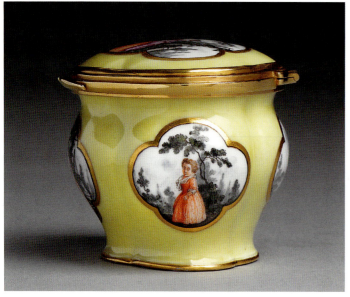
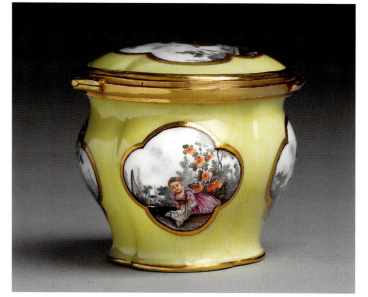

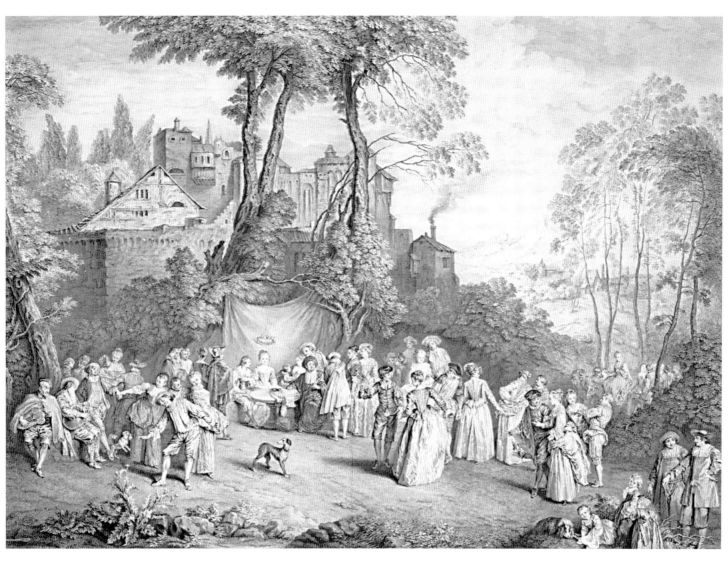

VI.20
Nicolas IV de Larmessin (1684–1755), etching after the painting
L'Accordée de Village by Jean-Antoine Watteau (1684–1721),
Dresden, Staatliche Kunstsammlungen Dresden, Kupferstichkabinett

192

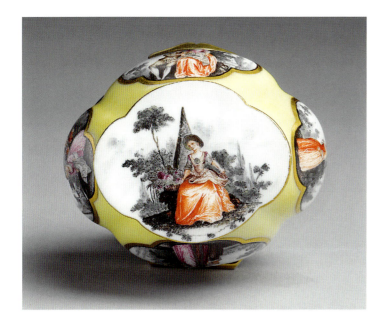

VI.22
Gabriel Huquier (1695–1772), copper engraving after the painting
La Berger Empressé by Jean-Antoine Watteau (1684–1721),
Paris, Bibliothèque des Arts décoratifs, Collection Maciet

VI.21
Laurent Cars (1699–1771), copper engraving after the painting
La Diseuse D'Aventure by Jean-Antoine Watteau (1684–1721),
London, British Museum

Cat. no. 39

SNUFF BOX

Painted c. c. 1740–45
With contemporary brass gilt mounts
Height 4.6 cm, width 5.8 cm, depth 4.4 cm

Literature:
Exh. cat. Cologne 2010, p. 215, cat. no. 92

This snuff box with a slightly domed lid is not only modelled in the shape of a basket but is also covered with a basket-weave relief. The box is decorated with ten pairs of gold lines placed at equal distances apart that start at the oval frame of the scene on the lid and are continued across all the edges of the piece on the bottom of the box.

Patricia Brattig (see exh. cat. Cologne 2010, p. 215, cat. no. 92) relates the following statement from the work report of Johann Joachim Kaendler (1706–1775) to this snuff box: "a very fine and elaborate snuff box in the form of a woven basket modelled in clay sent to the storeroom […]" ("Eine sehr Sauber und Mühsame Tabattiere in gestalt eines geflochtenen Korbes in Thon poußiret aufs Waaren Laager […]"; quoted from Pietsch 2002, May 1739, no. 12, p. 62). But this description could also possibly refer to the type of box shown in cat. no. 53.

All the picture areas are decorated with *galant* scenes, for some of which the graphic works that served as models can be named: while the oval of the outside of the lid was based on the print *L'Été* (see fig. VI.24) by Gabriel Huquier (1695–1772) after a painting by Jean-Antoine Watteau (1684–1721), the inside of the lid shows the elegant couple from *Le Baiser Donné* (see fig. VI.23), a print by Pierre Filloeul (1696– after 1754) a painting (now lost) by Jean-Baptiste François Pater (1695–1736). The porcelain painter's inventive approach to composition is particularly clearly illustrated here: he transfers the protagonists from the rustic setting depicted in the print to a park-like landscape with an architectural backdrop. The peasant woman in the etching, who seems to spy inquisitively on the amorous couple from behind an overgrown ruinous wall, is transformed in the scene on the snuff box lid into a *galant* secondary figure in the shape of a harlequin shown peeking from behind an obelisk. SKA

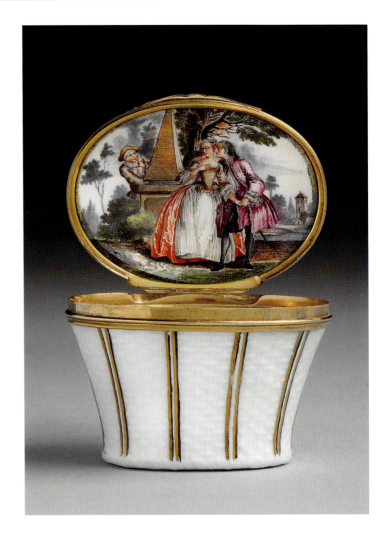

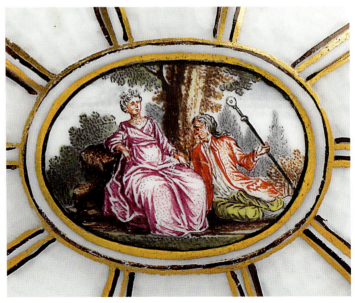

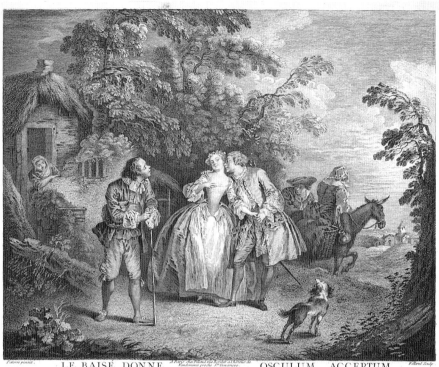

VI.23
Pierre Filloeul (1696–after 1754) copper engraving after the lost painting *Le Baiser Donné* by Jean-Baptiste François Pater (1695–1736), Staatliche Kunstsammlungen Dresden, Kupferstichkabinett (inv. no. A 69546)

VI.24
Gabriel Huquier (1695–1772), copper engraving after the painting *L'Été* by Jean-Antoine Watteau (1684–1721), Geneva, cabinet d'histoire, Musée d'art et d'histoire (inv. no. E 2012-0528)

Cat. no. 40

SNUFF BOX

Painted by Gottlob Siegmund Birckner (1712–1771),
c. 1745–47
With contemporary copper gilt mounts
Height 4.8 cm, width 7.1 cm, depth 5 cm

Literature:
Boltz 1978, p. 23, fig. 8; Beaucamp-Markowsky 1985, p. 99, cat. no. 68; Cassidy-Geiger 2007, p. 239, figs. 10–65

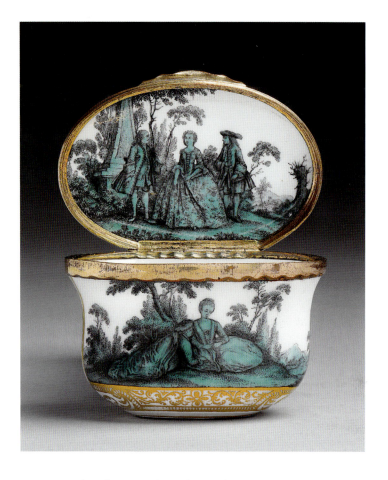

This oval snuff box with curved, inward tapering sides is closed by a slightly domed lid with gilt copper mounts. It forms part of a breakfast and toilette service which was presented as a gift to the King of the Two Sicilies, Charles IV (1716–1788), and his spouse, Maria Amalia Christina, Princess of Saxony, on the occasion of their tenth wedding anniversary in Naples by August III, King of Poland and Elector of Saxony (1724–1768), and his spouse Maria Josepha von Habsburg. This ensemble, which was made from July 1745 onwards in the Meissen manufactory, included a total of eighteen snuff boxes and lids, all of which but three were painted by Gottlob Siegmund Birckner with "Watteau figures." Consequently, we can assume with some degree of certainty that Birckner was the painter of the present snuff box. He used here exclusively a glowing shade of copper-green over black outlines. As Birckner administered the engravings owned by the manufactory from February 1745 onwards, he was able to make extensive use of this repertoire of models. He displayed great ambition in his attempts to conceal the provenance of his motifs by combining set pieces from different originals; clearly he wanted to demonstrate that his artistic achievements went far beyond mere "copying." For the décor of the lid, which proudly displays the alliance coats of arms of Saxony-Poland and Naples-Sicily surmounted by a crown all painted in polychrome and flanked by green figures on either side, he made use of three different reproductions of paintings by Watteau. On the right sits the flautist from a painting by Jean-Antoine Watteau not described in further detail (*Recueil Juillienne*, plate 159; see fig. VI.28), and on the left a lady in a crinoline whom Birckner took from the picture *La Lorgneuse* (see fig. VI.27), adding in front of her a kneeling girl from the painting *Les Champs Élisées*. For the scenes on the front and back of the box he chose two couples taken from larger groups of people; in both scenes the gentleman is shown reclining on the ground, with the lady seated in one case on his right, in the other on his left. In the main scene on the inside of the lid Birckner combines elements from two engravings by Charles Dupuis the Elder (1685–1745) after the paintings *Le Glorieux* and *Le Philosophe Marié* by Nicolas Lancret (1690–1745). A lady from the first mentioned engraving and two gentlemen form the latter mentioned engraving are combined to from a courtly group. Birckner places them in a garden with an obelisk in this way creating an entirely new composition.

In all the figures in early "Watteau painting" the skin colour is particularly striking; here, like everything else, it is green, whereas in later depictions a shade of pink was preferred.

UP

VI.25
Nicolas Gabriel Dupuis (1698–1771), etching after the painting *Le Glorieux* by Nicolas Lancret (1690–1745), Dresden, Staatliche Kunstsammlungen Dresden, Kupferstichkabinett

VI.26
Charles Dupuis (1685–1742), etching after the *Le Philosophe Marié* by Nicolas Lancret (1690–1745), Dresden, Staatliche Kunstsammlungen Dresden, Kupferstichkabinett

VI.27
Gérard Jean-Baptiste Scotin (1698–1755), etching after the painting *La Lorgneuse* by Jean-Antoine Watteau (1684–1721), Paris, Bibliothèque nationale de France

VI.28
Louis Crepy (born 1680), copper engraving entitled *Berger Dansant au Son de la Flûte* after a painting by Jean-Antoine Watteau (1684–1721), Geneva, Musée d'art et d'histoire

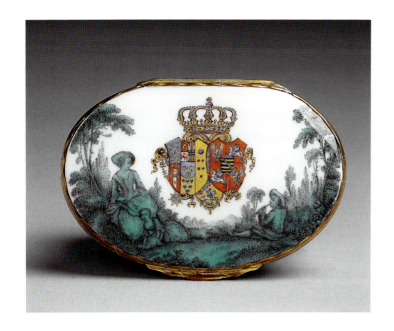
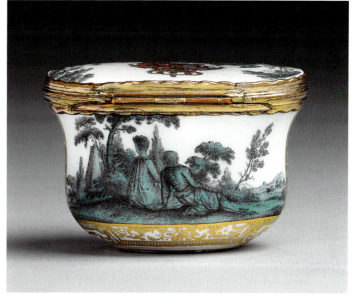

VI.29
Jacques-Philippe Le Bas (1707–1783), etching after the painting. *L'Île Enchantée* by Jean-Antoine Watteau (1684–1721), Geneva, Musée d'art et d'histoire

Cat. no. 41

SNUFF BOX

Painted c. 1750
With contemporary silver gilt mounts
Height 3.4 cm, width 6.7 cm, depth 5.3 cm

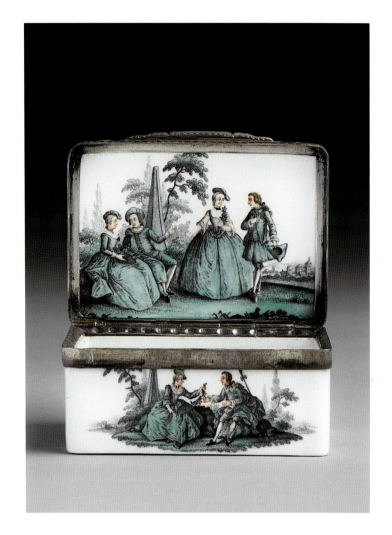

This rectangular snuff box with scenes of courtly life painted in copper-green could be regarded as a perfect example of what is known as "Watteau painting," were it not for that fact that not a single one of the motifs used here can be related to a work of graphic art made after a painting by this French Rococo master. Instead, for the front of the box the unknown porcelain painter used an etching by Nicolas III de Larmessin (1684–1755) after the painting *Le Matin* (see fig. VI.30) by Nicolas Lancret (1690–1745) that today is still in the archive of the Staatliche Porzellanmanufaktur, and for the outside of the lid an etching by André Laurent (1708–1747) after the painting *Le Pasteur Galant* (see fig. VI.31) by François Boucher (1703–1770). However, as both scenes on the snuff box are reversed versions of the *galant* scenes, it seems that the porcelain painter used later reversed prints, rather than these etchings, as his models. The precise attention to detail and the fluent manner indicate painting of a very high quality, allowing us to assume that it was done by a skilled and experienced artist. Whereas in early "Watteau painting" from the seventeen-forties all the figures are painted green *en camaïeu* (cf. cat. no. 40), the skin colour here is a light, transparent iron-red. In contrast, the artist coloured the stringed instruments yellow, while the blouses, lace collars, and silk stockings are painted in light grey. UP

VI.30
Nicolas III de Larmessin (1640–1725), etching after the painting *Le Matin* von Nicolas Lancret (1690–1745), Meissen, Staatliche Porzellanmanufaktur Meissen, archive, inv. no. VA 2258-3

VI.31
Andrew Lawrence aka. André Laurent (1708–1747), etching after the painting *Le Pasteur Galant* by François Boucher (1703–1770), Dresden, Staatliche Kunstsammlungen, Dresden, Kupferstichkabinett

201

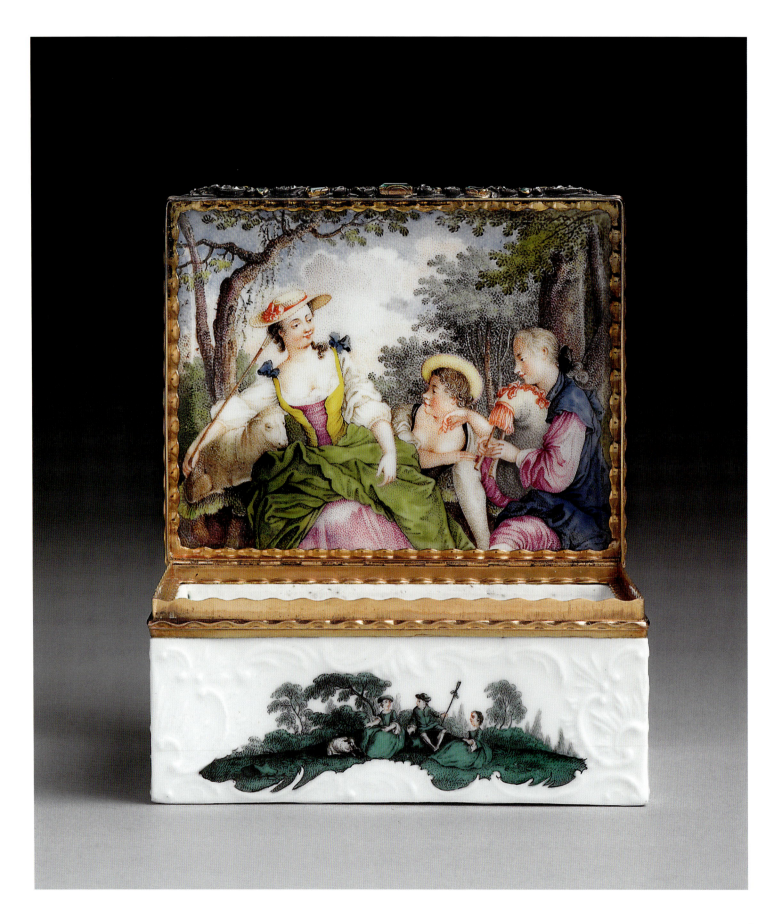

Cat. no. 42

SNUFF BOX

Painted c. 1755
With contemporary gold mounts
Height 4.2 cm, width 8.8 cm, depth 5.9 cm

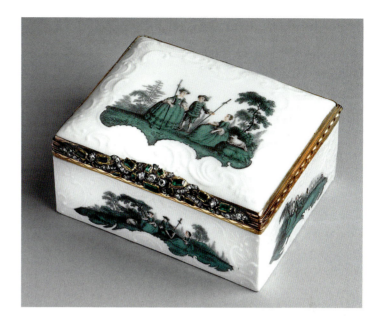

The outsides of this rectangular snuff box have white *rocaille* cartouches on the smooth surfaces of which the painter composed tiny *galant* scenes with a pastoral theme, painted in copper-green. Groups of people in court dress are shown playing at shepherds and shepherdesses; a number of them hold shepherd's crooks, some stand, others sit on the ground or on rocks, in a park-like landscape beside their sheep. Although the works of Jean-Antoine Watteau (1684–1721) and his contemporaries were little regarded in France after the mid-eighteenth century, in the rest of Europe, and presumably also in the Electorate of Saxony, they were seen as symbolising an unconstrained way of life that liberated society, at least in these idealised images, from the rigidity of court etiquette, and as expressive of a longing for an idyllic existence in harmony with nature. The polychrome pastoral scene on the inside of the snuff box lid was borrowed, along with the trees in the background, from an etching by J. Daylus after the painting *Les Amours Pastorales* (see fig. VI.32) by François Boucher (1703–1770), which the porcelain painter here quotes quite precisely. UP

VI.32
J. Daylus etching after the painting *Les Amours Pastorales* by François Boucher (1703–1770), Dresden,
Staatliche Kunstsammlungen Dresden, Kupferstichkabinett

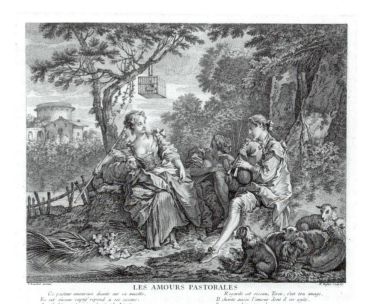

Cat. no. 43

SNUFF BOX

Inside of the lid painted by
Philipp Ernst Schindler Senior (1694–1765);
outside of the box probably painted by
Johann George Heintze (born c. 1706/07),
c. 1740
Cryptic painter's mark: "△"
With contemporary gold mounts
Height 5.7 cm, width 6.2 cm, depth 4.5 cm

Literature:
Joseph 1977, p. 27, fig. 10; Jakobsen/Pietsch 1997,
p. 102, cat. no. 67

Rectangular in plan with chamfered corners, this snuff box tapers downwards to flare slightly outwards just above the base. A powerful gilded profile runs around the rim and the box is closed by a domed lid with gold mounts. As was the case here it was not unusual for a box to be decorated by two different artists. Philipp Ernst Schindler Senior is confirmed as the creator of the pair of gardeners on the inside of the lid by his mark, the hollow triangle, while the scenes on the outside of the box can be attributed to Johann George Heintze on the basis of stylistic comparison. A male gardener stands behind his female

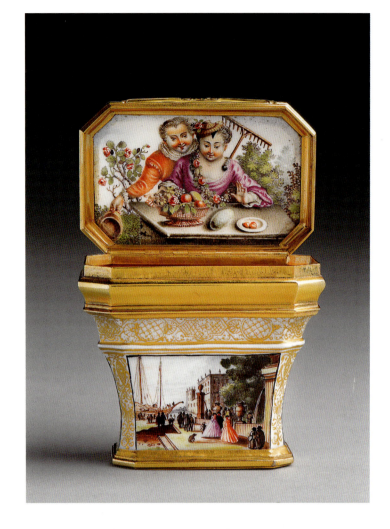

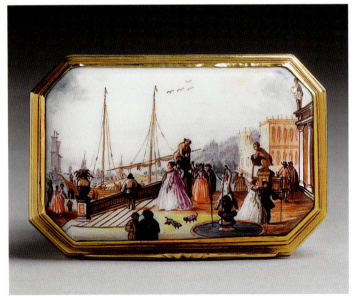

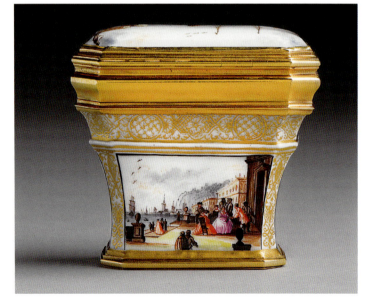

companion, both gaze admiringly at the fruit displayed in a basket and on a plate lying on a wooden table in front of them. The gardener has taken off his cap, which he holds in his extended right hand, while in his left hand he has a rake. The lady gardener, who wears a small straw hat on her braided hair and has a garland of flowers draped around her shoulder, raises her left hand in admiration. The strongly modelled painting, the full cheeks and round eyes are typical characteristics of Schindler's style.

For this scene the painter made use of an etching by Jean Moyreau (1690–1762) after a vanished painting by Jean-Antoine Watteau (1684–1721), which shows three cavaliers flirting with a lady (see fig. VI.36). Schindler transformed the lady and the man standing behind her into the pair of gardeners, furbishing them with different attributes to those in the print. On another snuff box with the same form he made use of the same print for the scene on the inside of the lid but in this case transformed the cavalier to the left of the lady into the gardener (cat. no. 44), giving him the rake.

The scenes painted by Heintze on the outside of the box, which are framed by vertical bands and a frieze of golden leaf- and network under the edge profile, contain merchant shipping scenes. For a number of these it has proved possible to identify the prints that served as models. They belong to a series entitled *Unterschidliche Prospecten…* by Melchior Küsel (1626–1683) after Johann Wilhelm Baur (1607–1640), Augsburg c. 1681, and present three different views of the harbour of Naples (see figs. VI.33–35) which were adopted almost exactly for the décor of the porcelain.

The bottom of the box is decorated with a bouquet of colourful blossoms against a yellowish green background with black dots.

UP

VI.33
Melchior Küsel (1626–1683), *Prospect der Schiffen, und Etlicher Pallazzie zu Neapoli alli Fodamenti novi*, etching from the series *Unterschidliche Prospecten…* by Johann Wilhelm Baur (1607–1640), Augsburg c. 1681, Brunswick, Herzog Anton Ulrich-Museum

VI.34
Melchior Küsel (1626–1683), *Prospect deß Golfo zu Neapolis*, etching from the series *Unterschidliche Prospecten…* by Johann Wilhelm Baur (1607–1640), Augsburg c. 1681, Brunswick, Herzog Anton Ulrich-Museum

VI.35
Melchior Küsel (1626–1683), *Prospect eines theilß der Statt und Golfo zu Neapolis*, etching from the series *Unterschidliche Prospecten…* by Johann Wilhelm Baur (1607–1640), Augsburg c. 1681, Brunswick, Herzog Anton Ulrich-Museum

VI.36
Jean Moyreau (1690–1762), etching after the painting
Le Concert by Jean-Antoine Watteau (1684–1721),
Paris, Bibliothèque nationale de France

Cat. no. 44

SNUFF BOX

Painting of the inside of the lid by
Philipp Ernst Schindler Senior (1694–1765),
painting on the outside most probably by
Johann George Heintze (born c. 1706/07), c. 1740
With contemporary gold mounts
Height 5.1 cm, width 6 cm, depth 4.2 cm

Same form as cat. no. 43. The inside of the lid is painted with a pair of gardeners after an engraving by Jean Moyreau (1690–1762) made after a lost painting by Jean-Antoine Watteau (1684–1721) as in cat. no. 43, but in the present box the gentleman to the left of the lady was changed into a gardener.

The merchant shipping scenes painted by Heintze on the outside of the box are based on prints by Melchior Küsel (1626–1683) from the series *Unterschidliche Prospecten* after Johann Wilhelm Baur (1607–1640), Augsburg c. 1681, while the depiction of a palace located beside a bay on the top of the lid can be traced back to another etching by Küsel, a view of the *Lusthoff deß Groß Herzogs von Florenz zu Livorno* (see fig. VI.37) from the series *Iconographia* by Johann Wilhelm Baur, Augsburg 1682, folio 4.

Externally, the bottom of this box is covered with a dense pattern of iron-red and blue-and-white chrysanthemums, possibly also painted by Schindler. UP

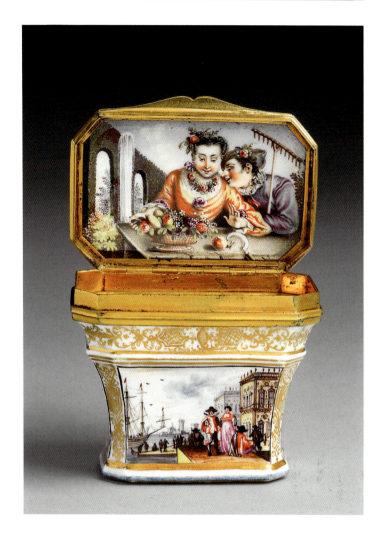

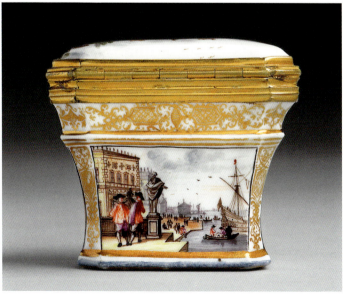

VI.37
Melchior Küsel (1626-1683), *Lusthoff desz Groß Herzogs von Florenz zu Livorno*,
etching from the series *Iconographia* by Johann Wilhelm Baur (1607–1640),
Augsburg 1682, Brunswick, Herzog Anton Ulrich-Museum

209

Cat. no. 45

SNUFF BOX

Painting on the inside of the lid by
Philipp Ernst Schindler Senior (1694–1765),
and painted on the outside by Johann George Heintze
(born c. 1706/07), c. 1745
Cryptic painter's mark: "△"
With contemporary gold mounts
Height 4.5 cm, diameter 7.6 cm

Literature:

Bursche 1998

Rounded inwards at the bottom, this cylindrical snuff box is closed at the top by a slightly domed lid with gold mounts. Frequently, the painted decoration of Meissen snuff boxes was carried out by two different artists; here Philipp Ernst Schindler Senior was responsible for the painting on the inside of the lid, as is confirmed by his cryptic painter's mark, the tiny hollow triangle, while the painting of the entire outside of the box can be attributed to Johann George Heintze on the basis of stylistic comparison. This pair often worked together on decorating snuff boxes (cf. cat. nos. 43 and 44).

The painting inside the lid shows a half-length portrait of a man wearing a brown fur cap with a guitar on his lap, who looks directly at the viewer over his left shoulder, while the lady standing beside him, her upper body inclined backwards, directs his attention to what seems to be a statue in front of them of which we can see only a pair of legs and a recumbent stone lion spouting water, as the remainder is cut off by the edge of the lid. While most of the scene is painted in restrained colours, the gentleman's jacket is a powerful shade of red as is the lady's jaunty little hat, which is trimmed with a white feather. This composition combines individual motifs from two different etchings, one made by Benoît Audran (1661–1721) after the painting *L'Aventurière* (see fig. VI.39) and the other by Charles-Nicolas II Cochin (1715–1790) after the painting *Le Bosquet de Bacchus* (see fig. VI.40) both by Jean-Antoine Watteau (1684–1721). Schindler places the two figures, which in *L'Aventurière* are positioned beside the figure of Giles and opposite an elegant lady, in front of the fountain with a statue of Bacchus drinking wine taken from the second etching. In this way he creates an entirely new context which no longer relates to the original theme of the adventuress or demirep but is purely decorative in intent.

The continuous décor running around the side of the box shows fine idealised landscapes with ruins, castles, a bridge leading across a river, and gentlemen strolling with their ladies, flanked by vases carried on pedestals. The themes of the painting on the bottom and the lid of the box are similar, the figures on the outside of the lid were taken from an etching by Pierre-Alexandre Aveline (1702–1760) after the painting *Récréation Italienne* (see fig. VI.38) by Jean-Antoine Watteau.

UP

VI.38
Pierre-Alexandre Aveline (1702–1760), etching after the painting
Récréation Italienne by Jean-Antoine Watteau (1684–1721),
Geneva, Musée d'art et d'histoire

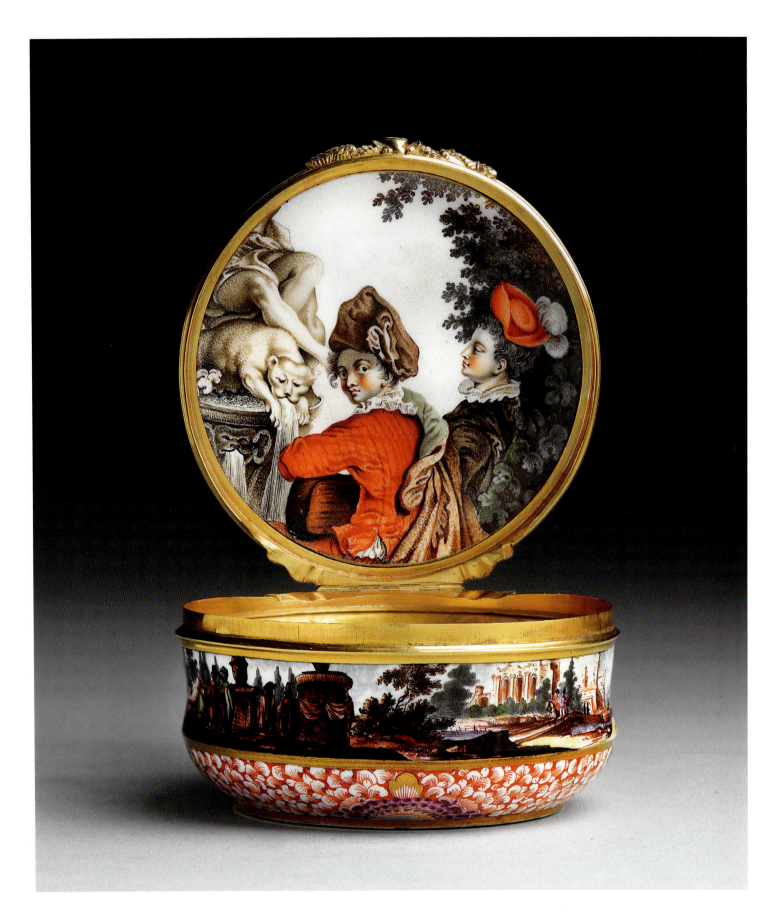

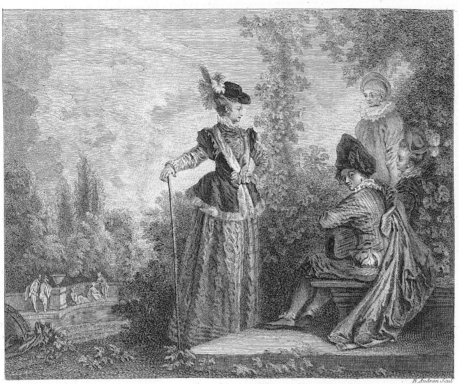

VI.39
Benoît Audran (1661–1721), etching after the painting *L'Aventurière* by Jean-Antoine Watteau (1684–1721), London, British Museum

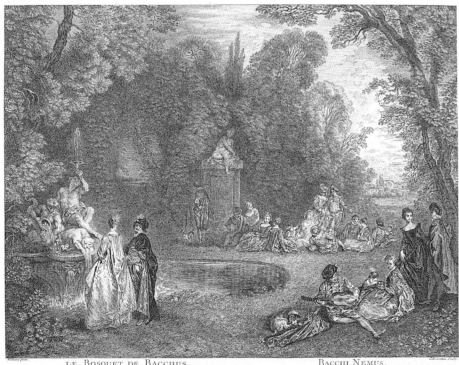

VI.40
Charles-Nicolas II Cochin (1715–1790), etching after the painting *Le Bosquet de Bacchus* by Jean-Antoine Watteau (1684–1721), Geneva, Musée d'art et d'histoire

Cat. no. 46

SNUFF BOX

Model by Johann Joachim Kaendler (1706–1775), 1737
Painted by Philipp Ernst Schindler Senior (1694–1765), c. 1740
Cryptic painter's mark: "△"
With contemporary gold mounts
Height 5.6 cm, width 6.8 cm, depth 5 cm

Literature:
Bursche 1998

In his work report from May 1737 Johann Joachim Kaendler states that he had "begun a most elaborate snuff box for Geheimrat von Brühl. It has a great deal of low relief decoration and it is intended to make hunting scenes on the lid and sides, but these will only be done next month" ("Eine sehr Mühsame Tabattiere Vor den Herrn geheimden Raht von Brühls Excellenz angefangen, darauf sehr viele flache Zieraten befindl. und sollen Jagdt Stückgen auf den Deckel und Seiten gefertiget werden, welche aber bis in kommenden Monath vollends zu fertigen auf behalten worden," SPMM, archive AA I Ab 9, sheets 88r–89v, quoted from Pietsch 2002, p. 47). However, he only completed this model in July 1737: "the extremely elaborate snuff box for His Excellence Count von Brühl has been completed. Fine hunting scenes and decoration in low relief were applied to it" ("Die sehr mühsame Tabattiere Vor Ihro Excell.: den Herrn Grafen von Brühl vollends gefertiget Worauf flach erhaben Jagten und Zieraten befindlich gewesen"), and then in August he records "two examples of the snuff box referred to above were put together and finished off" ("Zwey Stück der oben erwehnten Tabattieren in der Maßa verputzet," SPMM, archive, AA I Ab 9, sheets. 164r–166r, quoted from Pietsch 2002, p. 48), which meant that they were ready to be painted. However, whether both these pieces entered the possession of Heinrich Count von Brühl (1700–1763), the Polish-Saxon prime minister and owner of the largest collection of snuff boxes in Saxony, is not known.

The external form of the present snuff box matches precisely the description of the model from 1737 and it must therefore be one of the two examples made for Count von Brühl. Kaendler

VI.41
Jean Lepautre (1618–1682), *Wild Boar Hunt with Hounds*, private collection

decorated the narrow sides of the quatrefoil-shaped, bellied snuff box with a classic Baroque shell ornament, while on the long sides, the lid, and the bottom of the box there are further fine reliefs showing hunting scenes. Here Kaendler was inspired, in part, by an etching showing a deer hunt (see fig. VI.42) by Johann Elias Ridinger (1698–1767), which he used for the relief on the bottom of the box, and a print by Jean Lepautre (1618–1682) depicting a wild boar hunt with hounds (see fig. VI.41) that provided the motif used on the lid. The two scenes on the front and back of the snuff box were also based on prints which have not yet been identified. A snuff box with the same form is now in private ownership. It was previously exhibited as a loan in the Rijksmuseum Amsterdam (cf. Beaucamp-Markowsky 1985, p. 189, cat. no. 145).

The excellently painted picture on the inside of the lid is the work of Philipp Ernst Schindler Senior, whose cryptic painter's mark can be seen at the bottom right edge. It shows an elegant pair of lovers captured in a scene of great intimacy: the gentleman wearing a purplish-red jacket is shown half-length with his profile hidden, while the lady dressed in a brown crinoline and wearing a light-coloured bonnet coquettishly turns her upper body away from the young man, but at the same time she takes hold of his hand which is resting on her stomach, all the while they gaze deeply into each other's eyes. Schindler took the motif from an etching by Laurent Cars (1699–1771) after the painting *Fêtes Vénitiennes* by Jean-Antoine Watteau (1684–1721), detaching it so deftly that on the snuff box it seems to be an independent composition complete within itself (see fig. VI.43). UP

VI.42
Johann Elias Ridinger (1698–1767), *Der Anstand auf die Rehe*, etching from the series *Der Fürsten Jagd-Lust*, Augsburg 1729, Dresden, Staatliche Kunstsammlungen Dresden, Kupferstichkabinett

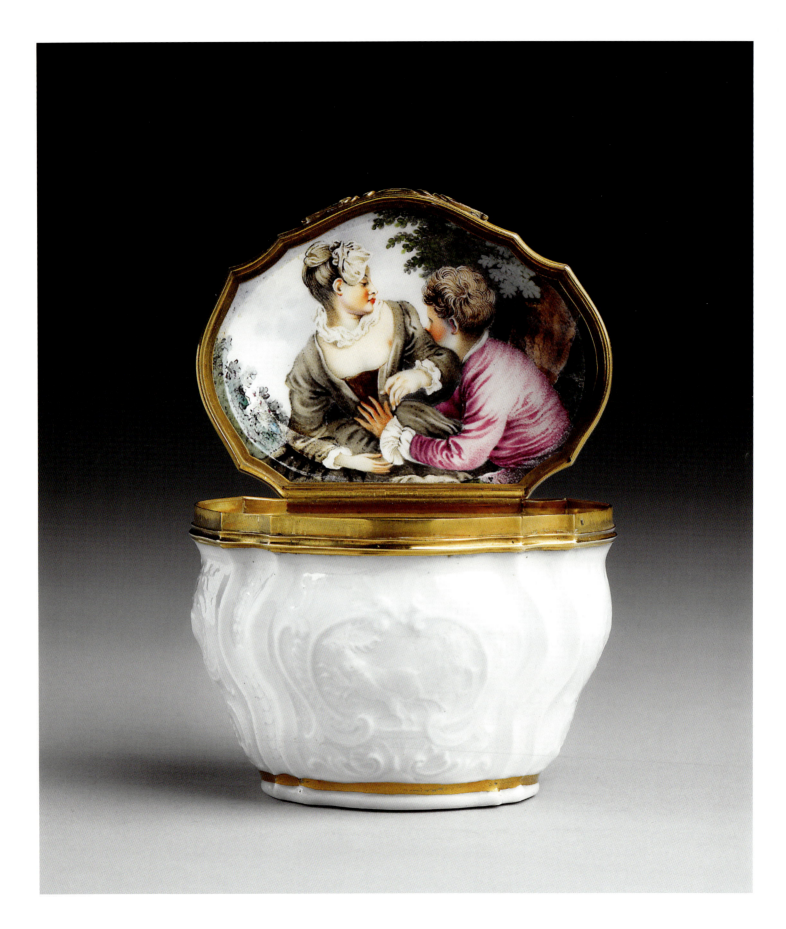

VI.43
Laurent Cars (1699–1771), etching after the painting *Fêtes Vénitiennes* by Jean-Antoine Watteau (1684–1721), Geneva, Musée d'art et d'histoire

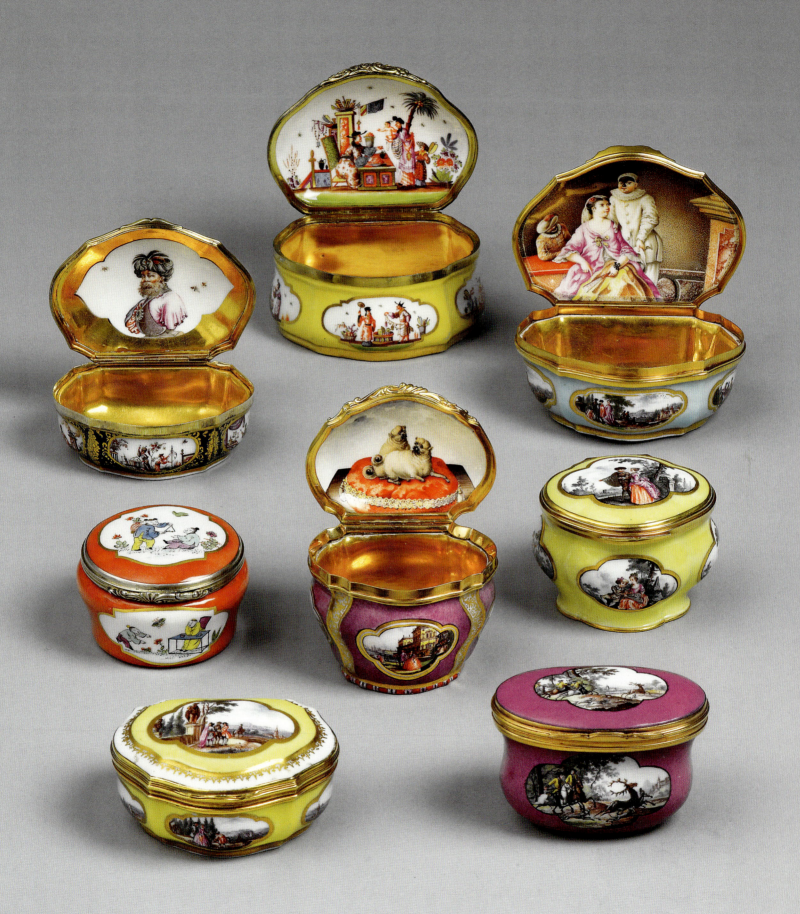

Cat. no. 47

SNUFF BOX

Painted by Johann George Heintze
(born c. 1706/07), c. 1745
With contemporary gold mounts
Height 3.5 cm, width 7.3 cm, depth 5.7 cm

Form as cat. no. 12. The quatrefoil, gold-framed reserves left in the yellow ground on all the sides of this snuff box, like the unframed picture on the inside of the lid, show idealised landscapes with figures. These scenes are always viewed from an elevated vantage point, looking down across mountainous regions traversed by rivers and dotted with lakes that end at a grey-violet horizon where palaces and church towers rise. In the foreground cavaliers and ladies in courtly dress and children disport themselves beside trees, obelisks, columns, or statues. Some of the miniature scenes are flanked on the left or right by ruins, pedestals, or other architectural elements that are cut off by the edge of the picture so that—as is so often the case with Heintze—the impression of depth conveyed is considerably strengthened. UP

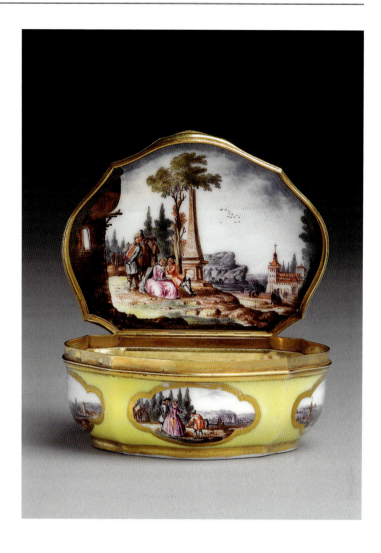

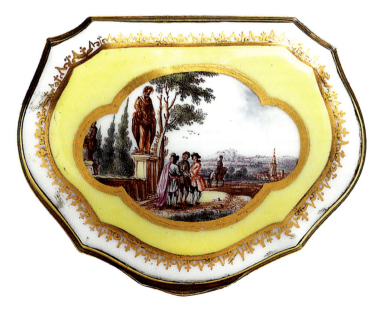

Cat. no. 48

SNUFF BOX

Inside of the lid painted by
Philipp Ernst Schindler Senior (1694–1765),
outside of the snuff box painted by Johann George
Heintze (born c. 1706/07), c. 1735
Cryptic painter's mark at the bottom right in
the marbling of the pedestal: "△"
With contemporary gold mounts
Height 4.3 cm, width 9 cm, depth 6.5 cm

Literature:
Joseph 1977, p. 28, fig. 11

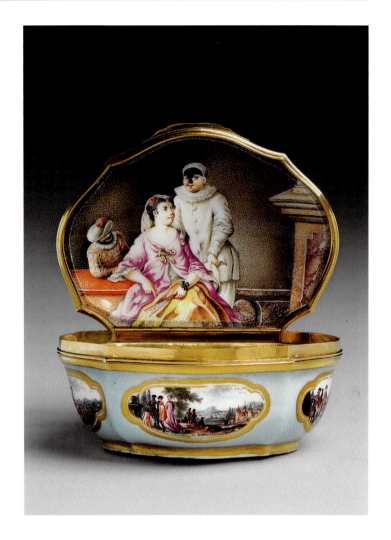

This scalloped quatrefoil snuff box with a straight edge at the back is closed by a slightly domed lid with gold mounts. In the quatrefoil gold-framed reserves left in the turquoise green ground that covers the outside of the box, the painter, Johann George Heintze, composed marvellously painted, idealised landscapes with figural staffage, while the *galant* scene on the inside of the lid was painted by Philipp Ernst Schindler Senior. This scene, apparently complete in itself, shows a lady in courtly dress at the centre, a Harlequin wearing a diamond-patterned costume on the left, and a Pierrot standing beside her on the right. It offers an excellent example of how the porcelain painters at Meissen used prints as their models, for each of the figures here was borrowed from a different etching: the harlequin comes from a print by Nicolas-Henri Tardieu (1674–1749) after the painting *L'Autonne* (see fig. VI.10) by Nicolas Lancret (1690–1745), the lady from the etching *La Vue—Das Gesicht* (see fig. VI.44) by Gottfried Bernhard Götz (1708–1774) and the Pierrot is from a further etching by Simon François Ravenet (1706–1774), after the painting *Marche Comique* (see fig. VI.72) by Jean-Baptiste François Pater (1695–1736). Schindler here succeeds brilliantly in placing these three figures together to make a new composition. It seems that he recorded it in his sketchbook, as he later used it for the decoration of two other snuff boxes, one of which is the Museum of Applied Arts in Budapest, inv. no. 5860 (cf. exh. cat. Dresden 2010, p. 366, cat. no. 459), and the other in the collection of Dr. and Mrs Julius Jacobsen, New York (cf. Beaucamp-Markowsky 1985, p. 167, cat. no. 123).

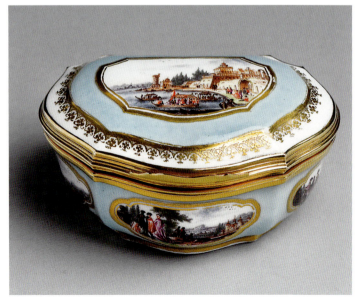

VI.44
Gottfried Bernhard Götz (1708–1774), *La Vue—Das Gesicht,* copper engraving from the series *Die Fünf Sinne* (The Five Senses), Dresden, Staatliche Kunstsammlungen Dresden, Kupferstichkabinett

The decorative landscapes by Johann George Heintze also demonstrate great powers of imagination. As was probably the case with this snuff box Heintze often borrowed motifs from prints but changed them so radically that it is extremely difficult to trace their origins. Consequently, the *galant* couples and groups strolling outdoors or the horsemen and people in boats as well as the scene with a cavalier and lady watching a young man blowing soap bubbles in the air may well have been taken from reproductions of paintings by French Rococo artists. In the case of the man blowing bubbles this approach can be precisely documented: Heintze borrowed this motif from a print by Nicolas-Henri Tardieu (see fig. VI.45) after the painting *L'Air* by Nicolas Lancret. He probably invented the remaining figures himself and the surrounding landscape is most likely also the product of his own imagination. UP

VI.45
Nicolas-Henri Tardieu (1674–1749), copper engraving
after the painting *L'Air* by Nicolas Lancret (1690–1745),
Meißen, Staatliche Porzellan-Manufaktur, archive,
inv.no. VA 4285

Cat. nos. 49 and 50

SNUFF BOX (cat. no.49)

Painted c. 1740
With contemporary silver gilt mounts
Height 3 cm, width 7.8 cm, depth 6 cm

SNUFF BOX (cat. no.50)

Painted c. 1745
With contemporary silver gilt mounts,
probably Dresden
Height 3.5 cm, width 8.5 cm, depth 6.6 cm

The outsides of these bulbous, scalloped snuff boxes are decorated with coloured harbour scenes and landscapes. Whereas the scenes in cat. no. 49 form a continuous décor and clearly belong to the tradition of depictions of merchant shipping, in the box listed as cat. no. 50 they are placed in rectangular reserves and were probably made after prints by Melchior Küsel (1626–1683). The areas between the reserves are filled with fine gold decoration.

As is so often the case with snuff boxes, the painting on the inside of the lid is thematically different, in both cat. no. 49 and cat. no. 50 the same scene is used. It shows Harlequin, easily identified by his mask and costume, and Columbine, who seductively displays her left breast. Their embrace is being observed by a young boy clad in courtly dress. This composition appears to be made up of elements of different origins: the motif of the embracing *commedia* figures is known from a print entitled *Columbine and Harlequin* (see fig. VI.47) by Gérard-Joseph Xavery (1700–1747; published in Chilton 2012, p. 138, fig. 226),

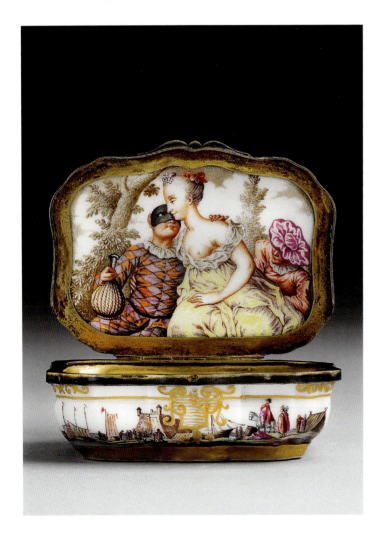
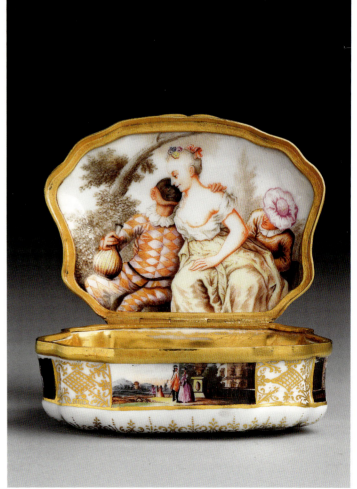

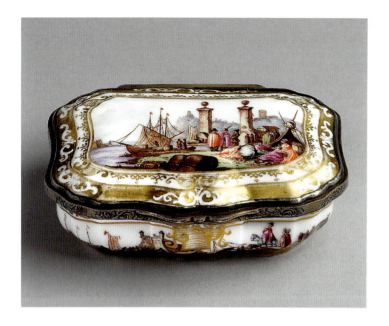
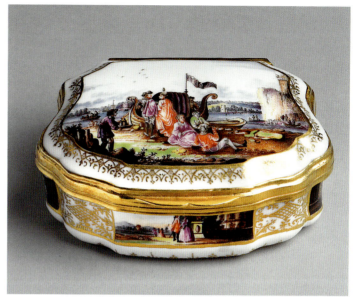

but Harlequin's pose in the snuff box lid differs clearly from that in Xavery's print. The inventor of this composition probably took the movement of the figure from a print by Gabriel Huquier (1695–1772) made after a painting by Jean-Antoine Watteau (1684–1721) with the title *Le Repos Gracieux* (see fig. VI.46). The motif of the unnoticed observer also comes from Watteau's repertoire and is found in François Boucher's (1703–1770) print *La Troupe Italienne*.

The great fondness of the early eighteenth century for theatrical spectacles of all kind was also reflected in the visual arts. As the debate about the *théâtre italien* towards the end of the seventeenth century had stirred up strong emotions, it was eventually broken up in 1697 and only permitted again after the death of Louis XIV in 1715. Jean-Antoine Watteau greatly enjoyed attending *commedia* performances and was in regular communication with the actors among whom he found subjects for his paintings. This led him to invent the genre of the *fêtes galantes*, which was introduced as a new branch of painting to the Academy in 1717 so that Watteau could be made a member with his painting *The Embarkation for Cythera* (cf. Los Llanos 2002, pp. 69ff.).

The term "inventor" with regard to the composition of this scene is deliberately chosen as, although the same motif is used in the lid of both boxes, they were clearly carried out by two different painters. This permits us to assume that a print with this invented composition was available in the painting studio for use by the painters of the manufactory, in much the same way as the Schulz Codex was employed in the area of chinoiseries. SKA

VI.46
Gabriel Huquier (1695–1772), copper engraving after the painting
Le Repos Gracieux by Jean-Antoine Watteau (1684–1721),
Paris, Bibliothèque des Arts décoratifs, Collection Maciet

VI.47
Gérard-Joseph Xavery (1700–1747), *Columbine and Harlequin*,
copper engraving the series *The Amours of Columbine*, Stockholm,
Music and Theatre Museum

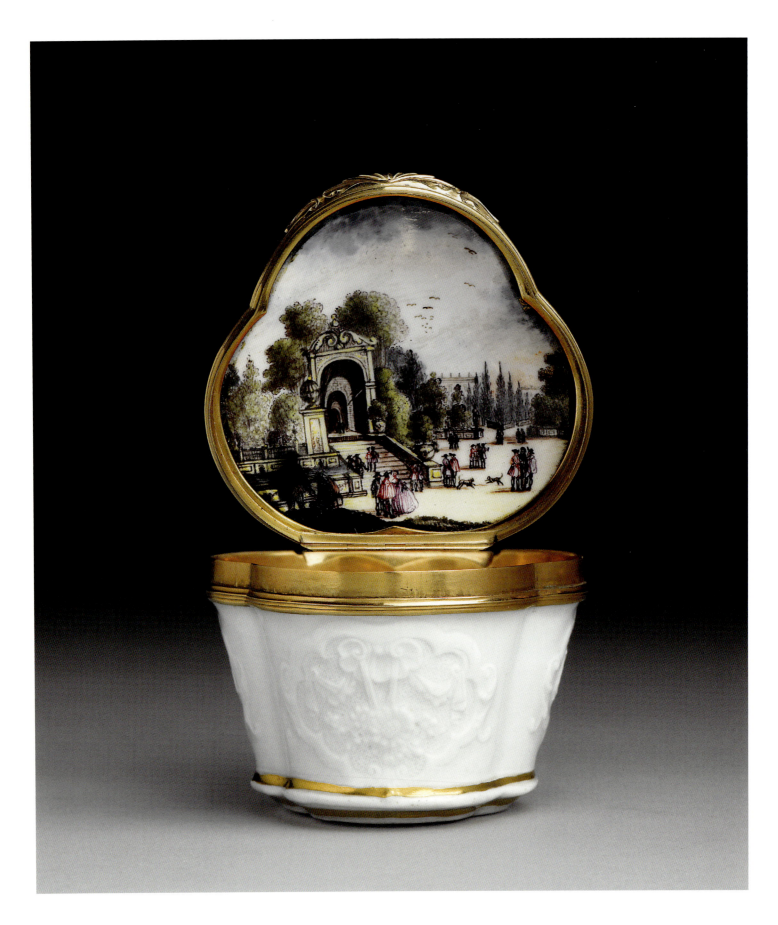

228

Cat. no. 51

SNUFF BOX

Model by Johann Joachim Kaendler (1706–1775),
c. 1737
Probably painted by Johann George Heintze (born c. 1706/07),
c. 1740
With contemporary gold mounts
Height 4.8 cm, width 8.5 cm, depth 6.6 cm

Literature:
Jakobsen/Pietsch 1997, p. 264, cat. no. 218

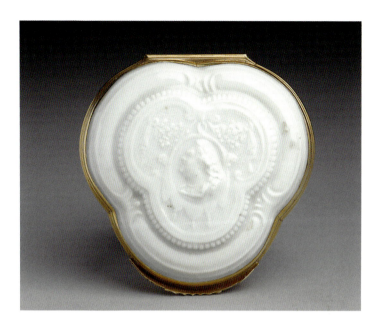

In his report on his work from May 1737 Johann Joachim Kaendler mentions "a very time-consuming snuff box [...] with flat antique decoration on the lid and a small, flat portrait of His Majesty, while on the bottom is a head of an ancient Roman" ("Eine sehr mühsame Tabattiere [...] mit Antiquen flachen Zieraten auf dem Deckel ist Ihro Maj. des Königs Porträit klein und flach befindlich, auf dem Boden aber ein altes Römisches Köpffgen"; cf. Pietsch 2002, p. 47). This description matches the external form of this snuff box so precisely that there can be no doubt about the identity of the model. The low relief portrait of King Augustus III mentioned is to be found on this piece, along with the "antique" decorative elements consisting of mussels, blossoms, and leaf-work. The painting, probably by Johann George Heintze, is particularly fine and shows a Baroque doorway with an external staircase in front of it, set in a park-like landscape occupied by numerous figures.

Further examples with the same form are in private ownership, formerly on loan to the Rijksmuseum Amsterdam (cf. Beaucamp-Markowsky 1985, pp. 192f., cat. no. 147), and in the Gardiner Museum of Ceramic Art, Toronto (cf. Cassidy-Geiger 2007, p. 289, figs. 12–26; with a painted portrait of the king on the inside of the lid). UP

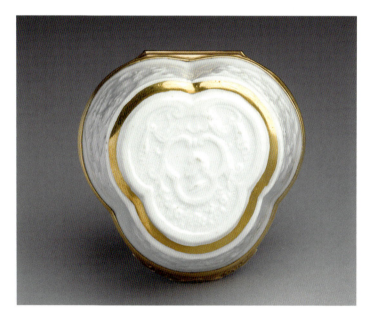

Cat. no. 52

SNUFF BOX

Painted by Philipp Ernst Schindler Senior (1694–1765),
c. 1745
With contemporary gold mounts
Height 3.8 cm, width 7.5 cm, depth 5.9 cm

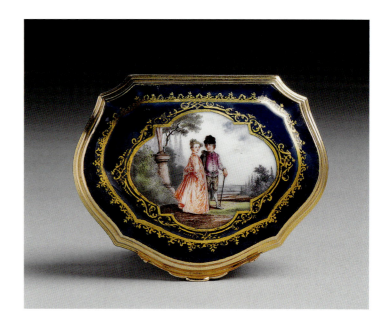

The gold-framed quatrefoil reserves left in the dark blue ground on the lid and sides of this cartouche-shaped, bellied snuff box contain coloured Watteau scenes, while the *galant* shepherdess with two sheep on the inside of the lid is painted in fine dots of colour. The stepped gold mount with a wide thumb rest is original.

The models for the *galant* scenes that were highly popular in the late seventeen-thirties and the seventeen-forties were mostly provided by prints made after drawings and paintings by the French artist Jean-Antoine Watteau (1684–1721), which were available to the painters in the Meissen manufactory in the form of print reproductions. The motif on the lid of the box can be traced to Watteau's painting *La Cascade—Aqua Saliens* from 1729 (see fig. VI.48). Several motifs that were taken from the painting *Les Champs Élisées* (see fig. VI.49) are found in a cartouche on the side as well as on the bottom of the box.

The coloured painting is by one of the earliest colleagues of Johann Gregorius Höroldt, the painter of "fine Chinese figures," Philipp Ernst Schindler Senior (1694–1765), who had worked at the manufactory since 1724 and was engaged by Höroldt as a journeyman painter on 4 October 1724.

A saucer in Schloss Lustheim, Ernst Schneider Foundation (see fig. VI.1) that bears the monogram "PES" distinguishes Schindler's painting method and technique from those of his contemporaries. The careful sculptural modelling in iron-red of the expressive oval faces is typical of his work. The eyes generally protrude somewhat, and the irises and eyebrows are emphasised in black. In addition to a number of highly characteristic chinoi-

VI.48
Gérard Jean-Baptiste Scotin (1698–1755), etching after the painting *La Cascade—Aqua Saliens* by Jean-Antoine Watteau (1684–1721), London, British Museum

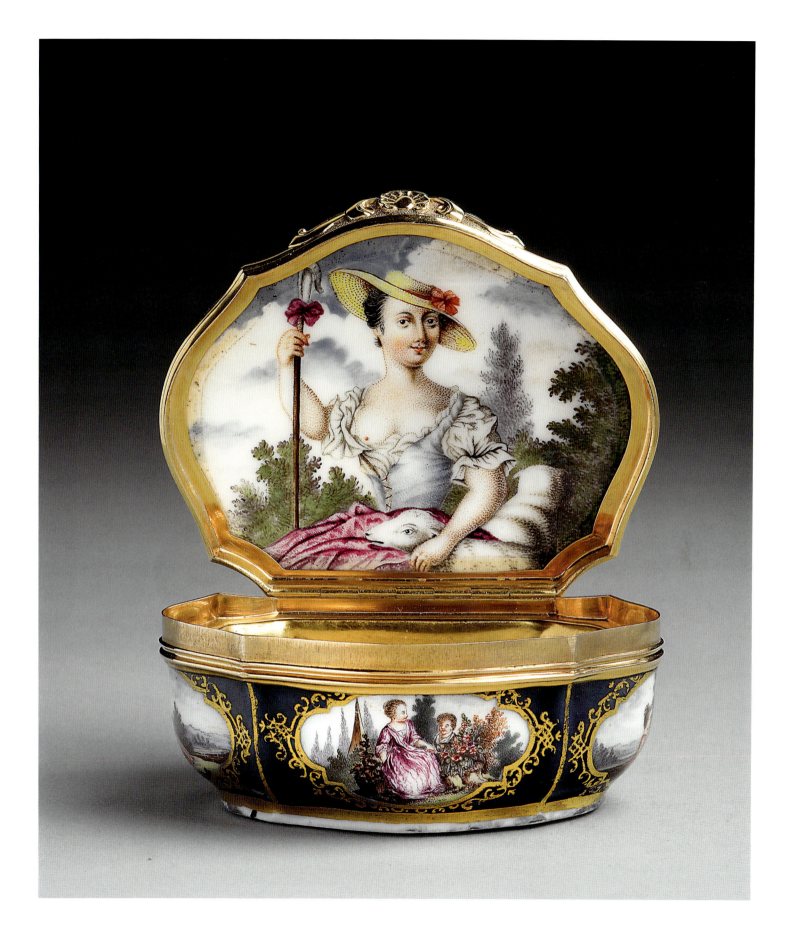

231

series a few snuff boxes with a small hollow triangle discretely positioned in the painting have survived—on the basis of a comparison with other, signed pieces Stefan Bursche has been able to show that these memorable and striking décors must have been painted by Philipp Ernst Schindler Senior.

Painting on porcelain seems to have offered the miniaturist Schindler the ideal métier to develop his unusual artistic abilities and to form his personal style which is, without doubt, among the finest in Meissen porcelain painting and indeed helped establish its world renown.

Snuff boxes with an underglaze blue ground are relatively rare (cf. a chinoiserie snuff box published in Beaucamp-Markowsky 1985, p. 55, cat. no. 26; also there, other boxes with similar painting, cat. nos. 82, 84, and 85).

MR

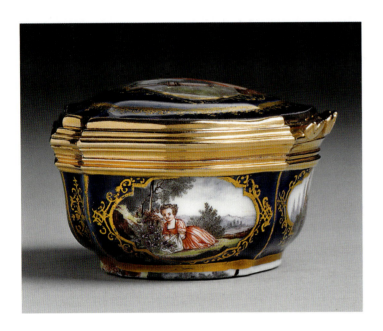

VI.49
Nicolas-Henri Tardieu (1674–1749), copper engraving after the painting *Les Champs Élisés* by Jean-Antoine Watteau (1684–1721), Dresden, Staatliche Kunstsammlungen Dresden, Kupferstichkabinett

Cat. no. 53

SNUFF BOX

Painted c. 1740–45
With contemporary silver gilt mounts
Height 6 cm, width 5.2 cm, depth 3.9 cm

Literature:
Rühle 1886

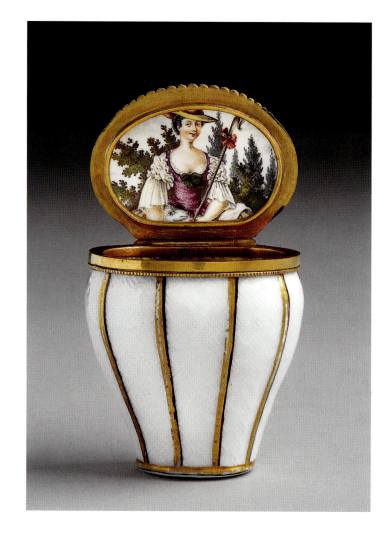

This snuff box is in the form of a basket that curves outwards from the base. It has a domed lid and is evenly covered with a basket-weave relief. The box is decorated with nine pairs of long gold lines placed at equal distances apart that start and end at the oval surrounds to the images on the bottom of the box and on the lid and are continued across all the edges of the snuff container. The inside of the lid has a portrait of a shepherdess painted after an unknown model (see also cat. no. 52).

Depictions of aristocratic ladies dressed as shepherdesses or gardeners are not unusual in eighteenth century art in general and on Meissen snuff boxes in particular. Although the discussion of the "pastoral or bucolic style" was very much present in the discourse about the eighteenth century's heroic image of landscape (cf. Lemasson 2002, pp. 161ff.), portraits of noble ladies dressed as shepherdesses probably originate from another branch of art: pastoral poetry and court theatre, which was closely interwoven with it in the eighteenth century.

Pastoral poetry was introduced to Germany at the end of the sixteenth century through foreign pastoral novels such as Montemayor's *Diana, Schäfereien von der schönen Juliana* by Nicola de Montreux or Biondi's *Eromena*, which were widely read in translation and were later integrated in almost all genres of poetry. Parallel to this the pastoral drama developed in Italy and France and its sweetly sentimental content led to the composition of music to accompany it. Whereas initially only lyrical sections, prologues, arias, and the final choruses were set to music, later, through the introduction of recitative, the entire work was transformed. The pastoral drama was thus turned into a pastoral opera. *Daphne* by Opitz, which is regarded as the first German pastoral opera, was set to music by Dresden *Kapelldirektor* Heinrich Schütz (1585–1672). Court festivities such as weddings or celebrations generally provided the setting for the performance of these spectacles. Of particular relevance for our snuff boxes is the fact that, until the reign of Louis XV, professional actors did not rule the stage and it was instead members of the court who played the role of shepherds or shepherdesses.

In the Historisches Museum am Hohen Ufer in Hanover, for example, there is a portrait by an unknown painter of Princess Sophie Dorothea (1666–1726) as a shepherdess, and Antoine Pesne (1683–1757) portrayed Princess Amalie von Preussen (1720–1782) in a shepherdess costume. SKA

VI.50
Antoine Pesne (1683–1757), *Princess Amalie of Preussen, Sister of Frederick the Great as Sheperdess*,
Berlin, um 1740, Stiftung Preussische Schlösser und Gärten Berlin c. 1740, inv.no. GK 1217

SNUFF BOX

Painted by Johann Jacob Wagner (1710–1797), 1746
Monogram on edge of lid: "JW"
With contemporary silver gilt mounts
Height 6.6 cm, width 7 cm, depth 5.1 cm

Literature:
Beaucamp-Markowsky 1985, pp. 104f., cat. no. 72

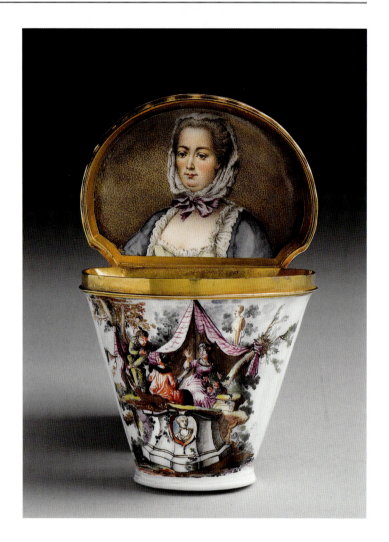

The same form as cat. no. 17. According to Beaucamp-Markowsky, the lady's portrait in the lid of this snuff box shows Elisabeth Auguste von Pfalz-Sulzbach (1721–1794). The monogram on top of the lid also supports this suggestion. Alternatively, the lady, probably portrayed by Johann Jacob Wagner, shows a great similarity with the portrait of Jeanne Antoinette Poisson, the Marquise de Pompadour (1721–1764) by François-Hubert Drouais (1727–1775) from 1763, Château de Versailles. The monogram "EA" at the front of the box, however, that doesn't match with the Marquise's name, remains peculiar. Stylistically, also neither form nor décor in "Watteau style" fit in the time after 1763. Without any knowledge of a copper etching after the painting, a depiction on porcellain was impossible. Whether Wagner was also responsible for the *commedia* figures taken from an etching by Simon François Ravenet (1706–1774) after the painting *Marche Comique* (see fig. VI.72) by Jean-Baptiste François Pater (1695–1736) remains unclear, as does the identity of the artist who painted the scene on the front of the snuff box made after the etching *Der Geruch* (The Smell; see fig. VI.51) by Gottfried Bernhard Götz (1708–1774), the harbour scene painted *en camaïeu* purple on the bottom of the box, and the knight surrounded by the tools of war on the back is painted after an engraving by Johann Evangelist Holzer (1709–1740; see fig. VI.52). A snuff box depicting the same portrait in the lid but of another form is honsed in the Collection Brigitte Britzke, Bad Pyrmont (published in exh. cat. Segovia 2009, p. 306). UP

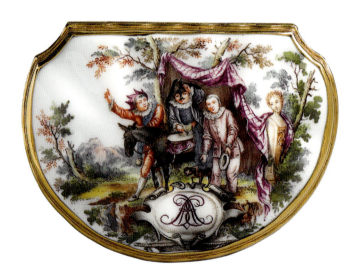

VI.51
Gottfried Bernhard Götz (1708–1774), *Der Geruch* (The Smell), copper engraving from the series *The Five Senses*, Dresden, Staatliche Kunstsammlungen Dresden, Kupferstichkabinett

VI.52
Johann Evangelist Holzer (1709–1740) after Johann Georg Bergmüller (1688–1762), *Cholerica*, etching from the series *Die vier Temperamente als Schäfergruppen und Kostümfiguren in Rocail-le-Ornament*, Vienna, Museum für Angewandte Kunst

Cat. no. 55

SNUFF BOX

Painted c. 1745
With contemporary copper gilt mounts
Height 6.9 cm, width 6.6 cm, depth 4.8 cm

Literature:
Exh. cat. Cologne 2010, p. 196, cat. no. 87

The same form as cat. no. 17. Apart from the inside of the lid and the bottom, which is decorated with a simple leaf-work ornament, all the faces of this snuff box are painted with figural scenes that can be traced back to etchings after paintings by the French Rococo painters Jean-Antoine Watteau (1684–1721) and Jean-Baptiste François Pater (1695–1736). As is so often the case, however, the porcelain painter did not take complete scenes from the prints, but used only certain elements which he placed together to create new compositions, in the process depriving them of their contextual meaning. For instance from the print by Laurent Cars (1699–1771) after the painting *Fêtes Vénitiennes* (see fig. VI.43) by Jean-Antoine Watteau he separated the lady dancing gracefully in front of a cavalier and placed her opposite a man seated on a stone bench playing the bagpipe, who comes from the same picture. For the scene on the front of the snuff box he used only the

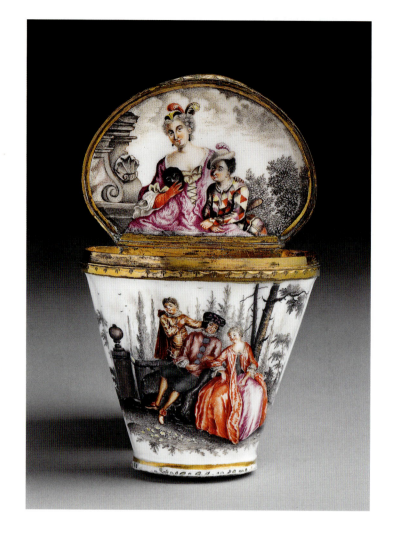

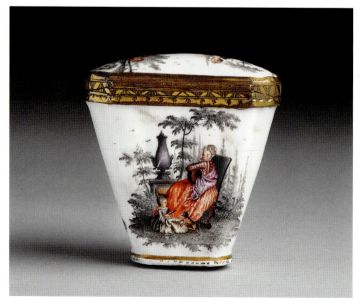

VI.54
Pierre Filloeuil (1686–after 1754), copper engraving after the painting *L'Amour et le Badinage* by Jean-Baptiste François Pater (1695–1736), Dresden, Staatliche Kunstsammlungen Dresden, Kupferstichkabinett

galant couple in the foreground of the reproduction of Jean-Baptiste François Pater's painting *L'Amour et le Badinage* (see fig. VI.54) and seated this pair on a bench, the gentleman standing behind them is not to be found in the painting nor in Laurent Cars's etching and was therefore probably taken from a different context. For the back of the box the painter used the figure of an elegant lady seated on a chair who bends sideways to a girl with a dog taken from a reproduction by Pierre Aveline (1656–1722) after Jean-Antoine Watteau's *Les Charmes de la Vie* (see fig. VI.53).

The picture on the inside of the lid—probably by a different painter than the other scenes—shows a lady wearing a purple crinoline, whom her little feathered hat and black theatre mask clearly identify as *Innamorata*, the woman in love from the *commedia dell'arte*. She lays her hand on the shoulder of a little Harlequin dressed in a diamond-patterned costume and feathered hat who nestles up close to her. The graphical manner in which the pedestal with shell ornament and the trees on the right are painted suggest that this composition, too, is based on an unknown piece of graphic art. UP

VI.53
Pierre Aveline (1656–1722), copper engraving after the painting *Les Charmes de la Vie* by Jean-Antoine Watteau (1684–1721), Dresden, Staatliche Kunstsammlungen Dresden, Kupferstichkabinett

Cat. no. 56

SNUFF BOX

Painted c. 1745
With contemporary brass gilt mounts
Height 6.9 cm, width 6.7 cm, depth 4.9 cm

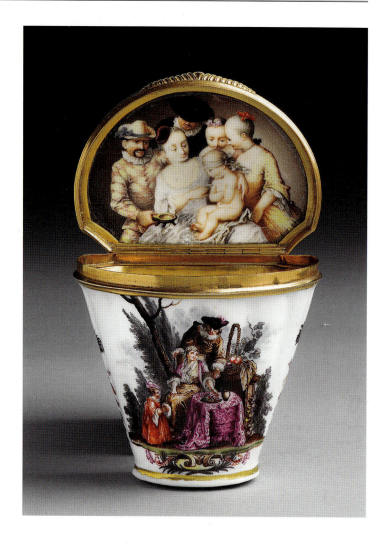

The same form as cat. no. 17. The enthusiasm for *commedia dell'arte* and, equally, for paintings by French Rococo masters were dominant factors in the fashion of society during the first half of the eighteenth century and consequently also influenced the décors of porcelain produced by the Meissen manufactory in this period. Generally, the porcelain painters worked from print reproductions of paintings that offered the requisite motifs of people abandoning their everyday life for the artificial world of the theatre or playing at shepherds in harmony with nature, such as depicted in an idealised fashion by Jean-Antoine Watteau (1684–1721) in his painting *The Embarkation for Cythera*. The scene in the lid of this snuff box shows a number of *commedia* figures gathered closely around a naked, apparently sick child with a piece of cloth tied around its head; they seem concerned to provide the little one with the correct medical attention. Most probably a print with the same composition that might have served as a model for this scene does not exist, as it is very likely that the porcelain painter here combined a number of individual figures from different paintings to create a new composition. For the scene on the outside of the lid he took a similar approach; he detached the figures of Scaramouche and a lady playing a mandolin from the engraving by Gérard Jean-Baptiste Scotin (1698–1755) after the painting *Les Jaloux* (see fig. VI.55) by Jean-Antoine Watteau, and, for the figure of the man standing between them, added *Frileux* (see fig. VI.56) from another picture by the same artist. It has not yet proved possible to identify the prints that served as models for the other scenes, but in stylistic terms they clearly belong to what is known as "Watteau painting," which played a dominant role in the decoration of Meissen porcelain in the first half of the eighteenth century and brought the business immense popularity coupled with economic success. UP

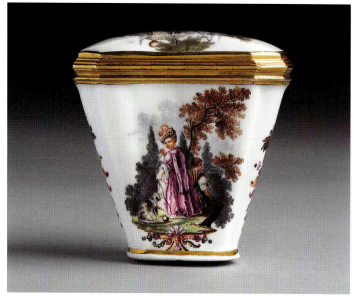

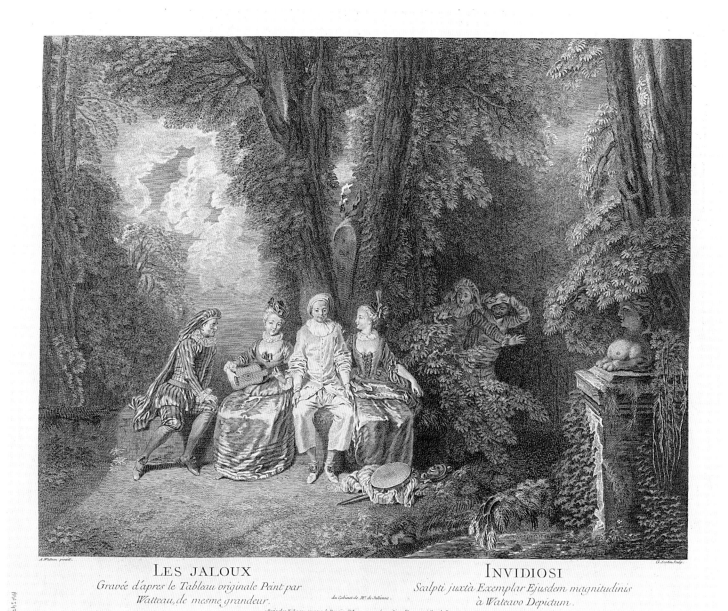

VI.55
Gérard Jean-Baptiste Scotin (1698–1755), copper engraving after
the painting *Les Jaloux* by Jean-Antoine Watteau (1684–1721),
London, British Museum

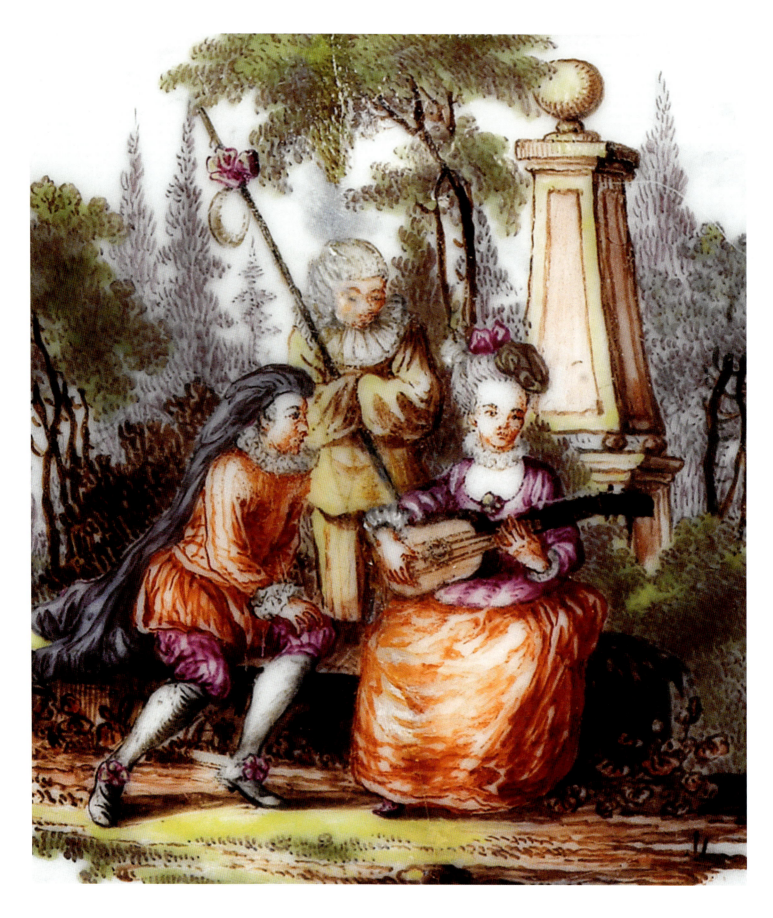

VI.56
Jean Moyreau (1690–1762), copper engraving after the painting *Le Frileux* by Jean-Antoine Watteau (1684–1721), Paris, Bibliothèque des Arts décoratifs, Collection Maciet

Cat. no. 57

SNUFF BOX

Painted c. 1745
With contemporary bronze gilt mounts
Height 7 cm, width 6.6 cm, depth 4.8 cm

The same form as cat. no. 17. This shape of snuff box appears to have been immensely popular, as there are innumerable casts of it decorated in a variety of different ways. Here, for the inside of the lid, the painter chose a charming half-length portrait of a young lady set in an oval that is surrounded by a golden ornament of trailing flowers. This piece was most probably commissioned by a noble gentleman who ordered the portrait of his beloved to be painted on porcelain so as to always have her near. The depiction on the front of the box of a *galant* couple outdoors before a fountain plays with the theme of flirtatious love which was particularly popular in the Rococo era. The children, also set in a park-like landscape, on the back and the lid of the box, who playfully imitate the life of adults, similarly embody this era's ideal of lighthearted freedom, a quality for which daily life in society offered little opportunity. In accordance with the prevailing fashion the painter based his scenes on print reproductions of paintings by Nicolas Lancret (1690–1745) and Jean-Antoine Watteau (1684–1721), from which he adapted various motifs: the dancing couple comes from the painting *Le Jeu de Pied de Beuf* (see fig. VI.58) and the two children from *Les Agréments de la Campagne* (see fig. VI.57). UP

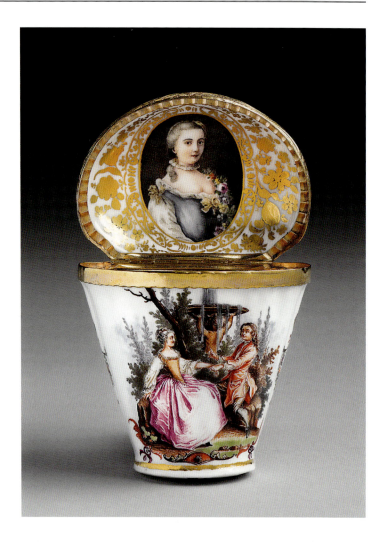

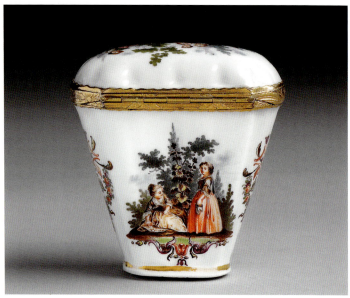

VI.57
François Joullain (1697–1778), etching after the painting *Les Agréements de la Campagne* by Nicolas Lancret (1690–1745), London, British Museum

VI.58
Nicolas IV de Larmessin (1684–1755), etching after the painting *Le Jeu de Pied de Beuf* by Nicolas Lancret (1690–1745), London, British Museum

Cat. no. 58

SNUFF BOX

Painted c. 1760
With contemporary gold mounts
Height 4.1 cm, width 8.6 cm, depth 7.1 cm

Literature:
Exh. cat. Cologne 2010, p. 204, cat. no. 89

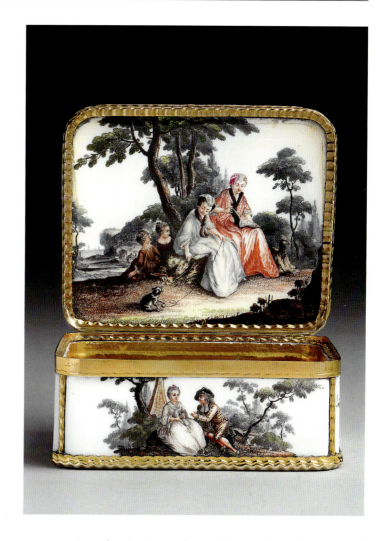

The rectangular snuff box with slightly domed lid and rounded corners shown here is decorated on all sides with *galant* scenes in a park-like setting, made after Jean-Antoine Watteau (1684–1721) and Nicolas Lancret (1690–1745). Whereas the couple on the front of the box was based on the print *Bon Voyage* (see fig. VI.59) by Benoît Audran II (1698–1772) from 1727, after a painting by Jean-Antoine Watteau, the seated courtly couple on the back was taken from François Boucher's (1703–1770) print *Le Repos Gracieux* (see fig. VI.46).

The seated lute player on the right-hand short end of the snuff box was taken from the print *Pour Garder l'Honneur d'une Belle* (see fig. VI.61) by Charles-Nicolas II Cochin (1715–1790). Unlike in the print, here the lady holding her instrument is not seated in front of a monumental stone vase but before a massive column surmounted by a sphere. The opposite side of the box shows a lady standing with her left arm outstretched, probably taken from Nicolas IV de Larmessin's (1684–1755) print *La Belle Greque* (see fig. VI.60) after a painting by Nicolas Lancret. The bottom of the snuff box uses the couple that are shown seated on harbour steps in the print *Le Printemps* (1732) by Etienne Brion (born 1729) after a painting by Jean-Antoine Watteau, now probably lost (see fig. VI.62).

For her catalogue published in conjunction with an exhibition in the Museum für Angewandte Kunst in Cologne in 2010, Patricia Brattig has already identified almost all the prints that served as models (cf. exh. cat. Cologne 2010, p. 204, cat. no. 89). SKA

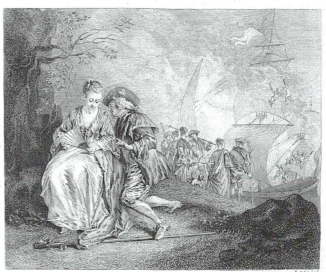

VI.59
Benoît Audran II (1698–1772), copper engraving after the painting *Bon Voyage* by Jean-Antoine Watteau (1684–1721), Paris, Bibliothèque des Arts décoratifs, Collection Maciet

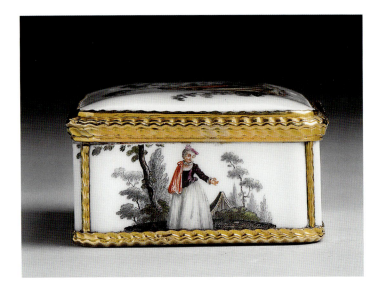
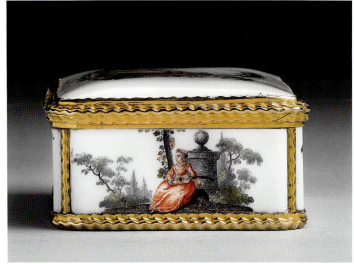

VI.61
Charles-Nicolas II Cochin (1715–1790), etching after the painting *Pour Garder l'Honneur d'une Belle* by Jean-Antoine Watteau (1684–1721), Paris, Bibliothèque nationale de France

VI.60
Nicolas IV de Larmessin (1684–1755), etching after the painting *La Belle Greque* by Nicolas Lancret (1690–1745), Brunswick, Herzog Anton Ulrich-Museum

VI.62
Etienne Brion (born. 1729), etching after the painting *Le Printemps* by Jean-Antoine Watteau (1684–1721), Paris, Bibliothèque nationale de France

Cat. no. 59

SNUFF BOX

Painted c. 1740
With contemporary fire-gilt bronze mounts
bronze mounts
Height 3.9 cm, width 7.3 cm, depth 5.7 cm

This fine rectangular snuff box with slightly rounded corners, a slightly domed lid, and original gilded mounts with a delicate wave and *rocaille* relief has a flat foot ring ornamented with a border of leaves mounted around the base.

All the sides and the top of the lid are decorated with scalloped reserves in which fine figural scenes in the manner of the *fêtes galantes* by Jean-Antoine Watteau (1684–1721) are painted. Various elegantly dressed figures and members of the *commedia dell'arte* stand on island-like surfaces against a background with numerous trees and bushes. The scene on the inside of the lid is differently composed and shows an expansive Arcadian landscape in which, in the right foreground, an elegant couple have seated themselves to play music at the foot of a memorial obelisk. A second lady, standing somewhat to one side, observes the seated couple.

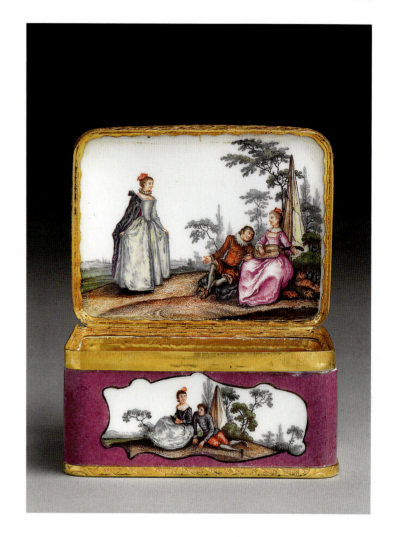

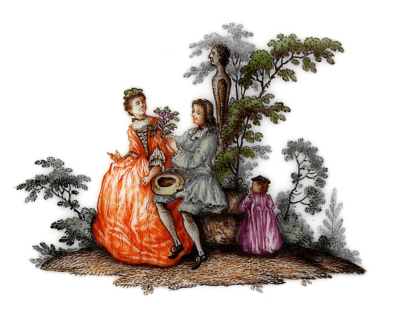

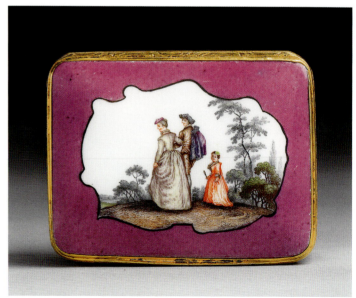

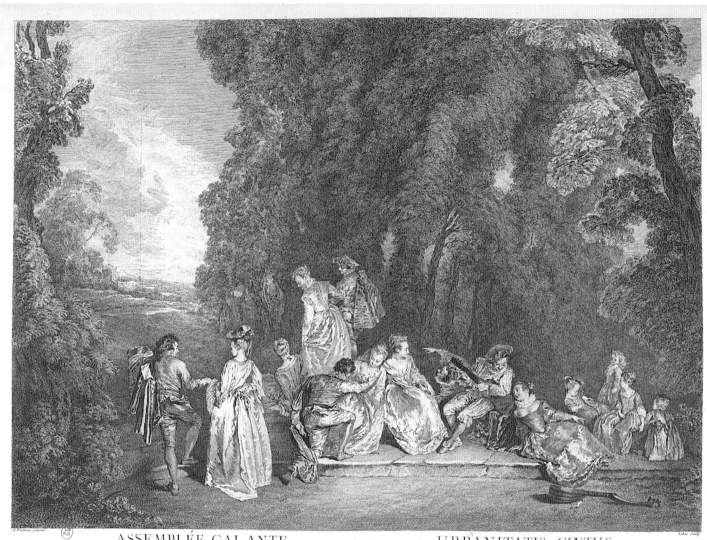

VI.63
Jacques-Philippe Le Bas (1707–1783), etching after the painting
Assemblée Galante by Jean-Antoine Watteau (1684–1721), Paris,
Bibliothèque nationale de France

The miniature on the inside of the lid continues the iconographic programme in the style of Watteau and—concealed inside the box—addresses the typical eighteenth-century yearning to escape the rigid corset of court etiquette. In a Baroque park that combines expansiveness and intimacy the cavalier gives free vent to his feelings. In Meissen regular use was made of prints after paintings of Watteau and around the time this snuff box was made they furnished some of the most popular motifs. Accordingly the Meissen painters very often varied the Watteau motifs and used them in different combinations.

A motif also frequently used and confirmation of the almost inexhaustible source of Watteau models is the pair making music on the inside of the lid, which Charles-Nicolas II Cochin shows in his etching *Pour Garder l'Honneur d'une Belle* (see fig. VI.61) after a Watteau painting (published in Ducret 1973, fig. 242) and is here augmented by a standing lady taken from the painting *Fêtes Vénitiennes* (see fig. VI.43). Further scenes on the outside of the snuff box quote from other print reproductions after Watteau. These are the *Assemblée Galante* (see fig. VI.63) by Jacques-Philippe Le Bas (1707–1783), *L'Odorat* (see fig. VI.64) from the series *The Five Senses* by Gabriel Huquier (1695–1772), and *Leçon d'Amour* (see fig. VI.15) by Gérard Jean-Baptiste Scotin (1698–1755) which dates from 1734. MR

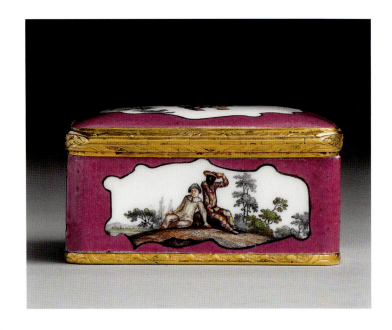

VI.64
Gabriel Huquier (1495–1772), copper engraving after the painting *L'Odorat* by Jean-Antoine Watteau (1684–1721), Paris, Bibliothèque des Arts décoratifs, Collection Maciet

Cat. no. 60

SNUFF BOX

Model by Johann Gottlieb Ehder (1717–1750), 1741
Painted c. 1745
With contemporary copper gilt mounts
Height 4.5 cm, width 8 cm, depth 6 cm

Literature:
Beaucamp-Markowsky 1985, pp. 232f., cat. no. 185

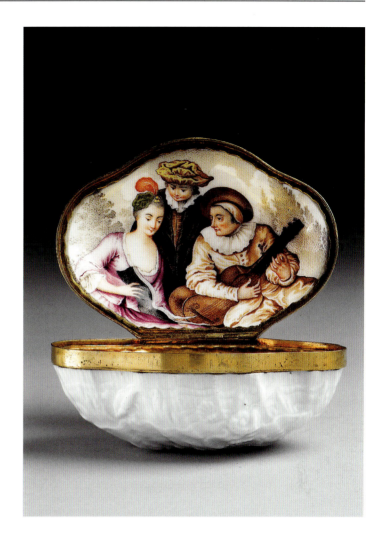

Johann Gottlieb Ehder, who modelled this snuff box that is a quatrefoil in plan, mentions it in his work report from June 1741: "1 snuff box in the form of a seashell with lid, modelled in clay" ("1 Tabattiere in Form einer Seemuschel samt Deckel in Thon bossirt," SPMM, archive, AA I Ab 16, fol. 175). This modeller worked at least some of the time on the large Swan Service for Count Heinrich von Brühl (1700–1763) and was therefore not unfamiliar with marine forms as they provide the basis for the design of numerous porcelain vessels. Consequently it seemed only logical to design a snuff box in the form of an opening shell, whose white surface replicates the typical ribbed structure of an oyster shell encrusted with algae, moss, and barnacles. The only painted scene is on the inside of the lid and shows a group of musicians. On the right of the picture sits Giles with a lace ruff, wide-brimmed hat over a white cap, and holding a guitar, on the left is a lady with a little feather hat holding a song or note-book, while the man standing behind the pair is looking into her book. He wears a beret, a white collar, and a brown coat and clearly represents a singer.

The painter took the two male figures from an etching by Gérard Jean-Baptiste Scotin (1698–1755) after the painting *La Serenade Italienne* (see fig. VI.11) by Jean-Antoine Watteau (1684–1721), whereas the lady comes from a different context. It is conceivable that he was inspired here by the singer in the print *La Leçon de Musique* (see fig. VI.65) by Louis Surugue (1686–1762)—also after Jean-Antoine Watteau. UP

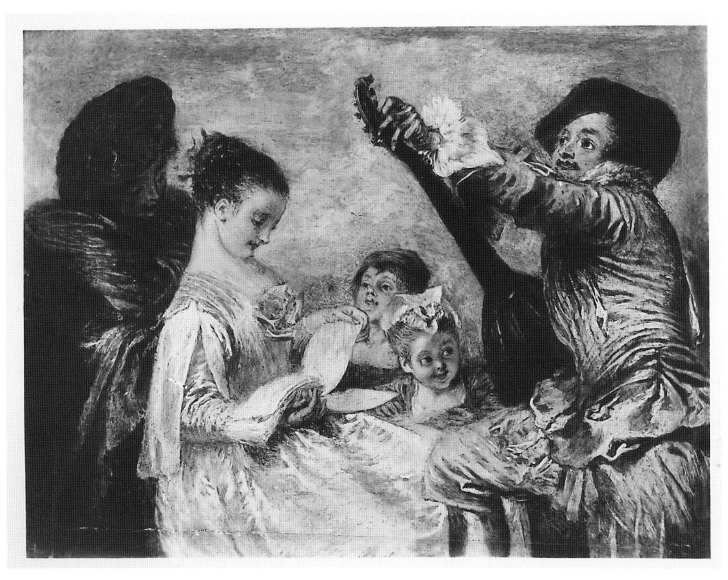

VI.65
Louis Surugue (1686–1762), etching after the painting
La Leçon de Musique by Jean-Antoine Watteau (1684–1721),
Paris, Bibliothèque des Arts décoratifs, Collection Maciet

Cat. no. 61

SNUFF BOX

Probably painted by Johann George
Heintze (born c. 1706/07), c. 1740/45
With contemporary copper gilt mounts
Height 4.5 cm, width 8.8 cm, depth 6.8 cm

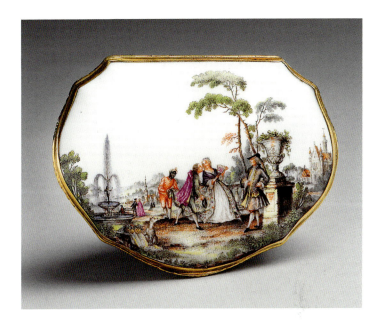

The form is like cat. no. 12. The painting inside the lid and the scenes on the outside of this snuff box, which is gilded completely internally, are by Johann George Heintze. As supervisor of the large painting studio in the Meissen manufactory on the Albrechtsburg until 1745 he could avail of the large number of the prints that had been acquired earlier and frequently used these for his porcelain décors. For instance for the scene on the inside of the lid he made use of an etching by Jean Michel Liotard (1702–1796) after the painting *La Conversation* (see fig. VI.69) by Jean-Antoine Watteau (1684–1721), borrowing almost all the figures from it. Here, as in the print, the scene is dominated by a noble couple standing in the middle, flanked on the left by a gentleman seated on the ground and a Moor wearing a turban and on the right by a group made up of further couples. The painter reduced the group on the right to just two couples opposite each other, but did not forget to include in his miniature depiction the small dog in the foreground standing beside a blanket spread out on the ground. He also introduced other elements that are not to be found in the print: on the left we see a palace with pointed spires and on the right a fountain with stone figures, which was taken from a mezzotint by Jean Simon (1675–after 1754) the painting *Le Midi* (see fig. VI.78) by Nicolas Lancret (1690–1745).

A similar scene to this can be found on a further snuff box in private ownership that was previously on loan to the Rijksmuseum Amsterdam (cf. Beaucamp-Markowsky 1985, p. 122, cat. no. 91).

The composition of the scene on the outside of the lid is taken almost entirely from an etching by Pierre Filloeul (1696–after 1754) after the painting *Le Baiser Rendu* (see fig. VI.66) by Jean-Baptiste François Pater (1695–1736); the only difference is that the chair against the back of which the gentleman on the right rests his lower arm is here replaced by the pedestal of a large stone vase.

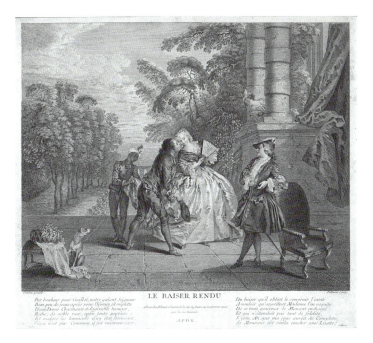

VI.66
Pierre Filloeul (1696–after 1754), copper engraving after the painting *Le Baiser Rendu* by Jean-Baptiste François Pater (1695–1736), Dresden, Staatliche Kunstsammlungen Dresden, Kupferstichkabinett

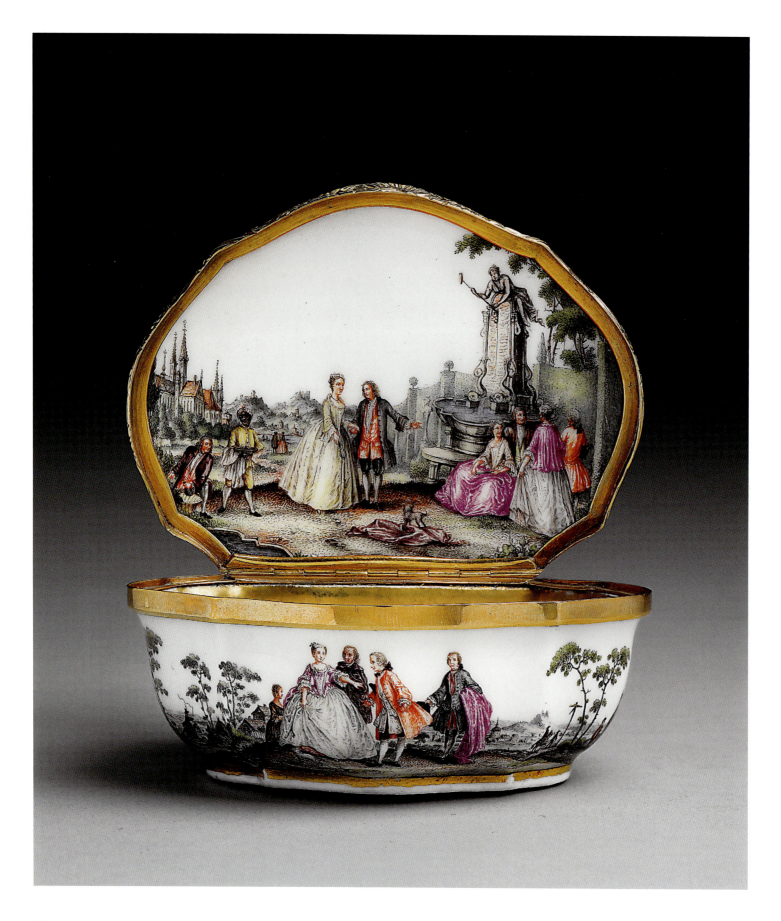

256

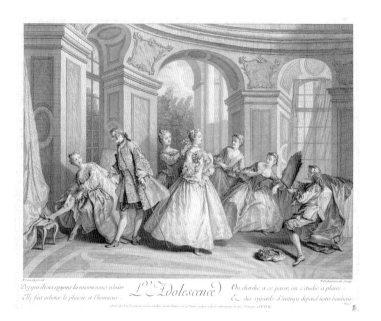

VI.67
Nicolas IV de Larmessin (1684–1755), copper engraving after the painting *L'Adolescence* by Nicolas Lancret (1690–1745), Dresden, Staatliche Kunstsammlungen Dresden, Kupferstichkabinett

VI.68
Georg Friedrich Schmidt (1712–1775), copper engraving after the painting *Nicaise* by Nicolas Lancret (1690–1745), Brunswick, Herzog Anton Ulrich-Museum

VI.69
Jean Michel Liotard (1702–1796), copper engraving after the painting *La Conversation* by Jean-Antoine Watteau (1684–1721), Geneva, Musée d'art et d'histoire

VI.70
Jean Simon (1675–1754), copper engraving after the painting *Le Midi* by Nicolas Lancret (1690–1745), London, British Museum

In contrast, the front of the box shows a compilation of different figures from print reproductions of the paintings *Nicaise* (see fig. VI.68) and *L'Adolescence* (see fig. VI.67) by Nicolas Lancret, which were made by Georg Friedrich Schmidt (1712–1775) and Nicolas III de Larmessin (1640–1725) respectively.

From the first mentioned print Heintze took the lady with outstretched hand, which she extends to be kissed by a gentleman from the print by Larmessin, while the cavalier to whom she makes this gesture in Schmidt's print is moved somewhat further to the right on the porcelain box. The girl behind the lady was also borrowed from the print by Schmidt.

By combining individual motifs from different sources the artist deliberately obscured the provenance of his figures and made it almost impossible for the viewer to trace them. The other *galant* scenes set in idealised landscapes are certainly also based on similar prints.

UP

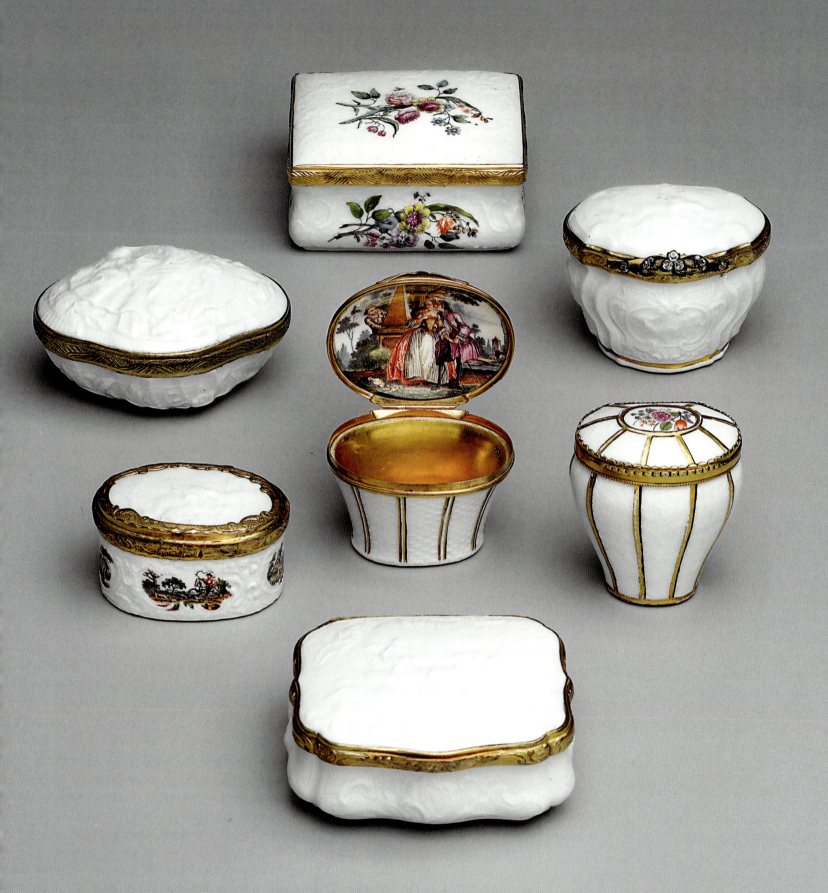

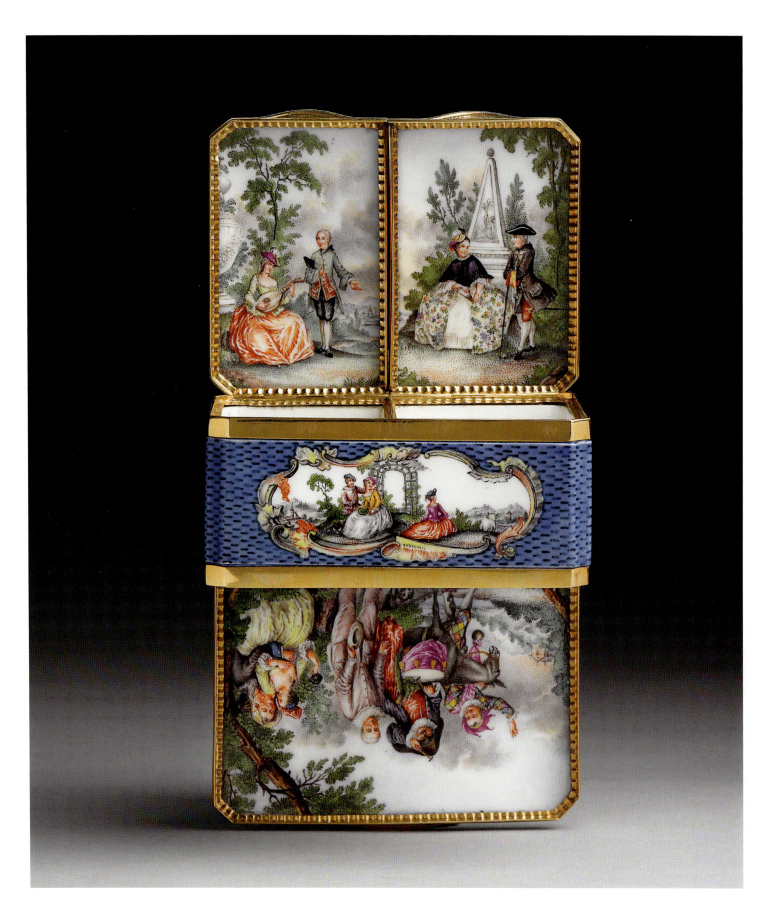

260

Cat. no. 62

TRIPLE SNUFF BOX

Painted c. 1765
With contemporary gold mounts
Height 4.5 cm, width 8.8 cm, depth 6.7 cm

Provenance:
London, Dr. Anton C. R. Dreymann Collection

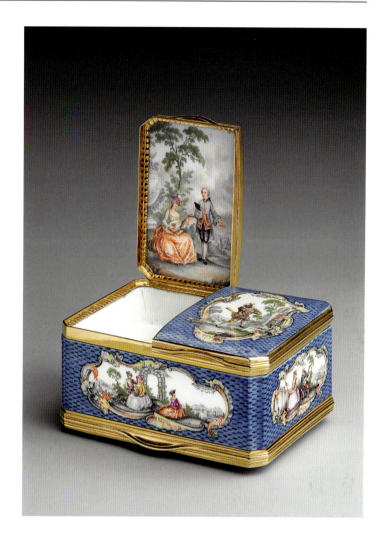

Double snuff boxes for keeping two different kinds of snuff tobacco were frequently produced by the Meissen manufactory (cf. cat. no. 93), and the modeller Johann Joachim Kaendler (1706–1775) created a form of this kind as early 1733. However, he makes no mention in his work reports of a triple snuff box (cf. also cat. no. 114), suggesting that this model was probably produced in the period between 1748 and 1765 for which there are no reports. The blue, so-called mosaic décor that is used as a ground to cover the entire outside of the box, was probably first made between 1763 and 1765 in connection with designs for services made by Frederick II of Prussia himself when he occupied the manufactory in the course of the Seven Years' War (1756–63) and had numerous pieces of porcelain produced for his own use. The reserves made in the ground and framed by irregular *rocailles* contain *galant* scenes in a park-like landscape, while there is a dancing *commedia dell'arte* figure on the top of each of the two small lids: a masked "Harlequine" and a Harlequin with slapstick. On the inside of each of these lids there is a couple in courtly dress in a park, while the inside of the large lid is decorated with a procession of *commedia* figures, a scene borrowed directly from an etching by Simon-François Ravenet (1706–1774) after the painting *Marche Comique* (see fig. VI.72) by Jean-Baptiste François Pater (1695–1736). The painter of the box quotes the Harlequins from a print by Georg Friedrich Schmidt (1712–1775) after the painting *Le Theatre Italien* (see fig. VI.66) by Nicolas Lancret (1690–1745). The slightly naive manner and the somewhat stilted depiction of movement, particularly in the smaller figures, are similar to the style of painting on another triple snuff box (cat. no. 93) that also has a blue mosaic ground. This suggests that the décors of both these boxes can be attributed to the same, unknown painter. UP

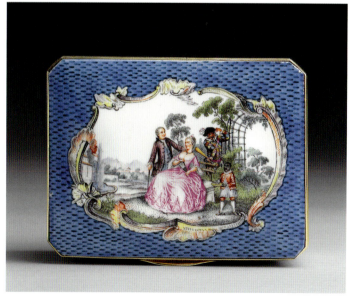

VI.71

Georg Friedrich Schmidt (1712–1775), copper engraving after the painting *Le Theatre Italien* by Nicolas Lancret (1690–1745), Brunswick, Herzog Anton Ulrich-Museum

VI.72
Simon François Ravenet (1706–1774), etching after the painting *Marche Comique* by Jean-Baptiste François Pater (1695–1736), private collection

Cat. no. 63

SNUFF BOX

Probably painted by Gottlob Siegmund Birckner (1713–1771), c. 1745
With contemporary silver gilt mounts,
Height 4 cm, width 8.7 cm, depth 6.7 cm

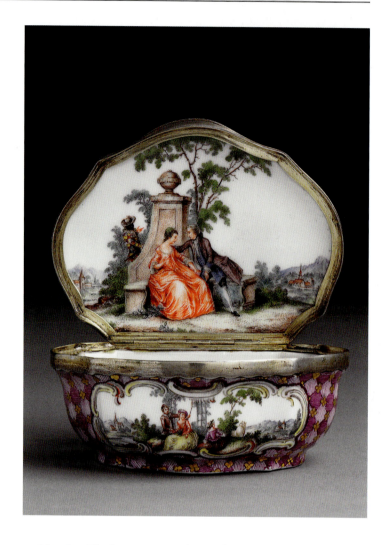

Externally this bellied snuff box in the form of a scalloped quatrefoil is covered with a purple mosaic décor in which *rocaille*-shaped vignettes were made. These contain *galant* scenes showing pairs of lovers in park-like landscapes. Johann Esaias Nilson's (1721–1788) prints *Le Chante* (see fig. VI.73) and *Atalanta* (see fig. VI.74) provided the motifs for the painting on the lid and bottom of the box. The main scene on the inside of the lid is painted with particular artistry and shows a pair of lovers seated on a bench in front of an obelisk. A Harlequin concealed in the shrubbery observes the intimate moment.

"Watteau scenes" along with all their various facets appeared in European painting and decorative arts in the second quarter of the eighteenth century. Around the start of the seventeen-forties chinoiseries and depictions of merchant shipping on Meissen porcelain began to fall out of fashion and their place was increasingly taken by *galant* scenes. The costly snuff boxes offered specialised painters an ideal medium on which to produce the loveliest depictions in this light-hearted genre. "Watteau painting" was carried out in copper-green *en camaïeu* and also—as in this example—using a variety of enamel colours.

The painter Gottlob Siegmund Birckner is known to have been in Meissen from 1726 onwards and in 1731 he is first mentioned as a "painter of coloured flowers." In 1740 Birckner was placed in charge of one of the five painting studios. There are a number of work reports by Birckner from 1744 in the Meissen business archive (unpublished) which state that the painter specialised in "Watteau scenes." According to these he played an important role in the painting of the *Green Watteau Service*, a gift to the King of Naples from the House of Wettin (see cat. no. 40).

After 1740 Birckner was listed in documents as the fourth Watteau painter in the manufactory. In 1745 he was appointed administrator of the manufactory's prints of "Watteau scenes" and battles. Birckner apparently employed his talents in a number of different areas: according to manufactory documents he also painted children, coat of arms, naval battles, hunting décors, peasant scenes, Freemasons, Ovid décors, and "German" flowers (see Rückert 1990, p. 139).

Modelling master Johann Joachim Kaendler probably based the elegantly scalloped form of this snuff box on an original in Dresden made of jasper. In his work reports there is an entry for May 1739, sheets 86r–87v, which reads: "13. A further very fine snuff box modelled in clay after a stone model provided, also sent to the warehouse," ("13. Noch Eine sehr feine Tabattiere [Schnupftabakdose] Nach Einem darzu gegebenen Steinern Modell in Thon poußiret, ebenfalls aufs Waren Laager"; cf. Pietsch 2002, p. 62).

MR

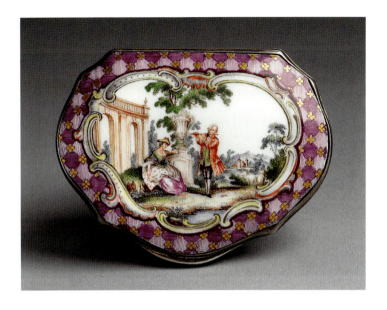
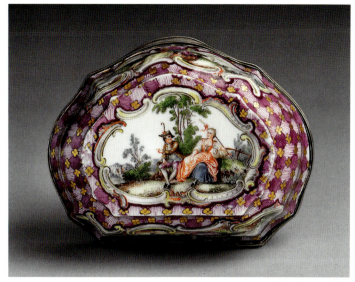

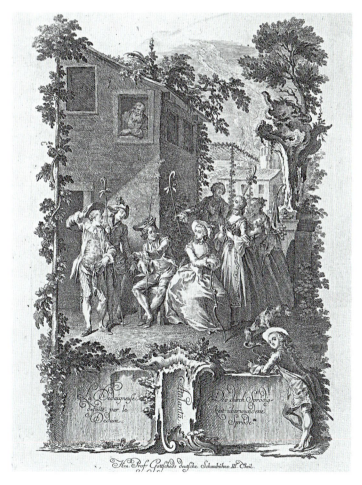

VI.73
Johann Esaias Nilson (1721–1788), *Le Chant,* etching from the series *Zwei galante Konversationsstücke,* Brunswick, Herzog Anton Ulrich-Museum

VI.74
Johann Esaias Nilson (1721–1788), *Atalanta* etching from the series *Gottscheds deutsche Schaubühne III,* Brunswick, Herzog Anton Ulrich-Museum

Cat. no. 64

SNUFF BOX

Form and painting c. 1755
With contemporary copper gilt mounts
Height 5.1 cm, width 6.1 cm, depth 8.1 cm

After the Rococo had finally reached Meissen in the seventeen-forties "Watteau scenes" remained fashionable in Meissen porcelain painting until into the seventeen-fifties and seventeen-sixties. This oval cylindrical box with a slightly domed lid is decorated with sculptural *rocaille* cartouches in relief, painted a purplish red, inside which the painter placed copper-green "Watteau scenes," while filling the areas between the cartouches with naturalistic flowers. For the *galant* scenes he referred back to an earlier form of this painting and, instead of giving the faces a transparent, iron-red skin colour, he painted them green, like everything else. The same applies to the painting on the outside of the lid which, like the polychrome painting inside it, is of a considerably higher quality and was certainly done by a different painter. Both the poses and gestures of the figures in the polychrome genre scenes are somewhat stiff compared to the way in which the lovers on the lid nestle intimately together with a graceful movement that the painter took from the model by Johann Esaias Nilson (1721–1788) with the title *La Musique Pastorale* (see fig. VI.75). UP

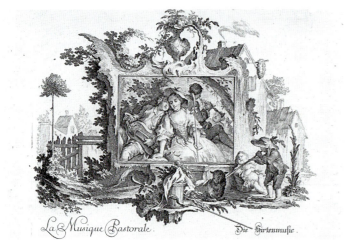

VI. 75
Johann Esaias Nilson (1721–1788), *La Musique Pastorale*, etching, Vienna, Museum für Angewandte Kunst

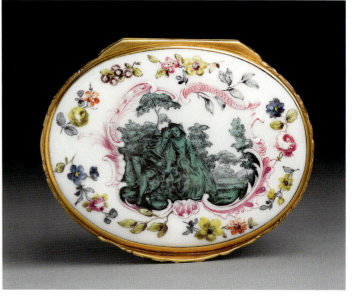

Cat. no. 65

SNUFF BOX

Painted c. 1765
With contemporary red-gold mounts *à cage*
Height 4.5 cm, width 8.5 cm, depth 5.2 cm

Literature:
Exh. cat. Cologne 2010, p. 210, cat. no. 91

The motifs used for the decoration of this elegant rectangular snuff box were provided by prints made after paintings by the French artists Jean-Baptiste François Pater (1695–1736) and François Boucher (1703–1770; published in exh. cat. Cologne 2010, p. 210, cat. no. 91). The scenes are painted in a practiced and harmonious manner using tiny dots of colour and must be attributed to one of Meissen's best painters of snuff boxes. On the snuff box picturesque landscapes were substituted for the original Rococo interiors in the prints, while continuous garlands of flowers on the tiny framed porcelain panels that form the edge of the lid complete the décor. The high quality of the painting is matched by the costly gold mounts in the rare *à cage* manner, which required that the fragile little porcelain panels be inserted with the greatest of care and was reserved for flawless boxes. SKA

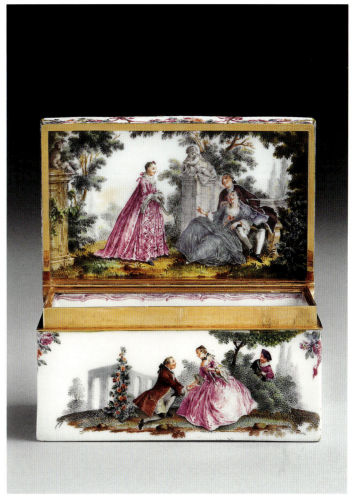

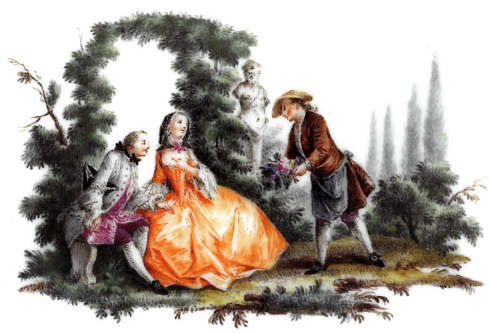

Cat. no. 66

SNUFF BOX

Painted c. 1745–50
With contemporary gold mounts
Height 4.3 cm, width 8.5 cm, depth 6.7 cm

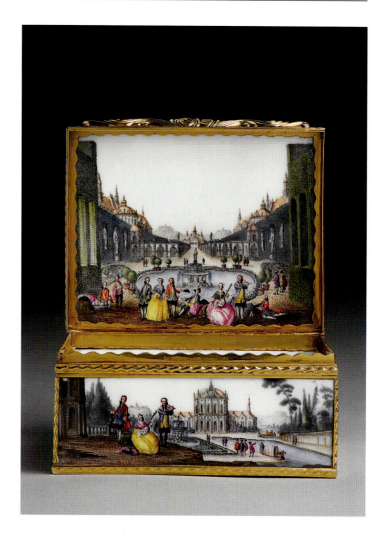

This rectangular snuff box is made from a number of small porcelain panels fitted *à cage*. All the sides are painted with views of Baroque gardens containing palaces and castles from different eras, while the flat-topped hills of the Saxon Elbe Sandstone Mountains appear at places in the background. There can be no doubt that the painter used graphic works as the models for the buildings, possibly also for the rich variety of figures which he certainly did not create entirely from his own imagination. However, it has been possible to identify only two prints by Jan van Call (1656–1703) with the title *De Seswegh by de Faunus* (see fig. VI.79) and *De Fontein van Venus in de grote Thuin* (see fig. VI.76) from the series *Admirandorum Quadruplex Spectaculum*, published in 1715 at Petrus Schenck in Amsterdam whose motifs the porcelain painter integrated in his miniatures. From the first-mentioned of these prints he took the fountain of Venus and on the inside of the lid placed it in a symmetrically laid-out garden that is lined on the left and right by pergolas, while he used the geometrically trimmed hedges from the second print in a further garden on the bottom of the box, but substituted a different figure at the centre of the fountain and placed a palace in the background to terminate the central visual axis. The painter used the print with the hedges a second time in decorating a further snuff box in private ownership (cf. cat. no. 68). UP

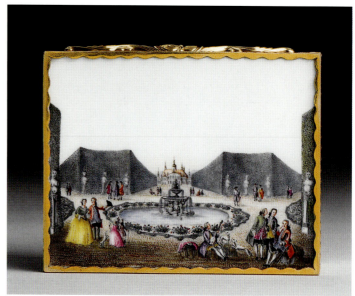

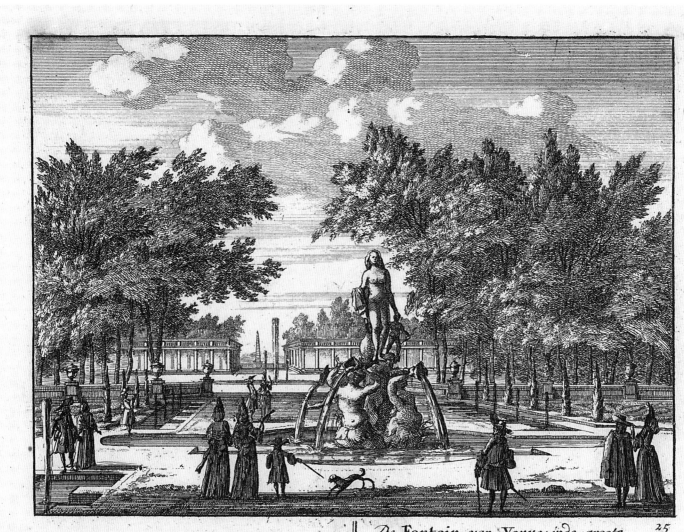

VI.76
Jan van Call (1656–1703), *De Fontein van Venus in de grote Thuin*, copper engraving from the series *Admirandorum Quadruplex Spectaculum*, Amsterdam 1715, Amsterdam, Rijksmuseum, Kupferstichkabinett

Cat. no. 67

SNUFF BOX

Painted c. 1745–50
With contemporary gold mounts
Height 4.2 cm, width 8.6 cm, depth 7 cm

Literature:
Jakobsen/Pietsch 1997, pp. 96ff., cat. no. 63

This rectangular snuff box with a domed lid is painted on all sides, including the inside of the lid, with fantastical architecture set in Baroque gardens and idealised landscapes peopled with numerous figures. The painter quotes individual motifs, such as the Renaissance palace on the front of the box or the symmetrically laid-out cypress garden with stone statues and a fountain on the bottom of the snuff box, from two prints by Melchior Küsel (1626–1683) that present the pleasure gardens of Cardinal de Medici and of Cardinal Mont Alto respectively, and he also borrows elements from the series *Prospecter von Italien, Friaul, Cärnthen* (Prospects of Italy, Friulia, and Carinthia) published in 1684 in Augsburg at Johann Wilhelm Baur. It is likely that he took further individual elements such as statues and palaces from other works of graphic art and mixed these to create colourful pictures with a high decorative quality which reflect the magnificent world of aristocratic society so accurately that the snuff box offered its owner, themselves probably a noble, numerous possibilities for identification. The snuff boxes with the cat. nos. 66 and 68 were decorated by the same painter. UP

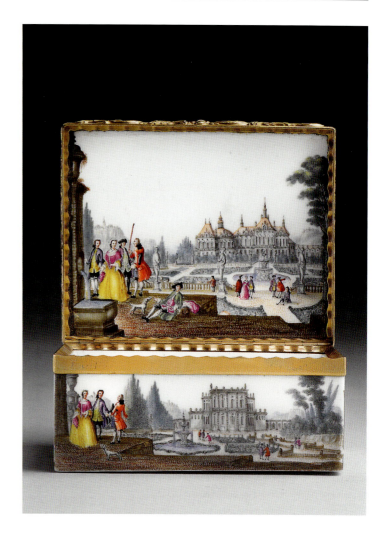

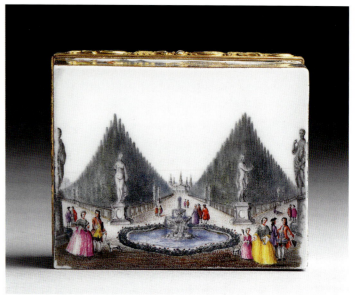

VI.77
Melchior Küsel (1626–1683), *Eine Fontana in dem Lustgarten desz Card. De Medici,* etching from the series *Iconographia* by Johann Wilhelm Baur (1607–1640), Augsburg 1670, Brunswick, Herzog Anton Ulrich-Museum

VI.78
Melchior Küsel (1626–1683), *Prospect von Cipressen in der Vingna desz Card. Mont Alto,* etching from the series *Iconographia* by Johann Wilhelm Baur (1607–1640), Augsburg 1670, Brunswick, Herzog Anton Ulrich-Museum

Cat. no. 68

SNUFF BOX

Painted c. 1745–50
With contemporary gold mounts
Height 3.8 cm, width 8.2 cm, depth 6.3 cm

All the sides of this rectangular snuff box with rounded edges are painted with what are known as "Watteau scenes," which, from around 1740, were used regularly in the Meissen manufactory and were based in terms of motif and style on print reproductions of paintings by Jean-Antoine Watteau (1684–1721) and other French Rococo artists. In the figural staffage used here the tiny size of the figures makes it difficult to identify any possible models. Only the garden dominated by tall hedges with, at the centre, a statue of a female figure in a basin of water could be traced to a print by Jan van Call (1656–1703) with the title *De Seswegh by de Faunus* (see fig. VI. 79) from the series *Admirandorum Quadruplex Spectaculum* published in 1715 at Petrus Schenck in Amsterdam. The painter also included the stone herms in front of the precisely trimmed hedges in his porcelain décor but his figures are very different to those in the print. The cloudy sky in the print is missing here and is absent also from the other scenes on the snuff box, in the background of which we see palaces, castles or churches.
UP

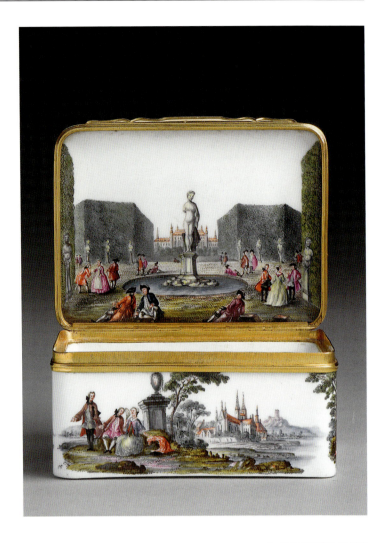

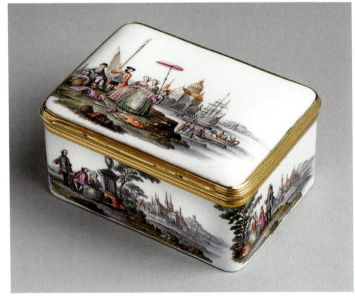

VI.79
Jan van Call (1656–1703), *De Seswegh by de Faunus*
copper engraving from the series *Admirandorum Quadruplex Spectaculum*, Amsterdam 1715, Amsterdam, Rijksmuseum, Kupferstichkabinett

Cat. no. 69

SNUFF BOX

Painted c. 1755
With contemporary silver gilt mounts
Height 4.4 cm, width 7.1 cm, depth 5.4 cm

Literature:
Exh. cat. Cologne 2010, p. 225, cat. no. 99

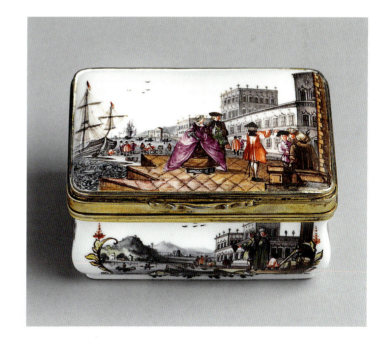

On this rectangular snuff box that bellies outwards near the bottom colourful, park-like landscapes and merchant shipping scenes are combined with carefully executed views of palace façades and castles. Elegant couples, merchants, and nobility, animate the foreground of some of the scenes. The models for the topographies that are painted in considerable detail, in particular the façades shown in perspective on the lid and the front of the box, were provided by the Strasbourg draughtsman Johann Wilhelm Baur (1607–1640), whose work was disseminated through reproductions by the Augsburg engraver Melchior Küsel (1626–1683). As is frequently the case, it is not possible to identify exact models for the painting on the snuff box. Painters in Meissen generally drew on a number of different sources and, like in the snuff box described here, combined elements from each of them to create new compositions. MR

Cat. no. 70

SNUFF BOX

Painted c. 1750–55
With contemporary silver mounts
Height 4.3 cm, width 7.8 cm, depth 6 cm

The rectangular snuff box with rounded corners and a domed lid shows the first indications of the early Romantic style as the rock formations in the idealised landscapes depicted resemble the typical table mountains of the Elbe Sandstone Range, while the palaces and ruins shown were probably freely invented. The only exception is the castle situated on a hill above a river that bears a strong resemblance to the Albrechtsburg, the home of the Königliche Porzellanmanufaktur. On an elevated plateau opposite it the painter placed a group of gentlemen and ladies beside a pedestal with an urn. The landscape here spreads out to the edge of the lid, whereas in the other scenes it ends at hilly islands of terrain from which green plants grow downwards into the white surfaces. These island-like areas are occupied by figures who can be identified by their dress, some appear to be shepherds or herdsmen, others gentlefolk. UP

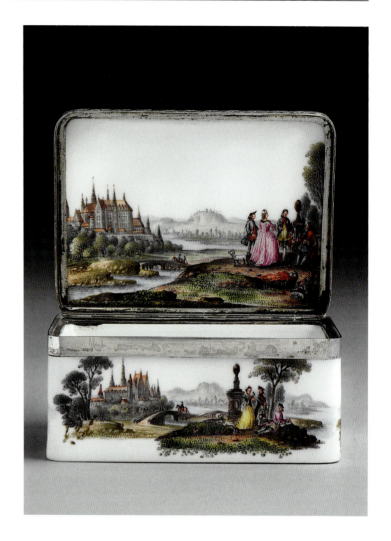

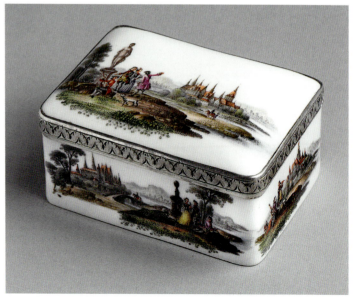

Cat. no. 71

SNUFF BOX

Most probably painted by
Johann Jacob Wagner (1710–1797),
c. 1765
With contemporary gold mounts
Height 4.4 cm, width 7.1 cm, depth 5.4 cm

Literature:
Exh. cat. Cologne 2010, p. 236, cat. no. 104

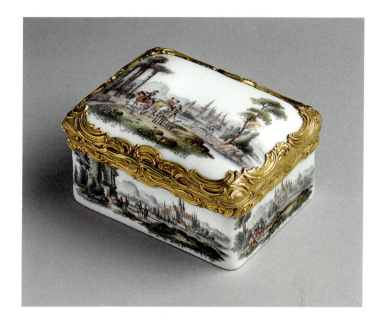

This transverse rectangular snuff box with a slightly domed lid and rounded corners has prominent, ornately worked gold mounts with a distinctive curved thumb-rest.

While the outside of the snuff box shows views of various palaces with figural staffage and landscapes with ruins, on the inside of the lid there is a portrait of a young lady engaged in handicraft. Bent elegantly forwards, she sits on a bergère in the style of Louis XV before an embroidery frame which stands in front of an open window. The combination of motifs from different sources–especially in scenes animated by a number of different figures–was standard practice in the Meissen painting studio. Prints generally furnished the models.

The depiction of the young lady is particularly remarkable, as it employs two sources of completely different origins and yet the composition seems unusually harmonious. In addition to the miniature portrait itself the painting of the carved chair back deserves particular mention, as it forms a harmonious transition to the exceptionally lavish mounts of this porcelain box.

We can assume that this portrait was painted by Johann Jacob Wagner, one of the best miniature masters of his time. He used the basic composition of the print *Amusement du Beau Sexe* (see fig. VI.81) by Johannes Esaias Nilson (1721–1788), replacing its protagonist with the portrait of a young woman doing embroidery (see fig. VI.80) made after an unknown pastel work by Rosalba Carriera (1675–1757). Both her dress and her activity differ from those of the lady with a cat on her lap in Nilson's print.

Wagner was employed from December 1738 in the manufactory and in the staff records for 1786 is still listed as a miniature painter for box lids. In his (incomplete) work reports he mentions paintings on lids that he frequently made after pastels by Rosalba Carriera. Rarely signed, all his works display the same painting style.

SKA

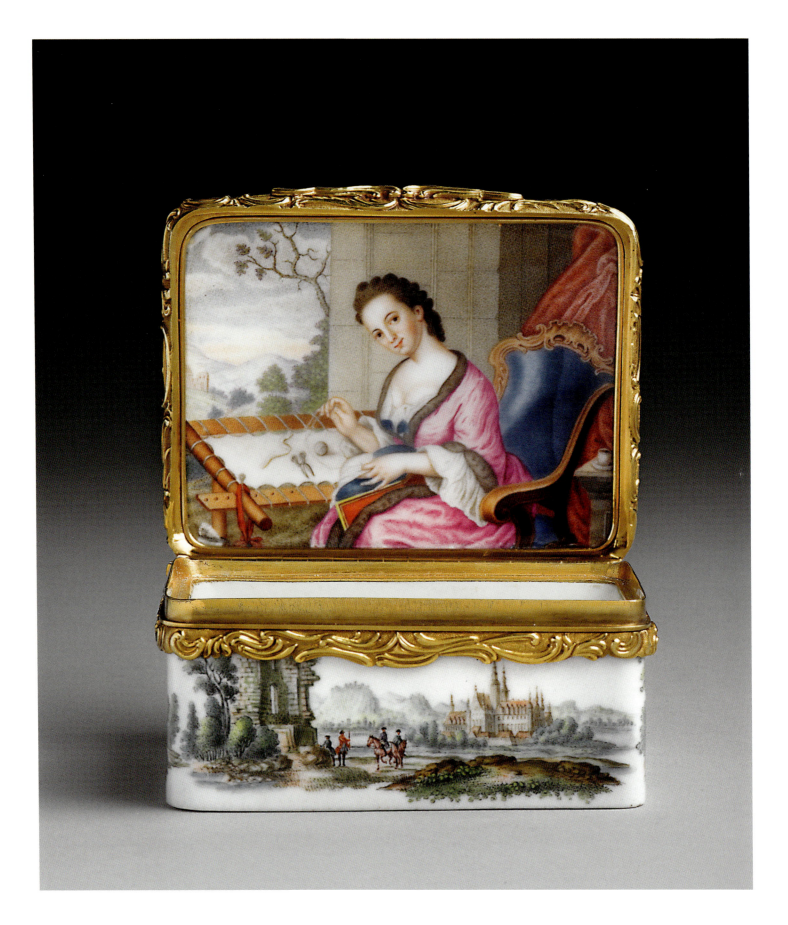

VI.80
Claude-Augustin Duflos the Younger (1700–1786), copper engraving after a portrait by Rosalba Carriera (1675–1757), Paris 1709, London, British Museum

VI.81
Johann Esaias Nilson (1721–1788), copper engraving, *Amusement du Beau Sexe* from the series *Verschiedene Vergnügungen*, Brunswick, Herzog Anton Ulrich-Museum

Cat. no. 72

SNUFF BOX

Painted c. 1755
With contemporary gold mounts
Height 4.6 cm, width 8.6 cm, depth 6.6 cm

Literature:
Jakobsen/Pietsch 1997, p. 269, cat. no. 228

This exceptional rectangular snuff box has slightly rounded corners and a flatly domed lid covered with fine wave and *rocaille* reliefs. The box still has its original gold mounts.

Groups of elegant ladies and gentlemen sitting in expansive park-like landscapes with architectural elements devote themselves to *galant* amusements and gracefully idle away their time. The figures and landscapes are painted in copper-green, the details are drawn in tones of grey and black, the faces and hands are accentuated in flesh shades. The palette on the inside of the lid is enriched with blue, purple, iron-red, manganese, and shades of green: in the foreground a couple dances under a garden pergola in an expansive setting of park architecture, while to the right, beside a column, a further elegant pair is deeply absorbed in conversation.

The scenes on the outside of the box are derived from the genre of the *fêtes galantes* by Jean-Antoine Watteau (1684–1721) and are executed in a kind of glazed monochrome painting newly developed in Meissen, here using copper (oxide) green. This painting technique represents one of the major branches of decoration of porcelain services which entered the literature through the famed "Copper Green Watteau Service." This service was commissioned between 1745 and 1747 by the Electress of Saxony, Maria Josepha, as a gift for her daughter, Maria Amalia Christina (1724–1760) the spouse of Charles III, heir to the Spanish throne and King of the Two Sicilies. The service, most of which is today in the Museo Archeologico Nacional in Madrid, included beside jugs and wash basins, pomade jars, manicure cases, and pin cushions, beside candlesticks, mirrors, and *pots de chambre*, beside coffee, tea, and chocolate services also snuff boxes. However, whereas in the famous service with the alliance coat of arms of Bourbon and the Two Sicilies and the coat of arms of Saxony-Poland the hands and faces are also coloured copper green, on this box these details are emphasised by using their natural colours.

The miniature on the inside of the lid continues the iconographic programme in the style of Watteau and—concealed in the inside of the box—addresses the yearning of the eighteenth century to escape the stiff corset of court etiquette. In the expansiveness and yet intimacy of a Baroque park the dancing gentleman gives free rein to his emotions. This emotional quality is also clearly expressed by the colouring, which distinguishes the miniature on the inside of the lid from the painting on the outside of the box. The manufactory files record that miniature and portrait painters specialised in producing these *tableaus*, as they are known, which are often of superb quality (cf. a snuff box painted with Watteau figures by the same hand published in Jakobsen Pietsch 1997, p. 269, cat. no. 230).

MR

Cat. no. 73

SNUFF BOX

Painted c. 1750–60
With contemporary bronze gilt mounts
Height 4.5 cm, width 9 cm, depth 6.8 cm

Literature:
Cat. Röbbig 2013, cat. no. 47

This snuff box is rectangular in plan with a slightly domed lid and rounded corners. On the outside it is decorated with a purple-violet scale ornament, in which, on all sides except for the bottom of the box, a reserve was made in the shape of cartouche framed by *rocailles*. These reserves contain various *galant* scenes set in parks and painted in copper green, purple-violet, and flesh tones.

From around 1740 the manufactory owned large numbers of reproductions of works by French *galant* artists as well as prints by German engraves such as Johann Esaias Nilson (1721–1788), which provided models and motifs for the painters and modellers. The painting on this box shows variations on motifs after and in the style of Nilson. SKA

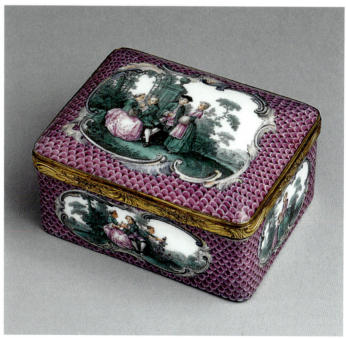

Cat. no. 74

DOUBLE SNUFF BOX

Painted c. 1755–60
With contemporary gold mounts
Height 8.8 cm, length 6.1 cm, depth 3.2 cm

This block-like box whose narrow sides are waisted is completely covered externally with a basket-weave relief over which scattered flowers are painted. The double snuff box has a slightly domed lid at both the top and the bottom. A group of courtly figures is painted on the inside of each lid, shown standing beside a tall deciduous tree in an idealised landscape with the buildings of a city in the background. Further figures stand on the shores of a body of water in the middle ground. This snuff box, which was certainly first painted during the Seven Years' War (1756–1763), offers proof of how long painters at Meissen continued to produce "Watteau scenes," the term used in the manufactory for such depictions of *galant* gentlemen and ladies, which had been extremely popular since as early as the seventeen-forties. UP

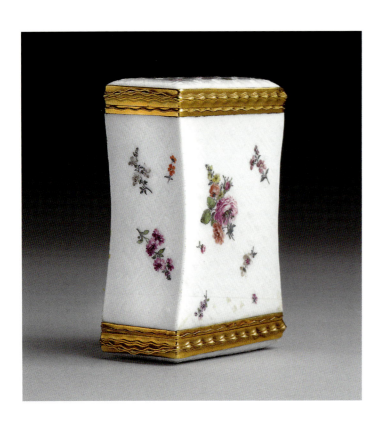

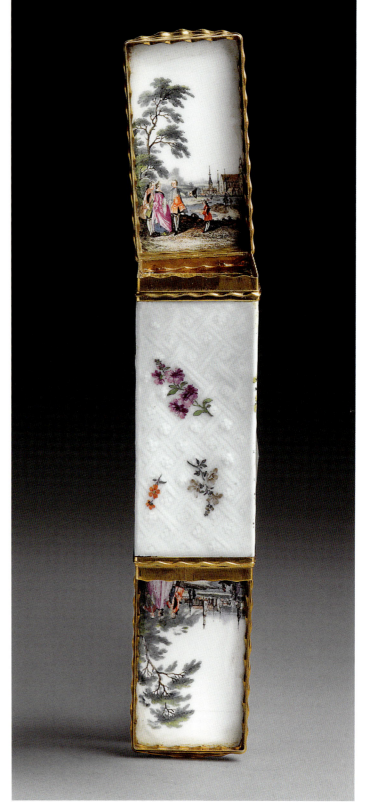

Cat. no. 75

DOUBLE SNUFF BOX

Painted c. 1765
With contemporary copper gilt mounts
Height 6.4 cm, width 7.1 cm, depth 3.6 cm

Each of the openings of this oval double snuff box with cubic sides is closed by a slightly domed lid, on the inside of each lid figures in courtly dress are painted against a background consisting of an idealised landscape with a river, a town, and mountains. The depiction inside the upper lid employs a sentimental motif that reflects a new stylistic direction taken by the Meissen manufactory. It shows a family scene with a lady standing on the left and a gentleman sitting on the right in a wooded landscape, both turn affectionately to their daughter who is placed between them. This expresses a new, more bourgeois understanding of marriage and familial happiness. In a similar vein the figure on the lower lid of a woman holding a burning torch can be seen as a symbol of truth, an ideal more strongly emphasised in the Age of Enlightenment. In contrast, the scene framed by *rocailles* on the front of the box still addresses the themes of the *ancien régime*: falconers on horseback and on foot are presented against the backdrop of a building that is reminiscent of the Moritzburg, the hunting lodge of the Electors of Saxony. UP

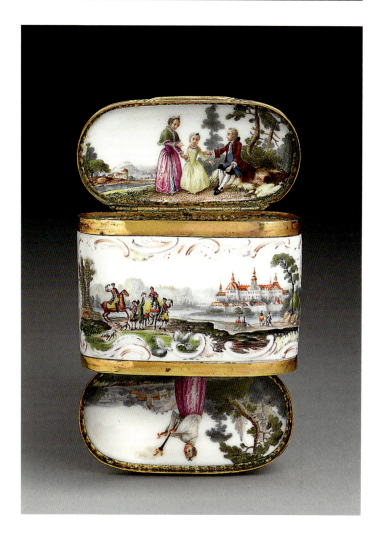

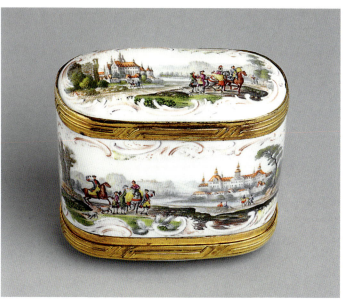

Cat. no. 76

SNUFF BOX

Painted c. 1760
With contemporary gold mounts
Height 3.5 cm, width 7 cm, depth 5.2 cm

Literature:
Helke 2005

This rectangular snuff box with a slightly domed lid has a flat relief on all sides that forms generous cartouches. These are filled with *galant* scenes, the main motifs for which were taken from prints by Johann Esaias Nilson (1721–1788). For instance the strolling couple from the plate with the title *Le Danse Ordinaire* (see fig. VI.82) is found again on the lid of this box, while the woman and child on the bottom of the box are borrowed from a print of series *Cartouches Modernes avec des Diferentes Figures*. The group of figures in an apparently Mediterranean landscape depicted on the inside of the lid is taken in its entirety from a print of the series *Cartouches Modernes a Compagnés par des Enfans* (see fig. VI.83).

The works of the Augsburg miniature painter, engraver and publisher Johann Esaias Nilson enjoyed great popularity in the mid-eighteenth century and were often used in decorative arts of this period. This was due in no small part to the fact that throughout his active life Nilson saw decorative artists as a central target group for his work. That this was, in fact, the case is confirmed by the use of many of his motifs on porcelain pieces from Meissen and other German manufactories. The models were provided by sixty-nine prints that made up a series of engravings which were generally sold in pairs or sets of four consecutive prints.

SKA

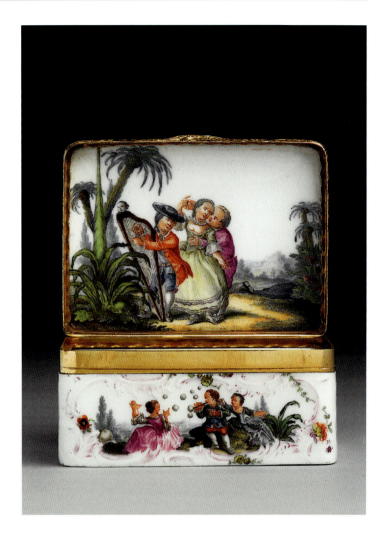

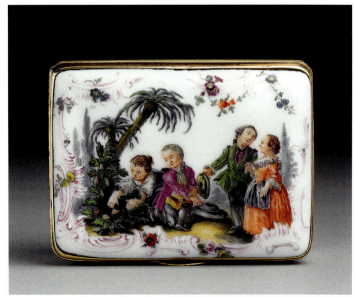

VI.82
Johann Esaias Nilson (1721–1788), *La Danse Ordinaire,* copper engraving from the series *Verschiedene Vergnügungen,* Brunswick, Herzog Anton Ulrich-Museum

VI. 83
Johann Esaias Nilson (1721–1788), *Das Herz hüpft in der Brust […]* copper engraving from the series *Cartouches Modernes a Compagnés par des Enfans,* Brunswick, Herzog Anton Ulrich-Museum

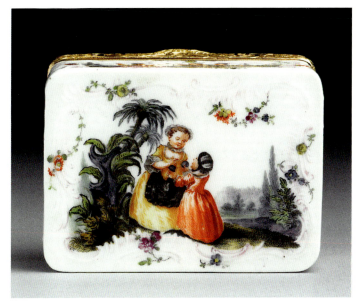

VI. 84
Johann Esaias Nilson (1721–1788), copper engraving from the series *Zwey Äpfel? […]* from the series *Cartouches Modernes avec des Diferentes Figures,* Brunswick, Herzog Anton Ulrich-Museum

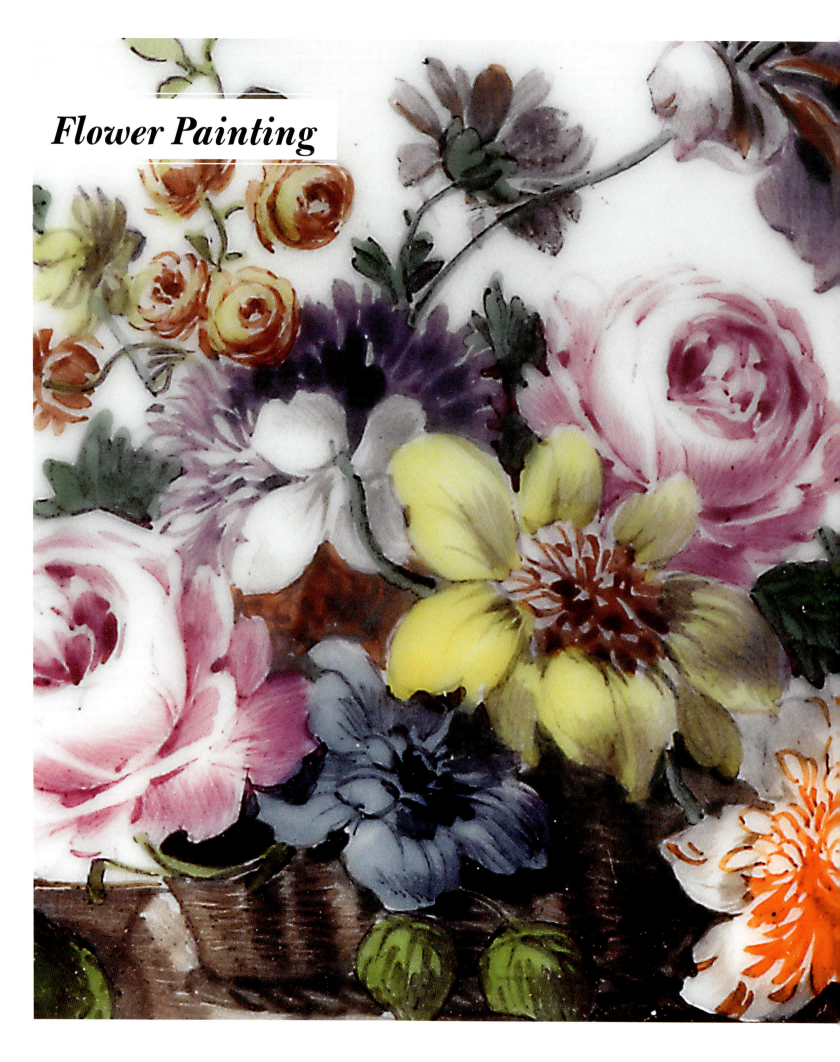

Flower Painting

Cat. no. 77

SNUFF BOX

Painted c. 1730
Crossed swords mark in enamel blue
With contemporary gold mounts
Height 2.5 cm, width 7.3 cm, depth 5.4 cm

Literature:
Exh. cat. Cologne 2010, p. 186, cat. no. 77

Snuff boxes with decoration based on East Asian originals in the style of Japanese Kakiemon décors were rarely produced in Meissen. The crossed swords mark applied on-glaze is concealed inside this delicate, shell-shaped box. The flat form is decorated with strewn *indianische Blumen* in the typical Kakiemon porcelain palette of colours, consisting of colourful chrysanthemums, peonies, and pomegranates. MR

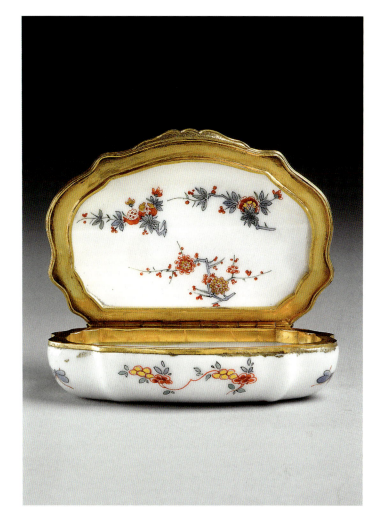

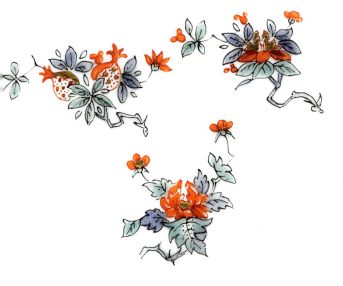

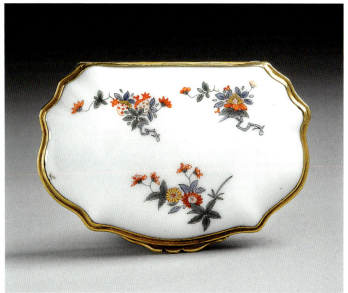

Cat. no. 78

SNUFF BOX

Painted c. 1750
With contemporary bronze gilt mounts
Height 3.7 cm, width 7.1 cm, depth 5.2 cm

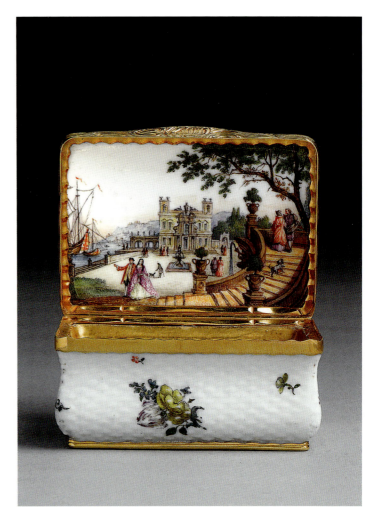

This rectangular bellied snuff box is gilded internally, while the sides and lid are covered with a basket-weave relief and colourfully decorated with scattered, naturalistically painted "German" flowers.

While the body of the box is covered internally in gold, the inside of the lid reveals an expansive coastal landscape with numerous courtly figures before a palace. As well as a large sailing ship and other boats, we can also make out a range of mountains in the background, painted in a delicate blue.

The right foreground is dominated by a large tree above a Baroque flight of steps curving upwards from the left. The steps end at a viewing terrace where an elegant couple has just arrived. Other couples populate the extensive grounds of the palace and the large forecourt, at the centre of which there is a fountain with a large rectangular water basin.

A print by Melchior Küsel (1626–1683) with the title *Lusthoff deß Groß Herzogs von Florenz zu Livorno* that comes from the series *Unterschiedliche Prospecten von Italien, Friaul und Cärnthen* (Different Prospects of Italy, Friulia, and Carinthia) published by Johann Wilhelm Baur, Augsburg 1684, provided the motif for the fine painting that was certainly carried out by an experienced hand hand (see fig. VI.37); it also served as a model for the lid's inside of cat. no. 44. SKA

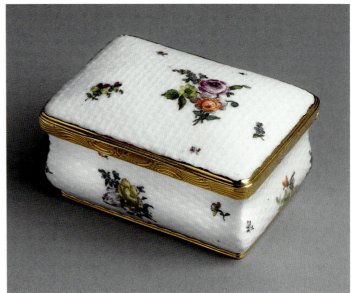

Cat. no. 79

SNUFF BOX

Painted c. 1745–50
With contemporary copper gilt mounts
and decorated with precious stones
Height 5.3 cm, width 6.8 cm, depth 5.2 cm

The same form as cat. no. 46. The sculptural relief décor on the outsides shows various hunting scenes that do not entirely harmonise with the painting on the inside of the lid, which dates from considerably later. A basket lavishly filled with a large rose, a tulip, peonies, sand violets, and other flowers was painted here by an unknown artist who probably borrowed freely from one of the numerous prints of floral still lifes made by Jean Baptiste Monnoyer (1636–1699). The mannered depiction of the flower petals turning this way and that is particularly reminiscent of such originals. UP

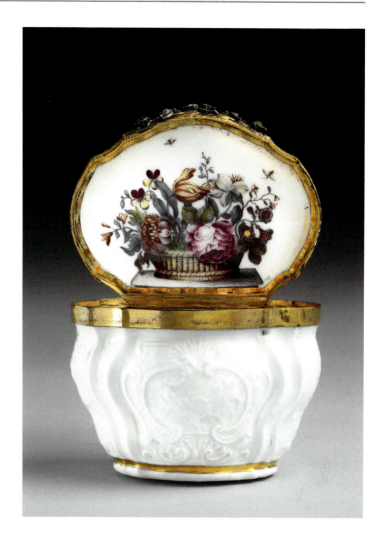

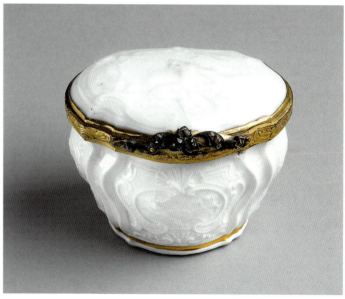

Cat. no. 80

SNUFF BOX

Painted c. 1750
With contemporary gold mounts
Height 4.5 cm, width 8.1 cm, depth 6.5 cm

Literature:
Exh. cat. Cologne 2010, p. 192, cat. no. 84

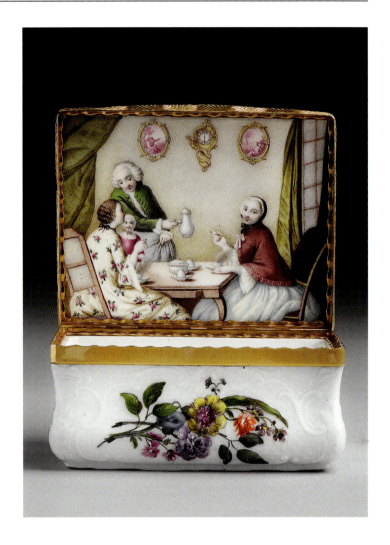

Decorated externally with reliefs and painted with large bouquets of flowers, this snuff box displays on the inside of the lid a scene excellently painted in tiny dots of colour that, at first glance, appears to be based on the painting *Le Déjeuner* by François Boucher (1703–1770).

However, comparisons with Boucher's painting in the Louvre in Paris (inv. no. R.F. 926) reveal distinct differences as regards both the habitus of the figures and the interiors, suggesting strongly that a different (as yet not identified) painting by or after Boucher served as the immediate model.

For instance the little girl in the right-hand foreground of the painting is being offered a spoon by her mother, whose attention is concentrated entirely on her child—in the Meissen version the girl is lacking and the lady's gaze is directed at the viewer. Much the same applies to the figures opposite her—on the snuff box the lady on the left raises her right hand, suggesting she wishes to tell her friend something, whereas in the work by Boucher she turns, holding a spoon in her left hand, to a reticent child on the left. Only the gentleman in the background who carries a silver chocolate pot in his right hand matches the figure in Boucher's painting. Of the elaborate Rococo interior all that remains is a cartel clock flanked by two oval pictures, green curtains draped on the left and right, and a door in which the glass is divided up by glazing beads. MR

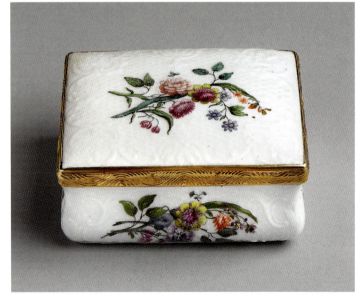

Cat. no. 81

SNUFF BOX

Model by Johann Joachim Kaendler (1706–1775), probably 1742
Painted c. 1745–50
With contemporary copper gilt mounts
Height 4.2 cm, width 7.3 cm, depth 5.8 cm

Literature:
Exh. cat. Cologne 2010, p. 187, cat. no. 78

The model for this quatrefoil-shaped box with a straight edge at the back (cf. cat. no. 12) was first made in the seventeen-twenties; here Johann Joachim Kaendler added a fully sculpted pug to it.

There are a number of different forms of "pug boxes" by Kaendler in existence (cf. cat. nos. 105 and 106), making it difficult to precisely relate the surviving examples to the pieces described in his work reports. We can distinguish between snuff boxes with a pug resting on the lid and those in which the lid itself consists of a recumbent pug, but the boxes are of different shapes, i.e. rectangular, quatrefoil, or oval. The model of the present box appears to have been made by Kaendler in January 1742: "a large snuff box for His Excellence, Cabinet Minister Count Brühl [Heinrich Graf von Brühl, 1700–1763, Saxon-Polish prime minister] with a pug dog on the lid, finished in clay and given a naturalistic appearance […] A further snuff box for the same and also with a pug dog, corrected and finished." (SPMM, archive AA I Aa 28, sheets 74r–75r, quoted from Pietsch 2002, p. 88).

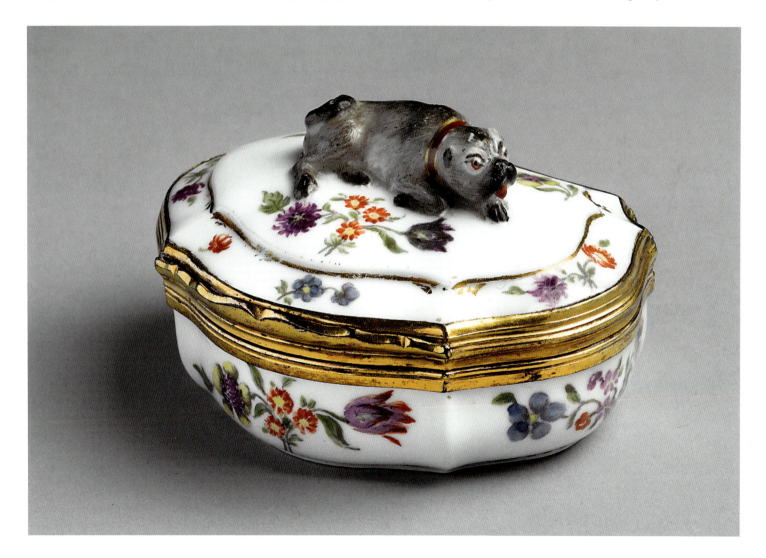

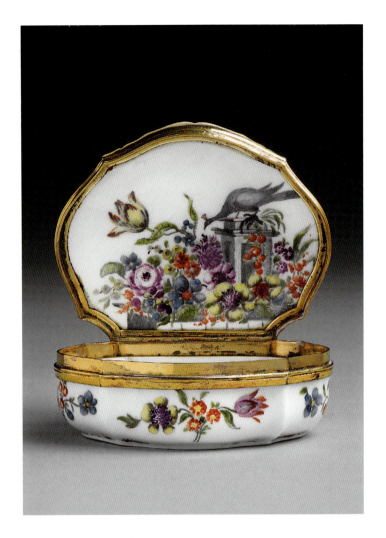

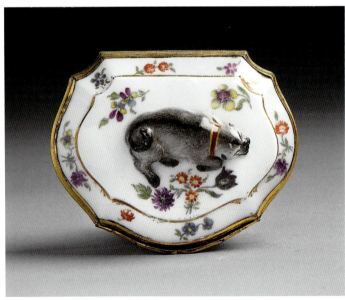

The dog, which is decorated with colour, lies with its muzzle open and tongue hanging out on a slightly raised plate on the lid where it is surrounded by painted flowers, which are found also on the other surfaces of the box, including the bottom, either in the form of strewn flowers or bound together in bouquets. In contrast the inside of the lid—probably decorated by the same artist—presents an entire floral still life, out of which a grey pedestal emerges on the right. A peacock, also grey, that has alighted on this pedestal bends its head low to a purple peony.

The attractiveness of this snuff box is derived less from the painting and far more from the sculptural decoration. The pug was, after all, the fashionable animal of court society in the eighteenth century and the commissioner of the pug boxes, Heinrich Count von Brühl, even had his favourite dog depicted, life-size, in porcelain in 1743 (Marianne Aschenbrenner Stiftung, Garmisch-Partenkirchen, cf. Pietsch 2000, p. 223, cat. no. 168; see fig. VI.11). UP

Cat. no. 82

SNUFF BOX

Model by Johann Joachim Kaendler (1706–1775), 1741
Painted c. 1750
With contemporary copper gilt mounts
Height 3.6 cm, width 6.9 cm, depth 5 cm

In October 1741 Johann Joachim Kaendler modelled "for Countess Khevenhüller [spouse of Ludwig Andreas von Khevenhüller, Austrian Field Marshal] a new snuff box […] in the dimensions required and decorated with basketwork, as the snuff boxes she had received were far too large" (SPMM, AA I Ab 16, sheets 272r–273r; quoted from Pietsch 2002, p. 83). This description could possibly apply to the present snuff box, the entire outside of which is decorated with a basketwork relief. However this piece was painted by an unidentified artist at a considerably later date using flowers, strewn individually or bound together to form little bouquets, while he decorated the inside of the lid with a magnificent floral still life arranged in a basket. For this he probably drew on prints by Jean Baptiste Monnoyer (1636–1699), altering them freely to suit his own approach. He also abandoned the mannered style of the twisted petals in the original prints in favour of a far more naturalistic depiction. UP

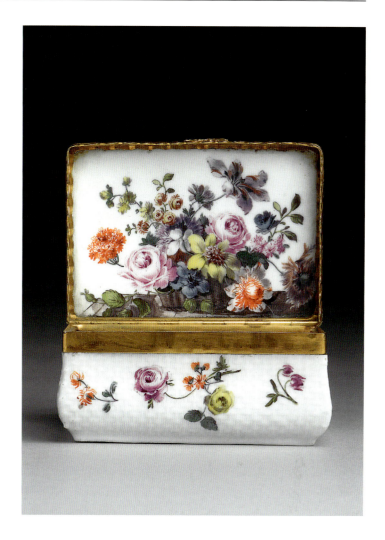

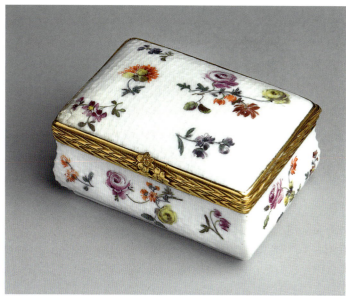

Cat. no. 83

SNUFF BOX

Painted by Johann Jacob Wagner (1710–1797),
c. 1740
With contemporary bronze gilt mounts
Height 4.8 cm, width 8.1 cm, depth 5.6 cm

Literature:
Cat. Röbbig 2013, cat. no. 44

This snuff box is a trefoil in plan with bellied sides and a slightly domed lid. The painting of what are known as *Manierblumen* (lit. mannered flowers) and insects on the outside of the box is of an unusually high quality, while the miniature on the inside of the lid shows a procession of three *commedia dell' arte* figures with a donkey. They are accompanied by a further group at the edge of road: a lady with two men, probably also members of a *commedia* troupe, who are admiring her charms in a very physical and most unseemly manner. This scene, painted in fine dots of colour and inserted in a landscape, could possibly have been carried out by the excellent Meissen painter of miniatures, Johann Jacob Wagner (1710–1797), after a print with the title *La Marche Comique* (see fig. VI.72) by Simon François Ravenet (1706–1774), which in turn can be traced back to a painting by Jean-Baptiste François Pater (1695–1736) that is in the Frick Collection in New York. SKA

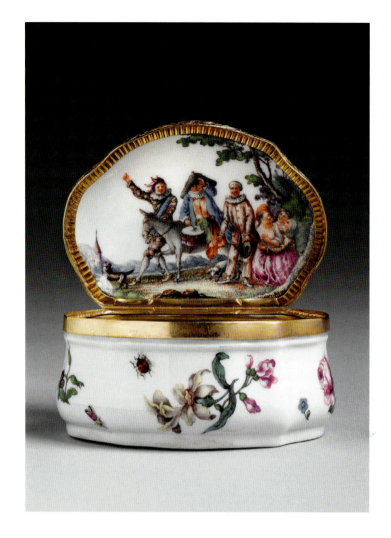

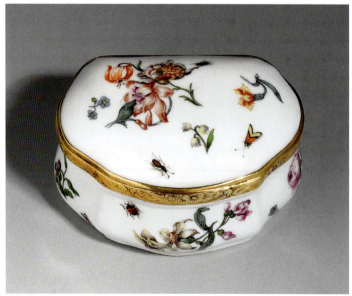

Detail from fig. VI.72

Ornithologic Depictions and Mythical Creatures

Cat. no. 84

SNUFF BOX

Painted c. 1765
With contemporary metal gilt mounts
Height 5.3 cm, width 9.7 cm, depth 8.2 cm

The cartouches on the outsides of this rectangular snuff box are framed by sculptural *rocailles* in relief, painted in transparent iron-red and yellow. On the smooth surfaces of the cartouches and the inside of the lid colourful birds are shown perched on rails or branches of trees, crouching on the ground or flying through the air. The background in each scene is formed by a landscape, painted in grey, with single buildings. The combination of domesticated birds such as ducks, chickens, pigeons, and turkeys with native wild birds such as herons, magpies, golden orioles, pheasants, green and great spotted woodpeckers, as well as more exotic species such as parrots and canaries is most curious. Although their colourful plumage gives them a naturalistic appearance the birds here are solely intended to serve decorative purposes rather than as subjects for ornithological study. UP

Cat. nos. 85 and 86

SNUFF BOX (cat. no. 85)

Painted c. 1765
With contemporary copper gilt mounts
Height 5.4 cm, diameter 6.4 cm

Provenance:
Helmut Joseph Collection

Literature:
Beaucamp-Markowsky 1985, p. 178, cat. no. 136; exh. cat. Cologne 2010, p. 195, cat. no. 86

SNUFF BOX (cat. no. 86)

Painted c. 1765
With contemporary copper gilt mounts
Height 5.3 cm, diameter 6.2 cm

Following the seizure of the Meissen manufactory by Frederick II of Prussia during the Seven Years' War (1756–63) the influence of the French porcelain manufactory Sèvres gradually increased and decorative depictions of birds became part of the repertoire of the painters in Meissen also. During this period numerous dinner services produced by the Saxon manufactory were decorated

with motifs of this kind. For instance the work reports of the painters Samuel Wilhelm Mann (1726–1799), Christian Lindner (1728–1806), and Justus Israel Hartwig (1718–1772) reveal that between 1765 and 1767 they were frequently occupied in painting birds (SPMM, archive, AA I Ab 40–43). The latter two were named in 1768 as the best avian painters (cf. Rückert 1990, p. 154), and one of them may have painted these round snuff boxes with bellied sides.

The painter placed his groups of brightly plumaged birds on a base formed by a piece of ground that, on the sides of the snuff boxes, is edged at the bottom by rather stiff *rocailles;* in the landscape behind a church can be made out. The *galant* scenes so popular in the first half of the eighteenth century are no longer found on snuff boxes in the era of Pietism; however the billing and cooing doves still suggest erotic allusions from earlier times.

UP

Cat. no. 87

SNUFF BOX

Painted c. 1765
With contemporary gold mounts
Height 5.4 cm, diameter 6.3 cm

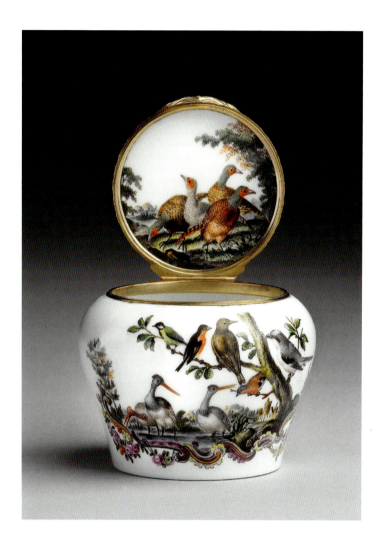

After 1763, when the Meissen manufactory gradually began to recover from the occupation by Frederick II during the Seven Years' War (1756–63), a stylistic change of direction was introduced, effected largely by the founding of an art school and the appointment of Christian Wilhelm Ernst Dietrich (1712–1774) as head painter in 1764. Dietrich, a friend of the art theorist Johann Joachim Winckelmann (1717–1768), attempted to reform the art of porcelain painting so that it matched more the style of Louis XVI or of classical antiquity. At this time his attempts met with only limited success, as the manufactory initially turned to décors from the manufactory in Sèvres, which through its figural motifs based on paintings and designs by François Boucher (1703–1770) was providing the manufactory in Meissen with stiff competition. The success of Sèvres also led the Meissen manufactory to take up a special kind of bird painting that combines exotic and native birds and presents them perched on branches or crouched in groups on the ground against a banal landscape, with, as a base, an area of grass that is edged at the bottom by stylised *rocailles*. The painter devoted particular attention to the picture in the lid that shows a host of ring-necked pheasants and may have been intended to cheer the heart of a huntsman as the owner of the snuff box. UP

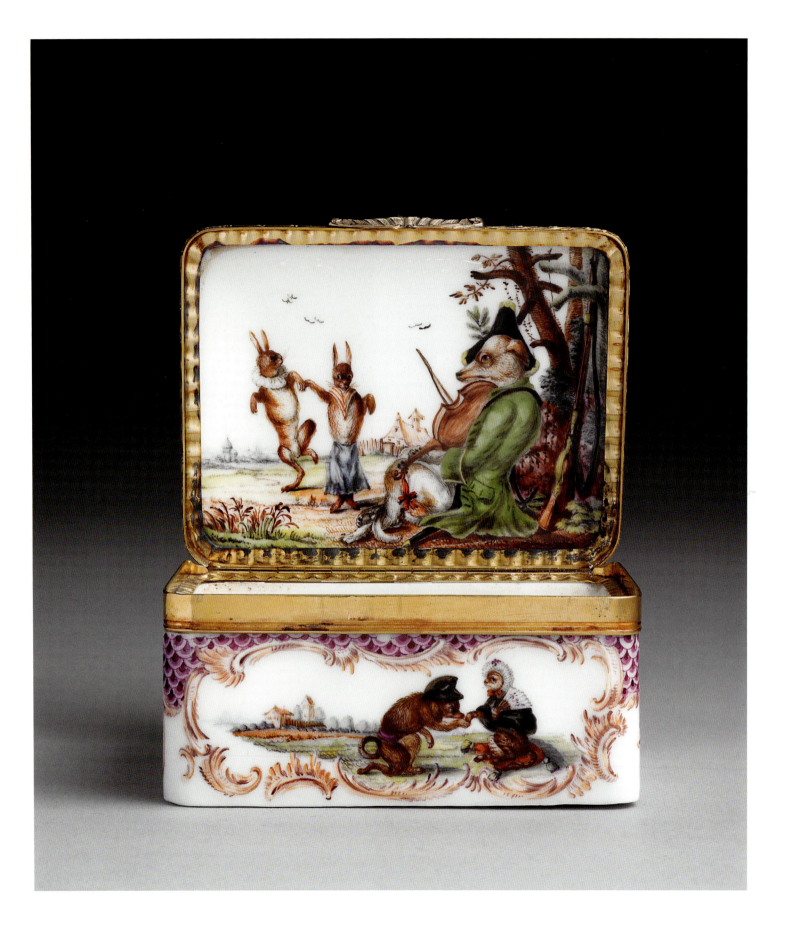

300

Cat. no. 88

SNUFF BOX

Painted c. 1765
With contemporary bronze gilt mounts
Height 4.4 cm, width 8.5 cm, depth 6.6 cm

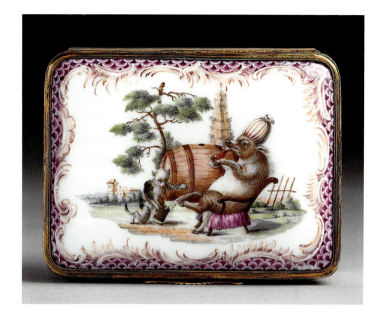

All the the sides of this rectangular snuff box with a domed lid are decorated with landscape vignettes whose *rocaille* frames divide the box into two parts: while the upper part was covered with a violet-coloured mosaic scale décor, on the lower part the area outside the scrolls of the frame was left undecorated. The cartouches contain lively animal scenes, probably based on Jean de la Fontaine's animal fables.

The main scene on the inside of the lid shows a fox, dressed as a hunter, playing the fiddle while a pair of hares dances behind him, one wearing a ruffle, the other a skirt and shawl. The other scenes also show animals satirically imitating aspects of human behaviour: a pair of apes in courtly dress exchange a hand kiss, there is a fox wearing a wig, a hare dressed as a gardener and, as the highpoint, a wild boar sitting on a bergère drinking beer or red wine, who relieves himself into a tankard held by a kneeling cat.

These original depictions are typical of the décors from the Meissen manufactory in the second half of the eighteenth century. The animal fables by Jean de la Fontaine (1621–1695), which appeared in 1668 under the title *Fables choisies, mises en vers par M. de La Fontaine*, were among the most popular works of classic French literature. Widespread use of his memorable and instructive tales was made in the visual and decorative arts of the Baroque and Rococo periods. The motifs reached the painting studios of the Meissen manufactory in the form of prints and were also used to decorate dinner services and solitaire or cabaret services.

A further snuff box with animal fable motifs is depicted in Beaucamp-Markowsky 1985, cat. no. 141. SKA

Hunting and Bataille Scenes

Cat. no. 89

SNUFF BOX

Manufactured 1722–23
Painted by Johann George Heintze (born c. 1706/07), c. 1740
"K.P.M."-mark in underglaze blue and
crossed swords mark in underglaze blue
inside under the gilding (in use from
December 1722 to April 1723)
With contemporary gold mounts
Height 2.5 cm, width 6.8 cm, depth 4.7 cm

Literature:
Jakobsen/Pietsch 1997, pp. 100f., cat. no. 64

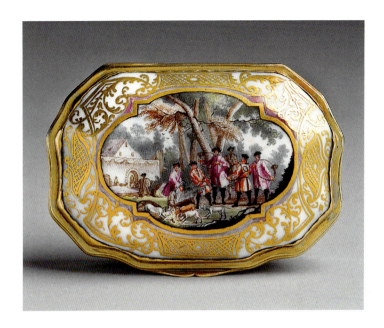

This box in the form of a scalloped quatrefoil with a straight edge at the back and bellied sides is closed by a domed lid, flattened at the top, with gold mounts. The container, which is gilded completely internally, has rich golden leaf- and lattice-work ornament on the outside that is interrupted on each of the four sides by a quatrefoil cartouche containing hunting and merchant shipping scenes painted purple *en camaïeu*.

For the hunting scenes in the three polychrome main views on the inside and outside of the lid and on the base the painter borrowed from prints by Johann Elias Ridinger (1698–1767): *Wie die Hunde ihr recht bekommen oder gepfneischt werden* (see fig. VI.85; outside of lid), *Wie die Rehe in Nezen oder Garn gefangen werden* (see fig. VI.86; inside of lid) and *Wie die Jagd angeblasen wird* (see fig. VI.87; base). He used these sources in different ways; from one plate he took only half of the figural staffage and the entire background, from a second the entire composition including the landscape, and from a third only the group of figures on the left, in addition he gave the scene a completely different background with hunting tents and huntsmen. This illustrates the oft-noted tendency of porcelain painters in Meissen to use such prints just as inspiration and to take from them only individual elements, which they then placed in a new context. These different borrowings could hardly be traced by outsiders and also relieved the painters of the need to constantly invent their own new motifs. A snuff box with the same motif, however shaped differently, is housed in the Bayerisches Nationalmuseum, Munich, Ernst Schneider Foundation, Schloss Lustheim, inv. no ES 2185.

UP

VI.85
Johann Elias Ridinger (1698–1767), *Wie die Hunde ihr recht bekommen und gepfneischt werden*, copper engraving from the series *Der Fürsten Jagd-Lust*, Augsburg 1729, Dresden, Staatliche Kunstsammlungen Dresden, Kupferstichkabinett

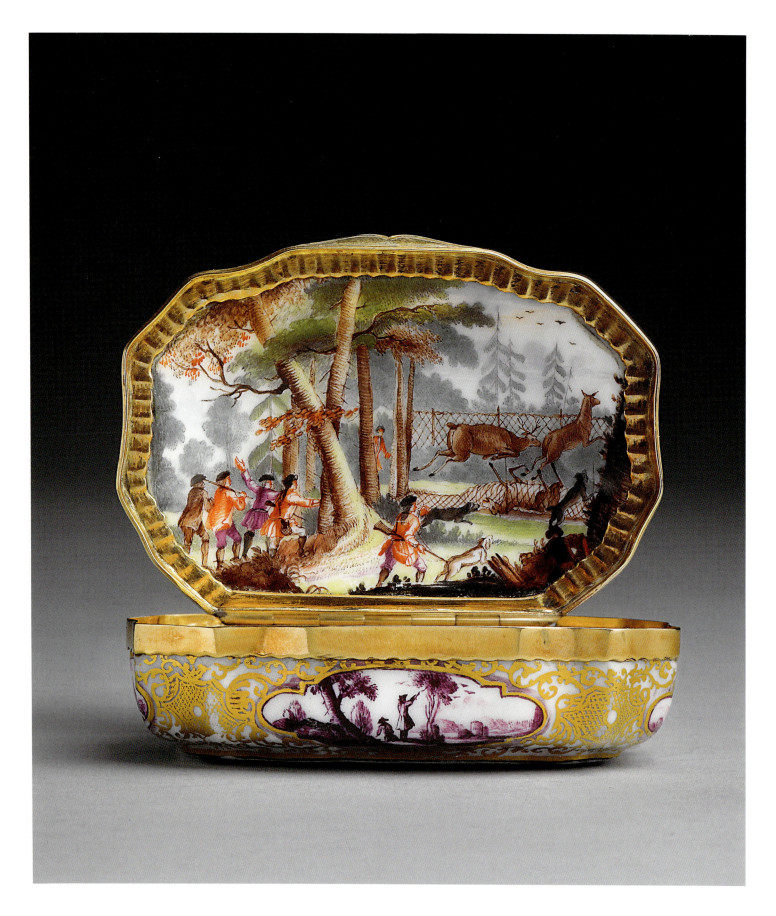

VI.86
Johann Elias Ridinger (1698–1767), *Wie die Rehe in Nezen oder Garn gefangen werden,* copper engraving from the series *Der Fürsten Jagd-Lust,* Augsburg 1729, Dresden, Staatliche Kunstsammlungen Dresden, Kupferstichkabinett

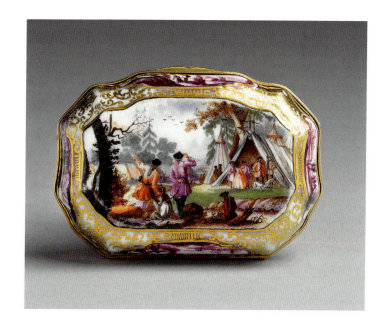

VI.87
Johann Elias Ridinger (1698–1767), *Wie die Jagd ausgeblasen wird,* copper engraving from the series *Der Fürsten Jagd-Lust,* Augsburg 1729, Dresden, Staatliche Kunstsammlungen Dresden, Kupferstichkabinett

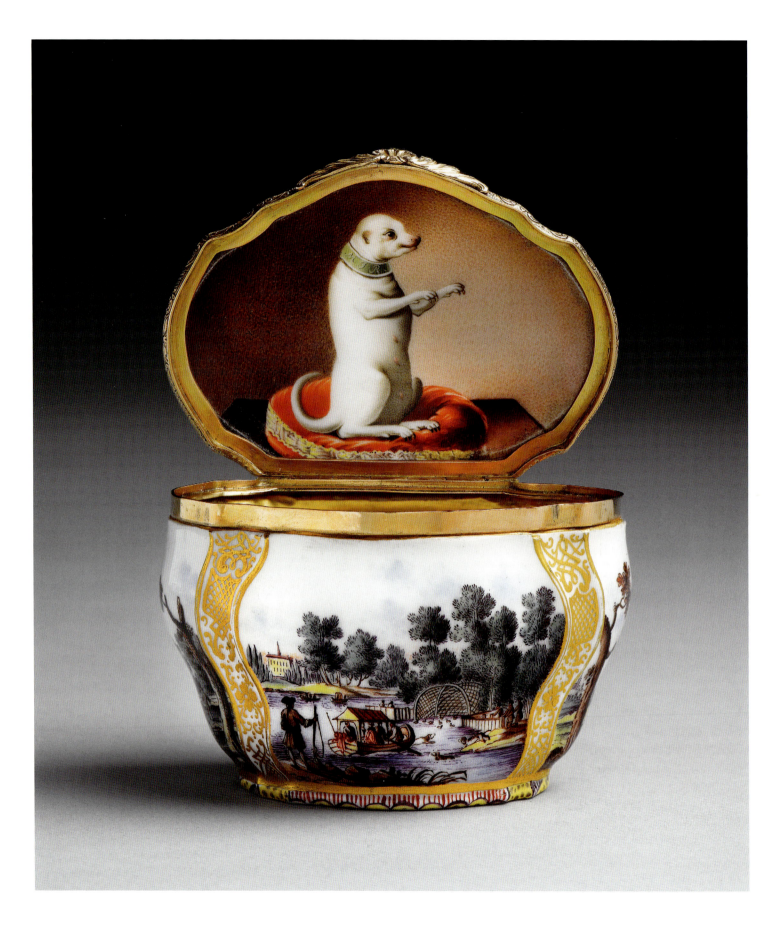

Cat. no. 90

SNUFF BOX

Manufactured c. 1740

Probably painted by Johann George Heintze (born c. 1706/07), c. 1740

Initials on the collar: "MJR" (Maria Josepha Regina)

With contemporary gold mounts

Height 4.9 cm, width 6.8 cm, depth 5 cm

Literature:

Beaucamp-Markowsky 1985, p. 93, cat. no. 64

This box, which is a quatrefoil in plan, has bellied sides and a straight edge at the back. It is closed by a slightly domed lid with gold mounts. The outside of the container, which is completely gilded internally, is divided up by vertical strips of golden leafwork, network, and strapwork ornament into two small and two larger picture areas that contain polychrome hunting scenes. The lid and the base of the box are also decorated with hunting motifs, the latter painted purple *en camaïeu*. This box can therefore be clearly identified as a hunting snuff box, and it is equally clear for whom it was made: none less than the spouse of King Augustus III of Poland and Elector of Saxony (1696–1763), Maria Josepha von Habsburg (1699–1757). This is placed beyond all doubt by the Queen's initials "MJR" on the collar of the white dog that is depicted on the inside of the lid sitting up and begging on a red ornamental cushion.

The same dog shown resting on a stool was modelled as a sculptural figure by Johann Joachim Kaendler in 1738, who writes in his work report: "1. For Her Majesty the Queen a little dog, after a painting provided, modelled in clay, the dog sits on a delicately made *tabouret*, the cushion looks as if it were covered with flowers" (quoted from Pietsch 2002, p. 58). A cast of this dog dated 1793 and with the initials "RPMJ" (Regina Poloniae Maria Josepha) on the collar is today in the Pauls-Eisenbeiss Collection (see fig. VI..88; published in Menzhausen 1993, p. 102).

The hunting scenes that depict various episodes, such as hunting waterfowl from a boat, heron hawking with a falcon, a par-force deer hunt (see fig. VI..89), a hunter who accustoms his hounds to the sound of the hunting horn (see fig. VI.91), a wild boar escaping from an enclosure (see fig. VI.90), and a huntsman with his hound, relate to Maria Josepha's passion for hunting, the Queen being just as enthusiastic a hunter as Augustus III. We can assume that the dog finely painted in dots of colour was her favourite animal, as otherwise it would not have been depicted so often. Most of the hunting scenes can be traced more or less directly to prints by Johann Elias Ridinger (1698–1767) from which the porcelain painter selected his motifs. UP

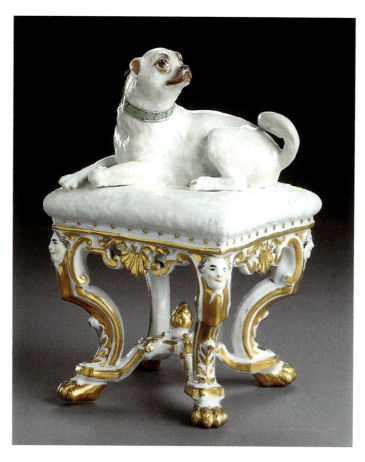

VI.88

Johann Joachim Kaendler (1706-1775), *Das Hündlein der Königin*, model, Meissen 1738, "R.P.M.J 1739" (Regina Poloniae Maria Josepha), height 11 cm, Pauls-Eisenbeiss Foundation

307

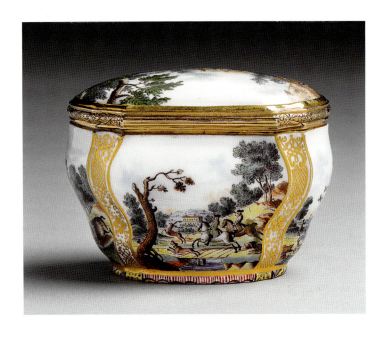

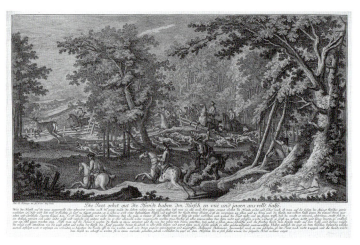

VI.89
Johann Elias Ridinger (1698–1767), *Die Jagt gehet gut die Hunde haben den Hirsch en vué und jagen aus vollen Halse*, copper engraving from the series *Die par force Jagd des Hirschen und deren ganzer Vorgang*, Augsburg 1756, Dresden, Staatliche Kunstsammlungen Dresden, Kupferstichkabinett

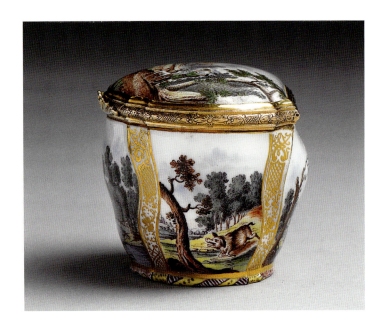

VI.90
Johann Elias Ridinger (1698–1767), *Der Einsprung an dem Saugarten*, copper engraving from the series *Der Fürsten Jagd-Lust*, Augsburg 1729, Dresden, Staatliche Kunstsammlungen Dresden, Kupferstichkabinett

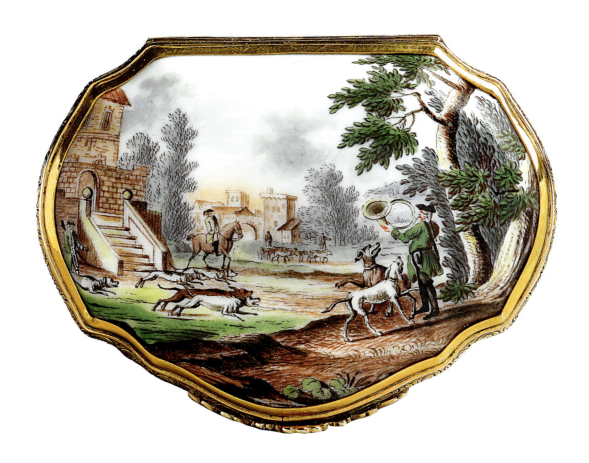

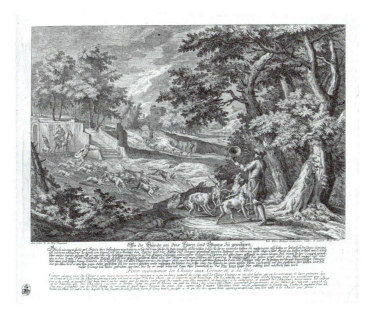

VI.91
Johann Elias Ridinger (1698–1767), *Wie die Hunde an das Horn und Stimme zu gewöhnen*, copper engraving from the series *Der Fürsten Jagd-Lust*, Augsburg 1729, Dresden, Staatliche Kunstsammlungen Dresden, Kupferstichkabinett

Cat. no. 91

SNUFF BOX

Painted c. 1745–50
With contemporary gold mounts
Height 4.7 cm, width 6.8 cm, depth 4.2 cm

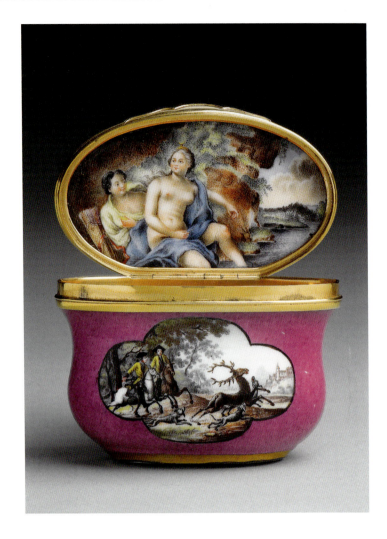

The same form as cat. no. 22. The outside of this snuff box is covered with a strong reddish-purple ground in which quatrefoil cartouches outlined in black and containing polychrome hunting scenes by an unidentified painter were made on the lid and each of the long sides. The oval cartouche outlined in gold on the bottom of the box also contains a hunting scene. A number of these depictions can be traced back to prints by Johann Elias Ridinger (1698–1767); the porcelain painter borrowed his motifs from these works but arranged them in a slightly different way to the originals. For instance on the front of the snuff box a par-force hunt of a red deer is depicted (see fig. VI.92) in which only three rather than six hounds attempt to bring the magnificent stag to bay and the *piqueurs* who follow on their horses were also altered somewhat. The porcelain painter wished to avoid directly copying the original image, while reducing the number of figures also lessened the amount of work required. He approached the painting on the back of the snuff box in a similar manner and used a further plate by Ridinger as inspiration. On the box and in Ridinger's print huntsmen are depicted "Waiting for the Deer" (see fig. VI..93): two hunters concealed in the bushes fire their shotguns at deer attempting to flee, one of which already lies dead on the ground. In the print there are three animals, in the porcelain painting only two, but this does not significantly change the content of the picture. There are two further hunting scenes, one on the lid and one on the base of the box, the former shows a deer chase, the latter a wild boar hunt. Here, too, we can assume that prints served as models. The painter distinguished clearly between the par force hunters, who in Saxony wore a yellow livery, and the stalkers dressed in green uniforms, suggesting that he had special knowledge of local customs.

The very different style of the fine picture painted in dots of colour on the lid makes it appear doubtful that it is by the same painter. It shows Diana bathing, attended by a nymph who stands beside the hunting goddess's quiver. Like the latter her body is only lightly covered with a piece of cloth. Both are seated on the banks of a river, in whose waters Diana has immersed her feet. In the background the river winds past a large, moss-covered rock into the distance. On account of the similar iconography of the painting outside and inside the box and the clear relationship to the hunt this piece can be described as a "hunting snuff box." UP

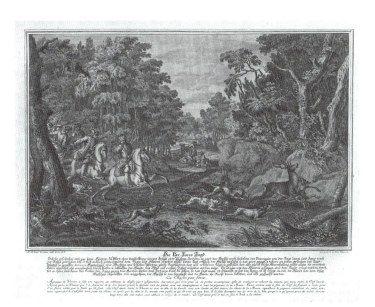

VI.92
Johann Elias Ridinger (1698–1767), *Die Par-Force Jagd*, copper engraving from the series *Der Fürsten Jagd-Lust,* Augsburg 1729, Dresden, Staatliche Kunstsammlungen Dresden, Kupferstichkabinett

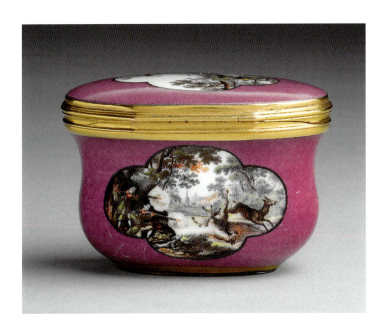

VI.93
Johann Elias Ridinger (1698–1767), *Der Anstand auf die Rehe*, copper engraving from the series *Der Fürsten Jagd-Lust,* Augsburg 1729, Dresden, Staatliche Kunstsammlungen Dresden, Kupferstichkabinett

311

Cat. no. 92

SNUFF BOX

Painted c. 1730
With contemporary gold mounts
Height 5.1 cm, width 6.1 cm, depth 8.1 cm

The same form as cat. no. 22. Apart from the base the outside of this same snuff box is covered with a turquoise-green ground in which, on the lid and the two long sides, a gold-framed quatrefoil cartouche was made that contains a polychrome hunting scene. A similar scene inside the lid is surrounded by a golden ground and a further hunting picture on the bottom of the box is enclosed in an oval frame. At the time this painting was done the prints by Johann Elias Ridinger (1698–1767) were not available in the Meissen manufactory and indeed not even known there, so that the painter had to rely on his own powers of imagination. It seems likely that he had some basic knowledge of how a princely par-force red deer hunt was conducted, as otherwise he would have been unable to depict it. Each of the miniature scenes shows a mountainous, wooded landscape with jagged cliffs of the kind found in the Elbe Sandstone Mountains, however the hunters do not wear the typical yellow livery of the Saxon par-force hunt, but are dressed in bright red or purplish violet. Horsemen with their daggers drawn hunt magnificent red deer while *piqueure* on foot, armed with boar spears, attempt to bag a wild pig. Beside a lake other game hunters with shotguns wait for waterfowl. The scene on the lid is particularly animated: a mounted huntsman fires his pistol at two wild boars charging at him, while two men on the ground attack the animals with their spears. The darkly clouded sky above a rugged landscape with gnarled trees heightens the sense of drama. Johann George Heintze (born c. 1706/07) may possibly have been the painter of these, in part, highly dramatic scenes. UP

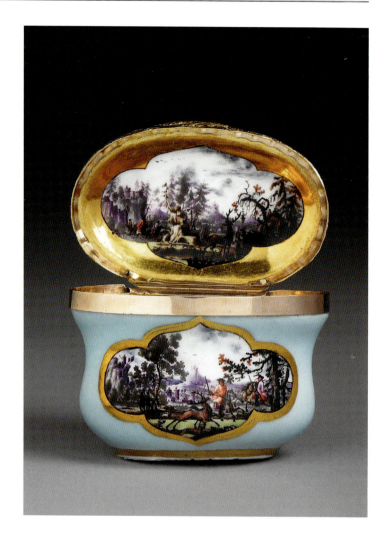

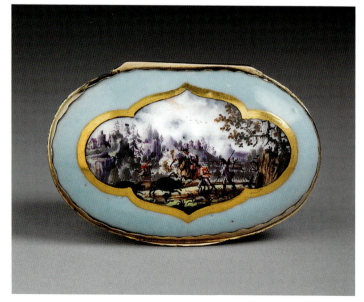

Cat. no. 93

DOUBLE SNUFF BOX

Model by Johann Joachim Kaendler (1706–1775), 1733
Probably painted by Johann George Heintze (born c. 1706/07), c. 1735
With contemporary silver gilt mounts
Height 4.4 cm, width 7.1 cm, depth 5 cm

Literature:
Exh. cat. Cologne 2010, p. 234 f., cat. no. 103

The model of this scalloped box with two lids and two compartments, separated by a central wall, to hold two different kinds of snuff was made by Johann Joachim Kaendler (1706–1775), according to his work report, in May 1733: "A snuff tobacco box of a new type as two kinds of snuff are to be kept in it; it has two lids and a separating wall in the middle" (SPMM, archive, AA I Aa 20, fol. 215r; quoted from Pietsch 2002, p. 19). The snuff box, which is gilded internally and covered externally with a purple-violet ground, offered numerous surfaces for miniature pictures which were painted in quatrefoil or oval reserves left in the ground. The quatrefoil cartouches on the inside of the lids are surrounded by a gold ground. They contain delicately painted idealised landscapes with a figural staffage of hunting, riding, or resting huntsmen as well as people simply taking a stroll. The slender figures and the confident and practiced style of the painting could possibly point to Johann George Heintze as the artist. UP

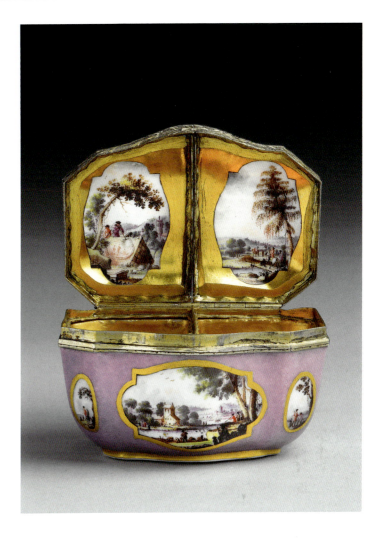

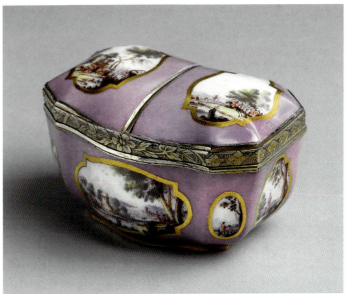

Cat. no. 94

SNUFF BOX

Manufactured c. 1722/23
Painted c. 1745
"K.P.M."-mark in underglaze blue and
crossed swords mark in underglaze blue
inside on the bottom
(in use from December 1722 to April 1723)
With contemporary gold mounts
Height 4.4 cm, width 7.8 cm, depth 4.7 cm

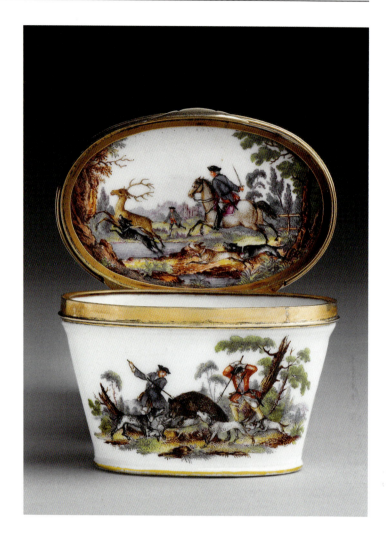

This bowl-shaped oval snuff box with tapering sides is closed by a slightly domed lid with gold mounts. While the mark indicates that it was cast at a relatively early date, it must have been kept in the storeroom of the manufactory until, in 1745, an unidentified painter decorated it with hunt motifs. On the sides and the lid he placed three polychrome scenes that show hunters pursuing wild boar and a bear, while on the inside of the lid a par-force red deer hunt is depicted. For these depictions the painter made use of prints by Johann Elias Ridinger (1698–1767), but also borrowed from other originals that have not yet been identified. For instance the hunting scene that shows a *piqueur* armed with a spear attacking a boar that has been brought to bay by the hounds can be related to a larger graphic work from which the painter took only this hunter and a further mounted huntsman, somewhat altered. However he quoted the hounds, in particular the animal lying dead on its back that has been killed by the boar, quite precisely. The scene on the bottom of the box painted purple *en camaïeu* shows a huntsman, accompanied by three hounds, blowing the par-force horn. It quotes from Ridinger's plate *Wie die Hunde an das Horn und Stimme Zu gewöhnen* (How to Accustom Hounds to the Horn and Voice). The distinctly linear style of the painting on the outside of the box brings it very close to the original graphic works, while the nuances and very fine details of the scene on the inside of the lid, most probably painted by the same hand, considerably enhances the already high quality of this piece.

A box with the same form and a very similar décor, but painted by a different hand, is in a private collection in New York (cf. Beaucamp-Markowsky 1985, p. 90, cat. no. 60). UP

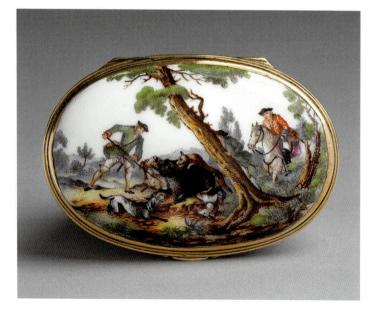

VI.94
Johann Daniel Herz the Elder (1693–1754), *Die Wildschweinjagd*, copper engraving after Johann Elias Ridinger (1698–1767) from the series *Jagden mit Titel*, Dresden, Staatliche Kunstsammlungen Dresden, Kupferstichkabinett

Cat. no. 95

SNUFF BOX

Painted probably by Christian Friedrich Kühnel (1719–1792), c. 1750
With contemporary silver gilt mounts
Height 4.5 cm, diameter 7.7 cm

The outside of this round box is decorated with a concentric wave relief that suggests the shape of a double-flowered blossom. Over this relief the unidentified artist painted various flowers, both strewn and bound in a natural manner to make small bouquets, while on the inside of the lid a different artist painted a miniature of a par-force red deer hunt. This depiction shows a magnificent stag fleeing; two dogs, one black, the other white are attempting to bring the deer to bay, while other dogs running from the right are followed by three mounted huntsmen wearing the typical yellow Saxon par-force hunt livery. Two of them are cracking their whips, while the central one blows the par-force horn. In the background we can see a hind and two further huntsmen on horseback. A group of coniferous and deciduous trees is placed at the centre of this dramatic activity. While the painter probably borrowed a number of his motifs from the numerous hunting prints by Johann Elias Ridinger (1698–1767), the composition as a whole remains his own work. Stylistically, the décor matches a saucer with a hunting scene, signed and dated by Kühnel in 1776. The saucer is in the Landesmuseum Württemberg, Stuttgart, inv. no. G 30,146 (see fig. IV.19). This saucer is the very reason why Kühnel can be identified as the painter of this snuff box. UP

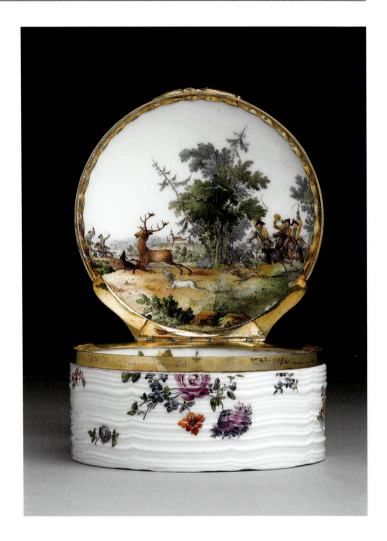

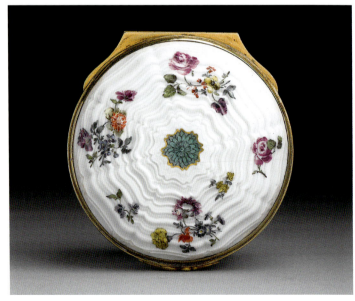

Cat. no. 96

SNUFF BOX

Probably painted by Johann Jacob Wagner, c. 1745
With contemporary gold mounts
Height 4.5 cm, width 7.8 cm, depth 6.2 cm

Literature:
Teuscher 1998; Held 1996

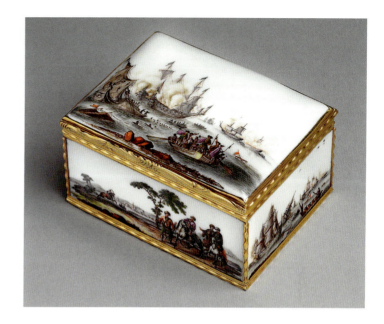

This rectangular snuff box with a slightly domed lid has finely worked gold mounts *à cage* decorated with a wave profile, which at the front of the lid forms a fine thumb rest with a *rocaille* relief. Using various muffle colours the sides of the box and the inside of the lid were painted with dramatic cavalry battle scenes after prints by Georg Philipp Rugendas the Elder (1666–1742) and naval battles after Reynier Nooms Zeeman (1623–1663).

There are numerous battle scenes by Georg Philipp Rugendas the Elder in existence, as the painter produced works on this theme throughout his life: in the first two decades of his active career he painted on canvas, later working on engravings and prints that were "sold throughout the world" (quoted from Keyssler 1751, vol. I, letter X from 1 July 1729, p. 65) and indeed even reached the imperial court in China. He specialised in painting battles and horses in response to a demand at the time for scenes with a martial context, which must be seen as an expression and consequence of the political situation. The process of driving the Turks out of Europe, which began with the relief of Vienna on 12 September 1683, in particular had a wide-ranging impact on the visual arts. The scenes on the present snuff box also belong to this context. The inside of the lid shows a bitter cavalry battle after the print *Ein Pandur mit fliegendem Pelz und Säbeltasche holt zum Hieb aus* (see fig. VI.95) by Johann Christoph Böcklin (1687–1712) after Rugendas the Elder. The front and the back (*Gangarten des Pferdes;* see fig. VI.96, and *Kriegsszenen;* see fig. VI.99) and the left-hand narrow end *(Gruppe von Reitern vor einem Zelt;* see fig. VI.95) of the box are also decorated with battle motifs taken from the Augsburg artist.

The martial theme addressed on this snuff box is expanded by three scenes showing stormy naval battles whose basic composition is derived from etchings from the series *Nieuwe Scheeps Batalien* by Reynier Nooms Zeeman (1623–1663), to which manned lifeboats were added (see figs. VI.97 and VI.98).

Two comparable snuff boxes are published in Beaucamp-Markowsky 1985, cat. nos. 51 and 52 (here a very similar version of our painting on the inside of the lid).

A further snuff box painted on all sides after works by Georg Philipp Rugendas the Elder and with especially fine mounts is in the Ernst Schneider Foundation, Schloss Lustheim.

SKA

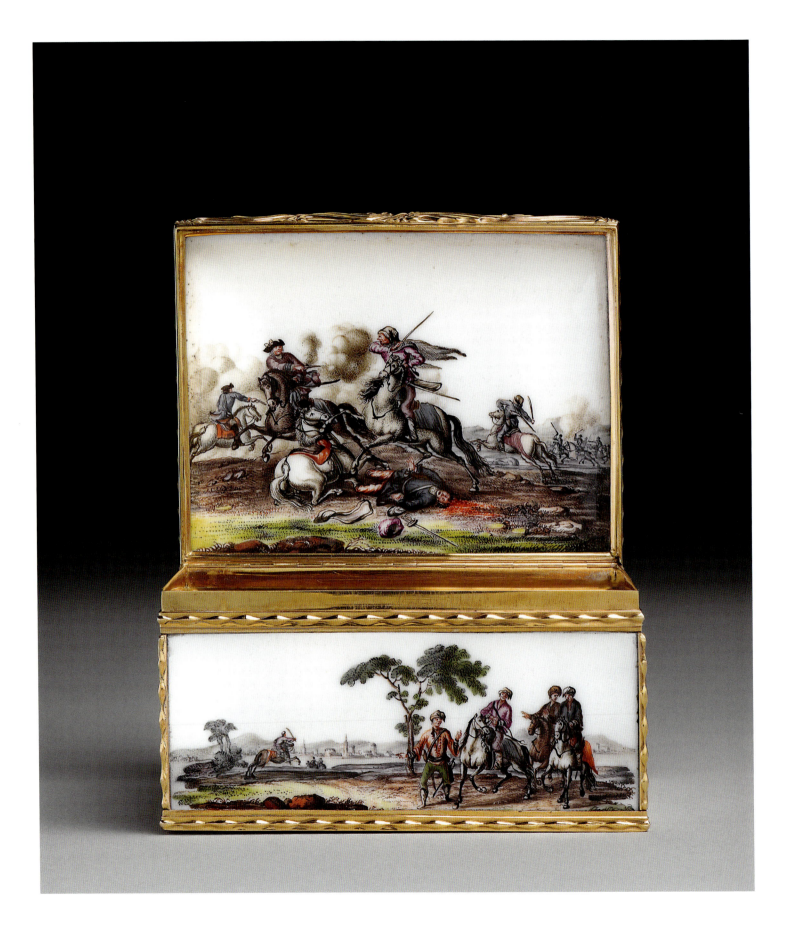

318

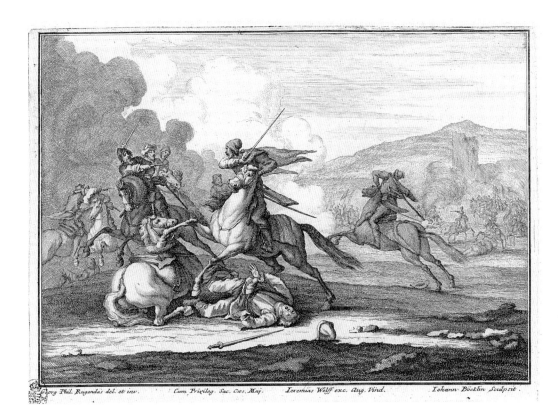

VI.95
Johann Christoph Böcklin (1687–1712), *Ein Pandur mit fliegendem Pelz und Säbeltasche holt zum Hieb aus,* etching after Georg Philipp Rugendas the Elder (1666–1742), Dresden, Staatliche Kunstsammlungen Dresden, Kupferstichkabinett

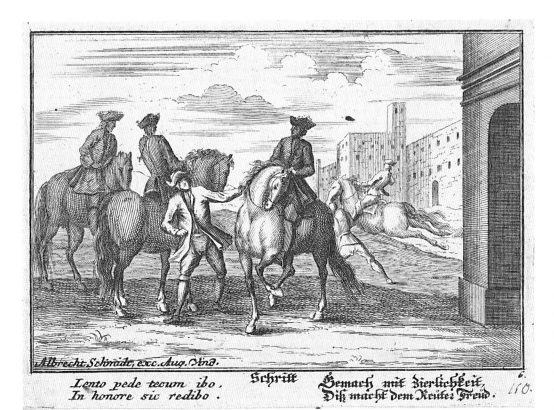

VI.96
Unknown engraver, etching after Georg Philipp Rugendas the Elder (1666–1742), *Schritt* from the series *Die Gangarten des Pferdes,* Coburg, Kunstsammlungen der Veste Coburg, Kupferstichkabinett

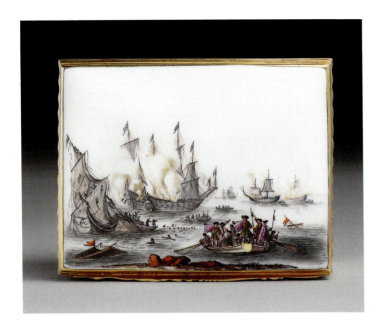

VI.97

Reynier Nooms Zeeman (1623–1663), *Seeschlacht mit sinkendem englischen Schiff links im Bilde,* etching from the series *Nieuwe Scheeps Batalien,* New York, The Metropolitan Museum of Art

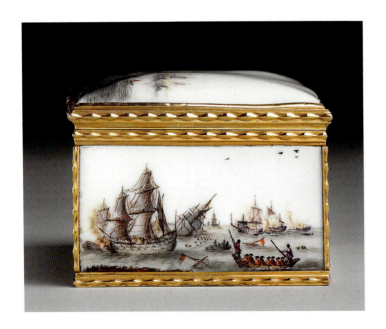

VI.98

Reynier Nooms Zeeman (1623–1663), *Seeschlacht,* etching from the series *Nieuwe Scheeps Batalien,* New York, The Metropolitan Museum of Art

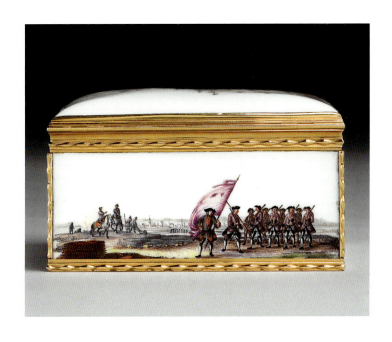

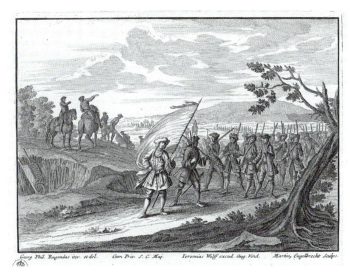

VI.99
Martin Engelbrecht (1684–1756), *Füiliere auf dem Marsch*, etching from the series *Kriegsszenen* by Georg Philipp Rugendas the Elder (1666–1742), Dresden, Staatliche Kunstsammlungen Dresden, Kupferstichkabinett

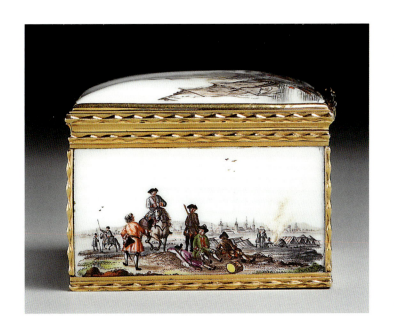

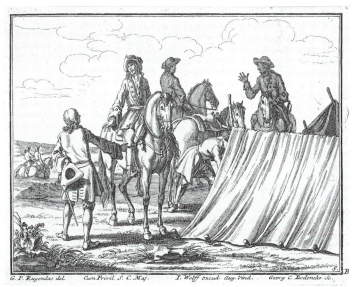

VI.100
Georg Conrad Bodenehr (1673–1710), *Gruppe von Reitern vor einem Zelt*, etching after Georg Philipp Rugendas the Elder (1666–1742), from the series *Reiterstudien und Reitergefechte*, Brunswick, Herzog Anton Ulrich-Museum

Cat. no. 97

SNUFF BOX

Model probably by Johann Joachim Kaendler (1706–1775), c. 1742
Painted c. 1750
With contemporary silver gilt mounts
Height 4.2 cm, width 7.8 cm, depth 6 cm

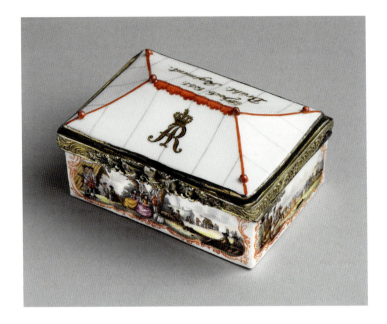

Although a snuff box in the form of a military tent is nowhere mentioned in the work reports of the modellers at Meissen, this piece is without doubt a product of the Saxon manufactory. The lettering on either side of the tent roof, painted in gold with black outlines, make the connection to Saxony particularly clear, on one side is written "Hoch löbl: Brühl: Regiment," while on the other we see an Augustus Rex monogram surmounted by a crown. The first reference relates to the Saxon-Polish Prime Minister, Heinrich Count von Brühl (1700–1763), the second to his ruler, King Augustus III of Poland and Elector Frederick Augustus I of Saxony (1697–1763). Brühl was not only Prime Minister but also Director General of the Meissen porcelain manufactory and from 1742 General of the infantry.

The painting on the four sides of the box shows military scenes depicted with great naivety with soldiers from the Brühl'sches Regiment who wear poppy-red waistcoats and breeches and white frock-coats and knee stockings. On one of the short sides we see two guardsmen standing watch on either side of the open entrance to the tent, while on the opposite side of the box two horsemen are shown at the left, of whom the one mounted on a grey performing a curvet could possibly be the Count himself. With his right hand he points to a group of soldiers in the distance who have settled in front of the silhouette of a table mountain crowned by the Königstein fortress, which is near the town of Struppen where the Brühl'sches Regiment regularly held manoeuvres. The front of the box shows numerous soldiers, alone or in groups, together with two camp followers under a tree, and on the back we see again the landscape with the Königstein but with a different figural staffage, while on the bottom of the box an officer's bivouac is depicted. Each of the scenes is enclosed by a *rocaille* frame painted in iron-red.

The decoration of the inside of the lid is surprising and highly unusual for Meissen porcelain painting; it is covered with a gold ground in which a symmetrical ornament of polychrome leaf-work and stylised blossoms is placed.

A snuff box with the same form and very similar décor is in the Muzeum Narodowe in Warsaw (inv. no. SZC 1350 MNW, cf. Pietsch 2000, p. 229, cat. no. 174), a further box with the same form but a different décor is kept in The Metropolitan Museum of Art, New York, (Bequest of Mrs. Emma Sheafer 1974, The Lesley and Emma Sheafer Collection, inv. no. 1974.356.308; cf. Beaucamp-Markowsky 1985, p. 84, cat. no. 53). The piece in the National Museum in Warsaw is probably the earliest example, while the *rocaille* framing used on the snuff box presented here allows us date it to around 1750. Perhaps snuff boxes of this kind were given by Count von Brühl as gifts to his officers, who had earned great merit through their services in the two Silesian Wars.

UP

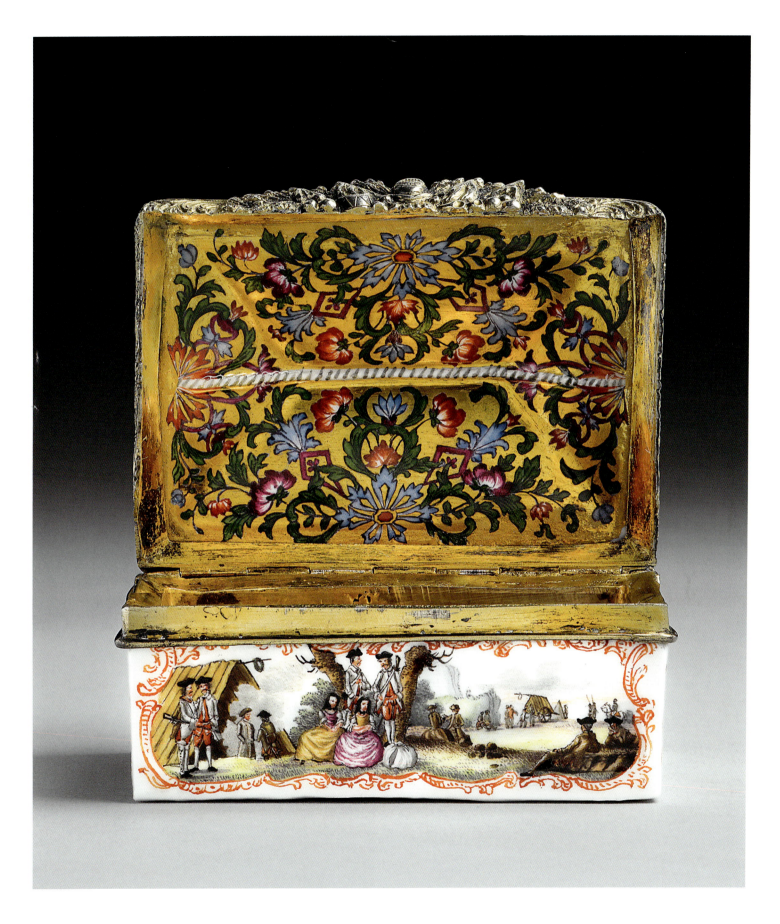

Cat. no. 98

SNUFF BOX

Probably painted by Bonaventura Gottlieb Häuer (1709–1782), c. 1740
With contemporary silver gilt mounts
Height 6.6 cm, width 6.6 cm, depth 4.9 cm

The same form as cat. no. 17. Its rich natural resources made the Electorate of Saxony into one of the wealthiest lands in the Holy Roman Empire of the German Nation. Mining in the Ore Mountains was an important economic factor, and miners were held in great esteem, not only by the population in general, but also by the ruler. Consequently, this tub-shaped snuff box with a large crowned escutcheon carried by two young miners that bears the coat of arms of the Polish King Augustus III and Saxon Elector (1697–1763) may have been a gift by the monarch to a deserving inspector of mines. Every time he opened the snuff box the depiction on the inside of the lid would have reminded him of his supreme employer, in whose favour he stood. The king may have given him the snuff box personally, as on the front of the box we see a mine inspector in his fine uniform with the golden Augustus Rex monogram on his cap, standing beside a noble gentleman whose physiognomy suggests that he could be King Augustus III. A young miner in front of them—who takes no notice of the pair—is engaged in gathering up gold nuggets

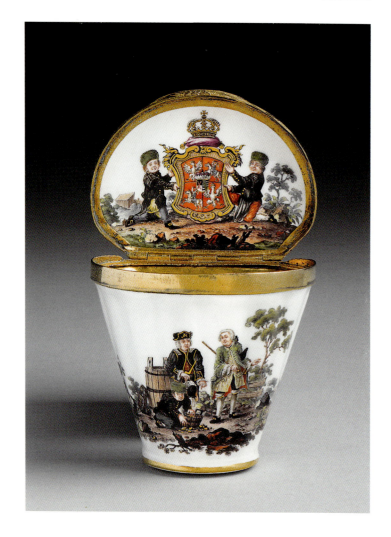

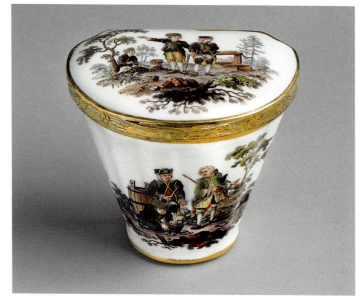

from the ground. The back of the box shows a miner wearing a black uniform jacket, the typical miner's leather apron, and a green cap. He holds a shovel in his left hand while pointing with the right to a young apprentice miner who is washing the gold. On the bottom of the snuff box we see a hewer or face-worker breaking up blocks of ore with his pickaxe and on the lid we discover the mining official yet again; his arm is held by a face-worker who points with his right hand to a young miner kneeling on the ground in the distance. The gold that glints everywhere from the brown rock should be seen as a symbol of the wealth and prosperity produced by mining, for in fact this precious metal is hardly found at all in Saxony. The metal intended was most probably silver, of which considerable amounts were extracted there in earlier times. However, as it turned black after firing, this colour could not be so easily depicted in painting on porcelain.

The squat, and in some cases childishly naive figures of the miners with their big heads, full cheeks, and somewhat old faces are typical of the style of the painter Bonaventura Gottlieb Häuer, as are the areas of ground used as a base, from which shrubs extend downwards into the white surface of the porcelain. A cup with saucer that he painted in the same manner is signed with his name, hidden in the painting (private ownership, cf. Slotta/Lehmann/Pietsch 1999, p. 170, cat. no. 199). Therefore Häuer probably also painted this snuff box. The son of the Freiberg *Obersteuer- und Knappschaftsältesten* (senior representative of the mining guild), Samuel Häuer, he was personally familiar with mining in Saxony and as a painter at Meissen was therefore predestined, so to speak, to work on mining décors, which he mostly painted on porcelain services. We know that in 1765 he painted a snuff box "with prospects" (cf. Rückert 1990, p. 153). UP

Pugs

Cat. no. 99

SNUFF-BOX

Model by Johann Joachim Kaendler (1706–1775),
1741–42
Inside of the lid painted by
Christian Friedrich Herold (1700–1779),
the box by Johann George Heintze
(born c. 1706/07), c. 1742
With contemporary silver gilt
Height 5 cm, width 6.5 cm, depth 5.8 cm

Johann Joachim Kaendler created his first scalloped snuff box with a pug lying on the lid in October 1741. In his work report it says: "For His Excellency Cabinet Minister von Brühl, a new snuff box with a small pug dog on the lid, very finely modelled" (SPMM, archive, AA I ab 16, fol. 272r–273r; quoted from Pietsch 2002, p. 83). In January 1742 there followed a further model of the same kind, so that it is not entirely clear on which model the present snuff box is based (cf. cat. no. 81). All the models, including somewhat earlier ones in which the entire lid is made up of a resting pug (cf. cat. no. 106), were made for the Saxon-Polish Prime Minister, Heinrich Count von Brühl (1700–1763), who was particularly fond of this breed and himself owned at least one of these dogs.

In the present snuff box it remains somewhat strange that the style of the painting suggests the time around 1735 rather than 1742, as the edge of the lid has a wide border of golden leaf-work, while to the left and right of the pug there is a merchant shipping scene, probably painted by Johann George Heintze. He used similar scenes for the continuous décor that runs around the side of the box. From an elevated vantage point the viewer looks down at a harbour below that is occupied by the usual figures of European and Oriental merchants, with ships and barges, castles, palaces, and towers. The painter used the motif of a ship dropping anchor, its deck covered with a large red-and-white striped cloth, on other boxes, too (cf. cat. nos. 29 and 30), which suggests that individual painters probably painted several snuff boxes at one time and, in order to reduce the amount of work involved, frequently used the same subjects. The picture on the bottom of the box, which shows a harbour scene painted purple *en camaïeu* with a large ship under full sail, merchants bargaining in the fore-

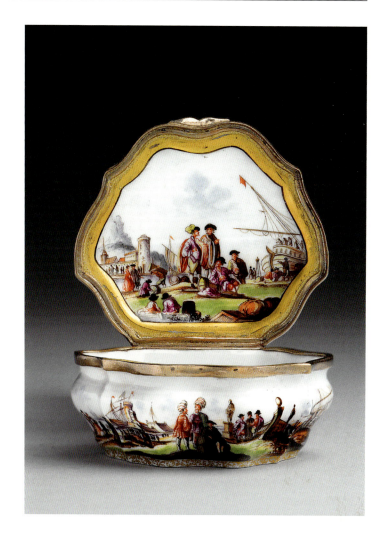

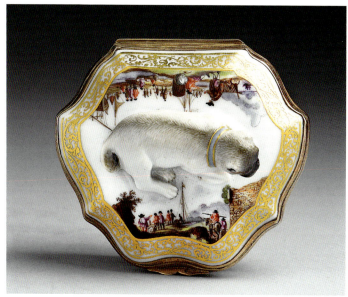

327

ground and the silhouette of a city, occurs again on the bottom of three other snuff boxes (cf. cat. nos. 29, 30, and 99).

It was usual to emphasise the inside of the lid as the principal face of the box and to have it decorated by a different painter; it was probably Christian Friedrich Herold who painted the inside of the lid of this piece with a merchant shipping scene that matches stylistically a similar scene on a snuff box that was signed by this artist (Porcelain Collection, Staatliche Kunstsammlungen Dresden, inv. no. PE 1536; see fig. VI.5). UP

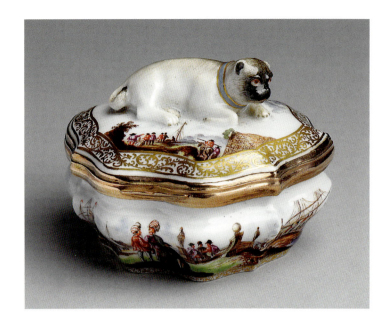

Cat. no. 100

SNUFF BOX

Model by Johann Joachim Kaendler (1706–1775), 1741–42
Painting of the outside by Johann George Heintze (born c. 1706/07), c. 1742
With contemporary silver gilt mounts
Height 4.7 cm, width 6.8 cm, depth 5.7 cm

The form of this box matches that of cat. no. 99 exactly and the painting of the outside and the lid shows very similar merchant shipping scenes, which the painter Johann George Heintze apparently produced in series. The only difference is a number of slight changes to the figural staffage, whereas the composition of the landscape in both pieces is almost identical. In contrast the

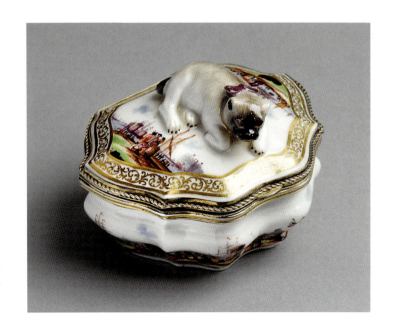

inside of the lid was decorated by a different, unidentified painter, who in selecting his motifs made use of a print with the title *Zeitvertreib der Frauenzimmer* (The Amusements of the Fair Sex) by Johann Esaias Nilson (see fig. VI.101). The original graphic work shows a noble couple seated at a table, the gentleman bows down close to the lady who seems to be engaged with her sewing utensils. It is left up to the viewer to speculate exactly which *Amusement du Beau Sexe*—the French title of the work—is meant here, whereas in the porcelain painting, which shows the lady alone, it is not difficult to guess. The question remains why the porcelain painter omitted the gentleman, as it is he who first gives the scene an erotic component of a kind frequently encountered in painting inside the lids of snuff boxes.

The harbour scene painted purple *en camaïeu* on the bottom of the box shows a ship with sails unfurled at a pier against the silhouette of a city fortified by walls and towers. The same depiction is found on three further snuff boxes in private ownership (cf. cat. nos. 29, 30, and 99), allowing us to assume that the same artist—probably Johann George Heintze—was responsible for all these scenes. UP

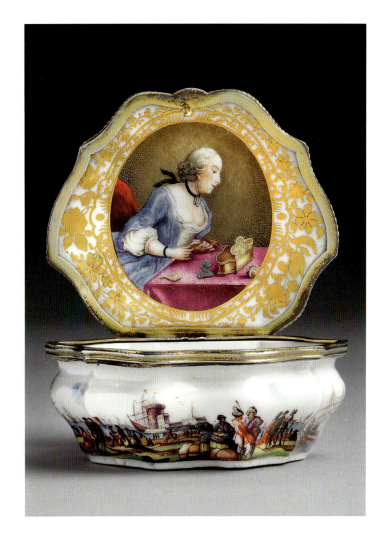

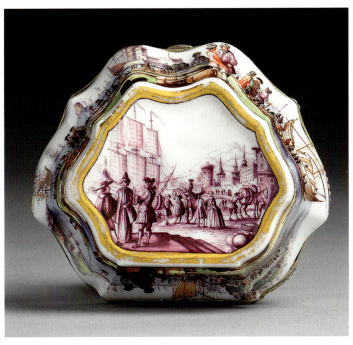

VI. 101

Johann Esaias Nilson (1721–1788), *Amusement du Beau Sexe—Zeitvertreib des Frauenzimers,* from the series *Verschiedene Vergnügungen,* Brunswick, Herzog Anton Ulrich-Museum

Cat. no. 101

SNUFF BOX

Inside of the lid painted by Philipp Ernst Schindler Senior (1694–1765), the outside of the box by Johann George Heintze (born c. 1706/07), c. 1740
Cryptic painter's mark on the inside of the lid, to the right above the braid edging to the cushion: "△"
With contemporary gold mounts
Height 4.8 cm, width 6.6 cm, depth 3.8 cm

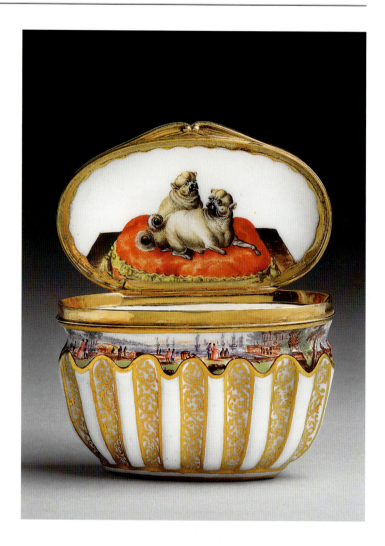

This oval, bowl-shaped snuff box, the lower part of which is fluted, is closed by a slightly domed lid. The fluting is decorated with gold leaf-work ornament, while the edge zone above it is painted with an uninterrupted merchant shipping scene set in a southern port. Johann George Heintze placed the *galant* figural scenes on the lid and on the bottom of the box in the garden of an Italian palace, borrowing the motifs on the lid from two prints by Melchior Küsel (1626–1683) that show part of the harbours of Naples and Genoa respectively. From the first plate he used only a fountain with a kind of Bacchus figure figure (see fig. VI.101) that he placed in the foreground of the park, whereas from the second plate he took the palace architecture that leads diagonally into the background (see fig. VI.102).

In contrast the elegantly dressed strolling couples probably come from an entirely different context, most likely from etchings after a painting by Jean-Antoine Watteau (1684–1721). The same applies to the scene with a similar composition on the base of the box. Heintze used the print of the harbour in Genoa a further time in painting the front of another box (cat. no. 103), which has a picture on the base that is very similar to the scene on the bottom of the present piece

Philipp Ernst Schindler Senior chose an entirely different motif for the inside of lid. He shows two pugs lolling on a red velvet cushion trimmed with gold braid that rests on a dark table-top. The painter repeated this scene almost identically on the box in private ownership already referred to above (cat. no. 103). UP

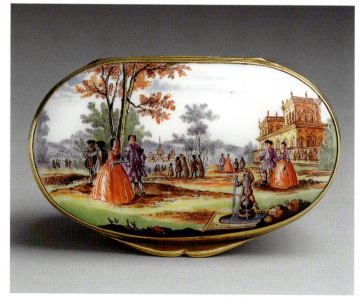

VI.102
Melchior Küsel (1626–1683), *Prospect des Golfo zu Neapolis,* etching from the series *Unterschidliche Prospekten…* by Johann Wilhelm Baur (1607–1640), Augsburg c. 1681, Brunswick, Herzog Anton Ulrich-Museum

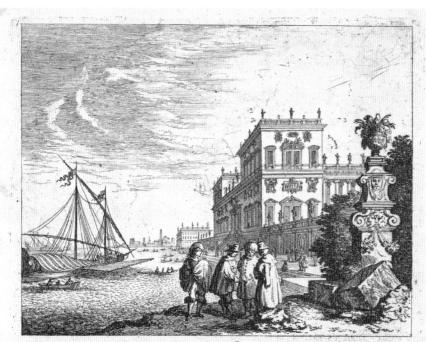

VI.103
Melchior Küsel (1626–1683), *Eine Arriva und anfahrt zu Genoua und Pallazzi der Sig.ri Spinolla,* etching from the series *Unterschidliche Prospekten…* by Johann Wilhelm Baur (1607–1640), Augsburg c. 1681, Brunswick, Herzog Anton Ulrich-Museum

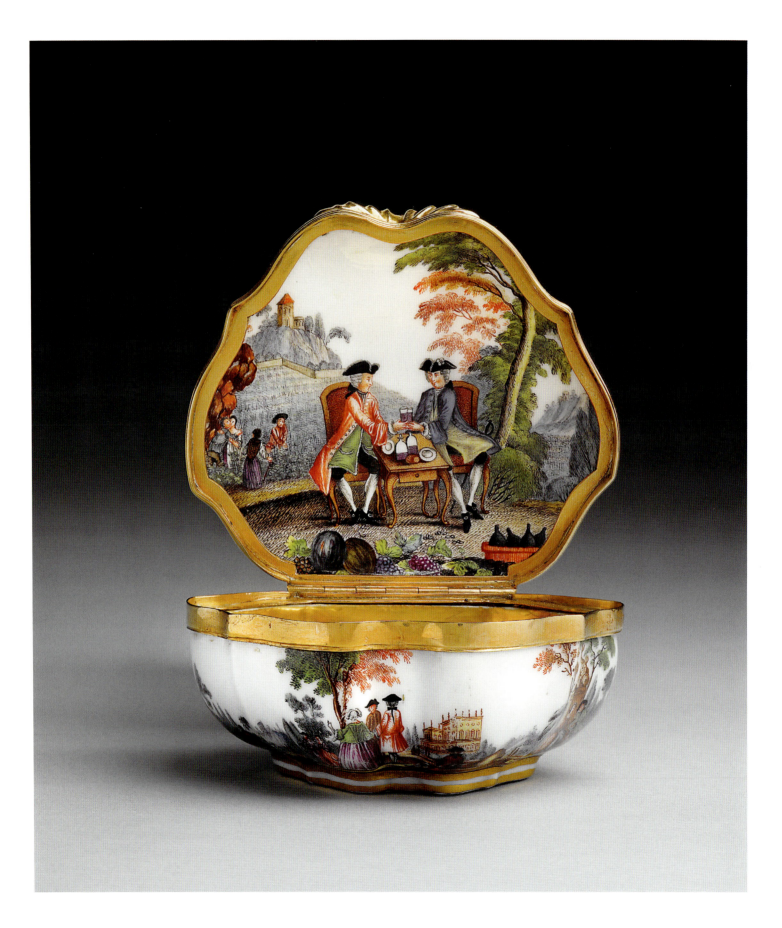

332

Cat. no. 102

SNUFF BOX

Model probably by Johann Gottlieb Ehder (1717–1750), 1741
Painted by Johann George Heintze (born c. 1706/07),
c. 1742
With contemporary gold mounts
Height 4.6 cm, width 7.2 cm, depth 6.5 cm

Literature:
Jakobsen/Pietsch 1997, p. 264, cat. no. 217

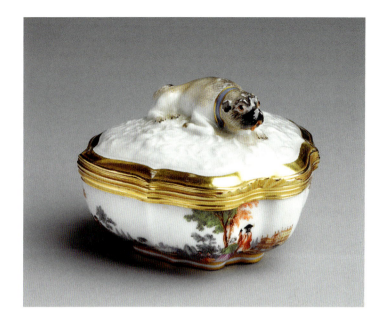

Similar form to cat. nos. 99 and 100. The pug lying on the lid of this scalloped-edged box makes it a special piece, as only rarely were snuff boxes given such elaborate, sculptural decoration. Which version of the "pug boxes" modelled by Johann Joachim Kaendler we are confronted with here is almost impossible to trace, as the descriptions of his models are not detailed enough to allow us attribute them accurately. In this snuff box the surface on which the pug lies and turns his gaze upwards to the viewer is different, as it is covered with a fine relief of blossoms and leaves whereas in the other boxes of this kind a simple, smooth plate is used (cat. nos. 99 and 100) This piece may even be a further development of Kaendler's model by Johann Gottlieb Ehder, who, according to his work report from December 1741, made "1 gadrooned snuff box, with a pug dog lying on the lid, surrounded with grass and flowers, for His Excellence Count von Brühl" (SPMM, archive, AA I Ab 16, loose sheet). Most of the pug box models were originally intended for the Saxon-Polish Prime Minister Heinrich Count von Brühl (1700–1763), who was regarded as a particular admirer of this breed of dog.

The painting was probably carried out by Johann George Heintze; on the outside he placed continuous park and landscape scenes that contain, at regular distances apart, groups of figures in what was called the "Watteau style," while on the inside of the lid two gentleman, wearing tricornes and seated at a table, raise glasses filled with red wine in a toast. In the background we see peasants working in a mountain vineyard. As so often Heintze painted the bottom of the box purple *en camaïeu*, with an idealised landscape and courtly figures. UP

Cat. no. 103

SNUFF BOX

Painting on the inside of the lid by Philipp Ernst Schindler Senior (1694–1765), painting of the outsides by Johann George Heintze (born c. 1706/07), c. 1740
Cryptic painter's mark in the inside of the lid under the braid trim of the cushion: "△"
With contemporary gold mounts
Height 5 cm, width 6.4 cm, depth 4.6 cm

Provenance:

Formerly Goldschmidt-Rothschild Collection

Literature:

Joseph 1977, p. 26, fig. 9; Beaucamp-Markowsky 1985, p. 109, cat. no. 77; Bursche 1998, p. 41, fig. 6

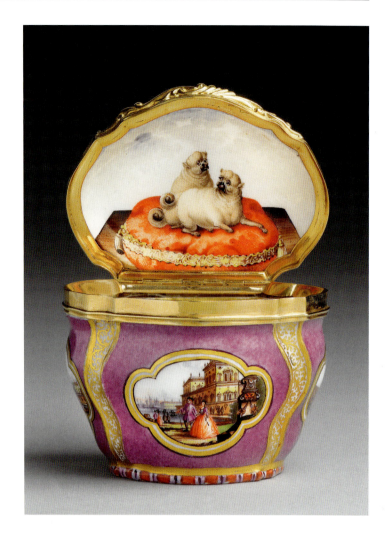

Same form as cat no. 90. The outside of the snuff box is covered with a powdery purple ground interrupted by vertical white strips in which gold lace bands were painted and by a gold-framed quatrefoil reserve on each of the long and short sides. In these reserves Johann George Heintze placed his typical idealised landscapes with figural staffage in what was known as the "Watteau style." He made use of the architecture in a print by Melchior Küsel (1626–1683) that shows a view of the harbour at Genoa with the "Palazzo of the Signori Spinolla" (see fig. VI.103). Heintze used this image a number of times, for instance on the lid of a snuff box in private ownership (cat. no. 101), which, incidentally, uses the same motif of a park with herms of Pan that is presented on the base of the present box. And the two pugs on a red ornamental cushion are also found on both these boxes, executed by painter Philipp Ernst Schindler Senior who left his cryptic painter's mark, the tiny hollow triangle, on this work. UP

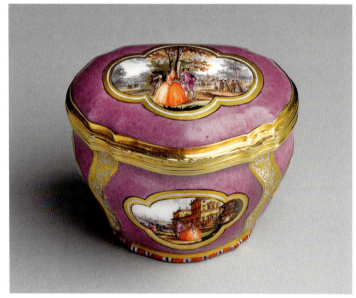

Cat. no. 104

SNUFF BOX

Painted c. 1750
With bronze gilt mounts
Height 2.9 cm, width 7.5 cm, depth 5.7 cm

This delicate scalloped box with a slightly domed lid has contemporary gilt bronze mounts decorated with a symmetrically plaited band. The outside of the snuff box is covered with a celadon ground in which scalloped, gold-framed reserves were made on the sides, the lid and the bottom that contain scenes in the "Watteau style."

The painting on the inside of the lid uses an entirely different theme. The viewer is presented with a little family of pugs on a plumped-up cushion whose tassels are painted in great detail, set in an elegant interior. While the mother dog suckles one of her litter, two other puppies with the typical pug stripe along their backs romp around her. This miniature is carried out entirely in purple *en camaïeu*.

Johann Joachim Kaendler (1706–1775) translated the theme of the pug family into Meissen porcelain sculptures, one of which shows a pug sitting upright as she suckles her young (see fig. VI.104). SKA

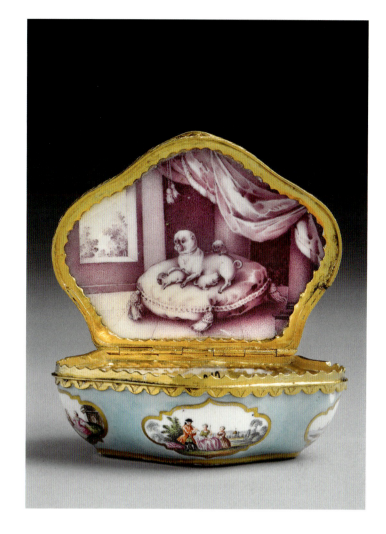

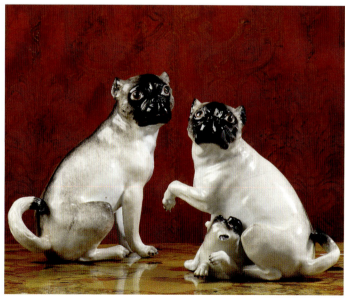

VI.104
Johann Joachim Kaendler (1706–1775),
Ein Paar Möpse, Meissen, c. 1741

Cat. no. 105

SNUFF BOX

Painted c. 1750
With contemporary gold mounts
Height 3.7 cm, diameter 6.6 cm

Literature:
Ziffer 2011

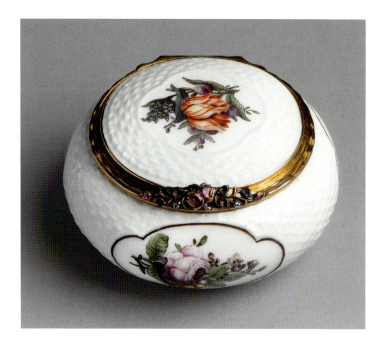

This circular snuff box has rounded sides and is distinguished by the raised basketwork relief that covers the box and lid. Three smooth, brown-framed quatrefoil reserves were left on the sides, another one on the bottom and a further one, without any frame, was made on the top of the lid. These reserves were painted using muffle colours with floral décors in the style known as "German flowers." The inside of the lid shows a pug finely painted in dots of colour that wears a blue collar and rests with its front paws stretched out on a purple cushion with golden tassels. Deciduous trees and shrubs add life to the left-hand side of the background. The inside of the box is finished in matt polished gold. The snuff box also has fine gold mounts and a thumb rest with floral motifs that use flowers made of red glass flux.

The popularity of the pug reached a highpoint in Europe in the eighteenth century. Originally from China, these animals were kept at many European ruling courts as part of the Rococo fashion for all things Chinese. However the pugs depicted on snuff boxes in the eighteenth century were not merely a motif, they could also be read as a discrete reference to their owner's membership of what was called the Order of the Pug. In Meissen the pug is frequently found in groups of figures and, as in the present piece, used as motif. The Order of Pug was a society founded by Roman Catholics that was modelled on Freemasonry. It is said to have been established in 1740 by Clemens Augustus (Duke of Bavaria), who hoped in this way to circumvent the papal bull *In eminenti apostolatus specula* (1738) issued by Pope Clement XII. This forbade membership of the Freemasons under pain of excommunication. The new order spread rapidly at German courts and also came to Saxony. In Meissen this was reflected in the production of figures—in addition to the piece described here many figures and groups produced at this time were related directly or indirectly to Freemasonry. In Amsterdam a so-called "exposure" was published in 1745 with the title *L'Ordre des Franc-Maçons Trahi et le Secret des Mopses Révélé*. It contains details of the rituals of the order and two engravings.

The internal constitution of the Pug Order also admitted women as long as they were Catholics. In these circles the pug was regarded as a symbol of fidelity, reliability, and steadfastness.

The members of these lodges called themselves pugs and novices were led in by collars. They had to scratch at the door to gain entry. Then, with their eyes bound, they were led nine times around a carpet covered with symbols while the male and female pugs of the order barked and made noise to test the steadfastness of the initiates. During the induction ceremony they had to kiss the (porcelain) pug below its tail which was meant as an expression of complete devotion. The main teaching of the order was: "just as all the diameters of the circle go through its centre point, so must all the actions of a pug come from one source, namely love."

The pug depicted on the inside of the lid of this box matches the modelled dog used for the box listed as cat. no. 107.

SKA

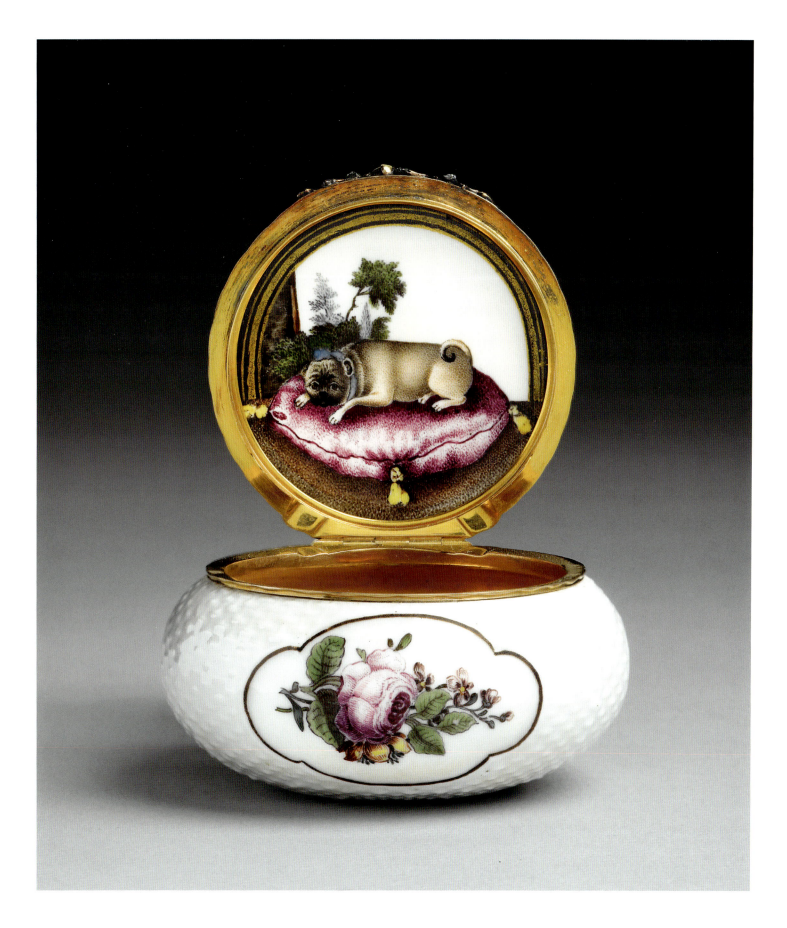

337

Cat. no. 106

SNUFF BOX

Painted c. 1745–50
With contemporary gold mounts
Height 4 cm, width 6.8 cm, depth 4.6 cm

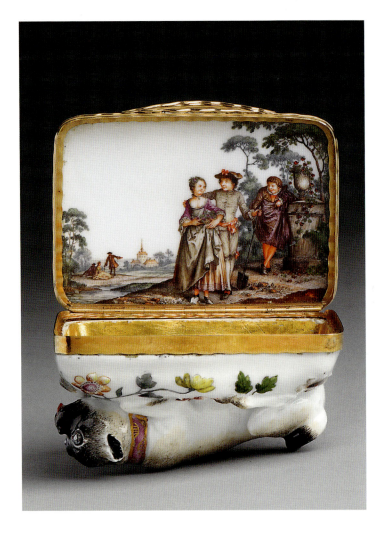

This special snuff box takes the form of a pug resting on a cushion. While the top and bottom of this "cushion" are decorated with a floral relief painted in different colours, the sweet little lap dog, a breed particularly popular at princely courts at the time, wears a purple collar edged in gold and was given glass eyes. The inside of the lid shows an unusual *galant* scene against the backdrop of a park: a lady carrying a flower basket is accompanied by a gentleman who holds a spade in his left hand while he places his right arm around her shoulder. They are being observed by another gentleman who stands, completely relaxed, with his lower left arm resting on a pedestal that carries a vase. In the background we see a further group of people with village buildings in the distance. This rural scene, too, is a variation on Watteau motifs, which the painter of this snuff box lid took from prints of two series made after Jean-Antoine Watteau (1684–1721) and combined in his composition: on the one hand he used the *Figures de Modes* (see figs. VI.105–07) by Edmé Jeaurat (1688–1738), on the other the *Figures Francoises et Comiques* (see figs. VI.108 and VI.109) by Louis Desplaces (1682–1739). SKA

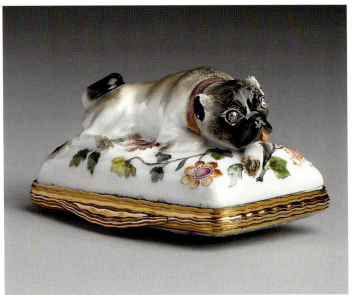

VI.105
Jean-Antoine Watteau (1684–1721), *Dame*, etching from the series *Figures de Modes*, Paris, Bibliothèque nationale de France

VI.106
Jean-Antoine Watteau (1684–1721), *Kavalier* (Gentleman), etching from the series *Figures de Modes,* Paris, Bibliothèque nationale de France

VI.107
Edmé Jeaurat (1688–1738), *Pilgerin* (Pilgrim), etching from the series *Figures de Modes,* after Jean-Antoine Watteau (1684–1721), Paris, Bibliothèque nationale de France

VI.108
Louis Desplaces (1682–1739), *Officier en Surtout,* etching from the series *Figures Francoises et Comiques,* after Jean-Antoine Watteau (1684–1721), Paris, Bibliothèque nationale de France

VI.109
Louis Desplaces (1682–1739), *Poisson en Habit de Païsan*, etching from the series *Figures Francoises et Comiques,* after Jean-Antoine Watteau (1684–1721), Paris, Bibliothèque nationale de France

Cat. no. 107

SNUFF BOX

Model by Johann Joachim Kaendler (1706–1775), 1741
Painted c. 1755
With contemporary copper gilt mounts
Height 4.6 cm, width 7.8 cm, depth 4.1 cm

Literature:
Jakobsen/Pietsch 1997, p. 263, cat. no. 216; Pietsch 2002

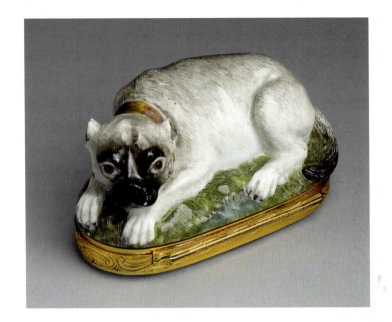

According to his work report from August 1741 the Meissen master modeller Johann Joachim Kaendler made "for His Excellence Cabinet Minister Count Brühl a snuff box in the form of a pug dog lying on a lawn, complete with lid" (Pietsch 2002, p. 81). Without doubt the present snuff box matches the description in the work report: after the porcelain piece had been cast a painter further refined it by giving the dog a finely painted coat, brown eyes, and a black muzzle, along with a brownish-red collar, while the scene on the lid that shows an amoretto with a pug in a park-like landscape was carried out by a different hand. Kaendler's report informs us that the model for this snuff box was made for the Saxon-Polish Prime Minister Heinrich Count von Brühl (1700–1763). However, the painting of the lid reveals that the present example was cast later and was probably intended either for public sale or for a different client. UP

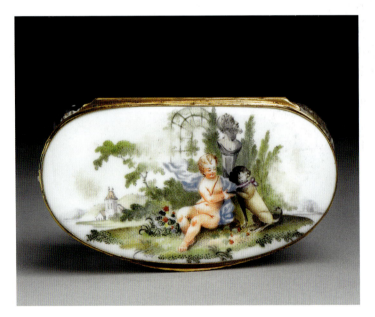

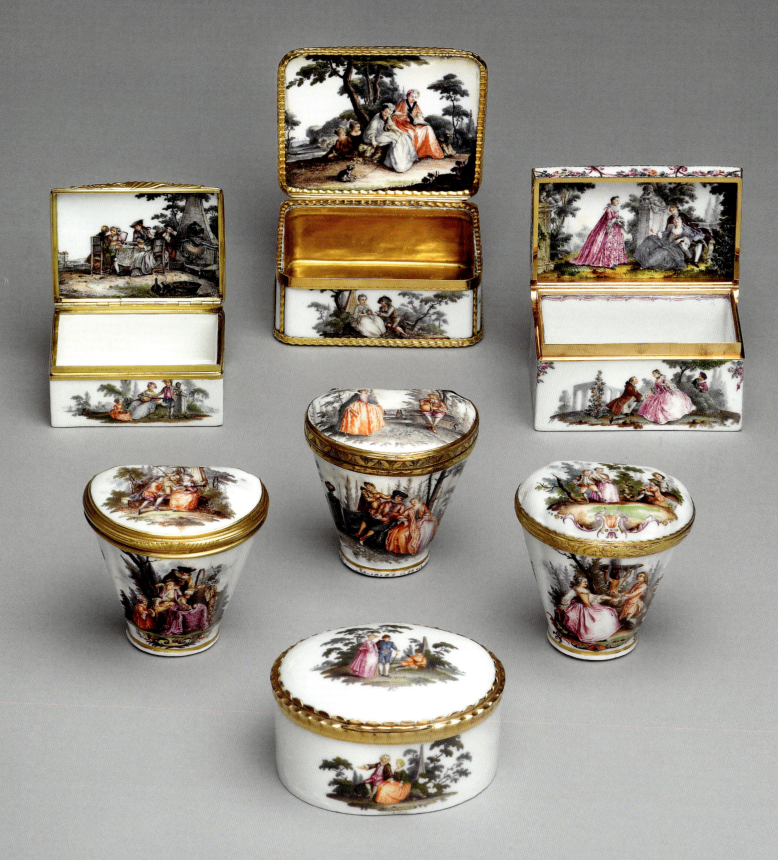

Portraits

Cat. no. 108

SNUFF BOX

Painted by Johann Martin Heinrici (1711–1786), c. 1754
With contemporary copper gilt mounts
Height 4.8 cm, width 9.1 cm, depth 7.3 cm

Literature:
Jakobsen/Pietsch 1997, p. 265, cat. no. 219

For the finely painted portrait of King Augustus III of Poland and Elector Frederick Augustus of Saxony (1697–1763) on the inside of the lid of this rectangular snuff box the painter, Johann Martin Heinrici, made use of a pastel by Anton Raphael Mengs (1728–1779) dating from 1745 in the Gemäldegalerie in Dresden. In 1753, using the same original model, Heinrici portrayed the King on a large porcelain plaque with a fine *rocaille* frame now in the Bayerisches Nationalmuseum, Meissen Porcelain Collection, Ernst Schneider Foundation (inv. no. ES 639), which is signed on the back with "Johann Martin Heinrici / Pinxit, 1753." This snuff box was probably produced in the same context. Two further portrait plaques, signed and dated 1754 and 1755, are today in the Porcelain Collection of the Staatliche Kunstsammlungen Dresden (PE 3608 and 3610). Heinrici received a special payment of 100 taler "for the large amount of work produced so far and for portraits" (Hauptstaatsarchiv Dresden, Locat1343, XVb, fol. 159, quoted from Rückert 1990, p. 155). Heinrici initially worked in the Meissen manufactory as what was called a "Watteau painter" but very soon became one of the best portrait painters there. Consequently we can assume with some degree of certainty that he also carried out the figural scenes set in park-like landscapes and edged at the bottom by colourful *rocailles* that decorate the outside of this snuff box. In the Meissen manufactory all décors of this kind that are based on quotations from prints made after paintings by French Rococo artists were described as "Watteau painting," which between 1739 and 1745 dominated the decorative painting done in the manufactory. However, it has not proved possible to relate any of the scenes on this box to specific paintings by Jean-Antoine Watteau (1684–1721). UP

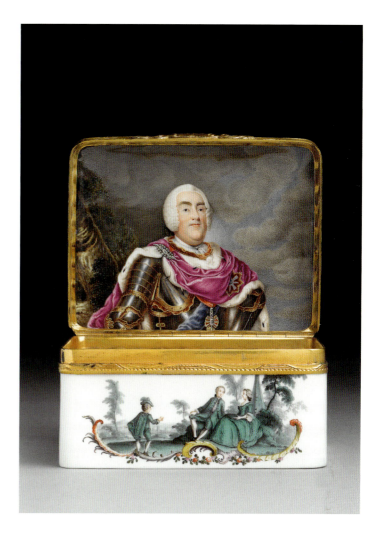

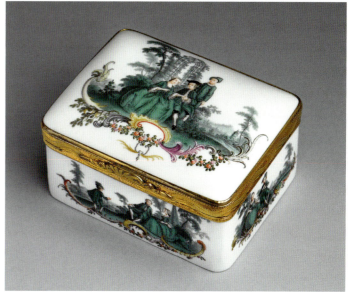

Cat. no. 109

SNUFF BOX

Painted c. 1755
With contemporary gold mounts
Height 4.6 cm, width 7.9 cm, depth 6.1 cm

Literature:
Exh. cat. Cologne 2010, p. 248, cat. no. 109

Works from the oeuvre of Jean-Antoine Watteau (1684–1721) showing light-hearted couples and people making music dressed in elegant *commedia* costumes were among the most popular motifs on Meissen snuff boxes from the mid-eighteenth century. The protagonists on the oval box shown here, placed in idealised, park-like landscapes in the style of Watteau that are painted on the smooth outside of the box in isolated "islands" offer an example of such motifs.

The inside of the lid reveals a portrait of the important Dresden court goldsmith Johann Melchior Dinglinger (1664–1731) beside an ornamental bowl that he designed known as the "Bath of Diana." In the Hermitage Museum in St. Petersburg today there is an oil painting by court painter Antoine Pesne (1683–1757) with an almost identically composition that shows Dinglinger posing self-confidently in a fur-trimmed coat. The fact that on the Meissen snuff box the ornate bowl is shown reversed along with other differences in the details may indicate that the painter of the box did not use as his model the portrait now in St. Petersburg but may have borrowed from a different portrait of Dinglinger. MR

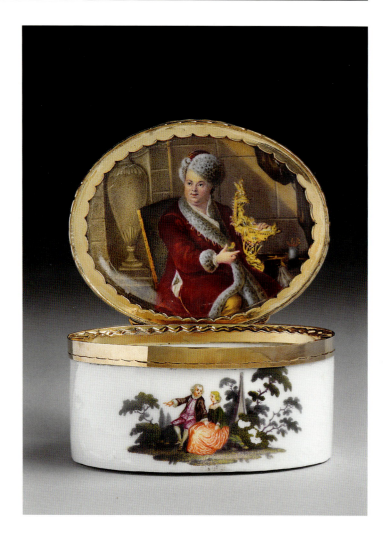

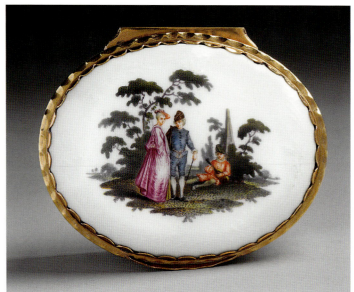

VI.110
Antoine Pesne (1683–1757), *Portrait of the Goldsmith Johann Melchior Dinglinger (1664–1731)*, St. Petersburg, State Hermitage

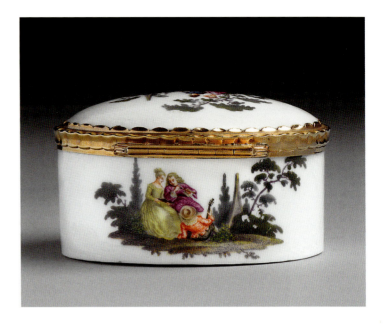
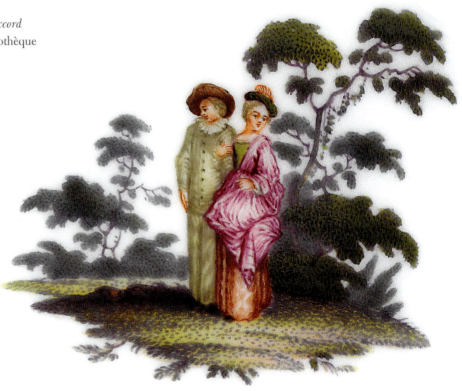

VI.111
Bernard Baron (1696–1726), etching after the painting *L'Accord Parfait* by Jean-Antoine Watteau (1684–1721), Paris, Bibliothèque nationale de France

346

Cat. no. 110

SNUFF BOX

Painted by Johann Martin Heinrici (1711–1786),
c. 1750–55
With contemporary bronze gilt mounts
Height 4.3 cm, width 8 cm, depth 5.9 cm

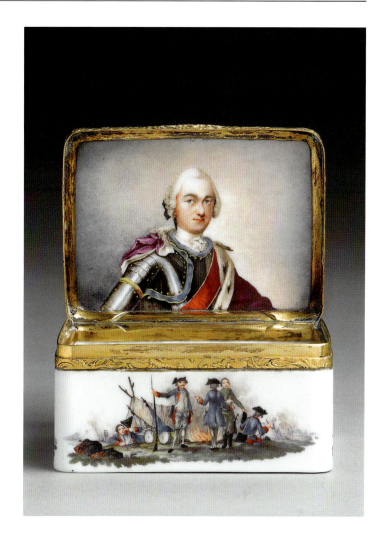

This rectangular snuff box with rounded corners has finely worked contemporary gilt-bronze mounts. The design of the thumb rest and the sides with their series of flags fanning out to the left and the right matches the subject of the painting on the outside of the box. It is decorated with coloured battle scenes in the so-called "island style" showing bivouacking soldiers and officers. On the inside of the slightly domed lid is a portrait finely painted in dots of colour of the Elector Palatine Carl Theodor (1724–1799), who is shown wearing a breastplate and an ermine cloak, against a diffuse background.

During the reign of the Elector Palatine Carl Theodor Mannheim developed from 1743 onwards into one of the main cultural centres among the eighteenth century German principalities. His move to Munich in 1777 to become the new Elector of Bavaria meant that main focus also shifted to Munich, although Carl Theodor always remained connected to his roots in the Palatinate.

Johann Martin Heinrici came to the Meissen manufactory in January 1742 as a painter. As well as the fine painting of miniatures on porcelain snuff boxes his specialities also included decorating the boxes with mother-of-pearl inlays. The painting attributed to Heinrici often uses allegorical or mythological subjects.

Heinrici painted Carl Theodor several times and he is depicted on three further snuff boxes. One of these is in the Gilbert Collection in London (inv. no. Gilbert.492-2008), a further one was published by Barbara Beaucamp-Markowsky (cf. Beaucamp-Markowsky 1985, pp. 138/39, cat. no. 103), while the third is in private ownership (cat. no. 114). All of these reference works are triple boxes that match cat. no. 114 in terms of the model and the concept of the design. They show the portrait of Carl Theodor with that of his spouse, Elisabeth Auguste von Pfalz-Sulzbach placed opposite. These depictions are based on the same—as yet unidentified—original as the painting on the present snuff box. SKA

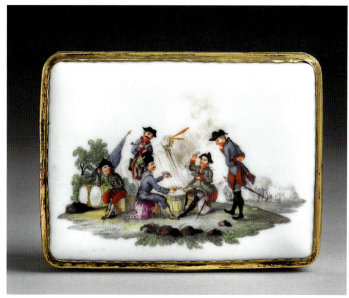

Cat. no. 111

SNUFF BOX

Painted by Johann Jacob Wagner (1710–1797),
c. 1765–70
With contemporary gold mounts
Gold mounts with later French tax stamp (1838–64)
Height 4.4 cm, width 8.7 cm, depth 6.7 cm

Provenance:
Lord Foley; C.W. Harris, Isle of Man

Literature:
Beaucamp-Markowsky 1985, cat. no. 108

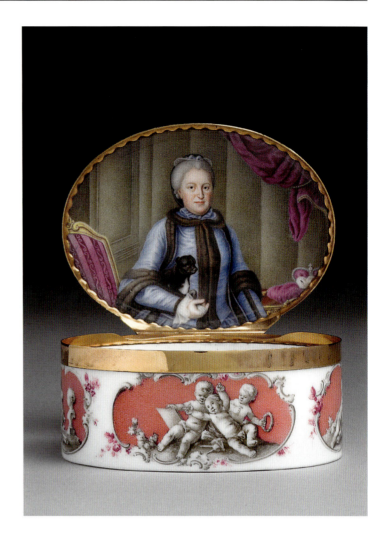

An oval box with a flatly domed lid, the lid and outside with reserves in the form of cartouches filled with a pink ground, finely framed by monochrome *rocailles* and purple flowers. Each cartouche is elaborately decorated with allegorical putti scenes of the arts and sciences painted in the most subtle shades of grey, which were based on prints by Louis Félix de La Rue (1731–1765) and Pierre-Alexandre Aveline (1702–1760) after François Boucher (1703–1770; see figs. VI.112–15). The putti, in pairs or groups of three, are shown employing the typical attributes of music, architecture, painting, geography, poetry, and sculpture and standing on a low base formed by a piece of ground against a pink background flanked by individual bouquets of flowers.

The inside of the lid was painted, using a fine stippling technique, with a coloured half-length portrait of Margravine Maria Anna Josefa Auguste von Baden-Baden (1734–1776) as a widow in a blue silk dress trimmed with dark fur. She wears a dark bonnet with a blue ribbon. In her right arm the Margravine holds a little black dog. To her left we see the back of a gilded armchair upholstered in a purple striped fabric, on the right the Margrave's crown rests on a purple cushion under a piece of drapery cut off diagonally. The background of the portrait is formed by bands of brownish stripes, while a *boiserie* wall running at an angle on the left-hand edge creates an impression of spatial depth.

Princess Maria Anna was a daughter of the Elector, and later Emperor, Karl VII Albrecht of Bavaria (1697–1745) from his marriage to Maria Amalie (1701–1756), daughter of Emperor Joseph I. On 10 July 1755 Princess Maria Anna married Margrave Ludwig Georg Simpert of Baden-Baden (1702–1761) in Ettlingen. The couple had no children and consequently the important political goal of the parties involved, the continuation of the Catholic line Baden-Baden, was not achieved. The state fell to the Protestant line Baden-Durlach. After the Margrave's death Maria Anna returned to Munich in 1761 and lived at the court of her brother, Maximilian III, until she died. The snuff box described here was produced during this period: the intimate portrait shows the Margravine at a mature age, the insignia of power and aristocratic pomp retire to the background—the style of the painting on this Meissen porcelain snuff box and the way it is executed suggest that it was probably made around 1770.

Whereas Meissen used boxes made of precious metals and other materials as models for the snuff box forms, the rich variety of the décors is entirely the manufactory's own achievement.

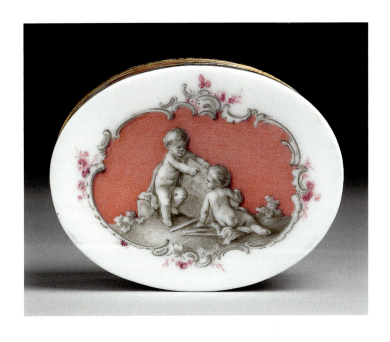

VI.112
Louis Félix de La Rue (1731–1765), copper engraving after the painting *L'Architecture* by François Boucher (1703–1770), New York, The Metropolitan Museum of Art

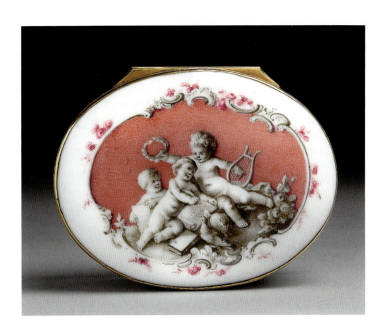

VI.113
Louis Félix de La Rue (1731–1765), copper engraving after the painting *La Poesie* by François Boucher (1703–1770), New York, The Metropolitan Museum of Art

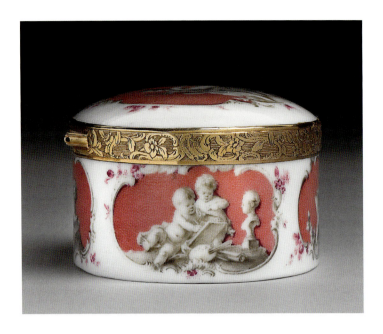

VI.114
Louis Félix de La Rue (1731–1765), copper engraving after the painting *La Peinture* by François Boucher (1703–1770), New York, The Metropolitan Museum of Art

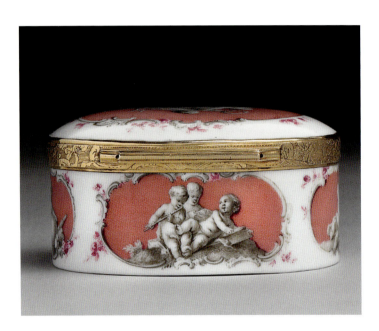

VI.115
Pierre-Alexandre Aveline (1702–1760), *Tours Amours avec des Instruments de Musique*, copper engraving from the series *Livre de Groupes d'Enfans* by François Boucher (1703–1770), New York, The Metropolitan Museum of Art

After the invention of porcelain in Meissen what were known as "snuff tobacco boxes" were initially made of Böttger stoneware. The earliest Meissen snuff boxes in porcelain were oval with a flatly domed lid and had slightly hollowed sides to make them easier to use. They were probably made by Fritsche, the best form-maker in the manufactory, from around 1725. However it was Johann Joachim Kaendler who from 1733 decisively shaped and enriched the formal type of the snuff box. While he based his work on the canon of forms and relief décors found in goldsmith work, the ease with which porcelain could be shaped and the artistic means of decorating it allowed him to make previously unimaginable creations.

A distinctive characteristic of such a *tabatiere*—as Kaendler later described them in his work reports—is the gold or silver mounts, frequently made by local goldsmiths, which have a closing mechanism and a hinge that allows the lid to be flipped open, whereas lids that are screwed or simply fitted in place indicate boxes intended for a other uses.

The painting with monochrome putti scenes after François Boucher and the portrait of the lady can be attributed to Philipp Ernst Schindler Junior (1727–1793) who, after his departure from Meissen to Vienna, had painted and signed numerous similar depictions on snuff boxes and boxes of pocket watches (cf. Pietsch 2001, p.150).

Johann Jacob Wagner, son of a court goldsmith from Eisenach and pupil of the painter Johann Georg Dietrich (1684–1752) in Weimar, who was employed in 1738 as "miniature painter" in Meissen, having proved his abilities on three snuff box lids that he painted as a kind of test. In January 1739 already we find an entry on Wagner in the manufactory documents that stresses his particular skill in painting snuff box lids and portraits. From this time onwards Wagner was one of the best-paid (box) painters in the manufactory and in 1741 was appointed director of painting. His work reports and earlier lists show that Wagner for the most part painted snuff boxes with subjects after Watteau, which were so popular at the time, as well as portraits and battles. In 1749 Höroldt, after having approved a bonus payment of 50 *Taler* to Wagner, wrote that he was "a skilled man in producing portraits and other painting."

Wagner's fine painting style can be identified by, for instance, a Meissen snuff box signed with "J. Wagner," which was made in 1741 and on 29 August 1742 was given by Frederick the Great to the 3rd Earl of Hyndford, the British envoy in Berlin, as a gift.

Two snuff boxes with similar putti scenes are to be found in Beaucamp-Markowsky 1985, cat. nos. 106 and 107. A further (oval) snuff box, also with comparable putti scenes, is published in Beaucamp-Markowsky 1988, p. 70, cat. no. 34. MR

Cat. no. 112

OVAL DOUBLE SNUFF BOX

Painted c. 1755
With contemporary gold mounts, both halves of the box are marked internally with three purple lines
Height 5 cm, width 8.2 cm, depth 5.8 cm

Literature:
Beaucamp-Markowsky 1985, p. 248, cat. no. 109

This double box made of two scalloped and domed halves of an oval is mounted with an extremely finely worked gold band and gold hinge. The band is engraved with a diamond-patterned border that is filled with half-palmettes on a hatched ground. A very narrow notched tongue serves as a thumb-rest.

The outside is painted using various muffle colours. Bouquets of *Manierblumen* at the centre are framed by hanging garlands of flowers. Just as unusual and rare as the form of this box are its original internal fittings, which consist of a pivoting portrait of a lady done in pastel on paper and a mirror inset in the back, probably the work of a Dresden goldsmith, of the kind commissioned by the Meissen manufactory for the most costly of its porcelain snuff boxes. MR

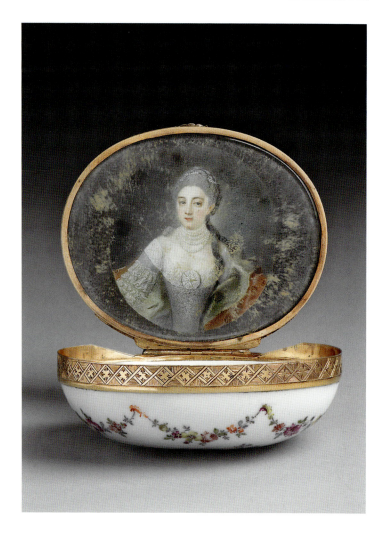

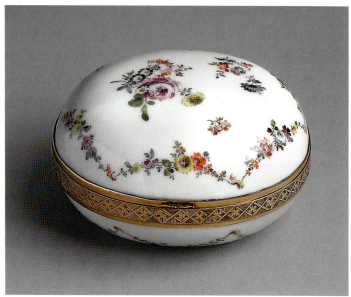

Cat. no. 113

SNUFF BOX

Painted by Johann Martin Heinrici (1711–1786), c. 1756
With contemporary gold mounts
Height 7.4 cm, diameter 4.2 cm

Literature:
Beaucamp-Markowsky 1985, pp. 120f., cat. no. 90

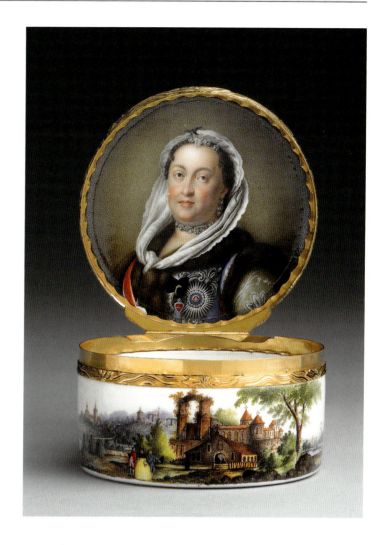

On the inside of the lid of this round snuff box with gold mounts Johann Martin Heinrici painted the portrait of the spouse of King Augustus III of Poland and Elector Frederick Augustus of Saxony (1697–1763), Maria Josepha from the House of Habsburg (1699–1757), using a very fine stippling technique. Heinrici was regarded as one of the best portrait painters in the Meissen manufactory. For this bust of the Queen he used as his model a painting by Pietaro Count Rotari (1707–1762) in the Gemäldegalerie Alte Meister of the Staatliche Kunstsammlungen Dresden that dates from 1755. Heinrici also painted a portrait of the Queen, after the same original, on a porcelain portrait plaque marked with "JM Heinrici fec: / 1756" that is in the Porcelain Collection of the Staatliche Kunstsammlungen Dresden (inv. no. PE 3609). There is a further rectangular snuff box lid with the same portrait in the Museum für Kunst und Gewerbe in Hamburg (inv. no. 1833.315; see fig. IV.5). It seems likely that the painting of the snuff boxes is directly connected to that of the plaque and can therefore be dated to around 1756.

The portrait shows the Queen in full regalia at the mature age of 57, shortly before her death. She wears a fur-trimmed jacket with an Oriental floral pattern, across it a red, silver-edged ribbon and the Russian Order of St. Catherine in a breast star made of diamonds. Her head covering is a length of white cloth that continues around the back of her neck and ends in a loosely tied knot above her décolleté. She wears a necklace of large diamonds with matching earrings, while her hairline is adorned with further precious stones mounted in gold and a black enamelled eagle carrying a pear-shaped diamond.

The décor on the outside of the box attains the same high artistic quality as the portrait. Idealised landscapes with fantastical architecture, grass-covered ruins and a figural staffage consisting of horsemen, people strolling, and and shepherds form a continuous panorama on the side of the box. Similar subjects are used in two further scenes, one on the lid, the other on the base, which are complete within themselves. The delicate and richly detailed miniature painting reveals a great mastery of a kind rarely encountered before this time in the Meissen manufactory, which only such a gifted painter as Heinrici possessed. Without doubt the decoration of this snuff box ranks among the very best achievements of eighteenth-century porcelain painting. UP

Cat. no. 114

TRIPLE SNUFF BOX

Insides of the lids painted by
Johann Martin Heinrici (1711–1786),
c. 1765
With contemporary gold mounts
Heigth 5.8 cm, width 8.9 cm, depth 7 cm

Literature:
Jakobsen/Pietsch 1997, p. 104, cat. no. 69

Similar form to cat. no. 62. This rectangular snuff box has a total of three compartments for different kinds of snuff and is closed by two smaller lids at the top and a larger one on the bottom. The outer surfaces are covered with a white and blue mosaic décor ground. On each of the sides of the box a reserve framed by coloured *rocailles* was left in this ground. These reserves contain naively painted mythological scenes set in landscapes with references to classical antiquity. Both the principle of the decoration and style of the painting of this box match a snuff box in private ownership (cf. cat. no. 62), which, similarly, has a blue mosaic ground.

The painting on the inside of the three lids is far more elaborate and of considerably higher artistic quality. The two smaller ones present portraits, the larger one contains a depiction of Vertumnus and Pomona translated into porcelain painting from a print by Augustin de Saint-Aubin (1736–1807) that was made after François Boucher's (1703–1770) painting *Vertumne et Pomone* (see fig. IV.116). The porcelain painter adhered very closely to the composition of his model but had to devise the colouring himself, as, of course, he did not know the original painting. The etching is dated 1765, which offers a definite indication when this snuff box was painted.

The portraits show the Elector Karl Theodor von der Pfalz (1724–1799) and his spouse, Elisabeth Auguste von Pfalz-Sulzbach (1721–1794), and were made after prints yet to be identified. A triple snuff box from the Frankenthal manufactory also shows the Elector and spouse (cf. Beaucamp-Markowsky 1985, pp. 349f., cat. no. 286). Here we should recall the fact that the Meissen painter Johann Martin Heinrici secretly left the manufactory in 1757 and records show that he was subsequently in Frankenthal. He could therefore possibly be the author of the portraits. He returned to Meissen in 1761, where he once again painted the Elector and his spouse on a similar triple snuff box (cf. Beaucamp-Markowsky 1985, pp. 138f., cat. no. 103). A depiction of the birth of Venus in the lid of this box can also be attributed to Heinrici, whereas the mythological scenes in the reserves in the white and blue mosaic ground are clearly by a different painter, the same one who decorated the outside of the present snuff box.

UP

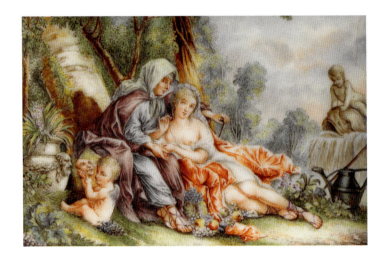

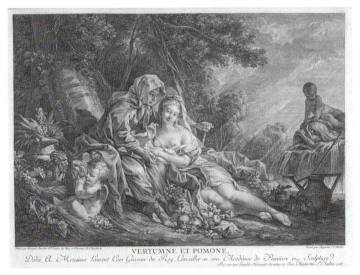

VI.116

Augustin de Saint-Aubin (1736–1807), etching after the painting *Vertumnus et Pomona* by François Boucher (1703–1770), New York, The Metropolitan Museum of Art

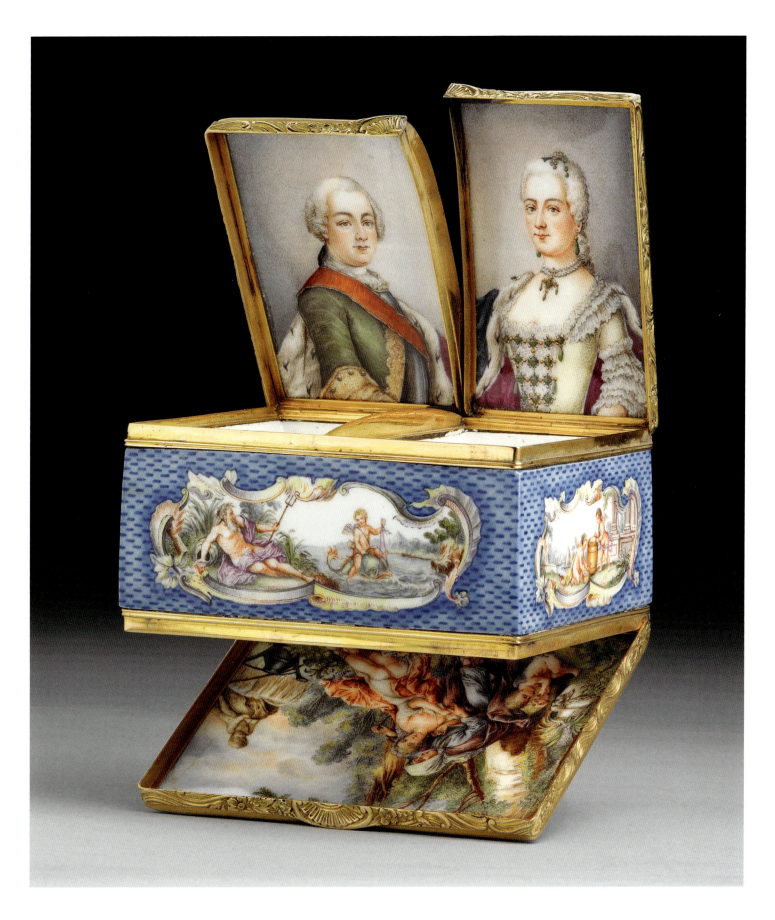

Cat. no. 115

SNUFF BOX

Painted c. 1760
With contemporary silver mounts
Height 5 cm, diameter 8.6 cm

Literature:
Mankart 2012

This round snuff box with slightly domed lid was painted on the outside, the lid, and the base with comic scenes that show amorini in disguise and children wearing *commedia* costumes. Although it has not been possible to identify a model, depictions of a similar kind are familiar from prints after François Boucher (1703–1770) or by Johann Esaias Nilson (1721–1788).

On the inside of the lid is a portrait of Frederick the Great that was probably made from a print after a portrait by Antoine Pesne (1683–1757). It shows the King of Prussia as a young man, clearly identifiable by the attributes that already made him unmistakeable for his contemporaries: the oversized tricorn, and the Order of the Black Eagle on a blue uniform, in later years he was also shown with a diamond-studded walking stick. In contrast to portraits of other rulers paintings of Frederick II as King of Prussia are rather rare. This may have to do with Frederick's ideas about portraits of his person: "one must be an Apollo, Mars or Adonis to have oneself painted and, as I do not have the honour of being one of these gentleman, I have, whenever it was solely my decision, hidden my face from the paintbrush," (quoted from Mankart 2012, p. 205). In principle no prince sat as model for every painting made of him and at sittings often only the monarch's head was sketched, while the details were worked out later in the artist's studio where the body and clothing were also added. Furthermore, it was not unusual for existing portraits to be used as models. In the case of Frederick the Great pictures of him made by the court painter Antoine Pesne when he was still a Crown Prince continued to be used as models even after he had ascended the throne. New portraits made in later years adapted these models to depict his actual age. It remains unclear on which likeness the depiction on the inside of the lid was based, but in type it matches a portrait by Antoine Pesne from around 1745 (see fig. VI.117). Although the body is shown in a somewhat different perspective, the facial features, clothing, and background depicted in the porcelain picture all resemble de Pesne's painting.

SKA

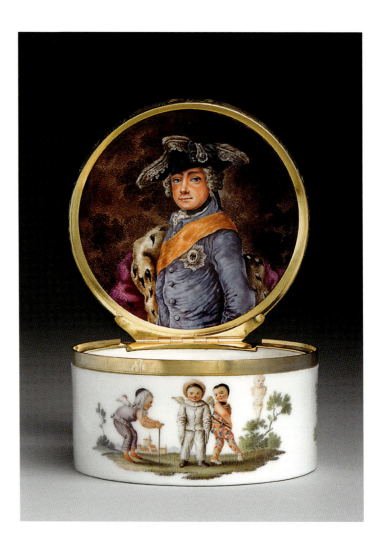

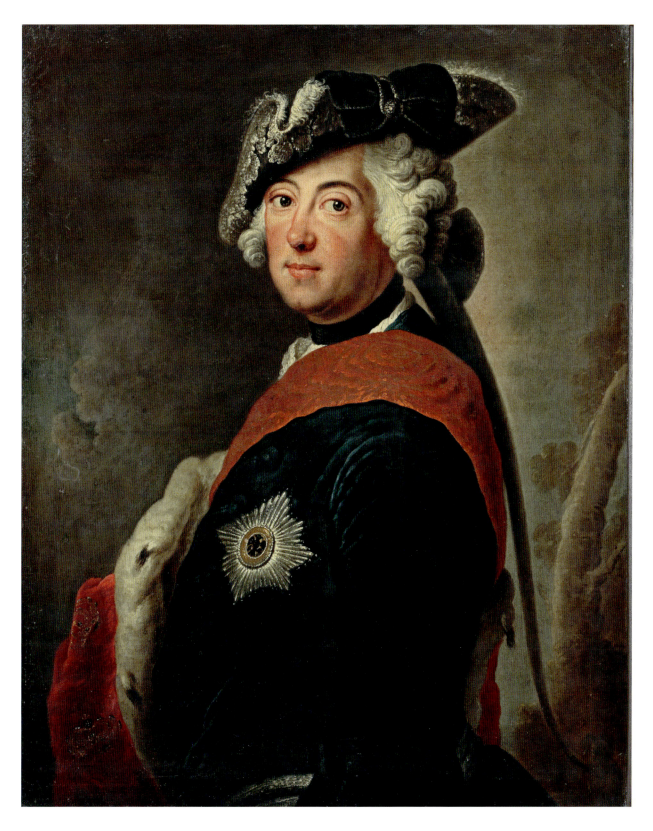

VI.117
Antoine Pesne (1683–1757), *Frederick the Great, King of Prussia*,
c. 1745, Hanover, Niedersächsisches Landesmuseum

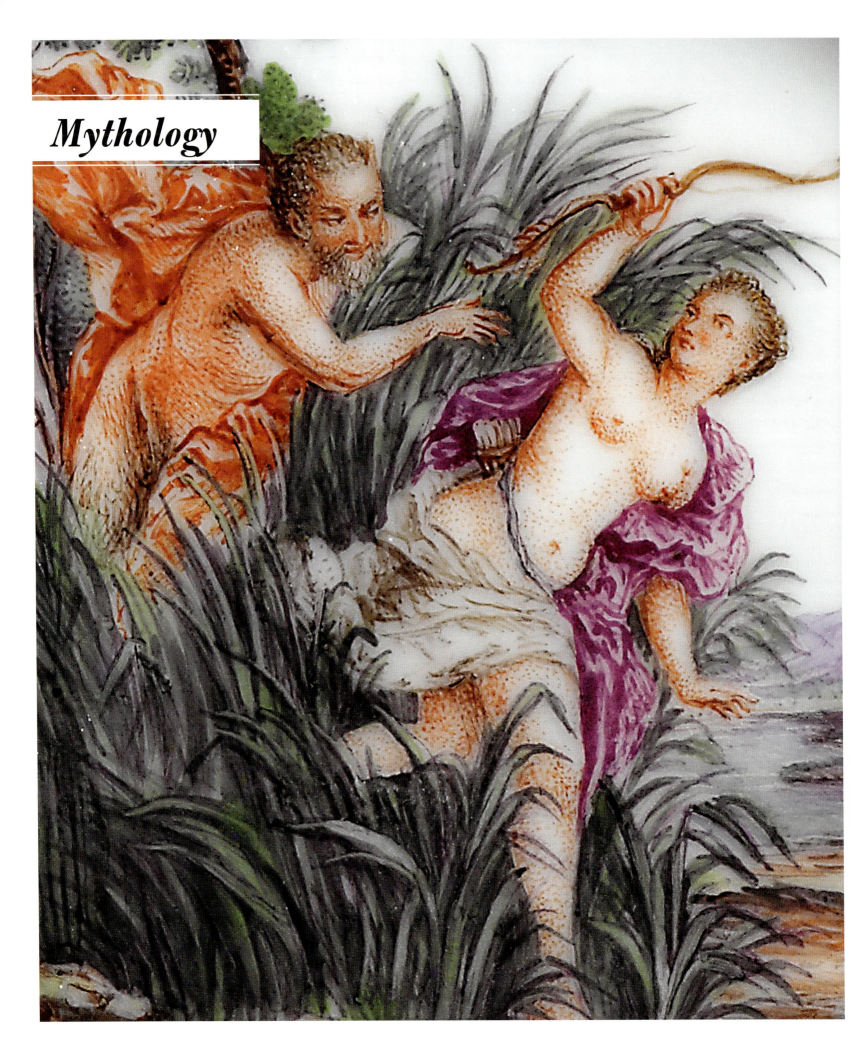

Mythology

Cat. no. 116

SNUFF BOX

Painted c. 1740
With contemporary silver gilt mounts
Height 4.1 cm, width 8.4 cm, depth 6.8 cm

The outside of this scalloped-edged box that is a transverse rectangle in plan is covered in richly designed reliefs, left in white. The depiction on the lid shows Apollo, god of light, with the chariot of the sun drawn by four stallions. The relief on the base of the snuff box presents a lute and a lyre backed by an aureole. Both attributes refer to Apollo in a different role, as the god of poetry and the fine arts.

The inside of the lid presents a scene taken from antique mythology, which was made after a print by the Dutch engraver, draughtsman and publisher, Jacob Matham (1571–1631), which dates from 1610 (see fig. VI.118). It depicts the final scene of the legend of Danaë, the daughter of Eurydice and King Acrisios of Argos. An oracle had predicted to the king that he would be robbed of his throne and killed by his daughter's son and so the ruler was compelled to keep his beautiful offspring with her nurse in an underground cavern (in some versions a tower). Although she was hidden from the gaze of any human eyes, Zeus caught sight of Danaë and descended upon her in the form of a shower of gold. Acrisios had the issue of this union, Perseus, locked in a chest together with his mother and thrown into the sea.

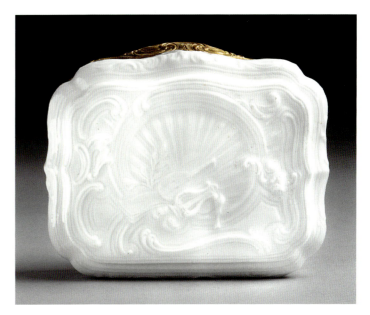

The print and the porcelain portrait show a naked Danaë asleep, only partly covered by a piece of cloth. A shower of gold falls on her, its divine origins suggested by the crowned and bearded head of Zeus that peers out of a cloud. The young woman's nurse stands behind her bed and apparently attempts to catch the gold in her outstretched apron. In particular the wrought golden vessels, which Matham also shows in his print, occupy a crucial position in the context of this picture. SKA

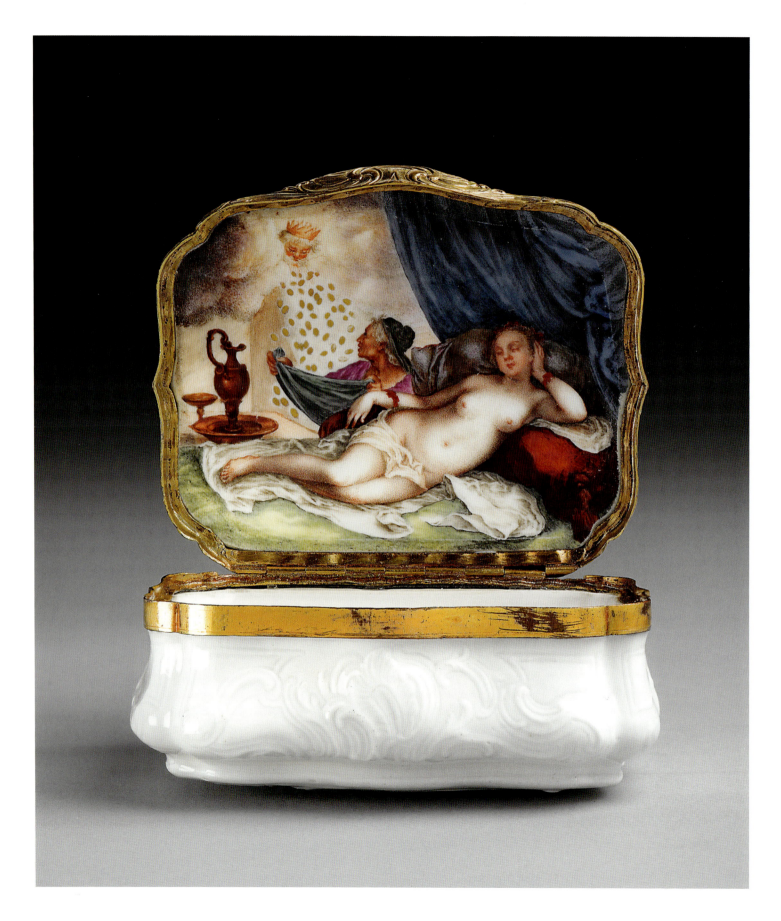

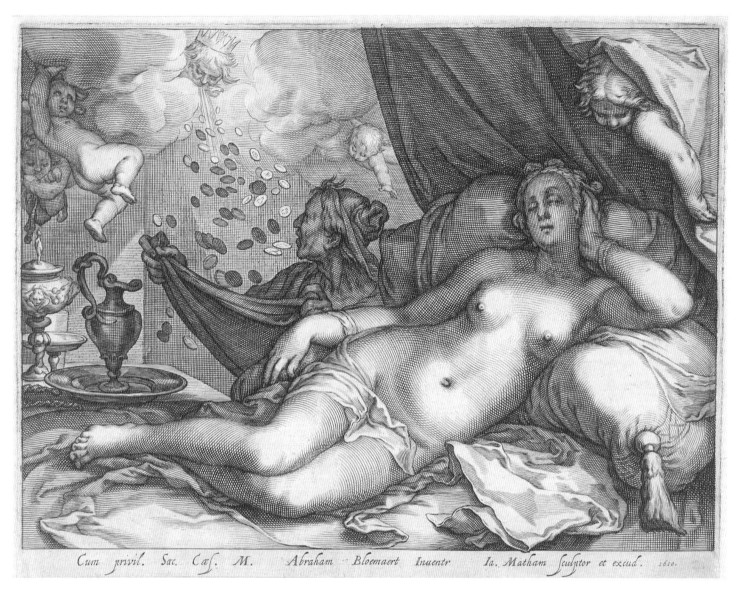

VI.118
Jacob Matham (1571–1631), *Jupiter and Danaë*, copper engraving, 1610, Amsterdam, Rijksmuseum, print collection

Cat. no. 117

SNUFF BOX

Painting of the inside of the lid probably by
Johann Jacob Wagner (1710–1797), c. 1765
With contemporary silver gilt mounts
Height 4 cm, width 9.2 cm, depth 9.2 cm

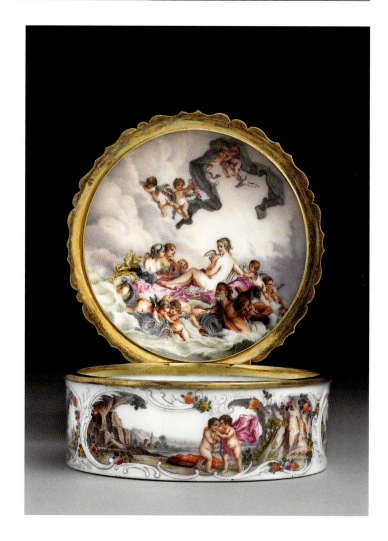

The outside of this round snuff box is decorated with relief cartouches in *rocaille* form, in which miniatures are painted that show putti playing in wooded landscapes. The base of the box is decorated with a naked Diana, goddess of the hunt, kneeling on a purplish-red cloth, beside a group of trees.

The main painting inside the lid is a finely executed depiction of the Birth and Triumph of Venus surrounded by putti and tritons in a foaming sea, after the famous painting by François Boucher (1703–1770) in the Hermitage in St. Petersburg. For his depiction the porcelain painter used a print made after this painting by Jean Daullé (1703–1763; see fig. VI.119). The high quality of the painting suggest that it was done by Johann Jacob Wagner, who worked in the Meissen manufactory from 1738 to 1797, mostly as a painter of miniatures. He succeeded in transferring the lascivious eroticism of the original to the porcelain painting made from the reversed print. He was also able to read the dark and light values of the composition from the graphic work alone, so that, for instance, he gave the two tritons in the foreground a brownish skin tone, whereas Venus, like in the original, is pale-skinned.

In view of their lesser quality it seems doubtful whether Wagner can have painted the other depictions on the box; here too, at least for the putti scenes, the painter used a print by Daullé, also made after a painting by Boucher (see fig. VI.20). UP

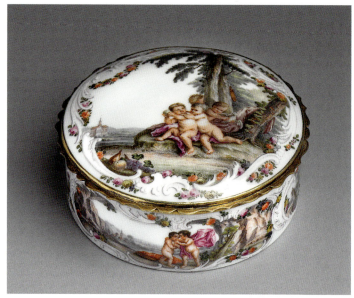

VI.119
Jean Daullé (1703–1763), copper engraving after the painting *Naissance et Triomphe de Venus* by François Boucher (1703–1770), 1760, Leipzig, Stadtmuseum

VI.120
Jean Daullé (1703–1763), copper engraving after the painting *Les Amours en Gayete* by François Boucher (1703–1770), 1750, New York, The Metropolitan Museum of Art

Cat. no. 118

SNUFF BOX

Painted by Johann Jacob Wagner (1710-1797), c. 1760
With contemporary gold mounts
Height 4.2 cm, diameter 7.8 cm

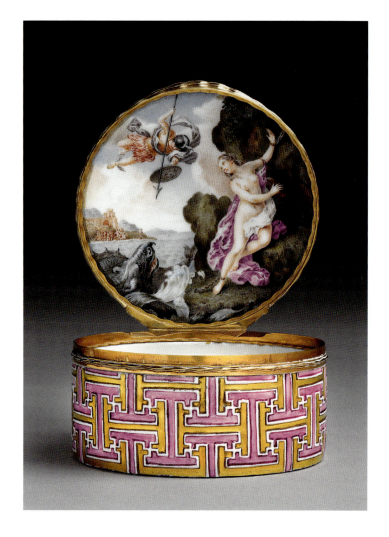

All the external surfaces of this round snuff box are decorated with a pseudo-meander in relief which has edges left white and is partly gilded over a purple ground.

The finely painted mythological scene showing Perseus and Andromeda on the inside of the lid was carried out by Johann Jacob Wagner using the finest stippling technique. As so often the case with snuff boxes, it differs thematically from the depictions on the outside. The scene shows the princess Andromeda being rescued by the demi-god Perseus. While flying above the coast of Ethiopia he spies the maiden Andromeda daughter of King Cepheus, chained to a rock. Tearfully she explains to Perseus: "I am called Andromeda and I am the daughter of King Cepheus. My mother Cassiopeia boasted to the daughters of Nereus that I was more beautiful than they. They were filled with wrath and their friend the sea-god punished the country with floods and sent a sea monster that devours everything. Our country can only be saved if the king's daughter is sacrificed to this monster." Perseus thereupon kills the approaching monster and, as a gesture of gratitude, the king bestows upon him his kingdom and the hand of his daughter, Andromeda.

What are known as *tableaus,* which were often carried out by specialist miniature and portrait painters using the finest technique, are the showpieces among porcelain boxes.

Johann Jacob Wagner, who was employed in the manufactory from December 1738 and in 1786 was still recorded in the staff lists as a miniature painter of snuff box lids, was numbered among the best miniature painters of this period. In his (incomplete) work reports he mentions painting on lids, which he often based on pastels by Rosalba Carriera (1675–1757). He rarely signed his works but those bearing his signature are painted in the same style.

The incorrectly made meander décor is probably the result of borrowing a popular surface ornament used on Chinese porcelain. A further box with two putti playing inside the lid is published by Beaucamp-Markowsky 1985, cat. no. 175. Mention is also made there of a box said to have a picture of Perseus and Andromeda on the inside the lid, made after François Lemoyne (1688–1737), which could possibly be the box described here (ibid.). A further snuff box with the same meander décor and putti at play is in the Jack and Belle Linsky Collection, The Metropolitan Museum of Art, New York. MR

Cat. no. 119

SNUFF BOX

Painted c. 1750
With contemporary copper gilt mounts
Height 3.5 cm, width 7.7 cm, depth 7 cm

This oval snuff box with a practically flat lid was decorated on all sides with mythological scenes. The painting on the inside of the lid depicts an episode from the moving story of Pan and the nymph Syrinx from Ovid's *Metamorphoses*, after an etching by Georg Kilian (1683–1745) after Israël Silvestre (1621–1691; see fig. VI.121) painted in fine stippling. Consumed by desire for the beautiful naiad, Pan pursues her to the reed-fringed banks of the River Ladon, who was Syrinx's father and is depicted here in the form a bearded man holding an oar with his back turned towards the viewer. Having reached the riverbank she pleads for help and is turned by her father into a bank of reeds.

The continuous decoration on the outside of the box shows other groups of mythological figures against a landscape: Cupid and Venus accompanied by two amorini (one putto is working with a hammer and anvil, probably a reference to Venus's husband, Vulcan, while the second rests in the goddess's chariot), and Leda with the swan after an illustration by Sébastien Leclerc I. (1637–1714) for Isaac de Benserade's *Les Métamorphoses d'Ovide en Rondeaux* (see fig. VI.122). Opposite her we see a faun accompanying a putto astride a billy-goat, in the style of the children and putti scenes by François Boucher (1703–1770).

The top of the lids shows a *Venus Triumphans* in a shell-shaped chariot after an unidentified model, while the scene on the bottom of the box shows a faun with a lightly-clad female figure, viewed from the back. At her feet two children lie among a group of leopards, this scene is based on a print by Wenceslaus Hollar (1607–1677) after Peter Paul Rubens (1577–1640; see fig. VI.123).

SKA

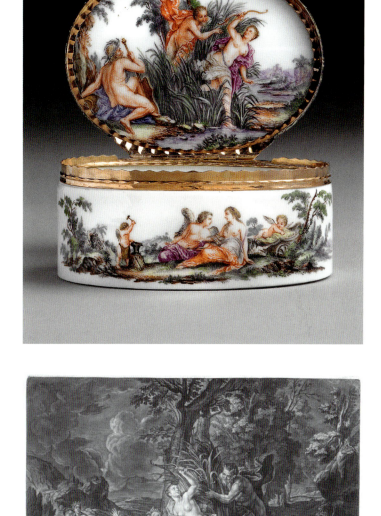

VI.121
Georg Kilian (1683–1745), *Pan verfolgt Syrinx*, etching after Israël Silvestre (1621–1691), Brunswick, Herzog Anton Ulrich-Museum

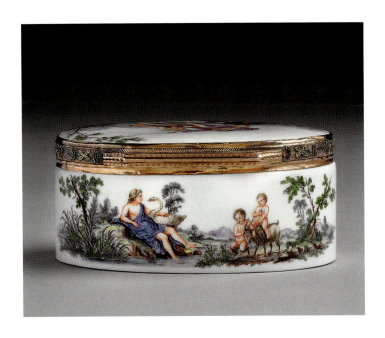

VI.122
Sébastien Leclerc I (1637–1714), *Leda and the Swan,* copper engraving, 1676, London, British Museum

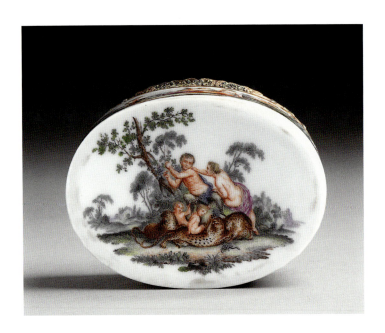

VI.123
Wenceslaus Hollar (1607–1677), *Zwei Kinder und drei Leoparden* from the series *Kinderspiele,* etching after a painting by Peter Paul Rubens (1577–1640), Brunswick, Herzog Anton Ulrich-Museum

Cat. no. 120

SNUFF BOX

Painted c. 1750
With contemporary gold mounts
Height 4.2 cm, width 7.3 cm, depth 5.8 cm

This slightly domed snuff box is rectangular in plan with rounded corners and discrete gold mounts *à cage*. It is decorated on all sides with putti engaged in various activities; the individual motifs are derived from scenes with putti and children by François Boucher (1703–1770). In particular, prints by the Parisian artist Claude-Augustin Duflos the Younger (1700–1786) were used as models and are clearly recognisable in the style of the porcelain painting. The children are characterised by their heavy, sometimes even crudely depicted physiognomy which, combined with the powerful contours of their bodies and the particularly distinctive faces framed by simply drawn hair, creates a strikingly memorable effect.

For the top of the lid the figures from the print *L'Amour Nageur* by Pierre-Alexandre Aveline (1702–1760) were combined with those from *L'Eau* by while the inspiration for the inside of the lid was provided by two other prints: *L'Hyver* (see fig. VI.124) by Claude-Augustin Duflos the Younger and *Le Feu* (see fig. VI.125) by Louis Félix de La Rue (1731–1765). The bottom and the sides of the box are decorated for the most part with Duflos's putti, which were taken from the prints *Pescheurs, Le Printemps, Le Feu,* and *L'Air* (see fig. 127). An additional inspiration came from a copper engraving by Benoît Audran II (1698–1772) after the painting *Autumnus-L'Automne* by Joseph Natoire (1700–1777).

SKA

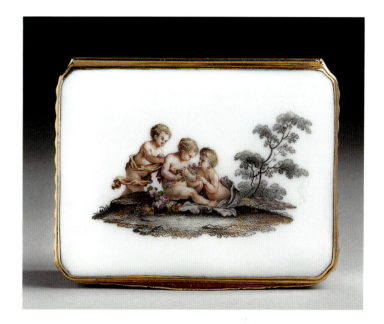

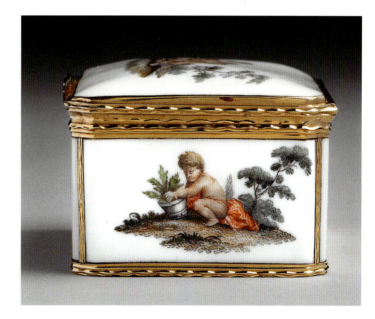

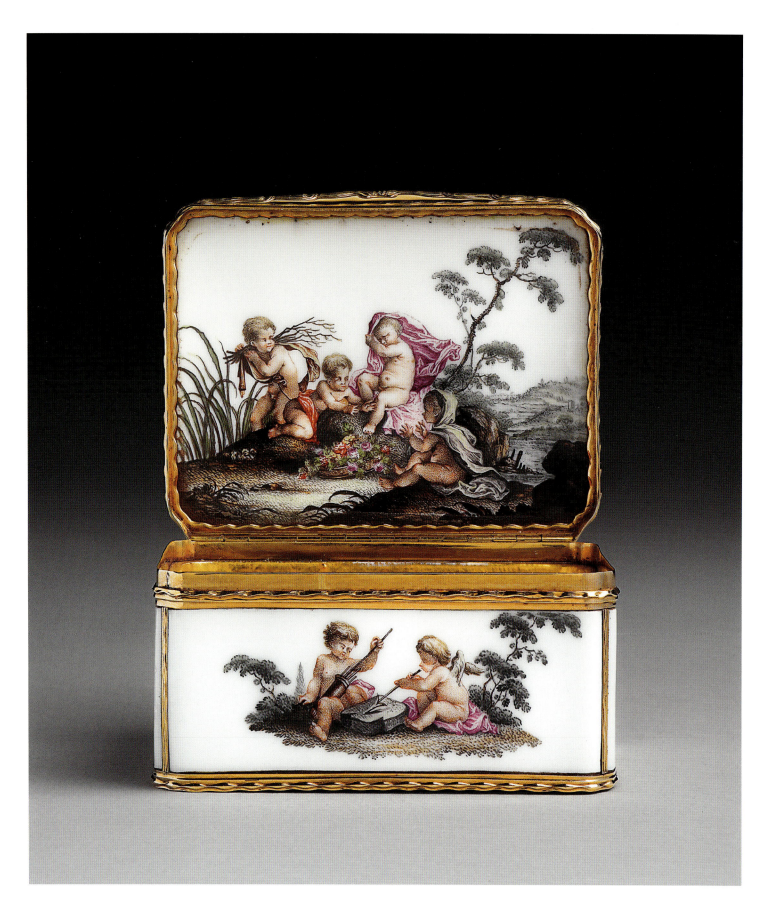

VI.124
Claude-Augustin Duflos the Younger (1700–1786), copper engraving after the painting *L'Hyver* by François Boucher (1703–1770), London, British Museum

VI.125
Claude-Augustin Duflos the Younger (1700–1786), copper engraving after the painting *Le Feu* by François Boucher (1703–1770), London, British Museum

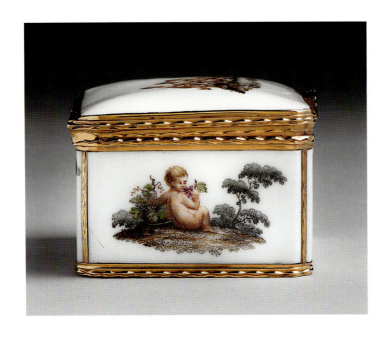

VI.126
Benoît Audran II (1698-1772), copper engraving after the painting *Autumnus-L'Automne* by Charles Joseph Natoire (1700–1777), London, British Museum

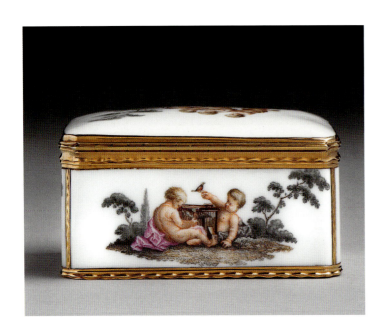

VI.127
Claude-Augustin Duflos the Younger (1700–1786), copper engraving after the painting *L'Air* by François Boucher (1703–1770), London, British Museum

Cat. no. 121

SNUFF BOX

Painted c. 1750
With contemporary gold mounts
Height 5.4 cm, diameter 5.4 cm

This snuff box is circular in plan with sides that taper slightly towards the base. It has a gently domed lid and gold mounts decorated with a regular wave pattern. Like the snuff box listed as cat. no. 120 this delicate container was also decorated with putti scenes after François Boucher (1703–1770), some of the figures on the inside of the lid were borrowed from the print *L'Hyver* (see fig. VI.126) by Claude-Augustin Duflos the Younger (1700–1786).

Unlike the reference piece, the painting here is continuous around the entire outside of the box, which in thematic terms appears to be devoted to the element water. SKA

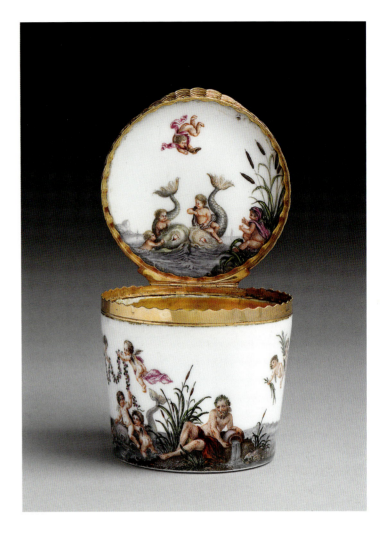

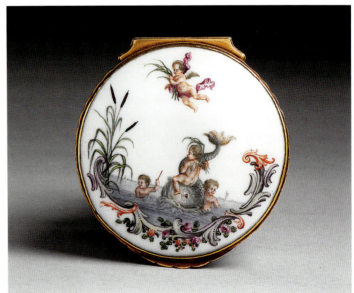

Cat. no. 122

SNUFF BOX

Painted c. 1755
With contemporary gold mounts
Height 4.4 cm, width 6.7 cm, depth 5.3 cm

Literature:
Beaucamp-Markowsky 1988, p. 70, cat. no. 34

Delicate *rocaille* reliefs decorate the outside of this oval snuff box with a domed lid. The original gold mounts are ornamented with corresponding reliefs.

The smooth cartouches on the outside show winged putti at play above delicate grey clouds, while on the inside of the lid four putti gambol in a park-like landscape at the foot of a large stone pedestal; the painting is carried out using fine dots of colour.

Winged putti were often used as minor figures in allegorical and mythological scenes but on this box they form the principal motif. Similarly the inside of the lid, frequently painted with a completely different subject to the outside of the box, is here devoted entirely to the playful activities of these winged boys. MR

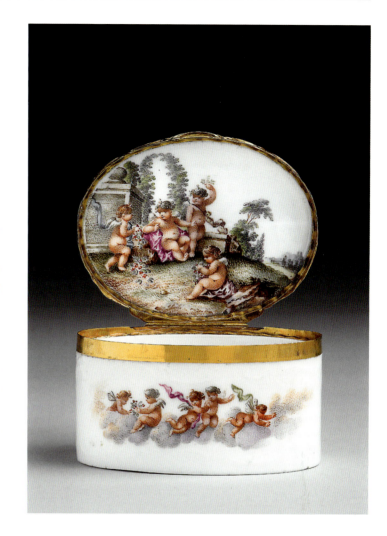

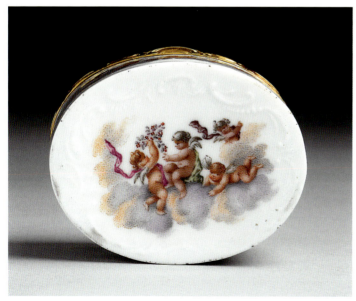

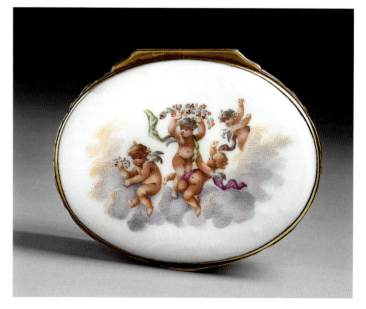

Cat. no. 123

OVAL SNUFF BOX WITH PUTTI SCENES

Painted c. 1755
With contemporary gold mounts
Height 3.8 cm, width 6.3 cm, depth 5.0 cm

This box bears great similarity cat. no. 122 but has somewhat more finely worked gold mounts and uses a different variation of *rocaille* reliefs.

The painted scenes, certainly by the same hand, again show putti and use the same fine stippling technique. The slightly different motif on the inside of the lid shows four putti dressed as soldiers, carrying out military drill. In the background on the left we can make out a ruined tower and on the right a village with a church steeple.
MR

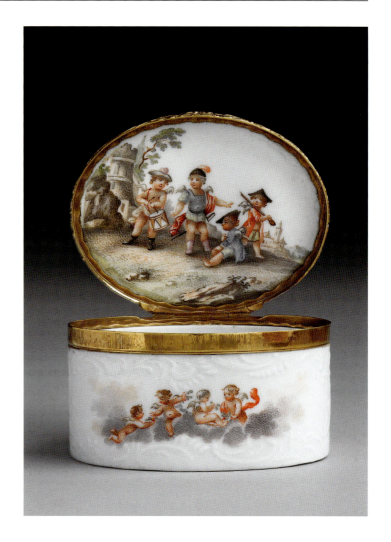

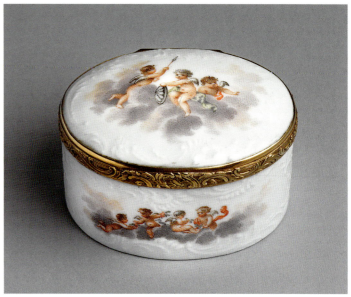

Cat.no. 124

SNUFF BOX

Probably painted by Johann Georg Loehnig (1743–1806), c. 1775
With contemporary gold mounts in yellow gold and red gold
Height 3.5 cm, width 7.3 cm, depth 5.7 cm

Literature:
Cat. Röbbig 2013, cat. no. 41

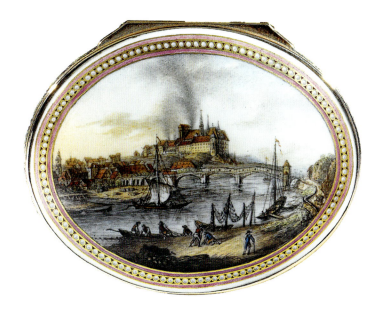

The sides of this snuff box are decorated with a continuous border of sphinxes with coiling tails painted in grisaille on a chestnut-brown ground. On the front and back of the box two portrait medallions are placed between two of the mythical creatures and wreathed in laurels in the manner of antique busts. This border is lined at the top and the bottom by a bead and reel ornament edged on both sides that harmonises in terms of colour with the gold mounts. The bust of a woman in an aureole against a chestnut-brown ground on the bottom of the snuff box appears to be a modified version of the Medusa Rondanini (a Roman copy of the Greek original can be seen in the Glyptothek in Munich). The depiction is framed by a bead ornament outlined in gold and edged on either side. The top of the lid is decorated with an oval cartouche, framed in the same way, which presents a topographical view of the Albrechtsburg. The antique mythological scene on the inside of the lid is based on a print by William Wynne Ryland (1732–1783) after a painting by Angelika Kauffmann (1741–1807; see fig. VI.128) depicting the returning Telemachus, who is greeted by Penelope.

This scene is described as follows in Homer's *Odyssey*, 17th book, verses 26–41 (translation from the Greek by Ian Johnston):

Telemachus walked away,
across the farmyard, moving with rapid strides.
He was sowing seeds of trouble for the suitors.

As he entered the beautifully furnished house,
he carried in his spear and set it in its place,
against a looming pillar. Then he moved inside,
across the stone threshold. His nurse Eurycleia
saw him well before the others, while spreading fleeces
on the finely crafted chairs. She burst out crying,
rushed straight up to him, while there gathered round them
other female servants of stout-hearted Odysseus.

They kissed his head and shoulders in loving welcome.
Then from her chamber wise Penelope emerged,
looking like Artemis or golden Aphrodite.
She embraced the son she loved, while shedding tears,
and kissed his head and both his beautiful eyes.
Through her tears, she spoke to him—her words had wings:
"You've come, Telemachus, you sweet light.
I thought I'd never see you any more,
when you secretly went off to Pylos
in your ship, against my wishes, seeking
some report of your dear father."

SKA

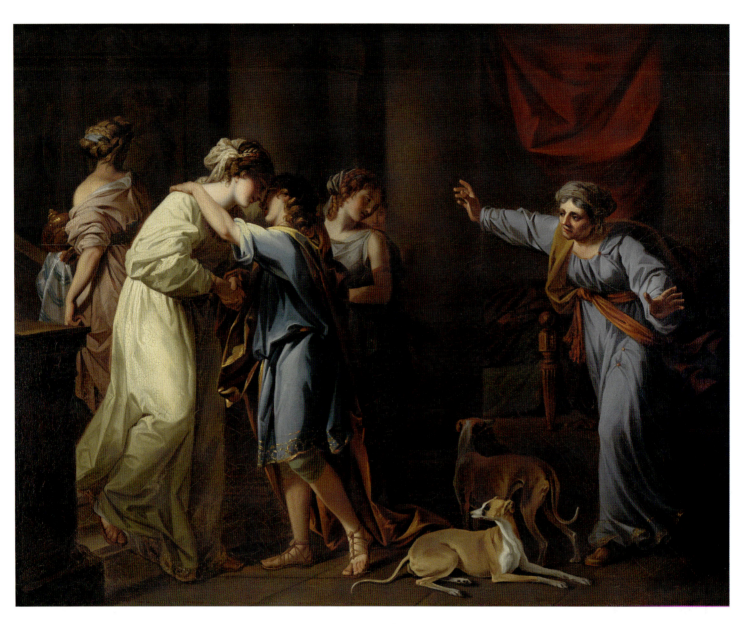

VI.128
Angelika Kauffmann (1741–1807), *Die Rückkehr des Telemachus*, 1770–80, oil on canvas, 116.3 x 126.4 cm, Mead Art Museum, Amherst College, Amherst, Mass.

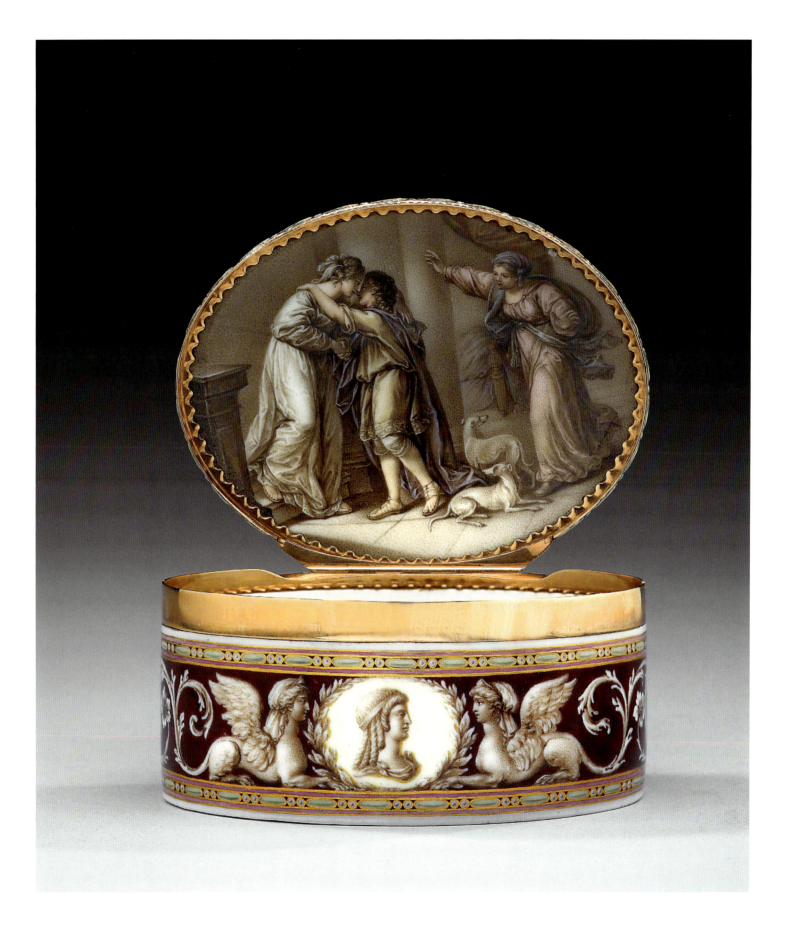

Appendix

The Work Reports of the Meissen Modellers and Decorators concerning Snuff Boxes

Selected and transcribed by Ulrich Pietsch

Work Reports: Modellers

NB: All references to "the King" or "His Majesty" relate to the Polish King and Saxon Elector Augustus III (born 1696, reg. 1734–63); "Brühl" is Count Heinrich von Brühl, long-standing prime minister of Saxony-Poland (1700–1763); "the Tsarina" is Empress Anna Ivanovna of Russia (born 1693, reg. 1730–40); "Wackerbarth" is the Saxon cabinet minister Count Joseph Anton Gabaleon von Wackerbarth-Salmour (1685–1761).

Johann Joachim Kaendler:

AA I Aa. 20

1733, May, fol. 215r:
»Eine Schnupff Tobacks Doße auff neue Art, da zweyerlei Tobacken hinein gethan werden solche bekömbt 2 Deckel, und hat in der Mitte einen Unterschied«.
"A snuff box in a new manner, as two kinds of snuff can be put in it; it will have 2 lids and has a partition down the middle."

1733, November, fol. 399r/v:
»Eine Neue 8Paßigte Schnupftobacks Doße gefertiget«.
»Zwey Stück Tobacks Doßen geändert und Accurat gemacht«.
"Made the model for a new 8-lobed snuff box."
"Changed two snuff boxes and made them more precise."

AA I Aa. 22

1734, May, fols. 175r–176r:
»Eine Tobacks Doße, in welcher Ein Unterschied und man zweyerlei Arten von Schnupfftaback darin führen kann, welche sich deßen ungeacht gantz Commode angreiffen läßet«.
"A snuff box with a partition so that it can hold two kinds of snuff, which nevertheless fits very comfortably in the hand."

AA I Aa. 24

1735, January, fol. 32r/v:
»Eine Schnupff Tabacks Doße mit Zieraten und allerhand mühsamen Laubwercke gefertiget«.
"Made the model for a snuff box with ornaments and all kind of elaborate foliate work."

1735, April, fols. 173r–174v:
»Eine Schnupf Tobacks Doße Nach einer Sielbernen gefertiget«.
"Made the model for a snuff box after a silver one."

1735, June, fols. 208r–209r:
»Einen Schnupff Tobacks Dosen Deckel«.
"A snuff box lid."

1735, July, fols. 259r–260v:
»Eine Tabattiere gemacht sammbt den darzu gehörigen Deckel und über und über sehr mühsam wie ein Körpgen geflochten«.
"Made a snuff box together with its lid, with an intricate weave pattern all over like a little basket."

AA I Aa 24 b

1736, August, fols. 234r–235v:
»Eine Schnupff Tobacks Dose Nach einem darzu gegebenen Modelle in Thon, sammbt dem darzu gehörigen Deckel poußiret«.
"Made a clay model for a snuff box after a box provided for the purpose, together with its lid."

1736, October, fols. 252r–253v:
»Zwey Schnupff Tobacks Dosen Deckel für den Herrn Grafen von Friesen in Thon gefertiget«.
"Made clay models for two snuff box lids for Count Friesen [Heinrich Friedrich von Friesen, 1681–1739, Saxon Cabinet Minister]."

AA I Ab 9

1737, May, fols. 88r–89v:
»Eine Tabattiere gefertiget in gestalt einer Wein oder Wintzer Putte«.
»Eine sehr mühsame Tabattiere gefertiget mit Antiquen flachen Zieraten auf dem Deckel ist Ihro Maj. des Königs Porträit klein und flach befindlich, auf dem Boden aber ein altes Römisches Köpffgen«.
»Eine sehr Mühsame Tabattiere Vor den Herrn geheimden Raht von Brühls Excellenz angefangen, darauf sehr viele flache Zieraten befindl. und sollen Jagdt Stückgen auf den Deckel und Seiten gefertiget werden, welche aber bis in kommenden Monath vollends zu fertigen auf behalten worden«.
"Made the model for a snuff box in the form of a grape hod [grape harvester's basket]."
"Made the model for a very elaborate snuff box with low-relief decoration in the antique manner, on the lid is the small low-relief portrait of His Majesty the King, but on the bottom an ancient Roman head."
"Started on a very elaborate snuff box for His Excellency Privy Councillor von Brühl with very much decoration in low relief, hunting scenes are to be done on the lid and sides but their entire completion will have to be left until the coming month."

1737, June, fols. 122r–123v:
»4 Stück Tabattieren Deckel Worauf Ihro Königl. Majt. Porträit befindl. in der Massa verputzet«.
"Applied finishing touches to 4 porcelain paste snuff box lids with the portrait of His Royal Majesty."

1737, July und August, fols. 164r–166r:
»Die sehr mühsame Tabattiere Vor Ihro Excell.: den Herrn Grafen von Brühl vollends gefertiget Worauf flach erhaben Jagten und Zieraten befindlich gewesen«.
»Zwey Stück der oben erwehnten Tabattieren in der Maßa verputzet«.
»4 Stück Tabattieren Deckel in der Maßa corrigiret Worauf das Königl. Porträit befindl.«.
"Completed the model for a very elaborate snuff box for His Excellency Count Brühl, with low-relief hunting scenes and ornaments."
"Put finishing touches to two examples of the above-mentioned snuff box in porcelain paste."
"Made corrections to 4 porcelain paste snuff box lids with portraits of the King."

AA I Ab 11

1738, February, fols. 60r–61r:
»Das Porträit von Ihro Majt. der Carin Welches Vorigen Monat in Wachß poußiret Worden«.
»Noch Einmal in Wachß solcher gestalt ein gerichtet, daß es auf einen rund erhabenen Rappe Dosen Deckel hat können gebraucht und aufs Neue abgeformet Werden können«.
»6 Stück Portraits Von Ersterer Sorte Welche blatt aufliegen in der Massa durch gängig Verputzet«.
»Ferner 3 St. Dosen Deckel Worauf Ihro Majt: der Carin Porträit befindl. Ebenfalls in der Massa Verputzet«.
"The portrait of Her Majesty the Tsarina that was modelled in wax last month, modelled in wax once again so that it can be used on a raised round lid of a rappee [kind of snuff] box and so that new moulds can be made."
"Put finishing touches to 6 porcelain paste examples of the first kind of portrait that are to lie flat."
"Furthermore put finishing touches to 3 porcelain paste snuff box lids with the portrait of Her Majesty the Tsarina."

1738, March, fols. 81r–82v:
»Ihro Majt: der Carin Porträit Zwey mahl in der Massa Verputzet Welche auf gedrehete Tabattieren gebrauchet worden«.
"Put finishing touches to two porcelain paste portraits of Her Majesty the Tsarina, which have been used for snuff boxes thrown on the wheel."

1738, April, fols. 113r–114r:
»Eine Tabattiere in Thon poußiret Nach Einem schon längst gangbar gewesenen Modell, aber um ein Merckliches größer Weiln solche bestellet worden«.
"Modelled a snuff box in clay after a long-standing model, but somewhat larger because such have been ordered."

1738, May, fol. 119r–119v:
»4 Stück Tabattieren Deckel Worauf der Carin Höchstes Bildnis in der Massa Corrigiret«.
»Drey Stück Tabattieren Deckel, wo Ihro Majt. Unsers Königs Hoh. Bildnis darauf befindl. In der Massa nachgeholfen«.
"Made corrections to 4 snuff boxes in porcelain paste with the most high portrait of the Tsarina."
"Made adjustments to three snuff box lids in porcelain paste with the most high likeness of His Majesty our King."

1738, June, fols. 143r–144v:
»Drey Tabattieren Deckel, Worauf der Carin Majt: Portrait befindl. in der Maßa Corrigiret und tüchtig gemacht Nebst einem Jagd Dosen Deckel«.
"Made corrections to three snuff box lids in porcelain paste with Her Majesty the Tsarina so that they are now ready for use. Also a lid of a hunting snuff box."

1738, November, fols. 242r–243r:
»Eine ovale Tabattiere aufs Waaren Lager Nach einem darzu erhaltenen Modelle gefertiget«.
"Made the model for an oval snuff box, to go to the depository, copied from a box provided for the purpose."

1738, December, fols. 256b/r–256c/r:
»Eine Tabattiere aufs Waaren Lager Muscheligt, Nach einem Von Schild Kröt Darzu erhaltenen Modelle gefertiget«.
"Made the model for a snuff box with shell decoration, copied from a tortoiseshell box provided for the purpose, to go to the depository."

..

AA I Ab 12

1739, February, fols. 23r–24r:
»Eine Ovale Tabattiere Nach geholfen und geändert aufs Waaren Laager«.
»Eine Neue sehr mühsame Tabattiere gefertiget sauber Verkröpffet Nach gehends aber über und über saubers Crotesco Werk Ein Rattiret sowohl auf den Corpus als auf den Deckel«.
»Annoch Eine Tabattiere nach einem Von Stein gefertigeten Modelle poußiret. Es ist solche Sauber verkröpfft und aus geschweifft sammbt dem Darzu gehörigen Deckel«.
"Made adjustments to an oval snuff box and changed it, to go to the depository."
"Made the model for a new and very elaborate snuff box edged with clear-cut mouldings but then incised it all over with neat grotesque work, both on the box and the lid."
"Made the model for another snuff box, copied from a stone box which has clear-cut mouldings and scalloping, with a matching lid."

1739, April, fols. 74r–75r:
»Sieben Stück Tabattieren Deckel Worauf Ihro Königl. Majt. Höchstes Porträit befindl. in der Massa Corrigiret und Nach geholfen, sammbt denen darzu gehörigen Untertheilen«.
"Made corrections and adjustments to seven snuff box lids in porcelain paste with the most high portrait of His Royal Majesty, along with their boxes."

1739, May, fols. 86r–87v:
»Eine sehr Sauber und Mühsame Tabattiere in gestalt eines geflochtenen Korbes in Thon poußiret aufs Waaren Laager«.
»Noch Eine sehr feine Tabattiere Nach Einem darzu gegebenen Steinern Modell in Thon poußiret, ebenfalls aufs Waaren Laager«.
"Made the model for a very clear-cut and elaborate snuff box in the form of a woven basket, to go to the depository."
"Made the clay model for another very fine snuff box, copied from a stone box provided for the purpose, likewise to go to the depository."

1739, November, fols. 237r–238r:
»Eine Tabattiere Vor den H. Ober Rechnungs Examinator Bühlern gefertiget«.
"Made the model for a snuff box for the senior accounts auditor Bühler."

1739, December, fol. 253r:
»Eine Tabattiere Vor Ihro Hoch Reichs Gräfl Excellenz den Herren geheimden Cabinets Minister de Brühl gefertiget«.
"Made the model for a snuff box for His Excellency the privy cabinet minister Count Brühl."

AA IAa 26

1740, April, fol. 63r/v:
»Einen Tobacks Dosen Deckel nach Messing Modelle gefertiget«.
"Made the model for a snuff box lid copied from a box in brass."

1740, June, fols. 111r–112v:
»Eine Tabattiere repariret und solche von Neuem brauch bar gemacht«.
"Mended a snuff box and made it good to be used again."

1740, August, September and October, fols. 225r-229r:
»Eine Dose in gestalt einer Rose zum rappee samt Deckel zum Waaren Lager«.
"A rose-shaped box for rappee [kind of snuff] with its lid, to go to the depository."

1740, December, fols. 314r–316v:
»Eine paßichte Tabattiere Vor den Herren Graf. de Brühl Neu poußiret, und eine andere repariret«.
"Made a new model of a scalloped snuff box for Count Brühl, and put another to rights."

AA I Ab 16

1741, January, fols. 8r–9v:
»Eine Tabattiere in gestalt eines Triangels, Welche Von den Herren Secretario Vithen bestellet worden, Vor Frey Mayer«.
»Einen Neuen Deckel Zu einer Tabattiere Vor den Herren Secretario Coeßarn, Worauf Ihro Majt. der Königin Porträt gemahlet werden soll«.
"A snuff box in the form of a triangle that was ordered by Secretary Vithen, for Freemasons."
"A new lid to a snuff box for Secretary Coeßarn, on which the portrait of Her Royal Majesty the Queen [Maria Josepha, 1699–1757, wife of King Augustus III] is to be painted."

1741, March, fols. 69r–70v:
»Einen Tabattieren Deckel für den Herren Zeug Secretario Coeßarn in Wackß pousiret Worauf das Bild der Gerechtigkeit mit der Waage und Schwerdt, flach erhaben oder Paßreliefi befindl. War, Wie sie auf einem Felsen sietzet«.
"Made a wax model of a snuff box lid for Secretary Coeßarn bearing an image of Justice with sword and scales in bas-relief, sitting on a rock."

1741, April, fols. 102r–103v:
»Eine Tabattiere auch Vor Mons. Dulong poussiret Welche Oval und gemuschelt samt Deckel aufs sauberste gefertiget«.
"Also made a very tidy model of a snuff box for Monsieur Dulong [the Amsterdam merchant Jean Dulong], which is oval and has shell decoration, with its lid."

1741, June, fols. 172r–173v:
»Vor Ihro Königl. Majt. eine Tabattiere samt Deckel poussiret«.
»Eine Tabattiere in gestalt eines Mopß Hundes Vor Ihro Hoch Reichß Gräfl. des Herren Cabinets Ministers Von Brühl gefertiget«.
"Made a model of a snuff box and lid for His Royal Majesty."
"Made a model of a snuff box in the shape of a pug dog for His Excellency the privy cabinet minister Count Brühl."

1741, July, fols. 192r–193v:
»Vor den Cammer Herren Pizowsky einen neuen Tabattieren Deckel 8Paßicht in ein Goldenes Beschläge gefertiget«.
»Eine Neue Tabattiere Vor Herrn Micheln bestellet nach der darzu gegebenen alten Dose gefertiget«.
"Made a model for a new eight-lobed snuff box for the chamberlain Herr Pizowsky, to fit a gold mount."
"Made a model for a new snuff box for Herr Micheln, copied from an old box provided for the purpose."

1741, August, fols. 204r–205v:
»Vor Ihro Hoch Reichßgr. des Herren Geheimden Cabinets Ministers de Brühls Excellenz eine Tabattiere in Gestalt eines Mopß Hündgens wie er auf einen rasen liget nebst darzu gehörigen Deckel in Thon poussiret«.
»Eine Neue Tabattiere zu einem goldenen Beschläge Vor des Herren Grafen von Wackerbarths Excellenz, Welche Von Herrn Böhmern bestellet worden in Thon poussiret«.
»Vor Hr. Caprano einen neuen Tabattieren Deckel zu einem goldenen Beschläge gefertiget«.

"Made a model for a snuff box in the form of a pug dog lying on the grass for the privy cabinet minister His Excellency Count de Brühl, and a lid to match."
"Made a clay model of a new snuff box to fit a gold mount for His Excellency Count Wackerbarth, which was ordered by Herr Böhmer."
"Made a model for a new snuff box lid to fit in a gold mount for Herr Caprano [the Dresden merchant Andreas Caprano]."

1741, October, fols. 272r–273r:
»Vor die Frau Gräfin von Keven Hüllerin eine Neue Tabattiere gefertiget und begehrter Maßen auf Kober arth geflochten weiln Selbiger die ehemals erhaltenen Tabattieren Viel zu groß gewesen«.
»Annoch eine Tabattiere Vor die Frau Von Keven Hüllerin geändert und um 1. Zoll kleiner gemacht, und auf eine andere Arth geflochten, sambt den darzu gehörigen Deckeln, Wie auch ein sehr Mühsames Belege von Blümgen Vergiß mein nicht darzu poussiret«.
»Vor Ihro Hoch Reichß Gräfl. Des Herren geheimden Cabinets Ministers von Brühls Excellenz eine Neue Tabattiere gefertiget und oben auf den Deckel ein kleines Mopß Hündgen aufs sauberste poussiret«.
»Eine Neue Tabattiere nach einem goldenen darzu gegebenen Beschläge gefertiget«.
"Made the model for a new snuff box for Countess Khevenhüller [wife of the Austrian Field Marshal Ludwig Andreas von Khevenhüller] with basket weave moulding as instructed because the snuff boxes received earlier were much too large for her."
"Changed another snuff box for Frau von Khevenhüller, making it one inch [1 Saxon inch = 2.36 cm] smaller and changing the kind of basket weave, together with its lid, for which I modelled a very elaborate piece of applied floral forget-me-not decoration."
"Made models of a new snuff box for the privy cabinet minister His Excellency Count Brühl and a very tidy little pug dog to go on the top."
"Made the model for a new snuff box to fit a gold mount provided for the purpose."

1741, November, fols. 287r–288r:
»Eine Tabattiere Vor Hr. Dinglingern in Thon poussiret deßen Cörper ziemlich erhaben und über all nebst darzu gehörigen Deckel auf Kober arth aufs Mühsamste geflochten ist«.
»Annoch 2. Tabattieren Vor Hr. Dinglingern nach darzu gegebenen Zeichnungen, alle aber Verändert in Thon poussiret allenthalben geflochten, nebst beiden darzu gehörigen Deckeln«.
»Eine Tabattiere Vor Hr Benz und Radern in Thon poussiret Welche Sauber Verkröpft und sehr Mühsam in das darzu gegebene Beschläge zu paßen gewesen«.
"Made the clay model for a snuff box for Herr Dinglinger [Georg Christoph Dinglinger, 1668–1746, goldsmith to the Saxon court], the box decorated all over in fairly high relief, and the lid with very elaborate basket weave decoration."
"Made clay models for two more snuff boxes for Herr Dinglinger after drawings provided for the purpose, with certain changes but nevertheless with basket weave, and their lids."
"Made the clay model for a snuff box for Herr Benz and Herr Rader [Philipp Adam Benz and August Wolfgang Rader, Augsburg merchants], which has clear-cut moulded borders very carefully done to fit a mount provided for the purpose."

AA IAa 28

1742, January, fols. 74r–75r:
»Eine Tabattiere große Sorte Vor Sr. Hoch Reichß Gräfl. des Hrn geheimden Cabinets Ministeri Von Brühls Excellenz worauf ein Mopß-Hund auf deren Decke befindl. in Thon corrigiret und Natürliches ansehen hinein gebracht«.
»Annoch Eine Tabattiere Vor Eben die selben aber Ebenfalls mit einem Mopß Hündgen Corrigiret und tüchtig gemacht«.
"Made corrections to a clay model for a snuff box of the large kind for His Excellency the privy cabinet minister Count Brühl with a pug dog lying on the lid, investing it with a more natural appearance."
"Yet another snuff box for the same gentleman and likewise with a pug dog, made corrections and put it in order."

1742, February, fols. 115r–116r:
»Ihro Königl. Majt. unser allergnädigsten Herren Höchstes Bildnis ins kleine zu einer Tabattiere Vor Ihro Hoch Reichß Gräfl. des Herren geheimden Cabinets Ministerii Von Brühls Excellenz aufs Sauberste gefertiget Welches flach erhaben auf antique arth vorgestellet worden«.

"Executed a very clear-cut small-scale likeness of our most gracious Lord His Royal Majesty on a snuff box for the privy cabinet minister His Excellency Count Brühl, in low relief in the antique manner."

1742, March, fols. 98r–99r:
»Eine Neue Tabattiere Vor den Herren Grafen von Wackerbarths Excellenz gefertiget Welche sehr verkröpfft und auf dem Deckel mit einem porträit versehen gewesen«.
"Made the model for a new snuff box for His Excellency Count Wackerbarth, which has very pronounced moulded borders and a portrait on the lid."

1742, April, fols. 147r–148r:
»Eine ovale Tabattiere gefertiget nebst Deckel Worauf lauter Zirckul gemahlet Werden sollen«.
»Einen Neuen Deckel zu der Tabattiere Vor den H. Brentano mit vielen Zieraten gefertiget«.
"Made the model for an oval snuff box on which a number of pairs of dividers are to be painted."
"Made the model for a new lid to the snuff box for Herr Brentano [the Dresden merchant Andreas Brentano] with many ornaments."

1742, June, fols. 174r–175r:
»An einer Tabattiere Zu poußiren angefangen, um solche zu Corrigiren an Welcher Vorhero der Bildhauer Ehder gearbeitet, Worauf die Historia des Meleagers und der Atlanta befindl., Woran aber noch zu thun übrig blieben«.
"Began to make corrections to a snuff box model made by the sculptor Ehder [Johann Gottlieb Ehder, 1717–1750] bearing the story of Meleager and Atlanta. There remains a certain amount to do."

1742, July, fols. 205r–206r:
»Eine Tabattiere Vor den Herren Grafen Von Wackerbarths Excellenz in Thon poußiret Worauf ein alter Römer Kopff befindlich War«.
"Made the clay model for a snuff box for His Excellency Count Wackerbarth with an ancient Roman head on it."

1742, September, fols. 271r–272r:
»Vor Ihro Königl. Majt. einen Tabattieren Deckel Modelliret worauf der Verzogene Nahme Augustus Rex oben mit einer Crone auf einem Postamente stehend zu sehen ist, Woran auch noch flache Blumen nebst andern ornamenten zu sehen sind«.
"Made the model for a snuff box lid for His Royal Majesty on which there is the name Augustus Rex in stylised form [AR monogram] resting on a pedestal with a crown above, with in addition flowers in low relief and other ornaments."

1742, October, fols. 299r–300r:
»Das Untertheil der Jagd Tabattiere Worauf die Historia des Meleagers flach erhaben Vorgestellet ist. Vollends gefertiget Vor Ihro Majt. den König«.
"The box part of the hunting snuff box bearing the story of Meleager in low relief. Model completed, for His Majesty the King."

AA IAb 20

1743, January, fols. 48r-49r:
»Vor den Herrn Grafen von Wratislaw Zu einer Tabattiere so wohl ober als unter Theil gefertiget«.
"Made the models for the upper and lower parts of a snuff box for Count Wratislaw [Austrian ambassador and Lord Chamberlain ("Obersthofmeister") at the court of Queen Maria Josepha, died 1750]."

1743, March, fol. 108r/v:
»Zwey Tabattieren blätter Vor den Herren Grafen von Wratislau poußiret«.
"Made models for two snuff box lids for Count Wratislaw."

1743, May, fols. 142r–143r:
»Vor den Herren von Hirchau eine Tabatiere nach einem darzu gegebenen Dessein Völlig geändert und zum abformen befördert«.
"Completely changed the model of a snuff box for Herr von Hirchau in accordance with a drawing provided for the purpose and sent it on for moulds to be made."

1743, September, fols. 230b/r–230c/r:
»Eine Verzierte Tabattjere Corrigiret Vor Sr. des Herren Cabinets Minister Von Brühl Excellenz«.
»Eine Neue Tabattjere Zu einem goldenen Beschläge gefertiget«.
"Made corrections to an ornate snuff box for His Excellency the Cabinet Minister von Brühl."
"Made the model for a new snuff box to fit a gold mount."

1743, October, fol. 254b r/v:
»Etliche Neue Modelle von Tabattjeren Corrigiret Vor Ihro Excellenz die Frau Gräfin von Brühl, nach denen darzu gegebenen Modellen«.
"Made corrections to a number of new models for snuff boxes for Her Excellency Countess Brühl [Maria Anna Franziska von Brühl, 1717–1762, wife of the Saxon Prime Minister Heinrich von Brühl], in accordance with boxes provided for the purpose."

AA I Ab 22

1744, March, fols. 87r–88r:
»Eine Tabattjere in gestalt einer Indianischen Fügur nach geholffen und zum abformen befördert«.
"Made adjustments to a snuff box in the form of an Indian [East Asian] figure and sent it on for moulds to be made."

1744, May, fol. 226r/v:
»Ein Unter und Obertheil zu einer Tabattjere nach einem darzu gegebenenen goldenen Beschläge gefertiget«.
»Vor Madam de Biberau eine neue Tabattjere nach einem darzu gegebenen steinern mit Gold aus gelegten Modell gefertiget«.
"Made the lid and box models for a snuff box to fit a gold mount provided for the purpose."
"Made the model for a new snuff box for Madame de Biberau, after a gold-mounted stone box provided for the purpose."

1744, August, fols. 330r–331r:
»Eine Tabattjere Corrigiret Vor Mons. Prantano«.
"Made corrections to a snuff box for Mons. Prantano [the Dresden merchant Andreas Brentano]."

AA I Ab 24

1745, April, fol. 201r/v:
»Eine Tabattiere repariret im Modell Vor Ihro Maj. den König«.
"Mended a snuff box model for His Majesty the King."

1745, May, fols. 222r–223r:
»Eine Tabattjere mit Jagd Corrigiret Vor Ihro Majt. den König«.
"Made corrections to a snuff box with hunting motifs for His Majesty the King."

1745, June, fols. 250r–251r:
»Eine sehr mühsame Tabattjere mit Watteauischen Fügüren Corrigiret und in tüchtigen Stand gesetzet«.
"Made corrections to a very elaborate snuff box with Watteau figures, and put it in order."

1745, August, fol. 316r/v:
»Vor den Sicilianischen Gesanden Herrn von Polognini eine sehr mühsame Tabattjere Worauf eine flach erhabene Hirsch Jagd befindl. Aufs Sauberste poußiret«.
»Annoch einen dergleichen sehr mühsamen Tabattjeren Deckel mit einer Wilden Schweins Jagd poußiret«.
"Made an extremely clear-cut model for a very elaborate snuff box for the Sicilian ambassador with a stag hunt in low relief."
"Made another model of a similarly elaborate snuff box lid with a boar hunt."

1745, September, fol. 366r/v:
»Einen großen Tabattjeren Deckel Vor die Prinzeßin von Herfort poussiret«.
"Made the model for a large snuff box lid for the Princess of Herfort [Duchess Johanna Charlotte of Anhalt-Dessau, 1682–1750, Prince-Abbess of Herford]."

AA I Ab 26

1746, January, fol. 7r/v:
»Einen Tabattjeren Deckel Worauf eine Hirsch Jagd flach erhaben in einem Landschäfftlein aufs Sauberste Vorgestellet poußiret«.

»Noch einen dergleichen Tabattjeren Deckel Worauf eine Wilde Schweins Jagd ebenfalls flach erhaben, Welches Vorhero Viel zu groß gewesen, aufs Sauberste ins kleine poußiret«.
"Made the model for a snuff box lid with a stag hunt shown in low relief in a little landscape, very tidily executed."
"Made the model for another snuff box lid of the same kind with a boar hunt shown in low relief, which was formerly far too big and is now tidily executed on a smaller scale."

1746, August, fols. 227r–228r:
»Eine sehr Mühsame mit Vielen ornamenten Versehene Tabattjere Corrigiret«.
"Made corrections to a very elaborate ornate snuff box."

AA I Ab 28

1747, April, fols. 100r–101r:
»Einen Tabattjeren Deckel in ein Goldenes beschläge gefertiget«.
"Made the model for a snuff box to fit a gold mount."

1747, July, fols. 232r–233r:
»Eine Tabattjere Worauf ein Portrait Welche nach Rom bestellet ist gefertiget«.
"Made the model for a snuff box with a portrait to an order from Rome."

1747, October, fols. 373r–374v:
»Eine Tabattjere auf Stroh arth geflochten Vor des Herren Premier Ministers Excellenz«.
"A snuff box with straw-like basket weave moulding for His Excellency the Prime Minister [Count Brühl]."

1747, November, fols. 396r–397v:
»Zwey Modelle zu Tabattjeren poußiret«.
"Made two snuff box models."

1747, December, fols. 425r–426r:
»Einen Sphinx welcher eine Tabattjere abgiebet im Modell Corrigiret«.
"Made corrections to a model for a sphinx that can be used for a snuff box."

AA I Ab 45

1769, July, fols. 284r–285r:
»Eine Tabatjere in Gestalt eines Schäfgens so ein Cupido gebunden hält liegend. Vor die durchlauchtigste Churfürstin poußiret, auf deßen Deckel welcher annoch zu fertigen ein Löwe baßirelieve, wie solcher Von Cupido gebunden geführet wird, mit der Unterschrift : Dompté par l'amour«.
"Made the model for a snuff box in the form of a little sheep lying down and being held on a line by a Cupid. For Her Most Serene Highness the Electress [Marie Amalie Auguste, wife of Elector Friedrich August III of Saxony], on the lid of which there is to be a lion in low relief, still to be completed, which is likewise being led on a leash by Cupid, with the inscription below: Dompté par l'amour."

1769, August, fols. 331r–332r:
»Was annoch an der Tabattjere in gestalt eines Schaffes zu thun gewesen Vollends in Ordnung gebracht«.
"Completely finished what was still to be done on the snuff box in the form of a sheep."

Johann Friedrich Eberlein:

AA I Ab 12

1739, November, fol. 239:
»Zwey Neue Schnupftoback Dosen von Doone gemacht«.
"Made two new clay models for snuff boxes."

1739, December, fol. 255:
»Eine Schnubtoback Dose wie ein oval Feßgen«.
»Ein dergleichen in Gibsforme, über und über, mit vielen Zierathen geschnitten«.
»Drey andere Dosen auf Silberart, Neu von Doone gemacht«.
"A snuff box like a little oval barrel."
"One of the same in plaster moulds, carved all over with many ornaments."
"Three new clay models for snuff boxes in the manner of silverware."

1740, November, fol. 257:
»Eine Schnubtobacks Dose von einer Indianischen Frucht«.
»Ein Schnubtobacks Dose von einen Krauthet«.
"A snuff box [in the form] of an Indian fruit."
"A snuff box [in the form] of a cabbage head."

AA I Ab 16

1741, August, fol. 206:
»Forme, zu einer Schnupff-Tobacks-Dose, mit vielen Bluhmen überschnitten«.
"Form carved all over with a great number of flowers, for a snuff box."

AA I Ab 24

1745, May, fol. 228:
»Eine Schnupff-Tabaccs-Dose geändert«.
"Made changes to a snuff box."

Peter Reinicke:

AA I Ab 20

1743, July, fol. 190:
»1 verzierte Tabattiere in Thon repariret«.
"Mended the clay model for an ornate snuff box."

1743, October, fol. 237:
»1 irregulair passigte Tabattiere mit Deckel in Thon bossirt«.
»1 dergl. mit verziertem Deckel u. Untertheil in Thon bossirt«.
"Made the clay model for an irregularly scalloped snuff box and lid."
"Made the model for one of the same with an ornate lid and lower section."

1743, November, fol. 273:
»1 Tabattiere nach der goldenen Modell Tabattiere in Thon bossirt«.
"Made the clay model for a snuff box after the gold snuff box."

1743, December, fol. 283:
»1 Tabattiere reparirt«.
"Rectified a snuff box [model]."

AA I Ab 22

1744, September, fol. 118:
»1 ovale glatte Tabattiere nebst Deckel in Thon bouhsirt«.
"Made the clay model for a smooth oval snuff box and lid."

AA I Ab 24

1745, April, fol. 208:
»1 ovale ganz verzierte Tabattiere nebst Deckel in Thon bossirt«.
"Made the clay model for a completely ornate oval snuff box and lid."

1745, October, fol. 402:
»1 glatte paßigte Tabattiere mit Deckel in Thon bossirt«.
"Made the clay model for a smooth-surfaced scalloped snuff box and lid."

AA I Ab 14

[1740], fol. 200:
»Von Thon verfertigt: 31 St. Tobattieren differenter Facon«.
"Modelled in clay: 31 snuff boxes in different styles."

AA I Ab 42

1766, January, fol. 190b:
»1 ovale Tabatiere mit Deckel in Thon pousiret«.
"Made the clay model for an oval snuff box and lid."

1766, July (no pagination):
»1 ovale Tabatiere mit Deckel in Gips geschnitten«.
"Carved an oval snuff box and lid in plaster."

AA I Ab 43

1767, November, fol. 109b:
»Eine Tobatier in Apfelgestalt in Thon posirt«.
»Je eine Tabatiere als Schneckenhaus und als Schiffgen in Thon posirt«.
»Eine ovale Tabatiere als Badewanne in Thon posirt«.
»Eine ovale Tabatiere nach Zeichnung No. 5 in Thon posirt«.
»Eine ovale Tabatiere zwiebelförmig in Thon posirt«.
»Eine ovale Tabatiere in gestalt eines Uhrgehäuses in Thon posirt«.
"Made the clay model for a snuff box in the shape of an apple."
"Clay models of two snuff boxes, one in the shape of a snail shell and one as a little boat."
"Clay model of a snuff box in the shape of a bath tub."
"Clay model of an oval snuff box after drawing no. 5."
"Clay model of an oval snuff box in the shape of an onion."
"Clay model in the shape of a clock case."

Johann Gottlieb Ehder:

AA I Ab 12

1739, October, fol. 240:
»1 Katze, zu einer Tobattiere«.
"1 cat for a snuff box."

1739, December, fol. 257:
»1 Tobattiere«.
"1 snuff box."

AA I Ab 14

1740, July, fol. 133:
»1 Tabattiere, welche einen Vogelbauer vorstellet«.
»1 Tabatiere godronnirt«.
»1 Tabatiere in Thon verputzt«.
"A snuff box in the form of a birdcage."
"Did gadrooning on a snuff box."
"Dressed the cracks on a clay snuff box model."

1740, September, fol. 234:
»3 St. Tabatieren«.
"3 snuff boxes."

1740, October, fol. 235:
»1 Tabatiere, welche eine Rose vorstellet«.
"A snuff box representing a rose."

AA I Ab 16

1741, January, fol. 10:
»Eine Tobatiere mit französ. Zierrathen nebst Deckel«.
"A snuff box and lid with French ornaments."

1741, June, fol. 175:
»1 Tabatiere in Form einer Seemuschel samt Deckel in Thon boss«.

»1 Tabattiere mit flammigten Laisten, nebst Deckel, zur Kewenhüllerschen Gestalt boss«.
"Made the clay model for a snuff box and lid in the form of a seashell."
"Made the model for a snuff box and lid with flame-like mouldings to the Khevenhüller design."

1741, December, loose pages:
»1 goudronnirte Tabattiere samt Decken mit französischen Zierrathen in Thon verputzt«.
»1 goudronnirte Tabattiere, auf deren Deckel ein liegender Mops Hund befindlich, welcher mit Gras und Blumen umgeben für Sr. (etc.) von Brühl«.
"Dressed the cracks on a clay model for a gadrooned snuff box and lid with French ornamentation."
"1 gadrooned snuff box, lying on the lid is a pug dog surrounded by grass and flowers, for His (etc. etc.) von Brühl."

AA I AB 18

1742, March, fol. 132:
»2 Deckel zum Tabattieren«.
"2 snuff box lids."

1742, May, fol. 161:
»1 Tabattiere von Thon neu bossirt, auf dem Deckel ist eine Ovidianische Historia, nehml. wie die Atalanta von dem Meleager beschenkt wird mit einem wilden Schweins-Kopfe. Auf dem Untertheile ist die Jagd und Meleager und Atalanta nach dem wilden Schwein, auf dem Boden ist die Erlegung des Schweins, als eines von der Atalanta zuerst ist angeschossen worden, in bariegelef [basrelief] gearbeitet«.
"Made a new clay model for a snuff box with a story from Ovid down in low relief on the lid, namely of Meleager presenting Atalanta with the head of a wild boar [the Calydonian boar]. On the box section is the hunt for the wild boar with Meleager and Atalanta, on the underside is the killing of the boar, after Atalanta had been the first to hit it."

1742, August, fol. 234:
»1 Hölzernen Tobaciere mit Füllungen geschnitten«.
"Carved a wooden snuff box model with hollows for inlay."

AA I Ab 20

1743, November, fol. 271:
»1 paßigte Tabattiere mit vielen französischen Zierrathen nebst Deckel sehr mühsam von Thon neu bossirt«.
"Made a new clay model for a very elaborate scalloped snuff box and lid with many French ornaments."

1743, December, fol. 282:
»1 paßigte Tabattiere mit französ. Zierrathen nebst Deckel sehr mühsam von Thon neu bossirt«.
"Made a new clay model for a very elaborate scalloped snuff box and lid with French ornaments."

AA I Ab 22

1744, January, fol. 46:
»1 Tabattiere mit französ. Zierrathen nebst Deckel rein bosirt«.
"Finished making the model for a snuff box and lid with French ornaments."

AA I Ab 26

1746, April, fol. 105:
»1 Tabaccs-Dosen-Deckel in Gips nachgeschnitten«.
"Copied a snuff box lid by carving it in plaster."

AA I Ab 28

1747, February, fol. 53:
»2 Tabattieren, als nehmlich 1 ovale u. 1 paßigte neu bouhsirt«.
»2 ovale Tabattieren von verschiedener Größe von Thon bouhsirt«.
"Made new models of 2 snuff boxes, one oval and one scalloped."
"Made clay models for 2 oval snuff boxes in different sizes."

1747, March, fol. 31:
»1 ovale Tabattiere mit verzierten Schildern gravirt u. geflochten«.
"1 oval snuff box with the basket weave pattern and incised ornamental cartouches."

1747, May, fol. 134:
»1 Tabattiere mit Blumen graffirt«.
"Incised a snuff box with flowers."

1747, July, fol. 241:
»1 Tabattiere und Früchten und Garten-Instrumenten in Gips radirt«.
»1 ovale Tabattiere von Thon neu bouhsirt«.
»1 vierpaßigte Tabattiere repariret«.
»1 ovale Tabattiere mit basrelief-Arbeit, Bacchanalia vorstellend, von Thon neu bouhsirt«.
"Incised a plaster snuff box model with fruits and gardening instruments."
"Made a new model for an oval snuff box."
"Mended [the model for] a quatrefoil snuff box."
"Made a new clay model for an oval snuff box with low relief work showing Bacchanalia."

1747, August, fol. 285:
»1 ovalen Tabattieren-Deckel mit französ. Zierathen u. Früchten v. Thon bouhsirt«.
"Made a clay model for an oval snuff box lid with French ornaments and fruits."

1747, October, fol. 383:
»2 viereckigte verzierte Tabaccs-Büchßen mit Deckeln von Thon bouhsirt«.
"Made clay models for 2 ornate quadrangular snuff boxes and lids."

1747, November, fol. 406:
»1 Tabattiere, eine Sphinx vorstellend, von Thon neu bouhsirt«.
"Made a new clay model for a snuff box representing a sphinx."

Work Reports: Decorators

Christian Gottlob Hentzschel:

AA I Ab 22

1744, September, fol. 364:
»Ein Dossen Teckel mit einer Landschafft«.
"[Painted] a lid for a box with a landscape."

1744, October, fol. 409:
»1. Dossen Teckel mit einer Landschafft«.
"A lid for a box with a landscape."

1744, December, fol. 460:
»1. Möpßgen, auf ein Küßgen, liegend, in einen Dossen Deckel«.
"A pug dog lying on a cushion, on the inside of the lid of a box."

AA I Ab 24

1745, August, fol. 320:
»1. Dosse mit einer Cante von allerley Medallien gemahlet«.
"A box with one side painted with all kinds of medallions."

1745, September, fol. 370:
»2. Tabattieren mit allerley Medallien gemahlet«.
"Painted 2 snuff boxes with all kinds of medallions."

1745, October, fol. 398:
»2. Dossen, mit allerley Medallien gemahlet, als Crodeske«.
"Painted 2 boxes with all kinds of medallions, as a grotesque."

AA I Ab 26

1746, February, fol. 37:
»1. Dossen Teckel aus wendig mit einen Auff wartenden Mopß, mit einen Blumen-Crantz umgeben, inwendig aber, ein Mopß liegend auf einem Küßen, daß Unter-Theil auch darbey mit Blumen, u. verzogenen Nahme, in gleichen die Vergoldung abgesetzt«.
1. Dossen Teckel inwendig ein Mopß liegend auf einem Küßen, den Boden dunckel,
1. Roßen Dosse ist inwendig geschrieben, u. abgesetzt«.
"Painted a box lid on the outside with a pug dog paying its respects, surrounded with a floral wreath, and on the inside with a pug lying on a cushion, decorated the lower part of the box with flowers and a name in the form of a monogram, and raised ornamental parts for gilding on the same pieces."
"Painted a box lid on the inside with a pug dog lying on a cushion, the floor dark.
A rose-shaped box, did an inscription on the inside, and raised parts for gilding."

1746, March, fol. 78:
»1 Unter-Theil zu einer Dosse Schwartz u. Gold mit weißen Blumen«.
»1 Dossen Teckel, inwendig liegend ein Mopß auf einen Küßen«.
»1. Dossen Teckel inwendig sitzend ein Mopß auf einem Küßen, auswendig auf dem Deckel ein liegender Mopß auf einem Küßen, unter einem Vorhang. Daß unter Theil zur Dosse an Seiten Vergißmein nicht, auf den Boden ein Nahme«.
»2. Dossen Teckel mit goldener Crodeske«.
"A lower section of a box, black and gold with white flowers."
"A box lid with a pug dog lying on a cushion on the inside."
"A box lid with a pug dog sitting on a cushion on the inside, on the outside a pug dog lying on a cushion, under a curtain. Forget-me-nots on the sides of the lower section of the box, and on the floor of the box a name."
"2 box lids with a grotesque in gold."

1746, April, fol. 103:
»1. Mopß Dossen Teckel inwendig liegend ein Mopß auf einem Küßen«.
»2. Dossen unter Theil mit vergoldenen Schildern Crodeska zusammen an der Zahl 10. Schilder verfertiget«.
»4. Jagd Teckel [Deckel] erhoben, durch wieschen gelb aus gefüllt«.
»7. Mopß Dossen Teckel ausgebeßert«.
"A pug dog box lid, with a pug lying on a cushion on the inside."
"2 boxes, lower part, with grotesque ornamental cartouches in gold, ten in number. Finished the cartouches."

"4 hunting lids, raised and filled out with yellow."
"Made improvements to 7 pug dog box lids."

1746, July, fol. 211:
»In einer Roßen Dossen, geschrieben«.
»2 Dossen Teckel inwendig bey einen jeden Teckel, 2. Mopßgen gemahlet auf einen Küßen«.
"Executed an inscription in a rose-shaped box."
"Painted 2 box lids on the inside, 2 pug dogs painted on a cushion."

1746, November, fol. 391:
»1. Dossen Teckel blau, darauf rattieret darin mit Golde gemahlet«.
»4. Dossen Teckel mit Schildern, Crodeska vergoldt zum Portroitern«.
"A box lid in blue with engraving upon it painted in gold."
"4 box lids with ornamental cartouches and a gilded grotesque for a portrait."

1746, December, fol. 407:
»2. Dossen Untertheile unten auf den Boden, u. an Seiten alles Schilder mit Crodeska vergold«.
"Painted 2 boxes on the undersides, and on the sides all over with shields and grotesque work in gold."

...

AA I Ab 28

1747, February, fol. 49:
»Dosse vor Ihro Majt. ist mit Indianischen Fieguren Indianischen Vögeln und Laub Werck gezeichnet u. vergoldet, unten auf den Boden, auf den Teckel inwendig auf die Vergoldung Blumen gezeichnet zum aus rattieren«.
"Box for His Majesty, line-painted and gilded with Indian figures, Indian birds and foliate ornamentation; on the underside and on the inside of the lid there are flowers drawn on the gilding, to be engraved."

1747, March, fol. 77:
»1. Unter-Theil einer Dosse an allen 4. Seiten Fransesische Schilder vergold«.
"Lower part of a box with French ornamental cartouches on all four sides."

1747, May, fol. 130:
»Dossen Teckel, inwendig mit der Kar. 9 gemahlet«.
"Box lid, painted on the inside with the "Kar. 9" [probably a particular colour, possibly a purple]."

1747, June, fol. 172:
»Dosse vor Ihro Majst wurde mit Purpur schwieschen der Vergoldung gemahlet, u. die goldene Crodeska ist auf allen Seiten, unten, u. oben, in Golde mit den Zahne aus schattieret«.
"Box for His Majesty was painted with purple between the gilding, and the gold grotesque work was embellished with a zig-zag pattern in gold, on the top and on the underside."

1747, July, fol. 237:
»29. Schilder gezeichnet, auf Dossen um die Landschafft herum, wird Bund gemahlet«.
"Line-painted 29 ornamental cartouches around the landscapes on boxes, which will be painted in colours."

1747, August, fol. 280:
»29. Schilder um die Dossen bund gemahlete Crodeska«.
"29 ornamental cartouches around grotesque work, painted in colours on boxes."

1747, September, fol. 339:
»6. Dossen mit goldenen Blumen, an allen Seiten, unten u. oben Partien gemahlet«.
"6 boxes with golden flowers, on all sides, painted parts on the lid and lower part."

1747, October, fol. 378:
»1. Dosse mit goldenen Blumen«.
»1. Dossen Teckel detto«.
"Painted a box with golden flowers."
"Painted a lid with ditto."

1747, November, fol. 401:
»2. Dossen Teckel inwendig mit Goldenen Schildern zu den Portretts«.
»1. Dossen Teckel Purpur Watteau ist die erhobene Crodeska mit Purpur gemahlet u. abgesetzt«.
"Inside of 2 box lids with golden cartouches to frame the portraits."

"Painted a box lid in purple Watteau, painted the raised grotesque work with purple and set it off [for gilding]."

1747, December, fol. 430:
»Dossen Teckel inwendig mit Schrift Schild u. Ancker gemahlet«.
"Painted a box lid on the inside with an inscription, a coat of arms and an anchor."

Gottlob Siegmund Birckner:

AA I Ab 22

1744, June, fol. 272:
»1. Tabattieren Deckel mit Watteauisch: Fig: «
"A snuff box lid with Watteau figures."

1744, July, fol. 301:
»2. Tabattieren große Sorte mit Watteauisch Figuren gantz verfertiget«.
"Entirely completed 2 snuff boxes of the large kind with Watteau figures."

1744, August, fol. 333:
»1. Tabatttiere mit Kindern sehr fein«.
»1. Tabattieren Deckel mit Watteauisch. Fig. Fein, nach Mahlerey verferdigt«.
"A snuff box with children, very fine."
"A snuff box with Watteau figures, fine, made ready after the painting."

1744, September, fol. 362:
»1. Tabatiere große Sorte mit Watteauisch. Fig: fein«.
"A snuff box of the large kind with Watteau figures. Fine."

1744, October, fol. 406:
»8. Tabattieren mit Watteauisch: und Japan: Fig: in Gold gezeichnet«.
»1. Tabattieren Deckel inwendig mit Watt: Fig«.
"8 snuff boxes with Watteau and Japanese figures line-painted in gold."
"A snuff box lid with Watteau figures on the inside."

1744, November, fol. 431:
»2. Tabattieren mit Watteauisch: Fig: gantz verfertiget«.
"2 snuff boxes, entirely completed with Watteau figures."

1744, December, fol. 458:
»1. Tabattieren Deckel mit See= Bataille«.
»1. Tabatiere viereckigt, große Sorte mit Jap: Fig. Fein«.
"A snuff box lid with sea [= battle] scene."
"A quadrangular snuff box of the large kind, with Japanese figures. Fine."

AA I Ab 24

1745, January, fol. 40:
»1. Tabattieren Deckel inwendig mit Bataille«.
"A snuff box lid, with a battle on the inside."

1745, April, fol. 203:
»1. Tabatiere große Sorte, mit Jappanisch Fig: fein«.
»1. Tabattieren Deckel mit Batail:«.
"A snuff box of the large kind, with Japanese figures, fine."
"A snuff box lid with battle."

1745, June, fol. 252:
»1. Tabattieren Deckel mit vielerley Mahlerey Watteauisch für den Herrn Cammer Herrn von Nimptsch«.
"A snuff box lid with a lot of diverse Watteau painting for the chamberlain Herr von Nimptsch."

1745, July, fol. 276:
»1. Tabattieren Deckel mit Watteauisch: Fig: und gezeichneter Grodesca zum einlegen«.
"A snuff box lid with Watteau figures and grotesque line-painting to be filled in."

1745, August, fol. 318:
»1. Tabattieren Untertheil mit Watteauisch Fig: aus Purpur fein, nebst gezeichneter Grodesca zum einlegen«.

»1. detto Untertheil mit Watteauisch Fig:«

»1. Tabattiere mit teutschen Blumen blau laßirt«.

"The lower part of a snuff box with Watteau figures, fine and in purple, with grotesque line-painting to be filled in."

"The lower part of a ditto with Watteau figures."

"A snuff box with *deutsche Blumen,* overlaid with transparent blue enamel."

1745, October, fol. 396:

»1. Tabattiere „ detto [die Watteauisch Fig. aus Grün laßirt]«.

"A snuff box ditto [Watteau figures, overlaid with transparent green enamel]."

AA I Ab 26

1746, February, fol. 36:

»1. Tabattieren Deckel corrigiret«.

"Made corrections to a snuff box lid."

1746, April, fol. 102:

»1. Tabattiere«.

"A snuff box."

1746, May, fol. 127:

»1. Tabattiere, detto [mit Watteauisch: Fig. Grün lassirt]«.

"A snuff box, detto [Watteau figures overlaid with transparent green enamel]."

1746, June, fol. 144:

»1. Tabattieren Deckel in Form ∆ in und auswendig mit dem Biulde des Stillschweigens und Frey Mäyrer dessein«.

»1. Tabattieren Deckel inwendig mit ovidisch: historie sehr fein«.

"A snuff box lid in the form of a triangle and painted on both sides with the image of taciturnity and a Freemasons design."

"A snuff box lid on the inside with a story from Ovid, very fine."

1746, July, fol. 209:

»1. Tabattiere die Watteauisch: Fig. Grün lassirt«.

»1. Tabattieren Deckel große Sorte 4 eckigt mit Watteauisch: Fig: aus Schwartz«.

"A snuff box with Watteau figures overlaid with transparent green enamel."

"A snuff box lid of the large kind, quadrangular, with Watteau figures drawn in black."

1746, August, fol. 230:

»1. Tabattiere mit nackenden Kindern und 6. Partien«.

»2. Tabattieren mit Watteauisch: Fig: Grün laßirt«.

»2. Tabattieren Deckel detto [mit Wattsch: Fig: corrigiret]«.

"A snuff box with naked children and 6 parts."

"2 snuff boxes with Watteau figures overlaid with transparent green enamel."

"2 snuff box lids ditto [with Watteau figures, made corrections]."

1746, September, fol. 251:

»1. Tabattiere detto [mit Watteauisch: Fig. Grün lassirt]«.

"A snuff box ditto [with Watteau figures overlaid with transparent green enamel]."

1746, October, fol. 369:

»1. Tabattieren Deckel inwendig mit ovidischer Historie«.

»1. Tabattieren deckel detto[die Watt. Fig. Grün laßirt]«.

"A snuff box lid, with a story from Ovid on the inside."

"A snuff box lid ditto [the Watteau figures overlaid with transparent green enamel]."

1746, November, fol. 389:

»3. Tabattieren Deckel inwendig mit Watteauisch: Fig«.

»1. Tabattiere mit Wattsch. Fig: blau gantz überarbeitet«.

"3 snuff box lids, with Watteau figures on the inside."

"A snuff box with Watteau figures in blue, retouched it entirely."

1746, December, fol. 404:

»1. Tabattieren Deckel inwendig mit ovidisch Fig: fein«.

»4. Tabattieren viereckigt detto [mit Watt: Fig: Grün laßirt]«.

»2. Tabattieren rund detto«.

"A snuff box lid with figures from Ovid on the inside, fine."

"4 quadrangular snuff boxes ditto [with Watteau figures overlaid with transparent green enamel]."

"2 round snuff boxes ditto."

AA I Ab 28

1747, January, fol. 28:
»1. Tabattiere mit Watt: Fig: aus Blau«.
»2. Tabattieren mit Watteauisch: Fig. Grün, gantz überarbeitet und lassirt«.
»1. Tabattiere detto grün lassiret«.
"A snuff box with Watteau figures in blue."
"2 snuff boxes with Watteau figures. Completely retouched and overlaid with transparent green enamel."
"A snuff box ditto overlaid with transparent green enamel."

1747, February, fol. 46:
»1. Tabattieren Deckel inwendig mit vielen Fig. und Mahlerey fein«.
»1. Tabattieren Deckel mit Kindern gantz überarbeitet«.
»1. Tabattiere mit Watt: Fig. Grün laßirt«.
"A snuff box lid on the inside with many figures and fine painting."
"A snuff box lid with children entirely retouched."
"A snuff box with Watteau figures overlaid with transparent green enamel."

1747, March, fol. 77:
»2. Tabattieren mit Watt: Fig. Grün laßirt«.
»1. Tabattiere, mit ovidisch: Fig: und Kindern, in Grodesca, fein«.
"2 snuff boxes with Watteau figures overlaid with transparent green enamel."
"A snuff box, with figures from Ovid and children, in grotesque work, fine."

1747, April, fol. 103:
»1. Tabattiere die Watt: Fig: Grün laßirt«.
»1. Detto Untertheil«.
"A snuff box, the Watteau figures overlaid with transparent green enamel."
"1 ditto lower section."

1747, May, fol. 127:
»1. Tabattieren Deckel inwendig mit Ovidisch: Fig: fein, aus Purpur«.
»2. Tabattieren mit Watt: Fig: Grün laßirt«.
»1. Deckel detto Grün laßirt«.
»2. Tabattieren mit Kindern und Blumen Grün laßirt«.
"A snuff box lid on the inside with figures from Ovid, in purple."
"2 snuff boxes with Watteau figures overlaid with transparent green enamel."
"A snuff box lid ditto overlaid with transparent green enamel."
"2 snuff boxes with children and flowers overlaid with transparent green enamel."

1747, June, fol. 169:
»1. Tabattieren Deckel inwendig mit der Göttin des Überflußes, und auswendig mit Vermählungs historie nach Mahlerey, fein«.
»2. Tabattieren mit Watteauisch: Fig. Grün laßirt«.
"A snuff box lid on the inside with the goddess of abundance, and on the outside with a marriage story after a painting, fine."
"2 snuff boxes with Watteau figures overlaid with transparent green enamel."

1747, July, fol. 235:
»3. Tabattieren Grün laßirt«.
"3 snuff boxes overlaid with transparent green enamel."

1747, August, fol. 278:
»9. Stück Tabattieren, detto [mit Watt: Fig:] laßirt«.
"9 snuff boxes ditto [with Watteau figures], overlaid with transparent green enamel."

1747, September, fol. 337:
»8. Tabattieren „ [mit Watt: Fig:] Grün laßirt«.
»1. Tabattieren Deckel überarbeitet«.
"8 snuff boxes ditto [with Watteau figures], overlaid with transparent green enamel."
"Retouched a snuff box lid."

1747, October, fol. 376:
»5. Tabattieren mit Bauern, Grün laßirt«.
»3. Tabattieren detto, so defect worden, gantz überarbeitet, und laßirt«.
"5 snuff boxes with peasants, overlaid with transparent green enamel."
"3 snuff boxes ditto that had not turned out well, entirely retouched, and overlaid with transparent enamel."

1747 November, fol. 399:
»1. Tabattieren Deckel mit historisch. Fig. überarbeitet«.
»2. Detto Deckel mit Kindern überarbeitet«.
"A snuff box lid with historical figures, retouched."
"2 snuff box lids with children, retouched."

Johann Jacob Wagner:

AA I Ab 22

1744, January, fol. 44:
»Bey allhiesiger Königl. Porcelain Manufaktur habe ich Endes gesetzter, auf den Monat Januar 1744 zu Miniaturarbeit verferttiget, als:
1. Tabattieren Deckel, inwendig mit einen Frauenzimmer, und Cupido gemahlt,
1. Detto Deckel, mit 2. Frey Mäurer Figuren, starck ausgebeßert,
1. Detto detto corrigiret,
1. Detto detto ausgebeßert und darin corrigiret,
1. Detto Deckel Mars und Venus corrigiret«.
"At the end of the month of January 1744 I completed the following miniature work at the Royal Porcelain Manufactory:
A snuff box lid, painted the underside with a female figure and Cupid,
1 ditto ditto with 2 figures of Freemasons, made considerable improvements,
1 ditto ditto, made corrections,
1 ditto ditto, made improvements and corrections,
1 ditto lid, made corrections to Mars and Venus."

1744, February, fol. 74:
»Einen Tabattieren Deckel inwendig mit 3. Figuren migniatur ganz verferttiget«.
»Ein Detto do. mit 4. Figuren übermahlt, und ausgebeßert«.
»Ein Detto do. mit 4. Figuren corrigirt«.
»Ein Detto do. mit Czarin Portrait übermahlt«.
»Ein Detto do. mit 2. Figuren übermahlt«.
"One snuff box lid, completed the painting of 3 miniature figures on the inside."
"Ditto ditto, painted it with 4 figures, and made improvements."
"Ditto ditto with 4 figures, made corrections."
"Ditto ditto, painted it with a portrait of the Tsarina."
"Ditto ditto, painted it with 2 figures."

1744, March, fol. 89:
»1. Tabattieren Deckel mit Czarin Portrait verferttiget«.
»1. Dergleichen angefangen, nebst einem Tugendbild«.
»1. Detto Deckel mit 2. Figuren corrigirt«.
»1. Detto Deckel mit den 7. freyen Künsten gezeichnet«.
"A snuff box lid, completed with a portrait of the Tsarina."
"One of the same, started, with the addition of an image of virtue."
"A ditto lid with 2 figures, made corrections."
"A ditto lid with the 7 liberal arts, did the line-painting."

1744, April, fol. 219:
»1. Königl. Mayth. Portrait, auf einen Tabattieren Deckel gemahlet«.
»2. Czarin Portrait auf Tabattieren Deckel ausgebeßert, und übermahlt«.
»1. Detto Deckel mit 4. Figuren corrigirt«.
"Painted a portrait of his Royal Majesty on a snuff box lid."
"Made improvements to two portraits of the Tsarina on snuff box lids, and painted them over."
"1 ditto lid with 4 figures, made corrections."

1744, May, fol. 239:
»1. Tabattieren Deckel mit einem Tugend Bild, so Ihro Mayth. der Czarin Portrait hält verferttiget«.
»3. Tabattieren Deckel jeden mit 2 Figuren migniatur, gemahlet, darin corrigiert und verbeßert«.
"A snuff box lid with an image of virtue that contains a portrait of Her Majesty the Tsarina, completed."
"3 snuff box lids with 2 miniature figures each, painted them and carried out corrections and improvements."

1744, June, fol. 271:
»1. Tabattieren Deckel inwendig mit Apollo und Daphne verferttiget«.
»3. Detto Deckel mit Mopshundgen ausgebeßert, und darin corrigirt«.
»1. Detto Deckel mit 1. Figur, darin corrigirt«.

"A snuff box lid with Apollo and Daphne on the inside, completed."
"3 ditto lids with little pug dogs, made improvements and corrections."
"1 ditto lid with 1 figure, made corrections."

1744, July, fol. 300:
»1. Tabattieren Deckel mit 3. Figuren fein gemahlt«.
»2. Detto Deckel mit 2. Figuren mign. corrigirt«.
"A snuff box lid with three figures, painted finely."
"2 ditto lids with 2 figures *en miniature,* made corrections."

1744, August, fol. 332:
»1. Tabattieren Deckel mit Czarin Portrait ausgeßert«.
»1. Detto Deckel mit 1. Figur mign. ausgebessert«.
»1. Detto do. mit 2. Do. mign. ausgebessert«.
»2. Detto do. mit 3 Do mign. ausgebessert«.
"A snuff box lid with a portrait of the Tsarina, made improvements."
"A snuff box lid with 1 miniature figure, made improvements."
"1 ditto ditto with 2 miniature figures, made improvements."
"2 snuff box lids with 3 miniature figures, made improvements."

1744, September, fol. 361:
»1 Tabattieren Deckel mit 2. Figuren ganz verfertiget«.
»1. Detto mit 2. Figuren corrigirt und ausgebeßert«.
»2. Detto mit 3. Figuren corrigirt und ausgebeßert«.
»1. Detto mit 1. Mopßgen corrigirt und ausgebeßert«.
"A snuff box lid with 2 figures, entirely completed."
"A ditto with 2 figures, made corrections and improvements."
"2 snuff box lids with 3 figures, made corrections and improvements."
"A ditto with one little pug dog, made corrections and improvements."

1744, October, fol. 405:
»1. Tabattieren Deckel mit Czarin Mayth. Portrait ganz verfertiget«.
»1. Detto mit 1. Figur verfertiget«.
»2. Detto mit 2. Figuren corrigirt«.
»2. Detto mit 3. Figuren corrigirt«.
"A snuff box lid with a portratit of Her Majesty the Tsarina, entirely completed."
"1 ditto with 1 figure, completed."
"2 snuff box lids with 2 figures, made corrections."
"2 snuff box lids with 3 figures, made corrections."

1744, November, fol. 430:
»1. Tabattieren Deckel mit 2. Figuren verfertiget«.
»2. Detto Deckel mit 1. Figur corrigirt«.
»1. Detto do mit 3. Figuren corrigirt«.
»1. Detto do mit 5. Figuren corrigirt«.
"A snuff box lid with two figures completed."
"2 ditto lids with 1 figure, made corrections."
"A ditto ditto with 3 figures, made corrections."
"A ditto ditto with 5 figures, made corrections."

1744, December, fol. 457:
»1. Tabattieren Deckel mit Ihro Mayth. der Czarin Portrait ganz verferttiget«.
»1. Detto Deckel mit 4. Figuren corrigirt«.
»1. Detto mit 3. Figuren, do.«.
»2. Detto do. mit 2. do. do.«.
"A snuff box lid with a portrait of Her Majesty the Tsarina, entirely completed."
"A ditto lid with 4 figures, made corrections."
"A ditto with 3 figures, ditto."
"2 ditto ditto with 2 ditto, ditto."

AA I Ab 24

1745, January, fol. 39:
»1. Tabattieren Deckel mit Czarischen Mayth. Portrait ganz verfertiget«.
»3. Detto Deckel, jeden mit 1. Figur corrigirt«.
»1. Detto Deckel, jeden mit 5. Figuren corrigirt«.
"A snuff box lid with a portrait of Her Majesty the Tsarina entirely completed."
"3 ditto lids, each with 1 figure, made corrections."
"1 ditto lid, [each] with 5 figures, made corrections."

1745, February, fol. 59:
»1. Tabattieren Deckel inwendig mit 4. Figuren aus den Ovidio ganz verfertiget«.
»4. Dergleichen Deckel worein Mopßhündgen gemahlt, corrigirt«.

"A snuff box lid with 4 figures from Ovid, entirely completed."
"4 ditto lids with pug dogs painted on them, made corrections."

1745, March, fol. 86:
»1. Tabattieren Deckel mit Zarin Mayth Portrait verferttiget«.
»1. Detto Deckel mit 1. Figur corrigirt«.
»1. Detto Deckel mit 3. Figuren corrigirt«.
"A snuff box lid with a portrait of Her Majesty the Tsarina, completed."
"1 ditto lid with 1 figure, made corrections."
"1 ditto lid with 3 figures, made corrections."

1745, April, fol. 202:
»1. Tabattieren Deckel, mit Ihro Königl. Mayth. Portrait angefangen«.
»1. Detto Deckel mit 2. Figuren corrigirt«.
"A snuff box lid with a portrait of His Royal Majesty, started."
"1 ditto lid with 2 figures, made corrections."

1745, May, fol. 224:
»1. Tabattieren Deckel mit Ihro Mayth. der Königin von Ungarn Portrait«.
»1. Detto Deckel mit den 7. Musen corrigirt, und«
"A snuff box lid with a portrait of Her Majesty the Queen of Hungary [Maria Theresa of Austria]."
"1 ditto lid with the 7 muses, made corrections."

1745, June, fol. 251:
»1. Königl. Mayth. Porttrait verferttiget«.
»1. Czarische Mayth. Portrait übermahlet«.
»1. Tabattieren Deckel mit 3. Figuren, corrigirt«.
"Portrait of His Royal Majesty, completed."
"Painted a portrait of Her Majesty the Tsarina."
"A snuff box lid with three figures, made corrections."

1745, July, fol. 275:
»1. Tabattieren Deckel mit 1. Schäferin verferttiget«.
»1. Detto Deckel mit Ihro Mayt. der Königin Portrait do«.
»1. Detto Deckel Narcissum corrigirt«.
"A snuff box lid with a shepherdess, completed."
"A ditto lid with a portrait of Her Majesty the Queen, ditto."
"A ditto lid, made corrections to Narcissus."

1745, August, fol. 317:
»1. Tabattieren Deckel mit Ihro Mayth. der Königin von Ungarn Portrait«.
»2. Detto Deckel mit 1. Figur corrigirt«.
"A snuff box lid with a portrait of Her Majesty the Queen of Hungary."
"2 ditto lids with 1 figure, made corrections."

1745, September, fol. 367:
»1. Tabattieren Deckel mit den Sieben freyen Künsten«.
»1. Dergl. Deckel corrigirt«.
»1. Dergl. Deckel mit der Königin von Ungarn Portrait übermahlt«.
"A snuff box lid with the Seven Liberal Arts."
"A snuff box lid, made corrections."
"A snuff box lid, painted over with a portrait of the Queen of Hungary."

1745, October, fol. 395:
»1. Tabattieren Deckel mit 1. Schäferin und schwarzen Hundgen ganz verferttiget«.
"A snuff box lid with a shepherdess and little black dogs, entirely completed."

1745, November, fol. 442:
»1. Ihro Königl. Mayth. auf einem Tabatieren Deckel übermahlt«.
»1. Tabattieren Deckel mit Tugend Bilder corrigirt«.
"A snuff box lid, painted over with His Royal Majesty."
"A snuff box lid with images of virtue, made corrections."

AA I Ab 26

1746, January, fol. 8:
»1. Portrait auf einen Tabattieren Deckel vor den Hr. General La Serren gemahlt«.
"On a snuff box lid, painted a portrait for General La Serren."

1746, February, fol. 35:
»1. Tabattieren Deckel mit Ihro Mayth. der Czarin Portrait verferttiget«.

»1. Detto Deckel mit Ovidischen Figuren corrigiret«.
"A snuff box lid with a portrait of Her Majesty the Tsarina, completed."
"A ditto lid with figures from Ovid, made corrections."

1746, March, fol. 76:
»1. Tabattieren Deckel mit 2. Ovidischen Figuren fein gemahlt«.
»3. Detto Deckel auscorrigirt«.
"A snuff box lid with 2 figures from Ovid, finely painted."
"3 ditto lids, made final corrections."

1746, April, fol. 101:
»1. Tabattieren Deckel mit Ihro Mayth. der Königin Portrait verferttiget«.
»2. Detto Deckel, jeder mit 2. Ovidischen Figuren, corrigirt, und«
"A snuff box lid with a portrait of Her Majesty the Queen, completed."
"2 ditto lids, each with 2 figures from Ovid, made corrections."

1746, May, fol. 126:
»1. Tabattieren Deckel mit 3. Ovidischen Figuren gemahlt, corrigiret«.
»1. Detto Deckel mit 2. Ovidischen Figuren angefangen«.
"A snuff box lid with 3 figures from Ovid, made corrections."
"A ditto lid with 2 figures from Ovid, started."

1746, June, fol. 143:
»1. Tabattieren Deckel mit Ovidischen Figuren verferttiget«.
»2. Detto Deckel corrigiret«.
"A snuff box lid with figures from Ovid, completed."
"2 ditto lids, made corrections."

1746, July, fol. 208:
»1. Czarin Portrait gemahlt«.
»4. Deckel mit ovidischer Mahlerey corrigiret«.
»1. Deckel mit Apollo und Daphne angefangen«.
"Painted a portrait of Her Majesty the Tsarina."
"4 lids with painting from Ovid, made corrections."
"A lid with Apollo and Daphne, started."

1746, August, fol. 229:
»1. Tabattieren Deckel mit 2. Figuren gemahlt«.
»1. Detto angefangen«.
»2. Tabattieren deckel, detto [mit Bataillen]«.
"Painted a snuff box lid with two figures."
"1 ditto, started."
"2 snuff box lids, ditto [with battles]."

1746, September, fol. 250:
»1. Tabattieren Deckel mit Ihro Mayth der Königin Portrait verferttiget«.
»2. Detto Deckel mit ovidischen Figuren corrigiret«.
"A snuff box lid with a portrait of Her Majesty the Queen, completed."
"2 ditto lids with figures from Ovid, made corrections."

1746, October, fol. 368:
»1. Deckel zu 1. Tabattiere mit ovidischer Mahlerey ganz verferttiget«.
»1. Detto Deckel, mit ovidischer Mahlerey angefangen«.
"A snuff box lid with painting from Ovid, entirely completed."
"A ditto lid with painting from Ovid, started."

1746, November, fol. 391:
»1. Tabattieren Deckel mit Apollo und Daphne verferttiget«.
»1. Detto Deckel mit der Churfürstin von der Pfalz verferttiget«.
»1. Detto Deckel mit 5. Figuren corrigiret«.
"A snuff box lid with Apollo and Daphne, completed."
"A ditto lid with the Electress of the Palatinate, completed."
"A ditto lid with 5 figures, made corrections."

1746, December, fol. 403:
»1. Tabattieren Deckel mit Ihro Durchl des Churfürst von der Pfalz Portrait verferttiget«.
»1. Detto Deckel mit einen franzö. Cavalier Portrait verferttiget«.
»2. Detto Deckel mit Figuren, corrigirt«.
"A snuff box lid with a portrait of His Serene Highness the Elector of the Palatinate, completed."
"A ditto lid with a portrait of a French nobleman, completed."
"2 ditto lids with figures, made corrections."

AA I Ab 28

1747, January, fol. 27:
»1. Tabattieren Deckel mit einer französischen Damen Portrait verferttiget«.
»1. Detto Deckel mit 1. Figur corrigirt«.
"A snuff box lid with a portrait of a French lady, completed."
"A ditto lid with 1 figure, made corrections."

1747, February, fol. 45:
»Tabattieren Deckel mit Ihro Churfürst. Durchl.«.
"Snuff box lid with His Serene Highness the Elector."

AA I Ab 41

1764, October, fol. 239:
»1 Tabattier Deckel mit Portrait mit Caninis nach der Rosalba«.
"A snuff box lid with portrait with rabbits after Rosalba [Rosalba Carriera, Italian pastel artist, 1675–1757]."

1764, November, fol. 294:
»1 Tabattieren Deckel inwendig mit Portrait ein nackends Frauenzimmer mit Vogel, nach Rosalba en migniatur«.
»1 Detto in der Arbeit mit 2. Figuren nach Rosalba«.
"A snuff box lid, painted on the inside with a portrait of a naked woman with a bird, after Rosalba *en miniature*."
"1 ditto, work in process with two figures after Rosalba."

AA I Ab 40

1765, January, fol. 20:
»1. Tabattieren Deckel inwendig mit 2. Figuren am Nacht Tisch sizend en migniature nach Rosalba«.
»1. Detto auscorrigirt«.
"Painted a snuff box lid on the inside with 2 figures sitting at a night table, *en miniature* after Rosalba."
"1 ditto, made extensive corrections."

1765, February, fol. 37:
»1. Tabattieren Deckel inwendig mit Frauen Zimmer an Coffee-Tisch en migniature nach Rosalba«.
»1. Detto dergl. übermahlt«.
"A snuff box lid on the inside with a woman at a coffee table, *en miniature* after Rosalba."
"1 ditto, repainted in the same manner."

1765, March, fol. 86:
»1. Tabattieren Deckel mit Venus und Cupido mit dem Spiegel en migniature nach Rosalba«.
»1. Detto corrigiret«.
"A snuff box lid with Venus and Cupid with the mirror, *en miniature* after Rosalba."
"One of the same, made corrections."

1765, April, fol. 106:
»1. Tabattieren-Deckel mit Frauenzimmer und Stroh Huth, nebst einen Kaninens nach Rosalba, en migniature«.
"A snuff box with a woman in a straw hat and a rabbit, *en miniature* after Rosalba."

1765, May, fol. 137:
»1. Tabattieren Deckel mit Portrait aus corrigiret«.
"A snuff box lid with portrait, made extensive corrections."

Joseph Annibal Heße:

AA I Ab 40

1765, January / February, fol. 35:
»1. Tabattiere inwendig ein Frauenzimmer an Coffee Tisch, auswendig en Camagéux mit Figur im Golden Grund, en migniature nach Rosalba«.
"A snuff box painted on the inside with a woman at a coffee table, on the outside a figure *en camaïeu* against a gold ground, *en miniature* after Rosalba."

1765, March and April, fol. 105:
»1. Tabattiere auswendig mit figur und ornamenta en camargeux in purpur Grund«.
»2. Tabattieren deckel inwendig mit Portraits, von Herrn Henrici angefangen, und von feder geseztes ausgemahlet, sehr mühsam en migniature, nach Rosalba«.
"A snuff box on the outside with a figure and ornaments *en camaïeu* on a purple ground."
"2 snuff box lids on the inside with portraits begun by Herr Henrici, drawn with a pen and then painted, very elaborate *en miniature*, after Rosalba."

1765, November, fol. 480:
»1. Tabattieren Untertheil mit Cupido u. Ornament«.
"A snuff box lower section with Cupid and ornamentation."

Johann Georg Loehnig:

AA I Ab 53 B/1

1776, März, fol. 164r:
»1 Tabatiere, auswendig mit Portrait von Friedrich Christian en Biscuit, inwendig mit feinen Genies gantz zugearbeitet für I.K.H. die verwittbete Frau Churfürstin«.
"A snuff box *en biscuit*, on the outside with a portrait of Friedrich Christian, on the inside with putti finely done … for Her Royal Highness the Dowager Electress."

Philipp Ernst Schindler:

AA I Ab 26

1746, July, fol. 210:
»Ein Tabattieuren-Deckel en miniatür«.
»Ein Detto so angefangen«.
"A snuff box lid *en miniature*."
"Another of the same, started."

1746, August, fol. 231:
»Einen Tabattieuren-Deckel mit Ovid: Historie der Diana«.
»Einen Tabattieuren-Deckel mit 3. Fig: von H. Weisen Sen: gemahlt ganz und gar übermahlet und corrigiret«.
"A snuff box lid with the story of Diana from Ovid."
"A snuff box with 3 figures painted by Herr Weisen, sen. [Johann Jacob Weise, sen.], entirely painted over, and then reworked and corrected."

1746, September, fol. 252:
»Einen Tabattieuren Deckel en miniatür mit ovidischer Hist.«.
"A snuff box with a story from Ovid *en miniature*."

1746, October, fol. 370:

»2 Tabattieuren-Deckel vor Mos. Weysen jun. gemahlet, so ich noch zu verbeßern, in Arbeit habe«.

"Painted 2 snuff box lids for Monsieur Weysen, jun. [Johann Jacob Weise Junior], which I am still working on and have to improve."

AA I Ab 28

1747, January, fol. 29:

»Zwei Tabattieuren mit Ovid: Mahlerey purpur überarbeitet«.

"Two snuff boxes with motifs from Ovid in purple, retouched."

1747, April, fol. 104:

»Einen Tabattieuren-Deckel en miniatür überarbeitet«.

"A snuff box lid with painting *en miniature*, retouched."

1747, May, fol. 128:

»Einen Tabattieuren-Deckel en miniatür ovid: Historie verfertiget«.

»2 Tabattieuren mit Kindergen von H. Wahnes ganz überarbeitet«.

"Completed and made ready a snuff box lid with a story from Ovid *en miniature*."

"2 snuff boxes with little children done by Herr Wahnes [Heinrich Christian Wahnes, porcelain painter at the Meissen manufactory], entirely retouched."

1747, June, fol. 170:

»Einen Tabattieuren Deckel miniatür mit 2. Figüren«.

"A snuff box with 2 figures *en miniature*."

1747, July, fol. 236:

»Einen Tabattieuren Deckel mit ovid: Historien, wegen Unpäßlichkeit aber nicht verfertigen können«.

"A snuff box lid with stories from Ovid, but I could not finish it because I was unwell."

1747, August, fol. 279:

»Einen großen ovalen Tabattieuren-Deckel mit 4. Figuren ovid: Vulcano, Marß p.p. verfertiget«.

»Einen Tabattieuren Deckel mit militair. Figuren so noch in Arbeit«.

"A large oval snuff box lid with 4 figures from Ovid: Vulcan, Mars etc. [*p.p.* = "perge perge," meaning "continue, continue"] completed and made ready."

"A snuff box lid with military figures that has still to be finished."

1747, September, fol. 338:

»Einen Tabattieuren Deckel mit 4. militairischen Figuren en miniatür verfertiget«.

"A snuff box lid with 4 military figures *en miniature*, completed and made ready."

1747, October, fol. 377:

»Einen Tabattieuren Deckel en miniatür ovid. groß oval«.

"A large oval snuff box lid, with a motif from Ovid *en miniature*."

1747, November, fol. 400:

»Einen Tabattieuren Deckel en miniatür mit 3. Figuren militair so noch in Arbeit«.

"A snuff box lid with 3 military figures that has still to be finished."

1747, December, fol. 429:

»Einen Tabattieuren Deckel en miniatür mit 3 Figuren und Mopsgen verfertiget«.

"A snuff box lid with 3 figures *en miniature* and pug dogs, completed and made ready."

Johann Christian Scheffler:

AA I Ab 40

1765, January, fol. 21:
»1. Dose mit vieler Mahlerey«.
»1. Dosen Deckel, detto [mit Watteau] mit Mos:[aique]«.
"A box with a lot of painting."
"A box lid, ditto [with Watteau] with mosaic ornamentation."

1765, February, fol. 36:
»1. runde Dose mit Mosaique«.
"A round box with mosaic ornamentation."

1765, April, fol. 108:
»2 Dosen Deckel vergoldet«.
»1. Dosen Deckel vergoldet«.
"Gilded two snuff box lids."
"Gilded a snuff box lid."

1765, June, fol. 212:
»1 Dose mit Vergiß mein nicht«.
"A box with forget-me-nots."

Johann Christian Wiebel:

AA I Ab 40

1765, January, fol. 22:
»1. Dose vergoldet«.
»1. Dosen Deckel detto«.
»1. Dose detto«.
»1. blau Dose mit Crodesce und Blumen vergoldet und radiret«.
"Gilded a box."
"Ditto a box lid."
"Ditto a box."
"Gilded and engraved a blue box with grotesque work and flowers."

1765, February, fol. 39:
»1. Dose, die Zieraden vergoldet«.
"Gilded the ornamentation on a box."

1765, March, fol. 87:
»3. Dosen vergoldet«.
"Gilded 3 boxes."

Hieronymus Christian Richter:

AA I Ab 40

1765, August, fol. 302:
»1. Tabatt. Deckel inwendig 2. Fig.«.
"2 figures on the inside of a snuff box lid."

1765, October, fol. 401:
»Auf 1. Tabattiere en Camayé«.
"On a snuff box [did painting] *en camaïeu*."

Christian Gottlieb Krahl:

AA I Ab 40

1765, November, fol. 482:
»1. Tabattiere mit Portrait en Camayé«.
"A snuff box with a portrait *en camaïeu*."

1765, December, fol. 541:
»1. Tabattieren Untertheil en Camayé«.
"Lower part of a snuff box *en camaïeu*."

Johann Carl Schütze:

AA I Ab 40

1765, August, fol. 302:
»1. Tabattieren Deckel in und auswendig ovid: fig: a Camayé nebst Unterth. welches schadhafft worden und das abgepl[atzte] übermahlet worden«.
"A snuff box lid inside and out with figures from Ovid *en camaïeu*, and painted over a defective box on which the painting had blistered and burst."

1765, December, fol. 541:
»1. Tabattieren Deckel mit ovid. Fig.«.
"A snuff box lid with figures from Ovid."

AA I Ab 53 B/2

1776, April, fol. 238r:
»1 Tabattieren Deckel, inwendig eine sitzende Venus und Cupido en Camayé in grünlichen Grund ganz zugearbeitet«.
"A snuff box lid, on the inside completed the painting of a sitting Venus and Cupid *en camaïeu* on a greenish ground."

1776, May, fols. 307v–308r:
»1. Tabattierendeckel inwendig die Erkenntlichkeit nach Zeichnung von Hr. Prof. Schenau«.
"A snuff box lid, on the inside Gratitude after a drawing from the hand of Professor Schenau."

1776, June, fol. 386r:
»1 Tabatierendeckel, inwendig die Laeta ganz zugearbeitet, auswendig Genies auf Wolken«.
"A snuff box lid, on the inside completed the painting of Laeta [possibly Laetitia, the Roman goddess of good cheer], on the outside putti on clouds."

Carl Gottlieb Thiele:

AA I Ab 53 B/1

1776, January, fol. 109v:
»1. Tabatiere«.
"A snuff box."

1776, February, fol. 84v:
»2. Tabatieren«.
"2 snuff boxes."

1776, March, fol. 165v:
»1. Tabatierendeckel inwendig mit ovid. Figuren«.
"A snuff box lid on the inside with figures from Ovid."

AA I Ab 53 B/2

1776, May, fol. 308r:
»1. Tabtieren Deckel, schwarz glasirt, auswendig mit ind.[ianischen] Figuren aus verschiedenen Golde gemahlt und gravirt, inwendig grünen Marmor geleget«.
"A black-glazed snuff box lid, painted it on the outside with Indian figures in various kinds of gold and then did the internal line drawing, painted it with green marbling on the inside."

Christian Ferdinand Matthaei:

AA I Ab 53 B/1

1776, March, fol. 164r:
»1 Tabatierendeckel inwendig mit Genies, aus Rosenpurpur ganz zu gearbeitet«.
"A snuff box lid, on the inside with putti, completed the painting in pinkish purple."

Johann Gotthelff Punct:

AA I Ab 53 B/1

1776, March, fol. 165r:
»1 Tabatierendeckel mit Ovidischen Figuren und Kinder in Wolken«.
"A snuff box lid with figures from Ovid and children in clouds."

AA I Ab 53 B/2

1776, May, fol. 307v:
»1 Tabatieren Deckel in und auswendig mit Tugendbildern«.
"A snuff box lid with images of virtue inside and out."

1776, June, fol. 385v:
»1. Tabatiere inwendig mit Kindern und Wolken«.
"A snuff box on the inside with children and clouds."

Christian Friedrich Kühnel:

AA I Ab 53 B/1

1776, March, fol. 166v:
»1. Tabatieren Deckel inwendig der regierende Kämpfer zu Pferde nebst seinem Gefolge«.
"A snuff box lid, on the inside the ruling fighter on horseback with his entourage."

Johann Gottfried Schmidt:

AA I Ab 53 B/2

1776, April, fol. 245v:
»1 Tabatiere, an Seiten 6 hängende Blumenguirl.[anden] auf den Deckel und Boden einen Cranz aus Rosenpurpur«.
"A snuff box, on its sides 6 floral festoons and a pinkish purple wreath on the lid and on the underside."

Carl Gottlob Schneider:

AA I Ab 53 B/2

1776, June, fol. 391v:
»2. Tabatieren Deckel in und auswendig bunte Blumen«.
"2 snuff box lids inside and out with coloured flowers."

Carl Gottlob Ehrlich:

..

AA I Ab 53 C/2

1776, October, fol. 661r:
»1. Tabatieren Deckel auswendig mit der Catholischen Kirche«.
"A snuff box lid with the Catholic church [the Dresden court church by Gaetano Chiaveri] on the outside."

Johann Gottlieb Tiebel:

..

AA I Ab 53 C/2

1776, November, fol. 739r:
»1. Tabatierendeckel in und auswendig, a la Vernet«.
"A snuff box lid inside and out à la Vernet [after a painting by Claude Joseph Vernet, 1714–1789]."

Christian Lindner:

..

AA I Ab 53 C/2

1776, November, fol. 739v:
»1. Tabatierendeckel mit der Churfürstin Portrait«.
"A snuff box lid with the portrait of the Electress."

1776, December, fol. 808r:
»1 Tabtieren-Deckel mit dem Churf. Portrait«.
"A snuff box lid with the portrait of the Elector."

Johann Gottlob Müller:

..

AA I Ab 53 C/2

1776, December, fol. 808r:
»1. Tabatieren Deckel mit galanten Figuren«.
"A snuff box lid with gallant figures."

Literature

Arnold 2001
Arnold, Ulli. *Die Juwelen Augusts des Starken.* Munich/Berlin, 2001.

Auct. cat. Christie's Amsterdam 2002
The Dr Anton C.R. Dreesmann Collection of Gold Boxes, Objects of Vertu and Portrait Miniatures. Christie's Amsterdam, 11 April 2002.

Auct. cat. Christie, Manson & Woods London 1855
Catalogue of the Celebrated Collection of Works of Art from the Byzantine Period to that of Louis Seize of that Distinguished Collector Ralph Bernal. Christie, Manson & Woods, London, 5 March 1855.

Auct. cat. Christie, Manson & Woods London 1973
The Ortiz-Patiño Collection of Highly Important French Gold Boxes. Christie, Manson & Woods, London, 27 June 1973.

Baer 2005
Baer, Winfried. "Hugenottische Goldschmiede und die hohe Schule der Bijouterie unter den Réfugiés in Berlin." In *Zuwanderungsland Deutschland: Migrationen 1500–2005.* Edited by Rosmarie Beier-De Haan. Exh. cat. Deutsches Historisches Museum Berlin, 22 October 2005 – 12 February 2006. Wolfratshausen, 2005, pp. 91–100.

Beaucamp-Markowsky 1985
Beaucamp-Markowsky, Barbara. *Porzellandosen des 18. Jahrhunderts.* Munich, 1985.

Beaucamp-Markowsky 1988
Beaucamp-Markowsky, Barbara. *Collection of 18th Century Porcelain Boxes.* Amsterdam, 1988.

Bischoff 2003a
Bischoff, Cordula. "Die handarbeitende Fürstin—zur Entstehung eines Typs des höfischen Privatporträts." In *Frau and Bildnis 1500–1750: Barocke Repräsentationskultur an europäischen Fürstenhöfen.* Edited by Gabriele Baumbach and Cornelia Bischoff. Kassel, 2003, pp. 245–71.

Bischoff 2003b
Bischoff, Cordula. "Fürstliche Appartements um 1700 und ihre geschlechtsspezifische Ausstattung." In *Wohnformen und Lebenswelten im interkulturellen Vergleich.* Edited by Magdalena Droste and Adolf Hoffmann. Frankfurt am Main/Berlin/Bern, 2003, pp. 67–79.

Bischoff 2004
Bischoff, Cordula. "Spiegel-, Lack- oder Porzellankabinett? Der chinoise Sammlungsraum und seine Ausdifferenzierung." In *Kritische Berichte* 32 (2004), no. 2, pp. 15–26.

Bischoff 2008
Bischoff, Cordula. "Presents for Princesses: Gender in Royal Receiving and Giving." In *Studies in the Decorative Arts,* 15/1 (2008), pp. 19–45.

Blusch 1997
Blusch, Jürgen. "Der Niederrhein im Zeitalter des Humanismus: Konrad Heresbach und sein Kreis." In *Referate der 9. Niederrhein-Tagung des Arbeitskreises niederrheinischer Kommunalarchive für Regionalgeschichte.* Edited by Meinhard Pohl. Bielefeld 1997, pp. 147–62.

Boltz 1978
Boltz, Claus. "Ein Beitrag zum grünen Watteau-Service für Neapel." In *Keramos* 79 (1978), pp. 5–24.

Boltz 2000
Boltz, Claus. "Steinzeug und Porzellan der Böttgerperiode." In *Keramos* 167/168 (2000), pp. 3–156.

Bouilhet 1908–12
Bouilhet, Henri. *L'Orfèvrerie Française.* Paris, 1908–12.

Brosche 2003
Brosche, Heidemarie. *Das Schnupftabakbücherl.* Dachau, 2003.

Bursche 1996
Bursche, Stefan. *Galanterien: Dosen, Etuis und Miniaturen aus Gold, Edelsteinen, Email und Porzellan. Eine Berliner Privatsammlung.* Berlin, 1996.

Bursche 1998
Bursche, Stefan. "Philipp Ernst Schindler und das hohle Dreieck." In *Keramos* 161 (1998), pp. 39–48.

Cassidy-Geiger 2007
Cassidy-Geiger, Maureen (ed.). *Fragile Diplomacy: Meissen Porcelain for European Courts ca. 1710–63.* New Haven/London, 2007.

Cassidy-Geiger 2008
Cassidy-Geiger, Maureen. *The Arnhold Collection of Meissen Porcelain 1710–1750.* New York, 2008.

Castelluccio 2002
Castelluccio, Stéphane. *Les Collections royales d'objets d'art de François I*er *à la Révolution.* Paris, 2002.

Cat. Röbbig 2011
Selected Works: Early German Porcelain & Eighteenth-Century Art, Furniture, and Objets d'Art. Edited by Röbbig München, Munich. Munich, 2013.

Chilton 2012
Chilton, Meredith. *Harlequin Unmasked: The Commedia dell'Arte and Porcelain Sculpture.* Toronto, 2012.

Claessens-Peré 1996
Claessens-Peré, Anne-Marie. "Introduction." In *Dozen om te niezen: Belgische en Franse snuifdozen en tabaksraspen uit de 18de eeuw.* Edited by Anne-Marie Claessens-Peré and Leo De Ren. Exh. cat. Provinciaal Museum voor Kunstambachten, Deurne (Antwerp), 17 December 1996 – 23 March 1997. Antwerp, 1996, pp. 42–45.

Cordey 1939
Cordey, Jean (ed.). *Inventaire des biens de Madame de Pompadour, rédigé après son décès.* Paris, 1939.

Cowart 2009
Cowart, Georgia J. "The Musical Theater in Watteau's Paris." In *Watteau: Music and Theater.* Edited by Katharine Baetjer. New York, 2009, pp. 9–18.

Davies 2004
Davies, Helen. "Bernal, Ralph (1783–1854)." In *Oxford Dictionary of National Biography.* Oxford University Press, 2004; online edition May 2007; [http://www.oxforddnb.com/view/article/2233, accessed 21 July 2013].

Den Blaauwen 2000
Den Blaauwen, Abraham L. *Meissen Porcelain in the Rijksmuseum.* Zwolle, 2000.

De Ren 1996
De Ren, Leo. "Die Schnupftabakdose am Hof des Generalstatthalters Karl Alexander von Lothringen." In *Dozen om te niezen: Belgische en Franse snuifdozen en tabaksraspen uit de 18de eeuw.* Edited by Anne-Marie Claessens-Peré and Leo De Ren. Exh. cat. Provinciaal Museum voor Kunstambachten, Deurne (Antwerp), 17 December 1996 – 23 March 1997. Antwerp, 1996, pp. 45–49.

Diderot 1796
Diderot, Denis. *Jacques le fataliste et son maître.* Paris, 1796 (first edition 1773).

Die Münchner Kunstkammer 2008
Die Münchner Kunstkammer (Bayerische Akademie der Wissenschaften, philosophy/history class, essays, new version, no. 129), 3 vols. Munich, 2008.

Dietrich 2004
Dietrich, Sigrid, and Lothar. *Lexikon der Tiersymbole: Tiere als Sinnbilder in der Malerei des 14–17. Jahrhunderts.* Petersberg, 2004.

Ducret 1973
Ducret, Sigfried. *Keramik and Graphik des 18. Jahrhunderts: Vorlagen für Maler and Modelleure.* Brunswick, 1973.

Eikelmann 2004
Eikelmann, Renate (ed.). *Meißener Porzellan des 18. Jahrhunderts: Die Stiftung Ernst Schneider in Schloss Lustheim.* Munich, 2004.

Eriksen 1968
Eriksen, Svend. *The James A. Rothschild Collection at Waddesdon Manor: Sèvres Porcelain*, London, 1968.

Exh. cat. Antwerp 1996
Dozen om te niezen: Belgische en Franse snuifdozen en tabaksraspen uit de 18de eeuw. Edited by Anne-Marie Claessens-Peré and Leo De Ren. Exh. cat. Provinciaal Museum voor Kunstambachten, Deurne (Antwerp), 17 December 1996 – 23 March 1997. Antwerp, 1996.

Exh. cat. Dresden 2010
Triumph der blauen Schwerter: Meissener Porzellan für Adel and Bürgertum 1710–1815. Edited by Ulrich Pietsch and Claudia Banz. Exh. cat. Staatliche Kunstsammlungen Dresden, Japanisches Palais, 8 May – 29 August 2010. Leipzig, 2010.

Exh. cat. Karlsruhe 1999
Jean Siméon Chardin 1699–1779: Werk, Herkunft, Wirkung. Edited by Dorit Schäfer. Exh. cat. Staatliche Kunsthalle Karlsruhe, 5 June – 22 August 1999. Ostfildern-Ruit, 1999.

Exh. cat. Cologne 2010
Meissen: Barockes Porzellan. Edited by Patricia Brattig. Exh. cat. Museum für Angewandte Kunst Köln, Cologne, 24 January – 25 April 2010. Stuttgart, 2010.

Exh. cat. Münster 2013
Vernis Martin: Französischer Lack im 18. Jahrhundert. Edited by Monika Kopplin and Anne Forray-Carlier. Exh. cat. Museum für Lackkunst, Münster, 13 October 2013 – 12 January 2014. Munich, 2013.

Exh. cat. Potsdam 1993
Prunk-Tabatieren Friedrichs des Großen. Edited by Winfried Baer. Exh. cat. Stiftung Schlösser und Gärten Potsdam-Sanssouci, Neue Kammern Sanssouci, 14 March – 25 April 1993. Munich, 1993.

Exh. cat. Rastatt 2008
Extra schön: Markgräfin Sibylla Augusta und ihre Residenz; eine Ausstellung anlässlich des 275. Todestages der Markgräfin Sibylla Augusta von Baden-Baden. Exh. cat. Schloss Rastatt mit Schlosskirche, 12 July – 21 September 2008. Petersberg, 2008.

Exh. cat. Segovia 2009
La Porcelana de Meissen en la Colección Britzke 1709–1765: Das Meissener Porzellan der Britzke-Sammlung 1709–1765. Exh. cat. Caja Segovia, 16 July – 11 August 2009. Segovia, 2009.

Exh. cat. St. Petersburg 2010
Since Tobacco You Love so much. Edited by Olga Kostjuk. Exh. cat. State Hermitage, St. Petersburg, 25 June – 10 October 2010. St. Petersburg, 2010.

Exh. cat. Waddesdon Manor 2012
Chardin's "Boy Building a House of Cards" and other Paintings. Edited by Juliet Carey. Exh. cat. Waddesdon Manor, Buckinghamshire, 28 March – 15 July 2012. Abingdon, 2012.

Fontane 1899
Fontane, Theodor. *Der Stechlin.* Berlin, 1899.

Fuchs 1999
Fuchs, Carl Ludwig. "Die Juwelen der Elisabeth Auguste." In *Lebenslust und Frömmigkeit: Kurfürst Carl Theodor (1724–1799) zwischen Barock und Aufklärung.* Edited by Alfried Wieczorek. Exh. cat. Reiss-Museum Mannheim and Stadtmuseum Düsseldorf. Regensburg, 1999, vol. 1, pp. 125–40.

Gobiet 1984
Gobiet, Ronald (ed.). *Der Briefwechsel zwischen Philipp Hainhofer und Herzog August d. J. von Braunschweig-Lüneburg* (research booklets, edited by the Bayerisches Nationalmuseum München, Munich, 8). Munich, 1984.

Grandjean/Aschengreen Piacenti/Truman/Blunt 1975
Grandjean, Serge, Kirsten Aschengreen Piacenti, Charles Truman, and Anthony Blunt (eds.). *The James A. de Rothschild Collection at Waddesdon Manor: Gold Boxes and Miniatures of the Eighteenth Century.* London/Fribourg, 1975.

Grégoire 2011
Grégoire, Christiane. "Boîtes en ôr et objèts de vertu dans la collection Cognacq-Jay." In Los Llanos, José de, and Christiane Grégoire. *Musée Cognacq-Jay: Musée du XVIIIᵉ siècle de la Ville de Paris. Les collections. Boîtes en ôr et objèts de vertu.* Paris, 2011, pp. 20–49.

Grimm 2008
"'… so mit agathen Täffeln and Steinen von Lapis Lazuli in Gold gefasst verziehret ist.' Sibylla Augustas Begeisterung für Werke der Steinschneidekunst." In *Extra schön: Markgräfin Sibylla Augusta und ihre Residenz; eine Ausstellung anlässlich des 275. Todestages der Markgräfin Sibylla Augusta von Baden-Baden.* Exh. cat. Schloss Rastatt mit Schlosskirche, 12 July – 21 September 2008. Petersberg, 2008, pp. 134–41.

Habsburg-Lothringen 1983
von Habsburg-Lothringen, Géza. *Gold Boxes: Superb Examples of the Goldsmiths' Art. From the Collection of Rosalinde and Arthur Gilbert.* Los Angeles, 1983.

Hall 2007
Hall, Michael. "Ferdinand de Rothschild. 'Bric-a-Brac': A Rothschild's Memoire of Collection, Annotated Edition." In *Apollo* (July/August 2007), pp. 50–77.

Hall 2009
Hall, Michael. *Waddesdon Manor: The Heritage of a Rothschild House.* Second revised edition. London/New York, 2009.

Havard 1890
Havard, Henri. *Dictionnaire d'ameublement et de la décoration.* Paris, 1890.

Held 1996
Held, Anke Charlotte. *Georg Philipp Rugendas (1666–1742): Gemälde and Zeichnungen.* Munich, 1996.

Helke 2005
Helke, Gun-Dagmar. *Johann Esaias Nilson (1721–1788): Augsburger Miniaturmaler, Kupferstecher, Verleger and Kunstakademiedirektor.* Munich, 2005.

Heuberger 1994
Heuberger, Georg (ed.). *The Rothschilds: Essays on the History of a European Family.* Cambridge, 1994.

Heym 2006
Heym, Sabine. "Kurfürst Karl Albrecht." In *Die Münchner Residenz: Geschichte—Zerstörung—Wiederaufbau.* Edited by Kurt Faltlhauser. Ostfildern, 2006, pp. 72–79.

Holland 1874
Holland, Wilhelm Ludwig (ed.). *Briefe der Herzogin Elisabeth Charlotte von Orléans aus den Jahren 1716 bis 1718.* Tübingen, 1874.

Holzhey 2012
Holzhey, Gerhard. "Die Verwendung von Schmucksteinen aus der Gruppe mikro- bis kryptokristalliner Quarze bei Tabatieren aus dem Nachlass des preußischen Königs Friedrich II. (1712–1786)." In *Zeitschrift der Deutschen Gemmologischen Gesellschaft,* 61/3–4 (2012), pp. 71–90.

Jakobsen/Pietsch 1997
Jakobsen, Christian, and Ulrich Pietsch. *Frühes Meissener Porzellan: Kostbarkeiten aus deutschen Privatsammlungen.* Munich, 1997.

Jedding 1982
Jedding, Hermann. *Meissener Porzellan des 18. Jahrhunderts in Hamburger Privatbesitz.* Hamburg, 1982.

Jones 2013
Jones, Kathryn. "Gold Boxes in the Royal Collection." In *Going for Gold: The Craftsmanship and Collecting of Gold Boxes.*

Edited by Tessa Murdoch and Heike Zech. Brighton/Chicago/Toronto, 2013, pp. 208–22.

Joseph 1977
Joseph, Helmut. "Das 'Hohle Dreieck' auf Meißen-Dosen." In *Keramos* 77 (1977), pp. 23–28.

Kauffmann 1943
Kauffmann, Hans. "Die Fünfsinne in der Malerei des 17. Jahrhunderts." In *Kunstgeschichtliche Studien*. Edited by Hans Tintelnot. Wroclaw, 1943, pp. 133–57.

Kemper 2005
Kemper, Thomas. *Schloss Monbijou: Von der königlichen Residenz zum Hohenzollern-Museum*. Berlin, 2005.

Keyssler 1751
Keyssler, J.G. *Neueste Reisen durch Deutschland, Böhmen, Ungarn, die Schweiz, Italien und Lothringen*. 2 vols. Hanover, 1751.

Koch 2009
Koch, Ute Christina. "'… für Sächsische Freande der Kunst gar schmerzlich:' Die Brühlschen Sammlungen und ihr Verkauf." In *Bilder-Wechsel: Sächsisch-russischer Kulturtransfer im Zeitalter der Aufklärung*. Edited by Volkmar Billig et al. Cologne/Weimar/Vienna, 2009, pp. 103–24.

Koch 2010
Koch, Ute Christina. "Die Tabatièren Friedrichs II." In *Kronschatz und Silberkammer der Hohenzollern*. Edited by Michaela Völkel. Berlin/Munich, 2010, pp. 116–27.

Koch 2013
Koch, Ute Christina. "Count Brühl and His Collection of Gold Boxes." In *Going for Gold: The Craftsmanship and Collecting of Gold Boxes*. Edited by Tessa Murdoch and Heike Zech. Brighton/Chicago/Toronto, 2013, pp. 184–94.

Kostjuk 2009
Kostjuk, Olga. "'… in Ehren Schätze des Wissens and guter Sitten nach Hause zu bringen…': Schatzsammeln am Zarenhof Peter[s] des Großen." In *Bilder-Wechsel: Sächsisch-russischer Kulturtransfer im Zeitalter der Aufklärung*. Edited by Volkmar Billig et al. Cologne/Weimar/Vienna, 2009, pp. 53–68.

Kugel 2012
Kugel, Alexis (ed.). *"Le luxe, le gout, la science…." Neuber, orfèvre, minéralogiste, à la cour de Saxe*. Saint-Remy-en-l'Eau, 2012.

Kunze-Köllensperger 2000
Kunze-Köllensperger, Melitta. "Brühl als Direktor der Porzellan-Manufaktur." In Ulrich Pietsch (ed.) *Schwanenservice: Meissener Porzellan für Heinrich Graf von Brühl*. Berlin, 2000, pp. 19–23.

Le Corbeiller 1966
Le Corbeiller, Clare. *European and American Snuff Boxes 1730–1830*. London/Batsford/New York, 1966 (German edition: *Alte Tabakdosen aus Europa und Amerika*. Munich, 1966).

Le Corbeiller 1977
Le Corbeiller, Clare. *The Wrightsman Collection: Gold Boxes*. New York, 1977.

Lemasson 2002
Lemasson, Patrick. "Das Naturgefühl im 18. Jahrhundert." In *Geist und Galanterie: Kunst und Wissenschaft im 18. Jahrhundert aus dem Musée du Petit Palais Paris*. Exh. cat. Kunst- und Ausstellungshalle der Bundesrepublik Deutschland Bonn, 13 December 2002 – 6 April 2003. Leipzig, 2002, pp. 161–74.

Lohneis 1985
Lohneis, Hans-Dieter. *Die deutschen Spiegelkabinette: Studien zu den Räumen des späten 17. und des frühen 18. Jahrhunderts*. Munich, 1985.

Loibl 1989
Loibl, Werner. "Ideen im Spiegel: Die Spiegelkabinette in den fränkischen Schönborn-Schlössern." In *Die Grafen von Schönborn: Kirchenfürsten, Sammler, Mäzene*. Edited by Hermann Maué and Sonja Brink. Exh. cat. Germanisches Nationalmuseum Nürnberg, Nuremberg, 18 February – 23 April 1989. Nuremberg, 1989, pp. 82–90.

Long 1923
Long, Basil. *Catalogue of the Jones Collection. Part III: Paintings and Miniatures.* London, 1923.

Los Llanos 2002
Los Llanos, José de. "Die Historie, das Theater und die Fabel." In *Geist und Galanterie: Kunst und Wissenschaft im 18. Jahrhundert aus dem Musée du Petit Palais Paris.* Exh. cat. Kunst- und Ausstellungshalle der Bundesrepublik Deutschland Bonn, 13 December 2002 – 6 April 2003. Leipzig, 2002, pp. 65–71.

Lübke 2008
Lübke, Diethard. "Schindler? Horn?—oder doch Dietze? Zuschreibungen von Malereien auf frühem Meißner Porzellan." In *Keramos* 200 (2008), pp. 3–20.

Mandt 2009
Mandt, Barbara. *Der Pommersche Kunstschrank des Augsburger Unternehmers Philipp Hainhofer für den gelehrten Herzog Philipp II. von Pommern.* Munich, 2009.

Mankartz 2012
Mankartz, Frauke. "Die Marke Friedrich: Der preussische König im zeitgenössischen Bild." In *Friederisiko: Friedrich der Grosse. Die Ausstellung.* Exh. cat. Stiftung Preussische Schlösser und Gärten Berlin-Brandenburg, Neues Palais und Park Sanssouci, 28 April – 28 October 2012. Munich, 2012, vol. 1: Die Ausstellung, pp. 204–23.

Mariën-Dugardin 1995
Mariën-Dugardin, Anne Marie. *Les Legs Madame Louis Solvay, II. Boîtes et Tabatières.* Brussels, 1995.

Marmontel 1818
Marmontel, Jean François. *Oeuvres complètes de Marmontel.* Paris, 1818.

Marr 2011
Marr, Thorsten. "Vom Königreich zur Republik: Die Schatzkammer in der Residenz München (1897–1937)." In *Oberbayerisches Archiv* 135 (2011), pp. 159–201.

Marth 2004
Marth, Regine. "Die Sammlungen von Rudolph August bis Ludwig Rudolph (1666–1735)." In *Das Herzog Anton Ulrich-Museum und seine Sammlungen 1578–1754–2004.* Edited by Jochen Luckhardt. Munich, 2004, pp. 44–87.

Maze-Sencier 1885
Maze-Sencier, Alphonse. *Le Livre des Collectionneurs.* Paris, 1885.

Menzhausen 1993
Menzhausen, Ingelore. *In Porzellan verzaubert: Die Figuren Johann Joachim Kaendlers in Meissen aus der Sammlung Pauls-Eisenbeiss Basel.* Basel, 1993.

Möller 2011
Möller, Karin Annette. "Pretiosen und Schatzkunststücke der Dinglinger-Familie für Herzog Christian Ludwig II. von Mecklenburg-Schwerin." In *Barocke Kunststücke. Festschrift für Christian Theuerkauff.* Edited by Regine Marth and Marjorie Trusted. Munich, 2011, pp. 160–69.

Munger 2010
Munger, Jeffrey. "Gold Boxes." In *The Wrightsman Galleries for French Decorative Arts, Metropolitan Museum of Art.* New York, 2010.

Murdoch 2013
Murdoch, Tessa. "Snuff-Taking, Fashion and Accessories." In *Going for Gold: The Craftsmanship and Collecting of Gold Boxes.* Edited by Tessa Murdoch and Heike Zech. Brighton/Chicago/Toronto, 2013, pp. 1–15.

Murdoch/Zech 2013
Murdoch, Tessa, and Heike Zech (eds.). *Going for Gold: The Craftsmanship and Collecting of Gold Boxes.* Brighton/Chicago/Toronto, 2013.

Mus. cat. Boston 1992
The Forsyth Wickes Collection in the Museum of Fine Arts Boston. Edited by Jeffrey Munger. Boston, 1992.

Mus. cat. London 1924
Catalogue of the Jones Collection: Ceramics, Ormolou, Goldsmiths' Work, Enamel, Sculpture, Tapestry, Books and Prints. Vol. 2. Victoria and Albert Museum, London. London, 1924.

Mus. cat. New York 1984
The Jack and Belle Linsky Collection in the Metropolitan Museum of Art. New York, 1984.

Parker/Le Corbeiller 1979
Parker, James, and Clare Le Corbeiller. *A Guide to the Wrightsman Galleries at The Metropolitan Museum of Art.* New York, 1979.

Paust 1995
Paust, Bettina. *Studien zur barocken Menagerie im deutschsprachigen Raum.* Worms, 1995.

Pietsch 1996
Pietsch, Ulrich. *Johann Gregorius Höroldt 1696–1775 und die Meissener Porzellanmalerei.* Leipzig, 1996.

Pietsch 2000
Pietsch, Ulrich. *Schwanenservice—Meissener Porzellan für Heinrich Graf von Brühl 1700–1763.* Leipzig, 2000.

Pietsch 2001
Pietsch, Ulrich. *Preziosen aus einer süddeutschen Kunstsammlung.* Munich, 2001.

Pietsch 2002
Pietsch, Ulrich. *Die Arbeitsberichte des Meissener Porzellanmodelleurs Johann Joachim Kaendler 1706–1775.* Leipzig, 2002.

Pietsch 2011
Pietsch, Ulrich. *Early Meissen Porcelain: The Wark Collection from the Cummer Museum of Art & Gardens.* London, 2011.

Rafael 2009
Rafael, Johannes. "Zur 'Taxa-Kaendler.'" In *Keramos* 203/04 (2009), pp. 25–70.

Renner 1941
Renner, Anna Maria. *Die Kunstinventare der Markgrafen von Baden-Baden.* Bühl in Baden, 1941.

Richter 1926
Richter, Johannes (ed.). *Die Briefe Friedrichs des Großen an seinen vormaligen Kammerdiener Fredersdorf.* Berlin-Grunewald, 1926.

Ricketts 1971
Ricketts, Howard. *Objects of Vertu.* London, 1971.

Rolland 1863
Rolland, Abraham Auguste. *Lettres inédites de la Princesse Palatine.* Paris, 1863.

Rothschild 1979
Rothschild, Dorothy de. *The Rothschilds at Waddesdon Manor.* London, 1979.

Rückert 1990
Rückert, Rainer. *Biographische Daten der Meißener Manufakturisten des 18. Jahrhunderts.* Munich, 1990

Rühle 1886
Rühle, Friedrich. *Das deutsche Schäferspiel des 18. Jahrhunderts.* Diss. Halle an der Saale, 1886.

Sargentson 1996
Sargentson, Carolyn. *Merchants and Luxury Markets: The Marchands Merciers of Eighteenth-Century Paris.* London, 1996.

Savill 1991
Savill, Rosalind. *The Wallace Collection: French Gold Boxes.* London, 1991.

Schepkowski 2009
Schepkowski, Nina Simone. *Johann Ernst Gotzkowsky: Kunstagent und Gemäldesammler im friderizianischen Berlin.* Berlin, 2009.

Schmidt 1995
Schmidt, Ralf. "Die Schmucksteinsammlung des Meininger Herzogs Anton Ulrich (1687–1763)." In *Veröffentlichungen des Naturhistorischen Museums Schleusingen* 10 (1995), pp. 87–120.

Schmidt 1996
Schmidt, Ralf. "Achate und Jaspise aus dem Nahegebiet in der Dosensammlung des Meininger Herzogs Anton Ulrich." In "Festschrift für Alfred Peth zum 65. Geburtstag und 25 Jahre ehrenamtlicher Museumsleiter Idar-Oberstein." In *Heimat and Museum* 11 (1996), pp. 88–120.

Schroder 2009
Schroder, Timothy (ed.). *The Gilbert Collection at the Victoria and Albert Museum.* London, 2009.

Schütte 1997
Schütte, Rudolf-Alexander. *Die Kostbarkeiten der Renaissance und des Barock: Pretiosa und allerley Kunstsachen aus den Kunst- und Raritätenkammern der Herzöge von Braunschweig-Lüneburg aus dem Hause Wolfenbüttel.* Brunswick, 1997.

Schwarm-Tomisch 2000
Schwarm-Tomisch, Elisabeth. "Die 'Reichs Gräfl. Brühl. Verlassenschafft.' Die Porzellansammlung Heinrich Graf von Brühls im Nachlassverzeichnis von 1765." In Ulrich Pietsch. *Schwanenservice—Meissener Porzellan für Heinrich Graf von Brühl 1700–1763.* Leipzig, 2000, pp. 124–35.

Seelig 1980
Seelig, Lorenz. "Die Ahnengalerie der Münchner Residenz: Untersuchungen zur malerischen Ausstattung." In *Quellen und Studien zur Kunstpolitik der Wittelsbacher vom 16. bis zum 18. Jahrhundert.* Edited by Hubert Glaser. Munich, 1980, pp. 253–327.

Seelig 2007
Seelig, Lorenz. *Golddosen des 18. Jahrhunderts aus dem Besitz der Fürsten von Thurn und Taxis. Die Sammlung des Bayerischen Nationalmuseums im Thurn und Taxis-Museum Regensburg* (Catalogues of the Bayerisches Nationalmuseum, new version, 3), Munich, 2007.

Seelig 2013
Seelig, Lorenz. "Gold Box Production in Hanau: The Extended Workbench of Frankfurt and Its Trade Fair." In *Going for Gold: The Craftsmanship and Collecting of Gold Boxes.* Edited by Tessa Murdoch and Heike Zech. Brighton/Chicago/Toronto, 2013.

Seitler 1959
Seitler, Otto. "Email- and Porzellanmalereien des Christian Friedrich Herold." In *Keramos* 6 (1959), pp. 20–26.

Seyffarth 1960
Seyffarth, Richard. "Johann Ehrenfried Stadler, der Meister der Fächerchinesen." In *Keramos* 10 (1960), pp. 151–59.

Shirley 2013
Shirley, Pippa. "The Rothschilds as Collectors of Gold Boxes." In *Going for Gold: The Craftsmanship and Collecting of Gold Boxes.* Edited by Tessa Murdoch and Heike Zech. Brighton/Chicago/Toronto, 2013, pp. 223–39.

Slotta/Lehmann/Pietsch 1999
Slotta, Rainer, Gerhard Lehmann, and Ulrich Pietsch. *Ein fein bergmannig Porcelan: Abbilder vom Bergbau in "weißen Gold."* Bochum, 1999.

Snodin 2010
Snodin, Michael (ed.). *Horace Walpole's Strawberry Hill.* New Haven/London, 2010.

Snowman 1966
Snowman, Abraham Kenneth. *Eighteenth-Century Gold Boxes in Europe.* London, 1966.

Snowman 1974
Snowman, Abraham Kenneth. *Eighteenth-Century Gold Boxes of Paris: A Catalogue of the J. Ortiz-Patiño Collection.* London, 1974.

Snowman 1990
Snowman, Abraham Kenneth. *Eighteenth-Century Gold Boxes of Europe.* Woodbridge, 1990 (first edition: London, 1966).

Somers Cocks/Truman 1984
Somers Cocks, Anna, and Charles Truman. *The Thyssen-Bornemisza Collection: Renaissance Jewels, Gold Boxes and Objets de Vertu.* London/New York, 1984.

Sommer 2012
Sommer, Claudia. "Edle Gesteine in den Schlössern Friedrichs II. von Preussen." In *Friederisiko: Friedrich der Große. Die Ausstellung.* Exh. cat. Stiftung Preussische Schlösser und Gärten Berlin-Brandenburg, Neues Palais und Park Sanssouci, 28 April – 28 October 2012. Munich, 2012. Vol. 1: Die Ausstellung, pp. 186–88.

Stengel 1950
Stengel, Walter. *Märkisches Museum: Quellen-Studien zur Berliner Kulturgeschichte. Tabatieren.* Berlin no date [1950].

Syndram 1999
Syndram, Dirk. *Die Schatzkammer Augusts des Starken: Von der Pretiosensammlung zum Grünen Gewölbe.* Leipzig, 1999.

Syndram 2006a
Syndram, Dirk. *Die Juwelen der Könige: Schmuckensembles des 18. Jahrhunderts aus dem Grünen Gewölbe.* Munich/Berlin, 2006.

Syndram 2006b
Syndram, Dirk. "Zwischen Intimität und Öffentlichkeit—Pretiosenkabinette and Schatzkammern im Barock." In *Sammeln als Institution: Von der fürstlichen Wanderkammer zum Mäzenatentum des Staates.* Edited by Barbara Marx and Karl-Siegbert Rehberg. Munich/Berlin, 2006, pp. 93–100.

Syndram 2008
Syndram, Dirk. *Juwelenkunst des Barock: Johann Melchior Dinglinger im Grünen Gewölbe.* Munich, 2008.

Syndram 2012
Syndram, Dirk. "August der Starke and seine Kunstkammer zwischen Tagespolitik und Museumsvision." In *Die kurfürstlich-sächsische Kunstkammer in Dresden: Geschichte einer Sammlung.* Edited by Dirk Syndram and Martina Minning. Dresden, 2012, pp. 120–41.

Teuscher 1998
Teuscher, Andrea. *Die Künstlerfamilie Rugendas 1666–1858: Werkverzeichnis zur Druckgrafik.* Augsburg, 1998.

Tillmann 2009
Tillmann, Max. *Ein Frankreichbündnis der Kunst: Kurfürst Max Emanuel von Bayern als Auftraggeber und Sammler.* Berlin/Munich, 2009.

Trauth 2008
Trauth, Nina. "Der Gemäldebesitz der Markgräfin Sibylla Augusta von Baden-Baden." In *Extra schön: Markgräfin Sibylla Augusta und ihre Residenz; eine Ausstellung anlässlich des 275. Todestages der Markgräfin Sibylla Augusta von Baden-Baden.* Exh. cat. Schloss Rastatt mit Schlosskirche, 12 July – 21 September 2008. Petersberg, 2008, pp. 92–99.

Truman 1977
Truman, Charles. *French Gold Boxes: Victoria and Albert Museum.* London, 1977.

Truman 1991
Truman, Charles. *The Gilbert Collection of Gold Boxes.* Los Angeles, 1991.

Truman 1999
Truman, Charles. *The Gilbert Collection of Gold Boxes.* Vol. 2. London, 1999.

Truman 2013a
Truman, Charles. *The Wallace Collection: Catalogue of Gold Boxes.* London, 2013.

Truman 2013b
Truman, Charles. "From the Boîte à Portrait to the Tabatière: The Production of Gold Boxes in Paris." In *Going for Gold: The Craftsmanship and Collecting of Gold Boxes.* Edited by Tessa Murdoch and Heike Zech. Brighton/Chicago/Toronto, 2013, pp. 17–28.

Vehse 1970
Vehse, Eduard. *Berliner Hof-Geschichten: Preussens Könige privat.* Düsseldorf/Cologne, 1970.

Wallis 2013
Wallis, Rebecca. "The History of the Collecting and Display of the Gold Boxes and Objects of Vertu in the Wallace Collection." In Charles Truman. *The Wallace Collection: Catalogue of Gold Boxes.* London, 2013, pp. 349–57.

Walz 2004
Walz, Alfred. "Das Zeitalter des aufgeklärten Absolutismus (1735–1806)." In *Das Herzog Anton Ulrich-Museum und seine Sammlungen 1578–1754–2004.* Edited by Jochen Luckhardt. Munich, 2004, pp. 122–75.

Warren 2008
Warren, Jeremy. "The 4th Marquess of Hertford's Early Years as a Collector." In *Burlington Magazine* 150 (2008), pp. 544–47.

Watson 1970
Watson, Francis J.B. *The Wrightsman Collection: Furniture, Gold Boxes.* Vol. 3. New York, 1970.

Watson 1974
Watson, Francis J.B. "Preface." In Abraham Kenneth Snowman, *A Catalogue of Eighteenth Century Gold Boxes of Paris: The J. Ortiz Patiño Collection.* London, 1974.

Westgarth 2009
Westgarth, Mark. *A Biographical Dictionary of Nineteenth Century Antique and Curiosity Dealers.* Glasgow, 2009.

Wittwer 2004
Wittwer, Samuel. *Die Menagerie der Meissener Tiere: Die Menagerie Augusts des Starken für das Japanische Palais in Dresden.* Munich, 2004.

Yonan 2009
Yonan, Michael. "Portable Dynasties: Imperial Gift-Giving at the Court of Vienna in the Eighteenth Century." In *The Court Historian* 14, 2 (2009), pp. 177–88.

Zech 2010
Zech, Heike. "Gold Boxes in the Gilbert Collection: A Grand New Home for Small Scale Masterpieces." In *Art Antiques* (London, 2010), pp. 11–20.

Zedler 1732–54
Zedler, Johann Heinrich. *Grosses vollständiges Universal-Lexicon Aller Wissenschaften und Künste.* Halle/Leipzig, 1732–54.

Zedler 1743
Zedler, Johann Heinrich. *Grosses Universallexikon Aller Wissenschaften und Künste.* Leipzig/Halle, 1743.

Zimmermann 1788
Zimmermann, Ritter von. *Ueber Friedrich den Großen und meine Unterredungen mit ihm kurz vor seinem Tode.* Leipzig, 1788.

Index

Ador, Jean-Pierre (1724–1784)	p. 33
Ahlden, Princess of, see Sophie Dorothea	
Albert, Carl Gottlob (c. 1728–1772)	p. 92
Albin, Eleazar (1680–1741/42)	p. 92
Albrechtsburg (Meissen)	pp. 93, 169, 255, 276, 375
Anna Ivanovna, Tsarina of Russia (1693–1740)	pp. 82, 381
Andromeda	pp. 92, 364
Anhalt-Dessau, Duchess, see Johanna Charlotte	
Anton Ulrich, Duke of Saxony-Meiningen (1687–1763)	p. 40
Apollo	pp. 356, 359, 399
AR-monogram, see Augustus Rex-monogram	pp. 83, 88, 90, 96, 322, 324
Atalanta	pp. 82, 266, 267, 391
Aubert, Michel Guillaume (1700–1757)	p. 185
Audran, Benoît (1661–1721)	pp. 210, 213
Audran, Benoît II (1698–1672)	pp. 247, 367, 370
Audran, Claude III (1658–1734)	p. 90
August the Younger, Duke of Braunschweig und Lüneburg (1579–1666)	p. 46
Augustus the Strong (1670–1733), see Frederick August I, Elector of Saxony	
August II, King of Poland, and Elector of Saxony (1724–1768)	pp. 196, 229
August II, King of Poland (1670–1733)	pp. 32, 33, 34, 35, 36, 37, 72, 73, 75, 76, 78, 80, 81, 113, 121, 150
Augustus III, King of Poland (1697–1763), see Frederick August II, Elector of Saxony	
August II Christian, Duke of Pfalz-Zweibrücken (1746–1795)	p. 19
August Wilhelm, Duke of Braunschweig und Lüneburg (1662–1731)	p. 39
Augustus Rex-monogram	pp. 83, 88, 90, 96, 322, 324
Aveline, Pierre (1656–1722)	pp. 90, 239
Aveline, Pierre-Alexandre (1702–1760)	pp. 116, 210, 211, 348, 350, 367
Baden-Baden, Margarve, see Ludwig Georg Simpert (1702–1761)	p. 348
Baden-Baden, Markgravine, see Maria Anna Josefa Auguste	p. 348
Baden-Durlach, Markgravine, see Caroline Luise	pp. 40, 41
Baron, Bernard (1696–1726)	p. 346
Baudesson, Daniel (1716–1785)	p. 40
Baur, Johann Wilhelm (1607–1640)	pp. 87, 92, 162, 163, 205, 207, 208, 272, 273, 275, 331
Bavaria, Electress of, see Maria Amalie (1701-1756)	p. 348
Benserade, Isaac de (1612/13–1691)	p. 365
Bentinck, Margaret (1715–1785), 2nd Duchess of Portland	p. 32
Benz, Philipp Adam (1709-1749), merchant in Augsburg	p. 99
Bergmüller, Johann Georg (1688–1762)	p. 237
Bernal, Ralph (1783–1854)	pp. 58, 59
Biondi, Gian Francesco (1572–1644)	p. 234
Birckner, Gottlob Siegmund (1712–1771)	pp. 88, 91, 92, 196, 266, 395

Blendinger, Georg (1667–1741)	p. 23
Böcklin, Johann Christoph (1687–1712)	pp. 317, 319
boîte à portrait	pp. 12, 110, 111
boîtier	p. 24
Böttger, Johann Friedrich (1682–1719)	p. 73
Böttger porcelain	pp. 73, 74, 75, 121, 122, 124, 132
Böttger stoneware	pp. 6, 73, 74, 122, 124, 132, 153, 351
Boucher, François (1703–1770)	pp. 11, 90, 92, 189, 200, 201, 203, 225, 247, 269, 290, 299, 348, 349, 350, 351, 354, 356, 362, 363, 365, 367, 369, 370, 372
Bourbon, Louis de, Dauphin de France (1661–1711)	p. 36
Bourbon, Louise-Françoise-Marie de, Duchess of Orléans (1677–1749)	pp. 31, 78, 81
Bourbon, Louis-François de, Prince de Conti (1717–1776)	pp. 21, 31
Braunschweig und Lüneburg, Duke, see August Wilhelm	
Braunschweig und Lüneburg, Duchess, see Sophie Dorothea	
Brentano, Andreas, merchant in Dresden	pp. 384, 385, 387
Brion, Etienne (born 1729)	pp. 179, 247, 249
Brueghel, Jan (1568–1625)	p. 114
Brühl, Heinrich Count of (1700–1763)	pp. 45, 48, 53, 57, 66, 81, 82, 83, 84, 85, 88, 89, 91, 93, 95, 96, 97, 98, 214, 253, 291, 292, 322, 327, 333, 340, 382, 383, 384, 385, 387, 388, 391
Brühl, Maria Anna Franziska Countess of (1717–1762)	pp. 91, 387
Buyrette, Louis (died c. 1746/47), goldsmith and jeweller in Berlin	p. 40
Call, Jan van (1656–1703)	pp. 270, 271, 274, 275
Cambridge, Duke of, see George, Prince of Great Britain, Ireland, and Hanover	
Caprano, Andreas (merchant in Dresden)	pp. 98, 384, 385
Carl Theodor, Elector Palatine (Pfalz-Sulzbach; 1724–1799)	pp. 91, 347
Caroline Luise, Markgravine of Baden-Durlach (1723–1783)	pp. 40, 41
Carriera, Rosalba (1675–1757)	pp. 277, 279, 364, 402, 403
Cars, Laurent (1699–1771)	pp. 193, 215, 217, 238, 239
Castlereagh, Viscount (Robert Stewart, 2nd Marquess of Londonderry; 1769–1822)	pp. 54, 67
Catherine I, Tsarina of Russia (1684–1727)	p. 32
Catherine II the Great, Tsarina of Russia (1729–1796)	pp. 32, 33, 52, 53
Caylus, Anne-Claude-Philippe, Comte de (1692–1765)	p. 90
Chardin, Jean-Baptiste Siméon (1699–1779)	pp. 102, 104, 105, 107
Charles III, King of Two Sicilies (1716–1788)	p. 280
Charles IV., King of Spain (1748–1819)	p. 110
Charles V, King of Sicily and Naples (1716–1788)	p. 90
Charlotte, Queen of Great Britain and Ireland (1744–1818)	p. 56
Chladni, Samuel (1684–1753)	pp. 78, 80
Clauce, Isaak Jakob (1728–1803)	pp. 92, 93

Clemens August, Duke of Bavaria (1700–1761)	p. 336
Clemens XII, Pope, born Lorenzo Corsini (1652–1740)	p. 67
Cochin, Charles-Nicolas II (1715–1790)	pp. 90, 210, 213, 247, 248, 252
Cognacq, Ernest (1839–1928)	pp. 59, 60
Cognacq-Jay, Marie-Louise (1838–1925)	p. 60
Cole, Henry (1808–1882)	pp. 59, 68
Collaert, Jan (1561–1620)	p. 115
Colliveaux, Samuel (c. 1669–1736)	p. 38
Columbine	pp. 224, 227
Commedia dell'Arte	pp. 110, 111, 172, 224, 225, 236, 239, 240, 250, 261, 294, 344, 356
Connoisseur	pp. 53, 67, 102
contrefait box	p. 110
Count Brühl, see Brühl, Heinrich Count of	
Crepy, Louis (born 1680)	p. 198
Cupid	pp. 84, 92, 98, 132, 365, 402, 403
Cuvilliés, François the Elder (1695–1768)	p. 37
D'Aubigné, Françoise (1635–1719), Marquise de Maintenon	p. 110
Danaë	pp. 359, 361
Daphne	pp. 234, 399
Daullé, Jean (1703–1763)	pp. 362, 363
Daylus, J.	p. 203
Decker, Paul the Elder (1677–1713)	p. 10
Della Bella, Stefano (1610–1664)	p. 138
De Montebello, Philippe	p. 64
Desplaces, Louis (1682–1739)	pp. 338, 339
Diana	pp. 234, 310, 344, 362, 403
Diderot, Denis (1713–1784)	pp. 21, 27
Dietrich, Christian Wilhelm Ernst (1712–1774)	pp. 93, 299
Dietrich, Johann Georg (1684–1752)	p. 351
Dinglinger, Georg Christoph (1668–1746)	p. 385
Dinglinger, Georg Friedrich (1666–1720)	p. 95
Dinglinger, Johann Friedrich (1702–1767)	p. 40
Dinglinger, Johann Melchior (1664–1731)	pp. 33, 35, 344, 345
drageoir	p. 31
Dreesmann, Anton C. R. (1923–2000)	p. 61
Ducrollay, Jean (c. 1708–after 1776)	p. 62
Duflos, Claude-Augustin the Younger (1700–1786)	pp. 279, 367, 369, 370, 372
Dulong, Jean, merchant in Amsterdam	p. 383
Du Paquier, Claudius Innocentius (1679–1751)	p. 74
Dupuis, Charles the Elder (1685–1740)	pp. 196, 197
Dupuis, Nicolas Gabriel (1698–1771)	p. 197
Durlacher, Brothers (1850–1938, art dealers in London and New York)	p. 54
Duvaux, Lazare (1703–1758)	pp. 31, 46
Eberlein, Johann Friedrich (1696–1749)	pp. 11, 83, 84, 97, 389
Ehder, Johann Gottlieb (1717–1750)	pp. 82, 83, 84, 85, 96, 97, 98, 253, 333, 386, 390
Ehrlich, Carl Gottlob (c. 1744–1799)	p. 408

Elisabeth Auguste, Electress of Pfalz-Sulzbach (1721–1794)	pp. 37, 91, 99, 236, 347, 354
Elisabeth Charlotte, Princess of the Palatine (1652–1722)	p. 81
Elisabeth I, Tsarina of Russia (1709–1762)	pp. 13, 91
Eugen Franz, Prince of Savoyen-Carignan (1663–1736)	p. 81
Faun	p. 365
Filloeul, Pierre (1696–after 1754)	pp. 104, 107, 116, 194, 195, 239, 255
Five Senses	pp. 113, 117, 221, 237, 252
Fontane, Theodor (1819–1898)	pp. 21, 27
Frederick August, Crown Prince, see Frederick August II, Elector of Saxony	
Frederick August I, Elector of Saxony (1670–1733)	pp. 32, 33, 34, 35, 36, 37, 72, 73, 75, 76, 78, 80, 81, 113, 121, 150
Frederick August II, Elector of Saxony (1696–1763), also Augustus III, the Strong, King of Poland	pp. 36, 45, 72, 78, 82, 83, 88, 89, 90, 91, 96, 307, 322, 324, 343, 353, 381, 382, 383, 384, 385
Frederick August III, Elector of Saxony, known as the Just (1750–1827)	pp. 84, 98, 386
Frederick the Great, see Frederick II, King of Prussia	
Frederick II, the Great, King of Prussia (1712–1786)	pp. 21, 23, 37, 38, 39, 40, 52, 59, 60, 69, 102, 235, 261, 297, 299, 351, 356, 357
Frederick Wilhelm I, King of Prussia, Margrave of Brandenburg (1688–1740)	p. 37
Fredersdorf, Michael Gabriel (1708–1758)	p. 23, 39
Freemasons	pp. 73, 84, 94, 266, 336, 396, 398
French Revolution (1789–1799)	pp. 54, 94
Friesen, Heinrich Friedrich von (1681–1739)	p. 381
Fromery, Alexander	p. 144
Fromery, Charles (1685–1738)	p. 86
Funcke, Georg (dates unknown), goldsmith	p. 75
George IV., King of the United Kingdom of Great Britain and Ireland (1762–1830)	p. 56
George, Prince of Great Britain, Ireland, and Hanover, 2nd Duke of Cambridge (1819–1904)	pp. 57, 159
Gilbert, Rosalinde	pp. 62, 63, 64
Gilbert, Sir Arthur (1913–2001)	pp. 6, 52, 53, 62, 63, 64, 68, 69
Giles	pp. 172, 210, 253
Götz, Gottfried Bernhard (1708–1774)	pp. 220, 221, 236, 237
Goltzius, Hendrick (1558–1617)	p. 115
Gotzkowsky, Christian Ludwig (1697–1761)	p. 38
Gotzkowsky, Johann Ernst (1710–1775)	pp. 39, 93
goût Rothschild	pp. 56, 63
Grand Dauphin, see Bourbon, Louis de, Dauphin de France	
Grund, Johann Georg (1708–1781)	p. 117
Habsburg, see Maria Josepha	
Hainhofer, Philipp (1578–1647)	p. 46
Hamburger, art dealer	p. 57
Harlequin	pp. 110, 111, 114, 117, 170, 172, 194, 220, 224, 225, 227, 239, 261, 266
Hartwig, Justus Israel (1718–1772)	p. 298
Häuer, Bonaventura Gottlieb (1709–1782)	pp. 89, 90, 324, 325

Heinrici, Johann Martin (1711–1786)	pp. 68, 76, 91, 93, 343, 347, 353, 354
Heintze, Johann George (born c. 1706/07)	pp. 76, 82, 86, 87, 88, 147, 153, 155, 156, 162, 165, 166, 167, 170, 174, 175, 204, 205, 207, 210, 219, 220, 222, 229, 255, 258, 303, 307, 312, 313, 327, 328, 329, 330, 333, 334
Hentzschel, Christian Gottlob (1709–1761)	p. 393
Heresbach, Konrad (born 1496)	p. 115
Herold, Christian Friedrich (1700–1779)	pp. 76, 85, 86, 87, 130, 139, 140, 143, 144, 156, 157, 159, 160, 161, 169, 174, 327, 328
Hertford, Marquess, see Seymour, Francis Charles, and also see Seymour-Conway, Richard	
Herz, Johann Daniel the Elder (1693–1754)	p. 315
Heße, Joseph Annibal (1733–1773)	p. 403
Hessen-Darmstadt, Landgrave, see Ludwig VIII	
Hogarth, William (1697–1764)	p. 17
Hollar, Wenceslaus (1607–1677)	pp. 365, 366
Holzer, Johann Evangelist (1709–1740)	pp. 236, 237
Höroldt, Johann Gregorius (1696–1775)	pp. 74, 75, 76, 78, 80, 81, 82, 85, 117, 122, 123, 124, 125, 127, 128, 129, 130, 132, 133, 134, 139, 140, 141, 143, 150, 153, 156, 157, 168, 230, 351
Hübner, Johann Christoph (c. 1665–1739)	p. 35
Huquier, Gabriel (1695–1772)	pp. 90, 193, 194, 195, 225, 226, 252
Iliad	p. 94
Innamorata	pp. 170, 239
Irminger, Johann Jakob (1635–1724)	pp. 74, 75, 78, 122, 123, 124, 127, 132, 153
Japanese Palace, Dresden	pp. 72, 75, 81, 113, 117, 150, 151
Jeaurat, Edmé (1688–1738)	pp. 338, 339
Johanna Charlotte, Duchess of Anhalt-Dessau, Prince-Abbess of Herford (1682–1750)	p. 387
Jones, John (1798/99–1882)	pp. 59, 60, 63, 65, 69
Joseph II., Emperor of the Holy Roman Empire, King of Bohemia, Croatia, and Hungary (1741–1790)	p. 44
Joullain, François (1697–1778)	pp. 90, 184, 245
Julienne, Jean de (1686–1766)	p. 90
Jupiter	pp. 86, 361
Justice, Allegory of	pp. 82, 95, 383
Kaendler, Johann Joachim (1706–1775)	pp. 6, 11, 73, 81, 82, 83, 84, 85, 88, 92, 94, 95, 97, 98, 102, 104, 106, 108, 109, 110, 111, 114, 116, 144, 162, 174, 194, 214, 229, 261, 266, 291, 293, 307, 313, 322, 327, 328, 333, 335, 340, 351, 381
Karl Albrecht, Elector of Bavaria, see Karl VII, Emperor	
Karl Alexander, Duke of Lothringen (1712–1780)	p. 44
Karl VII, Emperor of the Holy Roman Empire, Elector and Duke of Bavaria (1697–1745)	pp. 37, 348
Kauffmann, Angelika (1741–1807)	pp. 94, 375, 376

Khevenhüller, Ludwig Andreas von (1683–1744), Austrian Field Marshal	pp. 293, 383
Kilian, Georg (1683–1745)	p. 365
Kircher, Athanasius (1602–1680)	p. 157
Kirchner, Johann Gottlieb (born 1706)	p. 113
Krahl, Christian Gottlieb	p. 406
Krüger, Jean Guillaume George (1728–1791)	p. 59
Kühnel, Christian Friedrich (1719–1792)	pp. 88, 89, 316, 407
Küsel, Melchior (1626–1683)	pp. 87, 162, 163, 205, 207, 208, 224, 272, 273, 275, 288, 330, 331, 334
Kupecky, Johann (1667–1740)	p. 23
La Fontaine, Jean de (1621–1695)	p. 301
La Rue, Louis Félix de (1731–1765)	pp. 348, 349, 350, 367
Laetitia	p. 398
Lancret, Nicolas (1690–1745)	pp. 171, 172, 177, 179, 196, 197, 200, 201, 220, 222, 223, 244, 245, 247, 248, 255, 257, 258, 261, 262
Larmessin, Nicolas III de (1640–1725)	pp. 90, 200, 201, 258
Larmessin, Nicolas IV de (1684–1755)	pp. 191, 245, 247, 248, 257
Lauren, André, see Lawrence, Andrew	
Lawrence, Andrew (1708–1748), aka. Laurent, André	pp. 200, 201
Le Bas, Jacques-Philippe (1707–1783)	pp. 90, 102, 104, 179, 199, 251, 252
Le Sueur, enamel painter (c. 1750)	p. 65
Le Tellier, François-Michel, Marquis de Louvois (1641–1691)	p. 18
Le Vau, Louis (1612–1670)	p. 113
Leclerc I, Sébastien (1637–1714)	pp. 365, 366
Leda	pp. 365, 366
Lehndorff, Ernst Ahasverus Heinrich Count of (1727–1811)	pp. 46, 53
Lemoyne, François (1688–1737)	p. 364
Lepautre, Jean (1618–1682)	pp. 214, 215
Lépiciés, François-Bernard (1698–1755)	p. 116
Lesgewang, Hans Caspar Count of (died 1729)	p. 80
Lindemann, Georg Christoph (c. 1735–1780)	p. 44
Lindner, Christian (1728–1806)	pp. 298, 299, 408
Lingelbach, Johannes (1622–1674)	pp. 162, 163, 165, 166
Linsky, Belle	pp. 60, 62, 64
Linsky, Jack	pp. 60, 62, 64
Liotard, Jean Michel (1702–1796)	pp. 255, 257
Liselotte von der Pfalz, see Elisabeth Charlotte, Princess of the Palatine	
Loehnig, Johann Georg (1743–1806)	p. 403
Löwenfinck, Adam Friedrich von (1714–1754)	pp. 76, 150, 151
Lothringen, Duke of, see Karl Alexander	
Louis XIV, King of France and Navarra (1638–1715)	pp. 12, 31, 36, 81, 110, 113, 225
Louis XV, King of France and Navarra (1710–1774)	pp. 12, 21, 31, 102, 104, 110, 111, 234, 277
Louis XVI, King of France and Navarra (1754–1793)	pp. 93, 110, 299
Ludwig Georg Simpert, Margrave of Baden-Baden (1702–1761)	p. 348
Ludwig VIII, Landgrave of Hessen-Darmstadt (1691–1768)	pp. 56, 58

Luise Ulrike, Princess of Prussia, Queen of Sweden (1720–1782)	p. 102
Machiavelli, Niccolo (1469–1527)	p. 18
Mack, Franz von (1730–1807)	pp. 45, 48
Madame de Montespan, see Rochechouart de Mortemart, Françoise-Athénaïs de	
Madame de Pompadour, see Poisson, Jeanne Antoinette	
Mann, Samuel Wilhelm (1726–1799)	p. 298
marchands merciers	pp. 31, 36, 37, 53, 54, 66
Maria Amalie Auguste, Countess Palatine von Zweibrücken-Birkenfeld-Bischweiler, Electress and Queen of Saxony (1752–1828)	pp. 84, 98
Maria Amalia Christina, Princess of Saxony (1724–1760)	pp. 90, 196, 280
Maria Amalie, Countess Mniszech (1736–1772)	p. 53
Maria Amalie, Electress of Bavaria (1701–1756)	p. 348
Maria Anna Josefa Auguste, Margravine of Baden-Baden (1734–1776)	p. 348
Maria Anna, Archduchess of Austria (1718–1744)	p. 44
Maria Josepha, born von Habsburg, Archduchess of Austria, Electress of Saxony (1699–1757)	pp. 36, 76, 78, 88, 90, 91, 196, 280, 307, 353
Maria Luisa, Princess of Parma, Queen of Spain (1751–1819)	pp. 110, 113
Maria Theresa, Empress of Austria, Queen of Hungary (1717–1780)	pp. 44, 48, 91
Marmontel, Jean François (1723–1799)	pp. 111, 117
Marquis de Louvois, see Le Tellier, François-Michel	
Marquise de Maintenon, see D'Aubigné, Françoise	
Marquise de Pompadour, see Poisson, Jeanne Antoinette	
Mary, Queen of the United Kingdom and British Dominions, Empress of India (1867–1953)	p. 60
Matham, Jacob (1571–1631)	pp. 359, 361
Matthaei, Christian Ferdinand (1750–1815)	p. 407
Maximilian I Joseph, King of Bavaria, born von Pfalz-Zweibrücken (1756–1825)	p. 19
Maximilian II Emanuel, Elector of Bavaria (1662–1726)	p. 36
Maximilian III Joseph, Elector of Bavaria (1727-1777)	p. 348
Medici, Catharina de (1519–1589)	p. 16
Medici, Cardinal de	pp. 272, 273
Meleager	pp. 82, 96, 384, 391
Menagerie	pp. 113, 117
Mengs, Anton Raphael (1728–1779)	pp. 91, 343
Mercier, Louis-Sébastien (1740–1814)	pp. 31, 32
Metamorphoses	pp. 92, 365
Monnoyer, Jean Baptiste (1636–1699)	pp. 289, 293
Mont Alto, Cardinal	p. 272
Montanus, Arnoldus (1625–1683)	p. 157
Montemayor, Jorge de (1520–1561)	p. 234
Montesquieu, see Secondat, Charles de	
Montezuma	p. 16
Montreux, Nicolas de (1561–1608)	p. 234
Morin, Adrian (c. 1727–1800)	pp. 43, 44
Moyreau, Jean (1690–1762)	pp. 205, 206, 207, 243
Müller, Johann Gottlob (1750–1794)	p. 408
Napoleonic Wars (1792–1815)	p. 53
Nicot, Jean (1530–1600)	p. 16

Nieuhof, Joan (1618–1672)	p. 78
Nilson, Johann Esaias (1721–1788)	pp. 266, 267, 268, 277, 279, 281, 284, 285, 329, 356
Nooms Zeeman, Reynier (1623–1663)	pp. 317, 320
objet de vertu	pp. 13, 31, 33, 39, 41, 46, 47
Odyssey	pp. 94, 375
Opitz, Martin (1597–1639)	p. 234
Order of the Pug	pp. 67, 84, 336
orfèvre bijoutier	p. 18
Orléans, Duke of, see Philipp II	
Ortiz-Pantiño, Jimmy	p. 60
Ovid, Publius Ovidius Naso (43 BC – 17 AD)	pp. 92, 266, 365, 388, 392, 394, 395, 396, 397, 401, 403, 404, 406, 407
Palatinc, Elector, see Carl Theodor	
Palatine, Princess, see Elisabeth Charlotte	
Pan	pp. 182, 185, 186, 334, 365
Pane, Romano	p. 16
Parma, Princess of, see Maria Luisa	
Pater, Jean Baptiste François (1695–1736)	pp. 194, 195, 220, 236, 238, 239, 255, 261, 264, 269, 294
Pécheux, Laurent (1729–1821)	pp. 110, 113
Penelope	pp. 94, 375
Perseus	pp. 92, 359, 364
Pesne, Antoine (1683–1757)	pp. 234, 235, 344, 345, 356
Peter I the Great, Tsar of Russia (1672–1725)	pp. 32, 47
Pfalz-Sulzbach, Electress of, see Elisabeth Auguste	
Pfalz-Zweibrücken, Duke, see August II Christian	
Pfalz-Zweibrücken, see Maximilian I. Joseph	
Pfautz, Jonathan Gottfried (1687–1760)	p. 133
Philipp II, Duke of Orléans (1674–1723)	p. 31
Philip V, Duke of Anjou, King of Spain (1683–1746)	p. 110
Picart, Bernard (1673–1733)	p. 135
Pigtail style	pp. 93, 94
Poisson, Jeanne Antoinette (1721–1764), Marquise de Pompadour	pp. 21, 31, 57, 61, 67, 236
Polish Order of the White Eagle	pp. 80, 109
Polo, Marco (1254–1324)	p. 78
Pomona	p. 354
poudre de la reine	p. 16
Preussen, Princess, see Luise Ulrike	
Punct, Johann Gotthelff (1729–1803)	p. 407
Rader, August Wolfgang (died 1737), silver jeweller in Augsburg	pp. 99, 384
Rappé (type of tobacco)	pp. 96, 382, 383
Ravenet, Simon François (1706–1774)	pp. 90, 220, 236, 261, 264, 294
Reinhard, Johann David (born c. 1684)	p. 80
Reinicke, Peter (1711/15–1768)	pp. 83, 97, 389
Ricci, Matteo (1552–1610)	p. 78
Richter, Hieronymus Christian (1721–1776)	p. 397

Ridinger, Johann Elias (1698–1767)	pp. 87, 215, 303, 305, 307, 308, 309, 310, 311, 312, 314, 315, 316
Ritter von Lang, Karl Heinrich (1764–1835)	p. 21
Rochechouart de Mortemart, Françoise-Athénaïs de (1640–1707), Marquise de Montespan	p. 81
Rode, Christian Bernhard (1725–1797)	p. 25
Rotari, Pietro Count (1707–1762)	pp. 91, 353
Rothschild, Alice de (1847–1922)	pp. 56, 57, 59
Rothschild, Edmond de (1845–1933)	p. 57
Rothschild, Ferdinand de (1839–1898)	pp. 56, 57
Roucel, Louis (died 1787)	p. 61
Rousseau, Jean Jacques (1712–1778)	p. 94
Rubens, Peter Paul (1577–1640)	pp. 114, 365, 366
Rugendas, Georg Philipp the Elder (1666–1742)	pp. 56, 88, 317, 319, 321
Russia, Tsar, see Peter I the Great	
Russia, Tsarina, see Anna Ivanovna, see Catherine I, see Catherine II the Great, see Elisabeth I	
Ryland, William Wynne (1732–1783)	p. 375
Saxony, Queen, see Maria Amalie Auguste	
Saxony, Elector, see Frederick August III	
Saxony, Electress, see Maria Josepha	
Saxony, Electress, see Maria Amalie Auguste	
Saxony, Electress, see Maria Josepha	
Saxony, Princess, see Maria Amalia Christina	
Saxony-Meiningen, Duke, see Anton Ulrich	
Saxony-Poland, Elector, see Xaver	
Saint-Aubin, Augustin de (1736–1807)	p. 354
Savoyen-Carignan, Prince, see Eugen Franz	
Scaramouche	p. 240
Scheffler, Johann Christian (1718–1780)	p. 405
Schindler, Philipp Ernst Junior (1727–1793)	pp. 91, 351
Schindler, Philipp Ernst Senior (1694–1765)	pp. 76, 91, 131, 134, 135, 136, 137, 138, 170, 172, 204, 205, 207, 210, 214, 215, 220, 230, 232, 330, 334, 403
Silesian Wars (1740–42 and 1745)	pp. 89, 322
Schmidt, Albrecht (1667–1744)	pp. 105, 107
Schmidt, Georg Friedrich (1712–1775)	pp. 257, 258, 261, 262
Schmidt, Johann Gottfried (born 1750)	p. 407
Schneider, Carl Gottlob (1726–1781)	p. 407
Schütz, Heinrich (1585–1672)	p. 234
Schütze, Johann Carl (1723–1793)	p. 406
Schulz Codex	pp. 122, 127, 143, 225
Swan Service	pp. 81, 253
Scotin, Gérard Jean-Baptiste (1698–1755)	pp. 90, 170, 173, 180, 183, 198, 230, 240, 241, 252, 253
Secondat, Charles de, Baron de Montesquieu (1689–1755)	p. 94
Semele	p. 86
Seuter, Bartholomäus (1678–1754)	pp. 74, 121
Seymour, Francis Charles, 3rd Marquess of Hertford (1777–1842)	p. 57

Seymour-Conway, Richard, 4th Marquess of Hertford (1800–1870)	p. 57
Sibylla Augusta, Margravine of Baden-Baden (1675–1733)	pp. 40, 48
Seven Years' War (1756–1763)	pp. 53, 92, 261, 282, 297, 299
Silvestre, Israël (1621–1691)	p. 365
Simon, Jean (1675–1754)	pp. 255, 257
Sophie Dorothea, Duchess of Braunschweig und Lüneburg, Princess of Ahlden (1666–1726)	p. 234
Sophie Dorothea, Queen of Preussen, born of Braunschweig-Lüneburg (1687–1757)	pp. 23, 37, 38
Stadion zu Thann und Warthausen, Anton Heinrich Friedrich Count of (1691–1768)	p. 27
Stadler, Johann Ehrenfried (1701–1741)	pp. 76, 148
style rocaille	p. 93
Sulkowski, Alexander Joseph, Count (1695–1762)	p. 82
Sulkowski-Ozier	p. 95
Surugue, Louis (1686–1762)	pp. 253, 254
Syrinx	pp. 92, 365
Tardieu, Nicolas Henri (1674–1749)	pp. 171, 172, 220, 222, 223, 233
Taste, Allegory of	p. 114
Telemachus	pp. 94, 375, 376
Thiele, Carl Gottlieb (1741–1811)	p. 406
Thomassin, Simon Henri (1687–1741)	pp. 90, 186, 187
Thurn und Taxis, Carl Anselm Prince of (1733–1805)	pp. 41, 43, 44
Tiebel, Johann Gottlieb (1750–1796)	p. 408
Tischbein, Johann Heinrich (1722–1789)	p. 27
Töpfer, Johann Justus (c. 1713–1777)	p. 91
Uffenbach, Johann Friedrich Armand von (1687–1769)	p. 39
Untermyer, Irwin	p. 110
Van Blarenberghe, Family	p. 56
Van der Straet, Jan (1523–1605)	p. 115
Venus	pp. 270, 354, 362, 402
Vernet, Claude Joseph (1714–1789)	p. 408
vernis Martin	pp. 31, 39, 44
vernis noir	p. 31
Vertumnus	p. 354
Vienna, Congress of (1814–15)	p. 54
Vogel, Bernhard (1683–1737)	p. 123
Wackerbarth, August Christoph Count of (1662–1734)	pp. 78, 80, 96
Wackerbarth-Salmour, Joseph Anton Gabaleon of (1685–1761)	pp. 96, 98, 381, 384, 385, 386
Wagner, Johann Jacob (1710–1797)	pp. 91, 92, 236, 277, 294, 317, 348, 351, 362, 364, 398
Wahnes, Heinrich Christian (c. 1700–1782)	pp. 92, 404

Wallace, Sir Richard (1819–1890)	p. 57
Walpole, Horace (1717–1797)	pp. 32, 46, 55
Watteau, Jean-Antoine (1684–1721)	pp. 11, 72, 82, 90, 91, 92, 96, 170, 173, 177, 179, 180, 182, 183, 184, 185, 186, 187, 189, 191, 193, 194, 195, 196, 198, 199, 200, 203, 205, 206, 207, 210, 211, 213, 215, 217, 225, 226, 230, 233, 236, 238, 239, 240, 241, 243, 244, 247, 248, 249, 250, 251, 252, 253, 254, 255, 257, 266, 268, 274, 280, 282, 330, 333, 334, 335, 338, 339, 343, 344, 346, 351, 385, 395, 396, 397
Wegely, Wilhelm Kaspar (1714–1764)	p. 92
Weinmann, Johann Wilhelm (1683–1741)	p. 92
Weise, Johann Jacob Junior	p. 404
Weise, Johann Jacob Senior	p. 403
Wertheimer, Samson (1811–1892)	p. 54
Wiebel, Johann Christian Senior (1719–1788)	p. 405
Wilson, Harriet	p. 68
Winckelmann, Johann Joachim (1717–1768)	pp. 93, 299
Wolff, Jeremias (1663–1724)	p. 21
Wrangel, Carl Gustav (1613–1676)	p. 46
Wratislaw, Franz Karl, Count (died 1750)	p. 386
Wrightsman, Charles B. (1895–1986)	p. 60
Wrightsman, Jayne (born 1919)	p. 60
Wüst, Johann Leonard (c. 1665–1735)	p. 21
Xaver, Elector of Saxony-Poland (1730–1806)	p. 23
Xavery, Gérard-Joseph (1700–1747)	pp. 224, 225, 227
Zijlvelt, Anthony van (1637–1695)	pp. 162, 163, 165, 166
Zweibrücken-Birkenfeld-Bischweiler, Countess Palatine, see Maria Amalie Auguste	

Image Credits

Fig. I.1:
The National Gallery, London

Fig. I.2:
Bpk / Nationalgalerie, SMB / photograph: Bernd Kuhnert

Figs. I.3, VI.6, VI.33, VI.34, VI.35, VI.37, VI.60, VI.68, VI.71, VI.73, VI.74, VI.77, VI.78, VI.81, VI.82, VI.83, VI.84, VI.100, VI.101, VI.102, VI.103, VI.121, VI.123:
Herzog Anton Ulrich-Museum Braunschweig, Brunswick, Kunstmuseum des Landes Niedersachsen, photograph: museum

Figs. I.4, I.5, VI.22, VI.46, VI.56, VI.59, VI.64
Bibliothèque des Arts décoratifs, Paris, Collection Maciet

Fig. I.6:
Ursula Edelmann / ARTOTHEK

Figs. II.1, II.2, VI.110:
Photograph © The State Hermitage Museum / photographs: Vladimir Terebenin, Leonard Kheifets, Yuri Molodkovets

Figs. II.3, II.4:
Grünes Gewölbe, Staatliche Kunstsammlungen Dresden, photograph: Jürgen Karpinski

Fig. II.5:
Munich, Bayerische Verwaltung der Staatlichen Schlösser, Gärten und Seen, Schatzkammer der Residenz

Fig. II.6:
Property of the House Hohenzollern SKH Georg Friedrich Prinz von Preussen, SPSG, photograph: Hans Bach

Fig. II.7:
© Bayerisches Nationalmuseum, Munich, inv. no. 93/214-268

Figs. II.8, VI.52, VI.75:
© MAK

Figs. III.1, III.2, III.3, III.4, III.5, III.8, III.9, IV.23:
© Victoria and Albert Museum, London

Fig. III.6:
The Rothschild Collection (The National Trust), bequest of James de Rothschild, 1957; acc. no. 676, photograph: Mike Fear © The National Trust, Waddesdon Manor

Fig. III.7:
Trustees of The Wallace Collection, London

Fig. III.10:
Thyssen-Bornemisza Collections

Figs. IV.1, V.11, V.13, VI.97, VI.98, VI.112, VI.113, VI.114, VI.115, VI.116, VI.120:
bpk / The Metropolitan Museum of Art, New York

Fig. IV.2:
Private collection

Fig. IV.4:
Porcelain collection, Staatliche Kunstsammlungen Dresden, photograph: Elke Estel / Hans-Peter Klut

Fig. IV.10:
Porcelain collection, Staatliche Kunstsammlungen Dresden, photograph: Hans-Peter Klut

Figs. V.17, VI.4, VI.5:
Porcelain collection, Staatliche Kunstsammlungen Dresden, photograph: Jürgen Karpinski

Fig. VI.6:
Collection musée de l'Île-de-France, Sceaux, photograph: Pascal Lemaître

Fig. IV.11:
bpk, Staatliches Museum Schwerin, photograph: Gabriele Bröcker

Fig. IV. 12:
Museum Aschenbrenner, Garmisch-Partenkirchen

Fig. IV.13:
Porcelain collection, Staatliche Kunstsammlungen Dresden

Fig. IV.17:
© Bayerisches Nationalmuseum, Munich, inv. no. ES 2185

Fig. IV.19:
Landesmuseum Württemberg, Stuttgart, photograph:
P. Frankenstein, H. Zwietasch

Figs. V.1, V.7, V.9, V.14:
Collection Pauls-Eisenbeiss

Figs. V.2, V.5, VI.21, VI.23, VI.39, VI.48, VI.55, VI.57, VI.58, VI.70, VI.80, VI.122, VI.124, VI.125, VI.126, VI.127:
The Trustees of the British Museum, London

Fig. V.3:
Photograph © Erik Cornelius / Nationalmuseum, Stockholm

Fig. V.6:
Meissen, Porzellan-Manufaktur, archive, inv. no. VA 1885/2

Fig. V.12:
Meissen, Porzellan-Manufaktur, archive, inv. no. VA 1553

Figs. V.15, V.16:
Herzog August Bibliothek, Wolfenbüttel

Fig. VI.1:
© Bayerisches Nationalmuseum, Munich, inv. no. ES 102,
photograph: Walter Haberland

Fig. VI.2:
© Staatliche Kunsthalle Karlsruhe, Kupferstichkabinett

Fig. VI.3:
© Grassi Museum für Angewandte Kunst, Leipzig

Figs. VI.7, VI.8, VI.9, VI.76, VI.79, VI.118:
Collection Rijksmuseum, Amsterdam

Figs. VI.10, VI.12, VI.31, VI.32, VI.42, VI.44, VI.49, VI.51, VI.53. VI.54, VI.66, VI.67, VI.85, VI.86, VI.87, VI.89, VI.90, VI.91, VI.92, VI.93, VI.94, VI.95, VI.99:
Kupferstichkabinett, Staatliche Kunstsammlungen Dresden,
photograph: Herbert Boswank

Figs. VI.11, VI.14, VI.15, VI.17, VI.19, VI.27, VI.36, VI.61, VI.62, VI.63, VI.65, VI.105, VI.106, VI.107, VI.108, VI.109, VI.111:
Bibliothèque nationale de France, Paris

Fig. VI.13:
Musée d'art et d'histoire, Geneva, Cabinet d'arts graphiques,
inv. no. E 2011–52, photograph: André Longchamp

Figs. VI.16, VI.20, VI.25, VI.26:
SLUB Dresden / Deutsche Fotothek / Regine Richter

Fig. VI.18:
Musée d'art et d'histoire, Geneva, Cabinet d'arts graphiques,
inv. no. E 2011–108, photograph: André Longchamp

Fig. VI.24:
Musée d'art et d'histoire, Geneva, Cabinet d'arts graphiques,
inv. no. E 2012–0528, photograph: MAH-CdAG

Fig. VI.28:
Musée d'art et d'histoire, Geneva, Cabinet d'arts graphiques,
inv. no. E 2012–529/2, photograph: André Longchamp

Fig. VI.29:
Musée d'art et d'histoire, Geneva, Cabinet d'arts graphiques,
inv. no. E 2011–104, photograph: André Longchamp

Fig. VI.30:
Meissen, Staatliche Porzellan-Manufaktur, archive,
inv. no. VA 2258-3

Fig. VI.38:
Musée d'art et d'histoire, Geneva, Cabinet d'arts graphiques, inv. no. E 2012–609, photograph: André Longchamp

Fig. VI.40:
Musée d'art et d'histoire, Geneva, Cabinet d'arts graphiques, inv. no. E 2011–0104, photograph: André Longchamp

Fig. VI.43:
Musée d'art et d'histoire, Geneva, Cabinet d'arts graphiques, inv. no. E 2011–105, photograph: André Longchamp

Fig. VI.45:
Meissen, Staatliche Porzellan-Manufaktur, archive, inv. no. VA 4285

Fig. VI.47:
Music and Theatre Museum, Stockholm

Fig. VI.50:
Stiftung Preussische Schlösser und Gärten Berlin-Brandenburg / photo archive, Jörg P. Anders

Fig. VI.69:
Musée d'art et d'histoire, Geneva, Cabinet d'arts graphiques, inv. no. E 2011–54, photograph: André Longchamp

Fig. VI.88:
Pauls-Eisenbeiss Foundation, photograph: Jürgen Karpinski

Fig. VI.96:
Kunstsammlung der Veste Coburg

Fig. VI.117:
Landesmuseum Hannover / ARTOTHEK, Hanover

Fig. VI.119:
Stadtgeschichtliches Museum Leipzig

Fig. VI.128:
Amherst, Mass., Mead Art Museum, Amherst College, museum purchase

Acknowledgements

For commitment and support of this project our thanks go especially to

Sarah-Katharina Acevedo
Dr. Barbara Beaucamp-Markowsky
Claudia Bodinek
Dr. Peter Braun
Sylvia Braun
Kirsten Brünjes
Dr. Eva Dewes
Christoph Görke
Christian Mitko
John Nicholson
Roderick O'Donovan
Anna Ostermeier
Dr. Hans Ottomeyer
Dr. Ulrich Pietsch
Michael Röbbig-Reyes
Dr. Lorenz Seelig
Alix Sharma-Weigold
Livia Surovcikova
Andreas Unsöld
Helen Warren
Dr. Heike Zech

RÖBBIG · MÜNCHEN

Early German Porcelain & Eighteenth-Century Art,
Furniture, and Objets d'Art

Briennerstrasse 9 | 80333 Munich

Tel. +49 89 29 97 58 | Fax +49 89 22 38 22

E-Mail: info@roebbig.de

Web: www.roebbig.de

Illustration on Frontispiece

Johann Heinrich Tischbein (1722–1789),
*Portrait of Countess Marianne Schall von Bell,
née Countess Stadion*, private collection

Concept

Alfredo Reyes

Project Direction

Sarah-Katharina Acevedo

Authors

Sarah-Katharina Acevedo (SKA), Barbara Beaucamp-Markowsky,
Hans Ottomeyer, Ulrich Pietsch (UP), Michael Röbbig-Reyes (MR),
Lorenz Seelig, Heike Zech

Index

Alix Sharma-Weigold

Editing

Sarah-Katharina Acevedo, Eva Dewes

Copyediting

Alix Sharma-Weigold

Translation of German Texts

Roderick O'Donovan, John Nicholson, Helen Warren

Photography

Christian Mitko

Layout and Lithography

Mediengruppe Universal, Munich

Printing and Binding

Mediengruppe Universal, Munich

978-3-7774-2137-7 (English edition)

© RÖBBIG · MÜNCHEN

HIRMER VERLAG, MUNICH

2013 Printed in Germany